Oil Paintings in Public Ownership in
County Durham

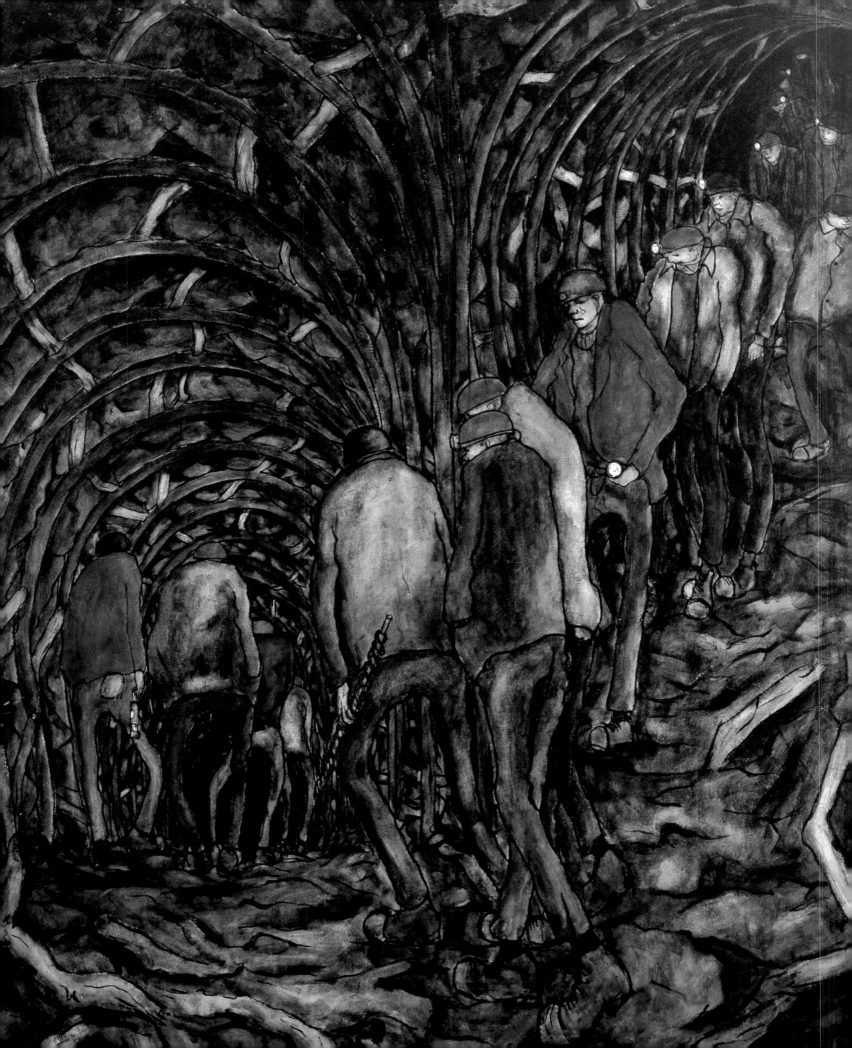

Oil Paintings in Public Ownership in County Durham

The Public Catalogue Foundation

Andrew Ellis, Director
Sonia Roe, Editor
Sally Pelham, County Durham Coordinator
Norman Taylor, Photography

Cover image:

El Greco 1541–1614
The Tears of St Peter (detail), c.1580–1589
The Bowes Museum, (p. 51)

Image opposite title page:

McGuinness, Tom 1926–2006
Miners in the Return (detail)
Darlington Borough Art Collection, (p. 241)

Back cover images (from top to bottom):

Sassetta 1395–1450
The Miracle of the Holy Sacrament, c.1423–1426
The Bowes Museum, (see p. 155)

Zurbarán, Francisco de 1598–1664
Zebulun V
Auckland Castle, (see p. 223)

Trevelyan, Julian 1910–1988
Lot, France, 1969
Durham University, (see p. 317)

Christie's is proud to be the sponsor of The Public Catalogue Foundation in its pursuit to improve public access to paintings held in public collections in the UK.

Christie's is a name and place that speaks of extraordinary art. Founded in 1766 by James Christie, the company is now the world's leading art business. Many of the finest works of art in UK public collections have safely passed through Christie's, as the company has had the privilege of handling the safe cultural passage of some of the greatest paintings and objects ever created. Christie's today remains a popular showcase for the unique and the beautiful.
In addition to acquisition through auction sales, Christie's regularly negotiates private sales to the nation, often in lieu of tax, and remains committed to leading the auction world in the area of Heritage sales.

CHRISTIE'S

Fedden 1979

Contents

Facing page: Fedden, Mary, b.1915, *Red Cupboard* (detail), 1979, Durham University, (p. 297)

Foreword

If there is something faintly un-English about County Durham it starts with its very name, with its faint hint of the celtic. For the Southerner too, the remote moor on the high Durham hill is strange though beautiful to the eye. This sense of difference is reinforced for the fortunate by a visit to the Zurbarán paintings at Auckland Castle, the Bishop's Palace in Bishop Auckland which, to my intense pleasure, are included in this catalogue though they, as well as all the other paintings at Auckland Castle, are not in our normal sense public works of art. We are extremely grateful to both the Church Commissioners and to the Bishop of Durham for allowing us to include these and the other paintings in the Castle. Beyond this, the existence of a gallery containing the largest collection of French paintings outside France, built as a French chateau on the outskirts of Barnard Castle, emphasizes the distinctiveness of this county even further.

The Bowes of course is more than just a collection of French paintings. It is a Northern version, perhaps, of the Wallace Collection displaying a wide range of fine art. The paintings though are the Foundation's concern and it is impossible to avoid concluding that the collection is extraordinary. The paintings are not exclusively French. There is a substantial Spanish collection, including the El Greco on the front of this Catalogue. The French paintings however represent what must have been at the time the Bowes collected them, an unpopular period of French art, covering as it does the Napoleonic era. I sense that this period has not become obviously popular in the century and a half since and it is therefore to the enormous credit of the curators of this collection that they continue to attract such large numbers of visitors to this remote attraction. There is much to wonder at on the well-covered walls of the gallery but for me, discovering that Joséphine Bowes herself was a better landscape painter than her reputation suggests, was a particularly happy discovery.

I have visited the Zurbaráns several times and have found them on every occasion, ever more breathtaking. It is wonderful that they will continue to be with us. But the wonders of County Durham do not end there. The Castle in Durham itself, now part of Durham University, both architecturally and for the paintings it contains, is perhaps even more astonishing yet – as this catalogue illustrates. For me, though a particular pleasure in the University's collection is a luminous portrait by a once-popular and highly successful Victorian painter, Lowes Cato Dickinson, a contemporary and friend of Millais, and close to the Pre-Raphaelite brotherhood. A wonderfully skilful painter, I have seen curiously little of his work in my perambulations.

So, my thanks to all those who have made this catalogue possible and in particular to Ian and Kate Bonas, who have shown strong support for the work of the Foundation since its beginning. I am enormously grateful to Lady Nicholson for her hard work, Norman Taylor for his contribution, and, of course, to our County Coordinator Sally Pelham; County Durham is her third catalogue to date. Our gratitude also extends to our generous funders, and in particular The Northern Rock Foundation and Renaissance North East.

Fred Hohler, Chairman

Preface

As Chair of Renaissance North East, I am delighted that we have been able to support the publication of the Public Catalogue Foundation's volume for County Durham. It has resulted in the research, documentation and digitisation of these important collections, followed by their publication in an accessible way that will feed the appetites of art lovers, academics and educationalists, alike.

This is the second PCF volume for the North East of England. The first covered the collections of Tyne & Wear Museums (2008) and a subsequent volume will cover the rest of the region including other Tyne and Wear collections, Northumberland and the Tees Valley. These three volumes will represent, collectively, the complete asset of oil paintings in public ownership across this great region.

Of the County Durham collections, best known, of course, is The Bowes Museum, an extraordinary French-style chateau nestling in the Durham countryside just outside Barnard Castle. The Museum's historic European painting collection is quite simply one of the richest in Britain and includes renowned works by El Greco, Goya, Boudin, Courbet, Monticelli and Canaletto. British artists represented include Gainsborough, Reynolds and Richard Wilson.

Other museums hold smaller collections, but perhaps County Durham is characterised by the number of important collections held in other types of public institution: The Durham University colleges hold important collections, whilst local councils own and display Norman Cornish's poignant paintings of only recently lost industrial landscapes; and of course there are the Zurbarán paintings at Auckland Castle.

This PCF volume for County Durham, like many of its predecessors, will impress and surprise its readers with the sheer quality and diversity of work in the public domain. Most importantly, it will facilitate and promote access to this resource for a much wider audience.

I would like echo Fred Hohler's thanks to the many people who have made this volume possible, particularly Sally Pelham and Kate and Ian Bonas. I would also like to thank The Bowes Museum which acted as lead partner and my colleagues at Tyne & Wear Museums who have supported the Renaissance North East contribution. Finally, of course, we must thank the Public Catalogue Foundation and, in particular, Fred Hohler for his vision, belief and single-minded determination to ensure that the enormous and incomparable resource that is Britain's distributed public collection of paintings will be accessible to all of us.

Alec Coles, Chair, Renaissance North East

The Public Catalogue Foundation

The Public Catalogue Foundation is a registered charity. It is publishing a series of illustrated catalogues of all oil paintings in public ownership in the United Kingdom.

The rationale for this project is that whilst the United Kingdom holds in its public galleries and civic buildings arguably the greatest collection of oil paintings in the world, an alarming four in five of these are not on view. Furthermore, few collections have a complete photographic record of their paintings let alone a comprehensive illustrated catalogue. In short, what is publicly owned is not publicly accessible.

The Public Catalogue Foundation has three aims. First, it intends to create a complete record of the nation's collection of oil, tempera and acrylic paintings in public ownership. Second, it intends to make this accessible to the public through a series of affordable catalogues which will later go online. Finally, it aims to raise funds for the conservation and restoration of paintings in participating collections through the sale of catalogues by these collections.

Collections benefit substantially from the work of the Foundation not least from the digital images that are given to them for free following photography and the increased recognition that the catalogues bring. These substantial benefits come at no financial cost to the collections. The Foundation is funded by a combination of support from individuals, companies, the public sector and charitable trusts.

Financial Supporters

The Public Catalogue Foundation would like to express its profound appreciation to the following organisations and individuals who have made the publication of this catalogue possible.

Donations of £10,000 or more

Northern Rock Foundation

Donations of £5,000 or more

Friends of The Bowes Museum

Renaissance North East

Donations of £1,000 or more

Mr Ian Bonas
Brewin Dolphin Ltd
Sir Tom Cowie, OBE
The Viscount Eccles, CBE
The Sir James Knott Trust
MLA North East
Stavros Niarchos Foundation

Sir Paul & Lady Nicholson
P. F. Charitable Trust
The Pilgrim Trust
The Shears Foundation
Mr Simon Still
Mr Michael Stone
The Hon. H. F. C. Vane

Other Donations

Richard & Jane Abram
Addisons of Barnard Castle,
 Auctioneers and Valuers
Valerie Ayton
A. J. & P. Betterton
The Isaac & Alan Berriman Memorial
 Trust
Mrs Ian Bonas
Sir David & Lady Chapman
Mr & Mrs R. L. Coad
Elizabeth Conran
Mr J. F. Cooke-Hurle
Professor John Gaskin
David J. Hall

Mr & Mrs R. Howell
Mr & Mrs Anthony Iremonger
Richard Lacey
J. C. Lumsden
Frank & Lavinia Nicholson
Oliver & Janet Pickering
Mrs S. J. Pollard
Professor P. J. Rhodes
Mr & Mrs N. D. B. Straker
Stephan & Lesley Taylor
Mr N. F. Tennant
Mr & Mrs Richard Tonks
A. J. & M. P. Wilks
Mr & Mrs Jonathan Trower

National Supporters

The Bulldog Trust
The John S. Cohen Foundation
Covent Garden London
Marc Fitch Fund
R. K. Harrison
Hiscox plc
The Monument Trust

National Gallery Trust
Stavros Niarchos Foundation
P. F. Charitable Trust
The Pilgrim Trust
The Bernard Sunley Charitable
 Foundation
Garfield Weston Foundation

National Sponsor

Christie's

Acknowledgements

The Public Catalogue Foundation would like to thank the individual artists and copyright holders for their permission to reproduce for free the paintings in this catalogue. Exhaustive efforts have been made to locate the copyright owners of all the images included within this catalogue and to meet their requirements. Copyright credit lines for copyright owners who have been traced are listed in the Further Information section.

The Public Catalogue Foundation would like to express its great appreciation to the following organisations for their kind assistance in the preparation of this catalogue:

Bridgeman Art Library
Flowers East
Marlborough Fine Art
National Association of Decorative & Fine Arts Societies (NADFAS)
National Gallery, London
National Portrait Gallery, London
Royal Academy of Arts, London
Tate

The participating collections included in this catalogue would like to express their thanks to the following organisations which have so generously enabled them to acquire paintings featured in this catalogue:

Contemporary Art Society
Durham County Council
The Friends of Beamish
The Friends of The Bowes Museum
Heritage Lottery Fund (HLF)
National Arts Collection Fund (The Art Fund)
The National Heritage Memorial Fund
The Prism Fund
The Trustees of The Bowes Museum
The Victoria and Albert Museum Purchase Grant Fund

Catalogue Scope and Organisation

Medium and Support

The principal focus of this series is oil paintings. However, tempera and acrylic are also included as well as mixed media, where oil is the predominant constituent. Paintings on all forms of support (e.g. canvas, panel, etc.) are included as long as the support is portable. The principal exclusions are miniatures, hatchments or other purely heraldic paintings and wall paintings *in situ*.

Public Ownership

Public ownership has been taken to mean any paintings that are directly owned by the public purse, made accessible to the public by means of public subsidy or generally perceived to be in public ownership. The term 'public' refers to both central government and local government. Paintings held by national museums, local authority museums, English Heritage and independent museums, where there is at least some form of public subsidy, are included. Paintings held in civic buildings such as local government offices, town halls, guildhalls, public libraries, universities, hospitals, crematoria, fire stations and police stations are also included.

Geographical Boundaries of Catalogues

The geographical boundary of each county is the 'ceremonial county' boundary. This county definition includes all unitary authorities. Counties that have a particularly large number of paintings are divided between two or more catalogues on a geographical basis.

Criteria for Inclusion

As long as paintings meet the requirements above, all paintings are included irrespective of their condition and perceived quality. However, painting reproductions can only be included with the agreement of the participating collections and, where appropriate, the relevant copyright owner. It is rare that a collection forbids the inclusion of its paintings. Where this is the case and it is possible to obtain a list of paintings, this list is given in the Paintings Without Reproductions section. Where copyright consent is refused, the paintings are also listed in the Paintings Without Reproductions section. All paintings in collections' stacks and stores are included, as well as those on display. Paintings which have been lent to other institutions, whether for short-term exhibition or long-term loan, are listed under the owner collection. In addition, paintings on long-term loan are also included under the borrowing institution when they are likely to remain there for at least another five years from the date of publication of this catalogue. Information relating to owners and borrowers is listed in the Further Information section.

Layout

Collections are grouped together under their home town. These locations are listed in alphabetical order. In some cases collections that are spread over a number of locations are included under a single owner collection. A number of collections, principally the larger ones, are preceded by curatorial forewords. Within each collection paintings are listed in order of artist surname. Where there is more than one painting by the same artist, the paintings are listed chronologically, according to their execution date.

The few paintings that are not accompanied by photographs are listed in the Paintings Without Reproductions section.

There is additional reference material in the Further Information section at the back of the catalogue. This gives the full names of artists, titles and media if it has not been possible to include these in full in the main section. It also provides acquisition credit lines and information about loans in and out, as well as copyright and photographic credits for each painting. Finally, there is an index of artists' surnames.

Key to Painting Information

Almost all paintings are reproduced in the catalogue. Where this is not the case they are listed in the Paintings Without Reproductions section. Where paintings are missing or have been stolen, the best possible photograph on record has been reproduced. In some cases this may be black and white. Paintings that have been stolen are highlighted with a red border. Some paintings are shown with conservation tissue attached to parts of the painting surface.

Adam, **Patrick William** 1854–1929

Interior, Rutland Lodge: Vista through Open Doors 1920

oil on canvas 67.3 × 45.7

LEEAG.PA.1925.0671.LACF

Artist name This is shown with the surname first. Where the artist is listed on the Getty Union List of Artist Names (ULAN), ULAN's preferred presentation of the name is given. In a number of cases the name may not be a firm attribution and this is made clear. Where the artist name is not known, a school may be given instead. Where the school is not known, the painter name is listed as *unknown artist*. If the artist name is too long for the space, as much of the name is given as possible followed by (…). This indicates the full name is given at the rear of the catalogue in the Further Information section.

Painting title A painting title followed by *(?)* indicates that the title is in doubt. Where the alternative title to the painting is considered to be better known than the original, the alternative title is given in parentheses. Where the collection has not given a painting a title, the publisher does so instead and marks this with an asterisk. If the title is too long for the space, as much of the title is given as possible followed by *(…)* and the full title is given in the Further Information section.

Execution date In some cases the precise year of execution may not be known for certain. Instead an approximate date will be given or no date at all.

Artist dates Where known, the years of birth and death of the artist are given. In some cases one or both dates may not be known with certainty, and this is marked. No date indicates that even an approximate date is not known. Where only the period in which the artist was active is known, these dates are given and preceded with the word *active*.

Medium and support Where the precise material used in the support is known, this is given.

Dimensions All measurements refer to the unframed painting and are given in cm with up to one decimal point. In all cases the height is shown before the width. An (E) indicates where a painting has not been measured and its size has been calculated by sight only. If the painting is circular, the single dimension is the diameter. If the painting is oval, the dimensions are height and width.

Collection inventory number In the case of paintings owned by museums, this number will always be the accession number. In all other cases it will be a unique inventory number of the owner institution. (P) indicates that a painting is a private loan. Details can be found in the Further Information section. Accession numbers preceded by 'PCF' indicate that the collection did not have an accession number at the time of catalogue production and therefore the number given has been temporarily allocated by the Public Catalogue Foundation. The ⁂ symbol indicates that the reproduction is based on a Bridgeman Art Library transparency (go to www.bridgeman.co.uk) or that Bridgeman administers the copyright for that artist.

Facing page: Delécluze, Étienne-Jean, 1781–1863, *The Emperor Augustus Rebuking Cornelius Cinna for His Treachery*, (detail), 1814, The Bowes Museum, (p. 42)

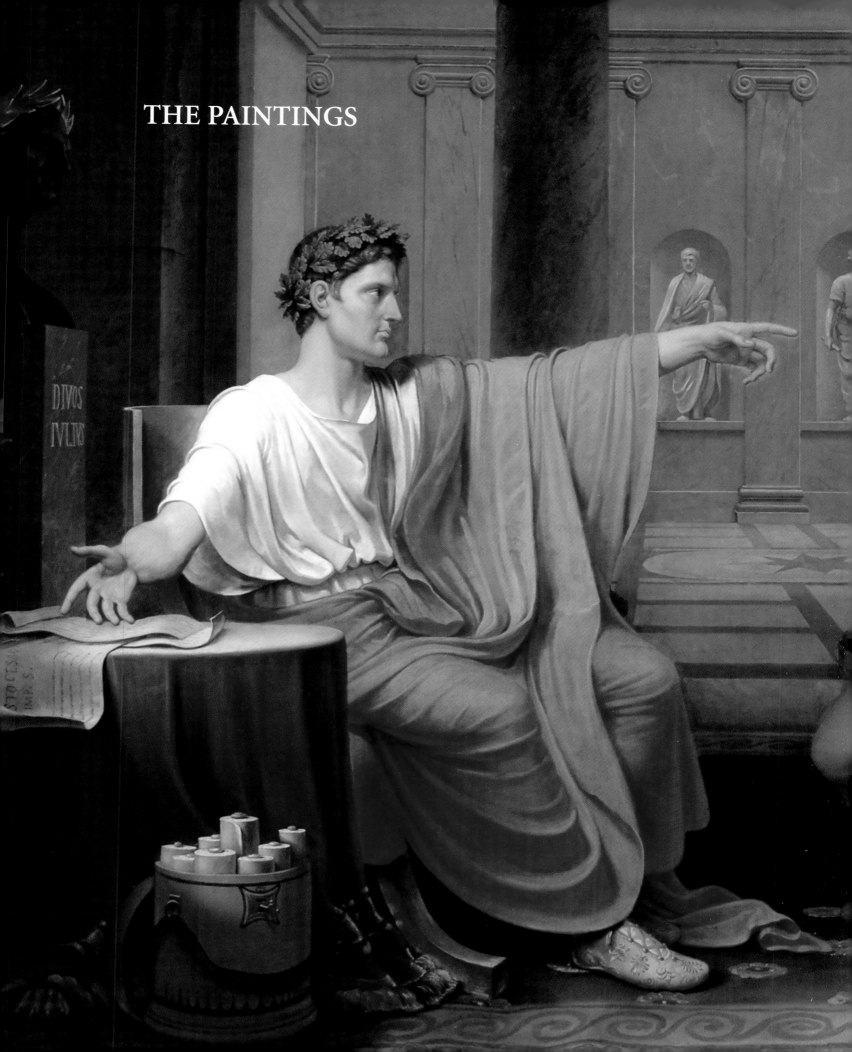

THE PAINTINGS

The Bowes Museum

The Bowes Museum, built in the style of a French château, is a striking piece of architecture set against the stunning English countryside of County Durham. The creation of the imaginative and visionary John and Joséphine Bowes, the Museum houses their magnificent collection of European fine and decorative arts.

John Bowes (1811–1885), the illegitimate, but fully acknowledged and beloved son of the 10th Earl of Strathmore, started collecting paintings at the age of 19, when on a trip to Switzerland. He acquired *The Temptation of St Anthony,* then ascribed to Teniers the elder, but now attributed to Cornelis Saftleven.

In 1832 he stood for Parliament and for the next 15 years served as Liberal MP for South Durham, whilst pursuing his interests as landowner, industrialist, collector and racehorse breeder of the Streatlam Stud. By 1844 John Bowes had purchased some 57 paintings, mostly from London dealers. Among these early acquisitions was *The Miracle of the Holy Sacrament* by Sassetta, a predella panel from the Arte della Lana altarpiece, commissioned from the Sienese guild of wool merchants and *The Rape of Helen,* by the circle of Francesco Primaticcio, which had comprised part of the Duke of Buckingham's magnificent collection of paintings.

In 1847 John gave up his parliamentary career and moved to Paris. There he invested in the Théâtre des Variétés on the boulevard Montmartre, and almost immediately formed a relationship with Mademoiselle Delorme, an actress in the theatre company, whose real name was Benoîte-Joséphine Coffin-Chevallier. The couple, who shared a passion for the arts, married in 1852 and later took the momentous decision to create a museum. During the 1860s, they travelled regularly between Paris, London and Teesdale, acquiring pieces for their collection from the great international exhibitions and a small number of trusted dealers.

In 1862 John and Joséphine Bowes purchased some 75 Spanish paintings from the Condesa de Quinto in Paris through their dealer Benjamin Gogué. The collection had been formed by the Condesa's late husband the Conde de Quinto who, until his exile in 1854, had been a leading Spanish politician and member of the Central Commission for Historic and Artistic Monuments in Spain. This group of works which includes *The Tears of St Peter* by El Greco and the *Interior of a Prison* by Francisco de Goya, together with the portrait of his close friend *Juan Antonio Meléndez Valdés (1774–1817),* now forms the nucleus of the Museum's important collection of Spanish paintings.

Joséphine Bowes was a talented and dedicated painter. She studied under the respected landscape artist Karl-Joseph Kuwasseg, whose work she imitated closely. In 1867 she exhibited *Landscape with Trees and Cattle* at the Paris Salon under the title *Lisière d'une forêt.* The following year she exhibited the same painting at the Royal Academy and had *Landscape with River and Trees, Sunset* accepted at the Salon. She exhibited further paintings at the Salon in 1869 and 1870. Joséphine attended the infamous Salon des Refusés in 1863 and was a keen collector of contemporary French paintings. In the 1860s she purchased works by major French painters such as *View at Ornans* by Gustave Courbet, *Fruit and Flowers* by Henri Fantin-Latour, *Beach Scene at Low Tide* by Eugène Louis Boudin and *Landscape with Figures and Goats* by Aldophe Joseph Thomas Monticelli, the latter being an influence on Van Gogh.

The Bowes Museum continues to acquire objects and works of art to complement the Founders' Collection through gifts and purchases. In 1982, following a public fundraising appeal the Museum acquired two fine paintings by Canaletto; *The Bucintoro Returning to the Molo,* which depicts the festival of the Sposalizio del Mare, when Venice is married to the sea with a wedding ring being cast into the water, and *Regatta on the Grand Canal* which illustrates the annual boat races. The Museum has since purchased *Mr John Bowes' Bay Colt 'Cotherstone'* by John Frederick Herring II. This sensitive portrait illustrates one of John Bowes' finest racehorses. In 1843 Cotherstone won the Epson Derby by a clear length, the Gratwicke Stakes at Goodwood, the Three-year-old Stakes at Doncaster and the Royal Stakes at Newmarket.

This catalogue makes The Bowes Museum's entire collection of oil paintings accessible in one volume for the first time. It will bring the Founders' Collection and their very personal approach to collecting to the attention of a wider audience and celebrates their legacy, and for that, the Museum is enormously grateful to the Public Catalogue Foundation.

Adrian Jenkins, Director

Aertsen, Pieter (after) 1507/1508–1575
Fruit and Vegetables with Figures in the Background late 16th C
oil on canvas 141.9 x 109.8
B.M.83

Albani, Francesco (after) 1578–1660
Venus and Vulcan 17th C
oil on canvas 81.6 x 114
B.M.522

Allegrain, Étienne 1644–1736
Classical Landscape with Figures and Ruins
oil on canvas 122.8 x 170.7
B.M.338

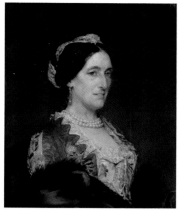

Alma-Tadema, Lawrence 1836–1912
*Catherine Lucy Wilhelmina Stanhope
(1819–1901), Duchess of Cleveland* 1883
oil on canvas 64.8 x 52.1
B.M.968

Amstel, Jan van c.1500–c.1542
Landscape with the Flight into Egypt
oil on panel 68.3 x 108
B.M.117

Anastasi, Auguste Paul Charles 1820–1889
Landscape with a Farm Waggon, Sunset 1857
oil on canvas 17.8 x 34.7
B.M.656

Anastasi, Auguste Paul Charles 1820–1889
Avenue of Poplars at Bougival, France
oil on panel 22.9 x 28.9
B.M.423

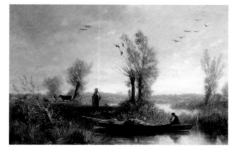

Anastasi, Auguste Paul Charles 1820–1889
Landscape, the Banks of a Canal
oil on panel 18.2 x 26.6
B.M.683

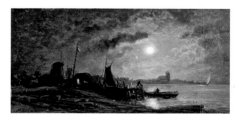

Anastasi, Auguste Paul Charles 1820–1889
River Scene, Moonlight
oil on panel 15 x 29.4
B.M.754

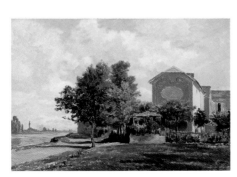

Anastasi, Auguste Paul Charles 1820–1889
The Cabaret Maurice at Bougival, France
oil on board 25.4 x 35.6
B.M.724

André, Jane
Still Life 1885
oil on board 15.9 x 22.9
O.27

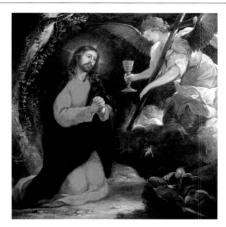

Antolínez, José 1635–1675
The Agony in the Garden 1665
oil on canvas 167.6 x 163.8
B.M.837

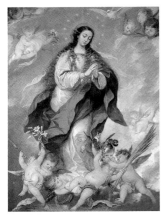

Antolínez, José 1635–1675
The Immaculate Conception
oil on canvas 188 x 135
B.M.22

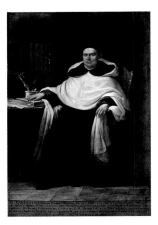

Aparicio, José 1773–1838
Reverend Father Manuel Regidor y Brihuega
1815
oil on canvas 210.5 x 140.3
B.M.4

Arco, Alonso del (circle of) 1625–1700
St Clare Holding a Monstrance 17th C
oil on canvas 189.7 x 76.9
B.M.808

Arnold, B. Y.
Waterfall
oil on canvas 127 x 101.5
O.330

Arredondo, Isidoro (attributed to)
1653–1702
*The Vision of St Gertrude with St Augustine
and the Holy Trinity*
oil on canvas 246.3 x 163.8
B.M.1008

Arthois, Jacques d' 1613–1686
Landscape, Riverbank with Figures
oil on panel 72.4 x 122.5
B.M.89

Arthois, Jacques d' (attributed to)
1613–1686
Hunting Party
oil on canvas 107.5 x 190.6
B.M.120

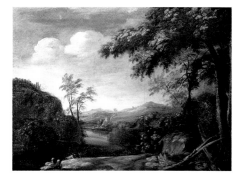

Arthois, Jacques d' (style of) 1613–1686
Landscape with a River and Figures 17th C
oil on canvas 74.5 x 96.5
B.M.158

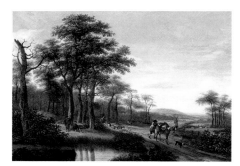

Asch, Pieter Jansz. van 1603–1678
Scene at the Edge of a Wood
oil on canvas 60.6 x 84.4
B.M.145

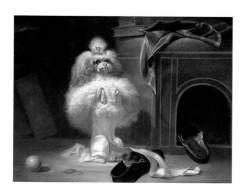

Bachelier, Jean Jacques 1724–1806
Dog of the Havana Breed 1768
oil on canvas 69.8 x 91.1
B.M.913

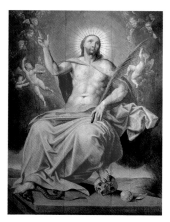

Backer, Jacob de (attributed to)
c.1545–1590s
The Victory of the Risen Christ
oil on canvas 102.5 x 90
B.M.921

Bale, Charles Thomas (style of) b.1849
Still Life
oil on canvas 32.5 x 40.5
O.213

Balen, Hendrik van I (style of) 1575–1632
Vintage Scene 17th C
oil on canvas 98.8 x 166.3
B.M.196

Bassano, Francesco II (studio of)
1549–1592
The Adoration of the Shepherds 17th C
oil on canvas 152 x 132.1
B.M.812

Batoni, Pompeo (after) 1708–1787
*Karl Theodore (1724–1799), Elector of
Bavaria* c.1777
oil on canvas 152.5 x 107.5
B.M.477

Bayer, William
Old Man with a White Beard 1826
oil on panel 23.1 x 17.2
B.M.983

Beale, S. active 18th C
Portrait of a Man
oil on canvas 69.3 x 55.9
O.130

Beaubrun, Charles 1604–1692
A Lady in a White Dress, with a Bouquet
oil on canvas 130 x 110
B.M.897

Beaubrun, Charles (circle of) 1604–1692
*Anne of Austria (1601–1666), Queen of
France, Consort of Louis XIII* mid-17th C
oil on canvas 112.5 x 86.9
B.M.243

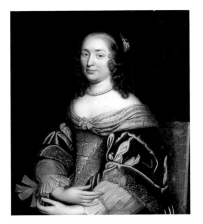

Beaubrun, Charles (after) 1604–1692 &
Beaubrun, Henri the younger 1603–1677
Portrait of a Lady in Blue and Gold 17th C
oil on canvas 81.2 x 68.9
B.M.295

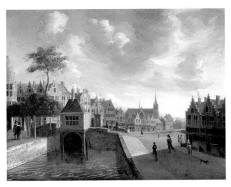

Beerstraten, Anthonie active c.1635–c.1655
Canal and Houses, Amsterdam, Holland
oil on canvas 79.4 x 97.5
B.M.170

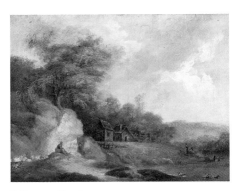

Bélanger, Eugène
active late 18th C-early 19th C
Landscape with River and Figures
oil on canvas 31.9 x 40.6
B.M.758

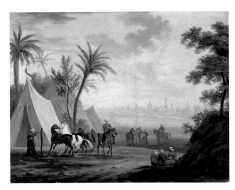

Bellier, Charles b.1796
An Eastern Encampment 1828
oil on canvas 35.6 x 45
B.M.402

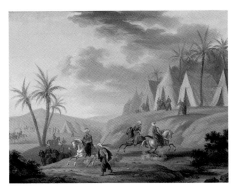

Bellier, Charles b.1796
An Eastern Encampment 1828
oil on canvas 38.1 x 46.3
B.M.404

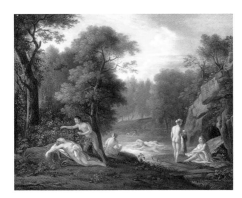

Bellier, Jean François Marie 1745–1836
Landscape with Nymphs Bathing
oil on canvas 38.2 x 46.4
B.M.665

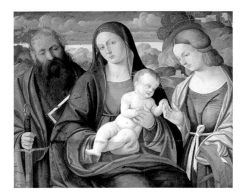

Bellini, Giovanni (style of) 1431–1436–1516
*The Madonna and Child with St Paul and
St Catherine* 19th C
oil on panel 52.1 x 62.2
B.M.592

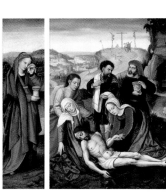

Benson, Ambrosius (circle of)
c.1495–before 1550
Lamentation (Pietà and the Two Marys)
16th C
oil on panel 33.7 x 38.5
B.M.175

Bérain, Jean I (style of) 1640–1711
Decorative Scrolls with Paschal Lamb
17th C–18th C
oil on canvas 64.5 x 122
O.338

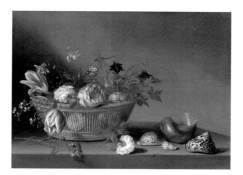

Berch, Gillis Gillisz. de c.1600–1669
A Basket of Flowers with Seashells 1642
oil on panel 47.7 x 63.8
B.M.619

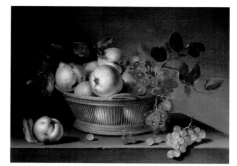

Berch, Gillis Gillisz. de c.1600–1669
A Basket of Pears and Grapes 1642
oil on panel 47.7 x 61.5
B.M.626

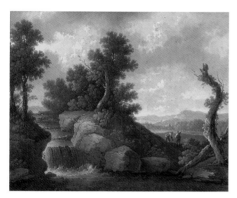

Beresteyn, Claes van 1629–1684
Landscape with a Waterfall
oil on canvas 50.5 x 61.5 (E)
B.M.132

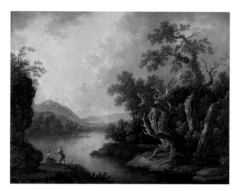

Beresteyn, Claes van (attributed to)
1629–1684
Landscape with a Lake among Hills
oil on canvas 52.5 x 63.1
B.M.128

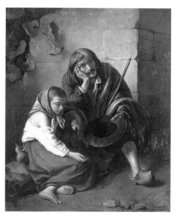

Bertier, Louis Eugène 1809–after 1870
A Spanish Beggar with His Daughter 1841
oil on canvas 90.6 x 71.6
B.M.496

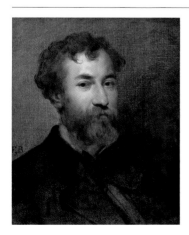

Besson, Faustin 1821–1882
Lorédan Larchey (1831–1902)
oil on canvas 55.5 x 46.4
B.M.377

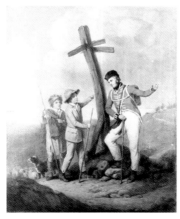

Bigg, William Redmore 1755–1828
Which Way? 1812
oil on canvas 127.5 x 102.5
B.M.1016

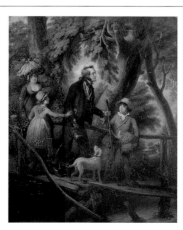

Bigg, William Redmore 1755–1828
Children Guiding Their Blind Father over a Bridge
oil on canvas 127.5 x 102.2
B.M.1017

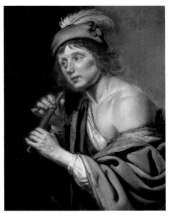

Bijlert, Jan van (after) 1597–1671
Shepherd with a Flute 1630s
oil on panel 27.3 x 21.6
B.M.228

Bijlert, Jan van (after) 1597–1671
Woman Dressed as a Shepherdess 1630s
oil on panel 27.3 x 21.6
B.M.227

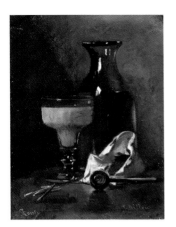

Billou, Paul 1821–1868
Still Life with a Carafe
oil on canvas 45 x 40
B.M.994

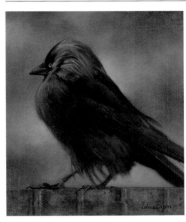

Bizon, Edna b.1929
Jackdaw
oil on canvas 30 x 24
1985.12.7

Blake, B.
Pheasant 1845
oil on canvas 27.3 x 21.5
O.216

Blanchard, Edouard-Théophile 1844–1879
*Woody Landscape with Buildings and Figures
above a River*
oil on canvas 23.7 x 31.9
B.M.672

Bland, John Francis 1856–1899
Scarborough Cliffs, North Yorkshire 1893
oil on canvas (?)
B.M.970

Blay, C. de
*A Young Girl, Attended by a Chaperone, Giving
a Rose to Her Lover Secretly* 1865
oil on panel 35.9 x 27.6
B.M.1030

Bloclant, Gerrit van 1589–1650
Flower Piece
oil on panel 53 x 42
1991.2

Facing page: unknown artist, 18th C, *Panorama of Durham City from the North West* (detail),
Durham University, (p. 319)

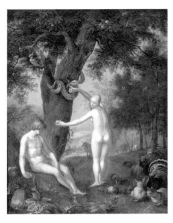

Bloemaert, Abraham (after) 1564–1651
Adam and Eve 18th C
oil on panel 36.8 x 27.6
B.M.800

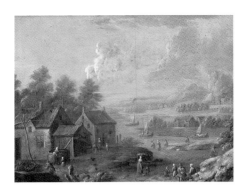

Blommaerdt, Maximilian (attributed to)
active 1696–1697
Landscape
oil on panel 26.9 x 34.4
B.M.213

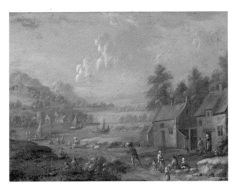

Blommaerdt, Maximilian (attributed to)
active 1696–1697
Landscape
oil on panel 26.9 x 34.4
B.M.215

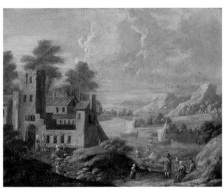

Blommaerdt, Maximilian (attributed to)
active 1696–1697
Landscape with a River, Buildings and Figures
oil on panel 24.8 x 29.2
B.M.233

Boilly, Louis Léopold (style of) 1761–1845
*Laetitia Ramolino Buonaparte (c.1750–1836),
Mother of Napoleon I* early 19th C
oil on canvas 26.2 x 20
B.M.667

Bonington, Richard Parkes (copy after)
1802–1828
Quentin Durward at Liège, Belgium 19th C
oil on canvas 26.2 x 21.2
O.5

Bonnefoi, Auguste 1813–1883
Flowers and Fruit 1867
oil on canvas 74 x 86
O.69

Bonnefoi, Auguste 1813–1883
Flowers and Fruit 1877
oil on canvas 80 x 95
O.328

Bonnefoi, Auguste 1813–1883
Trees
oil on canvas 97.5 x 79.5
O.327

Bonvin, François 1817–1887
Self Portrait 1847
oil on canvas 66.4 x 55.2
B.M.444

Bonvin, François 1817–1887
Two Countrywomen 1850s
oil on panel 32.7 x 23.7
B.M.1055

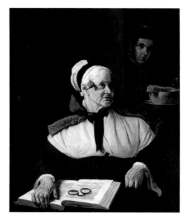

Bonvin, François 1817–1887
Grandmamma's Breakfast 1865
oil on canvas 101.6 x 83.2
B.M.325

Boquet, Pierre Jean 1751–1817
Landscape with Figures and a Castle on a Hill
oil on panel 41.2 x 56.9
B.M.344

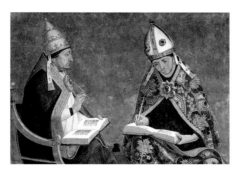

Borgoña, Juan de c.1495–1536
St Gregory and St Augustine c.1510
tempera & gold on panel 86 x 118
B.M.65

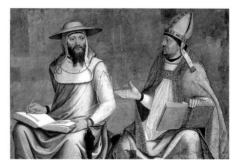

Borgoña, Juan de c.1495–1536
St Jerome and St Ambrose c.1510
tempera & gold on panel 87.6 x 120.7
B.M.8

Boss, H.
Portrait of a Gentleman 1592
oil on panel 108 x 77
B.M.107

Both, Jan (after) c.1618–1652
Landscape with Cattle 17th C
oil on canvas 66.3 x 86.3
B.M.79

Both, Jan (style of) c.1618–1652
Seaport with Shipping 17th C
oil on canvas 30.2 x 36.7
B.M.804

Boucher, François 1703–1770
Landscape with a Watermill 1743
oil on canvas 90.8 x 118.1
B.M.486

Boucher, François (school of) 1703–1770
Putti with a Goat in a Landscape 18th C
oil on canvas 83.7 x 130
B.M.285

Boudin, Eugène Louis 1824–1898
Beach Scene at Low Tide 1867
oil on canvas 31.1 x 47.9
B.M.689

Boudin, Eugène Louis 1824–1898
The Ferry at Deauville, France
oil on canvas 30.5 x 47
B.M.697

Boulangé, Louis-Jean-Baptiste 1812–1878
Landscape with Women Keeping Geese
oil on canvas 44.8 x 59.7
B.M.376

Bourges, Pauline Elise Léonide 1838–1910
*The House of Monsieur Edouard Frère at
Écouen, France*
oil on panel 16.5 x 27
B.M.722

Bout, Peeter 1658–1719
Landscape with Buildings and Figures
oil on panel 21.2 x 28.7
B.M.225

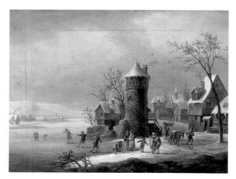

Bout, Peeter (style of) 1658–1719
Winter Landscape with Buildings and Skaters
late 17th C-early 18th C
oil on canvas 22.8 x 29.8
B.M.223

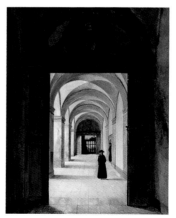

Bouton, Charles-Marie (attributed to)
1781–1853
Cloisters of a Cathedral
oil on canvas 38.7 x 30
B.M.436

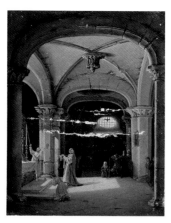

Bouton, Charles-Marie (attributed to)
1781–1853
Interior of a Church
oil on canvas 30.6 x 23.1
B.M.434

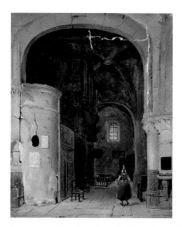

Bouton, Charles-Marie (attributed to)
1781–1853
Interior of a Church
oil on canvas 35 x 26.9
B.M.1071

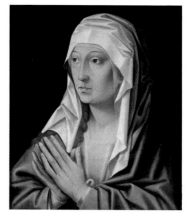

Bouts, Albert (circle of) c.1452/1455–1549
The Madonna at Prayer 16th C
oil on panel 38.4 x 30.5
B.M.214

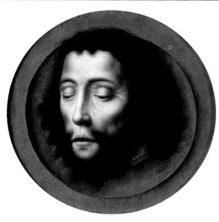

Bouts, Dieric the elder (after) c.1415–1475
The Head of St John the Baptist on a Gold Dish
early 17th C
tempera on panel 28.6
B.M.959

Bowes, Joséphine 1825–1874
The Château du Barry at Louveciennes, France
c.1860–1862
oil on canvas 225 x 107.5
J.45

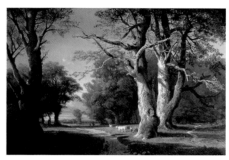

Bowes, Joséphine 1825–1874
Landscape with Trees and Cattle c.1860–1867
oil on canvas 127.5 x 183 (E)
J.3

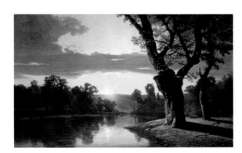

Bowes, Joséphine 1825–1874
Landscape with River and Trees, Sunset
c.1860–1868
oil on canvas 126 x 190.5
J.13

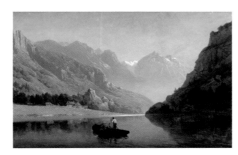

Bowes, Joséphine 1825–1874
Souvenir of Savoy, France, Sunrise in the Mountains c.1860–1869
oil on canvas 118.5 x 182
J.53

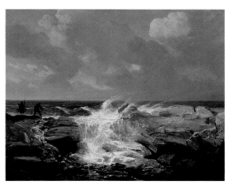

Bowes, Joséphine 1825–1874
Squally Weather, A Sketch near Boulogne-sur-Mer, France c.1860–1870
oil on canvas 62.5 x 77.5
J.44

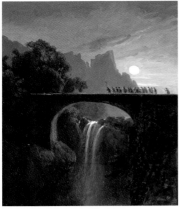

Bowes, Joséphine 1825–1874
A Monastic Funeral by Moonlight
c.1860–1872
oil on canvas 58.7 x 47.5
J.9

Bowes, Joséphine 1825–1874
Moonlight in the Forest c.1860–1872
oil on canvas 105.6 x 129.4
J.14

Bowes, Joséphine 1825–1874
A Cornfield near Calais c.1860–1874
oil on canvas 63.2 x 86.9
J.61

Bowes, Joséphine 1825–1874
A Country Lane c.1860–1874
oil on canvas 43.7 x 36.2
J.18

Bowes, Joséphine 1825–1874
A House with a Lake in the Background
c.1860–1874
oil on canvas 23.1 x 45.2
J.VI

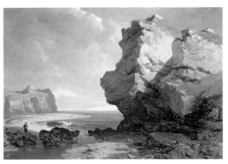

Bowes, Joséphine 1825–1874
A Rocky Cliff c.1860–1874
oil on canvas 70 x 93.5
J.33

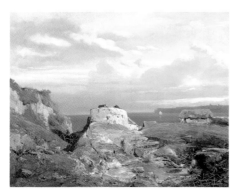

Bowes, Joséphine 1825–1874
An Old Tower near the Sea c.1860–1874
oil on canvas 50 x 60 (E)
J.40

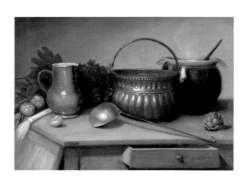

Bowes, Joséphine 1825–1874
Bodegón (copy after Diego Velázquez)
c.1860–1874
oil on canvas 65 x 88.7
J.20

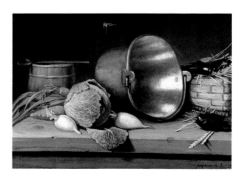

Bowes, Joséphine 1825–1874
Bodegón (copy after Diego Velázquez)
c.1860–1874
oil on canvas 65 x 88.7
J.34

Bowes, Joséphine 1825–1874
Bridge over a Mountain Stream c.1860–1874
oil on canvas 45 x 55
J.32

Bowes, Joséphine 1825–1874
Cliffs near Boulogne-sur-Mer, France
c.1860–1874
oil on canvas 227.5 x 106.2
J.60

Bowes, Joséphine 1825–1874
Fisherman's Cottage near the Sea c.1860–1874
oil on canvas 36.2 x 43.7
J.25

Bowes, Joséphine 1825–1874
Fishermen's Cottages near Boulogne-sur-Mer,
France, after the Cholera Epidemic
c.1860–1874
oil on canvas 36.2 x 43.7
J.56

Bowes, Joséphine 1825–1874
Forest Scene c.1860–1874
oil on canvas 52.5 x 43.1
J.30

Bowes, Joséphine 1825–1874
Fruit, Flowers and Vegetables c.1860–1874
oil on canvas 115 x 179.4
J.7

Bowes, Joséphine 1825–1874
Lake with Boatmen at Sunset c.1860–1874
oil on canvas 20 x 31.2
J.38

Bowes, Joséphine 1825–1874
Landscape (copy after Jean-Honoré
Fragonard) c.1860–1874
oil on canvas 31.2 x 25
J.37

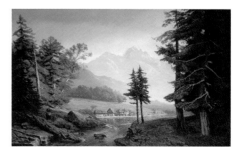

Bowes, Joséphine 1825–1874
Landscape, Souvenir of Switzerland
c.1860–1874
oil on canvas 125.6 x 184.4
J.12

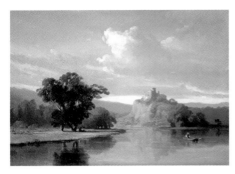

Bowes, Joséphine 1825–1874
Landscape with a Lake and a Ruined Castle
c.1860–1874
oil on canvas 51.2 x 70
J.8

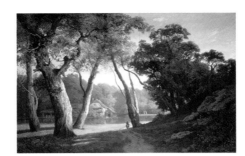

Bowes, Joséphine 1825–1874
Landscape with a River, Trees and a Mill
c.1860–1874
oil on canvas 126.9 x 180
J.2

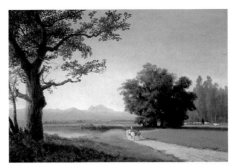

Bowes, Joséphine 1825–1874
Landscape with Trees, a Mountain in the Distance c.1860–1874
oil on canvas 63.7 x 86.9
J.41

Bowes, Joséphine 1825–1874
Landscape with Trees and a Cottage, Windmills in the Distance c.1860–1874
oil on canvas 53.1 x 71.9
J.48

Bowes, Joséphine 1825–1874
Old Woman beside a Fire c.1860–1874
oil on canvas 32.5 x 25
J.VII

Bowes, Joséphine 1825–1874
Pier with Fishing Boats, Town in the Background c.1860–1874
oil on canvas 51.2 x 61.9
J.5

Bowes, Joséphine 1825–1874
River and Bridge in the South of France
c.1860–1874
oil on canvas 112.5 x 175
J.52

Bowes, Joséphine 1825–1874
River Seine near the Bois-de-Boulogne, France
c.1860–1874
oil on canvas 127.5 x 180
J.35

Bowes, Joséphine 1825–1874
River View, Misty Weather c.1860–1874
oil on canvas 63.1 x 86.2
J.11

Facing page: Caprioli, Domenico, c.1495–1528, *Lelio Torelli (1489–1578), Jurisconsult at Fano* (detail), 1528,
The Bowes Museum, (p. 29)

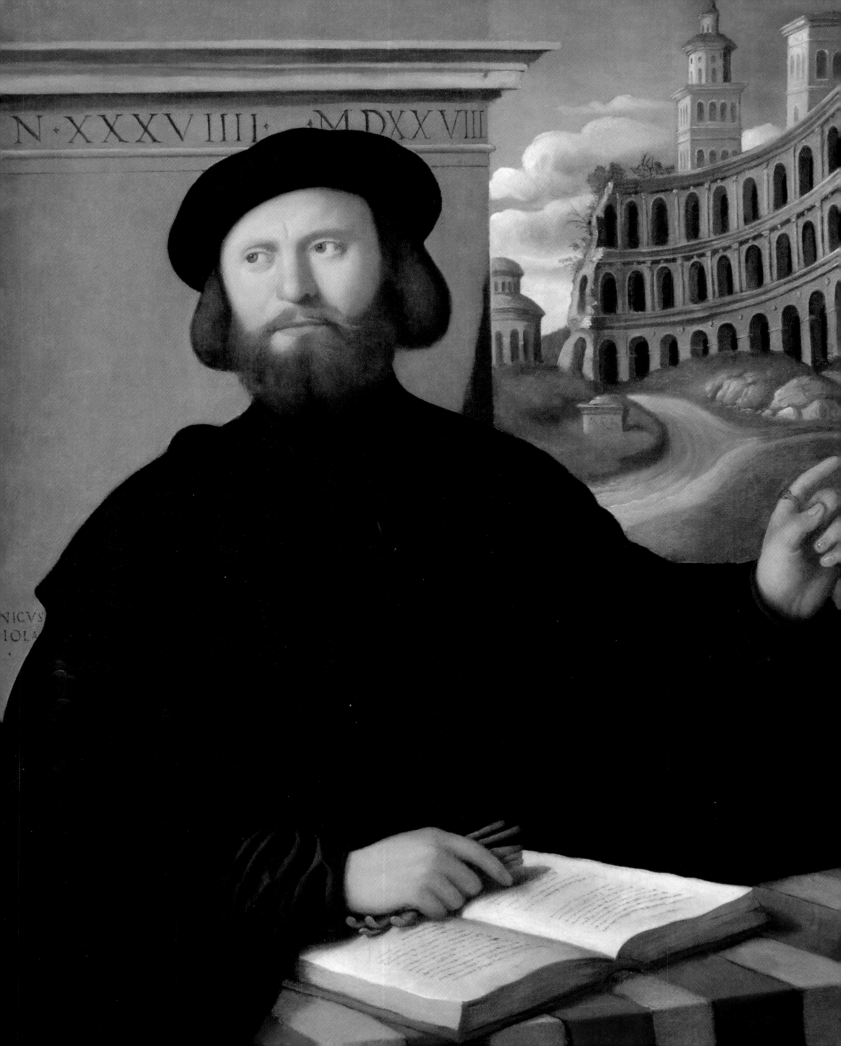

N · XXXVIIII · MDXXVIII

NICVS
IOLA

Bowes, Joséphine 1825–1874
River with Pollard Willows c.1860–1874
oil on canvas 126.9 x 180
J.21

Bowes, Joséphine 1825–1874
Sand Dunes near Boulogne-sur-Mer, France
c.1860–1874
oil on canvas 126 x 175
J.36

Bowes, Joséphine 1825–1874
Sea Beating against a Rocky Cliff c.1860–1874
oil on canvas 56.2 x 70.6
J.57

Bowes, Joséphine 1825–1874
Sea View, Sunset c.1860–1874
oil on canvas 17.5 x 25.6
J.15

Bowes, Joséphine 1825–1874
Sketch near Boulogne-sur-Mer, France
c.1860–1874
oil on canvas 46.2 x 62.5
J.19

Bowes, Joséphine 1825–1874
Sketch of a Rocky Cliff c.1860–1874
oil on canvas 13 x 23.5
J.17

Bowes, Joséphine 1825–1874
*Sketch of Cottages near Boulogne-sur-Mer,
France* c.1860–1874
oil on canvas 25.6 x 38.1
J.6

Bowes, Joséphine 1825–1874
Sketch of Ferns c.1860–1874
oil on board 46 x 34
2007.30.

Bowes, Joséphine 1825–1874
Sketch of Flowers and Ferns c.1860–1874
oil on canvas 38 x 46
2007.31

Bowes, Joséphine 1825–1874
Sketch of the Pavillon de Sully, France
c.1860–1874
oil on canvas 24.4 x 41.9
J.10

Bowes, Joséphine 1825–1874
*Sketch on the Seashore near Boulogne-sur-Mer,
France* c.1860–1874
oil on canvas 38.1 x 51.2
J.46

Bowes, Joséphine 1825–1874
Sketch, Sunset c.1860–1874
oil on canvas 51.2 x 70
J.4

Bowes, Joséphine 1825–1874
Snow Scene c.1860–1874
oil on canvas 39.4 x 52.5
J.31

Bowes, Joséphine 1825–1874
Snow Scene in the South of France
c.1860–1874
oil on canvas 131 x 185.3
J.22

Bowes, Joséphine 1825–1874
Still Life c.1860–1874
oil on canvas 151 x 246
J.V

Bowes, Joséphine 1825–1874
Street Scene in a French Town c.1860–1874
oil on canvas 51.5 x 43
J.24

Bowes, Joséphine 1825–1874
Study of Birch Trees c.1860–1874
oil on canvas 126.2 x 175
J.28

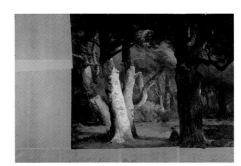

Bowes, Joséphine 1825–1874
Study of Birch Trees c.1860–1874
oil on canvas 128.7 x 180
J.49

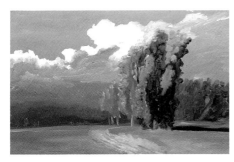

Bowes, Joséphine 1825–1874
Study of Poplars c.1860–1874
oil on canvas 30.6 x 44.4
J.29

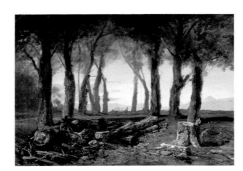

Bowes, Joséphine 1825–1874
Study of Trees c.1860–1874
oil on canvas 41.2 x 56.9
J.39

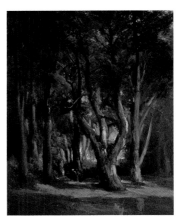

Bowes, Joséphine 1825–1874
Study of Trees c.1860–1874
oil on canvas 78.1 x 59.4
J.42

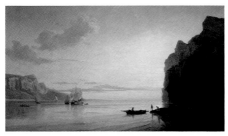

Bowes, Joséphine 1825–1874
*Sunset on the Sea near Boulogne-sur-Mer,
France* c.1860–1874
oil on canvas 112.5 x 175
J.59

Bowes, Joséphine 1825–1874
Sunset on the Seashore c.1860–1874
oil on canvas 52.5 x 87.5
J.27

Bowes, Joséphine 1825–1874
Tall Cliff with Two Figures on Top
c.1860–1874
oil on canvas 44.4 x 36.2
J.VIII

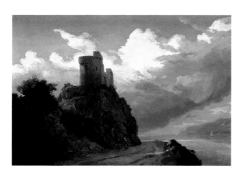

Bowes, Joséphine 1825–1874
The Castle on the Cliff c.1860–1874
oil on canvas 55.6 x 86.9
J.1

Bowes, Joséphine 1825–1874
The Forest King c.1860–1874
oil on canvas 140 x 200
J.58

Bowes, Joséphine 1825–1874
View on the Seashore c.1860–1874
oil on canvas 31.9 x 45.6
J.26

Bowes, Joséphine 1825–1874
Waterfall in the Black Forest c.1860–1874
oil on canvas 228.7 x 106.2
J.47

Bowes, Joséphine 1825–1874
Windmill c.1860–1874
oil on canvas 87.8 x 65.3
J.51

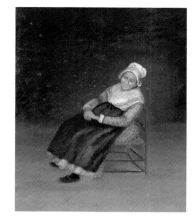

Bowes, Joséphine 1825–1874
Sketch of an Old Woman at Cernay-le-Roi,
France c.1865–1869
oil on canvas 43.1 x 35.6
J.23

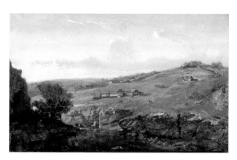

Bowes, Joséphine 1825–1874
View near Cernay-le-Roi, France c.1865–1869
oil on canvas 20 x 31.2
J.16

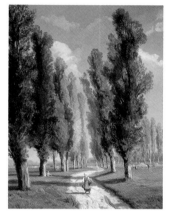

Bowes, Joséphine 1825–1874
Avenue of Poplars c.1866–1869
oil on canvas 86.9 x 63.1
J.43

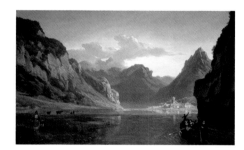

Bowes, Joséphine 1825–1874
Souvenir of the Danube, View in Hungary
c.1868–1874
oil on canvas 128.7 x 180
J.50

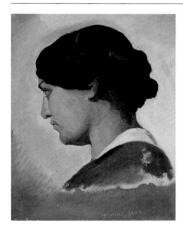

Bowes, Joséphine (attributed to) 1825–1874
Portrait of a Woman, Head and Neck in Profile
1856
oil on canvas 40.7 x 32.3
2007.18

Bowes, Joséphine (attributed to) 1825–1874
A Cottage in a Forest c.1860–1874
oil on card 26.2 x 21.1
2007.11

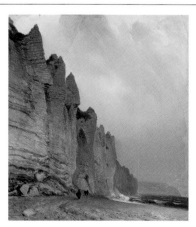

Bowes, Joséphine (attributed to) 1825–1874
Coastal Scene c.1860–1874
oil on board 38.5 x 32.7
2007.24

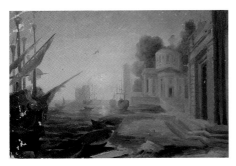

Bowes, Joséphine (attributed to) 1825–1874
Port Scene at Sunset with Classical Buildings
c.1860–1874
oil on canvas 14.2 x 29.5
2007.17

Bowes, Joséphine (attributed to) 1825–1874
Portrait of a Dog c.1860–1874
oil on canvas 23.7 x 18.7
J.I

Bowes, Joséphine (attributed to) 1825–1874
Portrait of a Lady with a Black Shawl
c.1860–1874
oil on canvas 24 x 18.5
2007.14

Bowes, Joséphine (attributed to) 1825–1874
Silver Ink Stand, Mug and Copper Coffee Pot
c.1860–1874
oil on card 8.5 x 27
2007.10.

Bowes, Joséphine (attributed to) 1825–1874
Sketch of a Church Interior with Figures
c.1860–1874
oil on board 27.2 x 37.8
2007.22

Bowes, Joséphine (attributed to) 1825–1874
Sketch of Kitchen Utensils c.1860–1874
oil on canvas 14.5 x 13.5
2007.13

Bowes, Joséphine (attributed to) 1825–1874
Study of a Tree c.1860–1874
oil on panel 37.5 x 19.4
J.II

Bowes, Joséphine (attributed to) 1825–1874
Study of a Tree c.1860–1874
oil on canvas 38.7 x 25.6
J.IV

Bowes, Joséphine (attributed to) 1825–1874
Study of Trees c.1860–1874
oil on panel 31.9 x 20.6
J.III

Bowes, Joséphine (attributed to) 1825–1874
Sunset, Coastal Scene c.1860–1874
oil on canvas 12 x 25.5
2007.12

Bowes, Joséphine (attributed to) 1825–1874
Still Life with Bread and Butter 1863
oil on canvas 14.5 x 15
2007.15

Bowes, Joséphine (attributed to) 1825–1874
Coastal Scene with Figures
oil on board 29.2 x 35.7
2007.23

Bredael, Alexander van 1663–1720
Cattle Market in Antwerp, Belgium 1693
oil on canvas 100 x 122.2
B.M.178

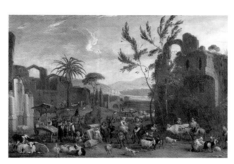

Bredael, Peeter van 1629–1719
A Market among Classical Ruins
oil on canvas 78.1 x 115.6
B.M.93

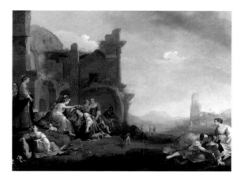

Breenbergh, Bartholomeus 1598–1657
*Amarillis Crowning Mirtillo with a Floral
Wreath* c.1630–1640
oil on canvas 75.6 x 99.4
B.M.122

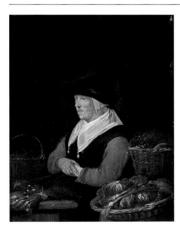

Brekelenkam, Quiringh van
after 1622–1669 or after
An Old Vegetable Dealer on Her Stall
oil on panel 25.4 x 20
B.M.221

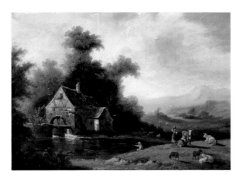

Bricard, François Xavier 1881–1935
Landscape with Watermill
oil on canvas 48.7 x 65.6
B.M.378

Brifaut active 19th C
A Rocky Coast with Grounded Fishing Boats
oil on canvas 36.8 x 55.4
B.M.426

Brissot de Warville, Félix Saturnin
1818–1892
Landscape with Figures 1846
oil on canvas 30.6 x 38.1
B.M.310

Brown, Mather 1761–1831
Lord Cornwallis Receiving the Sons of Tipu as Hostages 1792
oil on metal fixed on panel 44.5 x 52
O.174

Brueghel, Jan the elder (school of)
1568–1625
Cornfield with Reapers early 17th C
oil on panel 44.8 x 74
B.M.576

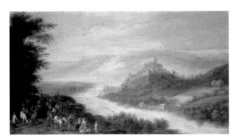

Brueghel, Jan the elder (school of)
1568–1625
Landscape with a Castle early 17th C
oil on panel 45.1 x 74
B.M.571

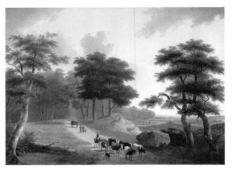

Budelot, Philippe active 1793–1841
Landscape with a Man on a Donkey and Cattle
1810
oil on canvas 55.2 x 74
B.M.518

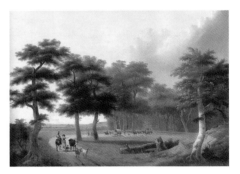

Budelot, Philippe active 1793–1841
Landscape with a Military Convoy
oil on canvas 53.5 x 72.5
B.M.308

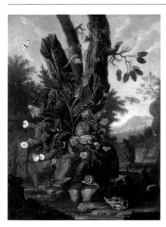

Burgau, Franciscus Michael Sigismund von (attributed to) 1678–1754
Forest Floor Still Life
oil on canvas 78 x 57
B.M.614

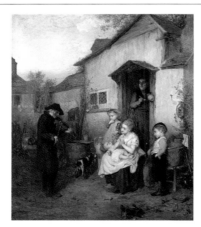

Burr, John 1831–1893
A Wandering Minstrel 1870
oil on canvas 105.6 x 92
B.M.955

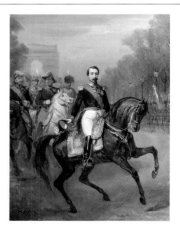

H. J. C.
The Emperor Napoleon III Reviewing Troops on the Champs Elysées, Paris, France
c.1852–1870
oil on canvas 40.5 x 32.5
B.M.512

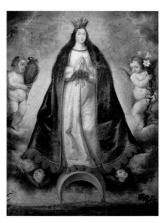

Cajés, Eugenio (follower of) 1575–1634
The Immaculate Conception 17th C
oil on canvas 159 x 115.5
B.M.826

Cajés, Eugenio (school of) 1575–1634
The Presentation of the Virgin in the Temple
early 17th C
oil on panel 61.9 x 31.4
B.M.585

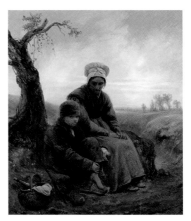

Cals, Adolphe Félix 1810–1880
Peasant Woman and Child 1846
oil on canvas 46.4 x 37.8
B.M.647

Cals, Adolphe Félix 1810–1880
The Seine at Saint-Ouen, France 1851
oil on canvas 16.9 x 29.7
B.M.682

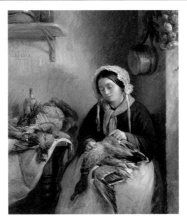

Cals, Adolphe Félix 1810–1880
A Cook Plucking a Wild Duck 1854
oil on canvas 45.7 x 38.4
B.M.360

Cals, Adolphe Félix 1810–1880
*Karl Josef Kuwasseg (1802–1877), Mrs Bowes'
Drawing Master* 1867
oil on canvas 35.6 x 27.3
B.M.1079

Camilo, Francisco c.1615–1671
*Our Lady and St John the Evangelist Crowning
St John of God with Thorns* 1653
oil on canvas 233.6 x 127
B.M.810

Camilo, Francisco (circle of) c.1615–1671
St Thomas of Villanueva 17th C
oil on canvas 143.5 x 102.9
B.M.809

**Camphuysen, Govert Dircksz.
(attributed to)** c.1623–1672
Landscape with Houses and Figures
oil on panel 45.6 x 61.2
B.M.115

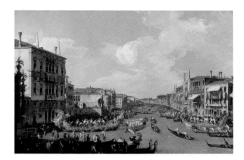

Canaletto 1697–1768
Regatta on the Grand Canal, Venice, Italy
c.1730–1739
oil on canvas 149.8 x 218.4
1982.32.2

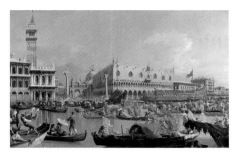

Canaletto 1697–1768
*The Bucintoro Returning to the Molo on
Ascension Day after the Ceremony of Wedding
the Adriatic, Venice, Italy* c.1730–1739
oil on canvas 156.3 x 237.5
1982.32.1

Cantarini, Simone (after) 1612–1648
The Rest on the Flight into Egypt 18th C
oil on copper 37.5
B.M.889

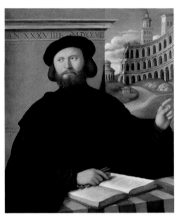

Caprioli, Domenico c.1494–1528
*Lelio Torelli (1489–1578), Jurisconsult at
Fano* 1528
oil on canvas 99.2 x 81.7
B.M.55

**Caracciolo, Giovanni Battista
(attributed to)** 1578–1635
St John the Baptist c.1610–1635
oil on canvas 127.7 x 94
B.M.23

Carducho, Bartolomé (after) 1560–1608
Fray José de Sigüenza (c.1544–1606)
c.1602–1606
oil on canvas 128.8 x 99
B.M.17

Carneo, Antonio (attributed to) 1637–1692
Venus, Vulcan and Cupid
oil on canvas 103.5 x 139.4
B.M.3

Carolus, Louis Antoine 1814–1865
The Reprimand
oil on canvas 63.1 x 51.9
B.M.502

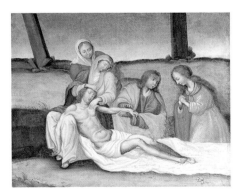

Carracci, Annibale (after) 1560–1609
Pietà c.1800–c.1875
oil on canvas 47.5 x 65
B.M.612

Facing page: Trevelyan, Julian, 1910–1988, *The Thames at Richmond* (detail), 1981, Durham University, (p. 317)

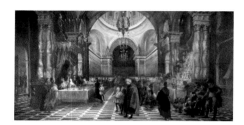

Carreño de Miranda, Juan 1614–1685
Belshazzar's Feast c.1647–1649
oil on canvas 172.5 x 327.6
B.M.19

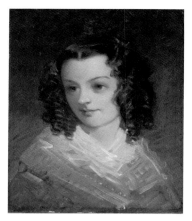

Cassie, James 1819–1879
Portrait of a Girl
oil on canvas 25.4 x 20.3
O.24

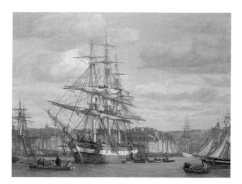

Cassinelli, B. active 1850–1860s
View in the Port of Le Havre, France
c.1855–1862
oil on panel 21.6 x 27.3
B.M.1043

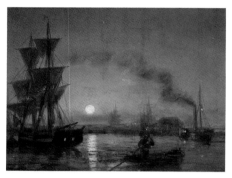

Cassinelli, B. active 1850–1860s
River with Shipping by Moonlight 1860s
oil on panel 21 x 25.7
B.M.782

Cassinelli, B. active 1850–1860s
View near Le Havre, France, Sunset 1860s
oil on panel 17.2 x 24.5
B.M.751

Cassinelli, B. active 1850–1860s
Ships in a Small Anchorage 1861
oil on panel 25 x 40
B.M.1068

Cassinelli, B. active 1850–1860s
Two Lines of Ships, One Ship Ablaze 1861
oil on panel 21.6 x 54.7
B.M.996

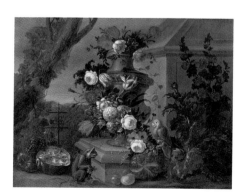

Casteels, Pieter 1684–1749
*A Stone Vase of Flowers with a Parrot, a
Monkey and Fruit*
oil on canvas 49.5 x 62.5
B.M.767

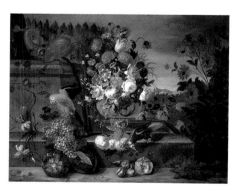

Casteels, Pieter 1684–1749
*A Stone Vase of Flowers with Fruit and Two
Parrots*
oil on canvas 53 x 64
B.M.768

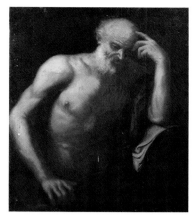

Castello, Valerio (school of) 1624–1659
St Jerome 17th C
oil on canvas 109 x 91.3
O.74

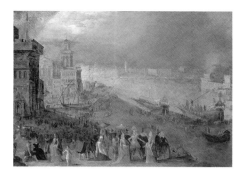

Caullery, Louis de (attributed to)
before 1582–after 1621
Ascension Day, Venice, Italy
oil on panel 54 x 75
O.80

Caullery, Louis de (attributed to)
before 1582–after 1621
Banqueting Scene in the Open Air
oil on panel 54.4 x 78.7
B.M.535

Cavallino, Bernardo (studio of)
1616/1622–1654/1656
The Immaculate Conception c.1640–1660
oil on canvas 75.6 x 55.3
B.M.580

Cazes, Pierre Jacques 1676–1754
La naissance de Vénus (The Birth of Venus)
c.1727
oil on canvas 119.7 x 180.3
B.M.266

Cecco Bravo 1607–1661
The Death of Cleopatra c.1640–1649
oil on canvas 92.1 x 123.5
B.M.629

Ceruti, Giacomo Antonio (style of)
1698–1767
Portrait of an Elderly Lady in Black 18th C
oil on canvas 55.9 x 46.3
B.M.116

Champaigne, Philippe de (attributed to)
1602–1674
Portrait of the Artist's Wife c.1628
oil on panel 41.9 x 32.4
B.M.335

Chaplin, Charles 1825–1891
A Young Girl Drawing c.1860–1866
oil on panel 24.7 x 15.5
B.M.698

Chaplin, Charles 1825–1891
Girl in a Pink Dress Sitting at a Table with a Dog c.1860–1870
oil on canvas 24 x 18.7
B.M.392

Chaplin, Charles 1825–1891
Girl in White, Reading c.1860–1870
oil on canvas 24 x 18
B.M.713

Chaplin, Charles 1825–1891
The Lost Bird c.1860–1870
oil on panel 32.4 x 24.1
B.M.705

Chaplin, Charles 1825–1891
Two Girls Bathing 1866
oil on canvas 17 x 12
B.M.707

Chaplin, Charles (style of) 1825–1891
Girl Caging a Bird c.1860
oil on canvas 25.6 x 20.6
B.M.709

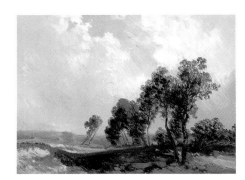

Cicéri, Eugène 1813–1890
Landscape with a Cloudy Sky c.1851–1866
oil on canvas 23.7 x 31.9
B.M.674

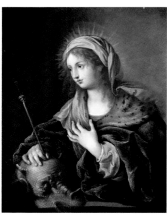

Cignaroli, Giambettino 1706–1770
St Martha
oil on canvas 97.5 x 77.4
B.M.64

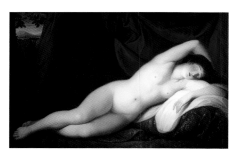

Cipriani, Giovanni Battista (style of)
1727–1785
Sleeping Female Nude 19th C
oil on canvas 93.6 x 147
B.M.207

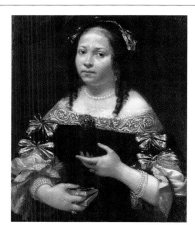

Cittadini, Pier Francesco (attributed to)
1616–1681
Portrait of a Lady Holding a Book
oil on canvas 74.8 x 60.8
B.M.35

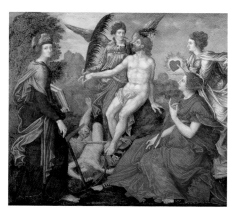

Claeissins, Pieter II (circle of)
before 1536–1623
A Christian Allegory of the Salvation of a Christian Soul late 16th C
oil on panel 90 x 102.5
B.M.953

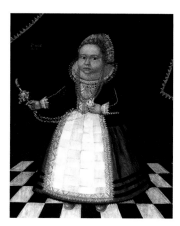

Claesz., Jan d.1636
Portrait of a Child with a Coral Necklace 1636
oil on panel 89.4 x 68.4
B.M.573

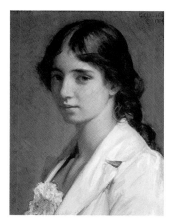

Clausen, George 1852–1944
Nellie St John Heaton 1914
oil on canvas 44.5 x 34.4
2007.37

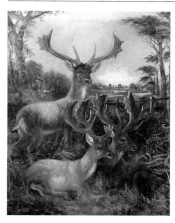

Cleminson, Robert active c.1864–c.1903
Three Stags
oil on canvas 90 x 70
O.329

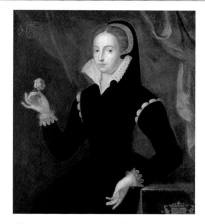

Clouet, François (attributed to)
c.1515–1572
A Lady in a Black Dress with Marie Stuart Coiffure
oil on canvas 85 x 75
B.M.279

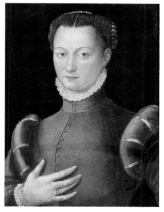

Clouet, François (attributed to)
c.1515–1572
Female Portrait
oil on panel 56.2 x 41.2
B.M.278

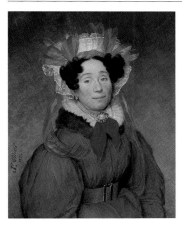

Cochet, Augustine 1792–c.1835
Portrait of a Lady with a Red and White Bonnet 1833
oil on canvas 71.9 x 58.4
B.M.506

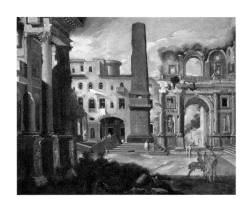

Codazzi, Viviano c.1604–1670
Town Scene in Italy with Ancient Ruins
oil on canvas 104 x 124.5
B.M.9

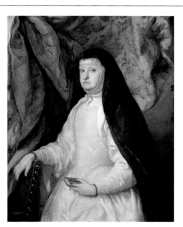

Coello, Claudio 1642–1693
Mariana of Austria (1634–1696), Queen of Spain c.1683–1693
oil on canvas 104.7 x 84.1
B.M.32

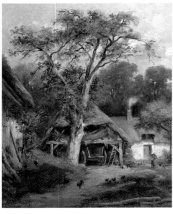

Colin, Paul Alfred 1838–1916
Farm Buildings among Trees c.1850–1860s
oil on panel 25.6 x 20.3
B.M.733

Colin, Paul Alfred 1838–1916
Lake in a Forest c.1850–1860s
oil on cardboard 13 x 19.7
B.M.760

Colin, Paul Alfred 1838–1916
Landscape with a River, Sunset c.1850–1860s
oil on panel 22.5 x 22.5
B.M.686

Colin, Paul Alfred 1838–1916
The Quarry c.1850–1860s
oil on canvas 37.5 x 65.6
B.M.988

Compte-Calix, François Claudius
1813–1880
*Madame de Lamartine Adopting the Children
of Patriots Killed at the Barricades* 1848
oil on canvas 81.3 x 99.3
B.M.470

Constantin, Auguste Aristide Fernand
1824–1895
Still Life with Bread and Onions
oil on canvas 35.6 x 51.9
B.M.507

Coosemans, Alexander 1627–1689
Fruit Piece
oil on canvas 55.6 x 78.7
B.M.597

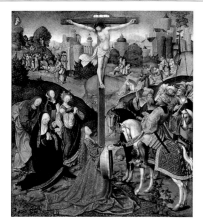

Cornelisz. van Oostsanen, Jacob (studio of)
c.1470–1533
The Crucifixion late 15th C-early 16th C
tempera on panel 106 x 91.7
B.M.174

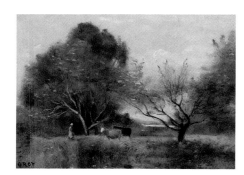

Corot, Jean-Baptiste-Camille 1796–1875
Landscape with Cattle c.1865–1868
oil on canvas 29.9 x 37.4
B.M.397

Cortés y Aguilar, Andrés 1810–1879
Cows at the Watering Place c.1865–1866
oil on canvas 55.2 x 40.9
B.M.645

Cottin, Pierre 1823–1886
Farmyard with Poultry
oil on canvas 27.3 x 34.3
B.M.400

Courbet, Gustave 1819–1877
View at Ornans, France 1864
oil on canvas 86.3 x 129.5
B.M.531

Court, Joseph-Désiré 1797–1865
*Le Maréchal Soult (1769–1851), Duc de
Dalmatie* c.1819–1835
oil on canvas 223 x 147.5
B.M.482

Court, Joseph-Désiré 1797–1865
François Guizot (1787–1874) c.1820–1835
oil on canvas 55.9 x 36.8
B.M.490

Court, Joseph-Désiré 1797–1865
La sortie du bal c.1821–1865
oil on canvas 125 x 93.7
B.M.532

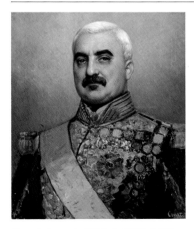

Court, Joseph-Désiré 1797–1865
*Le Maréchal Pélissier (1794–1864), Duc de
Malakoff* c.1850–1860
oil on canvas 65.4 x 54.6
B.M.479

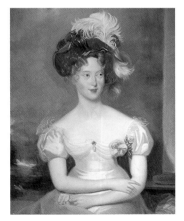

Court, Joseph-Désiré 1797–1865
La Duchesse de Berri (copy after Thomas
Lawrence)
oil on canvas 92.4 x 72.4
B.M.521

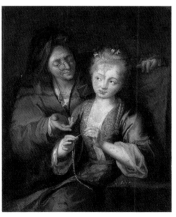

Courtin, Jacques François (after)
1672–1752
The Temptress 18th C
oil on canvas 100 x 96.2
B.M.565

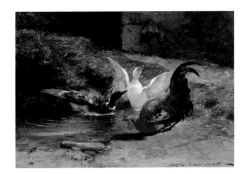

Couturier, Philibert Léon 1823–1901
A Cockerel with Two Ducks
oil on panel 15.9 x 21.6
B.M.673

Couturier, Philibert Léon 1823–1901
A Poultry Yard
oil on canvas 55 x 47.5
B.M.317

Couturier, Philibert Léon 1823–1901
A Poultry Yard
oil on canvas 30.5 x 44.5
B.M.679

Couturier, Philibert Léon 1823–1901
A Yard with Poultry and a Cock Pheasant
oil on canvas 45.3 x 54.7
B.M.359

Couturier, Philibert Léon 1823–1901
Ducks and Hens with a Dead Rat
oil on canvas 29.5 x 42.5
B.M.730

Cowning, T. W. active 20th C
Bright Cattle in Moorland and Slope
oil on panel 67 x 86.5
2007.28

Cowning, T. W. active 20th C
Decorative Panel
oil on panel 98.5 x 44.5
2007.27

Cowning, T. W. active 20th C
Reekie Lynn, Scotland
oil on panel 127 x 93
2007.29

Coxie, Goris de active 1685–1693
Landscape with Figures and a Château 1693
oil on canvas 161 x 212.5
B.M.156

Facing page: Master of the View of Saint Gudule (circle of), active c.1465–1500, *St Jerome and the Lion* (detail),
late 15th C, The Bowes Museum, (p. 130)

36

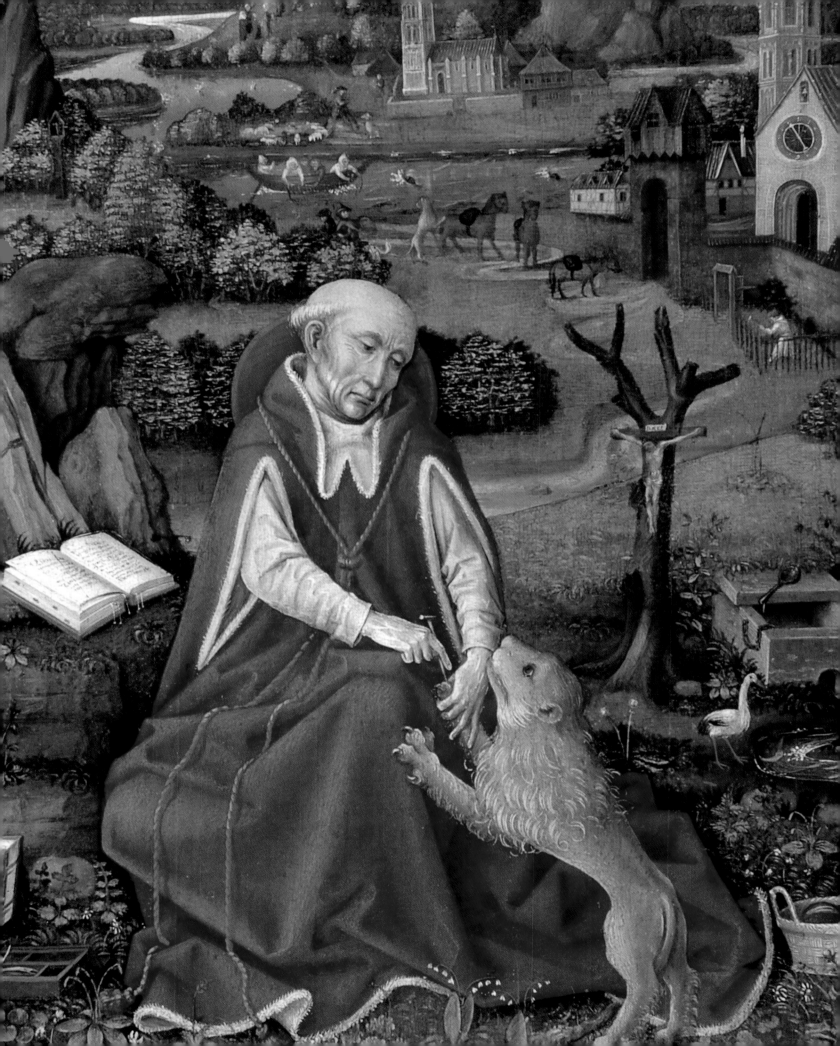

Coxie, Michiel I (circle of) 1499–1592
Mary Magdalene Washing Christ's Feet
16th C
oil on panel 47.5 x 65
B.M.591

Coypel, Antoine (after) 1661–1722
Susannah Accused by the Elders
late 17th C-early 18th C
oil on canvas 80 x 100
B.M.259

Craesbeeck, Joos van c.1605–1662
Interior of a Tavern
oil on panel 62.8 x 47.9
B.M.119

Craesbeeck, Joos van c.1605–1662
Man Holding a Cup and a Wine Bottle
oil on panel 17.5 x 13.1
B.M.984

Creswick, Thomas 1811–1869
A Relic of Old Times (Barnard Castle from the River) c.1860
oil on canvas 95.6 x 126.2
B.M.967

Croos, Anthonie Jansz. van der
c.1606–1662/1663
Landscape with Rijswijk Castle, Holland 1660s
oil on oak panel 25.4 x 38.7
B.M.719

Crosby, F.
The 'Red Lion' Inn 1930
oil on canvas 35.5 x 58.8
1971.1/ANT.

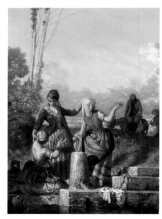

Croy, Raoul de b.1791
Italian Washerwomen
oil on canvas 32.4 x 24.1
B.M.678

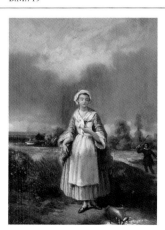

Croy, Raoul de b.1791
The Broken Pitcher
oil on canvas 28.7 x 21.2
B.M.388

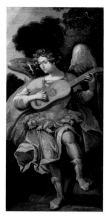

Cuesta, Juan M. de la
An Angel with a Guitar 1658
oil on canvas 97.5 x 45.4
B.M.870

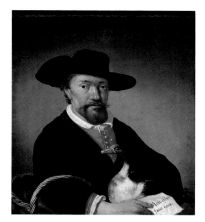

Cuyp, Aelbert (after) 1620–1691
Man with a Goose c.1650–1700
oil on canvas 36.2 x 30.2
B.M.785

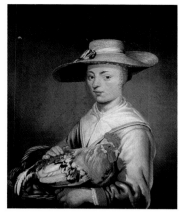

Cuyp, Aelbert (after) 1620–1691
*Woman with a Basket of Eggs and a
Cockerel* c.1650–1700
oil on canvas 36.2 x 30.2
B.M.783

W. D.
Flying Grouse 1887
oil on canvas 50.6 x 75
1985.12.11

Dagnan, Isidore 1794–1873
A Mediterranean Seaport
oil on canvas 27.8 x 38.4
B.M.725

Dahl, Michael I (attributed to)
1656/1659–1743
Portrait of a Lady 18th C
oil on canvas 82.4 x 51.3
O.134

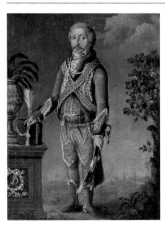

Dalvimar, S. active 18th C
Portrait of a Bavarian Officer
oil on canvas 45.8 x 34.5
O.11

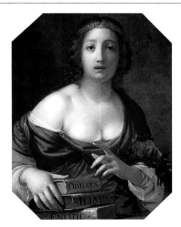

Dandini, Cesare (attributed to) 1596–1657
The Muse Calliope c.1640–1650
oil on canvas 78.7 x 58.7
B.M.1004

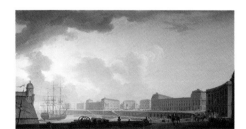

Dandrillon, Pierre Bertrand (attributed to)
1725–1784
A View of the Port of Bordeaux, France 1778
oil on canvas 79.2 x 138.4
B.M.292

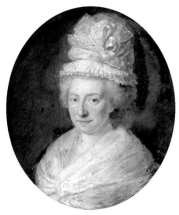

Danloux, Henri-Pierre 1753–1809
Portrait of a Lady in a White Dress
c.1770–1789
oil on canvas 57.4 x 46
B.M.260

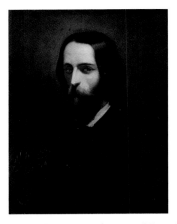

Darondeau, Stanislas Henri Benoît
1807–1841
Alfred de Musset (1810–1857) 1838
oil on canvas 27.1 x 21.8
B.M.731

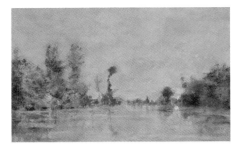

Daubigny, Charles-François 1817–1878
Soleil couchant, L'Ile de Bezons, France c.1851
oil on panel 22 x 34
2003.2322

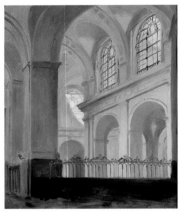

Dauzats, Adrien 1804–1868
Interior of the Church of St Roch, Paris, France
oil on panel 45.6 x 36.6
B.M.743

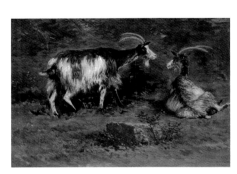

Dauzats, Adrien 1804–1868
Two Goats
oil on panel 24.1 x 34.4
B.M.728

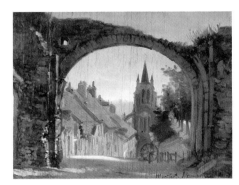

Dauzats, Adrien 1804–1868
View at Montfort l'Amaury, France
oil on panel 17.8 x 24.1
B.M.759

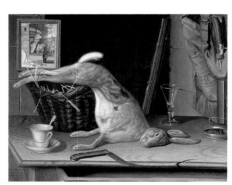

de Bréa active 1750–1761
Still Life with a Dead Hare 1761
oil on canvas 65 x 81.5
B.M.901

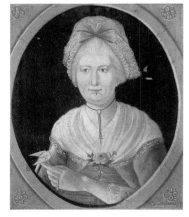

de Gombaud
Portrait of a Lady 1789
oil on canvas 73 x 60.4
O.129

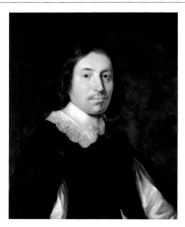

Decaisne, Henri 1799–1852
Portrait of a Man in Early to Mid-Seventeenth Century Costume
oil on canvas 71 x 59.3
B.M.866

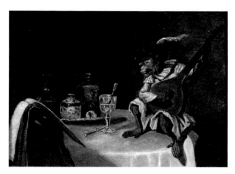

Decamps, Alexandre-Gabriel 1803–1860
A Monkey Playing a Lute
oil on panel 15 x 20.3
B.M.1054

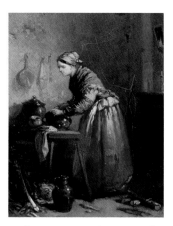

Dedreux-Dorcy, Pierre Joseph 1789–1874
Woman Scouring Pots 1860
oil on canvas 21.2 x 16.2
B.M.744

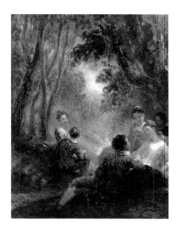

Dedreux-Dorcy, Pierre Joseph 1789–1874
A Fête Champêtre
oil on canvas 33.8 x 25.3
B.M.740

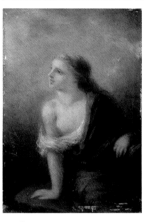

Dedreux-Dorcy, Pierre Joseph 1789–1874
A Young Girl
oil on panel 14.4 x 10
B.M.700

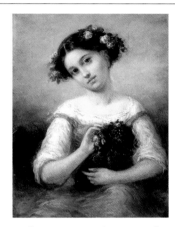

Dedreux-Dorcy, Pierre Joseph 1789–1874
Girl Crowned with Roses, Holding a Dog
oil on canvas 35 x 26.2
B.M.401

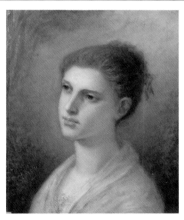

Dedreux-Dorcy, Pierre Joseph 1789–1874
Head of a Girl
oil on canvas 45 x 36.9
B.M.445

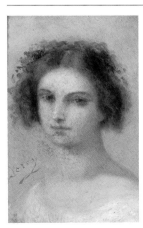

Dedreux-Dorcy, Pierre Joseph 1789–1874
Head of a Girl
oil on board 12.7 x 8.2
O.4

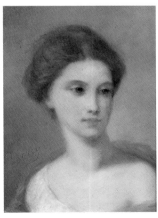

Dedreux-Dorcy, Pierre Joseph 1789–1874
Head of a Young Girl
oil on panel 21.6 x 15.9
B.M.702

Dedreux-Dorcy, Pierre Joseph 1789–1874
Head of a Young Girl
oil on panel 19.7 x 13.4
B.M.704

Dedreux-Dorcy, Pierre Joseph 1789–1874
Le repos
oil on canvas 45.6 x 36.2
B.M.443

Delaplace active 19th C
A Storm at Sea
oil on panel 23.1 x 32.5
B.M.779

Delaroche, Paul (attributed to) 1797–1856
An Elder Sister of Mrs Bowes
oil on canvas 38.7 x 31.2
B.M.513

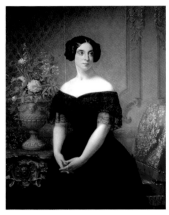

Delaval, Pierre-Louis 1790–1870
Portrait of a Lady in Black 1845
oil on canvas 128.1 x 98.1
B.M.315

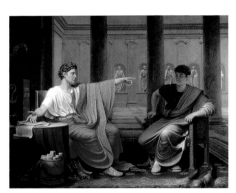

Delécluze, Étienne-Jean 1781–1863
*The Emperor Augustus Rebuking Cornelius
Cinna for His Treachery* 1814
oil on canvas 214.1 x 263.9
B.M.367

Delen, Dirck van 1604/1605–1671
*Jupiter and Alkmene in an Architectural
Setting* 1669
oil on canvas 48.1 x 58.4
B.M.606

Delrieux, Étienne
Landscape c.1870
oil on canvas 75 x 95
B.M.248

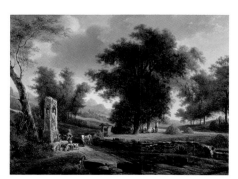

Demarne, Jean-Louis 1744–1829
*Landscape with Figures and a Gothic
Monument*
oil on canvas 24.5 x 32.5
B.M.661

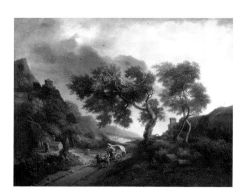

Demarne, Jean-Louis 1744–1829
Rocky Landscape with a Cart
oil on canvas 74 x 87.7
B.M.290

Denner, Balthasar 1685–1749
Portrait of a Man in a Fur-Trimmed Hat
18th C
oil on canvas 57.5 x 47.5
B.M.104

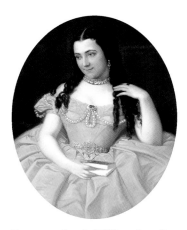

Desanges, Louis William (attributed to)
1822–after 1901
Joséphine Bowes (1825–1874) c.1852–1860
oil on canvas 94 x 73.5
B.M.529

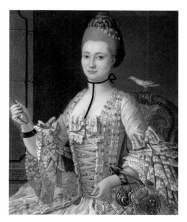

Descours, Michel Pierre Hubert 1741–1814
Portrait of Elizabeth de la Vallée de la Roche
1771
oil on canvas 80 x 63.7
B.M.547

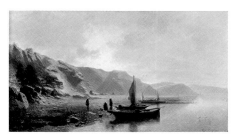

Deshayes, Eugène 1828–1890
The Shore of a Lake with Boats and Figures
c.1860–1866
oil on canvas 71.3 x 81.3
B.M.510

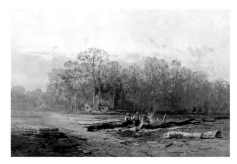

Deshayes, Eugène 1828–1890
*Misty Landscape with Woodcutters around a
Fire* 1860s
oil on panel 21.9 x 30.3
B.M.398

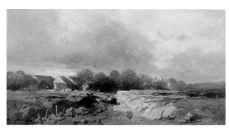

Deshayes, Eugène 1828–1890
View of a Village among Trees 1860s
oil on panel 21.9 x 39.4
B.M.749

Deshayes, Eugène 1828–1890
View on the Marne, France 1866
oil on panel 24.4 x 39.1
B.M.649

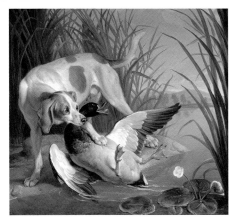

**Desportes, Alexandre-François
(attributed to)** 1661–1743
A Dog and a Wild Duck
oil on canvas 81 x 85.1
B.M.912

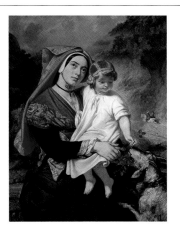

Devéria, Eugène 1808–1865
*A Young Woman of the Valley of Ossau with
Her Child* c.1847
oil on canvas 129.2 x 97.3
B.M.361

d'Haite active 19th C
Chickens in a Barn
oil on panel 32.7 x 23.8
B.M.676

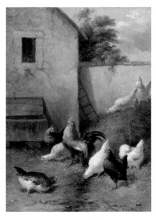

d'Haite active 19th C
Chickens near a Water Trough
oil on panel 32.7 x 23.8
B.M.677

Diziani, Gaspare 1689–1767
Antiochus and Stratonice c.1750–1767
oil on canvas 56 x 88.2
B.M.1

Domenichino (circle of) 1581–1641
St George 17th C
oil on canvas 134.3 x 98
B.M.62

Downman, John 1750–1824
Edwin and Emma c.1789
oil on canvas 44 x 59
1975.22.2

Droochsloot, Cornelis 1630–1673
The Parable of the Great Supper
oil on panel 55 x 81.2
B.M.605

Drouais, François Hubert (attributed to)
1727–1775
A Girl Holding a Canary, Time of Louis XV
c.1750
oil on canvas 52.5 x 44.4
B.M.548

Drouais, François Hubert (circle of)
1727–1775
Portrait of a Child 18th C
oil on canvas 47.1 x 36
B.M.294

Drummond, Samuel (attributed to)
1765–1844
Sir John Hullock (1767–1829)
oil on canvas 138.7 x 117
O.34

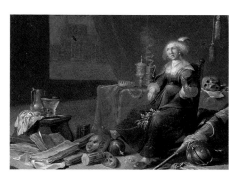

Duck, Jacob c.1600–1667
Vanitas Scene, an Interior
oil on panel 25 x 33.7
B.M.933

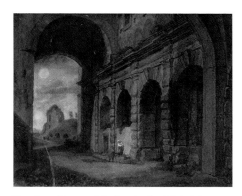

Dughet, Gaspard (school of) 1615–1675
Architectural Landscape 17th C
oil on canvas 50 x 60
B.M.595

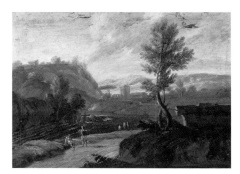

Dughet, Gaspard (style of) 1615–1675
Classical Landscape 17th C
oil on canvas 34.4 x 45.6
B.M.791

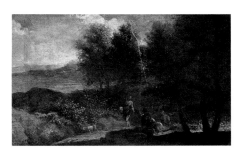

Dughet, Gaspard (style of) 1615–1675
Woods, Lake and Figures late 17th C
oil on panel 20 x 33
O.79

Dujardin, Karel (style of) 1626–1678
Girl Driving Cattle 17th C
oil on canvas 56.2 x 67.5
B.M.304

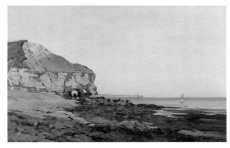

Dumax, Ernest-Joachim 1811–after 1882
Seacoast at Port-en-Bessin, Normandy, France
oil on canvas 33.1 x 51.9
B.M.411

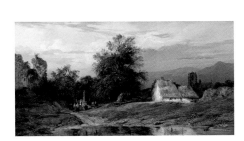

Dumée
An Open-Air Altar 1839
oil on canvas 32.5 x 58.7
B.M.447

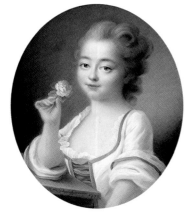

Duneuf-Germain, (Mlle)
Portrait of a Girl with a Rose 1772
oil on canvas 45 x 36.2
B.M.270

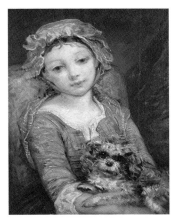

Dupont, Ernest 1825–1888
Portrait of a Young Girl Holding a Dog
oil on canvas 35.5 x 27.9
B.M.650

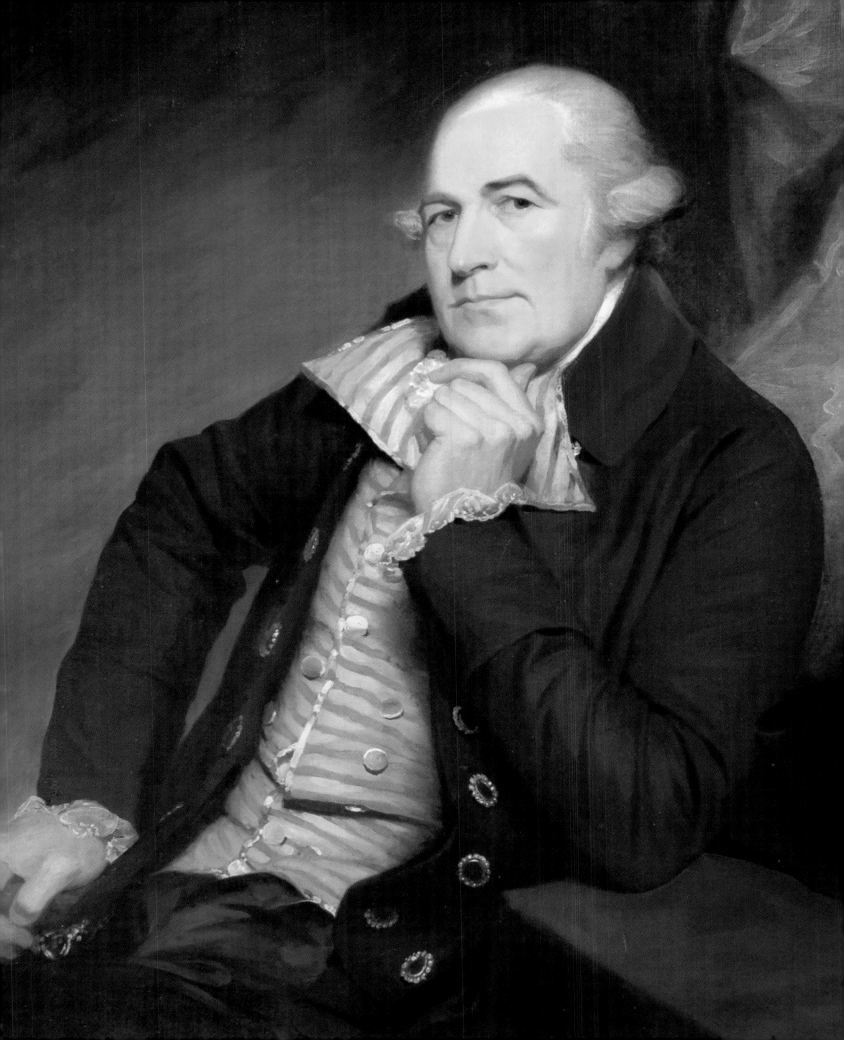

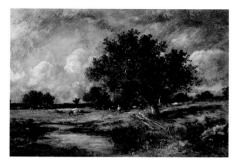

Dupré, Léon Victor 1816–1879
Landscape with Cows and Figures 1864
oil on canvas 32.5 x 46.2
B.M.399

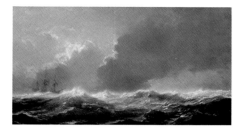

Durand-Brager, Jean Baptiste Henri
1814–1879
A Rough Sea 1862
oil on canvas 32.5 x 57.5
B.M.351

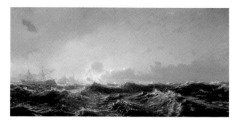

Durand-Brager, Jean Baptiste Henri
1814–1879
A Rough Sea
oil on panel 20 x 37.5
B.M.693

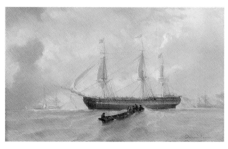

Durand-Brager, Jean Baptiste Henri
1814–1879
A Ship and a Longboat
oil on canvas 37.5 x 50
B.M.1003

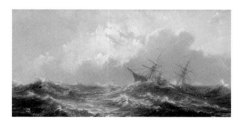

Durand-Brager, Jean Baptiste Henri
1814–1879
A Ship in a Stormy Sea
oil on panel 15.9 x 32.4
B.M.681

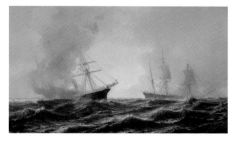

Durand-Brager, Jean Baptiste Henri
1814–1879
A Ship on Fire at Sea, Another Standing By
oil on canvas 48.3 x 81.1
B.M.372

Durand-Brager, Jean Baptiste Henri
1814–1879
Ships Standing off a Beach
oil on panel 15.9 x 32.4
B.M.1053

Durand-Brager, Jean Baptiste Henri
1814–1879
Vue de Trébizonde, Turquie
oil on panel 20.5 x 37.5
B.M.752

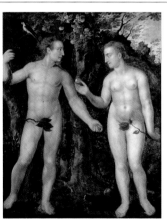

Dürer, Albrecht (after) 1471–1528
Adam and Eve 16th C
oil on panel 121 x 91
B.M.631

Facing page: Beechey, William, 1753–1839, *George Maltby, Esq. (1731–1794)* (detail) c.1782,
Durham University, (p. 290)

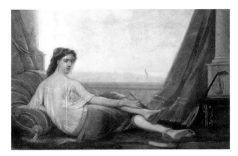

Durieux, Émile active 19th C
In the Seraglio
oil on canvas 51.2 x 64.7
B.M.528

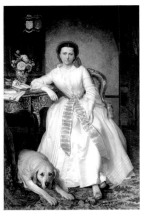

Dury, Antoine 1819–after 1878
Joséphine Bowes (1825–1874), Countess of Montalbo 1850
oil on canvas 195.8 x 127.9
B.M.297

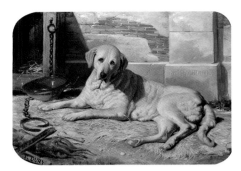

Dury, Antoine 1819–after 1878
Bernardine (Mrs Bowes's Dog) c.1850
oil on canvas 45.7 x 55.5
B.M.911

Dutch (Amsterdam) School
Portrait of a Man in a Fur Collar
c.1650–c.1700
oil on canvas 54.4 x 41.2
B.M.102

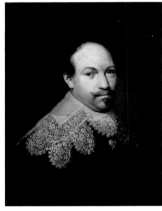

Dutch School
Portrait of a Man c.1600–c.1675
oil on canvas 68.1 x 51.3
B.M.177

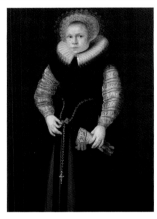

Dutch School
Portrait of a Girl with a Glove 1611
oil on panel 102.5 x 73.1
B.M.165

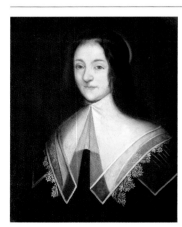

Dutch School
Portrait of a Lady in a Black Dress
c.1625–c.1650
oil on canvas 60 x 47.5
B.M.950

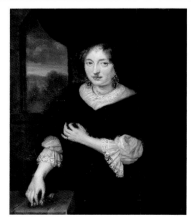

Dutch School
Portrait of a Lady in a Black Dress
c.1625–c.1675
oil on canvas 48.7 x 38.4
B.M.201

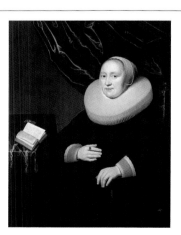

Dutch School
Portrait of a Lady in Black with a Ruff
c.1630–c.1655
oil on panel 110.6 x 85.6
B.M.209

Dutch School
Portrait of a Lady c.1650–c.1660
oil on panel 51.2 x 40
B.M.129

Dutch School
Portrait of an Old Lady in Seventeenth-Century Costume 1656
oil on panel 96.2 x 67.5
B.M.204

Dutch School
Cornelia van Vrybergen (1651–1714)
c.1675–c.1700
oil on canvas 46 x 38
O.295

Dutch School 17th C
A Seashore with a Beached Ship
oil on panel 50 x 67.5
B.M.161

Dutch School 17th C
Angels Appearing to Abraham
oil on panel 7 x 15.3
O.46

Dutch School 17th C
Boors in a Tavern
oil on canvas 22.5 x 30.6
B.M.229

Dutch School 17th C
Judith and Holofernes
oil on panel 7 x 15.3
O.47

Dutch School 17th C
Peasants Carousing
oil on canvas 20 x 30
B.M.231

Dutch School 17th C
Portrait of a Gentleman
oil on copper 13.8 x 10.6
B.M.802

Dutch School 17th C
Portrait of a Lady
oil on metal 13.8 x 10.6
B.M.803

Dutch School 17th C
Two Men
oil on canvas 43 x 38
O.210

Dutch School 17th C
View of Dunkirk, France
oil on canvas 80 x 154.4
B.M.601

Dutch School mid-17th C-mid-18th C
Interior Scene
oil on canvas 40 x 50
O.207

Dutch School 18th C
Landscape
oil on panel 65.4 x 87.6
O.43

Dutch School 18th C
The Gamblers
oil on canvas 40 x 53.7
B.M.598

Dutch School
A Boy with a Glass of Wine c.1800–c.1860
oil on canvas 55.6 x 44.4
B.M.607

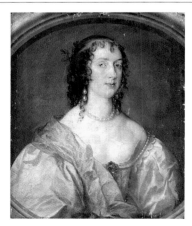

Dyck, Anthony van (after) 1599–1641
Olivia Boteler Porter (d.1633) c.1630
oil on canvas 72.4 x 61
O.88

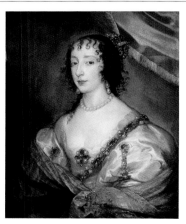

Dyck, Anthony van (after) 1599–1641
Queen Henrietta Maria (1609–1669) 17th C
oil on canvas 70.5 x 59
O.317

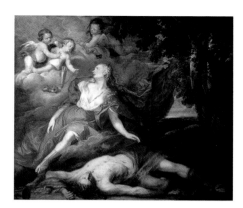

Dyck, Anthony van (circle of) 1599–1641
The Death of Adonis 17th C
oil on canvas 170 x 198.7
B.M.831

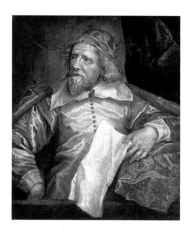

Dyck, Anthony van (copy after) 1599–1641
Inigo Jones (1573–1652) 19th C
oil on canvas 24.1 x 19.1
B.M.1026

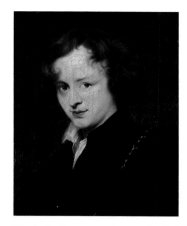

Dyck, Anthony van (copy after) 1599–1641
Self Portrait 19th C
oil on canvas 53.4 x 42.5
B.M.982

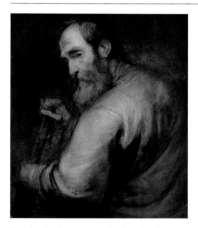

Dyck, Anthony van (school of) 1599–1641
A Man Leaning on a Spade 17th C
oil on canvas 72.5 x 60.5
B.M.169

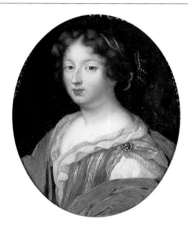

Egmont, Justus van 1601–1674
La Duchesse d'Aumont (1650–1711) c.1674
oil on panel 24.1 x 19
B.M.271

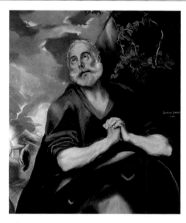

El Greco 1541–1614
The Tears of St Peter c.1580–1589
oil on canvas 108 x 89.6
B.M.642

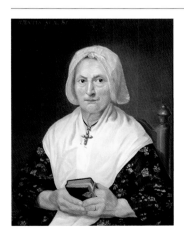

Elshoecht, Jean Louis 1760–1842
Portrait of a Lady of 81 years 1805
oil on panel 55.5 x 42.1
B.M.856

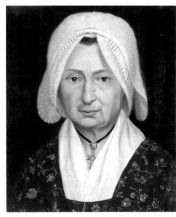

Elshoecht, Jean Louis 1760–1842
Madame Louis Suywens
oil on canvas 49.4 x 38.1
B.M.947

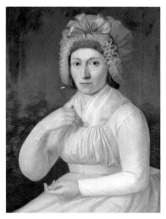

Elshoecht, Jean Louis 1760–1842
Portrait of a Lady
oil on canvas 66.2 x 46.2
B.M.926

Elton, Samuel Averill 1827–1886
View of Gainford from the Yorkshire Side of the River Tees 1860
oil on canvas 52.7 x 74.9
B.M.977

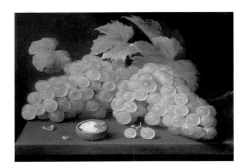

Es, Jacob Foppens van c.1596–1666
Grapes with a Half Walnut
oil on panel 24.7 x 35.2
B.M.790

Esselens, Jacob 1626–1687
Wooded Landscape with Figures
oil on panel 54 x 70.5 (E)
B.M.151

Everdingen, Allart van 1621–1675
Norwegian Landscape
oil on panel 73.1 x 60
B.M.106

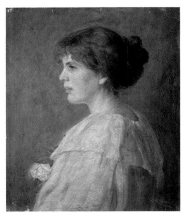

Eves, Reginald Grenville 1876–1941
Female Portrait 1898
oil on canvas 61 x 51
1973.103.20

Eves, Reginald Grenville 1876–1941
Portrait of a Boy 1930
oil on canvas 44.4 x 29.8
O.37

Eves, Reginald Grenville 1876–1941
William John Cavendish Bentinck (1857–1943), 6th Duke of Portland 1931
oil on canvas 61 x 50.5
O.61

Eves, Reginald Grenville 1876–1941
River Tees 1934
oil on canvas 49.5 x 60.5
1973.103.6

Eves, Reginald Grenville 1876–1941
Landscape 1936
oil on panel 25.5 x 35.5
1973.103.13

Eves, Reginald Grenville 1876–1941
The Duchess of Leinster 1937
oil on canvas 61 x 51
1973.103.19

Eves, Reginald Grenville 1876–1941
Portrait of a Man 1939
oil on canvas 61 x 50.5
O.62

Eves, Reginald Grenville 1876–1941
Above Winch Bridge, Durham
oil on panel 25.5 x 35
O.39

Eves, Reginald Grenville 1876–1941
Barnard Castle, County Durham
oil on panel 25.5 x 35
O.40

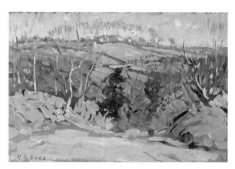

Eves, Reginald Grenville 1876–1941
Birch Trees with Houses
oil on panel 24 x 34
1973.103.45

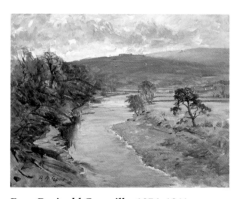

Eves, Reginald Grenville 1876–1941
Extensive River Scene
oil on canvas 62 x 75
1973.103.7

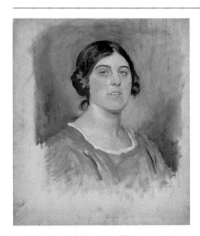

Eves, Reginald Grenville 1876–1941
Female Portrait
oil on canvas 61 x 51
1973.103.21

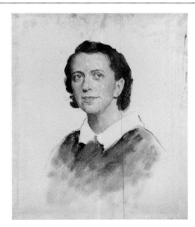

Eves, Reginald Grenville 1876–1941
Female Portrait
oil on canvas 61 x 51
1973.103.22

Eves, Reginald Grenville 1876–1941
Female Portrait
oil on canvas 61 x 51
1973.103.23

Eves, Reginald Grenville 1876–1941
Female Portrait
oil on canvas 61 x 51
1973.103.24

Eves, Reginald Grenville 1876–1941
Gorge
oil on canvas 45 x 61
O.340

Eves, Reginald Grenville 1876–1941
Hercules Brabazon Brabazon (1821–1906)
(copy after John Singer Sargent)
oil on canvas 73.5 x 43
O.60

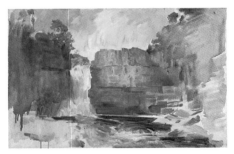

Eves, Reginald Grenville 1876–1941
High Force
oil on canvas 41 x 61
1973.103.17

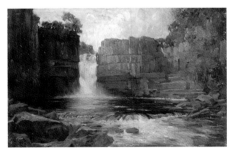

Eves, Reginald Grenville 1876–1941
High Force
oil on canvas 41 x 61
1973.103.18

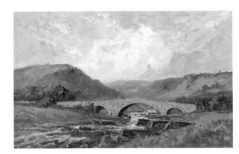

Eves, Reginald Grenville 1876–1941
Landscape
oil on canvas 35.5 x 57.2
O.36

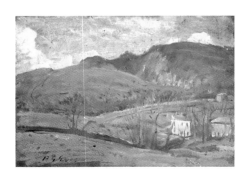

Eves, Reginald Grenville 1876–1941
Landscape
oil on panel 25.5 x 35.5
1973.103.11

Eves, Reginald Grenville 1876–1941
Landscape
oil on panel 25.5 x 35.5
1973.103.12

Eves, Reginald Grenville 1876–1941
Landscape
oil on panel 25.5 x 35.5
1973.103.14

Facing page: Tiepolo, Giovanni Battista, 1696–1770, *The Harnessing of the Horses of the Sun* (detail),
c.1731–1736, The Bowes Museum, (p. 165)

Eves, Reginald Grenville 1876–1941
Landscape
oil on panel 25.5 x 35.5
1973.103.15

Eves, Reginald Grenville 1876–1941
Landscape
oil on panel 25.5 x 35.5
1973.103.16

Eves, Reginald Grenville 1876–1941
Landscape with a River
oil on canvas 86 x 97
O.58

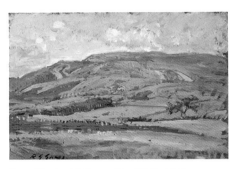

Eves, Reginald Grenville 1876–1941
Low Force
oil on canvas 49.5 x 67.5
1973.103.4

Eves, Reginald Grenville 1876–1941
March Day, Sussex
oil on panel 24 x 34
1973.103.46

Eves, Reginald Grenville 1876–1941
Over the Hills, Yorkshire
oil on panel 24 x 34.5
1973.103.43

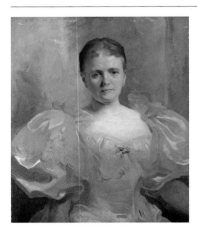

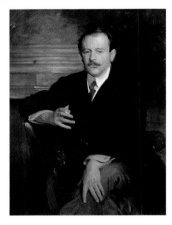

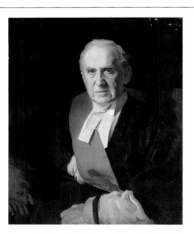

Eves, Reginald Grenville 1876–1941
Portrait of a Lady (copy after John Singer
Sargent)
oil on canvas 76 x 63
O.59

Eves, Reginald Grenville 1876–1941
Portrait of a Man
oil on canvas 101.5 x 76
O.53

Eves, Reginald Grenville 1876–1941
Portrait of a Man
oil on canvas 87 x 71.5
O.54

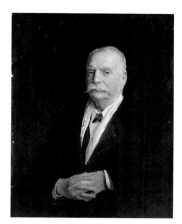

Eves, Reginald Grenville 1876–1941
Portrait of a Man
oil on canvas 93 x 73
O.55

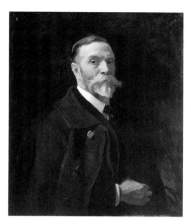

Eves, Reginald Grenville 1876–1941
Portrait of a Man
oil on canvas 87 x 72
O.56

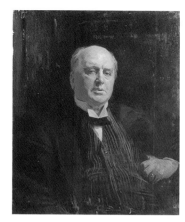

Eves, Reginald Grenville 1876–1941
Portrait of a Man
oil on canvas 87.5 x 69
O.57

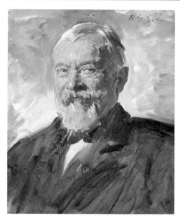

Eves, Reginald Grenville 1876–1941
Portrait of a Man
oil on canvas 51 x 41
1971.85

Eves, Reginald Grenville 1876–1941
River Gorge
oil on canvas 50.5 x 75.5
O.339

Eves, Reginald Grenville 1876–1941
River Scene
oil on canvas 48.7 x 71.9
O.35

Eves, Reginald Grenville 1876–1941
River Scene
oil on canvas 49.5 x 75
1973.103.3

Eves, Reginald Grenville 1876–1941
River Tees
oil on canvas 62 x 75
1973.103.8

Eves, Reginald Grenville 1876–1941
Self Portrait
oil on canvas 24 x 20
1985.11.A.1

Eves, Reginald Grenville 1876–1941
Stanley Baldwin
oil on canvas 58.5 x 48
1973.103.2

Eves, Reginald Grenville 1876–1941
Stream Scene
oil on canvas 62 x 100.5
1973.103.5

Eves, Reginald Grenville 1876–1941
The Marquess of Winchester
oil on canvas 60.5 x 49.5
1973.103.1.

Eves, Reginald Grenville 1876–1941
The Winding Road
oil on panel 24 x 34.5
1973.103.44

Eves, Reginald Grenville 1876–1941
View of a Gorge
oil on canvas 40.5 x 61
1973.103.10

Eves, Reginald Grenville 1876–1941
Waterfall in Teesdale
oil on board 43 x 60.5
O.64

N. F.
Portrait of a Lady in a Red Dress 1758
oil on canvas 67.5 x 48.7
B.M.852

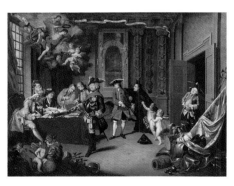

Faber, H.
The Treaty of Hubertusburg, 15 February 1763
1763
oil on canvas 101.3 x 131.3
B.M.623

Faes, Peter 1750–1814
A Marble Vase of Lilac with Other Flowers on a Marble Shelf 1796
oil on panel 61.2 x 43
B.M.764

Fantin-Latour, Henri 1836–1904
Fruit and Flowers 1866
oil on canvas 60 x 44.1
B.M.514

Feyen, Jacques Eugène 1815–1908
The Eldest Sister of Mrs Bowes 1850s
oil on canvas 22.2 x 16.5
B.M.515

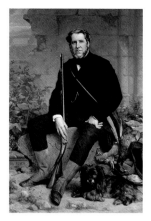

Feyen, Jacques Eugène 1815–1908
John Bowes, Esq. (1811–1885), 1863
oil on canvas 181.3 x 119.7
B.M.300

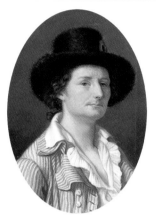

Feyen, Jacques Eugène 1815–1908
Monsieur Sergent
oil on canvas 22.2 x 16.5
B.M.516

Feyen-Perrin, François Nicolas Auguste
1826–1888
Digging for Bait, Group on the Seashore
oil on panel 14.4 x 27.5
B.M.706

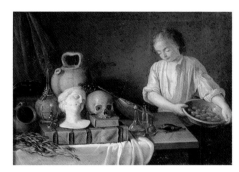

Fiamengo, P. S.
*Still Life Group of a Bust, Vases and a Skull
with a Boy Holding a Dish of Beans* 1758
oil on canvas 30.5 x 40
B.M.883

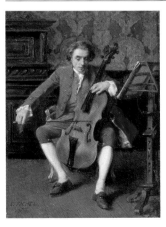

Fichel, Eugène 1826–1895
The Violoncello Player 1867(?)
oil on panel 14.7 x 10.3
B.M.703

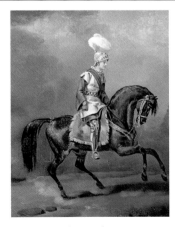

Finart, Noël Dieudonné 1797–1852
A Knight on a Horse 1823
oil on canvas 14.7 x 12.7
B.M.1078

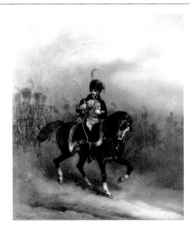

Finart, Noël Dieudonné 1797–1852
A Cavalry Soldier on Horseback 1842
oil on canvas 45.3 x 37.5
B.M.853

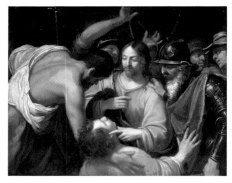

Finson, Louis (circle of) c.1580–1617
Christ Healing the Ear of Malchus 17th C
oil on canvas 96.9 x 121.2
B.M.632

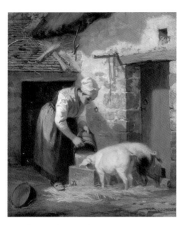

Fischer, Alexandre Georges 1820–1890
A Peasant Girl Feeding Pigs
oil on panel 41 x 32.7
B.M.753

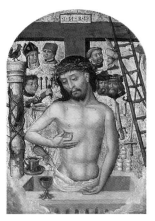

Flemish School
Christ as the Man of Sorrows c.1450–c.1500
oil on panel 21.9 x 14.4
B.M.1069

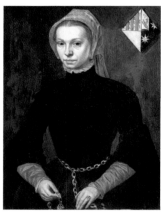

Flemish School
Anne van Weluwe (c.1528–1561)
c.1548–c.1550
oil on panel 40 x 30
B.M.416

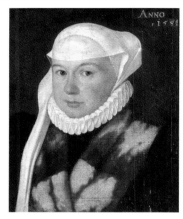

Flemish School
Portrait of a Lady in Brown c.1580–c.1581
oil on canvas 48.9 x 39.1
B.M.143

Flemish School 16th C
The Archangel Gabriel
oil on panel 20.3 x 16.5
O.188

Flemish School 16th C
The Virgin Mary
oil on panel 20.3 x 16.5
O.189

Flemish School mid-16th C-mid-17th C
Susannah and the Elders
oil on panel 48.8 x 62.5
B.M.929

Flemish School
*Lady in a Black and Red Dress and a Black
Flemish Hat* c.1600–c.1650
oil on canvas 124.4 x 98.1
B.M.112

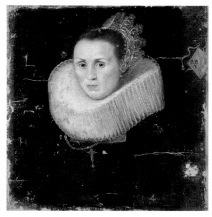

Flemish School
Portrait of a Lady c.1620–c.1640
oil on canvas 70 x 62.2
O.77

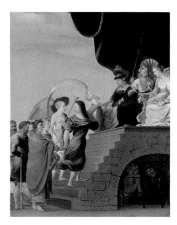

Flemish School
The Blessings of Peace c.1620–c.1640
oil on panel 39.4 x 31.2
B.M.884

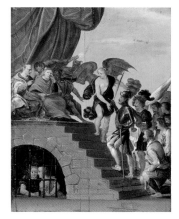

Flemish School
The Evil of War c.1620–c.1640
oil on panel 39.4 x 31.2
B.M.888

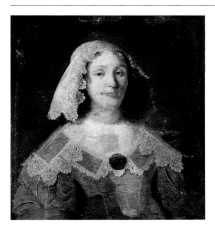

Flemish School
Portrait of a Lady c.1625–c.1635
oil on canvas 60.2 x 57.5
B.M.39

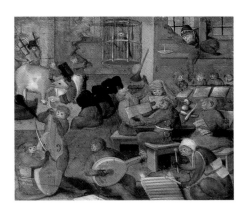

Flemish School
A School of Monkeys c.1625–c.1675
oil on panel 27 x 31.3
B.M.797

Flemish School
Mary Magdalene c.1630–c.1700
oil on panel 33.8 x 24
O.187

Flemish School
A Carmelite Friar 1639
oil on canvas 201.3 x 120.6
B.M.27

Flemish School
Portrait of a Man c.1640–c.1660
oil on canvas 63.5 x 49.5
B.M.54

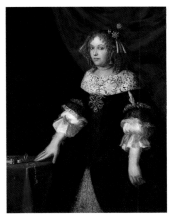

Flemish School
Maria Anna van Berchem, Countess of Crykenborch c.1650–c.1670
oil on canvas 102.5 x 95.6
B.M.90

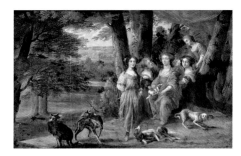

Flemish School
Diana and Nymphs c.1650–c.1700
oil on canvas 111.3 x 161.3
B.M.847

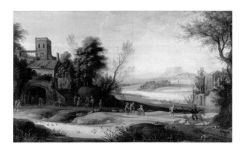

Flemish School
Landscape with Peasants c.1650–c.1700
oil on canvas 71.3 x 113.8
B.M.139

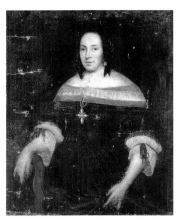

Flemish School
Portrait of a Lady c.1660–c.1670
oil on canvas 110.5 x 88.3
O.163

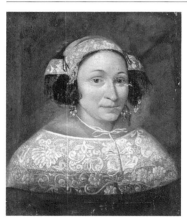

Flemish School
Portrait of a Lady c.1660–c.1680
oil on canvas 52.5 x 42.5
B.M.944

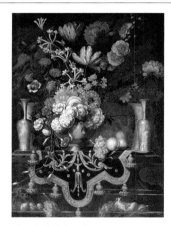

Flemish School
Flowers in a Gilt Vase with Porcelain Vases
c.1680–c.1720
oil on canvas 110.2 x 82.5
B.M.358

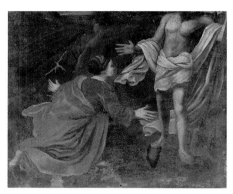

Flemish School 17th C
Biblical Scene
oil on canvas 38.1 x 46.3
O.126

Flemish School 17th C
Calvariae locus mons calvariae
oil on panel 47.5 x 35
B.M.604

Flemish School 17th C
Christ on the Road to Emmaus
oil on canvas 76.2 x 98.5
O.118

Flemish School 17th C
Interior, Peasants Playing Musical Instruments
oil on panel 78.7 x 111.9
B.M.202

Flemish School 17th C
Landscape
oil on canvas 61 x 95.2
O.170

Flemish School 17th C
Portrait of a Man
oil on canvas 84 x 107
O.169

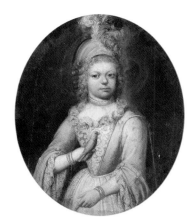

Flemish School 17th C
Portrait of a Young Girl Holding a Canary
oil on canvas 72.5 x 60
B.M.894

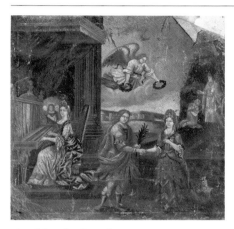

Flemish School 17th C
St Cecilia
oil on canvas 44.5 x 44.5
O.205

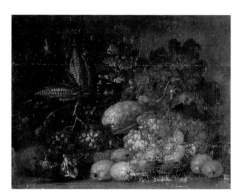

Flemish School 17th C
Still Life
oil on canvas fixed on panel 21.5 x 25.2
O.1

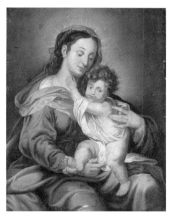

Flemish School 17th C
The Madonna and Child
oil on canvas 85 x 64
O.332

Flemish School mid-17th C-mid-18th C
Interior of a Church
oil on panel 67.8 x 32.3
B.M.586

Flemish School mid-17th C–mid-18th C
St Joseph with Putti
oil on canvas 33.7 x 25.6
B.M.422

Flemish School
River Scene with Boats c.1700–c.1750
oil on canvas 27.5 x 34.4
B.M.784

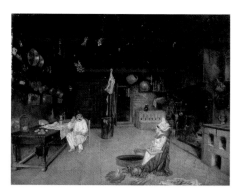

Flemish School mid-18th C-mid-19th C
Kitchen Interior with Figures
oil on canvas 33.7 x 39.4
B.M.795

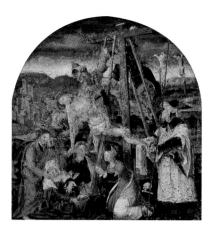

Flemish School
The Deposition from the Cross c.1800–c.1850
oil on panel 22 x 19
O.72

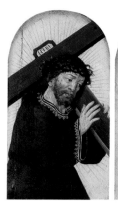

Flemish School
Christ Carrying the Cross and the Mater Dolorosa c.1800–c.1860
oil on oak panel 40 x 24.7; 40 x 24.7
B.M.173

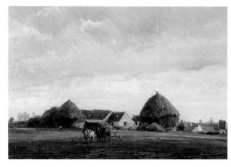

Flers, Camille 1802–1868
Landscape near Annet-sur-Marne, France
1860s
oil on panel 28 x 39.5 (E)
B.M.327

Fleury, Antoine Claude active 1787–1822
A Boy Sitting on a Dog's Back 1802
oil on canvas 95.6 x 128.2
B.M.533

Fleury, François Antoine Léon 1804–1858
Landscape with a Boathouse on a River
oil on canvas 48.8 x 65.3
B.M.505

Fontaine, André b.1802
Girl Reading 1850
oil on panel 40.9 x 32.4
B.M.375

Fontana, Prospero (attributed to)
1512–1597
The Holy Family with St Jerome, St Catherine and the Infant St John the Baptist
oil on panel 100.8 x 74.9
B.M.49

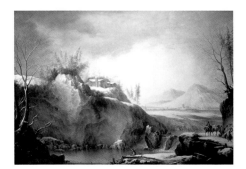

Foschi, Francesco 1710–1780
Snowy Landscape c.1770
oil on canvas 96.5 x 135.3
B.M.355

Facing page: Heem, Cornelis de, 1631–1695, *A Garland of Fruit* (detail), The Bowes Museum, (p. 107)

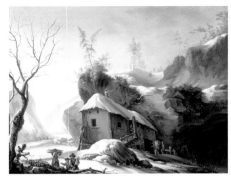

Foschi, Francesco 1710–1780
Snowy Landscape c.1770
oil on canvas 55 x 68.7
B.M.520

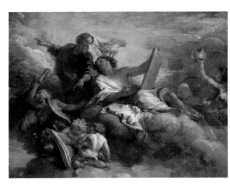

Fosse, Charles de la 1636–1716
*St Paul Commanding St Luke to Accompany
Him to Rome* c.1692
oil on canvas 81.5 x 104
1980.9

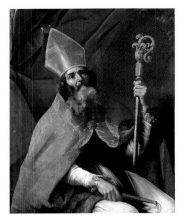

Fracanzano, Cesare (attributed to)
c.1605–1651
St Ambrose
oil on canvas 125.8 x 101
B.M.2

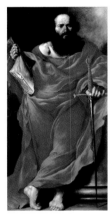

Fracanzano, Francesco (attributed to)
1612–1656
St Paul
oil on canvas 235.2 x 115.6
B.M.68

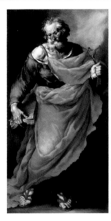

Fracanzano, Francesco (attributed to)
1612–1656
St Peter
oil on canvas 237.5 x 115.5
B.M.38

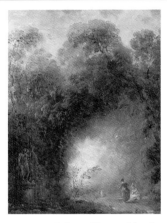

Fragonard, Jean-Honoré (style of)
1732–1806
Avenue with Figures 18th C
oil on canvas 26.8 x 20.3
B.M.396

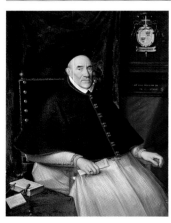

Franchoys, Lucas the elder (attributed to)
1574–1643
Mathias Hovius (d.1620) 1612
oil on canvas 146.8 x 110.5
B.M.261

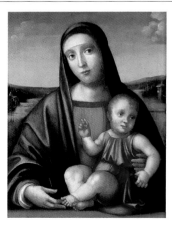

Francia, Francesco (after) c.1450–1517
Madonna and Child 17th C
oil on panel 56.2 x 41.6
B.M.50

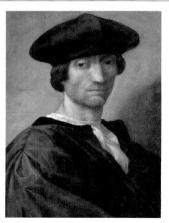

Franciabigio (attributed to) 1482–1525
Portrait of a Man in a Black Hat early 16th C
oil on panel 55.9 x 42.8
B.M.45

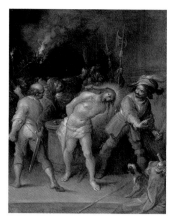

Francken, Frans II (attributed to)
1581–1642
The Flagellation of Christ early 17th C
oil on copper 38.1 x 28.6
B.M.172

Francken, Frans II (attributed to)
1581–1642
The Miracle of the Loaves and the Fish
oil on panel 27.2 x 39.1
B.M.581

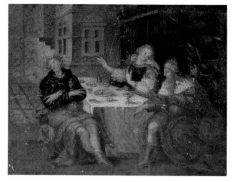

Francken family (style of)
active 16th C-17th C
Biblical Scene 16th C
oil on panel 31 x 38
O.182

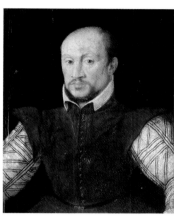

French School
Portrait of a Man in Brown with a Belt Marked 'AF' c.1490–c.1530
oil on panel 45.1 x 37.1
B.M.257

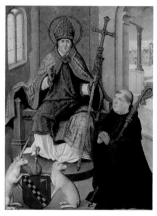

French School
St Claude and a Monk 1519
oil on panel 48.2 x 33.7
B.M.794

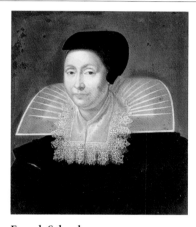

French School
Portrait of a Lady from the Time of Henri IV
c.1553–c.1610
oil on canvas 55 x 45.6
B.M.382

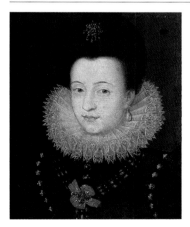

French School
Portrait of a Lady in Black c.1575–c.1600
oil on canvas 46.3 x 35.6
B.M.288

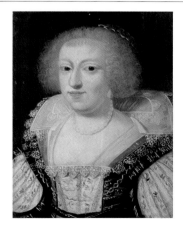

French School
Portrait of a Lady c.1575–c.1620
oil on panel 36.2 x 28
O.224

French School
Portrait of a Lady c.1575–c.1620
oil on panel 36.2 x 27.5
O.225

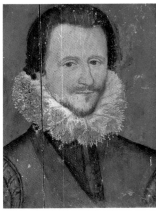

French School
Portrait of a Man c.1580–c.1600
oil on panel 36 x 27
O.183

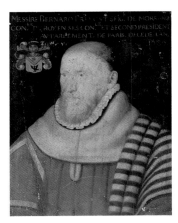

French School
Messire Bernard (c.1517–1585) 1586
oil on panel 57 x 43.8
O.176

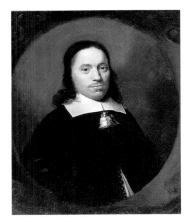

French School
Male Portrait of the Time of Louis XIII
c.1610–c.1640
oil on canvas 77.5 x 62.5
B.M.625

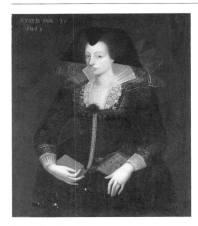

French School
Portrait of a Lady with a Book, Aged 35 1615
oil on canvas 87.5 x 67.5
B.M.258

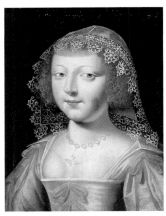

French School
Portrait of a Young Girl c.1620–c.1650
oil on panel 36 x 26.5
O.316

French School
Louis XV (1710–1774), as a Boy
c.1620–c.1720
oil on canvas 74 x 59.7
B.M.281

French School
Portrait of a Lady c.1625–c.1675
oil on canvas 73.8 x 56
O.2

French School
View of Paris, France c.1632–c.1670
oil on canvas 36.5 x 75.6
O.32

French School
Portrait of a Daughter of Louis XIV
c.1643–c.1715
oil on canvas 115 x 87.5
B.M.872

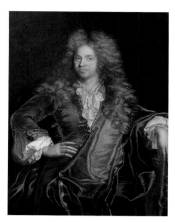

French School
Portrait of a French Admiral of the Time of Louis XIV c.1643–c.1715
oil on canvas 125.5 x 89
B.M.272

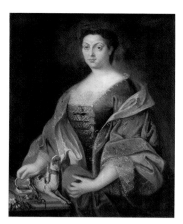

French School
Portrait of a Lady in a Blue and Red Cloak from the Time of Louis XIV c.1643–c.1715
oil on canvas 91.9 x 72.5
B.M.309

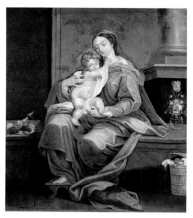

French School
The Virgin and Child c.1650–c.1699
oil on canvas 135.8 x 118.2
B.M.550

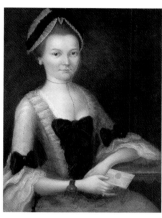

French School
Portrait of a Lady in White Holding a Letter c.1650–c.1700
oil on canvas 72 x 55.7
B.M.539

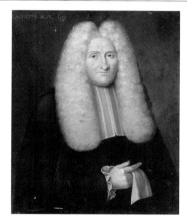

French School
Portrait of a French Judge from the Time of Louis XIV c.1650–c.1720
oil on canvas 76.2 x 62.5
B.M.569

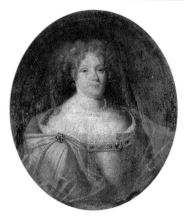

French School
Portrait of a Lady c.1670–c.1690
oil on canvas 73.5 x 60.5
O.260

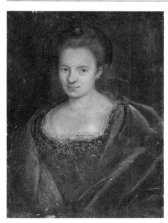

French School
Portrait of a Lady c.1670–c.1700
oil on canvas 68.5 x 50.8
O.281

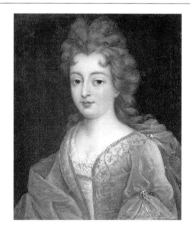

French School
Portrait of a Lady in a Pink Dress c.1670–c.1700
oil on canvas 40.6 x 32.7
B.M.660

French School
Young Boy as Cupid, Wearing a Red and Gold Dress c.1670–c.1700
oil on canvas 85 x 67.5
B.M.564

French School
Portrait of a Lady 1670s
oil on canvas 68.1 x 53.7
B.M.254

French School
Family Portrait Group c.1675–c.1699
oil on canvas 97.5 x 111.2
B.M.622

French School
Cupid and a Lady c.1675–c.1700
oil on canvas 69.3 x 92.8
O.226

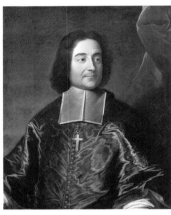

French School
Portrait of a Bishop c.1675–c.1725
oil on canvas 80.1 x 55.1
B.M.618

French School
Portrait of a Lady c.1675–c.1725
oil on canvas 68.5 x 49.5
O.13

French School
Portrait of a Lady of the Time of Louis XIV
c.1675–c.1725
oil on canvas 76.2 x 62.5
B.M.891

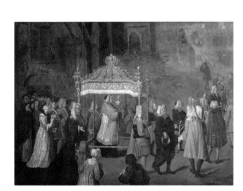

French School
Religious Procession c.1675–c.1725
oil on canvas 50 x 65
B.M.593

French School
Portrait of a Lady in a Red Dress
c.1680–c.1690
oil on canvas 40.6 x 32.5
B.M.267

French School
*A Young Prince Wearing the Order of
Saint-Esprit* c.1680–c.1699
oil on canvas 86.2 x 70
B.M.538

French School
Portrait of a Lady c.1680–c.1700
oil on canvas 100.6 x 82
O.100

French School
Portrait of a Lady c.1680–c.1700
oil on canvas 76 x 59.5
O.263

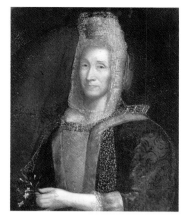

French School
*Portrait of a Lady with a Lace Fontange
Headdress* c.1680–c.1700
oil on canvas 71.9 x 58.7
B.M.899

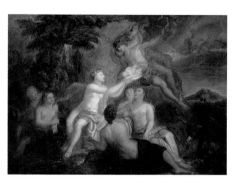

French School
*Mercury Delivering the Infant Bacchus into the
Care of the Nymphs of Nyssa* c.1680–c.1720
oil on canvas 93.7 x 125
B.M.75

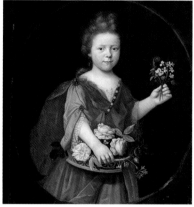

French School
Portrait of a Child with a Basket of Flowers
c.1680–c.1720
oil on canvas 75 x 60
B.M.890

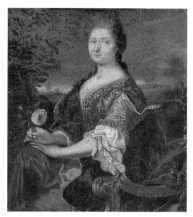

French School
Portrait of a Lady c.1680–c.1720
oil on canvas 31 x 26.8
O.299

French School
Portrait of a Lady Holding a Dog
c.1680–c.1720
oil on canvas 86.9 x 70
O.233

French School
Portrait of a Lady c.1683–c.1700
oil on canvas 73.6 x 62.3
O.87

French School
*Marie Anne de Bourbon (1666–1739),
Princesse de Conti* c.1685–c.1739
oil on canvas 69 x 59
O.29

French School
France, as Minerva, Presents the Portrait of Louis XV (or Louis XIV) to the Institut des Beaux-Arts c.1690–c.1710
oil on panel 57.5 x 117.5
B.M.875

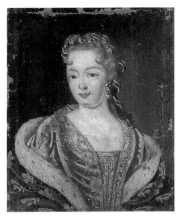

French School
Portrait of a Lady c.1690–c.1710
oil on canvas 40.5 x 32.5
O.287

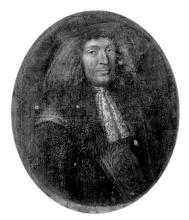

French School
Portrait of a Man c.1690–c.1710
oil on canvas 71 x 59.8
O.261

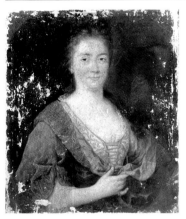

French School
Portrait of a Lady c.1690–c.1720
oil on canvas 73 x 60.5
O.149

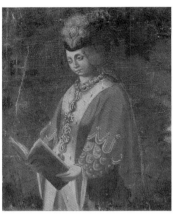

French School 17th C
Portrait of a Lady
oil on canvas 62.2 x 50.8
O.92

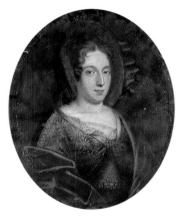

French School 17th C
Portrait of a Lady
oil on canvas 75.5 x 61
O.133

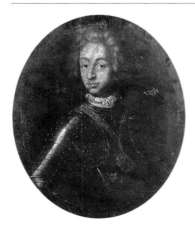

French School 17th C
Portrait of a Man
oil on canvas 76.2 x 64.2
O.136

French School
A Nude Young Prince Wearing the Order of Saint-Esprit c.1700–c.1720
oil on canvas 71.2 x 54.4
B.M.471

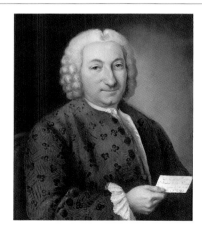

French School
Monsieur Nadaud, Treasurer of the Duc d'Orléans c.1700–c.1725
oil on canvas 65.4 x 55.6
B.M.559

Facing page: Wolfaerts, Artus, 1581–1641 (attributed to), *St Matthew* (detail), Auckland Castle, (p. 222)

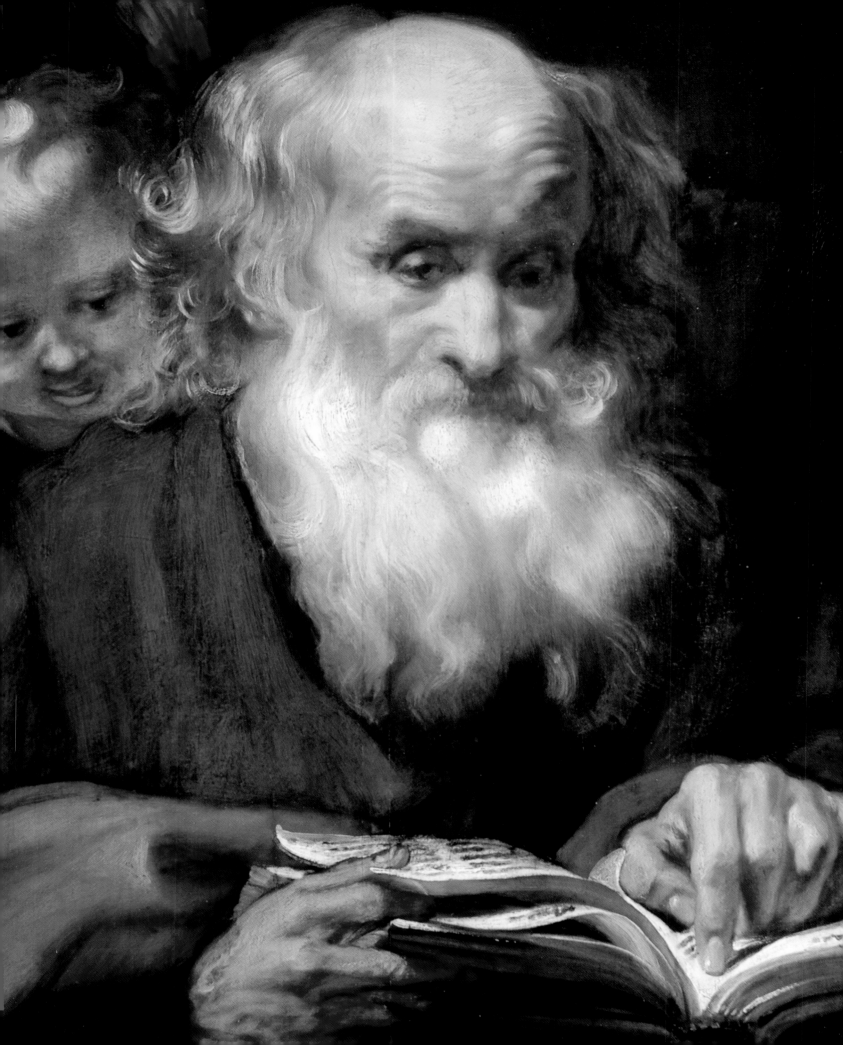

French School
Portrait of a Lady c.1700–c.1725
oil on canvas 81.2 x 64.2
O.145

French School
Portrait of a Lady c.1700–c.1725
oil on canvas 82.5 x 67.3
O.307

French School
Portrait of a Lady c.1700–c.1725
oil on canvas 71.2 x 56
O.312

French School
Portrait of a Lady c.1700–c.1750
oil on canvas 51.5 x 44
O.199

French School
Cupid Watching a Bird (dessus de porte)
c.1700–c.1760
oil on canvas 62.5 x 78.7
B.M.935

French School
Portrait of a Lady c.1700–c.1770
oil on canvas 62.3 x 54.5
O.249

French School
Flower Piece c.1700–c.1780
oil on canvas 70.6 x 56.2
B.M.488

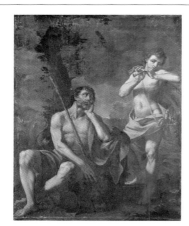

French School
Pan and Apollo c.1700–c.1780
oil on canvas 100 x 83.8
B.M.915

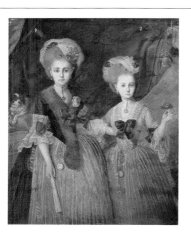

French School
*Two Ladies, One Holding a Fan and the Other
a Rose* c.1700–c.1780
oil on canvas 129 x 102
B.M.981

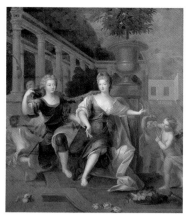

French School
Portrait of a Lady and Gentleman Dressed as Pomona and Vertumnus with Attendant Cupids c.1704
oil on canvas 109.8 x 92.7
B.M.274

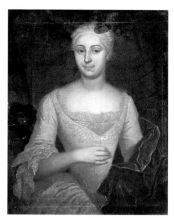

French School
Portrait of a Lady c.1715–c.1740
oil on canvas 82 x 62.9
O.86

French School
Portrait of a Lady c.1715–c.1750
oil on canvas 87.6 x 64.2
O.85

French School
Portrait of a Lady c.1720–c.1740
oil on canvas 56.2 x 42.5
B.M.849

French School
Portrait of a Lady and Her Child c.1720–c.1750
oil on canvas 94.6 x 77.5
O.112

French School
Portrait of a Lady in a Wrap c.1720–c.1760
oil on canvas 80 x 63.7
B.M.987

French School
Portrait of a Man c.1723–c.1774
oil on canvas 76.3 x 62.7
O.147

French School
Portrait of a Lady c.1725–c.1750
oil on canvas 81.3 x 65
O.305

French School
Portrait of a Lady c.1725–c.1760
oil on canvas 56 x 45.8
O.197

French School
Portrait of a Lady c.1725–c.1760
oil on canvas 54.5 x 45.8
O.236

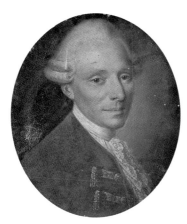

French School
Portrait of a Man c.1725–c.1770
oil on canvas 45.8 x 38
O.200

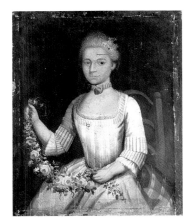

French School
Portrait of a Lady c.1725–c.1775
oil on canvas 79 x 63
O.166

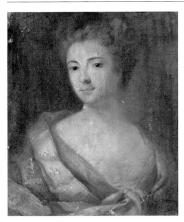

French School
Portrait of a Young Lady c.1730–c.1750
oil on canvas 52.5 x 45
B.M.857

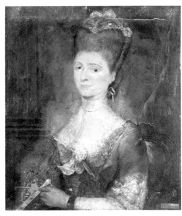

French School
Portrait of a Lady c.1730–c.1760
oil on canvas 64.7 x 54
O.156

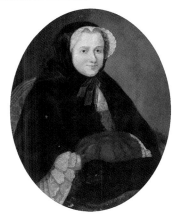

French School
Portrait of a Lady in Black with a Fur Muff
c.1730–c.1760
oil on canvas 79.4 x 63.7
B.M.843

French School
Portrait of a Boy c.1730–c.1770
oil on canvas 56 x 47
O.195

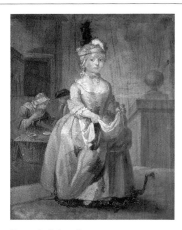

French School
A Young Girl Carrying Cherries in Her Apron
c.1740–c.1760
oil on canvas 41 x 33
B.M.664

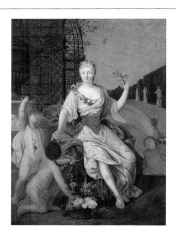

French School
La Marquise de Pompadour (1721–1764)
c.1740–c.1760
oil on canvas 132.5 x 96.2
B.M.860

French School
Portrait of a Lady c.1740–c.1760
oil on canvas 87 x 68.5
O.164

French School
Portrait of a Lady at Her Toilet Table, Dressed in a Peignoir c.1740–c.1760
oil on canvas 74.4 x 57.5
B.M.937

French School
Portrait of a Lady c.1740–c.1770
oil on canvas 81.3 x 64.8
O.304

French School
Portrait of a Lady in a Red Dress with an Embroidered Headdress c.1740–c.1770
oil on canvas 46.9 x 37.5
B.M.386

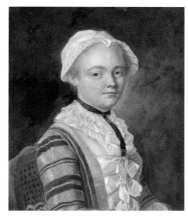

French School
Portrait of a Lady c.1740–c.1780
oil on canvas 59 x 50
O.229

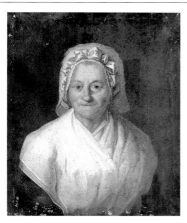

French School
Portrait of a Lady c.1740–c.1790
oil on canvas 61.5 x 51.5
O.158

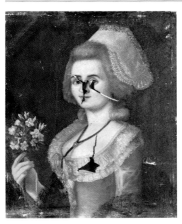

French School
Portrait of a Lady c.1750–c.1770
oil on canvas 65.5 x 53.4
O.150

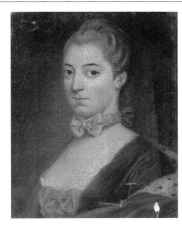

French School
Portrait of a Lady c.1750–c.1770
oil on canvas 49.5 x 39.5
O.285

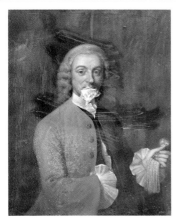

French School
Portrait of a Man c.1750–c.1775
oil on canvas 82 x 65
O.301

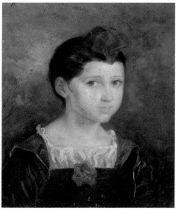

French School
Portrait of a Girl c.1750–c.1780
oil on canvas 46 x 38
O.294

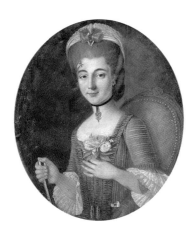

French School
Portrait of a Lady c.1750–c.1780
oil on canvas 87.6 x 68.6
O.138

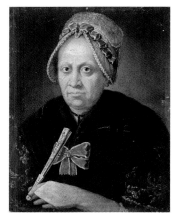

French School
Portrait of an Old Lady c.1750–c.1790
oil on canvas 68.6 x 52.7
O.282

French School
A Sacrifice at an Altar c.1750–c.1799
oil on canvas 30 x 45
B.M.775

French School
A Calm Moonlight c.1750–c.1800
oil on canvas 207.5 x 160
B.M.864

French School
Porta San Paolo, Rome, Italy c.1750–c.1800
oil on canvas 29.4 x 40
B.M.780

French School
Landscape c.1750–c.1820
oil on panel 24 x 33
O.186

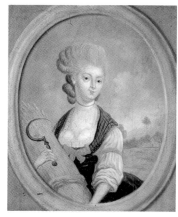

French School
Portrait of a Lady c.1760–c.1780
oil on canvas 33.6 x 28.3
O.18

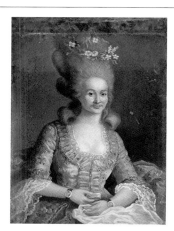

French School
Portrait of a Lady c.1760–c.1780
oil on canvas 87.6 x 64.1
O.83

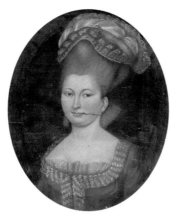

French School
Portrait of a Lady c.1760–c.1780
oil on canvas 65 x 49.8
O.144

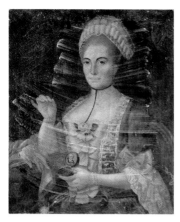

French School
Portrait of a Lady c.1760–c.1780
oil on canvas 80 x 63.5
O.306

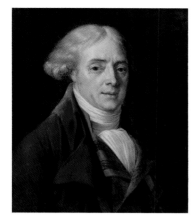

French School
Portrait of a Man (said to be Jean-Baptiste
Greuze, 1725–1805) c.1760–c.1780
oil on canvas 52.5 x 43.7
B.M.545

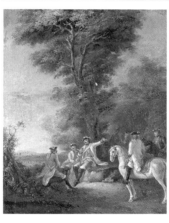

French School
Soldiers Resting c.1760–c.1780
oil on canvas 40.6 x 32
B.M.287

French School
François Jauffret c.1760–c.1789
oil on canvas 99 x 71.8
O.111

French School
Thérèse Jauffret c.1760–c.1789
oil on canvas 98 x 72.4
O.110

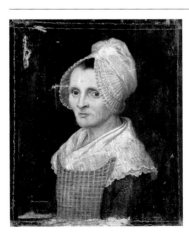

French School
Portrait of a Woman c.1760–c.1790
oil on canvas 61 x 50.8
O.153

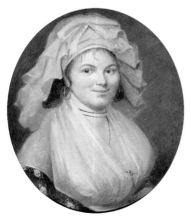

French School
Portrait of a Lady c.1770–c.1780
oil on canvas 30.5 x 26
B.M.670

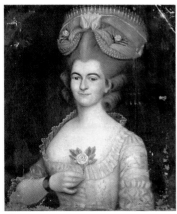

French School
Portrait of a Lady c.1770–c.1780
oil on canvas 72 x 60
O.89

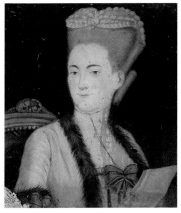

French School
Portrait of a Lady c.1770–c.1785
oil on canvas 54.5 x 44.5
O.283

French School
Portrait of a Lady c.1770–c.1790
oil on canvas 76 x 62
O.146

French School
Portrait of a Lady c.1770–c.1790
oil on canvas 65.5 x 54.6
O.151

French School
Portrait of a Lady c.1770–c.1790
oil on canvas 68 x 52
O.248

French School
Portrait of a Lady c.1770–c.1790
oil on canvas 79.4 x 62.8
O.309

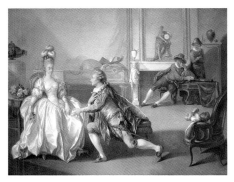

French School
Scene from a Comedy c.1773–c.1791
oil on canvas 130 x 188.7
B.M.301

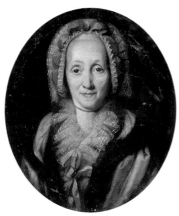

French School
Portrait of a Lady c.1775–c.1789
oil on canvas 56.2 x 46.2
B.M.854

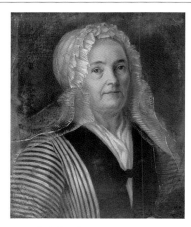

French School
Portrait of a Lady c.1775–c.1790
oil on canvas 55 x 45
O.259

French School
Head of a Girl Wearing a Wreath of Roses c.1775–c.1799
oil on canvas 39.7 x 30.6
B.M.859

French School
Portrait of a Gentleman c.1775–c.1799
oil on canvas 73.7 x 56
O.6

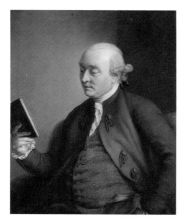

French School
Portrait of a Gentleman Reading a Book
c.1775–c.1799
oil on canvas 91.4 x 71.1
B.M.489

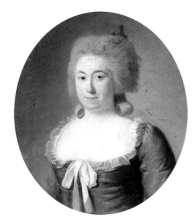

French School
Portrait of a Lady in a Brown Dress
c.1775–c.1799
oil on canvas 60.3 x 49.5
B.M.555

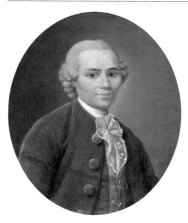

French School
Portrait of a Man in a Red Coat
c.1775–c.1799
oil on canvas 60.3 x 49.5
B.M.549

French School
Portrait of a Lady c.1778–c.1785
oil on canvas 71 x 61
O.84

French School
Portrait of a Girl c.1780–c.1790
oil on board 16 x 12
O.9

French School
Portrait of a Lady c.1780–c.1790
oil on canvas 65 x 53.3
O.192

French School
Portrait of a Lady c.1780–c.1795
oil on canvas 40.6 x 32.5
O.293

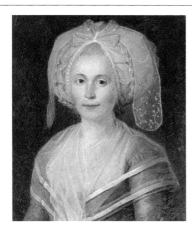

French School
Portrait of a Lady in Green with a Lace Bonnet
c.1780–c.1799
oil on canvas 55.6 x 47.8
B.M.850

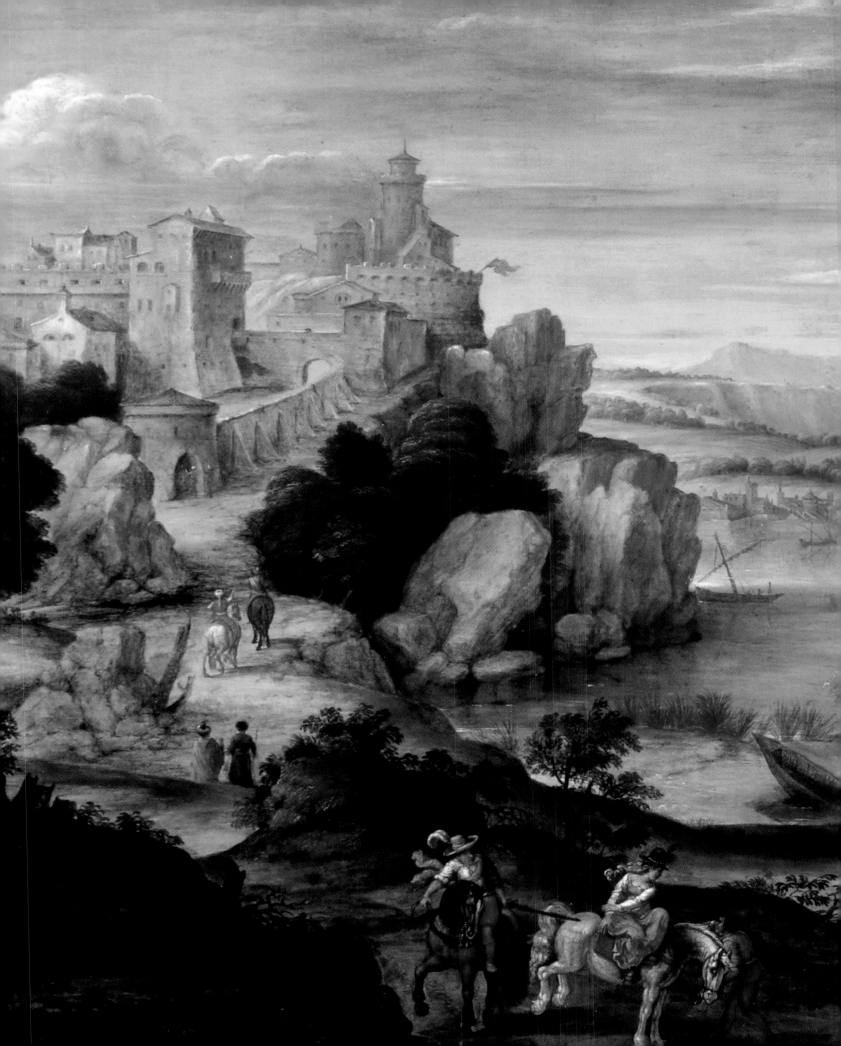

French School
Portrait of a Lady c.1780–c.1820
oil on canvas 81.3 x 64.7
O.311

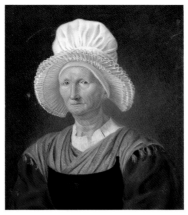

French School
Portrait of a Woman in Normandy Peasant Dress c.1780–c.1820
oil on canvas 63.8 x 52.5
B.M.848

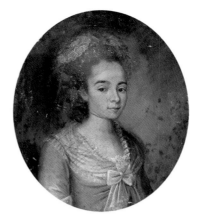

French School
Portrait of a Lady 1780s
oil on canvas 61 x 51
O.143

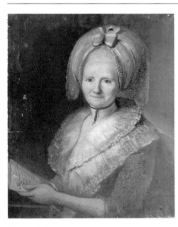

French School
Portrait of a Lady 1780s
oil on canvas 75 x 60
O.148

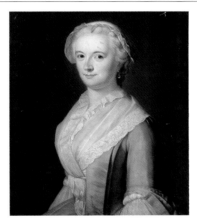

French School
Portrait of a Lady from the Time of Louis XV 1780s
oil on canvas 63.8 x 53.8
B.M.319

French School
Portrait of a Lady (recto) c.1789–c.1792
oil on canvas laid on board 45.9 x 38
O.177

French School late 18th C
Portrait of a Man (verso)
oil on board 45.9 x 38
O.177

French School,
Portrait of a Lady c.1789–c.1795
oil on canvas 54 x 43.2
O.237

French School
Marie-Jean Hérault de Séchell (1759–1794)
c.1790–c.1794
oil on canvas 48.3 x 38.4
B.M.526

Facing page: Viola, Giovanni Battista, 1576–1622, *A Seashore with a Castle* (detail), The Bowes Museum, (p. 193)

French School
Portrait of a Gentleman in a Green Coat
c.1790–c.1800
oil on canvas 40 x 32.4
B.M.666

French School
*Interior, a Peasant Woman Spinning, Her
Daughter Making Lace and Conversing with a
Young Man* c.1790–c.1810
oil on panel 25 x 22.5
B.M.428

French School
*Telemachus Refusing the Crown of
Crete* c.1790–c.1810
oil on canvas 111.2 x 145
B.M.523

French School
Portrait of a Young Man 1798
oil on canvas 31.2 x 23.7
B.M.658

French School 18th C
Boy with a Hurdy-Gurdy
oil on paper 11.9 x 14.8
B.M.1034

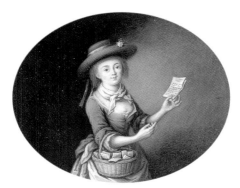

French School 18th C
Girl with a Basket of Pamphlets
oil on paper 11.9 x 14.8
B.M.1033

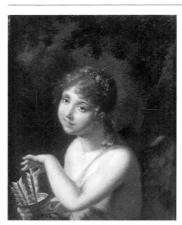

French School 18th C
Half-Length Figure of Cupid
oil on canvas 26.2 x 21.2
B.M.886

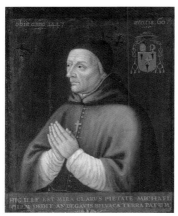

French School 18th C
Jean Michel (b.1387), Bishop of Angers
oil on canvas 77.5 x 63.8
B.M.575

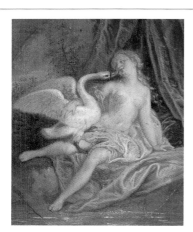

French School 18th C
Leda and the Swan
oil on canvas 17.5 x 14.4
B.M.432

French School 18th C
Portrait of a Man
oil on canvas 33.6 x 29.2
O.26

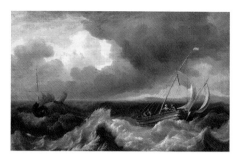

French School 18th C
Storm at Sea
oil on canvas 40.6 x 60.6
B.M.324

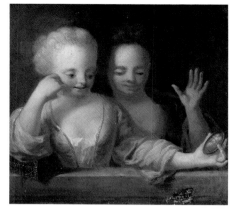

French School 18th C
Two Young Girls with a Portrait
oil on canvas 48.7 x 52.5
B.M.544

French School 18th C
Woody Landscape
oil on canvas 29.4 x 33.7
B.M.438

French School mid-18th C-mid-19th C
Flower Piece
oil on panel 42 x 31.8
O.178

French School mid-18th C-mid-19th C
Flower Piece
oil on panel 42 x 32
O.179

French School mid-18th C-mid-19th C
Portrait of a Boy
oil on canvas 31.5 x 26
O.10

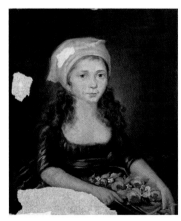

French School
Portrait of a Girl in Black with Roses on Her Lap c.1800–c.1810
oil on canvas 59.7 x 49.1
B.M.948

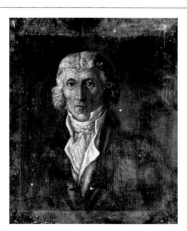

French School
Portrait of a Man c.1800–c.1810
oil on canvas 66 x 52
O.154

French School
Portrait of a Lady c.1800–c.1814
oil on canvas 46 x 38
O.241

French School
Girl in Green with a Bird c.1800–c.1815
oil on canvas 45 x 40
B.M.374

French School
Classical Landscape c.1800–c.1820
oil on canvas 30 x 25
B.M.657

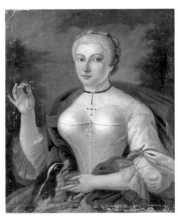

French School
Portrait of a Lady c.1800–c.1820
oil on canvas 79.5 x 64
O.3

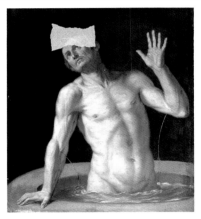

French School
The Death of Seneca (AD 65) c.1800–c.1820
oil on canvas 110 x 95.6
B.M.600

French School
Landscape with a Horseman and Beggars
c.1800–c.1825
oil on canvas 70 x 110
B.M.362

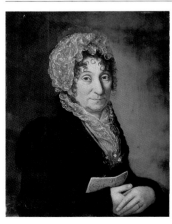

French School
Madame Caminet c.1800–c.1825
oil on panel 56.2 x 45
B.M.924

French School
Landscape with Equestrian and other Figures
c.1800–c.1830
oil on canvas 66.2 x 54.4
B.M.152

French School
*Landscape with Two Women and a Flock of
Sheep* c.1800–c.1830
oil on canvas 45 x 53
B.M.993

French School
Landscape c.1800–c.1850
oil on canvas 28 x 37.5
O.217

French School
Landscape with Trees c.1800–c.1850
oil on panel 19.4 x 25.6
B.M.718

French School
Portrait of a Lady c.1800–c.1850
oil on canvas 45.7 x 38
O.257

French School
Portrait of a Man c.1800–c.1850
oil on canvas 43.5 x 38.1
B.M.14

French School
Portrait of a Woman c.1800–c.1850
oil on canvas 61 x 50.2
O.139

French School
*Portrait of an Elderly Woman in Peasant
Costume* c.1800–c.1850
oil on canvas 53.7 x 42.5
B.M.946

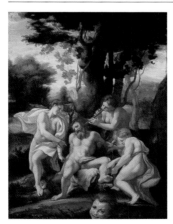

French School
Silenus and Bacchantes c.1800–c.1850
oil on canvas 128.8 x 97.5
B.M.567

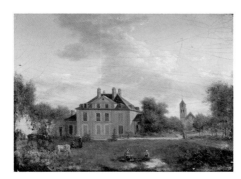

French School
Garden, Country House and Church
c.1800–c.1860
oil on panel 35.3 x 46
B.M.1032

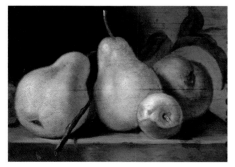

French School
Pears and Apples c.1800–c.1874
oil on canvas 20.9 x 29
B.M.1067

French School
Rigged Ship under Repair c.1800–c.1874
oil on canvas 29.4 x 19.7
B.M.999

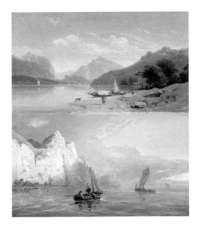

French School
Two Waterscapes on One Canvas
c.1800–c.1874
oil on canvas 58.7 x 48.1
B.M.508

French School
Still Life c.1800–c.1875
oil on canvas 72 x 92
O.117

French School
Two Ladies in a Garden c.1801–c.1815
oil on canvas 27.3 x 21.6
B.M.882

French School
Interior with Two Ladies with Dogs
c.1805–c.1810
oil on canvas 21.3 x 16.2
B.M.439

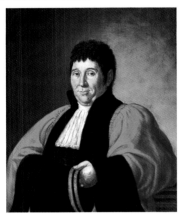

French School
Judge M. Caminet 1808
oil on canvas 73.8 x 60
B.M.868

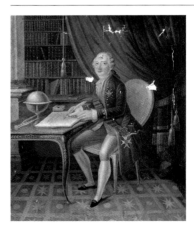

French School
Portrait of a Gentleman c.1810–c.1830
oil on canvas 64.8 x 53.8
O.12

French School
*Napoleon II (1811–1832), King of Rome
(1811–1814)* c.1811–c.1815
oil on canvas 19.7 x 15
B.M.1028

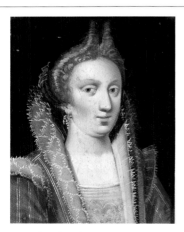

French School
Portrait of a Lady in Red c.1814–c.1845
oil on panel 26.9 x 20.9
B.M.427

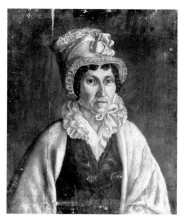

French School
Portrait of a Lady c.1815–c.1830
oil on canvas 65.5 x 52.7
O.155

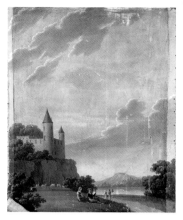

French School
Château, Lake and Figures c.1815–c.1850
oil on canvas 109.5 x 75
O.116

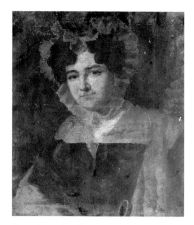

French School
Portrait of a Lady c.1820–c.1840
oil on canvas 59.2 x 49.5
O.157

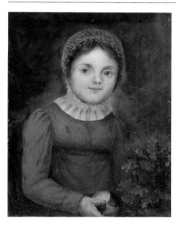

French School
Portrait of a Young Girl in a Red Dress
c.1820–c.1840
oil on canvas 40 x 31.2
B.M.302

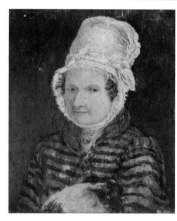

French School
Portrait of a Lady c.1820–c.1850
oil on canvas 41.2 x 32.5
O.290

French School
Still Life c.1820–c.1870
oil on canvas 40.5 x 31
O.201

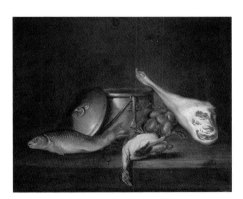

French School
A Leg of Mutton c.1820–c.1874
oil on canvas 78.1 x 95
B.M.902

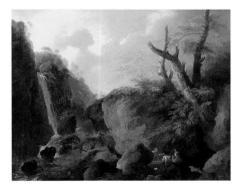

French School
A Cascade in a Rocky Landscape with Figures
1820s
oil on canvas 85.6 x 106.2
B.M.366

French School
Portrait of a Lady 1820s
oil on canvas 57.7 x 45
O.159

French School
Portrait of a Young Lady 1820s
oil on canvas 50.8 x 42.6
O.142

French School
Portrait of a Lady c.1825–c.1840
oil on canvas 65.5 x 53.5
O.280

French School
Portrait of a Lady c.1825–c.1840
oil on canvas 46.4 x 38
O.286

French School
Portrait of a Lady c.1825–c.1840
oil on canvas 39.5 x 35
O.292

French School
Portrait of a Lady c.1825–c.1845
oil on canvas 61 x 48.8
O.16

French School
Portrait of a Lady c.1825–c.1850
oil on canvas 40.5 x 30.5
O.288

French School
Portrait of a Lady in a Grey Dress
c.1825–c.1850
oil on canvas 53.7 x 43.7
B.M.943

French School
Still Life c.1825–c.1875
oil on canvas 44 x 35.5
O.214

French School
Portrait of a Boy c.1830–c.1850
oil on canvas 47 x 38
O.256

Facing page: Cook, Beryl, 1926–2008, *Two on a Stool* (detail), 1991, Durham County Council, (p. 273)

French School
Portrait of a Lady c.1830–c.1850
oil on panel 37.5 x 30.5
O.181

French School
Portrait of a Lady c.1830–c.1850
oil on canvas 40.5 x 32.5
O.291

French School
Sportsman Shooting with a Dog
c.1830–c.1874
oil on panel 10 x 16.2
B.M.685

French School
Portrait of a Lady 1830s
oil on canvas 62.2 x 49.5
O.234

French School
Peasant Woman c.1840–c.1850
oil on canvas 31.7 x 22.9
O.20

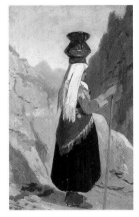

French School
Peasant Woman c.1840–c.1850
oil on canvas 30.5 x 19
O.21

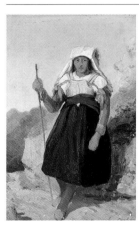

French School
Peasant Woman c.1840–c.1850
oil on canvas 30.8 x 20.3
O.22

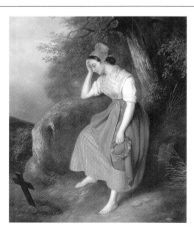

French School
*A Young Mother Weeping over the Tomb of Her
Child* c.1840–c.1860
oil on canvas 45 x 37.5
B.M.1072

French School
Forest Scene c.1840–c.1860
oil on canvas 48.1 x 37.8
B.M.643

French School
Interior of a Room with a Lady Painting
c.1840–c.1860
oil on canvas 28.7 x 32.8
B.M.379

French School
*Portrait of a Lady with a Hairpin in the Form
of an Arrow* c.1840–c.1860
oil on canvas 45.3 x 36.9
B.M.734

French School
Portrait of a Peasant Woman c.1840–c.1860
oil on canvas 40 x 33.1
B.M.511

French School
Wooded Landscape with Rocks c.1840–c.1860
oil on cardboard 34.6 x 25.1
B.M.680

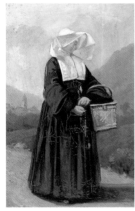

French School
A Sister of Charity c.1840–c.1870
oil on canvas 39.4 x 24.5
B.M.736

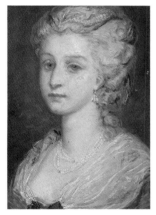

French School
Portrait of a Lady Wearing Pearls
c.1840–c.1874
oil on panel 27.6 x 19
B.M.727

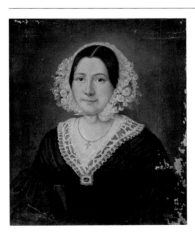

French School
Portrait of a Lady c.1845–c.1855
oil on canvas 65 x 54.5
O.250

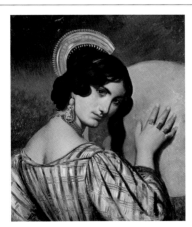

French School
Study of an Italian Girl with a Tambourine
c.1845–c.1855
oil on canvas 64.4 x 53.7
B.M.498

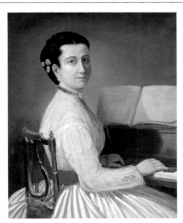

French School
A Lady at a Piano c.1850–c.1870
oil on canvas 78.5 x 63.5
O.318

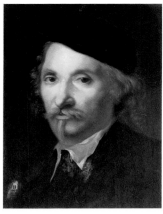

French School
Portrait of a Bearded Man c.1850–c.1870
oil on panel 39.7 x 31.2
B.M.7

French School
The Wayside Well c.1850–c.1870
oil on canvas 22.5 x 45.5
B.M.654

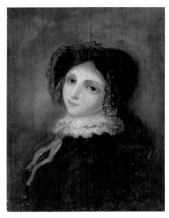

French School
Portrait of a Girl c.1850–c.1874
oil on canvas 33 x 25
O.298

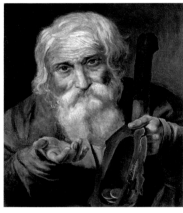

French School
Portrait of an Old Beggar c.1850–c.1874
oil on canvas 51.2 x 43.4
B.M.501

French School
River Scene in the Vaucluse, France
c.1850–c.1874
oil on canvas 60.6 x 145
B.M.494

French School
A Seaport Town c.1855–c.1865
oil on panel 26.2 x 36.2
B.M.741

French School
Willow Trees c.1855–c.1865
oil on canvas 25.1 x 35.2
B.M.435

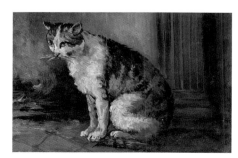

French School
Cat 1869
oil on panel 15.3 x 23
O.190

French School 19th C
Brick Arch
oil on canvas 39.4 x 26.6
O.246

French School 19th C
Marat's Sister
oil on canvas 64.7 x 53.1
B.M.1031

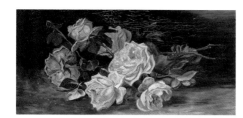

French School 19th C
Roses
oil on canvas 30.5 x 61
O.243

Frère, Charles Théodore 1814–1888
View at Siout, Upper Egypt 1856
oil on panel 27 x 41
B.M.1000

Fuchs, Georg Mathias c.1719–1797
Boy and Girl Dressed as a Shepherd and a Shepherdess with a Lamb 1750
oil on canvas 101.3 x 100.9
B.M.566

Fyt, Jan (style of) 1611–1661
Still Life with a Dead Hare 17th C
oil on canvas 83.8 x 108.1
B.M.190

Gabé, Nicolas Edward 1814–1865
Incident of the Revolution of 1848 in Paris in the Court of the Louvre c.1848
oil on canvas 78.7 x 96.2
B.M.484

Gabé, Nicolas Edward 1814–1865
Incident of the Revolution of 1848 in Paris at the Corner of Rue St Jacques 1849
oil on canvas 80 x 98
B.M.469

Gabé, Nicolas Edward 1814–1865
The Barricade at Porte St Denis, Paris, 1848 1849
oil on canvas 81.3 x 100.4
B.M.485

Gabé, Nicolas Edward 1814–1865
The Congress of Paris 1856
oil on canvas 79.7 x 99.4
B.M.536

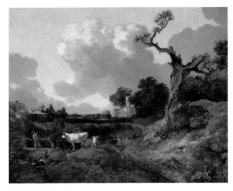

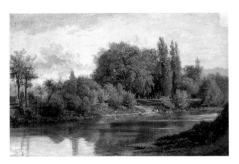

Gabé, Nicolas Edward 1814–1865
Cows, Sheep and a Goat at a Drinking Trough
oil on panel 21.2 x 32.5
B.M.710

Gainsborough, Thomas 1727–1788
Elmsett Church, Suffolk c.1750–1755
oil on canvas 63.5 x 76.2
B.M.1048

Gallier, Achille Gratien 1814–1871
View across a River with Wooded Banks 1865
oil on panel 37.5 x 55
B.M.687

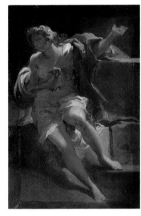

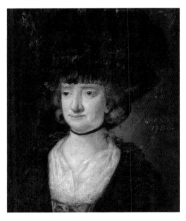

Gandolfi, Gaetano 1734–1802
Study of a Female Figure
oil on paper laid on canvas 41.3 x 26
B.M.1005

Garbrand, Caleb J. 1748–1794
*Portrait of a Lady in a Black Dress with a Large
Black Head-Dress* 1780
oil on canvas 60 x 50
B.M.384

García de Miranda, Juan 1677–1749
*The Miracle of Father Francisco de Torres
Attacked by Robbers* 1731
oil on canvas 110.8 x 193
B.M.825

Gardner, Daniel 1750–1805
Miss Alice Bullock of Wigan
oil on canvas 53.5 x 40.5
1975.22.1

Garez, G.
*A Notary from the Time of the First French
Republic* 1801
oil on canvas 78.7 x 62.5
B.M.936

Garez, G.
*Portrait of a Lady in Black, Seated, Holding a
Rose* 1801
oil on canvas 80 x 64.4
B.M.934

Garez, G.
A Donkey
oil on canvas 17.5 x 25
B.M.761

Gauffier, Louis 1761–1801
Nine Sample Portraits c.1801
oil on canvas 34.4 x 29.4
B.M.877

Gaunt, Jonas
Still Life 1847
oil on glass 25.5 x 30.5
O.15

Gautrin, Louise-Thérèse-Aline
active c.1830–1840
The Abbey of Saint-Denis, France c.1830
oil on canvas 57 x 71
B.M.525

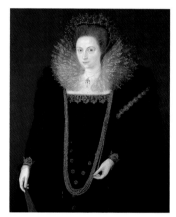

Geeraerts, Marcus the younger 1561–1635
A Lady in Black
oil on panel 112.5 x 85.3
B.M.1014

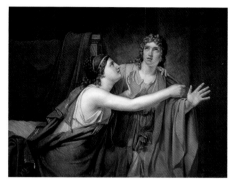

Geirnaert, Jozef 1791–1859
Phaedra and Hippolytus 1819
oil on canvas 112.5 x 141.3
B.M.819

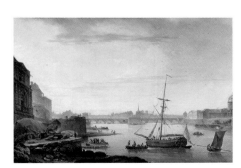

Genillion, Jean Baptiste François
1750–1829
View of the Seine, Paris, Looking East from the Porte St Nicolas towards (…) 1772
oil on canvas 55.8 x 81
B.M.331

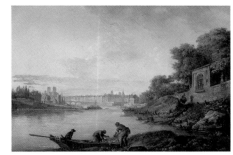

Genillion, Jean Baptiste François
1750–1829
View of the Seine, Paris, Looking West from the Ile Louviers, Evening Effect 1772
oil on canvas 55.9 x 81.3
B.M.339

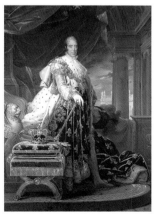

Gérard, François 1770–1837
Charles X (1757–1836), in His Coronation Robes c.1824–1830
oil on canvas 257.3 x 180.3
B.M.246

Gérard, François (after) 1770–1837
*La Duchesse de Berri and Her Two Children
Praying before a Bust of Her Husband* c.1821
oil on canvas 190 x 139
B.M.830

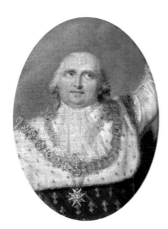

Gérard, François (school of) 1770–1837
*Louis XVIII (1755–1824), Receiving the Crown
of Henri IV* early 19th C
oil on canvas 17.5 x 14.3
B.M.765

German School mid-15th C-mid-16th C
St John the Baptist before His Execution
oil on panel 128.8 x 104.4
B.M.71

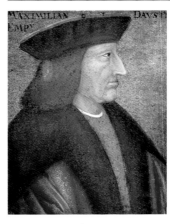

German School
The Emperor Maximilian (1449–1519)
c.1500–c.1520
oil on panel 27.3 x 21.3
B.M.212

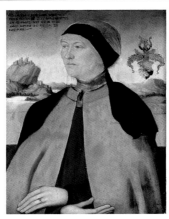

German School
Ursula Neff 1555
oil on panel 58.7 x 44
B.M.194

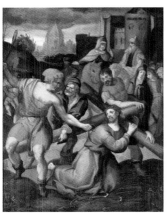

German School mid-16th C-mid-17th C
Christ Carrying His Cross
oil on metal 23.7 x 18.1
B.M.235

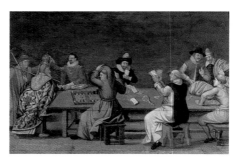

German School
Ecclesiastics Gambling c.1610–c.1630
oil on panel 43.7 x 65
B.M.610

German School
*Portrait of a Middle-Aged Lady in Grey
Holding a String of Pearls* c.1700–c.1770
oil on canvas 80 x 65
B.M.893

German School
Portrait of a Lady in Grey c.1750–c.1775
oil on canvas 83.1 x 68.1
B.M.881

German School
*Portrait of a Polish Noblewoman in a
Fur-Trimmed Coat* 1770s
oil on canvas 89.3 x 66.3
B.M.491

German School mid-18th C-mid-19th C
The Toper
oil on panel 11.9 x 8.1
B.M.699

German School
*Night in the Harz Mountains,
Germany* c.1830–c.1850
oil on board laid on canvas 26.2 x 35
B.M.446

German School
*Windmill at Sanssouci, Potsdam,
Germany* c.1840–c.1860
oil on canvas 30.5 x 38
O.128

Ghirlandaio, Domenico (studio of)
1449–1494
Madonna Adoring the Child late 15th C
tempera on panel 54.9 x 36.5
B.M.40

Giaquinto, Corrado 1703–1765
Venus Presenting Arms to Aeneas
oil on canvas 153 x 114.9
B.M.568

Giffroy active 19th C
Storm at Sea
oil on panel 23.7 x 31.9
B.M.778

Gillemans, Jan Pauwel II 1651–c.1704
Fruit and Vegetables 1674
oil on canvas 57.1 x 40.6
B.M.431

Gillemans, Jan Pauwel II (attributed to)
1651–c.1704
Still Life of Fruit in a Glass Bowl 1674
oil on copper 14.2 x 18.1
B.M.328

Gillemans, Jan Pauwel II (attributed to)
1651–c.1704
Still Life with Peaches and Grapes 1674
oil on copper 14.4 x 18.1
B.M.345

Gilroy, John Thomas Young 1898–1985
Sheep Shearing in Baldersdale, County Durham c.1949–1950
oil on canvas 101.5 x 127
1974.57

Giordano, Luca (attributed to) 1634–1705
The Triumph of Judith c.1703
oil on canvas 76.1 x 109.6
B.M.20

Girodet de Roucy-Trioson, Anne-Louis
1767–1824
Napoleon I (1769–1821), in Coronation Robes
c.1812
oil on canvas 251 x 179
B.M.364

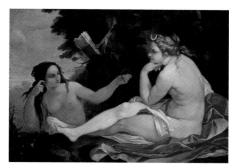

Girolamo da Carpi (style of) c.1501–1556
Diana with Nymph, Bathing 19th C
oil on canvas 120.7 x 167.1
B.M.822

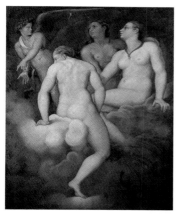

Giulio Romano (after) 1499–1546
The Three Graces with Cupid 18th C
oil on canvas 127 x 97.8
B.M.939

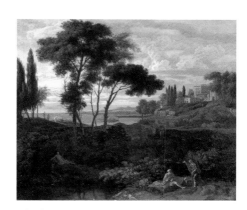

Glauber, Johannes (attributed to)
1646–1727
Classical Landscape with Figures
oil on canvas 31.4 x 37.1
B.M.179

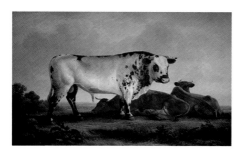

Glover, John 1767–1849
A Bull
oil on canvas 255.5 x 365.5
B.M.127

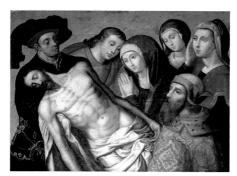

Goes, Hugo van der (after) c.1420–1482
Pietà (The Lamentation of Christ) 17th C
oil on panel 87.5 x 117.5
B.M.47

Facing page: Rootius, Jan Albertsz. (attributed to), c.1615–1674, *Portrait of a Lady in a Fur-Trimmed Dress Holding a Pair of White Gloves* (detail), c.1660–1670, The Bowes Museum, (p. 150)

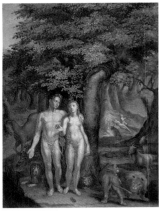

Goltzius, Hendrick (style of) 1558–1617
The Temptation of Adam 17th C
oil on canvas 83.1 x 50.2
B.M.798

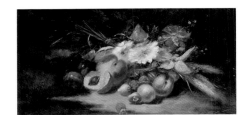

Gontier, Pierre-Camille b.1840
Flowers and Fruit
oil on canvas 28.9 x 52.7
B.M.776

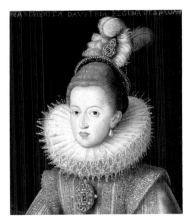

González, Bartolomé (after) 1564–1627
Margaret of Austria (1584–1611), Queen of Spain c.1600
oil on canvas 64.6 x 50.8
B.M.28.A

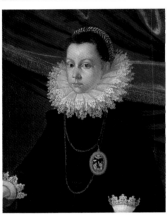

González, Bartolomé (circle of) 1564–1627
A Young Spanish Princess early 17th C
oil on canvas 65 x 51
B.M.36

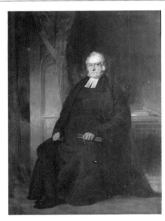

Gordon, John Watson 1788–1864
Archdeacon John Headlam
oil on canvas 204 x 144
1977.66

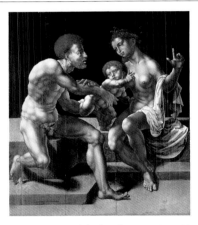

Gossaert, Jan (circle of) c.1478–1532
Cybele Beseeching Saturn to Spare Her Child 1520s
oil on panel 124.7 x 104
B.M.621

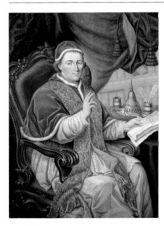

Goulet active c.1800–1803
Pope Pius VI (1717–1799) 1803
oil on canvas 138 x 99
B.M.556

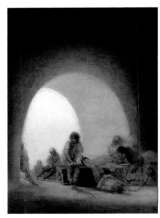

Goya, Francisco de 1746–1828
Interior of a Prison c.1793–1794
oil on tin plate 42.9 x 31.7
B.M.29

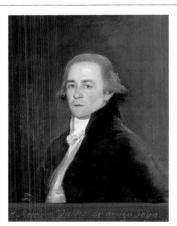

Goya, Francisco de 1746–1828
Juan Antonio Meléndez Valdés (1774–1817) 1797
oil on canvas 73.3 x 57.1
B.M.26

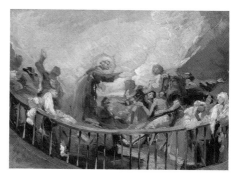

Goya, Francisco de (after) 1746–1828
St Anthony Raising a Dead Man 19th C
oil on canvas 25.5 x 33
1973.88

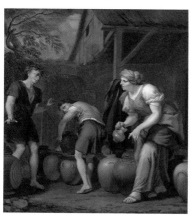

Graat, Barent 1628–1709
The Meeting of Rachel and Jacob 1696
oil on canvas 70.3 x 61.2
B.M.616

Granet, François-Marius 1775–1849
A Reading Lesson in a Convent 1810
oil on canvas 99 x 76.8
B.M.500

Grassi, Nicola 1682–1748
St John the Baptist
oil on canvas 101.6 x 78.3
B.M.58

Grenet de Joigny, Dominique Adolphe
1821–1885
*Landscape with Poplars, a Town in the
Distance*
oil on panel 21.6 x 31.9
B.M.409

Greuze, Jean-Baptiste (after) 1725–1805
Girl with a Dead Canary
late 18th C-early 19th C
oil on canvas 43.7 x 30
B.M.395

Greuze, Jean-Baptiste (after) 1725–1805
Head of a Young Girl late 18th C-early 19th C
oil on canvas 22.2 x 19
B.M.424

Greuze, Jean-Baptiste (after) 1725–1805
Portrait of a Lady early 19th C
oil on panel 40.5 x 31.7
O.240

Griffier, Jan II (circle of) active 1738–1773
Landscape with a River, Bridge and Buildings
18th C
oil on panel 24.8 x 34
B.M.419

Grimmer, Abel c.1570–c.1619
The Parable of the Sower
oil on panel 25.4
B.M.237

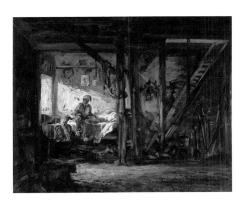

Grobon, François-Frédéric (attributed to)
1815–1901
Interior Scene
oil on canvas 50 x 60.5
O.7

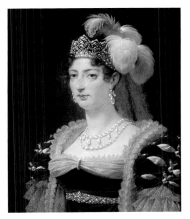

Gros, Antoine-Jean 1771–1835
*Marie-Thérèse-Charlotte of France
(1778–1851), Duchesse d'Angoulême* 1817
oil on canvas 73 x 60.9
B.M.303

Gros, Antoine-Jean (attributed to)
1771–1835
Head of a Young Girl
oil on canvas 43.1 x 35.6
B.M.369

Grove, John active 20th C
Hide and Seek
oil on board 46.5 x 72.2
2007.39

Guardi, Francesco 1712–1793
Capriccio
oil on panel 19.5 x 15
1975.9.1

Guardi, Francesco 1712–1793
Capriccio
oil on panel 19.5 x 15
1975.9.2

Gudin, Henriette Herminie 1825–1876
Shipping in a Calm c.1850–1865
oil on canvas 14.9 x 20.9
B.M.755

Gudin, Jean Antoine Théodore 1802–1880
Coast View in Scotland c.1860–1865
oil on canvas 48.1 x 63.7
B.M.311

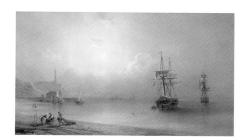

Gudin, Jean Antoine Théodore 1802–1880
Sea Piece, Calm Hazy Morning c.1860–1865
oil on canvas 53.1 x 91.2
B.M.380

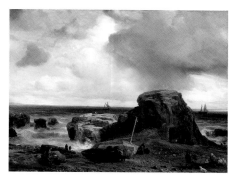

Gudin, Jean Antoine Théodore 1802–1880
View on the Coast of Scotland c.1860–1865
oil on canvas 46.3 x 61.8
B.M.326

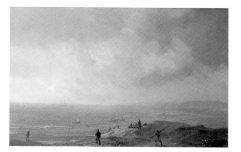

Gudin, Jean Antoine Théodore 1802–1880
On the Sands near Ostend, Belgium 1863
oil on panel 31.2 x 48.1
B.M.357

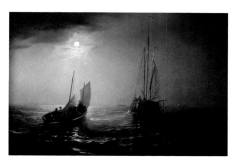

Gudin, Jean Antoine Théodore 1802–1880
A Marine View, Moonlight 1864
oil on canvas 75 x 108.1
B.M.244

Guérard, Henri Charles 1846–1897
Flowers in a Vase
oil on canvas 62.5 x 51.2
B.M.509

Guérard, Henri Charles (attributed to)
1846–1897
Flowers in a Vase
oil on canvas 57.5 x 38.1
B.M.763

Guercino (after) 1591–1666
Susannah and the Elders 17th C
oil on canvas 168.9 x 257
B.M.811

W. L. H. active 19th C
'SS John Bowes'
oil on canvas 98 x 158
O.337

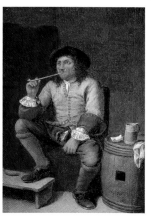

Haften, Nicolas van 1663–1715
A Man Smoking a Pipe
oil on canvas 20 x 14.6
B.M.587

Hagemann, Godefroy de d.1877
Landscape with a River and a Rustic Bridge
oil on canvas 36.2 x 44.4
B.M.720

Hall, Oliver 1869–1957
Dorset Moorland
oil on canvas 56.8 x 71.5
2007.32

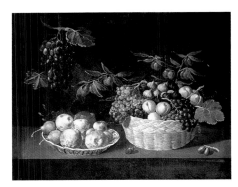

Hamen y León, Juan van der (circle of)
1596–1631
Still Life with a Basket and Dish of Fruit on a Ledge early 17th C
oil on canvas 80 x 100.5
B.M.200

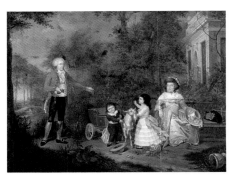

Hardenberg, Cornelis van 1755–1843
Family Group
oil on canvas 83.2 x 110.1
B.M.578

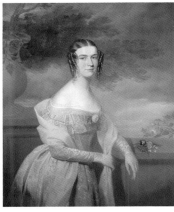

Hardey, Richard d.1902
Anne Whitaker (d.1902)
oil on canvas 107.5 x 86.3
1962.76/ANT.

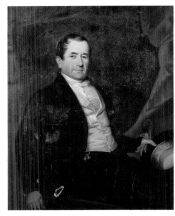

Hardey, Richard d.1902
Charles Whitaker of Melton Hall
oil on canvas 107.5 x 85
1962.78/ANT.

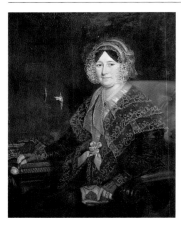

Hardey, Richard d.1902
Rachael Whitaker of Melton Hall
oil on canvas 107.5 x 85
1962.77/ANT.

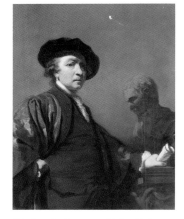

Harley, Robert c.1825–1884
Joshua Reynolds (1723–1792) (copy after
Joshua Reynolds)
oil on canvas 50.3 x 40.3
B.M.590

Haslehurst, Ernest William 1866–1949
The Abbey Bridge (The Dairy Bridge)
oil on canvas
B.M.971

Heem, Cornelis de 1631–1695
A Garland of Fruit
oil on panel 34.6 x 27.3
B.M.217

Heemskerck, Egbert van the elder
1634/1635–1704
Boors Carousing and Playing Cards
oil on canvas 37 x 42
B.M.192

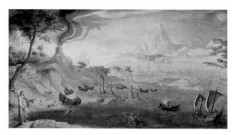

Heemskerck, Maerten van 1498–1574
*Christ Appearing to St Peter on the Sea of
Tiberias* 1567
oil on panel 69.9 x 124.5
B.M.952

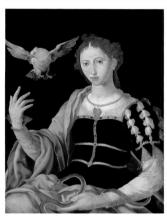

Heemskerck, Maerten van 1498–1574
An Allegory of Innocence and Guile
oil on panel 92.7 x 70.8
B.M.624

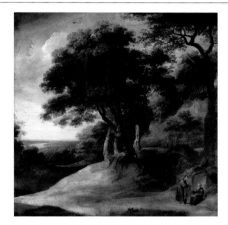

Heil, Daniel van 1604–1662
Landscape, Carmelite Friars in the Foreground
oil on canvas 186.2 x 178.7
B.M.189

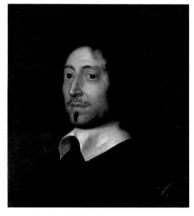

Helst, Bartholomeus van der (attributed to)
1613–1670
Portrait of a Man in Black
oil on canvas 55.3 x 45.6
B.M.103

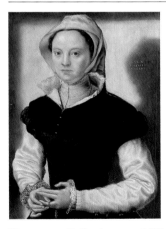

Hemessen, Catharina van 1528–after 1587
A Lady in Sixteenth-Century Costume
c.1548–1549
oil on panel 40.9 x 30.1
B.M.147

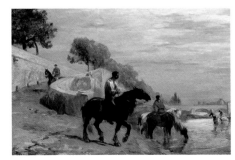

Héreau, Jules 1839–1879
Horses Drinking c.1860
oil on canvas 28.1 x 41.9
B.M.413

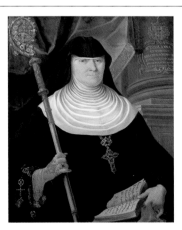

Hermann, Franz Ludwig 1710–1791
*Anna Gertrude Hofner, Abbess of
Münsterlingen*
oil on canvas 94.3 x 74
B.M.108

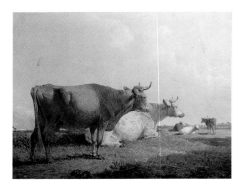

Herring, John Frederick I 1795–1865
Cows 1837
oil on panel 20.3 x 25.4
B.M.124

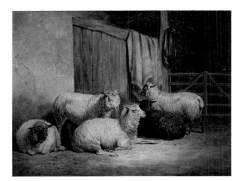

Herring, John Frederick I 1795–1865
Sheep 1837
oil on panel 20.3 x 25.4
B.M.141

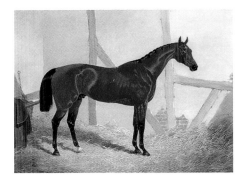

Herring, John Frederick II 1815–1907
Mr John Bowes' Bay Colt 'Cotherstone', by 'Touchstone' out of 'Emma', in a Loosebox 1844
oil on canvas 32.5 x 41.7
2006.14

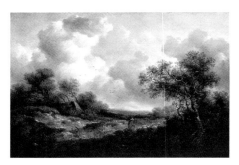

Hilder, Richard 1813–1852
A Storm Cloud
oil on panel 23.8 x 34.3
B.M.992

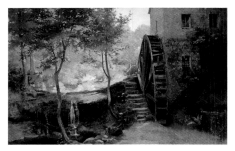

Hobson, Victor William 1865–1889
Rigg Mill, near Whitby, North Yorkshire
oil on canvas 88.7 x 137.5
B.M.956

Hoet, Gerard (style of) 1648–1733
Bacchanalia late 17th C-early 18th C
oil on canvas 50.8 x 82
O.124

Hoet, Hendrick Jacob c.1693–1733
Perseus and Andromeda 1720
oil on panel 31.2 x 39.1
B.M.930

Hold, Abel 1815–1891
Dead Grouse 1855
oil on board 41.2 x 51.2
1985.12.41

Hondecoeter, Melchior de (after)
1636–1695
Poultry 19th C
oil on canvas 91.9 x 72.5
B.M.904

Facing page: Bryce, Gordon, b.1943, *Renaissance* (detail), c.1980, Darlington Borough Art Collection, (p. 232)

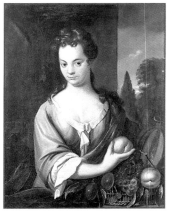

Hoogstraten, Abraham van d.1736
Portrait of a Lady with a Basket of Fruit 1715
oil on canvas 85.1 x 68.3
B.M.628

Hoppenbrouwers, Johannes Franciscus
1819–1866
Net Fishing, Moonlight (Paysage avec rivière et pêcheurs, effet de nuit) 1856
oil on panel 23.5 x 34
B.M.230

Horsley, T.
Pigs 1807
oil on canvas 50.6 x 61.1
ANT.238

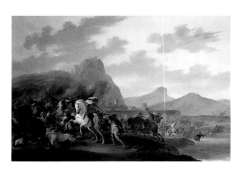

Huchtenburgh, Jan van 1647–1733
A Battle between Christians and Moors
oil on canvas 70 x 102.2
B.M.149

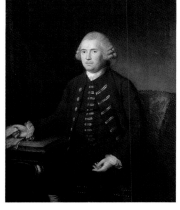

Hudson, Thomas 1701–1779
Bishop John Butler (1717–1802)
oil on canvas 124.1 x 100.6
B.M.136

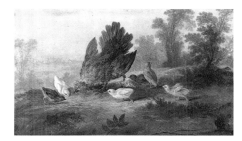

Huet, Jean-Baptiste I 1745–1811
Hen and Chickens
oil on canvas 40 x 70
B.M.318

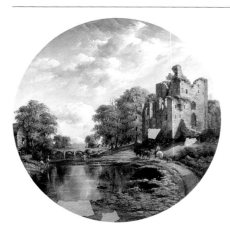

Hughes, John Joseph 1820–1909
Brougham Castle, near Penrith, Cumbria
1864
oil on canvas 132
1974.7

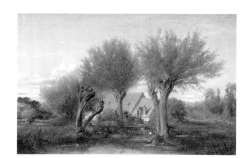

Hugues, Victor Louis 1827–1879
Pollard Willows
oil on canvas 16.2 x 25
B.M.659

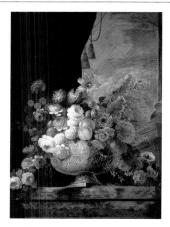

Huilliot, Pierre Nicolas 1674–1751
Flowers in a Silver Vase
oil on canvas 125 x 90
B.M.249

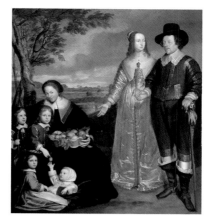

Hulle, Anselmus van c.1601–c.1674
Family Portrait Group c.1640–1650
oil on canvas 207.2 x 190.3
B.M.131

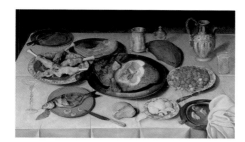

Hulsdonck, Jacob van 1582–1647
Breakfast Piece 1614
oil on panel 65.4 x 106.8
B.M.99

Hulsdonck, Jacob van 1582–1647
A Basket of Fruit
oil on panel 59.5 x 87.3
B.M.148

Italian (Neapolitan) School
Still Life c.1650–c.1700
oil on canvas 20 x 24.5
O.71

Italian (Neapolitan) School 17th C
Lot and His Daughters
oil on canvas 137.1 x 144.5
B.M.211

Italian (Neapolitan) School
mid-17th C-mid-18th C
Portrait of a Girl
oil on canvas 50.8 x 40
O.141

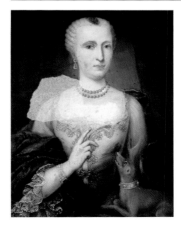

Italian (Piedmontese) School
La Contessa di Faule c.1746–c.1760
oil on canvas 67.3 x 53.3
B.M.617

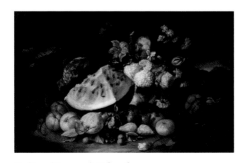

Italian (Roman) School
*Still Life of Fruit and Flowers with a Cut Piece
of Watermelon* c.1650–c.1700
oil on canvas 68.6 x 99
B.M.80

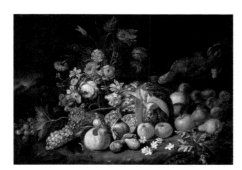

Italian (Roman) School
*Still Life of Fruit and Flowers with a Split
Watermelon* c.1650–c.1700
oil on canvas 68.6 x 96.8
B.M.86

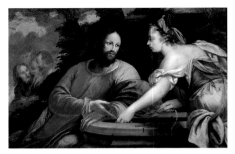

Italian (Venetian) School
Christ and the Woman of Samaria
c.1600–c.1650
oil on canvas 81.2 x 122.5
B.M.639

Italian School 17th C
St Agnes
oil on canvas 68 x 48.3
O.165

Italian School 17th C
The Holy Family
oil on canvas 220 x 155
B.M.813

Italian School 17th C
The Virgin and Child
oil on canvas 91.9 x 83.1
B.M.73

Italian School mid-17th C-mid-18th C
Still Life
oil on canvas 20 x 35.7
O.17

Italian School mid-17th C-mid-18th C
The Holy Family and St John
oil on canvas 110.5 x 174.6
B.M.641

Italian School
Portrait of a Lady c.1770–c.1800
oil on canvas 40.6 x 32.5
O.242

Italian School 18th C
Landscape
oil on canvas 46.4 x 61.5
O.125

Italian School 18th C
Venus with Putti
oil on canvas 22.9 x 31.1
B.M.440

Italian School
Landscape c.1800–c.1850
oil on canvas 20 x 32.5
B.M.792

Italian School
Mountainous Wooded Landscape with
Husbandmen in the Foreground
c.1800–c.1850
oil on canvas 20 x 33.1
B.M.796

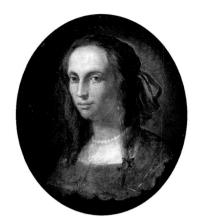

Italian School
Portrait of a Lady with Long Hair
c.1800–c.1850
oil on canvas 54.4 x 45.6
B.M.61

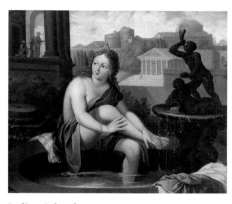

Italian School
David and Bathsheba c.1800–c.1860
oil on canvas 62.8 x 75
B.M.932

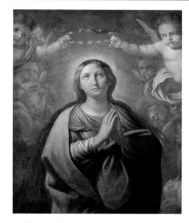

Italian School
The Virgin Crowned with Stars c.1800–c.1860
oil on canvas 93.1 x 73.1
B.M.78

Italian School
Battle Piece c.1800–c.1875
oil on canvas 20.6 x 51.9
B.M.771

Italian School
Battle Piece c.1800–c.1875
oil on canvas 20.6 x 50.5
B.M.772

Italian School
Holy Family c.1800–c.1875
oil on canvas 56 x 46.5
O.198

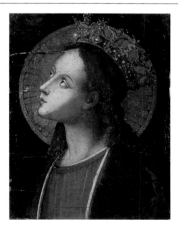

Italian School
Head of a Female Saint c.1830–c.1860
oil on panel 55.9 x 45.5
B.M.599

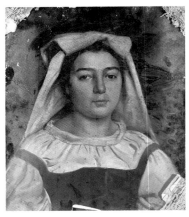

Italian School
Portrait of a Woman c.1850–c.1875
oil on canvas 54 x 44.5
O.252

Jacobber, Moïse 1786–1863
Flower Piece 1828
oil on panel 32.1 x 26.7
B.M.646

Jacobber, Moïse (attributed to) 1786–1863
Decoration of Flowers and Grapes
oil on canvas 32 x 40
B.M.989

Jacque, Charles Émile 1813–1894
Mowers 1860s
oil on panel 27.3 x 21.9
B.M.735

Jarry, Joseph
Cottages 1862
oil on panel 15.9 x 21.3
B.M.746

Jollain, Pierre 1720–c.1762
The Assumption of the Virgin 1752
oil on canvas 112 x 144.4
B.M.448.A

Jonghe, Jan Baptiste de (circle of)
1785–1844
The Entrance to Brussels, Belgium 19th C
oil on panel 25.7 x 32.2
B.M.224

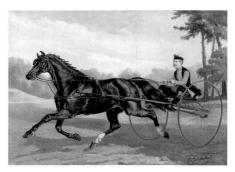

Jonquières, Victor Philippe Auguste de
active 1838–c.1873
Pony Trotter c.1873
oil on canvas 40.7 x 55.3
O.245

Jordaens, Jacob (style of) 1593–1678
Portrait of a Man 17th C
oil on canvas 52 x 44.5
O.239

Jouvenel, Nicholas Wulfram 1788–1878
View of Amiens Cathedral from along the River
1865
oil on canvas 53.1 x 64.1 (E)
B.M.368

Jouvenel, Nicholas Wulfram 1788–1878
View of Amiens Cathedral from across the River
c.1865
oil on canvas 53.1 x 64.1 (E)
B.M.370

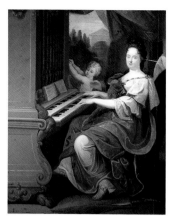

Jouvenet, Jean 1644–1717
Madame de Maintenon as St Cecilia and a Boy
(possibly the Duc de Maine) *as an Angel*
Blowing an Organ
oil on canvas 190 x 162.4
B.M.832

Keuninck, Kerstiaen de (attributed to) after
1560–1632/1633
Lot and His Daughter, Guided by Angels
Fleeing from Sodom late 16th C-early 17th C
oil on panel 47.5 x 73.1
B.M.620

Kieser, K. R.
Alnwick Castle, Northumberland 1911
oil on canvas 19.4 x 24.7
1998.256/ANT.

Kieser, K. R.
Barnard Castle, County Durham 1911
oil on canvas 19 x 24.7
1998.257/ANT.

Kieser, K. R.
High Force 1911
oil on canvas 29.5 x 44.8
1998.120/ANT.

Kinsoen, François Joseph 1771–1839
Self Portrait c.1800–1810
oil on canvas 15.6 x 13.7
B.M.766

Kinsoen, François Joseph 1771–1839
Jérôme Bonaparte (1784–1860), King of
Westphalia c.1807–1813
oil on canvas 224.2 x 145.4
B.M.472

Kinsoen, François Joseph 1771–1839
Joseph Bonaparte (1768–1844), King of Spain
c.1808–1813
oil on canvas 64.1 x 53.4
B.M.478

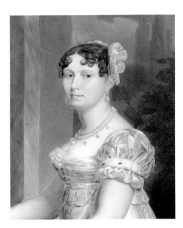

Kinsoen, François Joseph 1771–1839
Catherine of Würtemberg (1783–1835), Wife of Jérôme Bonaparte, King of Westphalia
c.1810–1820
oil on canvas 60 x 49.4
B.M.483

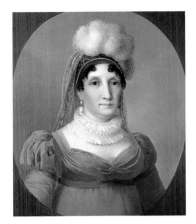

Kinsoen, François Joseph 1771–1839
Laetitia Ramolino Bonaparte (1750–1836)
c.1811
oil on canvas 61.3 x 50.2
B.M.473

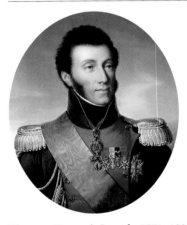

Kinsoen, François Joseph 1771–1839
Le Duc d'Angoulême (1775–1844)
c.1813–1824
oil on canvas 63.7 x 53.1
B.M.474

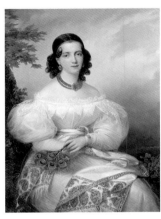

Kinsoen, François Joseph 1771–1839
Portrait of a German Princess c.1825–1830
oil on canvas 112.4 x 93.3
B.M.305

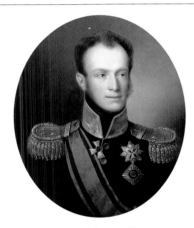

Kinsoen, François Joseph 1771–1839
William II of Holland (1792–1849), as Prince of Orange c.1830
oil on canvas 61.9 x 54.7
B.M.475

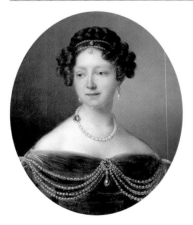

Kinsoen, François Joseph 1771–1839
The Princess of Orange c.1821–1839
oil on canvas 72.7 x 62.9
B.M.480

Kinsoen, François Joseph 1771–1839
Mademoiselle Mars (1779–1847), the Celebrated French Actress c.1830–1835
oil on canvas 113.7 x 86.2
B.M.365

Kinsoen, François Joseph 1771–1839
Portrait of a Russian Lady
oil on canvas 115.6 x 89.4
B.M.291

Kneller, Godfrey (style of) 1646–1723
Portrait of a Lady 17th C
oil on canvas 71.1 x 53.4
O.137

Knijff, Wouter c.1607–after 1693
River Scene with a Castle
oil on panel 50 x 65.6
B.M.123

Kobell, Hendrik 1751–1779
A Rocky Coast with a Town and Ships
c.1770–1779
oil on canvas 59.7 x 82.2
B.M.144

Koningh, Leendert de 1777–1849
Winter Scene, Frozen River with Skaters
oil on panel 67.9 x 96.8
B.M.155

Kuwasseg, Karl-Joseph 1802–1877
A Waterfall among Mountains with Figures
oil on canvas 64.8 x 54
B.M.114

Lacoeur
At the Altar 1835
oil on panel 33 x 24.1
B.M.653

Lacroix, Charles François de (attributed to)
c.1700–1782
A Seaport
oil on canvas 112.4 x 150.3
B.M.333

Lacroix, Charles François de (style of)
c.1700–1782
Landscape with Washerwomen 18th C
oil on canvas 41.5 x 32.5
B.M.346

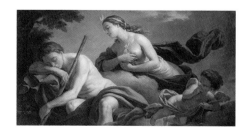

Lagrenée, Louis Jean François (after)
1725–1805
Diana and Endymion, Allegory of Fidelity
(dessus de porte) c.1760–1765
oil on canvas 76.2 x 133.7
B.M.862

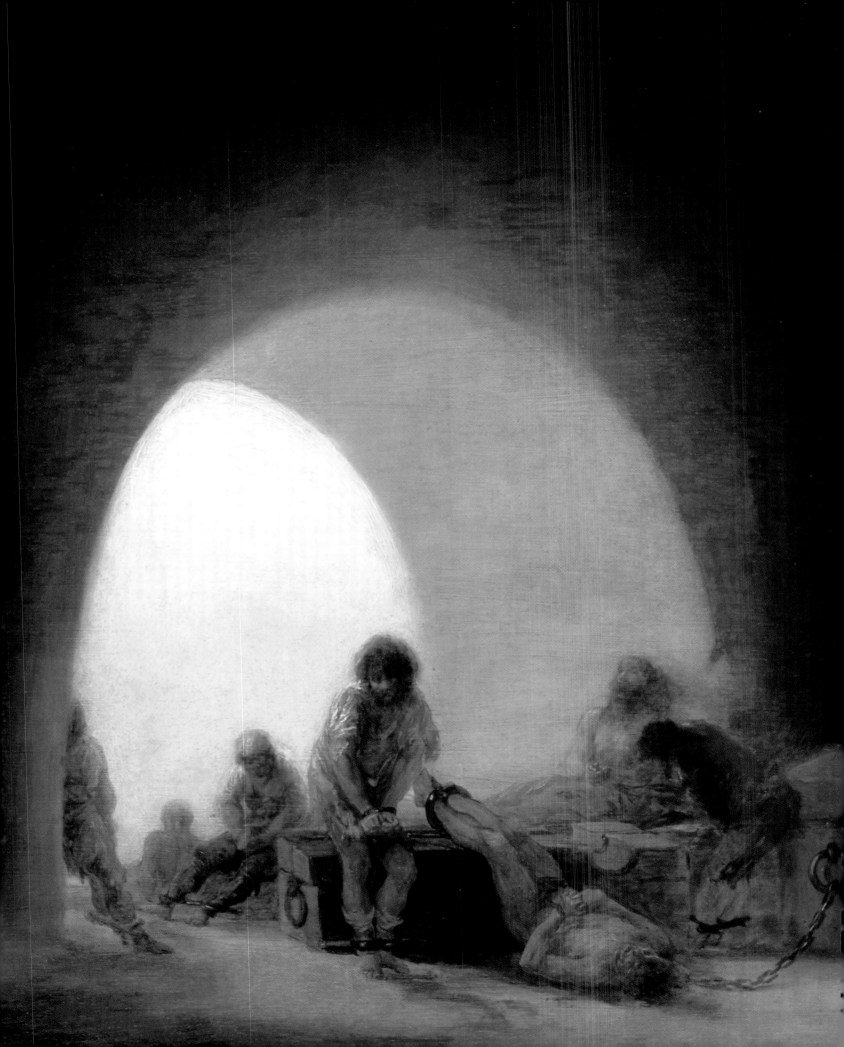

Lagrenée, Louis Jean François (after)
1725–1805
Cupid and Psyche, Allegory of the Five Senses
(dessus de porte) c.1760–1765
oil on canvas 76.9 x 134.4
B.M.865

Lagrenée, Louis Jean François (after)
1725–1805
Two Muses, Allegory of the Five Senses (dessus
de porte) c.1760–1765
oil on canvas 76.2 x 132.5
B.M.863

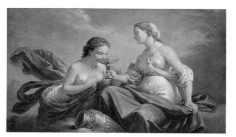

Lagrenée, Louis Jean François (after)
1725–1805
Two Nymphs, Allegory of the Five Senses
(dessus de porte) c.1760–1765
oil on canvas 76.2 x 133.7
B.M.861

Lambert, George c.1700–1765
View of Chatham, Kent
oil on canvas 72.5 x 117
B.M.1081

Lanfant, François-Louis 1814–1892
An Old Lady Walking with a Boy and a Girl
(Les batons de vieillesse)
oil on panel 22.2 x 33
B.M.717

Lanfant, François-Louis 1814–1892
Brigands Waiting in Ambush
oil on panel 27.3 x 21.9
B.M.737

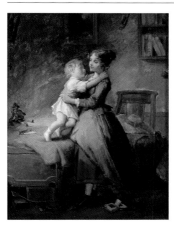

Lanfant, François-Louis 1814–1892
Le lever de l'enfant
oil on panel 27.3 x 21.3
B.M.712

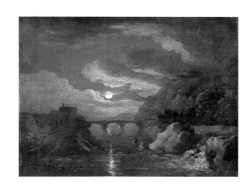

Lantara, Simon Mathurin (style of)
1729–1778
Landscape, Moonlight early 19th C
oil on canvas 31.9 x 42.5
B.M.371

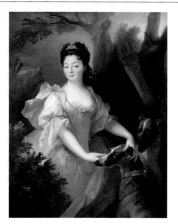

Largillière, Nicolas de (attributed to)
1656–1746
Portrait of a Lady as Diana c.1700–1710
oil on canvas 65.4 x 54.6
B.M.383

Facing page: Goya, Francisco de, 1746–1828, *Interior of a Prison* (detail), c.1793–1794, The Bowes Museum, (p. 102)

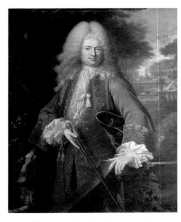

Largillière, Nicolas de (attributed to)
1656–1746
A Nobleman from the Time of Louis XIV
oil on canvas 140 x 104
B.M.252

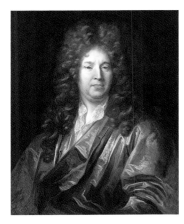

Largillière, Nicolas de (circle of) 1656–1746
Portrait of a Nobleman
late 17th C-early 18th C
oil on canvas 77.5 x 61.9
B.M.540

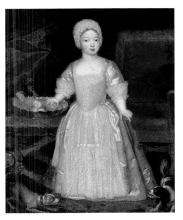

Largillière, Nicolas de (style of) 1656–1746
An Infanta of Spain late 17th C
oil on canvas 110.6 x 86.2
B.M.284

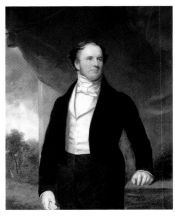

Lawrence, Thomas (style of) 1769–1830
Mr John Hodgson of Norton Conyers c.1825
oil on canvas 186 x 100
1962.79

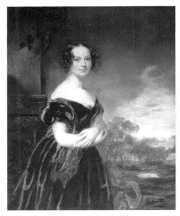

Lawrence, Thomas (style of) 1769–1830
*Mrs Elizabeth Hodgson of Norton
Conyers* c.1825
oil on canvas 186 x 100
1962.76

Lazerges, Paul Jean Baptiste 1845–1902
Still Life with Crabs and a Bottle 1867
oil on canvas 39.5 x 50
B.M.991

Le Chevalier d'Arborville active 18th C
*Portrait of an Elderly Woman Holding a Spray
of Orange Blossom*
oil on canvas 81.5 x 65.7
B.M.898

Le Prince, Charles Edouard 1784–after 1850
Le Château d'Arc 1834
oil on board 19.5 x 26
O.25

Lecat active 1862–1865
Portrait of a Lady in Black 1862
oil on canvas 62.5 x 51.6
B.M.524

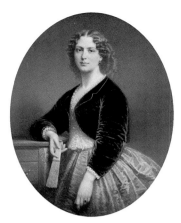

Lecat active 1862–1865
Portrait of a Lady 1865
oil on canvas 88.7 x 70
B.M.343

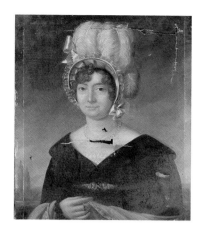

Lecerf, Louis Alexis 1787–after 1844
Portrait of a Lady 1816
oil on canvas 64.2 x 53.3
O.90

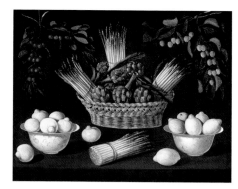

Ledesma, Blas de c.1580–c.1640
*Still Life with Asparagus, Artichokes, Lemons
and Cherries*
oil on canvas 80 x 99.1
B.M.146

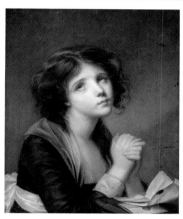

Ledoux, Jeanne Philiberte 1767–1840
A Girl in Prayer
oil on canvas 55.3 x 45
B.M.867

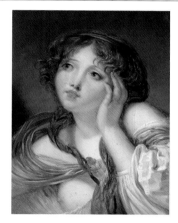

Ledoux, Jeanne Philiberte 1767–1840
Girl Leaning on Her Hand
oil on canvas 46.3 x 37.4
B.M.869

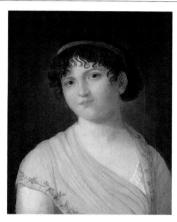

Ledoux, Jeanne Philiberte 1767–1840
Mademoiselle M. A. Lenormand (1772–1843)
oil on canvas 45 x 35
B.M.851

Lee, John c.1869–1934
Sir Joseph Pease (1828–1903) 1901
oil on canvas 129.5 x 83.8
O.30

Lee, John c.1869–1934
English Landscape in Woods
oil on canvas 40.5 x 60.5
O.63

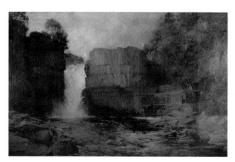

Lee, John c.1869–1934
High Force, Middleton-in-Teesdale
oil on canvas 126 x 179
2007.5

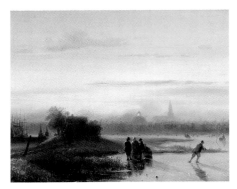

Leeuw, Alexis de c.1822–1900
River Scene with Skaters
oil on canvas 18.6 x 23.2
B.M.781

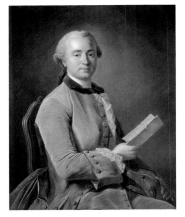

Lefèvre active c.1750–1780
Portrait of a Gentleman 1760
oil on canvas 90.8 x 71.7
B.M.492

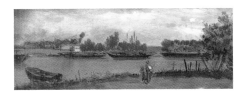

Legrip, Frédéric 1817–1871
A Canal in Brittany, France
oil on canvas 15.6 x 36.9
B.M.684

Legrip, Frédéric 1817–1871
Landscape with Boats Tied up on a Riverbank
oil on panel 20 x 32.7
B.M.671

Legrip, Frédéric 1817–1871
River Scene with Poplars and a Boatman
oil on canvas 20.6 x 34.4
B.M.714

Legrip, Frédéric 1817–1871
The Banks of the Seine near Roche-Guyon, France
oil on canvas 18.5 x 32
B.M.675

Legrip, Frédéric (attributed to) 1817–1871
The Ferry
oil on canvas 17.5 x 28.7
B.M.696

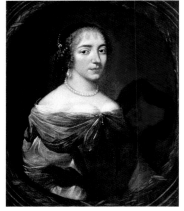

Lely, Peter (circle of) 1618–1680
Portrait of a Lady Wearing a Pearl Necklace
late 17th C
oil on canvas 68.7 x 55.6
B.M.985

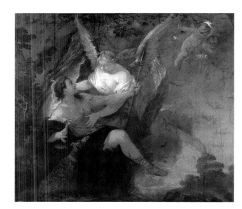

Lemoyne, François (circle of) 1688–1737
Cephalus and Aurora 18th C
oil on canvas 142 x 161.5
B.M.823

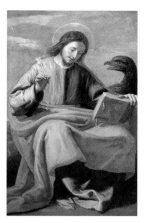

Leonardo, Jusepe 1601–1656
St John the Evangelist c.1630–1640
oil on canvas 94.6 x 65.1
B.M.920

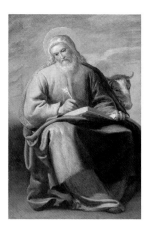

Leonardo, Jusepe 1601–1656
St Luke c.1630–1640
oil on canvas 94.6 x 65.1
B.M.923

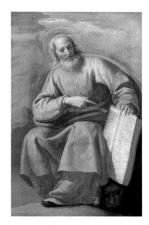

Leonardo, Jusepe 1601–1656
St Mark c.1630–1640
oil on canvas 94.6 x 65.1
B.M.922

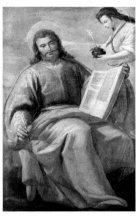

Leonardo, Jusepe 1601–1656
St Matthew c.1630–1640
oil on canvas 94.6 x 65.1
B.M.919

Leoni, Ottavio Maro (after) 1578–1630
Medallion Portraits of 40 Celebrated Venetians
early 17th C
oil on canvas 46.2 x 62.5
B.M.609

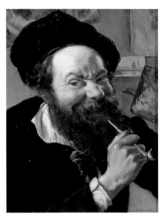

Lepesqueur, Hyacinth Florentin
A Man Smoking a Pipe (Self Portrait) 1873
oil on panel 21.3 x 16.2
B.M.716

Lépine, Stanislas 1835–1892
La forêt de Fontainebleau, France
oil on paper on panel 23.5 x 30.5
2003.2326

Lepoittevin, Eugène Modeste Edmond
1806–1870
Farm Girl at Her Toilet, Lacing Her Corset
oil on canvas 44.4 x 40.6
B.M.313

Leprince, Léopold 1800–1847
Peasant Woman and Boy 1845
oil on canvas 38.1 x 45.7
B.M.688

Leprince, Léopold 1800–1847
Landscape with Figures and Sheep
oil on canvas 36.2 x 46
B.M.412

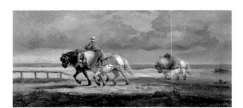

Levis, Henri Jean Baptiste active 1844–1874
Horses Towing a Boat along a River (Chevaux de halage) 1866
oil on panel 21.6 x 46.3
B.M.738

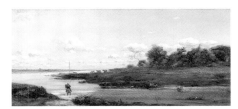

Levis, Henri Jean Baptiste active 1844–1874
View on the River near Asnières, France (A Village near Paris) 1866
oil on panel 20.6 x 45
B.M.739

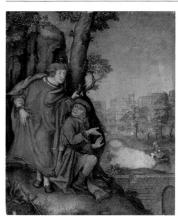

Leyden, Lucas van (copy after) c.1494–1533
Susannah and the Elders 17th C
oil & tempera on panel 20 x 16.9
B.M.220

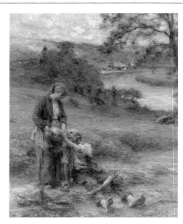

Lhermitte, Léon-Augustin 1844–1925
The Reaper's Rest (Le repos du faucheur)
oil on canvas 45.3 x 37.5
1977.53.6

Liberi, Pietro (attributed to) 1605–1687
Venus Disarming Cupid
oil on canvas 97.1 x 76.8
B.M.77

Liemaker, Nicolaes de (style of) 1600–1644
The Coronation of the Virgin 18th C
oil on canvas 97.8 x 118.4
B.M.833

Ligozzi, Jacopo (copy after) 1547–1627
Christ Bound 17th C
oil on panel 61.9 x 47.5
B.M.589

Linard, Jacques 1597–1645
Still Life, Plums, Melons and Peaches 1642
oil on panel 56.2 x 75.8
B.M.1070

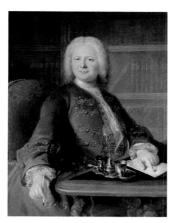

Loir, Marianne (attributed to)
c.1715–after 1769
Portrait of a Gentleman Writing a Letter c.1750
oil on canvas 112 x 86.7
B.M.354

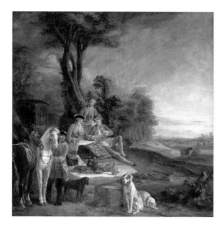

Loo, Carle van (attributed to) 1705–1765
A Hunting Luncheon
oil on canvas 205.7 x 203.8
B.M.299

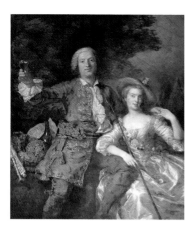

Loo, Carle van (attributed to) 1705–1765
A Lady and Gentleman as a Shepherd and Shepherdess
oil on canvas 156.5 x 126.5
B.M.265

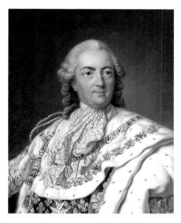

Loo, Louis Michel van (after) 1707–1771
Louis XV (1710–1774) 18th C
oil on canvas 31.1 x 25.4
B.M.268

Lorrain, Claude (school of) 1604–1682
Landscape 17th C
oil on canvas 51 x 66
O.203

Lorrain, Claude (style of) 1604–1682
View of the Seashore with Figures 17th C
oil on canvas 40 x 53.7
B.M.385

M.
Head of a Girl c.1800–1810
oil on canvas 57.5 x 47.5
B.M.519

McLachlan, Thomas Hope 1845–1897
Landscape of Upper Teesdale 1884
oil on canvas 19.4 x 43.8
1951.33.B/ANT

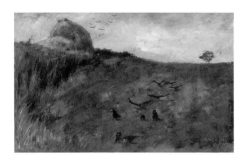

McLachlan, Thomas Hope 1845–1897
Meadow Landscape 1887
oil on canvas 18 x 27.5
1951.33.A/ANT.

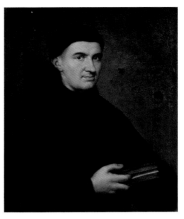

Maella, Mariano Salvador de (after)
1739–1818
Portrait of a Monk 18th C
oil on canvas 72.7 x 60
B.M.13

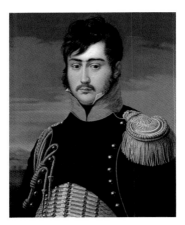

Maes, Jan Baptiste Lodewijk 1794–1856
An Officer of the First Empire 1813
oil on canvas 62.2 x 49.7
B.M.476

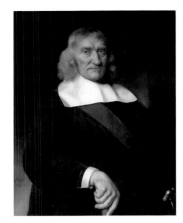

Maes, Nicolaes 1634–1693
Portrait of a Venerable-Looking Old Man 1666
oil on canvas 87.6 x 69.2
B.M.142

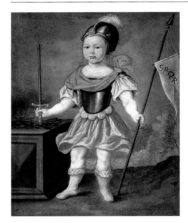

Maes, Nicolaes (school of) 1634–1693
Boy in Fancy Dress as a Roman Soldier 1675
oil on canvas 93.8 x 76.3
B.M.846

Maino, Juan Bautista 1569–1649
St Agabus
oil on canvas 110.5 x 90.2
B.M.807

Malbrouck
Rustic Landscape 1827
oil on canvas 24.4 x 32.5
B.M.410

Mallet, Jean Baptiste 1759–1835
A Nursery Scene
oil on panel 32.5 x 41.2
B.M.430

Mallet, Jean Baptiste 1759–1835
The Proposal
oil on panel 25 x 40
B.M.429

Manglard, Adrien 1695–1760
A Seaport on a Rocky Coast
oil on canvas 71.9 x 133.7
B.M.577

Facing page: Sutherland, Graham Vivian, 1903–1980, *Fallen Tree against Sunset* (detail), 1940,
Darlington Borough Art Collection, (p. 248)

Marchais, J. B. 1818–1876
Girl in a Blue Skirt, Sewing
oil on panel 31.2 x 22.2
B.M.997

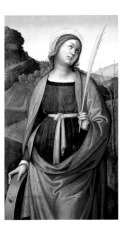

Marchesi, Girolamo 1471/1481–1540/1550
St Catherine
oil on panel 119.8 x 68.6
B.M.44

Maréchal, Charles Laurent 1801–1887
A Fishing Village
oil on canvas 26.2 x 40
B.M.691

Marées, Georges de 1697–1776
Maria-Anna-Sophie von Saxe (1728–1797)
1774
oil on canvas 83.7 x 65
B.M.562

Marienhof, Jan A. active c.1640–c.1652
The Sacrifice of Elijah 1651
oil on canvas 46.7 x 60.3
B.M.627

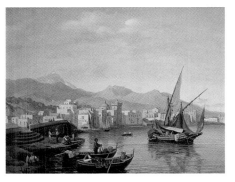

Marilhat, Prosper Georges Antoine
1811–1847
An Eastern Seaport 1830s
oil on canvas 26.2 x 35
B.M.393

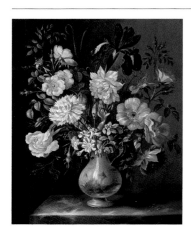

Marrel, Jacob 1614–1681
Flowers in a Blue and White Vase 1680
oil on copper 42 x 34
1990.3

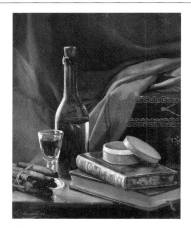

Marsal, Edouard Antoine 1845–1929
Still Life with Books, a Bottle and a Bundle of Cigars 1866
oil on canvas 40 x 32.2
B.M.855

Master of Palanquinos (circle of)
active c.1490–1500
St Paul
oil on panel 80.3 x 31.4
B.M.1001

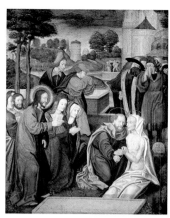

Master of Saint Severin (attributed to)
active c.1485–1515
The Raising of Lazarus (recto) c.1500–1515
oil & tempera on panel 133.6 x 102.6
B.M.242

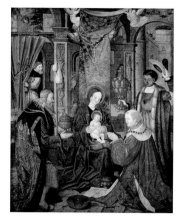

Master of Saint Severin (attributed to)
active c.1485–1515
The Adoration of the Magi (verso)
c.1500–1515
oil & tempera on panel 133.6 x 102.6
B.M.242

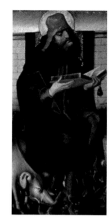

Master of the View of Saint Gudule
active c.1465–1500
St Jerome (verso) c.1465–1470
oil on panel 132.5 x 60.5
B.M.1018

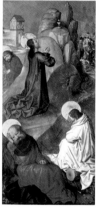

Master of the View of Saint Gudule
active c.1465–1500
The Agony in the Garden (recto) c.1465–1470
oil on panel 132.5 x 60.5
B.M.1018

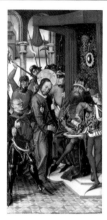

Master of the View of Saint Gudule
active c.1465–1500
Christ Before Pilate (recto) c.1465–1470
oil on panel 133.5 x 60.5
B.M.1019

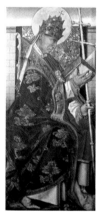

Master of the View of Saint Gudule
active c.1465–1500
St Gregory (verso) c.1465–1470
oil on panel 133.5 x 60.5
B.M.1019

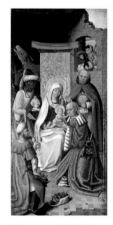

Master of the View of Saint Gudule
active c.1465–1500
The Adoration of the Magi (recto)
c.1465–1470
oil on panel 84.5 x 38.5
B.M.1020

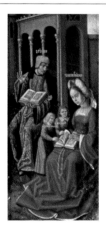

Master of the View of Saint Gudule
active c.1465–1500
The Family of Zebedee (verso) c.1465–1470
oil on panel 84.5 x 38.5
B.M.1020

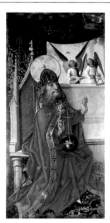

Master of the View of Saint Gudule
active c.1465–1500
God the Father (recto) c.1465–1470
oil on panel 84 x 39.5
B.M.1021

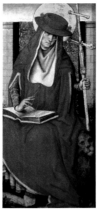

Master of the View of Saint Gudule
active c.1465–1500
St Anthony (verso) c.1465–1470
oil on panel 84 x 39.5
B.M.1021

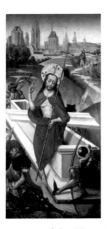

Master of the View of Saint Gudule
active c.1465–1500
The Resurrection (recto) c.1465–1470
oil on panel 133.5 x 60.5
B.M.1022

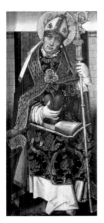

Master of the View of Saint Gudule
active c.1465–1500
St Ambrose (verso) c.1465–1470
oil on panel 133.5 x 60.5
B.M.1022

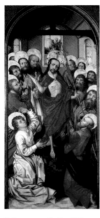

Master of the View of Saint Gudule
active c.1465–1500
The Risen Christ (recto) c.1465–1470
oil on panel 133.5 x 60.5
B.M.1023

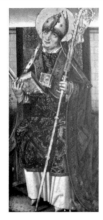

Master of the View of Saint Gudule
active c.1465–1500
St Augustine (verso) c.1465–1470
oil on panel 133.5 x 60.5
B.M.1023

Master of the View of Saint Gudule
(**circle of**) active c.1465–1500
St Jerome and the Lion late 15th C
oil on panel 56.8 x 39.7
B.M.596

Master of the Virgo inter Virgines
active c.1483–1498
Crucifixion (left panel, recto) 1490s
oil on panel 218.8 x 106
B.M.168

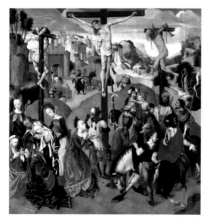

Master of the Virgo inter Virgines
active c.1483–1498
Crucifixion 1490s
oil on panel 218.8 x 196.3
B.M.168

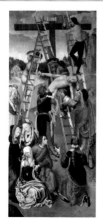

Master of the Virgo inter Virgines
active c.1483–1498
Crucifixion (right panel, recto) 1490s
oil on panel 218.8 x 106
B.M.168

Master of the Virgo inter Virgines
active c.1483–1498
Crucifixion (The Annunciation) (left panel, verso) 1490s
oil on panel 218.8 x 106
B.M.168

Master of the Virgo inter Virgines
active c.1483–1498
Crucifixion (The Annunciation) (right panel, verso) 1490s
oil on panel 218.8 x 106
B.M.168

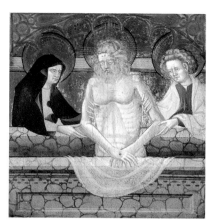

Master of Torralba active c.1440
Christ Standing in the Tomb between the Virgin and St John
tempera & gold on panel 51.6 x 50.8
B.M.1082

Mathieu, Alexis
Still Life with a Copper Kettle, Candlestick and Flowers in a Glass 1866
oil on canvas 31.9 x 24.1
B.M.986

Mauduit, Louise-Marie-Jeanne 1784–1862
Pauline Bonaparte (1780–1825) 1806
oil on canvas 71.9 x 52.5
B.M.307

Mauduit, Louise-Marie-Jeanne 1784–1862
Portrait of a Boy in Green 1815
oil on canvas 64.4 x 53.7
B.M.517

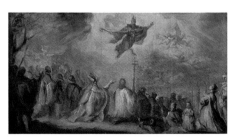

Menéndez, Miguel Jacinto 1679–1734
St Augustine Appearing to Prevent a Plague of Locusts 1734
oil on canvas 25.4 x 42.2
B.M.805

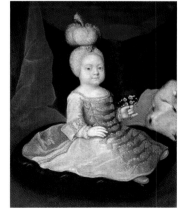

Menéndez, Miguel Jacinto (attributed to)
1679–1734
A Spanish Princess c.1719–1721
oil on canvas 81.2 x 66.1
B.M.28

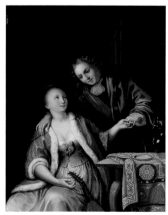

Mettenleiter, Johann Jakob 1750–1825
The Lovers
oil on copper 31.4 x 24.7
B.M.218

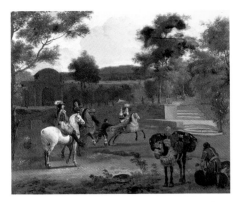

Meulen, Adam Frans van der (follower of)
1631/1632–1690
A Group on Horseback in a Landscape
mid-17th C-mid-18th C
oil on canvas 55.6 x 65
B.M.184

Meusnier, Philippe the elder 1655–1734
A Quay 1719
oil on canvas 57.5 x 70
B.M.527

Michallon, Achille Etna 1796–1822
After the Thunderstorm 1817
oil on canvas 79.3 x 99.1
B.M.348

Michallon, Achille Etna 1796–1822
*Landscape with a Man Frightened by a Serpent
among Ruins* 1817
oil on canvas 78.1 x 98.4
B.M.320

Mignard, Pierre I (after) 1612–1695
Equestrian Portrait of Louis XIV c.1673–1674
oil on canvas 170.2 x 102.8
B.M.286

Mignard, Pierre I (school of) 1612–1695
*Madame de Grignan (1646–1705), Daughter
of the Comtesse de Sévigné* 17th C
oil on canvas 31.9 x 16.9
B.M.337

Mignard, Pierre I (studio of) 1612–1695
*Madame de Montespan (1641–1707),
a Mistress of Louis XIV* c.1670–1680
oil on canvas 126.9 x 95.6
B.M.255

Mignard, Pierre I (style of) 1612–1695
Portrait of a Young Lady, Time of Louis XIV
17th C
oil on canvas 117.5 x 93.5
B.M.247

Mignard, Pierre I (style of) 1612–1695
Portrait of a Lady c.1730–1760
oil on canvas 51.2 x 40.6
B.M.336

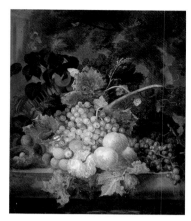

Mignon, Abraham 1640–c.1679
Flower Piece 1667
oil on canvas 74.4 x 60.3
B.M.191

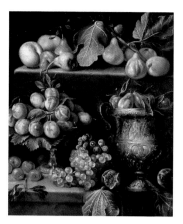

Mignon, Abraham (style of) 1640–c.1679
Fruit Piece late 17th C-early 18th C
oil on canvas 71.1 x 59.1
B.M.499

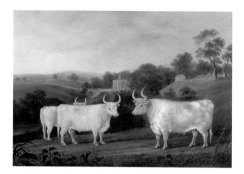

Miller, Joseph active c.1812–1858
Streatlam Castle, County Durham c.1812
oil on canvas 80 x 101
1972.116

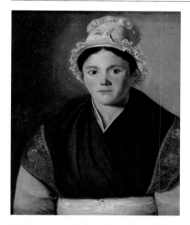

Millet, Jean-François (after) 1814–1875
Peasant Woman of Burgundy, France
c.1840–1860
oil on canvas 55.6 x 45.7
B.M.330

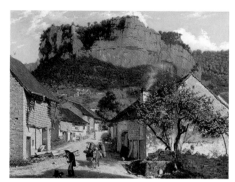

Mire, Noël Jules le 1814–1878
View of Arbois in the Jura, France
oil on canvas 64.3 x 80
B.M.296

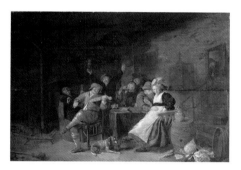

Molenaer, Jan Miense c.1610–1668
Boors Carousing
oil on panel 46.2 x 62.5
B.M.199

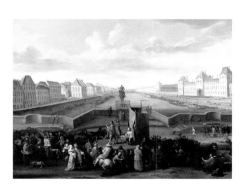

Mommers, Hendrick 1623–1693
View from the Pont Neuf, Paris, France
c.1670–1675
oil on canvas 93.6 x 122.8
B.M.162

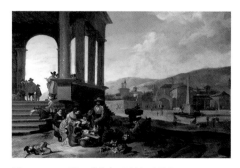

Mommers, Hendrick 1623–1693
Italian Market Scene
oil on canvas 112.5 x 162.5
B.M.137

Momper, Joos de the younger (attributed to)
1564–1635
A Grotto Landscape
oil on panel 42.5 x 35
B.M.584

Momper, Joos de the younger (follower of)
1564–1635
*Landscape with a Sportsman Shooting Ducks
and a Boy Playing Bagpipes* mid-17th C
oil on panel 43.1 x 51.2
B.M.602

Monnoyer, Jean-Baptiste (style of)
1636–1699
Two Vases of Flowers 17th C
oil on canvas 182.2 x 136.8
B.M.334

Monticelli, Adolphe Joseph Thomas
1824–1886
Landscape with Figures and Goats
c.1864–1865
oil on panel 59.4 x 40
B.M.391

Monticelli, Adolphe Joseph Thomas
1824–1886
The Garden of Delights I
oil on panel 32.5 x 65
B.M.669

Monticelli, Adolphe Joseph Thomas
1824–1886
The Garden of Delights II
oil on panel 33.4 x 66.3
B.M.668

Moormans, Frans 1832–after 1882
A Game of Chess 1862
oil on canvas 21.9 x 27
B.M.408

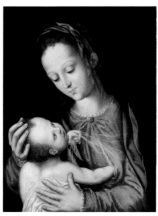

Morales, Luis de (after) c.1509–c.1586
Madonna and Child 16th C
oil on panel 36.2 x 25.1
1995.31

Moucheron, Isaac de (attributed to)
1667–1744
Classical Landscape
oil on canvas 26.9 x 34.4
B.M.757

Muller, Charles Louis Lucien 1815–1892
The Wounded Soldier
oil on canvas 53.7 x 36.2
B.M.504

Muñoz, Pedro active c.1640–1650
The Virgin of Mercy
oil on canvas 190.2 x 270.8
B.M.816

Mura, Francesco de (school of) 1696–1782
Maria Xavieri Romano 1770
oil on canvas 102.5 x 76.2
B.M.557

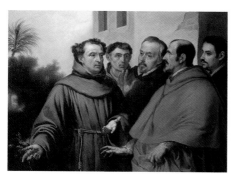

Murillo, Bartolomé Esteban (copy of)
1618–1682
San Diego of Alcalá in Ecstasy before the Cross
19th C
oil on canvas 87 x 113.6
B.M.67

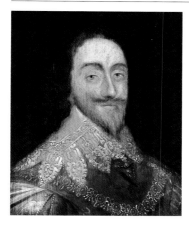

Mytens, Daniel I (follower of)
c.1590–before 1648
Charles I (1600–1649) 17th C
oil on panel 31.4 x 25.4
B.M.133

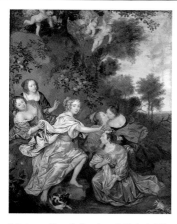

Mytens, Jan (after) c.1614–1670
La Duchesse de la Valliere, Mistress of Louis XIV, Crowning the King with Flowers, Who is Disguised in Female Attire c.1661–1667
oil on canvas 136.2 x 105
B.M.282

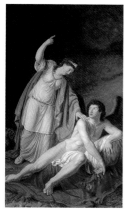

Naigeon, Jean Claude (attributed to)
1753–1832
Juno Instructing Cupid c.1791
oil on canvas 126.2 x 69.4
B.M.363

Naigeon, Jean Claude (attributed to)
1753–1832
Numa Consulting the Nymph Egeria c.1791
oil on canvas 129.4 x 71.2
B.M.245

Naiveu, Matthys (attributed to) 1647–1726
Girl with a Dog 17th C
oil on canvas 46.3 x 34.6
B.M.193

Nardi, Angelo (attributed to) 1584–1665
Christ on the Cross c.1635–1640
oil on canvas 238.7 x 162.6
B.M.640

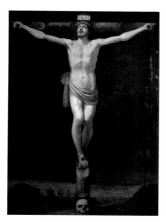

Nardi, Angelo (studio of) 1584–1665
Christ on the Cross c.1635–1650
oil on canvas 228.6 x 167
B.M.633

Nattier, Jean-Marc (school of) 1685–1766
Portrait of a Lady of the Time of Louis XV Dressed as Hebe 18th C
oil on canvas 92 x 74
B.M.269

Nattier, Jean-Marc (school of) 1685–1766
Portrait of a Lady with Powdered Hair
late 17th C–early 18th C
oil on canvas 70 x 60
B.M.845

Neeffs, Peeter the elder c.1578–1656–1661
Interior of a Catholic Church
oil on canvas 61.9 x 81.3
B.M.205

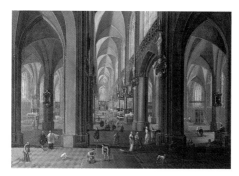

Neeffs, Peeter the elder c.1578–1656–1661
Interior of the Cathedral of Our Lady at Antwerp, Belgium (Onze-Lieve-Vrouwekerk, Cathédrale de Notre Dame)
oil on canvas 49.5 x 64.7
B.M.118

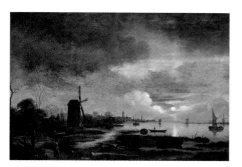

Neer, Aert van der (after) 1603–1677
Landscape, Moonlight 17th C
oil on canvas 51.3 x 72.5
B.M.210

Neer, Aert van der (style of) 1603–1677
Mountainous Landscape 17th C
oil on panel 17.5 x 23.1
B.M.786

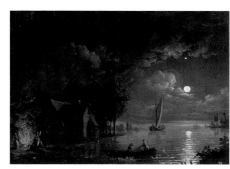

Neer, Aert van der (style of) 1603–1677
River Scene with a Bonfire, Moonlight 18th C
oil on panel 21.2 x 29.4
B.M.777

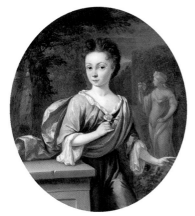

Netscher, Constantin (attributed to)
1668–1723
Portrait of a Young Girl Holding a Rose
oil on canvas 33.1 x 28.1
B.M.390

Facing page: Dury, Antoine, 1819–after 1878, *Joséphine Bowes (1825–1874), Countess of Montalbo* (detail), 1850,
The Bowes Museum, (p. 48)

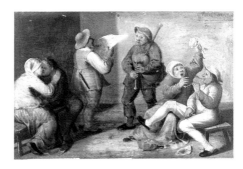

Nieudorp, Thys Wiertsz. active mid-17th C
Boors Carousing
oil on panel 23.8 x 34.3
B.M.236

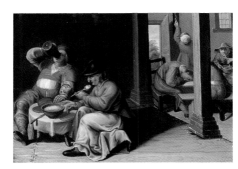

Nieudorp, Thys Wiertsz. active mid-17th C
Interior with an Old Woman Eating Soup
oil on panel 27.6 x 38.7
B.M.887

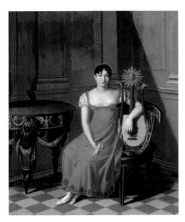

Nocchi, Pietro c.1783–c.1855
A Lady with a Harp Lute 1811
oil on canvas 59.7 x 48.2
B.M.876

Noël, Gustave Joseph 1823–1881
River Landscape with Figures and Buildings
oil on canvas 39.7 x 59.7
B.M.774

Noël, Jules Achille 1815–1881
Souvenir of Fécamp, France c.1850–1860
oil on canvas 24 x 38
B.M.723

Noël, Jules Achille 1815–1881
Souvenir de Douarnenez, France
oil on canvas 38 x 61.5
B.M.729

Noël, Jules Achille 1815–1881
Stormy Sea at the Entrance to a Harbour
oil on canvas 27.3 x 38.4
B.M.726

Nogaro, Carlo active 1837–1881
The Fable of the Fox and the Crow 1873
oil on canvas 140.3 x 86.3
B.M.493

Northcote, James 1746–1831
Vulture and Snake
oil on canvas 75.6 x 85
B.M.957

Northern Italian School
mid-17th C–mid-18th C
Susannah
oil on canvas 31.2 x 22.5
B.M.420

Northern Italian School
mid-17th C–mid-18th C
The Martyrdom of St Agnes
oil on panel 29.5 x 47
B.M.43

Northern Italian School
Portrait of a Gentleman in Black
c.1800–c.1875
oil on canvas 121.2 x 95.3
B.M.94

Núñez del Valle, Pedro c.1590–1657
Portrait of a Cleric
oil on canvas 36.5 x 29.8
B.M.662

Orley, Bernaert van (circle of) c.1492–1541
The Holy Family with St Catherine and St Barbara c.1510–1520
oil on panel
73.7 x 28.1; 73.7 x 66.9; 73.7 x 28.1
B.M.630

Oudry, Jacques Charles 1720–1778
A Dog Pointing Partridge (dessus de porte)
1753
oil on canvas 93.5 x 107.5
B.M.900

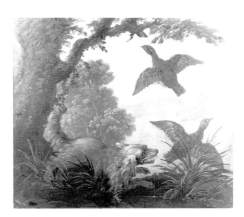

Oudry, Jacques Charles 1720–1778
A Spaniel Chasing Two Partridges 1753
oil on canvas 93.5 x 107.5
B.M.903

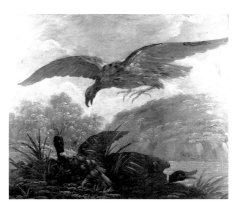

Oudry, Jacques Charles 1720–1778
An Eagle Attacking Two Ducks 1753
oil on canvas 95.8 x 108.3
B.M.906

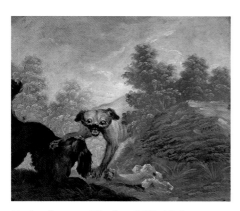

Oudry, Jacques Charles 1720–1778
Two Dogs Fighting over a Bone 1753
oil on canvas 93.7 x 107.5
B.M.914

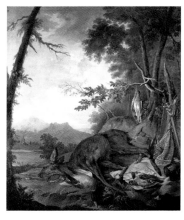

Oudry, Jean-Baptiste (attributed to)
1686–1755
Dead Game
oil on canvas 194.5 x 164.5
B.M.298

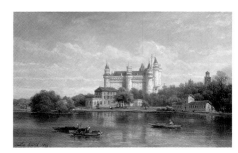

Ouvrie, Pierre Justin 1806–1879
Vue de Château de Pierrefonds, France 1869
oil on panel 30 x 45.3
B.M.692

Ouvrie, Pierre Justin 1806–1879
A Derelict Country Church
oil on canvas 24.1 x 32.2
B.M.655

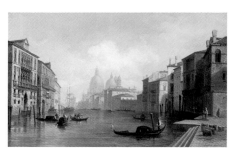

Ouvrie, Pierre Justin 1806–1879
View on the Grand Canal, Venice, Italy
oil on panel 27.6 x 43.8
B.M.651

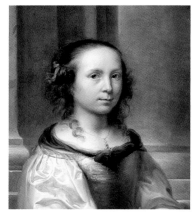

Ovens, Jürgen (attributed to) 1623–1678
Portrait of a Girl with a Watchful or Guarded Look c.1660–1670
oil on canvas 61.9 x 51.8
B.M.153

Pacheco, Francisco 1564–1644
The Last Communion of St Peter Nolasco 1611
oil on canvas 203.8 x 248.9
B.M.1007

Pacheco, Francisco (circle of) 1564–1644
The Surrrender of Seville to Ferdinand III
17th C
oil on canvas 63.5 x 136.5
B.M.69

Palamedesz., Anthonie 1601–1673
Portrait of a Lady Wearing a Wreath of Roses
1633
oil on oak panel 28.6 x 21.6
B.M.648

Palizzi, Filippo 1818–1899
A Spaniel with Two Puppies 1849
oil on canvas 54.6 x 66
B.M.909

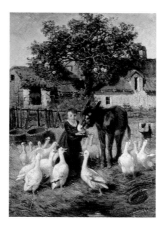

Palizzi, Giuseppe 1812–1888
A Child Feeding a Donkey in a Farmyard
oil on canvas 48.9 x 34.6
B.M.389

Palizzi, Giuseppe 1812–1888
A Horse in a Stable
oil on panel 15.9 x 21
B.M.762

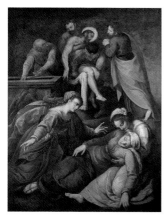

Palma, Jacopo il giovane (after)
1544/1548–1628
The Entombment early 17th C
oil on canvas 137.1 x 100.3
B.M.59

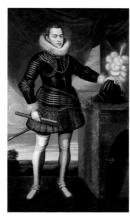

Pantoja de la Cruz, Juan (after) 1553–1608
Philip IV of Spain (1605–1665) 17th C
oil on canvas 198.1 x 111.8
B.M.341

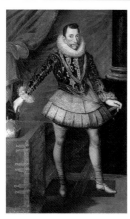

Pantoja de la Cruz, Juan (after) 1553–1608
*The Archduke Albert of Austria (1559–1621),
Governor of The Netherlands* 17th C
oil on canvas 198.1 x 111.8
B.M.277

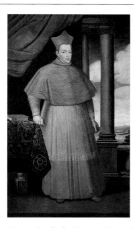

Pantoja de la Cruz, Juan (after) 1553–1608
The Infante Cardinal Ferdinand (1609–1641)
17th C
oil on canvas 198.1 x 111.8
B.M.553

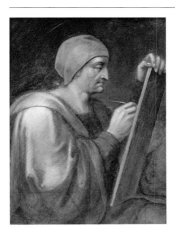

Pantoja de la Cruz, Juan (attributed to)
1553–1608
St Luke
oil on oak panel 64 x 50
2002.1

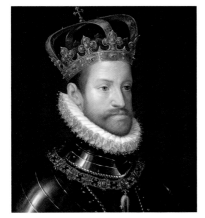

Pantoja de la Cruz, Juan (style of)
1553–1608
The Emperor Charles V (1500–1558) 16th C
oil on panel 52.1 x 46.7
B.M.6

Parrocel, Joseph (style of) 1646–1704
Landscape with Horsemen late 17th C
oil on canvas 56.8 x 78.7
B.M.140

Patel, Pierre Antoine (style of) 1648–1707
Architectural Landscape with Ruins
early 18th C
oil on canvas 78.7 x 61.2
B.M.85

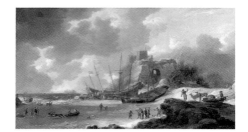

Peeters, Jan I 1624–c.1677
Coast Scene (On the Baltic Sea)
oil on canvas 42 x 71
B.M.171

Pere, Antonio van de c.1618–c.1688
*The Communion of St Maria Maddalena de'
Pazzi* (detail) 1659
oil on canvas 203.5 x 528.2
B.M.18

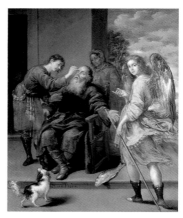

Pereda y Salgado, Antonio 1611–1678
Tobias Restoring His Father's Sight 1652
oil on canvas 192 x 157
B.M.34

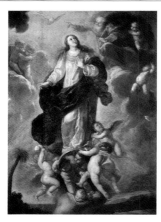

Pereda y Salgado, Antonio (circle of)
1611–1678
The Immaculate Conception late 17th C
oil on canvas 208.3 x 146
B.M.15

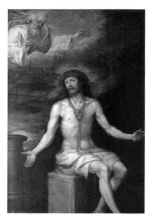

Pereda y Salgado, Antonio (follower of)
1611–1678
Christ Shown to the People 17th C
oil on canvas 236.2 x 143.5
B.M.817

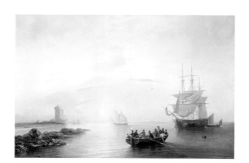

Perrot, Ferdinand 1808–1841
Seascape Sunset 1832
oil on canvas 43.5 x 65
B.M.314

Pether, Sebastian 1790–1844
Ruined Church by Moonlight
oil on canvas 45 x 59
O.70

Petit, Pierre Joseph 1768–1825
*Landscape with a Temple and an Artist
Sketching* 1792
oil on canvas 53.7 x 80.3
B.M.342

Petit, Pierre Joseph 1768–1825
Landscape with Cattle and a River
oil on canvas 23.1 x 31.9
B.M.433

Petit, Pierre Joseph 1768–1825
Mountainous Landscape with a Ruined Castle
oil on panel 21.9 x 31.9
B.M.442

Phillip, John 1817–1867
Italian Pifferari
oil on board 58.7 x 45
B.M.125

Piemean (Professor) active 19th C
View in Greece
oil on cardboard 28 x 37.6
B.M.721

Pignoni, Simone (style of) 1611–1698
*Two Women, One with a Caduceus, the Other
with Fasces* 17th C
oil on canvas 68.9 x 51.1
B.M.63

Pils, Edouard-Aimé (attributed to)
1823–1850
A Dead Bittern 1848
oil on canvas 81.5 x 65.7
B.M.905

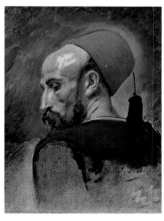

Pils, Isidore Alexandre Augustin
1813/1815–1875
Head of an Arab in a Fez c.1854–1857
oil on canvas 35.2 x 27.5
B.M.748

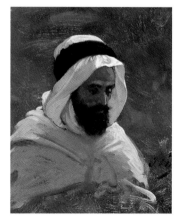

Pils, Isidore Alexandre Augustin
1813/1815–1875
An Arab c.1860–1867
oil on canvas 23.5 x 18.4
B.M.742

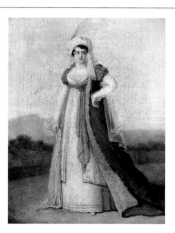

Pinchon, Jean Antoine 1772–1850
A Lady in Oriental Fancy Dress
oil on canvas 31.9 x 23.7
B.M.405

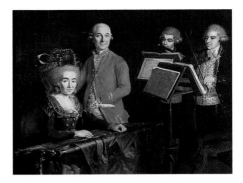

Pinson, Isabelle (attributed to)
active 1763–1823
Family Group 1781
oil on canvas 71 x 90
B.M.942

Pittuck, Douglas Frederick 1911–1993
The Bowes Museum from the Kitchen Gardens of Barnard Castle School, County Durham
1950
oil on board 41.5 x 67
1993.27

Plas, Laurens 1828–1893
Sheep and Goats
oil on panel 17.5 x 21.9
B.M.756

Plasschaert, Jacobus c.1730–1765
Trompe l'Oeil Still Life 1743
oil on canvas 53.4 x 64.4
B.M.608

Platzer, Johann Georg 1704–1761 & **Orient, Josef** 1677–1747
The Judgement of Paris
oil on panel 44.1 x 65
B.M.198

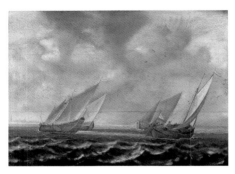

Porcellis, Jan (school of) c.1584–1632
Sea Piece 17th C
oil on panel 52.5 x 72.5
B.M.121

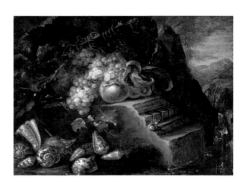

Porpora, Paolo (school of) 1617–1673
Fruit and Shells c.1650–1770
oil on canvas 30.6 x 41.2
B.M.793

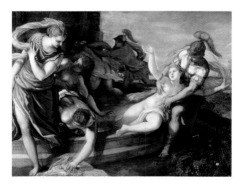

Porta, Giuseppe 1520–1575
The Rape of the Sabine Women c.1550–1555
oil on canvas 153.5 x 211.1
B.M.208

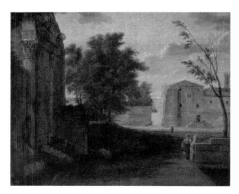

Poussin, Nicolas (style of) 1594–1665
Architectural Landscape c.1650–c.1699
oil on canvas 47.7 x 60
B.M.603

Facing page: Sutherland, Brian b.1942, *Stick Man* (detail), 1969, Durham County Council, (p. 283)

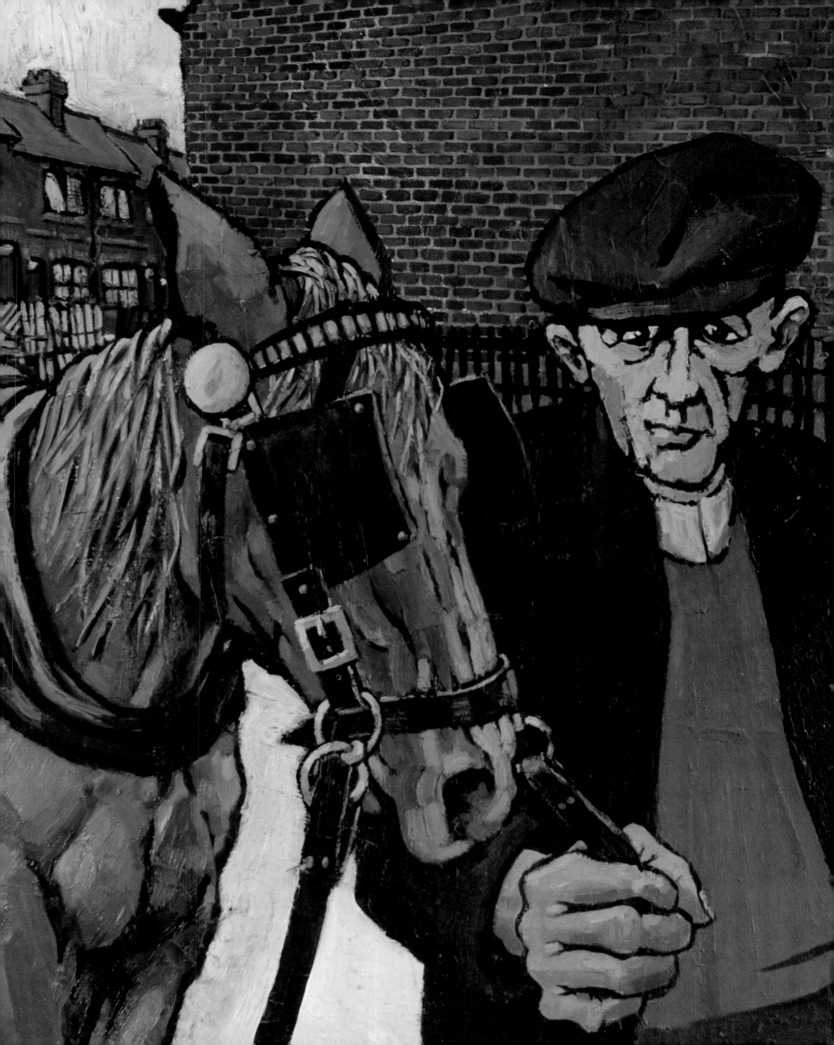

Primaticcio, Francesco (circle of)
1504–1570
The Rape of Helen 1533–1535
oil on canvas 155.6 x 188.6
B.M.76

Primaticcio, Francesco (style of) 1504–1570
The Three Graces (Aglaia, Thalia and Euphrosyne) 18th C
oil on panel 74.9 x 57.1
B.M.613

Provost, Jan (attributed to) c.1465–1529
The Adoration of the Magi with St John the Baptist, St Anne and Donors c.1515–1520
oil on panel 75 x 23; 75 x 57.5; 75 x 23
1980.14.2

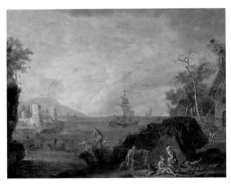

Prudhomme, Antione Daniel 1745–c.1826
Coast Scene with Figures 1800
oil on canvas 45 x 54.4
B.M.387

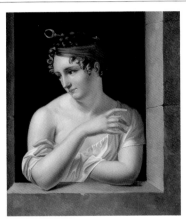

Prud'hon, Pierre-Paul (style of) 1758–1823
Girl Looking out of a Window c.1780–1810
oil on canvas 73 x 59.7
B.M.844

Pryde, James 1866–1941
The Birdcage
oil on panel 52 x 40
1977.53.7

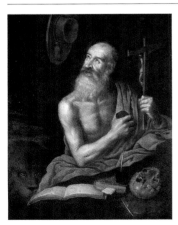

Puga, Antonio 1602–1648
St Jerome 1636
oil on canvas 134 x 103.5
B.M.11

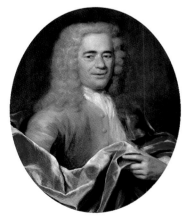

Quinkhard, Jan Maurits 1688–1772
Portrait of a Gentleman with a Red Cloak 1735
oil on canvas 77.6 x 65.1
B.M.135

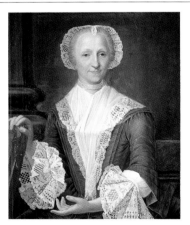

Quinkhard, Jan Maurits (circle of)
1688–1772
Portrait of a Lady in a Blue Dress 1754
oil on canvas 81.3 x 67.3
B.M.560

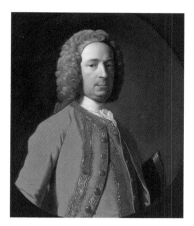

Ramsay, Allan 1713–1784
Portrait of a Man
oil on canvas 73.7 x 60.6
B.M.1047

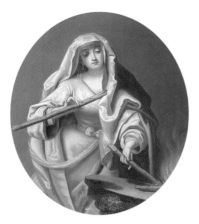

Raoux, Jean (follower of) 1677–1734
Vestal Virgin 18th C
oil on canvas 59.4 x 49.4
B.M.275

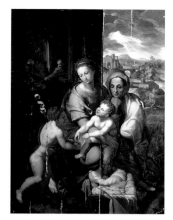

Raphael (after) 1483–1520
*The Holy Family with St Elizabeth and the
Infant St John the Baptist* 16th C
oil on panel 162.5 x 123
B.M.820

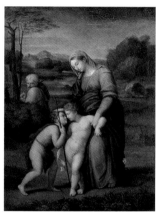

Raphael (copy of) 1483–1520
*The Holy Family with the Infant St John the
Baptist*
oil on panel 92.7 x 63.5
B.M.839

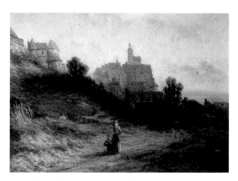

Rauch, Johann Nepomuk 1804–1847
Landscape with a Château
oil on canvas 30 x 40.6
B.M.695

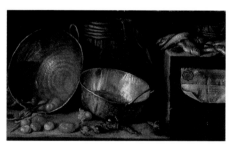

Recco, Giuseppe (circle of) 1634–1695
Kitchen Utensils 17th C
oil on canvas 59.4 x 69.5
B.M.25

Régnier, Nicolas (after) c.1590–1667
Portrait of a Girl, Aged 16 1633
oil on oak panel 38.7 x 31.9
B.M.181

Regters, Tibout 1710–1768
*Portrait of a Lady in a Black Dress Holding a
Book* 1749
oil on canvas 74.4 x 58.7
B.M.858

Rembrandt van Rijn (copy of) 1606–1669
Portrait of a Boy 18th C
oil on canvas 24.5 x 20
B.M.663

Reni, Guido (after) 1575–1642
The Abduction of Helen 17th C
oil on canvas 62 x 75.5
O.76

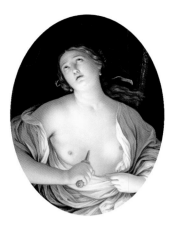

Reni, Guido (after) 1575–1642
The Death of Lucretia 17th C
oil on canvas 96.5 x 71.1
B.M.72

Reni, Guido (follower of) 1575–1642
St Francis in Ecstasy 17th C
oil on canvas 78.4 x 66
B.M.1011

Reus, Johann George 1730–c.1810
Portrait of a Lady in Blue and Black 1769
oil on canvas 79.1 x 65.9
B.M.347

Reynolds, Joshua 1723–1792
Portrait of a Lady
oil on canvas 54.4 x 46.3
B.M.130

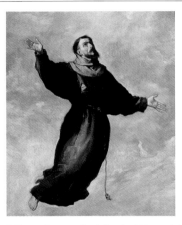

Ribera, Jusepe de (after) 1591–1652
A Levitation of St Francis early 17th C
oil on canvas 100 x 81.6
B.M.21

Richard, Pierre Louis 1810–1886
A Girl with a Flock of Geese 1867
oil on canvas 63.1 x 52.5
B.M.353

Richard, Pierre Louis (attributed to)
1810–1886
The Tears of St Peter (copy after Jusepe de
Ribera)
oil on panel 22.5 x 18.1
B.M.41

Richardson, J. (attributed to) active 18th C
Christopher Sanderson III
oil on canvas 88 x 69.5
O.342

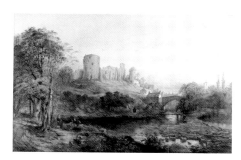

Richardson, Thomas Miles I 1784–1848
Barnard Castle, County Durham
oil on canvas 82.6 x 124.6
O.28

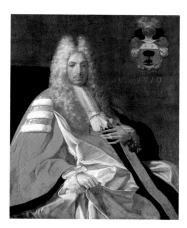

Rivalz, Antoine (studio of) 1667–1735
Jean Jacques Fortic, Capitoul of Toulouse 1719
oil on canvas 118.7 x 71.2
B.M.263

Rizi, Juan Andrés 1600–1681
The Virgin of Montserrat with a Donor c.1645–1653
oil on canvas 264.4 x 167.6
B.M.824

Rizi, Juan Andrés (attributed to) 1600–1681
St Gregory
oil on canvas 123.2 x 97.8
B.M.30

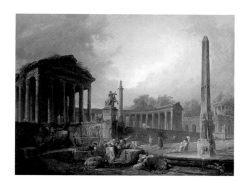

Robert, Hubert 1733–1808
Architectural Capriccio with Obelisk 1768
oil on canvas 106 x 139.1
B.M.273

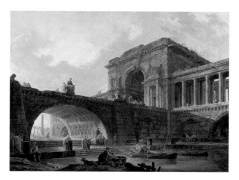

Robert, Hubert 1733–1808
Architectural Capriccio with Bridge and Triumphal Arch c.1768
oil on canvas 106 x 139.1
B.M.264

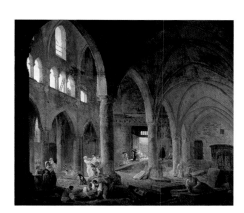

Robert, Hubert 1733–1808
The Dismantling of the Church of the Holy Innocents, Paris, France, 1785 c.1785–1787
oil on canvas 114.6 x 129.5
B.M.312

Robert-Fleury, Tony 1837–1911
Lesbia and the Sparrow
oil on canvas 55 x 46.6
B.M.468

Rochussen, Charles 1814–1894
Fisherfolk with a Boat on the Seashore 1850
oil on panel 16.5 x 23.8
B.M.715

Rodríguez Barcaza, Ramón 1820–1892
Head of an Italian Woman 1866
oil on canvas 55.9 x 46.3
B.M.927

Román, Bartolomé (attributed to)
1596–1647
Behold My Hand
oil on canvas 221 x 159.1
B.M.838

Romano, Giulio (after) 1499–1546
A Boar Hunt 17th C-18th C
oil on canvas 27.9 x 48.9
B.M.773

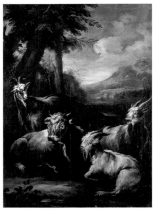

Roos, Joseph (attributed to) 1726–1805
Landscape with Oxen and Goats
oil on canvas 125.3 x 90
B.M.908

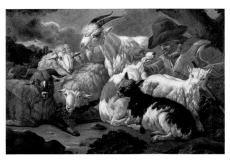

Roos, Philipp Peter (attributed to)
1657–1706
Shepherd with Dog, Goats and Sheep
oil on canvas 115 x 165
B.M.206

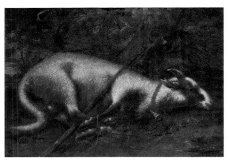

Roos, Philipp Peter (follower of) 1657–1706
Sheep 18th C
oil on canvas 68.1 x 96.9
B.M.907

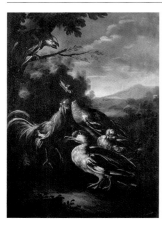

Roos, Philipp Peter (style of) 1657–1706
Birds in a Landscape 17th C
oil on canvas 126.3 x 90
B.M.910

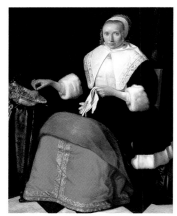

Rootius, Jan Albertsz. (attributed to)
c.1615–1674
*Portrait of a Lady in a Fur-Trimmed Dress
Holding a Pair of White Gloves* c.1660–1670
oil on canvas 136.2 x 107
B.M.100

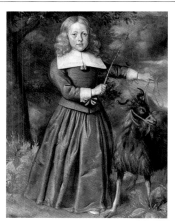

Rootius, Jan Albertsz. (style of)
c.1615–1674
Portrait of a Boy with a Goat c.1640–1660
oil on canvas 98.7 x 76.2
B.M.182

Rosa, Salvator (style of) 1615–1673
Landscape with Figures 18th C
oil on canvas 41.3 x 72.3
B.M.150

Rosa, Salvator (style of) 1615–1673
Rocky Landscape with River, Ruin and Figures
18th C
oil on canvas 74 x 97.1
B.M.111

Rosa, Salvator (style of) 1615–1673
Wild Landscape with Castle on a Crag 18th C
oil on canvas 23.1 x 43.5
B.M.745

Roslin, Alexander (attributed to)
1718–1793
Portrait of a Lady in Green and Pink
oil on panel 71.1 x 59.7
B.M.251

Rousseau, Philippe 1816–1887
The Heron's Pool 1869
oil on panel 16.9 x 33.4
B.M.708

Rozier, Jules Charles 1821–1882
Wooded Landscape with Cottages 1862
oil on panel 18.7 x 35
B.M.690

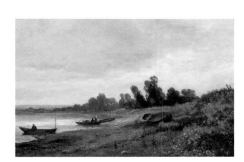

Rozier, Jules Charles 1821–1882
The Seine at Carrières Saint-Denis, France
oil on panel 25 x 40
B.M.694

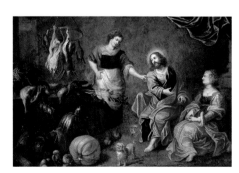

Rubens, Peter Paul (after) 1577–1640
Christ with Martha and Mary at Bethany
17th C
oil on canvas 108.1 x 162
B.M.634

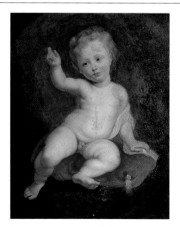

Rubens, Peter Paul (copy after) 1577–1640
Child Seated on a Red Cushion 17th C-18th C
oil on canvas 60.6 x 45
B.M.481

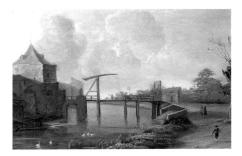

Ruelles, Pieter des c.1630–1658
Landscape with a Castle and a Drawbridge
oil on panel 41.9 x 62.5
B.M.166

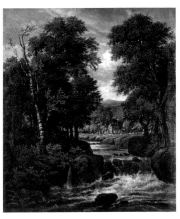

Ruisdael, Jacob van (follower of)
1628/1629–1682
Wooded Landscape with a River c.1650–1700
oil on canvas 95.2 x 78.7
B.M.109

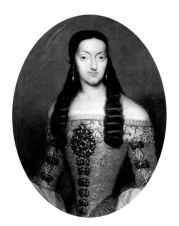

**Ruiz de la Iglesia, Francisco Ignazio
(attributed to)** 1649–1704
*Marie Louis of Orleans (1662–1689), Queen of
Spain* 1680–1690
oil on canvas 76.5 x 58.4
B.M.925

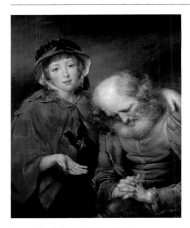

Russell, John 1745–1806
The Blind Beggar and His Granddaughter
oil on canvas 90.6 x 70.3
B.M.1029

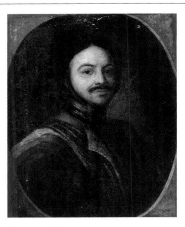

Russian School
Peter the Great (1672–1725) c.1692–c.1721
oil on canvas 71.9 x 58.4
B.M.954

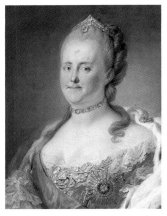

Russian School
*The Empress Catherine the Great of Russia
(1729–1796)* c.1762–c.1770
oil on canvas 57.5 x 46.2
B.M.979

Ruysdael, Salomon van (style of)
c.1602–1670
View at the Mouth of a River early 18th C
oil on oak panel 20 x 28.6
B.M.222

Ruysdael, Salomon van (style of)
c.1602–1670
View at the Mouth of a River with Shipping
18th C
oil on panel 18.7 x 24.5
B.M.788

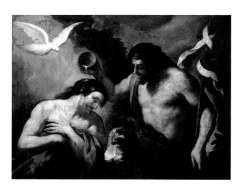

Sacchi, Andrea (after) 1599–1661
The Baptism of Christ 17th C
oil on canvas 115.6 x 152.4
B.M.636

Saeys, Jakob Ferdinand (follower of)
1658–c.1725
A Palace with a Courtyard and Figures
late 17th C-early 18th C
oil on canvas 78 x 110
B.M.84

Saftleven, Cornelis (attributed to)
1607–1681
Still Life of Inanimate Objects in a Peasant Interior
oil on panel 45.1 x 38.7
B.M.167

Saftleven, Cornelis (attributed to)
1607–1681
The Temptation of St Anthony
oil on panel 42.5 x 51.7
B.M.197

Saftleven, Herman the younger 1609–1685
View on the Rhine 1672
oil on panel 44.7 x 59.7
B.M.183

Saftleven, Herman the younger 1609–1685
Mountainous Landscape 1681
oil, pen & pencil on panel 35 x 47.5
B.M.160

Saftleven, Herman the younger (style of)
1609–1685
Landscape 17th C
oil on copper 13.7 x 20.6
B.M.226

Sánchez Coello, Alonso c.1531–1588
Catherine of Austria (1507–1578), Queen of Portugal (copy of Antonis Mor)
oil on oak panel 45.4 x 35.2
B.M.5

Sánchez Coello, Alonso (follower of)
c.1531–1588
The Duchess of Lerma 16th C
oil on canvas 104.4 x 81.9
B.M.66

Sánchez Coello, Alonso (follower of)
c.1531–1588
Portrait of a Boy late 16th C
oil on canvas 132 x 98.5
O.162

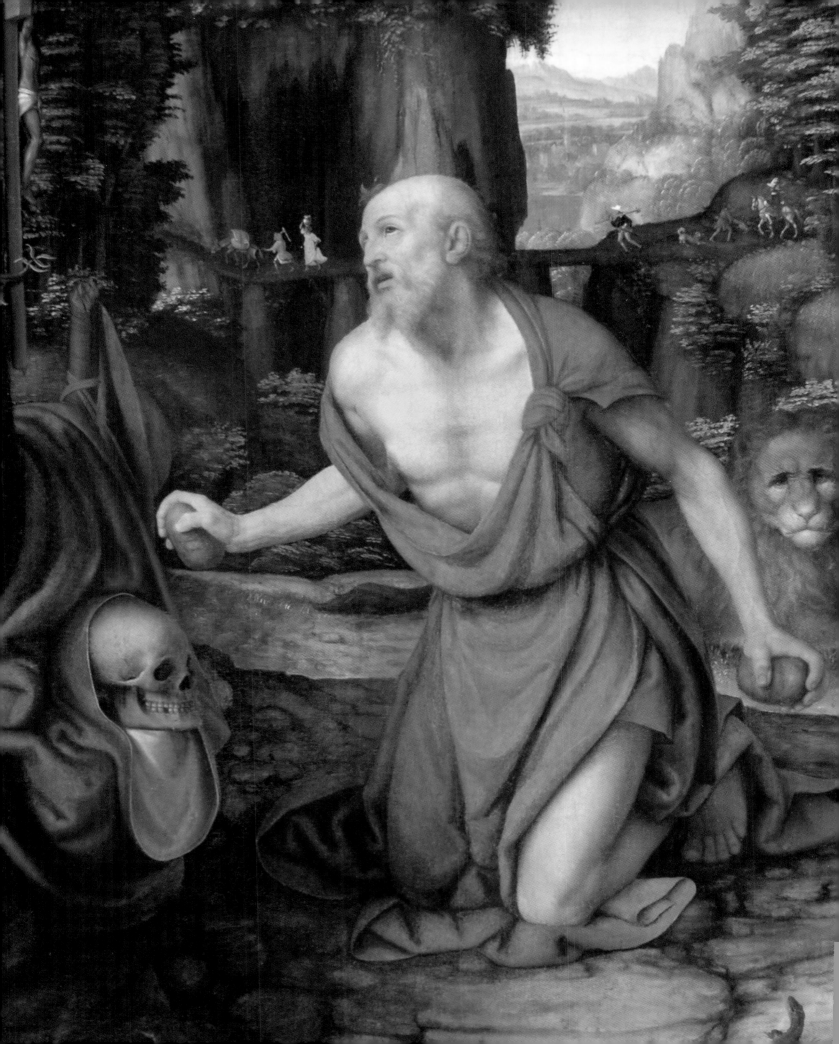

Sánchez Cotán, Juan (circle of) c.1561–1627
St Joseph Leading the Infant Christ
early 17th C
oil on canvas 221 x 156.2
B.M.836

Santa Croce, Girolamo da 1480/1485–1556
The Presentation in the Temple
tempera on panel 73.6 x 88.9
B.M.48

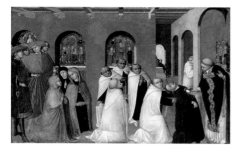

Sassetta 1395–1450
The Miracle of the Holy Sacrament
c.1423–1426
tempera & gold on panel 26.7 x 40.6
B.M.52

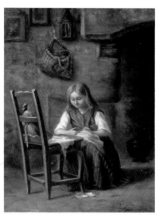

Sauvage, Philippe François active 1872
Girl Making Clothes for a Doll (La robe de la poupée)
oil on panel 21.3 x 16.2
B.M.711

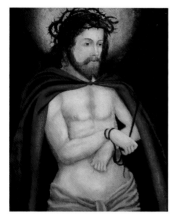

Schäufelein, Hans (style of)
c.1480/1485–1538/1540
Christ Crowned with Thorns 19th C
oil on panel 37.2 x 27.5
B.M.176

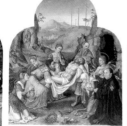

Scorel, Jan van (school of) 1495–1562
The Deposition with Donors and Saints c.1571–1573
oil on panel 85.2 x 25; 85.1 x 67; 85.2 x 25
B.M.615

Sellaer, Vincent (attributed to)
c.1500–c.1589
The Death of Lucretia
oil on canvas 91.4 x 69.8
B.M.941

Snayers, Pieter (school of) 1592–1667
The Battle of Kalloo, 1638 c.1638–1640
oil on canvas 55.3 x 98.1
B.M.163

Snyders, Frans 1579–1657
A Boar Hunt c.1636–1640
oil on canvas 211 x 333
B.M.88

Facing page: Solario, Andrea (attributed to), c.1465–1524, *St Jerome in the Wilderness* (detail), c.1510–1515,
The Bowes Museum, (p. 156)

Snyders, Frans (attributed to) 1579–1657
A Fruit Stall c.1620–1630
oil on canvas 220 x 357
B.M.101

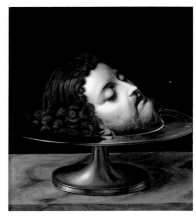

Solario, Andrea (after) c.1465–1524
The Head of the Baptist on a Tazza
mid-16th C–mid-17th C
oil on panel 47.6 x 41.6
B.M.56

Solario, Andrea (attributed to) c.1465–1524
St Jerome in the Wilderness c.1510–1515
oil on panel 69.8 x 54.3
B.M.42

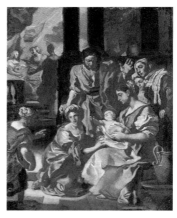

Solimena, Francesco 1657–1747
The Birth of the Virgin c.1680–1690
oil on canvas 39.4 x 31.7
B.M.1006

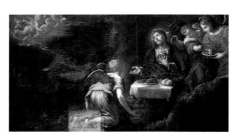

Solis, Francisco de 1629–1684
Angels Ministering to Christ c.1665
oil on canvas 114.9 x 204.1
B.M.827

Solis, Francisco de 1629–1684
St Mark
oil on canvas 143.5 x 270
B.M.1010

Solis, Francisco de 1629–1684
St Matthew
oil on canvas 142.5 x 270
B.M.1009

Sorg, Johann Jacob 1743–1821
Portrait of a Lady 1779
oil on canvas 57.5 x 48.3
O.196

Sorg, Johann Jacob 1743–1821
Portrait of an Elderly Lady in a Large Ruched Lace Cap 1779
oil on canvas 56.3 x 47.5
B.M.951

156

Sorg, Johann Jacob (style of) 1743–1821
Portrait of a Lady c.1772–1785
oil on canvas 56 x 47
O.254

Soulacroix, Joseph Frédéric Charles
1825–1879
Madonna and Child in a Landscape
oil on canvas fixed on panel 31.2 x 17.5
B.M.418

Spada, Leonello (attributed to) 1576–1622
Christ Disputing with the Doctors
oil on canvas 99.1 x 142.2
B.M.37

Spaendonck, Gerard van (school of)
1746–1822
Flowers and Fruit c.1785
oil on canvas 83.1 x 64.4
B.M.157

Spanish School mid-16th C-mid-17th C
Christ before Pilate
oil on canvas 157.5 x 345.4
B.M.637

Spanish School
Portrait of a Lady with a Dog c.1600–c.1650
oil on canvas 113 x 91.7
B.M.316

Spanish School
Nativity Scene c.1625–c.1700
oil on canvas 190.5 x 139.7
O.247

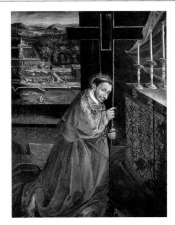

Spanish School
St Charles Borromeo in Prayer c.1650–c.1700
oil on canvas 194.3 x 141.6
B.M.835

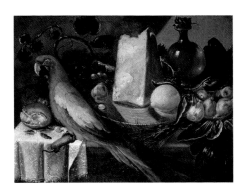

Spanish School
Still Life with a Red Macaw c.1650–c.1700
oil on canvas 73.4 x 92.8
B.M.113

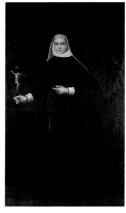

Spanish School
A Carmelite Nun with a Crucifix
c.1675–c.1700
oil on canvas 206.3 x 115.6
B.M.15a

Spanish School
A Franciscan Nun with a Crucifix
c.1675–c.1700
oil on canvas 206.3 x 115.6
B.M.22a

Spanish School 17th C
A Saint
oil on canvas 86.5 x 62.3
O.107

Spanish School 17th C
A Saint
oil on canvas 86.5 x 62.3
O.108

Spanish School 17th C
A Saint
oil on canvas 86.5 x 62.3
O.109

Spanish School 17th C
A Saint
oil on canvas 89 x 66
O.113

Spanish School 17th C
St Bartholomew
oil on canvas 86.5 x 63
O.104

Spanish School 17th C
St James the Younger
oil on canvas 86.5 x 63
O.102

Spanish School 17th C
St Peter
oil on canvas 86.5 x 63
O.103

Spanish School 17th C
St Simon
oil on canvas 86.5 x 63
O.101

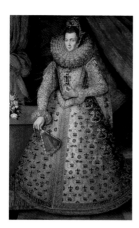

Spanish School 17th C
*The Infanta Isabel Clara Eugenia (1566–1633),
Governess of The Netherlands*
oil on canvas 198.1 x 111.8
B.M.256

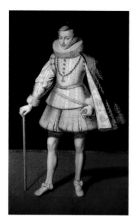

Spanish School 17th C
*The Infante Carlos von Habsburg
(1607–1632), Grand Admiral of Spain*
oil on canvas 198.1 x 111.8
B.M.323

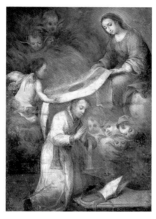

Spanish School 17th C
*The Presentation of the Chasuble to St
Ildephonsus*
oil on canvas 90 x 62
O.331

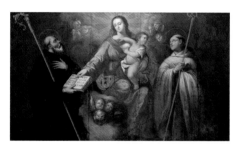

Spanish School mid-17th C-mid-18th C
*The Madonna and Child Giving Rules to St
Basil and St Bernard*
oil on canvas 107.9 x 180.3
B.M.821

Spanish School
The Virgin Mary c.1750–c.1800
oil on canvas 28.6 x 21.6
B.M.414

Spanish School
Portrait of a Lady 1780s
oil on canvas 60.5 x 49.5
O.228

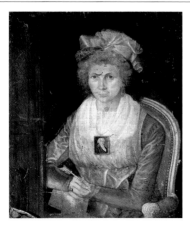

Spanish School
Portrait of a Lady c.1790–c.1810
oil on canvas 81 x 64.2
O.303

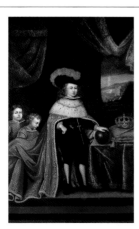

Spanish School 18th C-19th C
Charles II (1661–1700), King of Spain
oil on canvas 188 x 107.3
B.M.53

Spanish School
A Spanish Beggar Boy c.1800–c.1875
oil on canvas 46.9 x 35.9
B.M.33

Spanish School 19th C
The Madonna and Child with Saints
oil on canvas 60 x 51
O.202.A

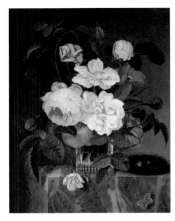

Speeckaert, Michel Joseph 1748–1838
Roses with a Bird's Nest
oil on panel 35 x 25
B.M.644

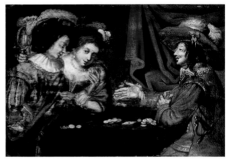

Spirinx, Louis (after) 1596–1669
Rooks and Pigeons 17th C
oil on panel 28.1 x 38.7
B.M.421

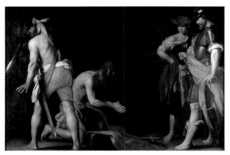

Stanzione, Massimo (copy of) 1585–1656
The Beheading of St John the Baptist 17th C
oil on canvas 180.3 x 247.6
B.M.818

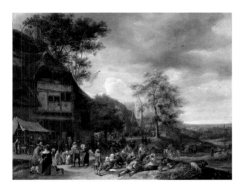

Steen, Jan 1626–1679
Villagers Merrymaking Outside an Inn 1652
oil on canvas 43.5 x 56
2007.33

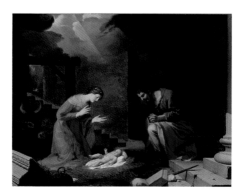

Stella, Jacques 1596–1657
The Nativity 1639
oil on copper 65.4 x 80.6
B.M.60

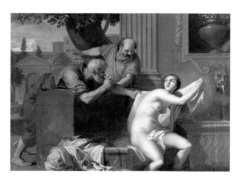

Stella, Jacques (circle of) 1596–1657
Susannah and the Elders c.1655–1660
oil on canvas 71.2 x 96.2
B.M.541

Stevens, Albert George 1863–1927
Portrait of a Man 1895
oil on canvas 29.2 x 19
O.41

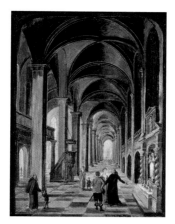

Stöcklin, Christian 1741–1795
Interior of a Church with Figures 1788
oil on millboard 21.9 x 16.5
B.M.239

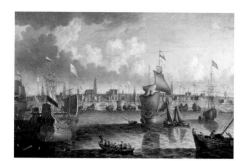

Storck, Abraham 1644–1708
View of Amsterdam, Holland
oil on canvas 80 x 112.5
B.M.572

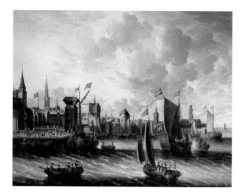

Storck, Abraham 1644–1708
View of Antwerp, Belgium
oil on canvas 92.5 x 110
B.M.82

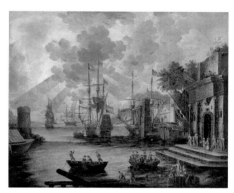

Storck, Abraham (follower of) 1644–1708
Dutch Sea Port with Shipping 17th C
oil on canvas 93 x 115
B.M.110

Strozzi, Bernardo (circle of) 1581–1644
Head of an Apostle 17th C
oil on canvas 64.1 x 44.5
B.M.546

Subleyras, Pierre Hubert 1699–1749
Academic Study of a Seated Male Nude
oil on canvas 65 x 50
B.M.931

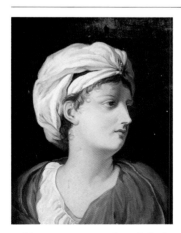

Subleyras, Pierre Hubert (after) 1699–1749
A Girl in a Turban late 18th C-early 19th C
oil on canvas 52.5 x 43.7
B.M.487

Subleyras, Pierre Hubert (style of)
1699–1749
*Academic Study of a Standing Male
Figure* 18th C
oil on canvas 65.6 x 48.7
B.M.928

Swagers, Frans 1756–1836
*Landscape with a River, Boats, Sheep and a
Tower* 1821
oil on canvas 24.1 x 32.8
B.M.406

Swagers, Frans 1756–1836
Coast Scene with a Wooded Landscape
oil on canvas 31.9 x 40
B.M.188

Swagers, Frans 1756–1836
Landscape
oil on canvas 32.5 x 40.7
O.212

Swagers, Frans 1756–1836
Landscape with a River and a Sportsman
oil on canvas 32.1 x 40.3
B.M.186

Swagers, Frans 1756–1836
Landscape with Figures
oil on canvas 48.5 x 80
B.M.195

Swagers, Frans 1756–1836
Landscape with River and Sunset
oil on canvas 30.6 x 50.6
B.M.159

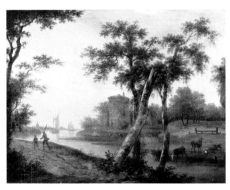

Swagers, Frans 1756–1836
Landscape with River, Ships in the Distance
oil on canvas 31.2 x 39.4
B.M.407

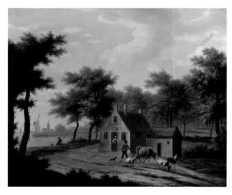

Swagers, Frans 1756–1836
Riverside Inn
oil on canvas 43.5 x 53.1
B.M.503

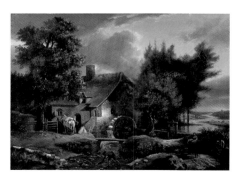

Swagers, Frans 1756–1836
The Mill
oil on panel 22.5 x 31.2
B.M.187

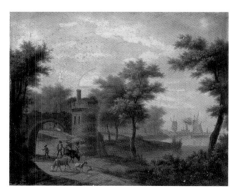

Swagers, Frans (attributed to) 1756–1836
Landscape
oil on canvas 45.5 x 55.5
O.206

Facing page: Robson, George, b.1945, *Durham Miners' Gala* (centre panel) (detail), 2000,
Easington District Council, (p. 326)

Swiss School
Portrait of a Swiss Girl in a Black Bonnet
c.1800
oil on canvas 90.6 x 71.9
B.M.497

Tabar, François Germain Léopold
1818–1869
View on the Grand Canal, Venice,
Italy c.1865–1868
oil on panel 23.1 x 42.5
B.M.747

Tabar, François Germain Léopold
1818–1869
A Shipbuilding Yard
oil on canvas 62.5 x 51.9
B.M.495

Taillasson, Jean Joseph 1745–1809
Spring (or Flora) *Leading Cupid Back to*
Nature c.1790–1792
oil on canvas 115 x 88.7
B.M.262

Tanché, Nicolas c.1740–c.1776
Infant Bacchus and Putti 1776
oil on canvas 95.6 x 168.3
B.M.332

Tanneur, Philippe 1795–1878
Wooded Landscape with Farm Buildings and a
Woman Drawing Water
oil on panel 26.9 x 34.7
B.M.995

Tavella, Carlo Antonio 1668–1738
Snowy Landscape
oil on canvas 73.7 x 106.9
B.M.306

Tendran, A. (school of) active 18th C
Landscape
oil on canvas 37 x 45.8
O.211

Teniers, David I (after) 1582–1649
Interior, Woman Cleaning Vegetables 17th C
oil on canvas 45.6 x 63
B.M.834

Teniers, David II (circle of) 1610–1690
Fête champêtre 17th C
oil on canvas 90.5 x 118
B.M.635

Tennick, William George 1847–1913
Blacksmith's Shop 1900
oil on canvas 40.5 x 66.6
1984.62.3/ANT.

Tennick, William George 1847–1913
Ground Beck, Selaby, County Durham
oil on canvas 51.6 x 39.5
1998.82/ANT.

Thompson, Mark 1812–1875
Sheep Walk, Cronkley Crags, Teesdale, County Durham c.1866
oil on canvas 86 x 145
O.66

Thulden, Theodore van 1606–1669
Allegory of the Submission of Magdeburg to Frederick William of Brandenburg and of the Birth of Frederick's Son, Ludwig c.1666–1669
oil on canvas 77.5 x 114.4
B.M.542

Tiepolo, Giovanni Battista 1696–1770
The Harnessing of the Horses of the Sun c.1731–1736
oil on canvas 98.1 x 73.6
B.M.51

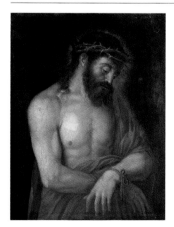

Titian (copy after) c.1488–1576
Ecce Homo 17th C
oil on canvas 82.5 x 61.9
B.M.570

Titian (style of) c.1488–1576
Portrait of a Man with a Beard 19th C
oil on canvas 58.4 x 45.7
B.M.558

Tocqué, Louis (attributed to) 1696–1772
Portrait of a Man 'en robe de chambre' c.1735–1745
oil on canvas 76.2 x 61
B.M.552

Touzé, Jacques Louis François (after)
1747–1807
Panel of Trompe l'Oeil Ornament
late 18th C-early 19th C
oil on panel 239.4 x 66.3
B.M.579

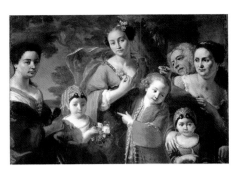

Traversi, Gaspare (attributed to)
c.1722–c.1770
Family Portrait Group c.1750–1770
oil on canvas 99.4 x 138.4
B.M.91

Treleaven, Richard Barrie b.1920
'Chaku', First Year Goshawk
oil on board 54.4 x 39.4
1985.12.43

Treleaven, Richard Barrie b.1920
Hen 'Merlin' on the Moors
oil on board 41.2 x 53.7
1985.12.42

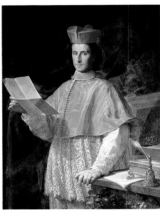

Trevisani, Francesco 1656–1746
Cardinal Pietro Ottoboni (1667–1740)
c.1689–1700
oil on canvas 134.3 x 98.5
B.M.70

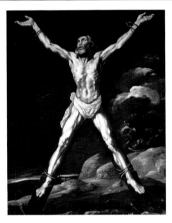

Tristán de Escamilla, Luis 1585–1624
The Martyrdom of St Andrew c.1616–1624
oil on canvas 111.1 x 93.8
B.M.945

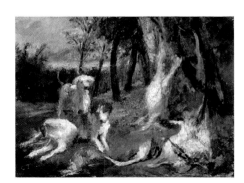

Troyon, Constant (style of) 1810–1865
Wooded Landscape with Dogs and Dead Game
c.1850–1860
oil on canvas 15.9 x 21.6
B.M.750

Uden, Lucas van 1595–1672
Ulysses and Nausicaä 1635
oil on panel 53.3 x 74.3
B.M.16

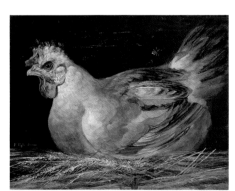

Ughi, F. active 19th C
Hen
oil on canvas 37 x 45.8
O.244

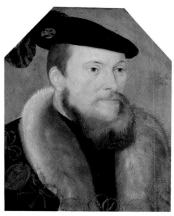

unknown artist 16th C
Portrait of a Gentleman
oil on oak panel 30 x 23.7
B.M.216

unknown artist 16th C
Triptych Wing
oil on panel 53.3 x 14
O.49

unknown artist 16th C
Triptych Wing
oil on panel 53.3 x 14
O.50

unknown artist late 16th C-early 17th C
Portrait of a Girl in a Grey Dress with a Lace Collar
oil on panel 41.2 x 30.6
B.M.164

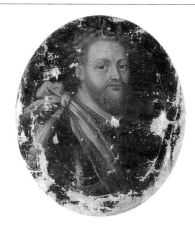

unknown artist
Portrait of a Man c.1600–c.1650
oil on canvas 45.8 x 36.8
O.258

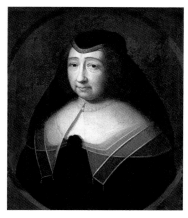

unknown artist
Portrait of a Lady c.1640–c.1690
oil on canvas 61.2 x 51.2
B.M.543

unknown artist
A Mill c.1650
oil on canvas 24 x 18
O.202

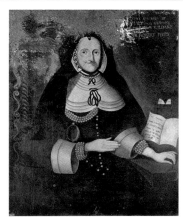

unknown artist
Lettice, Baroness of Offaly (c.1580–1588–1653) c.1650–c.1658
oil on canvas 115 x 94
O.81

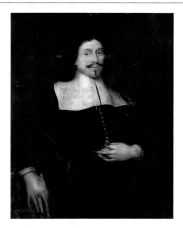

unknown artist
Portrait of a Gentleman Dressed in Black, Holding a Pen c.1660–c.1680
oil on canvas 103.7 x 78.7
B.M.574

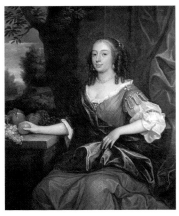

unknown artist
Portrait of a Lady Holding an Apple
c.1675–c.1685
oil on canvas 128.3 x 102.5
B.M.352

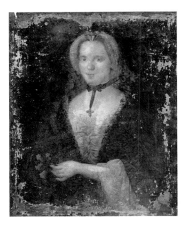

unknown artist
Portrait of a Lady c.1675–c.1700
oil on canvas 85.8 x 65
O.302

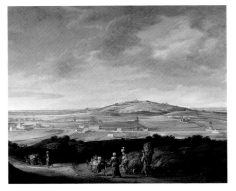

unknown artist
Landscape with a Town on a Hill c.1675–
c.1725
oil on canvas 106.7 x 126.4
B.M.185

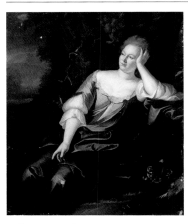

unknown artist
*Portrait of a Lady Resting Her Head on Her
Hand* c.1680–c.1750
oil on canvas 157.4 x 127
B.M.276

unknown artist early 17th C
A Basket of Flowers with a Dog Chasing a Bird
oil on canvas 19.7 x 37.5
B.M.770

unknown artist early 17th C
A Basket of Flowers with Birds
oil on canvas 18.7 x 36.9
B.M.769

unknown artist 17th C
Crucifix
oil on panel 35.5 x 17.5
B.M.990

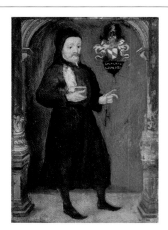

unknown artist 17th C
Geoffrey Chaucer (c.1343–1400)
oil on board 37 x 26
O.320

unknown artist 17th C
Interior Scene
oil on panel 9.5 x 22.9
O.45

unknown artist 17th C
Landscape with a Building
oil on panel 21.2 x 28.5
2007.49

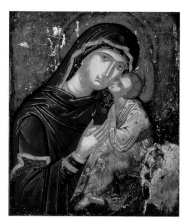

unknown artist 17th C
Madonna and Child
oil on panel 48.1 x 36.9
B.M.588

unknown artist 17th C
Night Scene
oil on slate 19 x 24
O.172

unknown artist 17th C
Night Scene
oil on slate 19 x 24
O.173

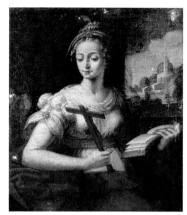

unknown artist 17th C
Portrait of a Lady
oil on canvas 101.5 x 82.5
O.73

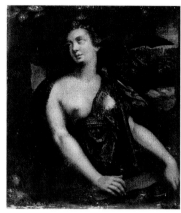

unknown artist 17th C
Portrait of a Lady
oil on canvas 101.5 x 82.5
O.75

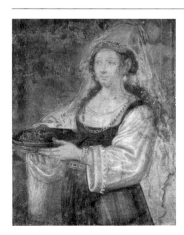

unknown artist 17th C
Portrait of a Lady
oil on canvas 87.6 x 68
O.82

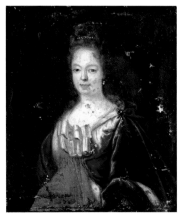

unknown artist 17th C
Portrait of a Lady
oil on canvas 72.4 x 59.6
O.132

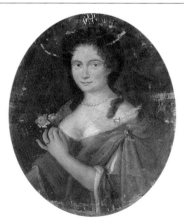

unknown artist 17th C
Portrait of a Lady
oil on canvas 73.7 x 59.7
O.135

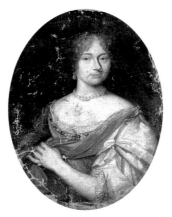

unknown artist 17th C
Portrait of a Lady
oil on canvas 76.3 x 58.3
O.191

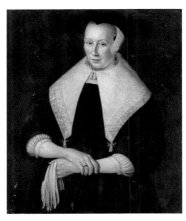

unknown artist 17th C
Portrait of a Lady
oil on canvas 89 x 77.5
O.223

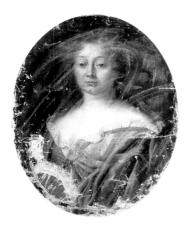

unknown artist 17th C
Portrait of a Lady (recto)
oil on canvas 73.7 x 59.7
O.230

unknown artist 17th C
Landcape (verso)
oil on canvas 59.7 x 73.7
O.230

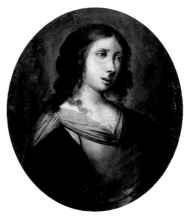

unknown artist 17th C
Portrait of a Lady
oil on canvas 63.5 x 53.3
O.232

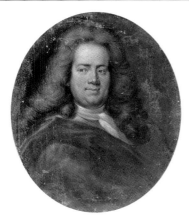

unknown artist 17th C
Portrait of a Man
oil on canvas 67.3 x 56.5
O.131

unknown artist 17th C
Religious Scene
oil on board 28 x 33
O.185

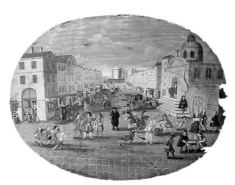

unknown artist 17th C
Street Carnival Scene
oil on panel 31.9 x 40.4
B.M.1038

unknown artist 17th C-19th C
Fragment of Ruff and Neck
oil on canvas 22.5 x 22
2007.16

unknown artist late 17th C–early 18th C
Portrait of a Lady
oil on panel 33 x 29.2
O.44

unknown artist
Portrait of a Lady c.1700–c.1740
oil on canvas 59 x 49.5
O.161

unknown artist
Portrait of a Lady c.1700–c.1750
oil on canvas 43.2 x 33
O.289

unknown artist
Venus and Cupid (Mother and Child)
c.1700–c.1750
oil on canvas 61 x 51
O.204

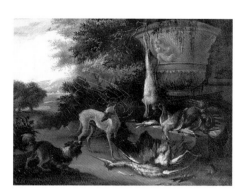

unknown artist
Dead Game c.1700–c.1775
oil on canvas 31.9 x 40
B.M.381

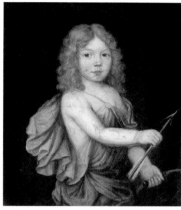

unknown artist
A Child Dressed as Cupid c.1700–c.1780
oil on canvas 64.4 x 52.9
B.M.895

unknown artist
Landscape c.1720–c.1780
oil on panel 46.7 x 33.8
O.184

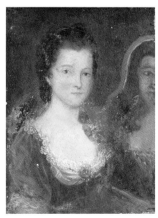

unknown artist
Portrait of a Lady c.1725–c.1750
oil on canvas 32.5 x 23
O.300

unknown artist
Portrait of a Man c.1730–c.1770
oil on canvas 40.5 x 34.5
O.296

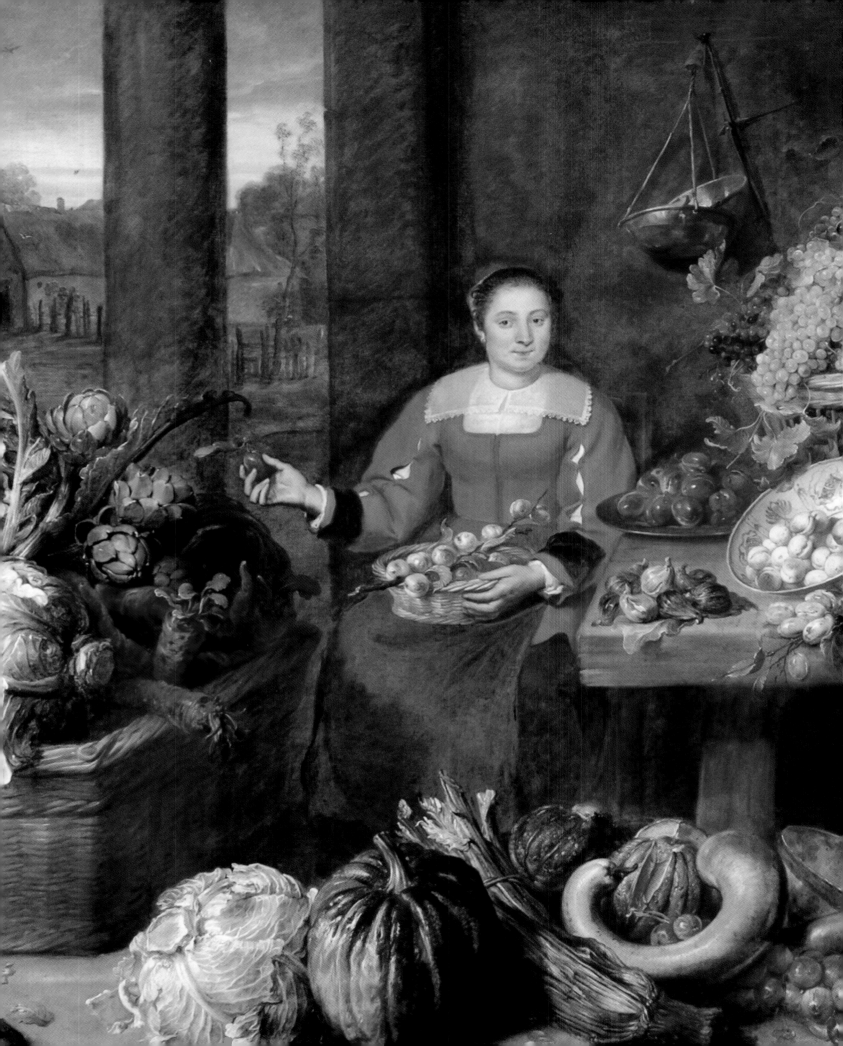

unknown artist
Portrait of a Lady c.1730–c.1780
oil on canvas 43 x 37
O.297

unknown artist
Portrait of a Man c.1740–c.1760
oil on canvas 72.5 x 61
O.314

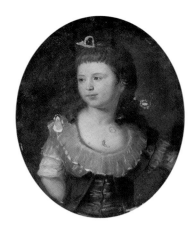

unknown artist
Portrait of a Girl c.1740–c.1780
oil on canvas 61 x 49.5
O.160

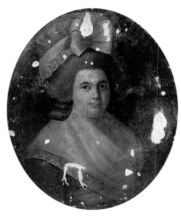

unknown artist
Portrait of a Lady c.1750–c.1780
oil on canvas 64.8 x 53.3
O.193

unknown artist
Fountain near a River c.1750–c.1800
oil on canvas 196 x 67.5
B.M.582

unknown artist
Fountain near a River c.1750–c.1800
oil on canvas 198.5 x 82.5
B.M.583

unknown artist
Portrait of a Lady c.1750–c.1800
oil on panel 65 x 50
O.175

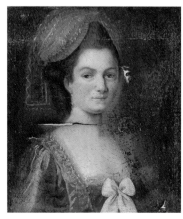

unknown artist
Portrait of a Lady c.1750–c.1800
oil on canvas 60 x 49.5
O.251

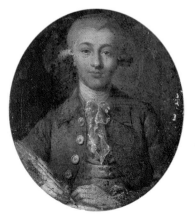

unknown artist
Portrait of a Man c.1750–c.1800
oil on canvas 58.5 x 49.5
O.255

Facing page: Snyders, Frans (attributed to), 1579–1657, *A Fruit Stall* (detail), c.1620–1630, The Bowes Museum, (p. 156)

unknown artist
Portrait of a Lady 1760s
oil on canvas 73 x 60.5
O.167

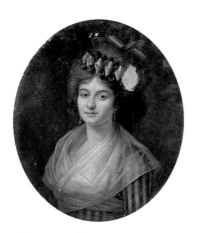

unknown artist
Portrait of a Lady c.1770–c.1790
oil on canvas 64.8 x 49
O.194

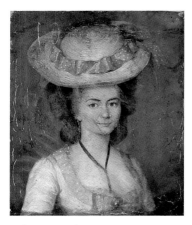

unknown artist
Portrait of a Lady c.1770–c.1790
oil on canvas 61 x 50.3
O.265

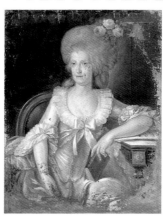

unknown artist
Portrait of a Lady 1770s
oil on canvas 100.4 x 74
O.98

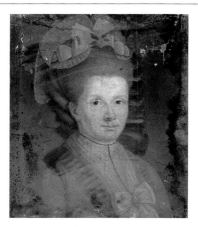

unknown artist
Portrait of a Lady c.1775–c.1790
oil on canvas 56 x 45.7
O.238

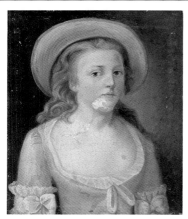

unknown artist
Portrait of a Girl c.1780–c.1800
oil on canvas 49 x 40
O.284

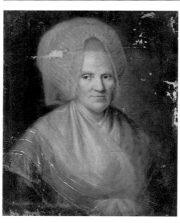

unknown artist
Portrait of a Lady 1780s
oil on canvas 59.2 x 50.1
O.140

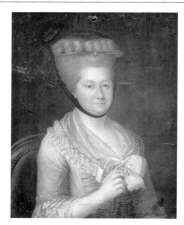

unknown artist
Portrait of a Lady 1780s
oil on canvas 80.5 x 65
O.262

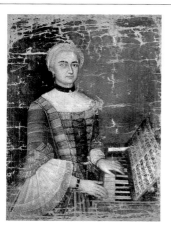

unknown artist early 18th C
Portrait of a Lady
oil on canvas 99 x 73
O.97

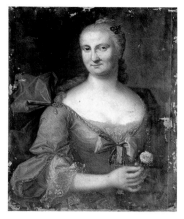

unknown artist early 18th C
Portrait of a Lady
oil on canvas 80.6 x 64.8
O.114

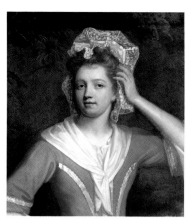

unknown artist early 18th C
Portrait of a Lady in Red with a Lace Cap
oil on canvas 75.6 x 63.1
B.M.134

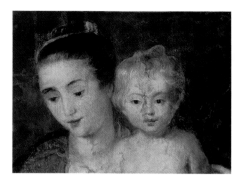

unknown artist early 18th C
Woman and Child
oil on canvas 37.2 x 48.1
B.M.1013

unknown artist 18th C
A Man on Horseback
oil on zinc 40.6 x 30.5
O.180

unknown artist 18th C
A Seaport with Ruins and an English Ship
oil on canvas 90.6 x 179.4
B.M.96

unknown artist 18th C
A Storm
oil on canvas 207.5 x 160
B.M.873

unknown artist 18th C
A Wooded Coastal Scene
oil on panel 23.1 x 28.1
B.M.806

unknown artist 18th C
*A Youth in Blue and White Dress with a Hawk
and a Hunting Spear*
oil on canvas 138.7 x 107.5
B.M.878

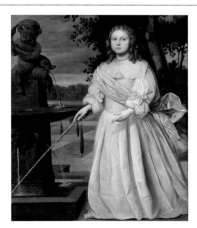

unknown artist 18th C
*A Young Girl in a Blue and White Dress with a
Yellow Scarf*
oil on canvas 138.7 x 107.5
B.M.880

unknown artist 18th C
Church Interior
oil on canvas 174.5 x 223
O.341

unknown artist 18th C
Cupid Blindfolded Carrying a Sword and Scales
oil on canvas 51.2 x 48.1
B.M.563

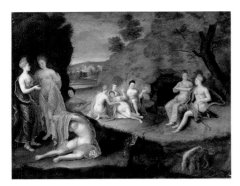

unknown artist 18th C
Diana and Her Companions in a Landscape
oil on canvas 70 x 87.6
2007.42

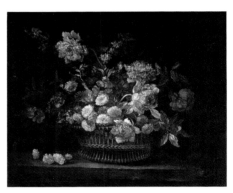

unknown artist 18th C
Flower Piece
oil on canvas 43.7 x 52.5
B.M.594

unknown artist 18th C
Interior Scene
oil on canvas 40 x 32.5
O.215

unknown artist 18th C
Jacob Christian Schäffer (1718–1790)
oil on canvas 87 x 68
O.227

unknown artist 18th C
Landscape
oil on canvas 350 x 92
B.M.534.1

unknown artist 18th C
Landscape
oil on canvas 350 x 213
B.M.534.2

unknown artist 18th C
Landscape
oil on canvas 350 x 213
B.M.534.3

unknown artist 18th C
Landscape
oil on canvas 350 x 213
B.M.534.4

unknown artist 18th C
Landscape
oil on canvas 350 x 92
B.M.534.5

unknown artist 18th C
Landscape
oil on canvas 350 x 213
B.M.534.6

unknown artist 18th C
Landscape
oil on canvas 350 x 213
B.M.534.7

unknown artist 18th C
Landscape
oil on canvas 350 x 92
B.M.534.8

unknown artist 18th C
Landscape
oil on canvas 40.5 x 54
O.208

unknown artist 18th C
Landscape
oil on canvas 40 x 54
O.209

unknown artist 18th C
Landscape (one of a series representing different times of the day)
oil on canvas 53.3 x 63.5
O.120

unknown artist 18th C
Landscape (one of a series representing different times of the day)
oil on canvas 53.3 x 63.5
O.121

unknown artist 18th C
Landscape (one of a series representing
different times of the day)
oil on canvas 53.3 x 63.5
O.122

unknown artist 18th C
Landscape (one of a series representing
different times of the day)
oil on canvas 53.3 x 63.5
O.123

unknown artist 18th C
*Landscape with Palm Trees and Chinese
Figures*
oil on canvas 104.2 x 84.7
B.M.916

unknown artist 18th C
Margaret Melbourne
oil on canvas 74 x 61.5
O.344

unknown artist 18th C
Mater Dolorosa
oil on canvas 65.7 x 56.2
B.M.12

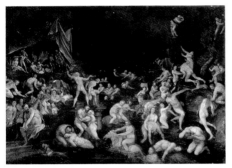

unknown artist 18th C
Mythological Scene
oil on canvas 73.3 x 98
2007.41

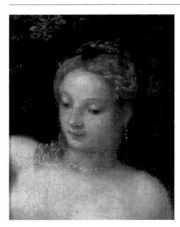

unknown artist 18th C
Nude Female Bust
oil on canvas 22.5 x 16.2
B.M.441

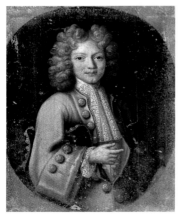

unknown artist 18th C
Portrait of a Boy
oil on canvas 73.7 x 58.4
O.313

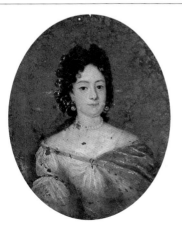

unknown artist 18th C
Portrait of a Lady
oil on copper 21.6 x 17
2007.47

unknown artist 18th C
Portrait of a Lady
oil on canvas 55.8 x 45.7
O.94

unknown artist 18th C
Portrait of a Lady
oil on canvas 99 x 82
O.99

unknown artist 18th C
Portrait of a Lady
oil on canvas 70 x 57
O.152

unknown artist 18th C
Portrait of a Lady
oil on canvas 69.2 x 60.2
O.168

unknown artist 18th C
Portrait of a Lady
oil on canvas 63 x 47
O.231

unknown artist 18th C
Portrait of a Lady
oil on canvas 80 x 64.7
O.310

unknown artist 18th C
Portrait of a Man
oil on canvas 94 x 76.2
O.96

unknown artist 18th C
Portrait of a Man
oil on canvas 54 x 43
O.253

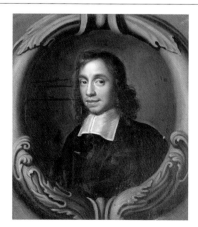

unknown artist 18th C
Portrait of a Man
oil on canvas 75 x 62
O.317.A

unknown artist 18th C
Ship Sinking
oil on panel 14 x 14
2007.44

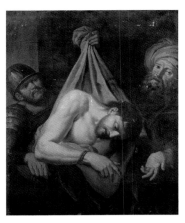

unknown artist 18th C
The Dead Christ
oil on canvas 88.3 x 73.6
O.333

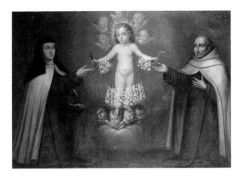

unknown artist 18th C
*The Infant Christ Giving Emblems of the
Passion to Carmelite Saints*
oil on canvas 118.7 x 160.3
B.M.829

unknown artist 18th C-19th C
*Fragment of a Study of a Female Hand
Holding a Brush*
oil on canvas 22 x 11.5
2007.8

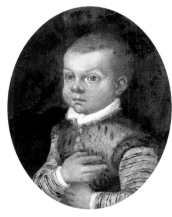

unknown artist 18th C-19th C
Portrait of a Boy
oil on canvas 39.4 x 31.7
B.M.24

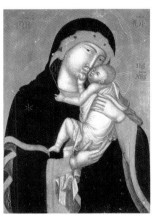

unknown artist 18th C-19th C
The Virgin and Child
oil on panel 33.7 x 25
B.M.611

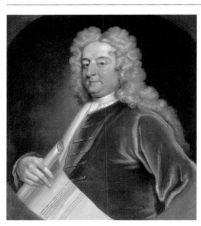

unknown artist late 18th C
Portrait of a Gentleman
oil on canvas 71 x 58
O.343

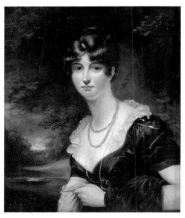

unknown artist late 18th C-early 19th C
Portrait of a Lady
oil on canvas 75 x 60
B.M.879

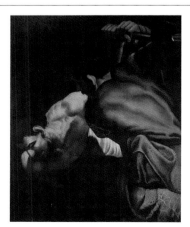

unknown artist late 18th-early 19th C
The Martyrdom of St John the Baptist
oil on canvas 110 x 88.7
B.M.46

Facing page: Ribera, Jusepe de (after), 1591–1652, *A Levitation of St Francis* (detail), early 17th C,
The Bowes Museum, (p. 148)

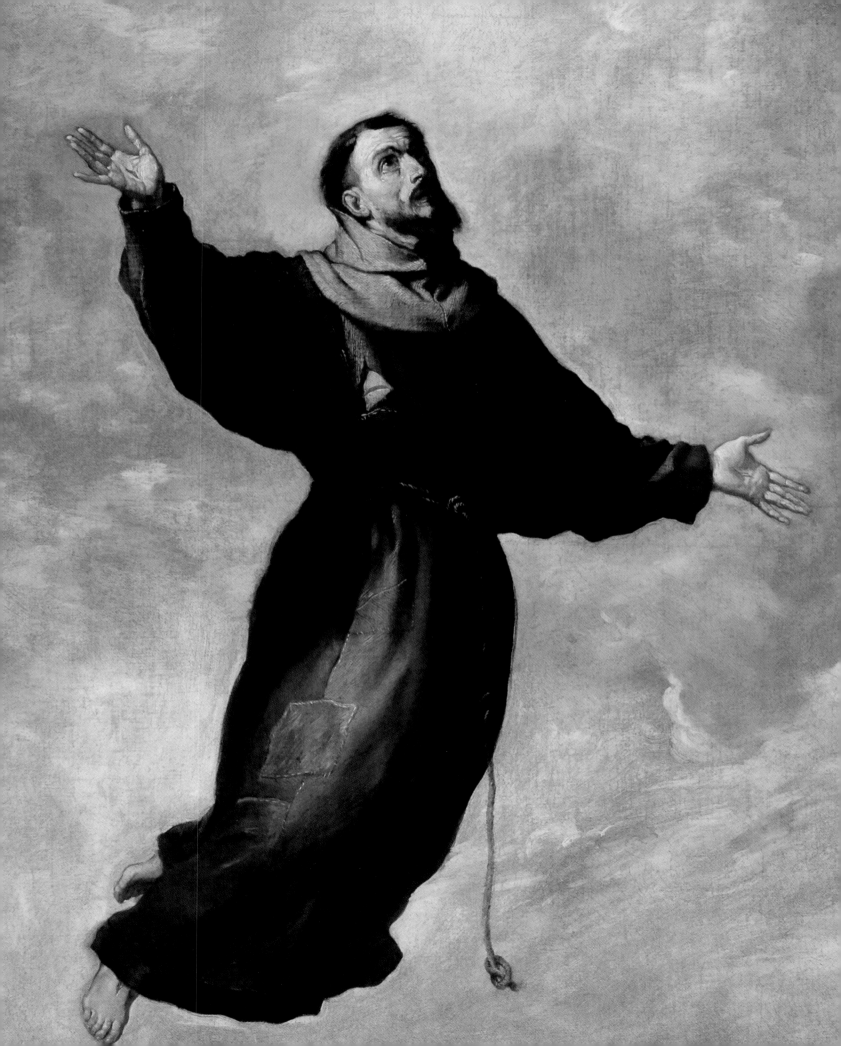

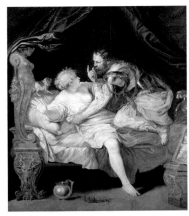

unknown artist
Tarquin and Lucretia c.1800–c.1850
oil on canvas 134.6 x 109.8
B.M.828

unknown artist
Portrait of a Lady 1820s
oil on canvas 73.7 x 61
O.91

unknown artist
*Startforth Old Church before Restoration,
Barnard Castle, County Durham* 1863
oil on canvas 29 x 44.5
1962.229/ANT.

unknown artist early 19th C
Landscape with Figures and Horses
oil on canvas 30.5 x 25.5
O.334

unknown artist early 19th C
Portrait of a Lady
oil on panel 17 x 14
2007.45

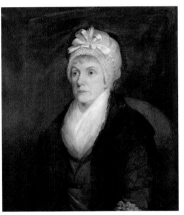

unknown artist early 19th C
*Portrait of an Elderly Lady in Black with a
White Cap*
oil on canvas 75 x 62.5
B.M.896

unknown artist early 19th C
Sketch of a Woman and Children
oil on canvas 29.5 x 26.7
2007.19

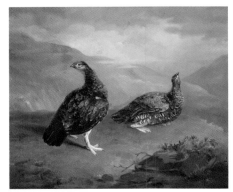

unknown artist 19th C
A Pair of Female Grouse
oil on canvas 63.8 x 75.6
1985.12.12

unknown artist 19th C
A White Dog
oil on board 9.2 x 12.5
2007.6

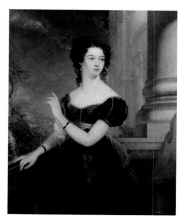

unknown artist 19th C
*Catherine Stephens (1794–1882), Later
Countess of Essex*
oil on canvas 125.6 x 101.9
B.M.126

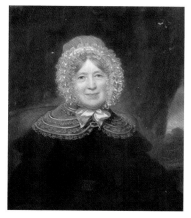

unknown artist 19th C
Elizabeth Hodgson (d.1859), Breckamore
oil on canvas 74.5 x 62.5
1998.288/ANT.

unknown artist 19th C
Horses Standing in a Mews
oil on canvas 21 x 45.7
2007.25

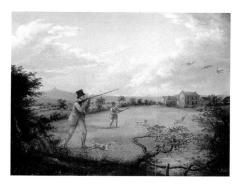

unknown artist 19th C
Hunting Scene
oil on canvas 27.5 x 47.5
1985.12.56.A

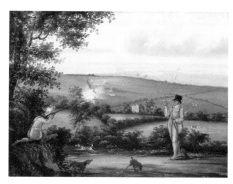

unknown artist 19th C
Hunting Scene
oil on canvas 27.5 x 47.5
1985.12.56.B

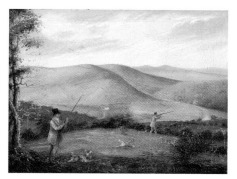

unknown artist 19th C
Hunting Scene
oil on canvas 27.5 x 47.5
1985.12.56.C

unknown artist 19th C
*John Lambton (1792–1840), 1st Earl of
Durham, MP for County Durham*
oil on canvas 33 x 25.4
O.42

unknown artist 19th C
John Walker
oil on canvas 37 x 30.5
1974.58

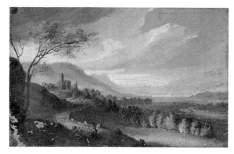

unknown artist 19th C
Landscape
oil on canvas 21.6 x 33
O.51

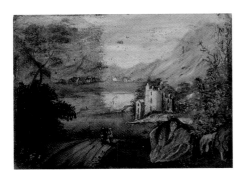

unknown artist 19th C
Landscape with a Castle, Lake and Two Figures on a Path
oil on board 10.5 x 14
2007.7

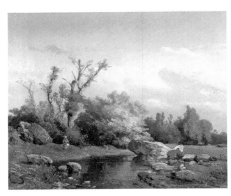

unknown artist 19th C
Landscape with a Figure and a Stream
oil on canvas 38.2 x 46.2
2007.4

unknown artist 19th C
Lord Herbert Vane Stewart
oil on canvas 28.6 x 22.7
1998.195/ANT.

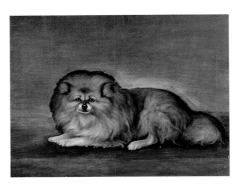

unknown artist 19th C
Portrait of a Dog
oil on canvas 71.1 x 91.5
O.31

unknown artist 19th C
Portrait of a Dog
oil on canvas 91.5 x 73
O.119

unknown artist 19th C
Portrait of a Lady
oil on canvas 59 x 49.5
O.93

unknown artist 19th C
Portrait of a Lady
oil on canvas 53.4 x 43
O.95

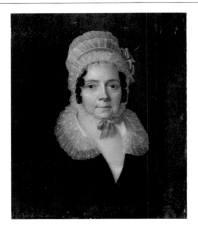

unknown artist 19th C
Portrait of a Lady
oil on canvas 60.5 x 49.5
O.235

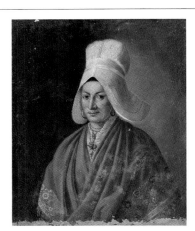

unknown artist 19th C
Portrait of a Lady
oil on canvas 77.5 x 63.5
O.308

unknown artist 19th C
Portrait of a Lady with a Fan
oil on metal 17.2 x 8.9
2007.46

unknown artist 19th C
Portrait of a Man
oil on canvas 90.7 x 71
2007.43

unknown artist 19th C
Portrait of a Man in Classical Robes
oil on canvas 55 x 43
2007.26

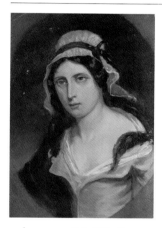

unknown artist 19th C
*Portrait of a Woman in a Blue Dress and a
White Cap*
oil on canvas 34 x 24
2007.2

unknown artist 19th C
Profile of a Roman Soldier
oil on canvas 36.3 x 32
2007.21

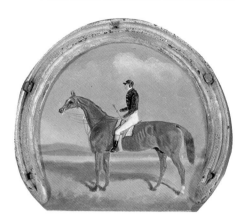

unknown artist 19th C
Racing Plate of 'Daniel O'Rourke'
oil on metal 12.8 x 11.2
1988.2.2

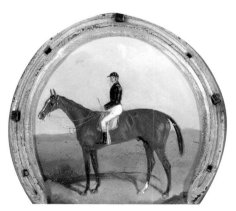

unknown artist 19th C
Racing Plate of 'West Australian'
oil on metal 13.7 x 12.8
1988.2.1

unknown artist 19th C
Seascape
oil on board 14.5 x 20
O.335

unknown artist 19th C
Still Life
oil on slate 17.7 x 24.7
O.48

unknown artist 19th C
Still Life with a Dog
oil on board 24.5 x 19
O.323

unknown artist 19th C
Still Life with a Dog and a Cat
oil on board 35.5 x 27
O.326

unknown artist 19th C
Still Life with a Green-Headed Duck
oil on board 32 x 27.5
O.325

unknown artist 19th C
Still Life with a Hen
oil on board 30 x 24
O.324

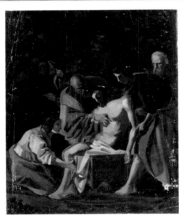

unknown artist 19th C
The Deposition from the Cross
oil on canvas fixed on card 39.5 x 32
O.321

unknown artist 19th C
The Lakeland Shepherd
oil on canvas 102.5 x 150
O.78

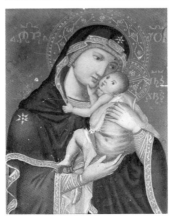

unknown artist 19th C
The Madonna and Child
oil on panel 18.5 x 14.5
O.315

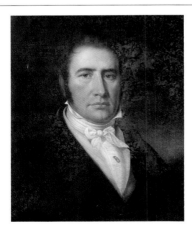

unknown artist 19th C
Thomas Dixon
oil on canvas 59.5 x 49.4
1961.52.A/ANT

unknown artist 19th C
View through a Doorway
oil on canvas 20.3 x 12.6
2007.9

unknown artist 19th C
William Blackett of Wolsingham
oil on canvas 129.4 x 101.9
B.M.958

unknown artist 19th C-20th C
Barnard Castle Bridge, County Durham
oil on canvas 39 x 28.8
1958.1308/ANT.

unknown artist 20th C
Balder Mill, Teesdale, County Durham
oil on board 25.5 x 35.8
2007.38/ANT.

unknown artist 20th C
Moorland Scene with Stream
oil on canvas 38 x 53.1
1985.12.44

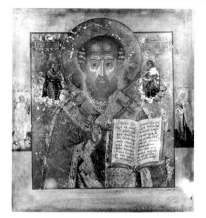

unknown artist
Icon
oil on panel 35.6 x 30.7
O.23

unknown artist
Melon
oil on card 31.5 x 44.5
O.322

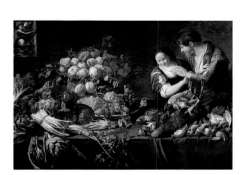

Utrecht, Adriaen van 1599–1652
Still Life with Lovers 1631
oil on canvas 130 x 182.5
B.M.92

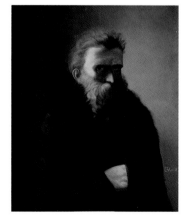

E. V.
Study of an Old Man 1838
oil on canvas 78.7 x 62.5
B.M.530

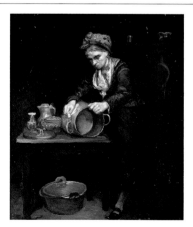

E. V.
A Woman Polishing Kitchen Utensils
oil on canvas 44.4 x 36.2
B.M.403

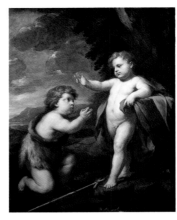

Vaccaro, Andrea 1604–1670
*The Infant Christ with the Infant St John the
Baptist*
oil on canvas 128.6 x 102.2
B.M.57

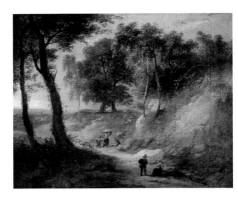

Vadder, Lodewijk de 1605–1655
Wooded Landscape with Figures in a Ravine
oil on canvas 45.6 x 55
B.M.203

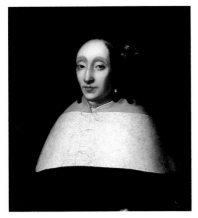

Vaillant, Wallerand (after) 1623–1677
Marie Marion del Court (1634–1702) 1662
oil on canvas 66.4 x 57.3
B.M.1015

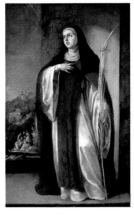

Valdés Leal, Juan de 1622–1690
St Eustochium c.1657–1658
oil on canvas 206 x 122
B.M.10

Valenciennes, Pierre Henri de 1750–1819
Mercury and Argus 1793
oil on panel 24.5 x 32.4
B.M.437

Valenciennes, Pierre Henri de 1750–1819
Landscape, Moonlight 1817
oil on canvas 33.1 x 41.2
B.M.417

Valenciennes, Pierre Henri de 1750–1819
Landscape, Storm 1817
oil on canvas 33.7 x 41.9
B.M.448

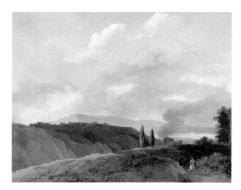

Valenciennes, Pierre Henri de 1750–1819
Landscape with a Man Frightened by a Snake
1817
oil on canvas 33.7 x 42
B.M.415

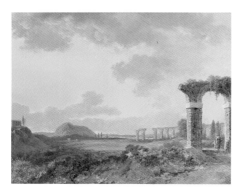

Valenciennes, Pierre Henri de 1750–1819
Landscape with Ruins, Sunset 1817
oil on canvas 33.3 x 41.9
B.M.373

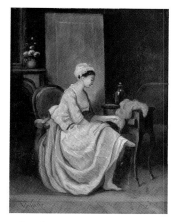

Valentin active mid-19th C
Girl Disrobing
oil on panel 31.2 x 23.7
B.M.701

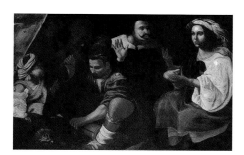

Valentini, Pietro (style of) active 17th C
Gypsies
oil on canvas 125.6 x 189.4
B.M.293

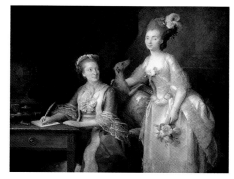

Vallayer-Coster, Anne 1744–1818
*Portrait of an Elderly Woman with Her
Daughter* 1775
oil on canvas 136.9 x 170.6
B.M.329

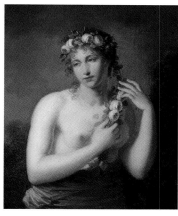

Vallin, Jacques Antoine c.1760–after 1831
Half-Length Figure of a Bacchante c.1815
oil on canvas 70 x 58.7
B.M.250

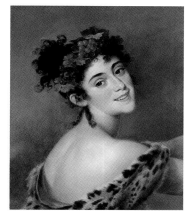

Vallin, Jacques Antoine c.1760–after 1831
*Madamme Bigottini (1785–1858), as a
Bacchante* 1817
oil on canvas 56.2 x 46.3
B.M.340

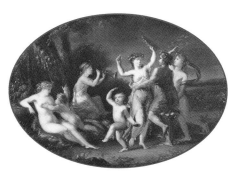

Vallin, Jacques Antoine c.1760–after 1831
Nymphs Dancing with a Faun
oil on panel 15.6 x 21.3
B.M.322

Vaudet, Auguste Alfred 1838–1914
Landscape with a Lake, Evening
oil on canvas 32.5 x 45
B.M.425

Velde, Adriaen van de (style of) 1636–1672
Landscape with Cattle and Sheep
17th C-18th C
oil on panel 27 x 37.3
B.M.238

Velde, Willem van de II (school of)
1633–1707
A Warship and Other Vessels 17th C
oil on canvas 57.4 x 80.6
B.M.138

Venne, Adriaen van de (attributed to)
1589–1662
Death with the Three Orders of Church, State and People 1628
oil on panel 46.8 x 44.8
B.M.885

Venusti, Marcello (attributed to)
c.1512–1579
Time with Four Putti Representing the Seasons
oil on canvas 78.1 x 66.6
B.M.938

Verbeeck, Cornelis c.1590–c.1637
Beach Scene
oil on panel 28.9 x 51.1
B.M.180

Verdussen, Jan Peeter c.1700–1763
A Cavalry Engagement
oil on canvas 30 x 41.2
B.M.234

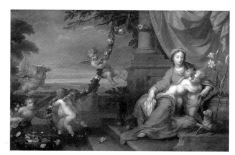

Verelst, Herman c.1642–1702
Virgin, Child and St John 1665
oil on canvas 127.5 x 188.7
B.M.554

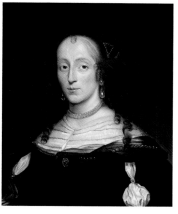

Verelst, Herman (circle of) c.1642–1702
Portrait of a Lady 1660s
oil on panel 58.7 x 47.5
B.M.537

Verelst, Pieter Harmensz. c.1618–c.1678
Boors Carousing
oil on canvas 24.8 x 21
B.M.799

Vermeer van Haarlem, Jan I (style of)
c.1600–1670
Evening 17th C
oil on panel 31.2 x 41.9
B.M.240

Vermeer van Haarlem, Jan III 1656–1705
Landscape with a River
oil on canvas 31.2 x 38.1
B.M.789

Facing page: Peart, Tony, b.1961, *Fear of the Unknown* (detail), Darlington Borough Art Collection, (p. 246)

Vernet, Claude-Joseph 1714–1789
Nymphs Bathing, the Time is the Morning
1771
oil on canvas 65.1 x 98.8
B.M.280

Vernet, Claude-Joseph (style of) 1714–1789
View of a Fortified Seaport 18th C
oil on canvas 83.8 x 151.9
B.M.253

Veron, Alexandre René 1826–1897
Paris, the Outlying Boulevards 1856
oil on canvas 44.4 x 69.4
B.M.356

Verwee, Charles Louis 1818–1882
A Nun 1855
oil on canvas 41.2 x 30
B.M.732

Vestier, Antoine 1740–1824
*The Wife of the Composer Christoph Willibald
Gluck* (copy after Étienne Aubry) 1777
oil on canvas 62.2 x 52.1
B.M.892

Veyrassat, Jules Jacques 1828–1893
Interior with an Old Woman Eating Soup
1853
oil on canvas 35.6 x 27
B.M.321

Vignon, Claude 1593–1670
Croesus and Solon
oil on canvas 83.7 x 98.7
B.M.917

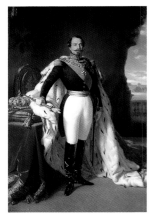

Vignon, Jules de 1815–1885
The Emperor Napoleon III (1808–1873)
(copy after Franz Xaver Winterhalter) 1867
oil on canvas 183.1 x 155
B.M.1052

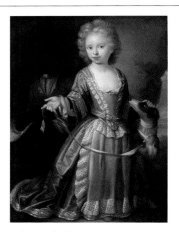

Vilain, Philip active 1694–1717
Girl with a Dog 1708
oil on canvas 108.7 x 82.5
B.M.874

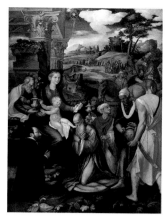

Vincenzo da Pavia c.1495/1500–1557
The Adoration of the Magi with a Donor
c.1546–1550
oil & tempera on panel 258.3 x 209.5
B.M.31

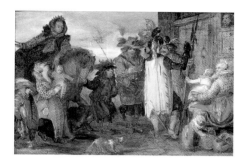

Vinckeboons, David 1576–1632
Joanna of Flanders Freeing Prisoners 1605
oil on panel 19.8 x 30
B.M.241

Viola, Giovanni Battista 1576–1622
Landscape with Figures c.1620–1622
oil on panel 49 x 77.5
B.M.81

Viola, Giovanni Battista 1576–1622
A Seashore with a Castle
oil on panel 49.7 x 78.3
B.M.87

Vita, Vincenzo d.1782
A Musical Party c.1770–1782
oil on canvas 75.6 x 97.8
B.M.940

Vlieger, Simon de 1601–1653
Dutch Men of War at Anchor 1650
oil on panel 102.2 x 125.7
B.M.98

Vogler, F.
Genre Scene 1865
oil on panel 16.5 x 24
O.218

Vogler, F.
Genre Scene 1865
oil on panel 16.5 x 24
O.219

Vogler, F.
Genre Scene 1865
oil on panel 16.5 x 24
O.220

Vogler, F.
Genre Scene 1865
oil on panel 16.5 x 24
O.221

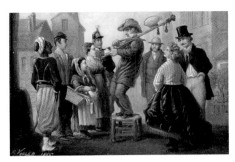

Vogler, F.
Genre Scene 1865
oil on panel 16.5 x 24
O.222

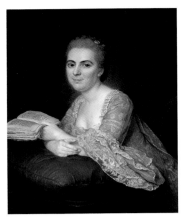

Voille, Jean Louis 1744–c.1796
A Lady with a Book 1764
oil on canvas 78.7 x 65
B.M.949

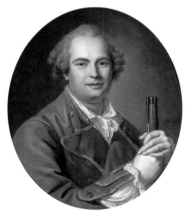

Voiriot, Guillaume 1713–1799
Caillaud (1732/1733–1816), the Singer, in Costume for the Opera 'Les chasseurs et la laitière' 1765
oil on canvas 64.8 x 55.5
B.M.561

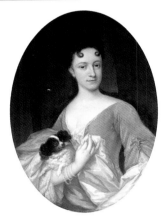

Vollevens, Johannes II 1685–1758
A Lady with a Dog 1718
oil on canvas 84.5 x 61.5
B.M.283

Vollon, Antoine 1833–1900
Old Houses
oil on canvas 21.6 x 16.2
B.M.394

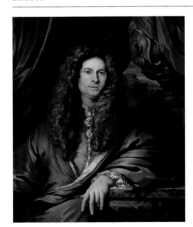

Voorhout, Johannes 1647–1723
Portrait of a Gentleman 1686
oil on canvas 83.1 x 67.5
B.M.97

Vos, Maarten de (attributed to) 1532–1603
The Death of St Anthony Abbot
oil on canvas 167.5 x 125
B.M.814

Vos, Maarten de (style of) 1532–1603
Peasants with a Man Dancing 19th C
oil on panel 22.5 x 33.1
B.M.232

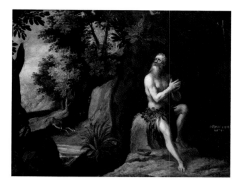

Vos, Maarten de (after) 1532–1603 & **Sadeler family** active 16th C-17th C
St Paul the Hermit in the Desert
late 16th C-mid-17th C
oil on canvas 30.6 x 41.2
B.M.815

Vries, Roelof van (attributed to)
c.1631–after 1681
Landscape with Ruins and a River
oil on canvas 51.2 x 75
B.M.154

G. W.
Still Life
oil on canvas 66 x 57
O.336

Watteau, François Louis Joseph (attributed to) 1758–1823
An Assemblage of Monkeys in a Park Dressed as Humans
oil on canvas 31.4 x 39.3
B.M.801

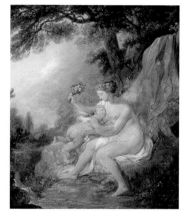

Watteau, Louis Joseph 1731–1798
Venus Chastising Cupid 1760
oil on panel 26.8 x 23.1
B.M.652

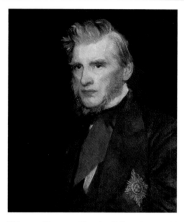

Watts, George Frederick 1817–1904
Harry George (1803–1891), 4th Duke of Cleveland
oil on canvas 64.8 x 52.1
B.M.969

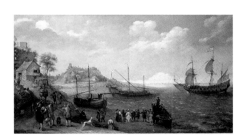

Willaerts, Adam 1577–1664
An Embarkation Scene 1626
oil on canvas 81.2 x 145.6
B.M.95

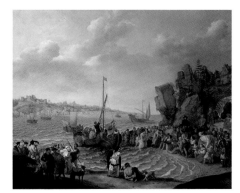

Willaerts, Adam (attributed to) 1577–1664
Christ Preaching from a Ship on the Sea of Galilee
oil on canvas 137.5 x 165
B.M.105

Wilson, Richard 1714–1787
River Scene with a Farmhouse c.1751
oil on canvas 43.1 x 54.4
B.M.1046

Wilson, Thomas Fairbairn (attributed to)
1776–1847
Sheep in a Sale Pen c.1812
oil on canvas 43.2 x 53.3
ANT.237

Winghe, Joos van (copy of) 1544–1603
Solomon Surrounded by His Wives
oil on canvas 135.9 x 182.9
B.M.638

Wouwerman, Philips (imitator of)
1619–1668
A Seashore with Figures and Horses 19th C
oil on panel 32.4 x 44.1
B.M.219

Wyck, Jan (style of) c.1640–1700
Hunting Scene 17th C-18th C
oil on canvas 97.8 x 129.6
O.115

**Ziem, Félix François Georges
Philibert** 1821–1911
A Windmill, Snow Effect c.1850–1860
oil on canvas 25.6 x 40
B.M.349

Zucchi, Antonio (attributed to) 1726–1796
Autumn
oil on canvas 84.5 x 119.5 (E)
1975.23.3

Zucchi, Antonio (attributed to) 1726–1796
Spring
oil on canvas 84.5 x 119.5 (E)
1975.23.1

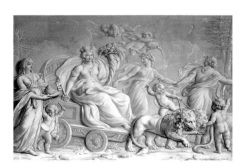

Zucchi, Antonio (attributed to) 1726–1796
Summer
oil on canvas 84.5 x 119.5 (E)
1975.23.2

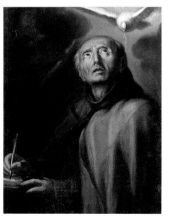

Zurbarán, Francisco de (school of)
1598–1664
St Peter of Alcántara 17th C
oil on canvas 82.6 x 62.2
B.M.918

Beamish, The North of England Open Air Museum

Beamish, The North of England Open Air Museum was established in 1970 and is administered by a Joint Committee representing North Eastern City, County and District Councils. It was established as 'an Open Air Museum for the purpose of studying, collecting, preserving, interpreting and exhibiting buildings, machinery, objects and information illustrating the development of industry and agriculture and the way of life in the North of England'.

Beamish is not a traditional museum. Most of the houses, shops and other buildings have been deconstructed from elsewhere in the region and rebuilt here, though a few already existed on the site, which is of special scientific and historic interest. The buildings are all filled with objects, furniture and machinery – real items from our extensive collections.

Some of the oil painting collections are on display within relevant buildings on site, but due to the lack of a display gallery, a large number are housed within the huge collections access facility, the Regional Resource Centre, where they are available for reference and study.

The Beamish paintings are very much part of the social, industrial and agricultural history collections. Highlights are the late eighteenth- and early nineteenth-century farm animal paintings, primarily portraits of cattle, horses, and sheep, recording the early development of and improvements to locally-important breeds. In addition, there is a good collection of naïve paintings of horses and pigs as well as those illustrating the people and places of the coal-mining industry.

A large part of the Collection is made up of those paintings which ordinary people would have had in their homes, many of which would not find a home in an art gallery collection, but survive in the wide ranging collections at Beamish as a reflection of everyday taste of the people of the North East of England over almost two centuries.

Christine Stevens, Head of Collections

N. B.
Cats in a Basket
oil on board 24 x 44.4
GS/15/02/1985/1

N. B.
Dogs in a Basket
oil on board 24 x 44.4
GS/15/02/1985/2

Bateman, Norman active 1926–1928
A Rest on the Way 1926
oil on canvas 53.8 x 35.3
GS/21/11/1984/1

Bateman, Norman active 1926–1928
Sunset on the Highlands 1928
oil on canvas 44.2 x 59.8
GS/21/11/1984

Bowes, J.
A Cobbler at Work
oil on board 76.4 x 50.8
GS/21/05/2001/2

Bradley, Norman active 1906–1914
The Braes of Balquhidder, Lochearnhead, Scotland 1906 (?)
oil on canvas 54 x 23
1968-215

Bradley, Norman active 1906–1914
At the Close of Day 1908
oil on canvas 54 x 23
1968-215

Cooper, Herbert 1911–1979
Beehive Coke Ovens
oil on board 35.7 x 50.5
1979-341

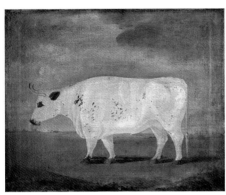

Cuitt, George the elder (style of) 1743–1818
Teesdale Ox c.1780–1790
oil on canvas 64 x 73.5
2001-12

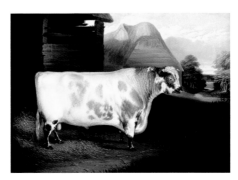

Dalby, John 1810–1865
'Duke of Northumberland' (A Bull) 1839
oil on canvas 63.8 x 85
1988-240

Dousa, Henry 1820–after 1891
The Stallion 'Hewson' 1891
oil on canvas 56.5 x 83
1980-481.6

Duval, John 1816–1892
Prize Pigs
oil on canvas 41 x 50.7
1990-353.1

Facing page: Girodet de Roucy-Trioson, Anne-Louis, 1767–1824, *Napoleon I (1769–1821), in Coronation Robes,* (detail), c.1812, The Bowes Museum, (p. 101)

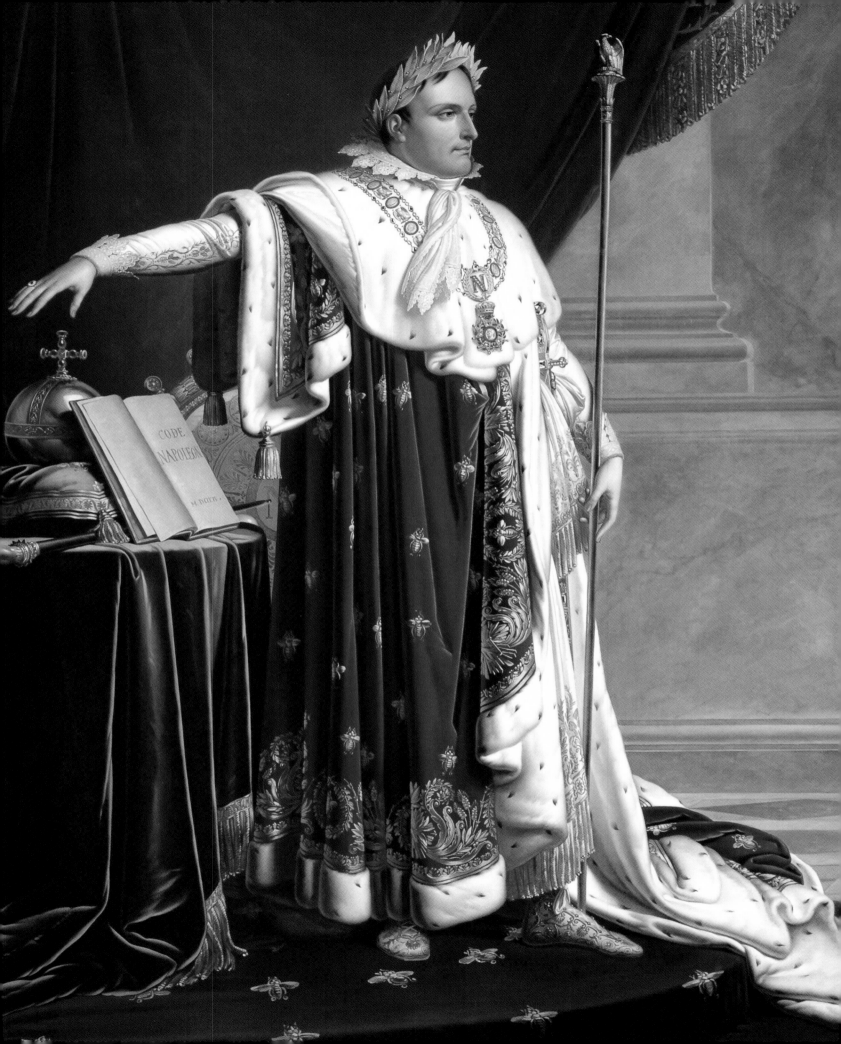

Duval, John 1816–1892
Suffolk Punch
oil on canvas 41 x 51
1990-353.2

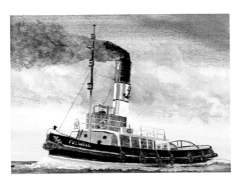

Finn, R.
Tug Boat 'Fulwell'
oil on board 14.2 x 19
2002-30.6

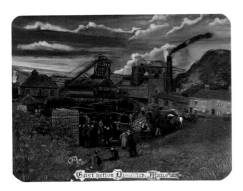

Galloway, S.
East Hetton Disaster, 6 May 1897
oil on board 49.2 x 63
1973-540.2

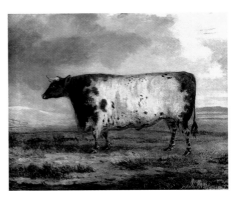

Garrard, George 1760–1826
A Durham Ox 1804
oil on canvas 63.5 x 75.4
1988-339.3

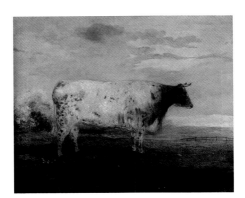

Garrard, George 1760–1826
'Juno'
oil on canvas 61 x 76.7
1988-339.4

Harrogate, Davey active late 19th C
Mrs Elizabeth Murray, née Seymour
oil on canvas 91 x 71.5
1992-173.2

Harrogate, Davey active late 19th C
*Richard Murray (b.1839), JP, Director of the
Neptune Steam Navigation Company*
oil on canvas 91 x 71.5
1992-173.1

Hedley, Ralph (copy after) 1848–1913
Geordie Haa'd the Bairn
oil on canvas 56.1 x 46.2
1994-70.1

Hood, D. active c.1900–1921
Cottage near the 'Rose and Crown' c.1900
oil on canvas 43 x 53.2
2000-23.1

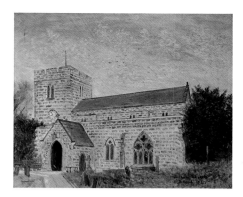

Hood, D. active c.1900–1921
Whickham Church, County Durham 1921
oil on board 53 x 62
2001-78.1

Hood, D. active c.1900–1921
Lang Jack's House, Whickham, County Durham
oil on board 29.3 x 45.3
2001-78.2

Hood, D. active c.1900–1921
Pennyfine Road, Sunniside
oil on canvas 50.7 x 40.6
2000-23.2

Hudson, Willis Richard Edwin 1862–1936
Bridlington Quay, East Yorkshire 1884
oil on canvas 25.4 x 35.9
1968-147.14

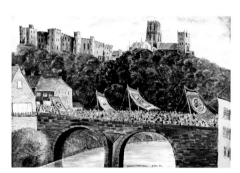

Jolly, J. active 1976–1985
The Big Meeting, Durham Cathedral 1976
oil on board 51 x 71.2
1985-187

Lennox, E.
A British Soldier Attending to His Wounds in South Africa 1906
oil on canvas 42 x 28.5
1978-854.2

Linton, Jane active 1999
Taylor's Farm, Beamish, County Durham
oil on board 39.2 x 50.9
1992-160 (P)

Longbottom, Sheldon 1856–after 1901
Old Gentleman with a Jack Russell Leaving an Off-Licence
oil on canvas 58.5 x 40.5
1964-2032

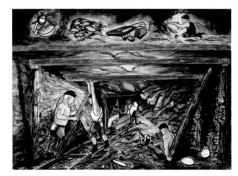

Mackenzie, James b.1927
Back Canch Man, Bedlington 'A' Pit 1950
oil on board 31 x 40.1
1993-27.16

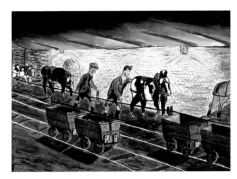

Mackenzie, James b.1927
Back to Stables, Bedlington 'A' Pit
oil on board 31 x 40.8
1993-27.10

Mackenzie, James b.1927
Barrington Colliery
oil on board 30.9 x 40.7
1993-27.6

Mackenzie, James b.1927
Barrington Colliery School
oil on board 31 x 40.1
1993-27.18

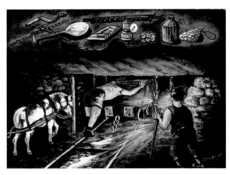

Mackenzie, James b.1927
Bedlington 'A' Pit, Plessey Seam
oil on board 30.8 x 40.8
1993-27.5

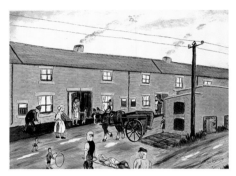

Mackenzie, James b.1927
Bill's Been Hurt
oil on board 31 x 40.8
1993-27.4

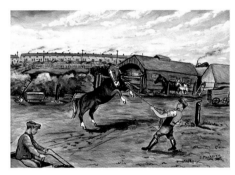

Mackenzie, James b.1927
Breaking in the Riding Cob, Barrington Stables
oil on board 31 x 41
1993-27.9

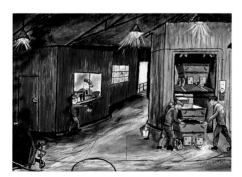

Mackenzie, James b.1927
Calling the Weigh
oil on board 31 x 40.8
1993-27.14

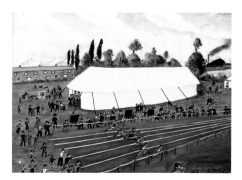

Mackenzie, James b.1927
Choppington Flower Show, £50 Professional Handicap Race
oil on board 31 x 40.9
1993-27.8

Mackenzie, James b.1927
Down the Barrington Burn
oil on board 31 x 40.8
1993-27.15

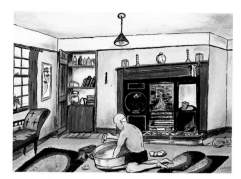

Mackenzie, James b.1927
End of Shift, Bathing at 19 Alexandra Road
oil on board 31 x 40.8
1993-27.13

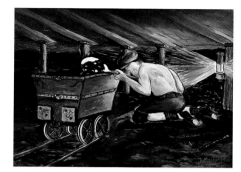

Mackenzie, James b.1927
Filler, Bedlington 'A' Pit, Harvey Seam
oil on board 31 x 40.8
1993-27.12

Mackenzie, James b.1927
Howicking Preparing Leeks on Show Day,
Alexandra Road, Barrington
oil on board 31 x 40.9
1993-27.7

Mackenzie, James b.1927
Jack Arkle at the Pigeons, Alexandra Road,
Barrington
oil on board 31 x 40.8
1993-27.19

Mackenzie, James b.1927
Miner's Still Life
oil on board 31 x 40.8
1993-27.1

Mackenzie, James b.1927
Paddy Gets a Rabbit
oil on board 31 x 40.9
1993-27.2

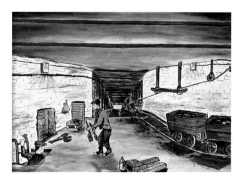

Mackenzie, James b.1927
The Busty Kip Collecting Jockies and Pushing
around to the Shaft
oil on board 31 x 40.9
1993-27.3

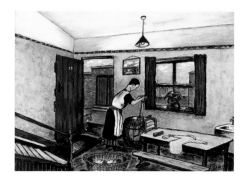

Mackenzie, James b.1927
Washing Day
oil on board 31 x 40.8
1993-27.17

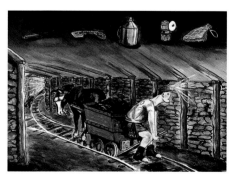

Mackenzie, James b.1927
'You Haven't Lost Your Touch Bill'
oil on board 31 x 40.8
1993-27.11

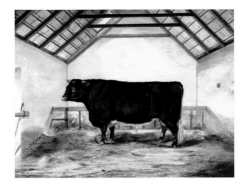

Marsden, M.
Shorthorn
oil on canvas 71.1 x 91.3
1991-185

Matthewson, M.
Lang Jack's House 1909
oil on board 22 x 29.4
1972-169.2

Matthewson, M.
Winlaton Mill, County Durham 1909
oil on board 23 x 30.7
1972-169.3

Mills, S.
Country Scene with River
oil on board 26.7 x 49.7
GS 29/11/1984A

Mills, S.
Country Scene with River
oil on board 26.7 x 49.7
GS 29/11/1984B

Mitchell, R. J.
Victorian London Street Scene
oil on canvas 50.7 x 86.6
GS 26/1/1999/2

Norman-Crosse, George c.1871–1912
Ayresome Ironworks, Middlesbrough, Tees Valley
oil on canvas 35.5 x 57.7
1980-177

Oughton, Francis
Thomas Ramsay ('Craky Tommy')
oil on board 55.5 x 42.7
1999-86

Parker, Henry Perlee (copy after)
1795–1873
Quoit Players
oil on canvas 59.3 x 48.2
2003-86

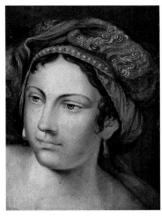

Phillip, John 1817–1867
Portrait of an Unknown Lady c.1840
oil on board 39.7 x 28.4
1971(H)-340

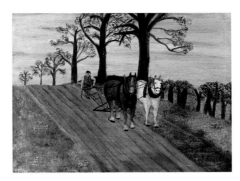

Reid, C.
The Tanfield Ploughman
oil on canvas 31 x 40.8
1979-347.2

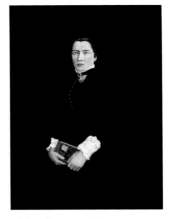

Richardson, A. W.
Lady with a Book 1887
oil on canvas 91.5 x 66
1990-297-1

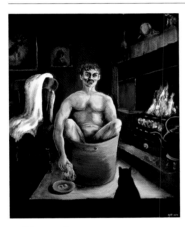

Robinson, R.
Bath Night 1975
oil on canvas 53 x 43
1988-187

Rutherford, W.
Arab 1910
oil on canvas 53.6 x 35.6
GS/17/01/1990/3

Speight, B.
Forest Scene 1949
oil on canvas 49 x 62
2002-180.1

Stephenson, Charles W. b.c.1900
Gateway to Greencroft Hall, near Stanley,
County Durham 1920
oil on canvas 41.6 x 56.5
1999-18

Stuart, C.
Highland Scene with Stag
oil on canvas 67.4 x 96.3
1968(E) 147.42

Thirby, F.
'Highland Laddie' 1918
oil on canvas 51.1 x 61.4
1993-67

Thornfield, Fred active 1892–1893
Still Life 1892
oil on canvas 35.9 x 30.9
1997-99.3

Thornfield, Fred active 1892–1893
Still Life with a Dark Blue Vase 1893
oil on canvas 35.7 x 30.8
1997-99.4

unknown artist 17th C/18th C
Portrait of an Unknown Man
oil on canvas 40.7 x 33.1
GS/14/05/2001/5

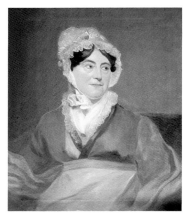

unknown artist
Portrait of an Unknown Lady 1825
oil on canvas 76.4 x 63.6
1995-102

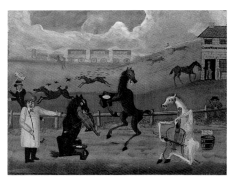

unknown artist
*Early Days of the Steam Train (Effects of the
Railroad on the Brute Creation)* 1838
oil on canvas 28 x 35.4
1994-191

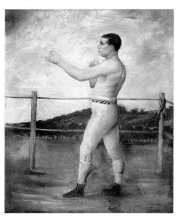

unknown artist
Tom Sayers c.1860
oil on board 54 x 44.5
1993-144

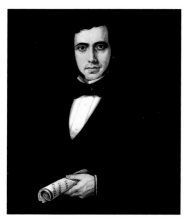

unknown artist
*Portrait of an Unknown Gentleman with a
Scroll in His Hand* c.1870
oil on canvas 74.4 x 63
1979-719

unknown artist
Portrait of an Unknown Man c.1880
oil on canvas 60.5 x 55.1
GS/31/3/95/12

unknown artist
Mountain Scene with a Broken Ring of Rocks
c.1884
oil on canvas 31 x 36.7
1971-385.4

unknown artist
Mountain Scene with a Ring of Rocks and a Tree c.1884
oil on canvas 31 x 36.7
1971-385.3

unknown artist
Portrait of an Unknown Man c.1900
oil on board 34.3 x 28.4
1990-135.2

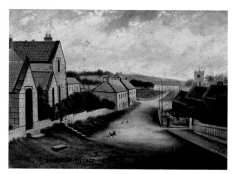

unknown artist
Tanfield Village, County Durham 1907
oil on canvas 30.7 x 40.8
1972-115

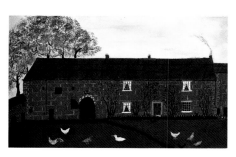

unknown artist
Farmhouse and Farmyard 1918
oil on canvas 29 x 35
1992-193

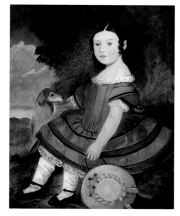

unknown artist
Mary Alice Oliver with Her Dog c.1956
oil on canvas 86.6 x 71.5
1987-228.21

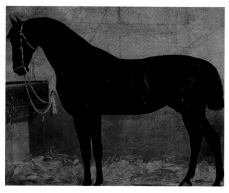

unknown artist
A Horse
oil on canvas 39 x 43
1972-261

unknown artist
An Old Time Miner
oil on canvas 133 x 73
1965-9

unknown artist
Ballet Dancers
oil on canvas 36.7 x 26.8
2002-180.261

unknown artist
Bridge with River Below
oil on canvas 30.4 x 40.7
1978-837.2

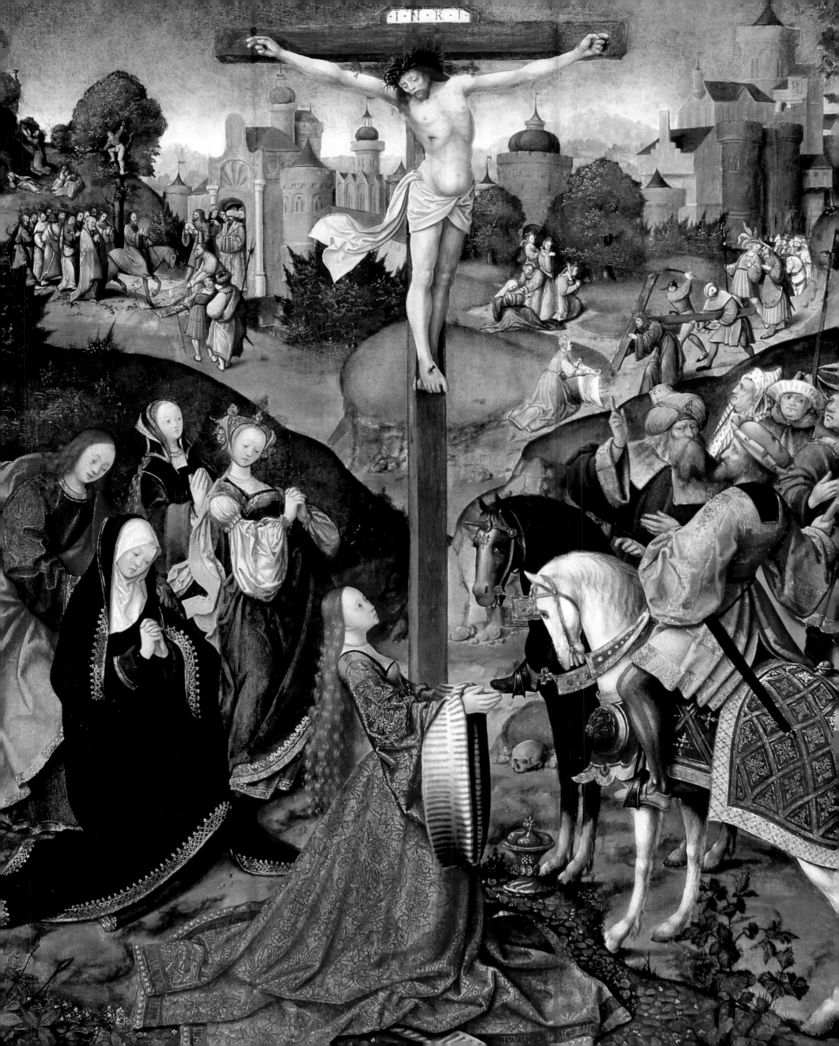

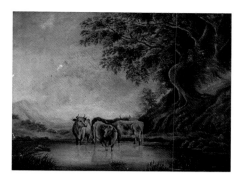

unknown artist
Cattle by a River
oil on canvas 45.9 x 48.8
1971(H)-385

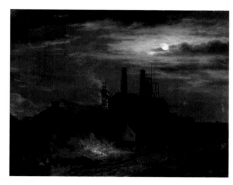

unknown artist
Colliery by Moonlight
oil on canvas 65 x 86.6
1980-576

unknown artist
Cottage Scene
oil on board 16.5 x 22.5
GS 12/02/2003.5

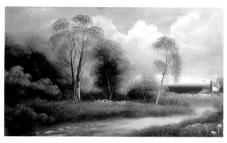

unknown artist
Country Scene with a Woodland Path Leading to the Sea
oil on canvas 32 x 46.5
1971-385.3

unknown artist
Durham Cathedral
oil on board 51.2 x 72.6
1970-21.1

unknown artist
Flour Mill
oil on canvas 51 x 69
2003-85

unknown artist
Horse Working in a Harness
oil on canvas 51.1 x 61.2
1982-178

unknown artist
House and a River
oil on canvas 71 x 92.3
1993-210.3

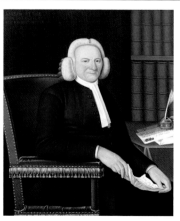

unknown artist
Joseph Pease
oil on canvas 100 x 77.5 (E)
1998-13.23

Facing page: Cornelisz. van Oostsanen, Jacob (studio of), c.1470–1533, *The Crucifixion* (detail), late 15th C-early 16th C, The Bowes Museum, (p. 34)

209

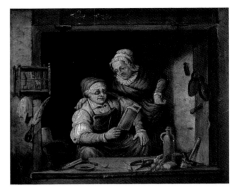

unknown artist
Man and Woman Shoemakers
oil on board 16.4 x 19.5
1999-3.1016

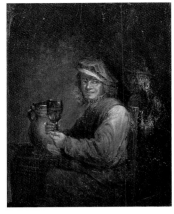

unknown artist
Man Drinking
oil on board 23.2 x 18.4
2007-152.1

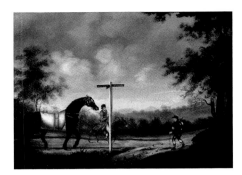

unknown artist
Man on a Donkey Leading a Stallion
oil on canvas 38.4 x 50.3
1997-106

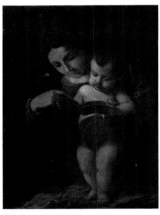

unknown artist
Mother and Child Reading from a Book
oil on canvas 77 x 57.6
2007-116

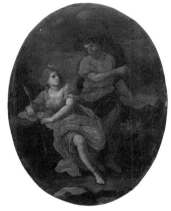

unknown artist
Mythological Figures
oil on canvas 67.6 x 51.2
1970-436A

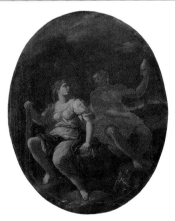

unknown artist
Mythological Figures
oil on canvas 67.6 x 51.2
1970-436B

unknown artist
Old Gentleman Standing with a Greyhound
oil on canvas 59.1 x 43.5
1999-119

unknown artist
Portrait of an Unknown Man
oil on board 45.7 x 27
GS 07/02/2001.11

unknown artist
Portrait of an Unknown Woman in a Bonnet
oil on canvas 35.8 x 30.5
GS/14/05/2001/6

unknown artist
Profile of a Small Boy
oil on board 17.3 x 13
1974-316

unknown artist
Profile of a Small Girl
oil on board 17.3 x 13
1974(L)-316.2

unknown artist
Religious
oil on canvas 72.9 x 48.5
1972-301

unknown artist
Seascape
oil on canvas 55.9 x 76.6
GS 26.5.92.4

unknown artist
Seaside Scene
oil on board 14.1 x 23.2
1971-397.28

unknown artist
Seaton Delaval Colliery
oil on canvas 61 x 91.5
1998-58.1

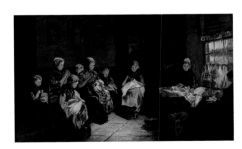

unknown artist
Sewing Group
oil on canvas 40.9 x 66.2
1991-222.1

unknown artist
Soldier with a Young Woman
oil on canvas 25 x 48.3
1993-3.1037

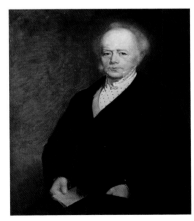

unknown artist
William Woods
oil on canvas 90 x 69
1996-184.2

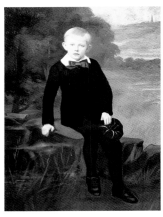

unknown artist
Young Boy with a Bow Tie and a Cap
oil on canvas 64.8 x 49.8
1988-397.20

unknown artist
Young Girl in a Red Dress
oil on canvas 35.3 x 30.5
1999-3.1002

Walker, Miranda (attributed to)
Samphire Gatherer 1857
oil on board 23 x 13
1967-940.3

Weaver, Thomas 1774–1843
'Comet' 1817
oil on canvas 72.3 x 91.2
1988-339.2

Weaver, Thomas 1774–1843
'Wildair' 1827
oil on canvas 63.3 x 76.5
1988-339.1

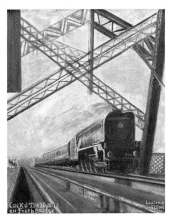

Wilson, Lawrence
Cock o' the North on the Forth Bridge
oil on board 52.8 x 39.9
1979-496.1

Wilson, Thomas Fairbairn 1776–1847
Collings Sheep 1809
oil on canvas 53.5 x 67.9
1984-7 (P)

Wilson, Thomas Fairbairn 1776–1847
Houghton Ox 1811
oil on canvas 63.5 x 81.4
1988-339.5

Wylie
Euphemia Douglas (1840–1925) c.1856–1860
oil on canvas 78 x 64
1961-63a

Young, R. T. active 1908–1909
Boat Offshore 1908
oil on canvas 61.3 x 30.6
1995-20.5

Young, R. T. active 1908–1909
Ships at Anchor 1909
oil on canvas 61.2 x 30.3
1995-20.4

Young, Robert
Philadelphia, County Durham 1899
oil on canvas 31 x 60.1
1986-103

Zampighi, Eugenio 1859–1944
Elderly Couple Reading
oil on canvas 33.1 x 25.9
GS/19/06/91/4

Auckland Castle

Auckland Castle stands high above the River Wear, ten miles or so upstream from Durham itself. It is close to the ancient Roman road of Dere Street and the enormous (and still mostly unexcavated) Roman fort of Binchester. Thus, though the earliest part of the present Castle is less than 1,000 years old, the Norman building almost certainly replaced an earlier Roman structure on the same site.

For most of its life, the present Castle has been the home of the Bishops of Durham – one of his many castles and manors, of course, in the days before easy travel enabled the Bishop to visit remote parishes and return home each night. In the Middle Ages Auckland had an enormous, two-storey chapel and a household including choir and clergy. Successive bishops left their mark on the building. Major renovations were undertaken by Bishop John Cosin (1660–1672), the most notable being the conversion of the ancient dining hall into the present magnificent chapel (the earlier one had been demolished after Cromwell's victory in the Civil War). Bishop Richard Trevor (1752–1771) added the southern extension which today forms the main part of the Bishop's private accommodation.

The Castle became the Bishops' sole residence after the last of the Prince Bishops, William Van Mildert (1826–1836) gave Durham Castle, his city residence, to be the heart of the new University. This coincided with the abolition of the Palatinate authority in which the Bishops of Durham had been 'Prince Bishops' exercising secular as well as spiritual authority. (The long west wing of the Castle is known as the 'Scotland Wing' because in the Middle Ages it included a prison for Scottish prisoners captured by the Bishop's private army.) Van Mildert himself, and then later Bishop J. B. Lightfoot (1879–1889), contributed to further reordering of the Chapel.

Today, Auckland Castle is a working building, including not only the Bishop's home and office, and the Diocesan Office, but several large public rooms which are open to the public from Easter to the end of September, and are able to host conferences, weddings, and other events. This has not lessened the remarkable impact which the building still has on the visitor, who will be struck both by the variety of architecture and by the beauty of the Castle in its surroundings of gardens and parkland.

But Auckland Castle is especially known for its important collection of paintings. Not surprisingly, this includes many fine portraits of former residents. The earliest portrait is that of Richard Fox, Bishop from 1494 to 1501, and the most recent that of Michael Turnbull (1994–2003). There is a large portrait of Henry VIII's famous chancellor Thomas Wolsey, who, though holding the Bishopric from 1523 to 1530, never even visited the county, let alone the Castle. Many of these portraits hang in the large Throne Room (so called because of the Bishop's Throne which faces you as you enter the room). The styles vary, as did the Bishops themselves, with perhaps the most imposing being the last two Prince Bishops, Shute Barrington (1791–1826) and Van Mildert (1826–1836). Among the impressive modern portraits are those of Michael Ramsey (1952–1956), who went on to be Archbishop of York and then Canterbury, and David Jenkins (1984–1994). The portrait of Ian Ramsey (1966–1972) was deliberately left unfinished in poignant commemoration of his sudden death.

It is, however, Bishop Richard Trevor (1752–1771) who made the most striking contribution to the art collection at the Castle – and who, perhaps fittingly, is commemorated in the only marble statue at Auckland, standing at the back of the Chapel. Trevor was a generous benefactor and energetic builder, among whose visible legacies is the remarkable Deer House in the park. He bought the paintings of the Four Evangelists, painted on wood and attributed to Artus Wolfaerts; *The Judgment of Solomon*, by the circle of Giorgione; and a copy of Paolo Veronese's *Wedding Feast at Cana in Galilee*, probably by Vincenzo Danini. All these are in the King Charles Room. But the jewel in the crown of the Collection, and the Castle, is without doubt the series of 13 larger-than-life paintings of *Jacob and His Sons* by Francisco de Zurbarán (1598–1664), which for the last 250 years have hung in the Long Dining Room, which Trevor had redesigned (by James Wyatt) for the purpose.

Bishop Trevor bought this splendid set in 1756 for £124, but already the paintings had had an interesting career. Painted somewhere between 1640 and 1645, they depict Jacob and his 12 sons in peasant costume. At the time, many believed that the ten 'lost tribes of Israel' might be found in the newly discovered Americas, and paintings such as these were sent to South America. This set, however, never made it, being captured by pirates and brought back to Europe. Their whereabouts for the next hundred years or so is uncertain, but they came into the hands of a London merchant, James Mendez, a Portuguese Jew, in the middle of the eighteenth century.

Trevor bought the paintings for a particular reason. In 1753 Parliament had passed the 'Jew Bill', giving the Jewish people more civil rights than before. A massive anti-Jewish backlash in the country had caused the bill to be repealed, but Trevor and other Bishops had spoken up on behalf of the Jewish people, and by hanging the paintings in his great dining room he was making a powerful statement to his guests, among whom would be numbered the great and good of England, that the Jewish people and their traditions should have a valued and honoured place within the national life. This is just one of many ways in which Auckland Castle sends a symbolic and powerful message, rooted in a generous and prayerful Christian faith, which resonates into the wider world as much today as ever.

All the paintings in the set are original, except one. In the biblical story, Benjamin gets left behind while his brothers go to Egypt; and so it was here. The Duke of Ancaster had already bought 'Benjamin', so Trevor commissioned the copyist and critic Arthur Pond to paint him a copy. Pond, realising Trevor wanted to complete the set, charged the Bishop roughly as much for the copy of 'Benjamin' as he might have paid for the original itself.

Auckland Castle has many other fascinating features and stories of former times. It remains a national treasure, and particularly a jewel of the North East of England. Both the Castle and its paintings belong to the Church Commissioners and as such are not publicly owned. However, it was felt that the paintings, which the public can come and see, are of such artistic and historical importance that they should be included in this volume. I am grateful to the Public Catalogue Foundation for this opportunity to bring the paintings, and the whole Castle, to a wider audience and to the Church Commissioners for agreeing to this.

Thomas Dunelm, Lord Bishop of Durham

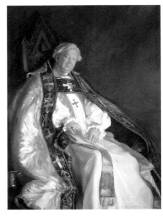

Bruce, George J. D. b.1930
*David Jenkins (b.1925), Bishop of Durham
(1984–1994)* 1994
oil on canvas 186 x 125 (E)
29

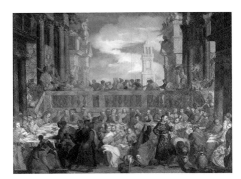

Dandini, Vincenzo (attributed to)
1686–1734
The Wedding Feast at Cana in Galilee (copy
after Paolo Veronese)
oil on canvas 130 x 169 (E)
40

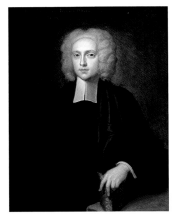

Fayram, William (attributed to)
active c.1730
*Joseph Butler (1692–1752), Bishop of Durham
(1750–1752)*
oil on canvas 100 x 75 (E)
16

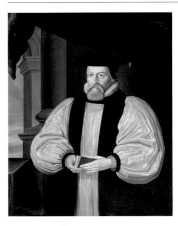

Fox, Buscall c.1819–1887
*Thomas Morton (1564–1659), Bishop of
Durham (1632–1659)* (copy after an earlier
painting) 1850
oil on canvas 109 x 85 (E)
5

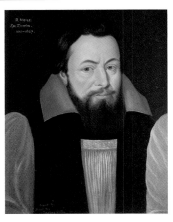

Fox, Buscall c.1819–1887
*Richard Neile (1562–1640), Bishop of Durham
(1617–1628)* (copy after an earlier painting)
oil on canvas 55.5 x 43 (E)
3

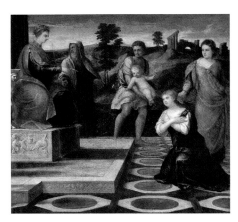

Giorgione (circle of) 1477–1510
The Judgement of Solomon
oil on canvas 154 x 159 (E)
45

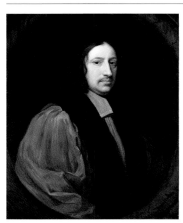

Kneller, Godfrey (attributed to) 1646–1723
*Nathaniel, Lord Crewe (1633–1721), Bishop of
Durham (1674–1721)*
oil on canvas 74 x 61 (E)
18

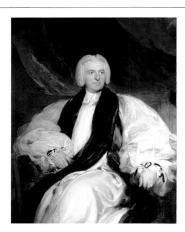

Lawrence, Thomas 1769–1830
*Shute Barrington (1734–1826), Bishop of
Durham (1791–1826)* 1816
oil on canvas 141 x 110.5 (E)
37

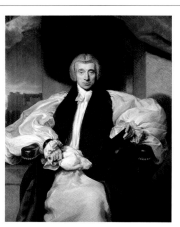

Lawrence, Thomas 1769–1830
*William Van Mildert (1765–1836), Bishop of
Durham (1826–1836)* 1829
oil on canvas 142.5 x 111 (E)
15

Facing page: Haynes-Williams, John, 1836–1908, *The Miniature* (detail), Darlington Borough Art Collection, (p. 238)

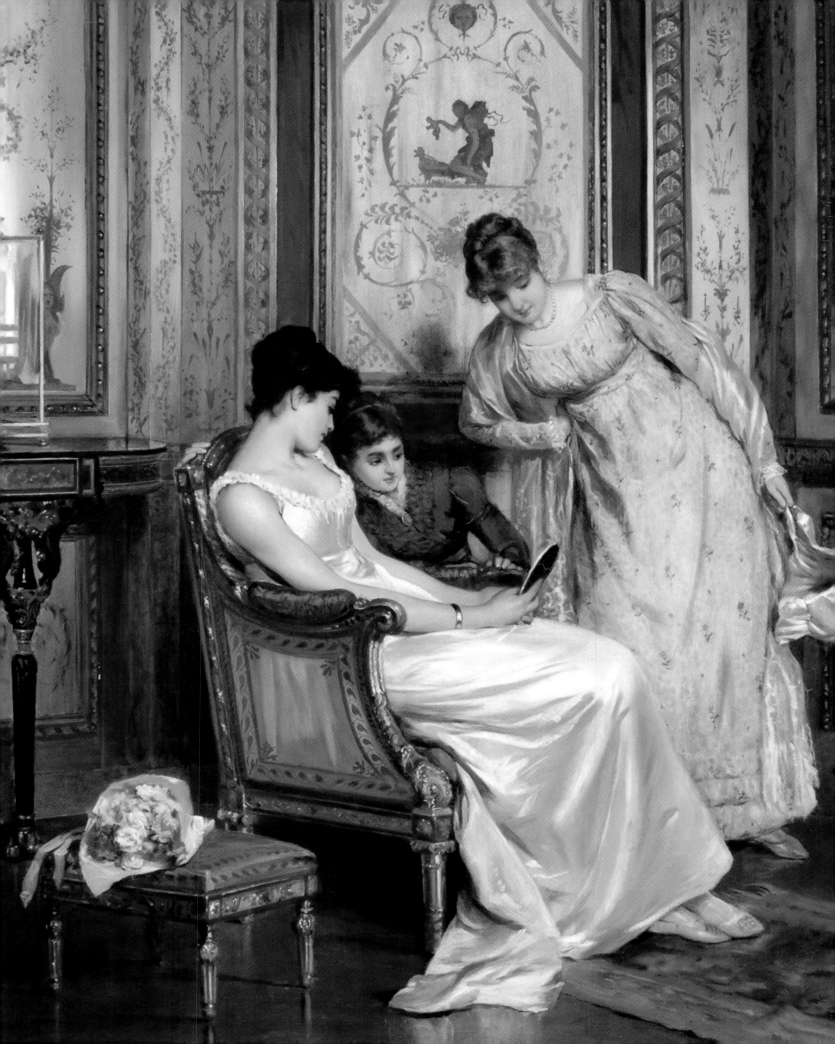

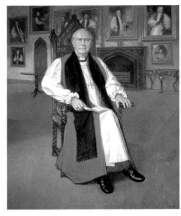

Noakes, Michael b.1933
Michael Turnbull (b.1935), Bishop of Durham
(1994–2003) 1999–2000
oil on canvas 180 x 135 (E)
31

Pond, Arthur 1701–1758
Benjamin XII (copy after Francisco de
Zurbarán)
oil on canvas 197 x 101.5 (E)
X743

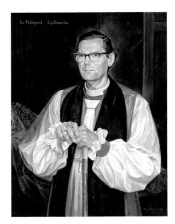

Powell, Hugh
John Habgood (b.1927), Bishop of Durham
(1973–1983) 1979
oil on canvas 102 x 75 (E)
33

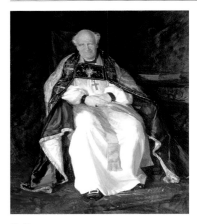

C. R.
Michael Ramsey (1904–1988), Bishop of
Durham (1952–1956)
oil on canvas 185 x 130 (E)
30

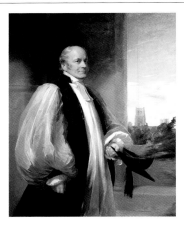

Richmond, George 1809–1896
Charles Longley (1794–1868), Bishop of
Durham (1856–1860)
oil on canvas 140 x 110 (E)
28

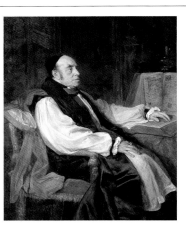

Richmond, William Blake 1842–1921
Joseph Lightfoot (1828–1889), Bishop of
Durham (1879–1889)
oil on canvas 144 x 109 (E)
25

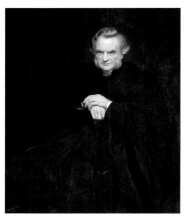

Richmond, William Blake 1842–1921
Brooke Westcott (1825–1901), Bishop of
Durham (1890–1901) 1902
oil on canvas 130 x 100 (E)
35

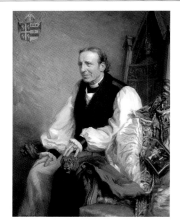

Riviere, Hugh Goldwin 1869–1956
Handley Moule (1841–1920), Bishop of
Durham (1901–1920) 1914
oil on canvas 137 x 101 (E)
39

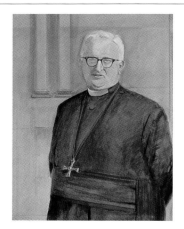

Speake, George active 1966–1976
Ian Ramsey (1915–1972), Bishop of Durham
(1966–1972) 1976
oil on canvas 103.5 x 78 (E)
32

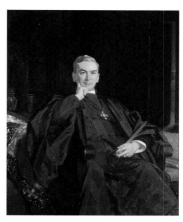

Speed, Harold 1872–1957
Hensley Henson (1863–1947), Bishop of Durham (1920–1939) 1929
oil on canvas 140 x 112 (E)
27

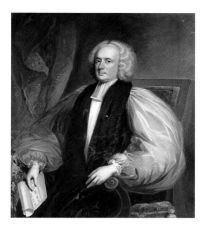

Taylor (of Durham) active 1750–1752
Joseph Butler (1692–1752), Bishop of Durham (1750–1752)
oil on canvas 128 x 100 (E)
26

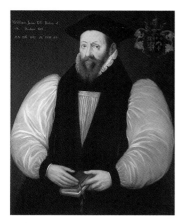

unknown artist
William James (1542–1617), Bishop of Durham (1606–1617) 1617 (?)
oil on canvas 90 x 68.5 (E)
11

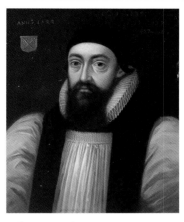

unknown artist
George Monteigne, Bishop of Durham (1627–1628) 1622
oil on canvas 55 x 45 (E)
2

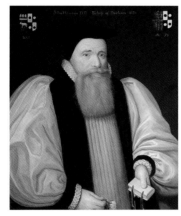

unknown artist
John Howson (d.1632), Bishop of Durham (1628–1632) 1631
oil on canvas 78 x 62 (E)
10

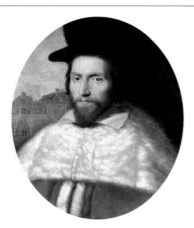

unknown artist
John Cosin (1594–1672), Bishop of Durham (1660–1672) c.1635
oil on canvas 72.5 x 60 (E)
19

unknown artist
Auckland Castle 1680
oil on canvas 164 x 225 (E)
1

unknown artist
Auckland Castle, View from the South East c.1700
oil on canvas 165 x 224 (E)
4

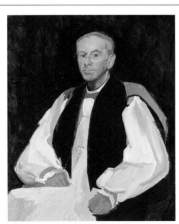

unknown artist
Alwyn Williams (1888–1968), Bishop of Durham (1939–1952)
oil on canvas 100 x 80 (E)
20

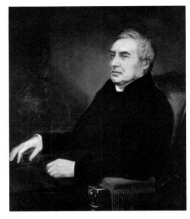

unknown artist
Charles Baring (1807–1879), Bishop of Durham (1861–1879)
oil on canvas 89.5 x 74 (E)
21

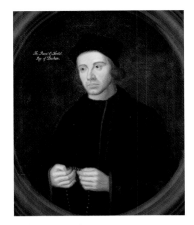

unknown artist
Cuthbert Tunstall (1474–1559), Bishop of Durham (1530–1559)
oil on canvas 89 x 72 (E)
8

unknown artist
Devotional Painting
oil on canvas 89 x 131 (E)
12

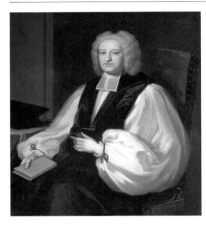

unknown artist
Edward Chandler (1668–1750), Bishop of Durham (1730–1750)
oil on canvas 120 x 100 (E)
36

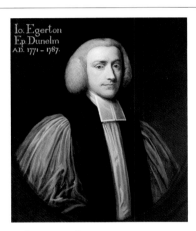

unknown artist
John Egerton (1721–1787), Bishop of Durham (1771–1787)
oil on canvas 75.5 x 63 (E)
17

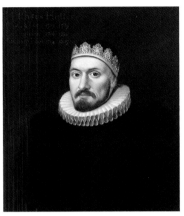

unknown artist
Mathew Hutton (1529–1606), Bishop of Durham (1589–1595)
oil on canvas 60 x 50 (E)
9

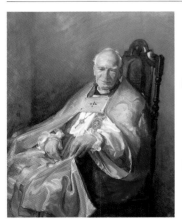

unknown artist
Maurice Harland (1896–1986), Bishop of Durham (1956–1966)
oil on canvas 125 x 100 (E)
38

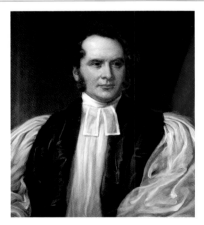

unknown artist
Montagne Villiers (1813–1861), Bishop of Durham (1860–1861)
oil on canvas 76 x 62 (E)
14

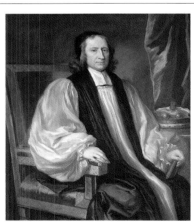

unknown artist
Nathaniel, Lord Crewe (1633–1721), Bishop of Durham (1674–1721)
oil on canvas 128 x 100 (E)
24

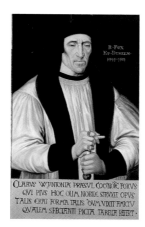

unknown artist
Richard Fox (c.1448–1528), Bishop of Durham
(1494–1501)
oil on wood panel 77.5 x 47 (E)
13

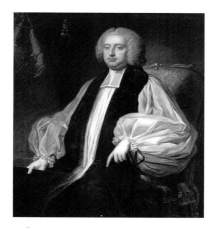

unknown artist
Richard Trevor (1707–1771), Bishop of
Durham (1752–1771)
oil on canvas 128 x 100 (E)
34

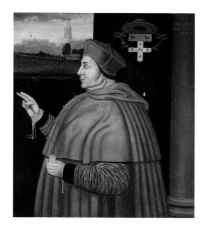

unknown artist
Thomas Wolsey (1473–1530), Bishop of
Durham (1523–1529)
oil on canvas 119 x 93.5 (E)
6

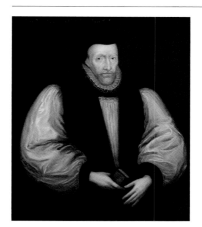

unknown artist
Tobias Matthew (1546–1628), Bishop of
Durham (1595–1606)
oil on canvas 95 x 79 (E)
7

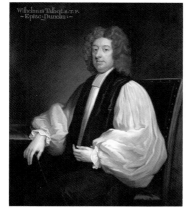

unknown artist
William Talbot (1658–1730), Bishop of
Durham (1721–1730)
oil on canvas 129 x 101 (E)
23

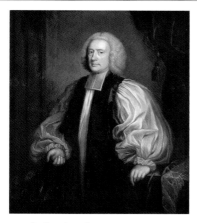

Vanderbank, John c.1694–1739
Joseph Butler (1692–1752), Bishop of Durham
(1750–1752)
oil on canvas 127 x 101 (E)
22

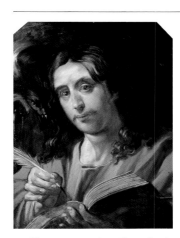

Wolfaerts, Artus (attributed to) 1581–1641
St John
oil on wood panel 64 x 48 (E)
44

Wolfaerts, Artus (attributed to) 1581–1641
St Luke
oil on wood panel 64 x 48 (E)
43

Wolfaerts, Artus (attributed to) 1581–1641
St Mark
oil on wood panel 64 x 48 (E)
42

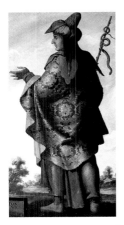

Wolfaerts, Artus (attributed to) 1581–1641
St Matthew
oil on wood panel 64 x 48 (E)
41

Zurbarán, Francisco de 1598–1664
Asher VIIII
oil on canvas 197 x 101 (E)
X740

Zurbarán, Francisco de 1598–1664
Dan VII
oil on canvas 197 x 101 (E)
X738

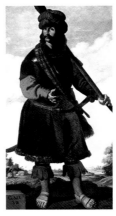

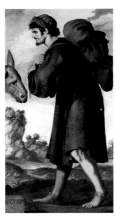

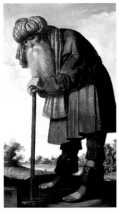

Zurbarán, Francisco de 1598–1664
Gad VIII
oil on canvas 197 x 101 (E)
X739

Zurbarán, Francisco de 1598–1664
Issachar VI
oil on canvas 197 x 101 (E)
X737

Zurbarán, Francisco de 1598–1664
Jacob
oil on canvas 197 x 101 (E)
X731

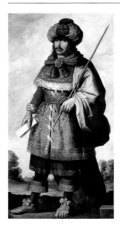

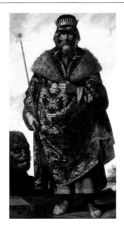

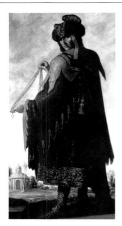

Zurbarán, Francisco de 1598–1664
Joseph XI
oil on canvas 197 x 101 (E)
X742

Zurbarán, Francisco de 1598–1664
Judah IIII
oil on canvas 197 x 101 (E)
X735

Zurbarán, Francisco de 1598–1664
Levi III
oil on canvas 197 x 101 (E)
X734

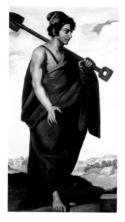

Zurbarán, Francisco de 1598–1664
Naphtali X
oil on canvas 197 x 101 (E)
X741

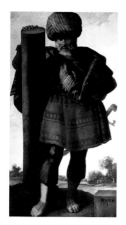

Zurbarán, Francisco de 1598–1664
Reuben I
oil on canvas 197 x 101 (E)
X732

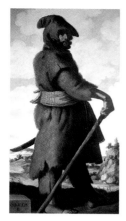

Zurbarán, Francisco de 1598–1664
Simeon II
oil on canvas 197 x 101 (E)
X733

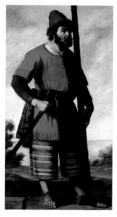

Zurbarán, Francisco de 1598–1664
Zebulun V
oil on canvas 197 x 101 (E)
X736

Bishop Auckland Town Hall

A collection of 50 works by the late Tom McGuinness (1926–2006), including five oil paintings, was bequeathed by Jack Reading to Bishop Auckland Town Hall in June 1996, 'Visual Arts Year'. Jack had spent most of his working life serving the welfare side of the mining industry. His duties included the direction of national events on behalf of the National Coal Board (NCB): National Brass Band Championships, National Coal Board Amateur Boxing Championships, the Miners Welfare Scholarship Scheme and foreign exchanges, to name but a few.

In his private life he had an active interest in the theatre and visual arts which he carried into his employment by seeking out and fostering the work of mining artists. The early work and potential of Tom McGuinness came to his attention as a result of the purchase of the now iconic *Miner and Child* by the Shipley Art Gallery, Gateshead, in 1949. Jack contacted Tom and organised his first one-man show in the National Coal Board offices in London. Towards

the end of his working life Jack Reading initiated the major exhibition *Coal*, jointly sponsored by the NCB and the Arts Council.

Tom McGuinness joined the coal industry as a 'Bevin Boy' in 1944. Despite having many opportunities to leave and become a full-time artist, he remained a coal miner for 39 years. Tom exhibited widely, both nationally and internationally, and had two sell-out exhibitions in London in the 1970s. The NCB featured him in their news film *Mining Review* and his work was used by the BBC in the *Omnibus* programme.

Tom worked in a variety of media. In the 1950s he began to experiment with oils and in the 1970s developed his interest in printmaking to include both etching and lithography. In his later years his work broadened to encompass religious themes as well as documenting the decline of the once-thriving mining communities. Throughout his career, Tom remained constant to the original source of his inspiration – the coal mine. As a painter of the industrial scene Tom McGuinness was unique in that he continued in his profession as a miner whilst pursuing an artistic career. His work is his autobiography.

The Bequest includes examples of preparatory drawings and sketches, lithographs, etchings and the five oils which are documented here. The Collection is not on permanent public display but is shown annually in the McGuinness Gallery at Bishop Auckland Town Hall.

In addition the Town Hall holds an assortment of works associated with and depicting the Bishop Auckland area.

Gillian Wales, Centre Manager

Abel, Sue b.1950
Deer Park 2007
oil on board 12.5 x 18.3
6

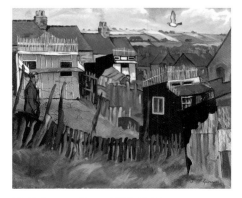

McGuinness, Tom 1926–2006
Pigeon Crees 1953
oil on canvas 61 x 72
2

McGuinness, Tom 1926–2006
Canchmen 1958
oil on board 48 x 100
1

McGuinness, Tom 1926–2006
Miners in the Roadway 1958
oil on board 45.2 x 41
4

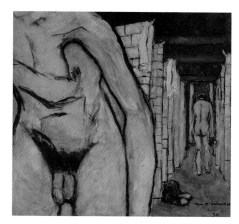

McGuinness, Tom 1926–2006
Pit Head Bath 1958
oil on board 44 x 46.5 (E)
3

McGuinness, Tom 1926–2006
Salvage Men Brawing Rings 1958
oil on board 51.5 x 60
5

Meehan, Myles 1904–1974
*Panorama of South Church, Bishop Auckland,
County Durham* 1957
oil on board 46 x 158
11

Parkin, Gloria
*Triptych of Twelfth-Century Figures in the
Chapter House of Durham Cathedral*
mixed media on board
60.5 x 30; 60.5 x 30; 60.5 x 30
7

Robson, George b.1945
Following the Banner on Gala Day 2002
oil on canvas 80 x 100
10

Rogers, George John 1885–1996
*Newton Cap Bridge and Viaduct, near Bishop
Auckland, County Durham* 1952
oil on canvas 29 x 44 (E)
8

Rogers, George John 1885–1996
*Market Place, Bishop Auckland, County
Durham* 1964
oil on canvas 24.5 x 40 (E)
9

Wilkinson Daniel, Henry 1875–1959
Joseph Lingford (1829–1918) 1911
oil on canvas 223 x 131 (E)
12

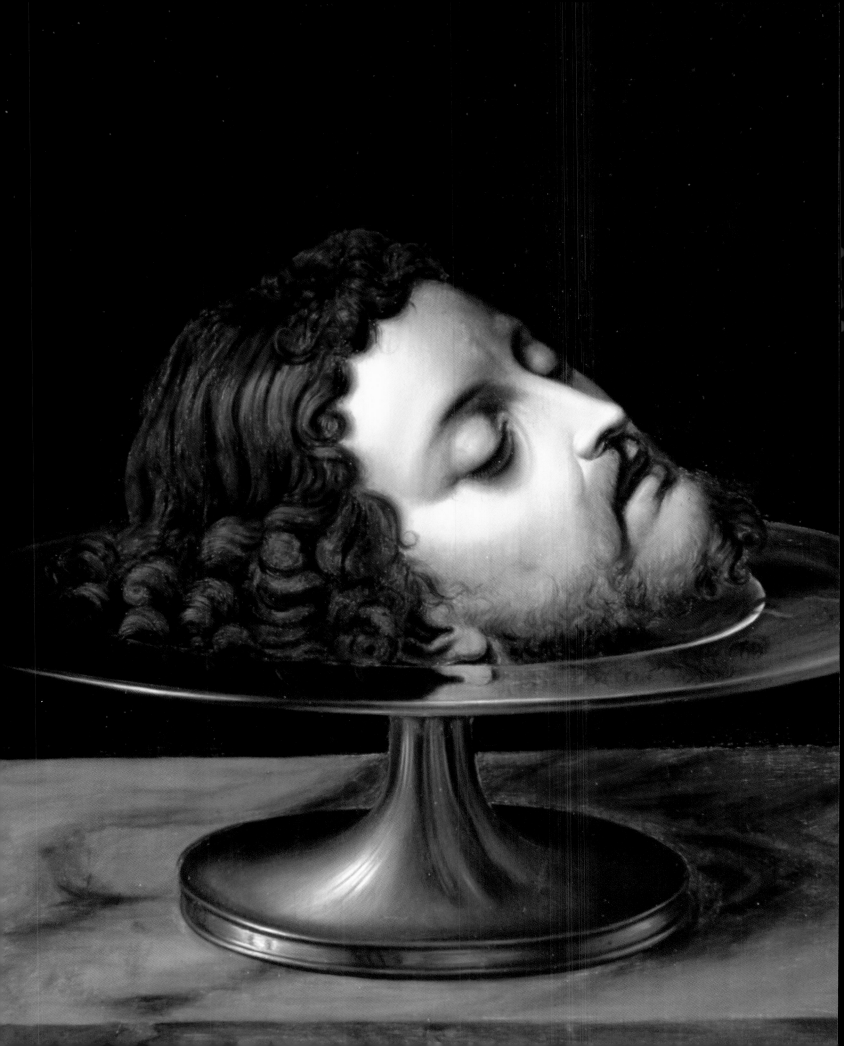

Derwentside District Council

Kipling, Mary Jane 1912–2004
*Landscape with Consett Steel Works** 1972
acrylic on board 49 x 74.5 (E)
1

Mackie, Sheila Gertrude b.1928
It's Good to Be Home 1996
oil on board 63 x 68 (E)
3

Mackie, Sheila Gertrude b.1928
Lazy Days at the Spa 1996
oil on paper 78 x 68 (E)
6

Mackie, Sheila Gertrude b.1928
Roe Deer Fawn 1996
acrylic on board (?) 87.5 x 95.5 (E)
2

Mackie, Sheila Gertrude b.1928
Taking a Dip in the Derwent 1996
oil on board 90.5 x 65 (E)
5

Mackie, Sheila Gertrude b.1928
Waiting in the Undergrowth 1996
oil on board 55 x 59.5 (E)
4

Facing page: Solario, Andrea (after), c.1465–1524, *The Head of the Baptist on a Tazza* (detail), mid-16th C-mid-17th C,
The Bowes Museum, (p. 156)

Wear Valley
District Council

Carmichael, John Wilson 1800–1868
Flower Show in Auckland Park, County Durham, 1859 1860
oil on canvas 82 x 120 (E)
1

Doyle, Caroline
Jesmond Dene, Newcastle-upon-Tyne
acrylic on paper 46 x 35.3 (E)
5

Mansell, C.
Busy Abstract: Black and Gold
acrylic on paper 77 x 63.5
3

Mansell, C.
Busy Abstract: Blue, Black, Gold and Green
acrylic on paper 75 x 63
4

Mansell, C.
Busy Abstract: White on Gold
acrylic on paper 76.5 x 62.5
2

McGuinness, Tom 1926–2006
Procession to Durham Cathedral 1997
oil on board 50 x 151 (E)
6

Darlington Borough Art Collection

Darlington Borough Council was delighted to have the opportunity to work with the Public Catalogue Foundation to include the oils from the Darlington Borough Art Collection in the County Durham catalogue. This has provided an additional opportunity to increase public access to the Collection and celebrate the work to be found in Darlington. The paintings in this catalogue have been exhibited at the Myles Meehan Gallery, at Crown Street Library and have also been displayed in publicly-accessible buildings in Darlington, including the Town Hall and the Dolphin Centre.

Darlington Borough Art Collection has been acquired over many years through donations, purchases and bequests. The Collection has both local and national significance with artworks featuring local scenes and figures as well as works of art by internationally acclaimed artists such as *Fallen Tree against Sunset* by Graham Sutherland, *In the Studio* by Conrad Kiesel and *Yorkshire Landscape* by Spencer Gore.

The paintings held at the Darlington Library are mainly portraits of Darlington men and women who have made a notable contribution to the history of the town, some being aldermen, other eminent Quakers. Many of the paintings are of buildings and scenes of Darlington, which form an historic and valuable record for study now and for future generations. The Collection includes much-loved works painted for the Library and many of the smaller works are used in temporary displays in the Centre for Local Studies at the Library.

Andy Scott, Councillor, Darlington Borough Council

Alderson, Dorothy Margaret 1900–1992 &
Alderson, Elizabeth Mary 1900–1988
Poodlemania 1966
oil on board 50 x 60.5
176

Appleyard, John b.1923
Bondgate Chapel, Darlington, County Durham
mixed media on board 50 x 62.5 (E)
DL L594A

Appleyard, John b.1923
Cockerton Chapel, Darlington, County Durham
mixed media on board 39 x 29 (E)
DL L666A

Appleyard, John b.1923
The Brickyard
oil & mixed media on board 64 x 51
DL L534A

Appleyard, John b.1923
*Victoria Road Methodist Church, Darlington,
County Durham*
oil on board 53 x 30.5
DL L718A

Banting, John 1902–1972
Abstract with Holes 1937
oil on board 44 x 56.2 (E)
190

Barnes, George E.
Myles 1952
oil on canvas 76 x 63.5
249

Beaton, Malcolm A. b.1918
Tubwell Row, Darlington 1971
oil on board 49.5 x 74.5 (E)
279

Bewick, William 1795–1866
Cauldron Snout 1825
oil on board 49.5 x 36 (E)
208

Bewick, William 1795–1866
Castle Eden Dene
oil on board 42.5 x 34
207

Bewick, William 1795–1866
Jeremiah (copy after Michelangelo)
oil on canvas 235 x 145 (E)
384

Bewick, William 1795–1866
John Buckton of Buckton's Yard
oil on canvas 88.5 x 68.5 (E)
464

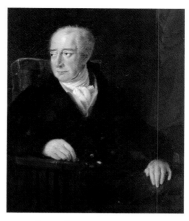

Bewick, William 1795–1866
John Douthwaite Nesham
oil on canvas 92 x 77
345

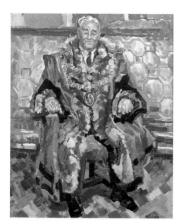

Bird, James Lindsay 1903–1972
Alderman Robert Henry Loraine, JP, Mayor of Darlington (1961–1962) 1962
oil on canvas 89 x 70
534

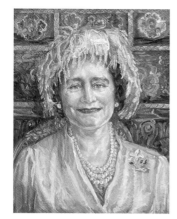

Bird, James Lindsay 1903–1972
The Queen Mother (1900–2002)
oil on canvas 66.5 x 49.5
220

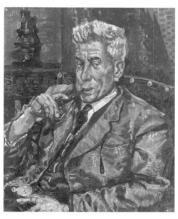

Bird, James Lindsay 1903–1972
Walter Woodward Allen
oil on canvas 76 x 61
531

Bond, W.
Blackwell Mill
oil on board 31 x 49 (E)
187

Briault, Sydney 1887–1955
Man Holding a Sword
oil on hardboard 35 x 25.5
236

Brocklebank, W.
Off Church Row, Darlington, County Durham
oil on canvas 53.5 x 35.5
62

Brocklebank, W.
Old Smithy, Cockerton, Darlington, County Durham
oil on canvas 40.5 x 56
243

Browne, Piers b.1949
Castle Bolton, Yorkshire, March Afternoon 1985
oil on board 39.5 x 45 (E)
271

Bryce, Gordon b.1943
Renaissance c.1980
oil on canvas 151 x 179
381

Bryett, M. Theodore
Margaret Caroline Surtees (1816–1869)
1862 (?)
oil on canvas 98 x 74 (E)
453

Burlison, Clement 1803–1899
Holy Trinity Church, Darlington, County Durham 1860
oil on canvas 42.5 x 52.5 (E)
192

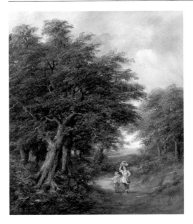

Burrows, Robert 1810–1893
Gainsborough's Lane 1881
oil on canvas 30.4 x 25.7
186

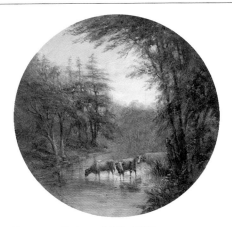

Burrows, Robert 1810–1893
Cattle on Road
oil on wood panel 20
184

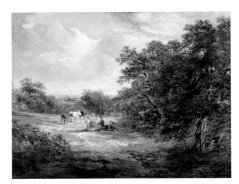

Burrows, Robert 1810–1893
Evening
oil on wood panel 20.5 x 25
183

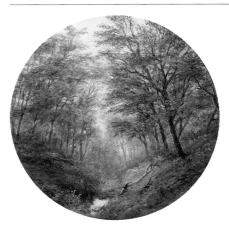

Burrows, Robert 1810–1893
Woodland Scene
oil on wood panel 19.5
185

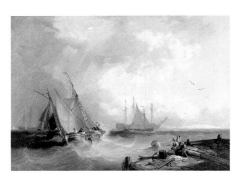

Carmichael, John Wilson 1800–1868
Seascape
oil on canvas 62 x 84.5
223

Cemmick, David b.1955
After the Snowstorm 1985
acrylic on board 34.5 x 45.5
8

Clark, J.
Alderman J. K. Wilkes, Mayor (1885–1886)
oil on canvas 111.5 x 86
DL L0517

Clarke, Howard
Uphill Road
oil on board 44.5 x 35.5
155

Clarke, May
Equipoise 1960s
oil on board 52 x 37 (E)
153

Cleeland, J. Alan
Little Girl 1954
oil on board 40 x 30
270

Coad, Charles 1854–1914
Sir Henry Havelock-Allan (1830–1897) 1895
oil on canvas 61 x 51
311

Cole, George Vicat 1833–1893
Landscape
oil on canvas 51 x 100 (E)
435

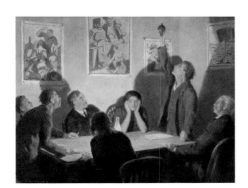

Collier, John 1850–1934
Brotherhood of Man c.1900
oil on board 28 x 36 (E)
135

Common, Alfred
Landscape in Autumn 1960s
oil on board 29 x 29
129

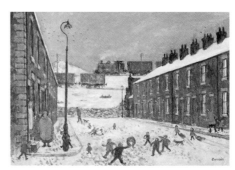

Cornish, Norman Stansfield b.1919
Bishop's Close Street, Spennymoor, County Durham
oil on board 33 x 45
188

Crosby, William 1830–1910
A Victorian Lady 1883
oil on canvas 212 x 124 (E)
383

Cuberle, A. active 1871–1895
Landscape 1871
oil on canvas 74 x 99.8
443

Cuberle, A. active 1871–1895
Landscape 1895 (?)
oil on canvas 72 x 98.5 (E)
436

Dadswell, Margaret
Sunflowers c.1974
oil on board 60.5 x 50.5 (E)
16

Dillon, Paul b.1943
Pease House, Houndgate, Darlington, County Durham 1982
oil on board 41 x 51
391

Downman, John 1750–1824
Jane Surtees (daughter of Robert Surtees) 1771
oil on canvas 126 x 98 (E)
450

Drinkwater, Milton H.
St Cuthbert's Church, Darlington, County Durham 1896
oil on canvas 71 x 92
346

Dunning, R.
Richmond Castle, North Yorkshire 1821
oil on canvas 47 x 61
307

Dunstan, Bernard b.1920
Dawn
oil on canvas 58 x 76
427

Facing page: Allegrain, Étienne, 1644–1736, *Classical Landscape with Figures and Ruins* (detail),
The Bowes Museum, (p. 4)

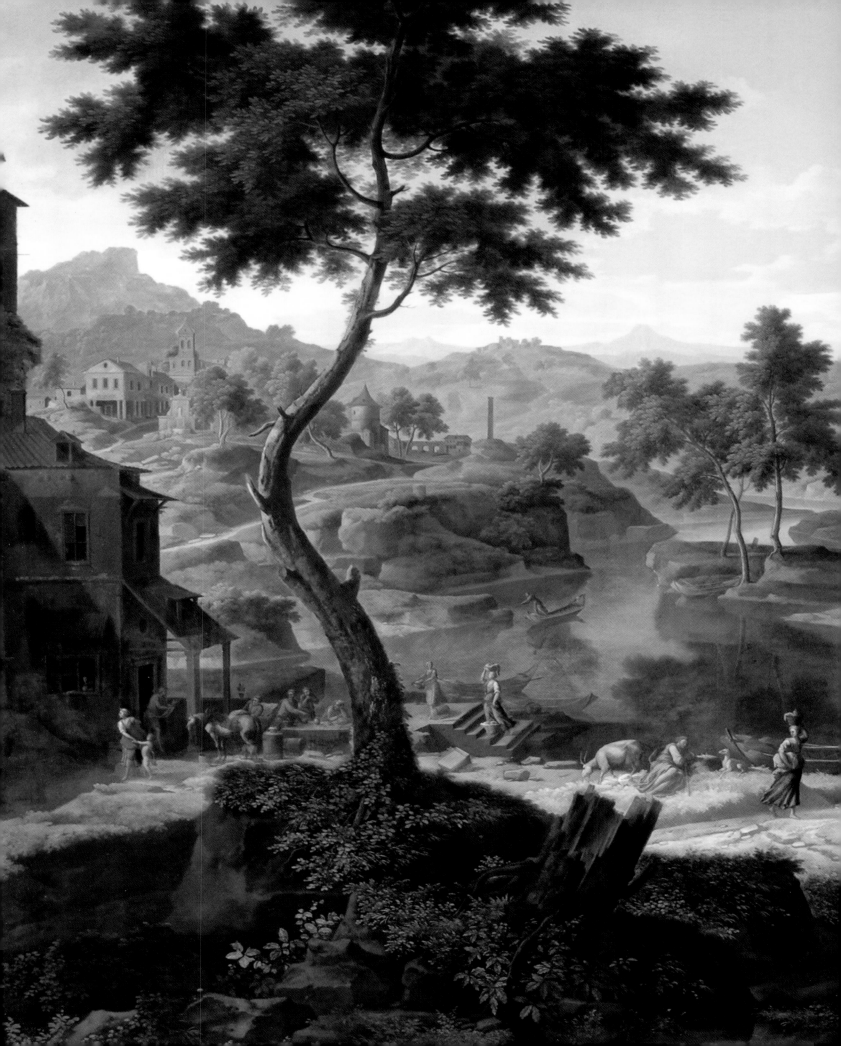

Elgood, Thomas Scott 1845–1912
Hurworth-on-Tees, County Durham c.1875
oil on board 29.5 x 49.5
12

Eurich, Richard Ernst 1903–1992
Landscape 1926
oil on canvas 34.4 x 39.2
241

Fenwick, C.
J. G. Harbottle (1858–1920) 1920
oil on canvas 109 x 82
DL LOS38

Fothergill, George Algernon 1868–1945
Dog and Pheasant (1)
oil on board 19.5 x 28.5 (E)
227

Fothergill, George Algernon 1868–1945
Dog and Pheasant (2)
oil on panel 21 x 30
228

Fothergill, George Algernon 1868–1945
English Setter
oil on panel 21.5 x 30
230

Fothergill, George Algernon 1868–1945
Hunt Terriers (1)
oil on panel 20 x 28
225

Fothergill, George Algernon 1868–1945
Hunt Terriers (2)
oil on panel 20 x 28
226

Fothergill, George Algernon 1868–1945
Pointer
oil on panel 21.5 x 30
229

Fothergill, S.
Swans on the River
oil on canvas 45.5 x 31
302

Fothergill, S.
Thread Mill and Dam
oil on canvas 40 x 29.5 (E)
DL L666B

Freiles, Antonio b.1943
Colloquio
oil on canvas 78.5 x 89
428

Fulleylove, John 1845–1908
Holy Trinity Church, Darlington, County Durham
oil on board 22 x 32
DL B450

Gibb, Thomas Henry 1833–1893
Otter Hunting on the Tweed
oil on canvas 59.5 x 90
429

Gibbs, John Binney 1859–1935
High Row, Darlington, County Durham 1896
oil on canvas 71 x 102
472

Gibbs, John Binney 1859–1935
William Ferguson (1841–1908) 1901
oil on canvas 90 x 70 (E)
DL LOS30

Gore, Spencer 1878–1914
Yorkshire Landscape 1907
oil on canvas 45 x 60 (E)
245

Gray, Laurie E.
Church Lane, Darlington, County Durham 1981
oil on board 54 x 74
280

Gush, William 1813–1888
Robert Lampton Surtees
oil on canvas 104 x 79
460

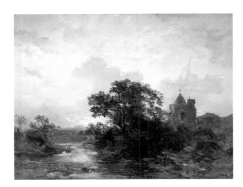

Halswelle, Keeley 1832–1891
Landscape
oil on panel 23 x 28
237

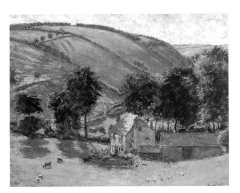

Harmar, Fairlie 1876–1945
Chibbet, Exmoor, Somerset
oil on canvas 55 x 67 (E)
334

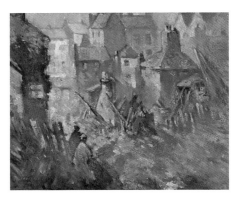

Harrison, John Brown 1876–1958
The Morning After 1941
oil on canvas 51 x 61
503

Haughton, Benjamin 1865–1924
Wild Hyacinths c.1900
oil on canvas 51 x 51
431

Hawksley, Maude
The Long Bill 1896
oil on canvas 46 x 61
244

Haynes-Williams, John 1836–1908
The Miniature
oil on canvas 67.5 x 89.5 (E)
367

Heath, Adrian 1920–1992
Composition 1960s
oil on canvas 81 x 61
199

Hedley, Ralph 1848–1913
Breezy Day 1895
oil on canvas 46 x 35.5
432

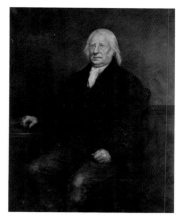

Heywood, Harry
Edward Pease (1767–1858)
oil on canvas 140 x 110
449

Hicks, Peter Michael b.1937
Inland Cliff, Cleveland
acrylic on canvas 148 x 183
514

Hill, Ernest
Jarrow Slake, Tyne and Wear 1911
oil on canvas 51 x 76
351

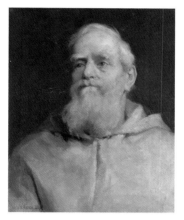

Hobson, Victor William 1865–1889
Portrait of an Old Man 1887
oil on canvas 51 x 41
308

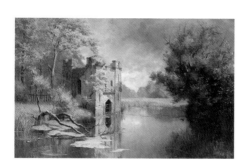

Hobson, Victor William 1865–1889
North Lodge Park, Darlington, County Durham
oil on canvas 92 x 138
374

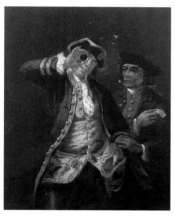

Hogarth, William (attributed to)
1697–1764
The Writ
oil on board 34 x 27.5 (E)
127

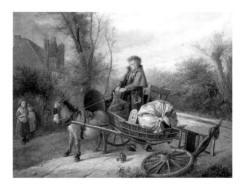

Hunt, C.
The Donkey Cart 1883
oil on canvas 36 x 46
233

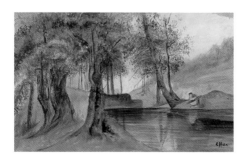

Hyde, E.
Autumn Tints in the Wood
oil on board (?) 28 x 43 (E)
189

Jennens & Bettridge active c.1845–1850
El Kaf, the Ancient Sicca Veneria, Tunis, Tunisia
oil on lacquered panel 53.5 x 85
312

Jennens & Bettridge active c.1845–1850
Suez, Egypt
oil on lacquered panel 53.5 x 85
313

Jennens & Bettridge active c.1845–1850
Tripoli, Libya
oil on lacquered panel 53.5 x 85
314

Johnson, Derek Blyth b.1943
Figure in Crowd
oil on hardboard 121 x 90.5
421

Kessell, Mary 1914–1977
The Bombed House
oil on paper 44 x 33
273

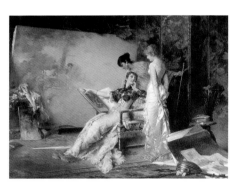

Kiesel, Conrad 1846–1921
In the Studio 1885
oil on canvas 88 x 112
366

Lake, Philip
Flower Study 1970s
oil on board 25 x 20
122

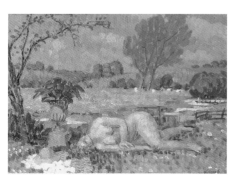

Lamb, Henry 1883–1960
The Garden, Coombe Bissett, Wiltshire
oil on hardboard 31 x 41
240

Larry, K.
Works
oil on canvas 44 x 49.5 (E)
322

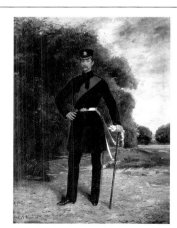

Laudelle, E. (attributed to)
Brigadier Sir General Conyers Surtees of Mainsforth Hall
oil on canvas 61 x 46
DL L583B

Lawson, F.
Darlington Market Place, County Durham
oil on canvas 40.5 x 61
DL L719

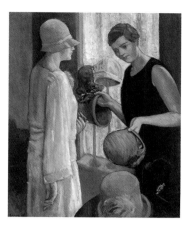

Layng, Mabel Kathleen 1898–1987
Millinery
oil on canvas 77 x 63.5
250

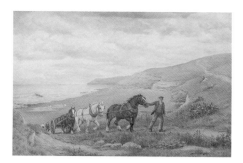

Lear, William Henry 1860–1932
Carting Sand 1930–1932
oil on board 44.5 x 65
193

Lee, I.
George David Wilson (1846–1903) 1902
oil on canvas 127 x 86.5
DL LO523

Lee, John c.1869–1934
Victor Hobson (1865–1889) 1886
oil on canvas 61.5 x 51
276

Lévy, Simon 1886–1973
Skull
oil on panel 26 x 31
238

Mark, Brenda 1922–1960
Girl with a Bowl of Fruit
oil on canvas 76 x 63
335

McBeth, Murray
Edmund Backhouse (1824–1906)
oil on canvas 141 x 111 (E)
512

McGuinness, Tom 1926–2006
Miners in the Return
oil on hardboard 113 x 86
356

McGuinness, Tom 1926–2006
The Caller
oil on hardboard 106.5 x 61
357

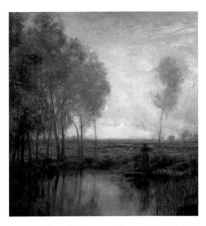

McLachlan, Thomas Hope 1845–1897
Pastoral 1887
oil on canvas 100 x 88.5
368

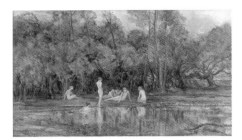

McLachlan, Thomas Hope 1845–1897
Bathers 1892
oil on canvas 60.5 x 102
369

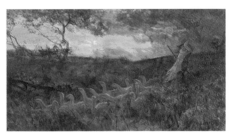

McLachlan, Thomas Hope 1845–1897
Goose Girl 1892
oil on board 46 x 79 (E)
370

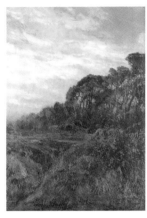

McLachlan, Thomas Hope 1845–1897
Moorland Scene 1892
oil on canvas 103.5 x 69.5
216

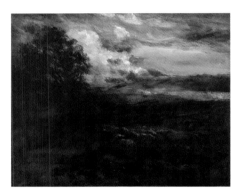

McLachlan, Thomas Hope 1845–1897
At Shut of Eve 1896
oil on canvas 44 x 54.5 (E)
215

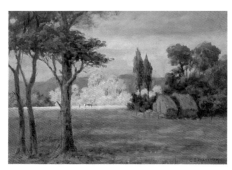

Meecham, Charles Stephen
Goodnight Kiss
oil on board 25.5 x 35.5
128

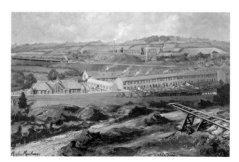

Meehan, Myles 1904–1974
North Country 1949
oil on board 44.5 x 64.5
268

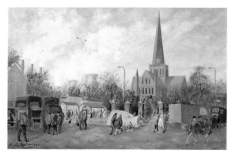

Meehan, Myles 1904–1974
*St Cuthbert's, Darlington, County
Durham* 1970
oil on board 51 x 76
269

Meehan, Myles 1904–1974
The Birthplace of Edward Pease, Darlington,
County Durham 1970
oil on board 44.5 x 60 (E)
53

Meehan, Myles 1904–1974
White Lilac 1971
oil on canvas 46 x 35.5
51

Meehan, Myles 1904–1974
Pease's Mill, Darlington, County Durham 1972
oil on board 51 x 41 (E)
52

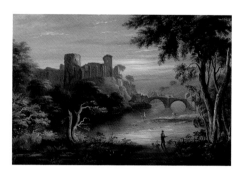

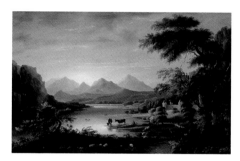

Miller, Joseph active c.1812–1858
Landscape with Castle and Bridge 1858
oil on canvas 60 x 85.5 (E)
218

Miller, Joseph active c.1812–1858
Barnard Castle, County Durham
oil on canvas (?) 60 x 86 (E)
219

Miller, Joseph active c.1812–1858
Borrowdale, Cumbria
oil on canvas 58 x 82 (E)
442

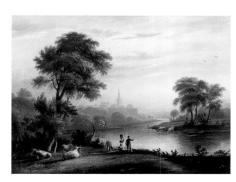

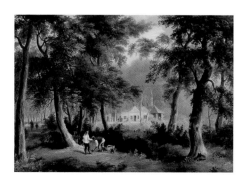

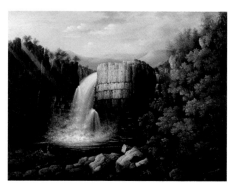

Miller, Joseph active c.1812–1858
Coniscliffe Church, Bishop Auckland, County
Durham
oil on canvas 45 x 60
217

Miller, Joseph active c.1812–1858
Dog Kennels, Raby Castle, County Durham
oil on board (?) 50 x 60.6
425

Miller, Joseph active c.1812–1858
High Force
oil on canvas 59 x 73
424

Miller, Joseph active c.1812–1858
Raby Castle, County Durham
oil on canvas (?) 58 x 83 (E)
446

Minton, John 1917–1957
The Entombment
oil on canvas 74 x 84
416

Moore, Henry 1831–1895
The North Sea 1876–1877
oil on canvas 46 x 81 (E)
352

Nasmyth, Patrick 1787–1831
A Homestead 1828
oil on board 31 x 41.5 (E)
182

Nasmyth, Patrick 1787–1831
Yews near Turner's Hill, East Grinstead, West Sussex
oil on wood panel 21 x 32.5
181

Neasham, W. W.
Building Shop, Faverdale, Darlington, County Durham
oil on board 36.4 x 48 (E)
DL L715B

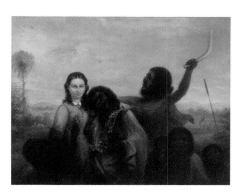

Noble, R.
Woman with Aborigines
oil on canvas 52.5 x 68
310

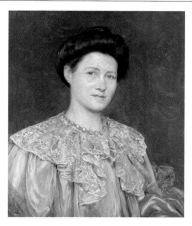

Olivier, Herbert Arnould 1861–1952
Lady Southampton (d.1957)
oil on canvas 61 x 50.5
309

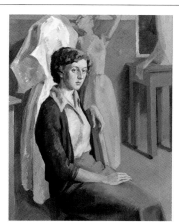

Parkinson, Harold
Pat 1954
oil on board 50 x 39
274

Facing page: Sokolov, Kirill, 1930–2004, *Monastery at Panteleimon, Three Monks on Mount Athos, Greece* (detail), 1997, Durham University, (p. 314)

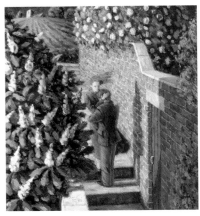

Peart, Tony b.1961
Fear of the Unknown
oil on canvas 55 x 51
275

Peel, James 1811–1906
The Tinker 1842
oil on canvas 35 x 30.5
417

Peel, James 1811–1906
Borrowdale, Cumbria
oil on canvas 57 x 90 (E)
447

Peel, James 1811–1906
Landscape with Cows
oil on canvas 39 x 65 (E)
202

Peel, James 1811–1906
Landscape with Cows and Cowman
oil on canvas 26 x 42 (E)
205

Peel, James 1811–1906
Landscape with Fisherman
oil on canvas 19 x 29 (E)
204

Peel, James 1811–1906
Landscape with Shepherd and Sheep
oil on canvas 19 x 29
203

Peel, James 1811–1906
Landscape with Two Figures
oil on canvas (?) 39.5 x 65 (E)
333

Peel, James 1811–1906
The Reaper
oil on board 19 x 28
206

Potworowski, Peter 1898–1962
Window on the Sun
oil on canvas 59.5 x 90.5 (E)
349

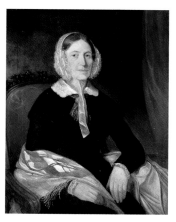

Rathwell, William
Mary Spark
oil on canvas 91 x 70
467

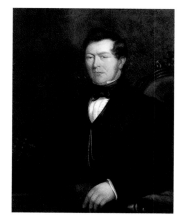

Rathwell, William
*Henry King Spark (1824–1899), Landowner
and Colliery Owner* 1846
oil on canvas 92 x 71 (E)
466

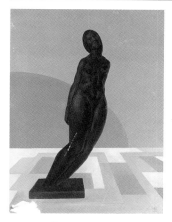

Reuss, Albert 1889–1975
Black Statue
oil on canvas 61 x 45.5 (E)
246

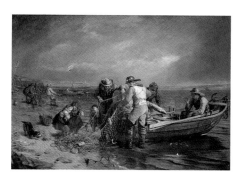

Ross, Robert Thorburn 1816–1876
The Salmon Fishers 1869
oil on canvas 95 x 127 (E)
444

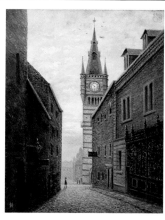

H. S. (attributed to)
*Post House Wynd, Darlington, County
Durham*
oil on canvas 43 x 33
L3164

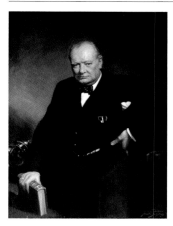

Salisbury, Frank O. 1874–1962
Sir Winston Churchill (1874–1965) 1946
oil on canvas 126 x 95 (E)
L541

Schmitt, Guido Philipp 1834–1922
*Henry King Spark (1824–1899), Landowner
and Colliery Owner*
oil on canvas 157 x 107 (E)
DL LOS13

Selby, James
Carnival 1966
oil on board 26.4 x 54.2 (E)
158

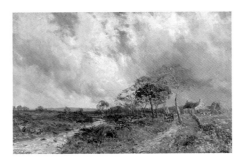

Slater, John Falconar 1857–1937
Landscape
oil on canvas 59 x 90 (E)
350

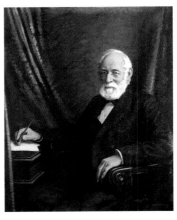

Stephenson, J. E.
Joseph Lingford (1829–1919) 1921
oil on canvas 127 x 102
364

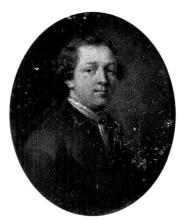

Surtees, Robert d.1802
Self Portrait
oil on metal 14 x 11
461

Sutherland, Graham Vivian 1903–1980
Fallen Tree against Sunset 1940
oil on canvas (?) 66.5 x 49.5 (E)
380

Swift, John Warkup 1815–1869
Off Flamborough, East Yorkshire
oil on canvas 23 x 40.5
239

Swinden, Ralph Leslie 1888–1967
The Venerable Bede Teaching at Jarrow 1945
oil on board 158 x 135
DL LOS74

Swinden, Ralph Leslie 1888–1967
Caxton and the Printing Press 1945 (?)
oil on board 160 x 168
DL LOS78

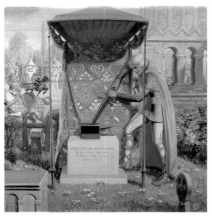

Swinden, Ralph Leslie 1888–1967
King Arthur and the Sword in the Stone 1950
oil on board 158 x 152.5
DL LOS75

Swinden, Ralph Leslie 1888–1967
Councillor Clive Dougherty (1907–1988) 1954
oil on canvas 91 x 71
375

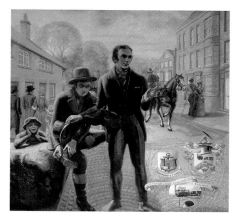

Swinden, Ralph Leslie 1888–1967
George Stephenson and Nicholas Wood at Bulmer Stone before Going to Interview Edward Pease, 1821 1955
oil on board 145 x 147 (E)
DL LOS77

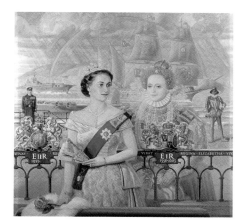

Swinden, Ralph Leslie 1888–1967
The Elizabethan Eras 1956
oil on board 152 x 157
DL LOS79

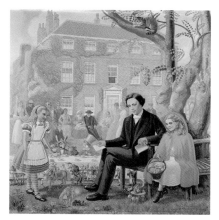

Swinden, Ralph Leslie 1888–1967
Lewis Carroll at St Peter's Rectory, Croft, Yorkshire 1957
oil on board 159 x 152.5
DL LOS78

Swinden, Ralph Leslie 1888–1967
A Scriptorium
oil on board 159 x 169
DL LOS79

Swinden, Ralph Leslie 1888–1967
Audrey Reid (1914–1999), in Fancy Dress
oil on canvas 91.5 x 71.5
376

Taylor, Frank active 1884–1897
Bridge and Moonlight 1884
oil on panel 25 x 31.5
292

Taylor, Frank active 1884–1897
Waterfall 1884
oil on canvas 25.5 x 35.5
294

Taylor, Frank active 1884–1897
Snow Scene with Watermill 1885
oil on board 46.5 x 31
298

Taylor, Frank active 1884–1897
Figures on a Bridge above a Waterfall 1887
oil on board 47 x 30
297

Taylor, Frank active 1884–1897
White Flowers 1888
oil on panel 30 x 23.5
288

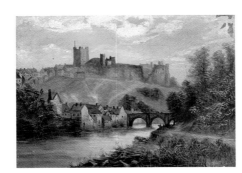

Taylor, Frank active 1884–1897
Landscape with Bridge and Castle 1897
oil on canvas 40.5 x 55
285

Taylor, Frank active 1884–1897
Bridge and Moonlight
oil on panel 25 x 31
287

Taylor, Frank active 1884–1897
By the Well
oil on panel 23.7 x 30
290

Taylor, Frank active 1884–1897
Church at Moonlight
oil on canvas 51 x 61
284

Taylor, Frank active 1884–1897
Lake Scene
oil on canvas 49.5 x 61
293

Taylor, Frank active 1884–1897
Lake Scene
oil on panel 20.5 x 30.5
293A

Taylor, Frank active 1884–1897
Lake Scene and Minarets
oil on board 20 x 28.5
286

Taylor, Frank active 1884–1897
Landscape in Moonlight
oil on board 23.5 x 30
291

Taylor, Frank active 1884–1897
Moonlit Castle
oil on board 36 x 30
295

Taylor, Frank active 1884–1897
Rural Scene with Girl and Geese
oil on board 23 x 31
296

Taylor, Frank active 1884–1897
The Mill
oil on board 23 x 15.5
289

Taylor, Henry King 1799–1869
Fishing on the Zyder Zee, Holland
oil on canvas 38.8 x 53.8
242

Taylor, R.
Windmill 1854
oil on panel 22.5 x 16
299

Thirtle, Pat b.1938
Centenary of Darlington Library 1985
oil on board 120 x 243
DL LOS80

Thompson, Mark 1812–1875
Doune Castle, near Stirling, Scotland 1864 (?)
oil on board 34.4 x 44.4 (E)
161

Thompson, Mark 1812–1875
Sniffing the Breeze 1868
oil on panel 23.5 x 35.5
234

Thompson, Mark 1852–1926
Lynn Burn, near Witton-le-Wear, County Durham 1872
oil on canvas 45.5 x 56
235

Thomson, Alfred Reginald 1894–1979
Joseph Malaby Dent (1849–1926), Publisher
1974
acrylic on canvas 150 x 152 (E)
DL LOS81

Thorp, William Eric 1901–1993
The Tower Pier, Late Afternoon 1950s
oil on canvas 50.5 x 60.5
196

Tindle, David b.1932
Thames Warehouses and Barge 1958
oil on hardboard 76 x 100.5
412

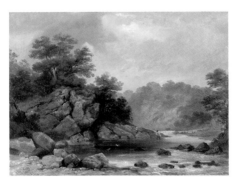

Train, Edward 1801–1866
On the Esk 1849
oil on canvas 44 x 57
413

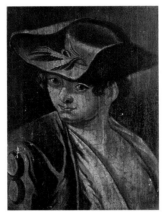

unknown artist 18th C
Bobby Shafto (d.1797)
oil on canvas (?) 42 x 31 (E)
321

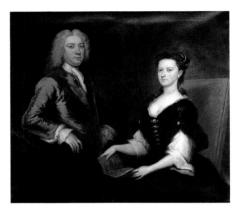

unknown artist 18th C
Crozier Surtees and His Wife, Jane
oil on canvas 152 x 155 (E)
452

unknown artist
Plan of Action near Corunna, Spain 1809
oil on canvas 95 x 75
507

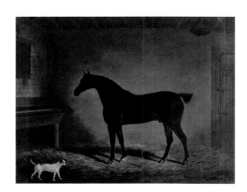

unknown artist
Horse and Dog in a Stable 1833
oil on canvas 58.5 x 76
330

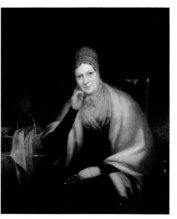

unknown artist
*H. M. Whitwell (1799–1886), Wife of Isaac
Whitwell* 1847
oil on canvas 50 x 41 (E)
DL L45OB

Facing page: Tristán de Escamilla, Luis, 1585–1624, *The Martyrdom of St Andrew* (detail), c.1616–1624,
The Bowes Museum, (p. 166)

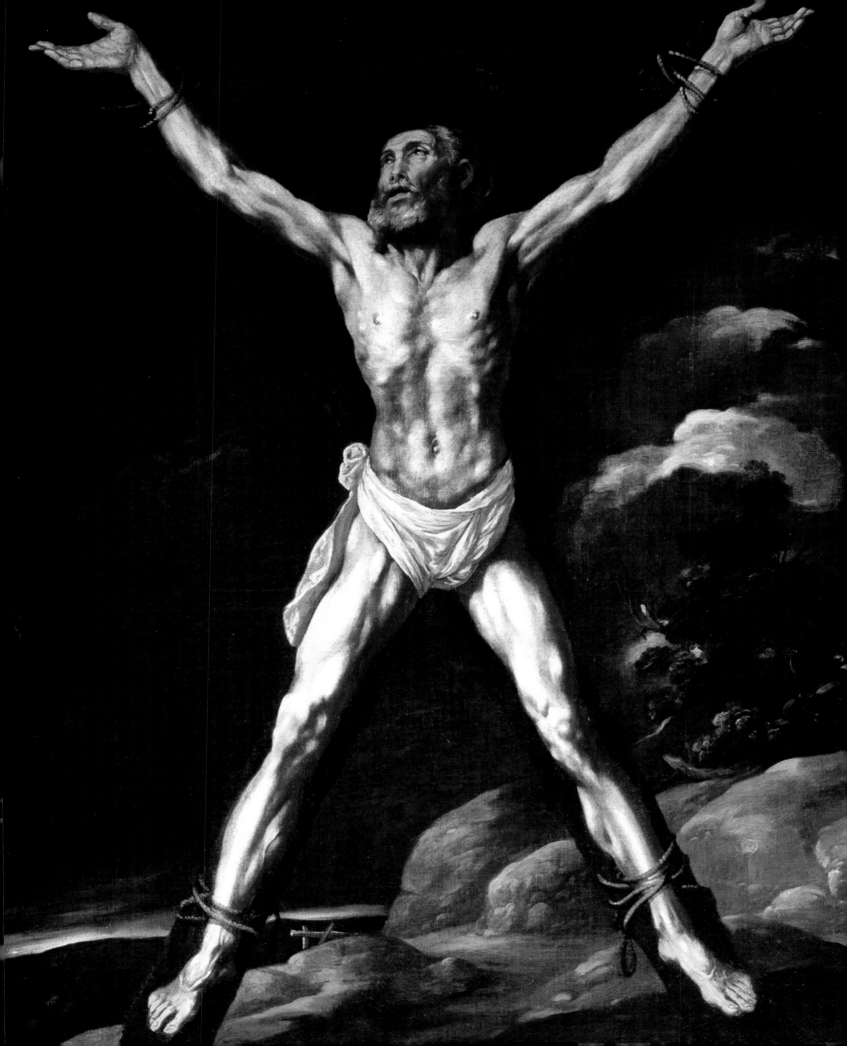

unknown artist
John Morell 1875
oil on canvas 112 x 86
DL LOS32

unknown artist
*Arthur Pease (1866–1927), Mayor
(1873–1874)* 1899
oil on canvas 78 x 60.5 (E)
DL LOS53

unknown artist early 19th C
Landscape with Children
oil on canvas 37 x 56
329

unknown artist early 19th C
Woman Threading a Needle
oil on panel 31 x 25.5
318

unknown artist 19th C
Fisherman and Lady
oil on canvas 108 x 80.5
337

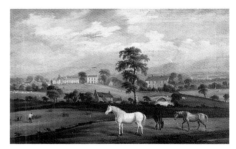

unknown artist 19th C
Landscape with Horses
oil on canvas 45 x 66 (E)
328

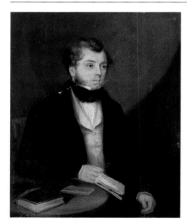

unknown artist 19th C
Man with Books
oil on board 35.5 x 30.5
320

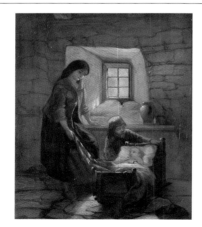

unknown artist 19th C
Woman with Children
oil on panel 34 x 28 (E)
319

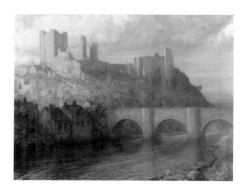

unknown artist
Richmond Castle, North Yorkshire c.1900
oil on canvas 70.5 x 91
331

unknown artist
Mrs G. D. Wilson 1902 (?)
oil on canvas 127 x 86.5
DL LOS20

unknown artist early 20th C
The Meeting of the Waters
oil on canvas 76 x 127
372

unknown artist 20th C
High Row, Darlington, County Durham
oil on panel 44 x 62 (E)
327

unknown artist 20th C
Young Woman
oil on canvas 51 x 41.5
325

unknown artist
*Alderman T. T. Sedgewick (1843–1904), Mayor
(1887–1888)*
oil on canvas 91.5 x 71
DL LOS33

unknown artist
*'Baydale Beck Inn', Darlington, County
Durham*
oil on board 23.2 x 35.5
DL L647

unknown artist
'Comet' (The Durham Ox)
oil on board 76 x 104.5
DL LOS63

unknown artist
Cooling Towers, Darlington, County Durham
oil on board 74 x 122 (E)
373

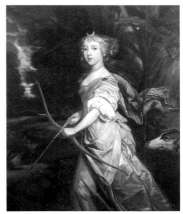

unknown artist
Diana
oil on canvas 61 x 51
502

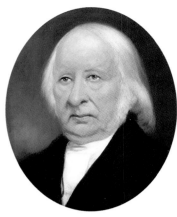

unknown artist
Edward Pease (1767–1858)
oil on board 24 x 20 (E)
DL L627A

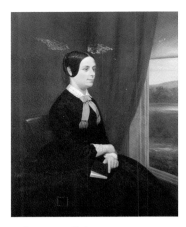

unknown artist
Eliza Chauncey of Dane End
oil on canvas 130 x 101.5
451

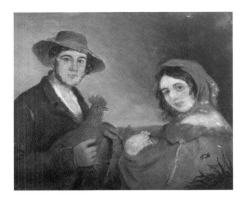

unknown artist
Irish Peasants
oil on board 40 x 48
323

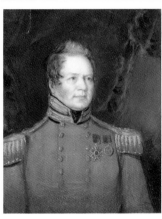

unknown artist
James Atkinson
oil on board 11 x 8.8 (E)
DL L54A

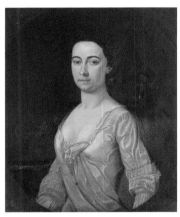

unknown artist
Jane Crozier of Redworth
oil on canvas 74 x 63.5
459

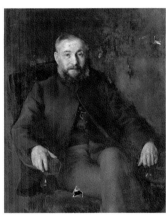

unknown artist
John Feetham (1833–1917)
oil on canvas 111.5 x 87
DL LOS22

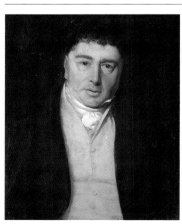

unknown artist
John Peacock (1761–1841)
oil on board 61 x 51
DL LOS9

unknown artist
Joseph Pease (1799–1872)
oil on board 60.3 x 45.2
DL L723

unknown artist
Joseph Pease (1799–1872)
oil on canvas 144.2 x 113
DL LOS14

unknown artist
Joseph Pease (1799–1872)
oil on canvas 143 x 105
DL LOS16

unknown artist
Joseph Whitwell Pease (1828–1903)
oil on canvas 128.5 x 85
DL LOS18

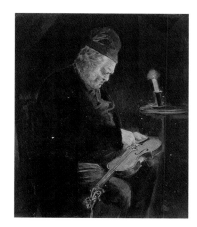

unknown artist
Neddy Place of Blakehouse Hill, Darlington
oil on board 39.5 x 34
324

unknown artist
Northgate Cottages and Bulmer Stone,
Darlington, County Durham
oil on tile 15 x 20
DL L68A

unknown artist
Pierremont, Darlington, County Durham
oil on tile 9 x 13.5
DL L163B

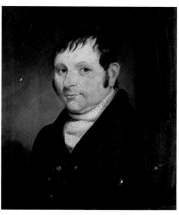

unknown artist
Portrait of an Unknown Gentleman
oil on canvas 59 x 49 (E)
DL L443A

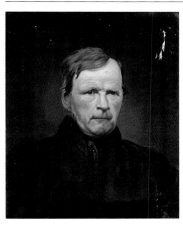

unknown artist
Portrait of an Unknown Gentleman
oil on canvas 61 x 51
DL LOS43

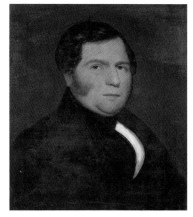

unknown artist
Portrait of an Unknown Gentleman
oil on canvas 61 x 51
DL LOS44

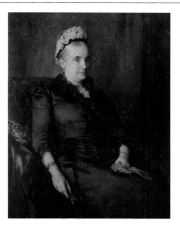

unknown artist
Portrait of an Unknown Woman
oil on canvas 112.5 x 85 (E)
DL LOS21

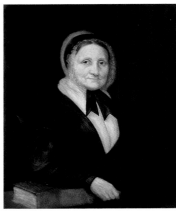

unknown artist
Portrait of an Unknown Woman
oil on canvas 76 x 64
DL LOS42

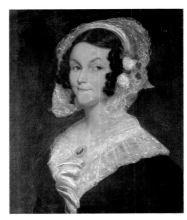

unknown artist
Portrait of an Unknown Woman
oil on canvas 61 x 51
DL LOS45

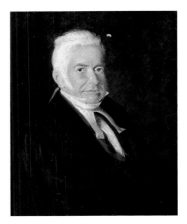

unknown artist
*Reverend W. Clementson, Headmaster of
Darlington Grammar School (1807–1836)*
oil on canvas 74 x 61 (E)
DL LOS46

unknown artist
*St Cuthbert's Church, Darlington, County
Durham*
oil on board 34 x 45 (E)
DL L617B

unknown artist
*St Cuthbert's Church, Darlington, County
Durham*
oil on canvas 102 x 73.5
DL LOS24

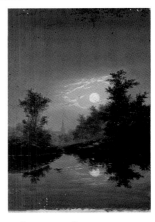

unknown artist
*St Cuthbert's Church, Darlington, County
Durham, in the Moonlight*
oil on board 46.5 x 31.8
DL D202

unknown artist
Sir David Dale (1829–1906)
oil on canvas 112 x 86.5
DL LOS19

unknown artist
Sir Henry Moreton Havelock-Allan
oil on canvas 92 x 69 (E)
468

unknown artist
Sir John Harbottle (1858–1920)
oil on canvas 91 x 71
DL LOS29

unknown artist
The Welcome
oil on panel 26 x 21 (E)
317

unknown artist
*Thomas Bowes (1777–1846), Bailiff of
Darlington (1816–1846)*
oil on canvas 77 x 61.5
DL LOS8

unknown artist
Unknown Man
oil on canvas 76 x 64
471

unknown artist
William Emerson of Hurworth (1701–1782)
oil on canvas 28.8 x 24.5
DL L290

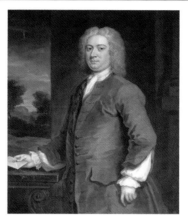

Vanderbank, John c.1694–1739
Robert Surtees of Redworth (1694–1785)
oil on canvas 120 x 75 (E)
454

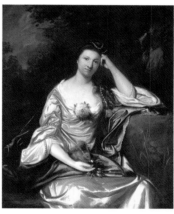

Vanderbank, John (attributed to)
c.1694–1739
*Dorothy Lampton of Hardwick, Wife of Robert
Surtees*
oil on canvas 120 x 75 (E)
455

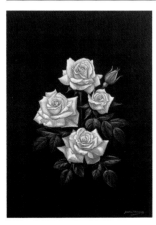

Wallace, Aidan b.1903
Yellow Roses on Black Velvet
oil on velvet 35.5 x 25.5
125

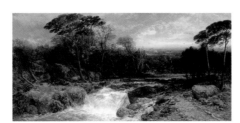

Webb, James 1825–1895
Mountain Torrent 1871
oil on canvas 60 x 119 (E)
445

White, Ethelbert 1891–1972
Woods
oil on board 51 x 40.5
191

Wicksteed, Owen 1904–1999
View of the Queen Elizabeth Grammar School
early 1980s
oil on board 40.7 x 53
DL D165

Wigston, John Edwin b.1939
The Stockton and Darlington Railway 1975
oil on canvas 149 x 165 (E)
DL LOS76

Wilson, Henry active 20th C
Landscape
oil on canvas 96.5 x 125
365

Darlington
Railway Museum

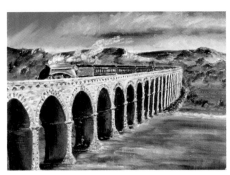

Carr, Ann active 1987
*Mallard'**
oil on canvas 33.6 x 44
1999.135

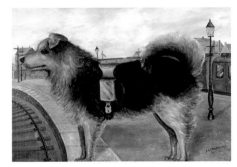

Glendenning, J. A.
A Collecting Dog 1906
oil on canvas 73 x 92.5
1998.64

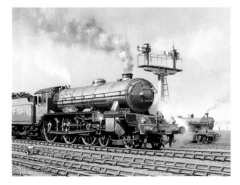

Richardson, Warwick
'Darlington' 1991
oil on canvas 48 x 58
1991.579

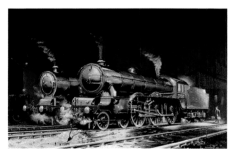

Wigston, John Edwin b.1939
'Darlington' 1975
oil on canvas 88.5 x 107
1991.435

Durham City Council

The City of Durham Council can trace its roots back to the late twelfth century when the Bishop of Durham granted the City its first charter. From then to the 1830s the Bishops retained a large degree of control over the City and the road to full civic autonomy was a long and difficult one. Consequently Durham Town Hall and Guildhall are a source of great pride for the City, the Council and its citizens, not just because they comprise a fine building but also because they represent the culmination of this struggle and the continuation of the City Council into the present.

An integral part of the building, its story and significance is its collection of 66 oil paintings. Just under half are portraits of former civic dignitaries of Durham ranging from the late eighteenth century to the first half of the twentieth century. In the past these paintings have been overlooked and sometimes undervalued. The work of the Public Catalogue Foundation in cataloguing them has allowed these portraits to be enlivened through exposing their original colour, detail and technique. This presents an opportunity for reappraisal not only of the artists but their subjects and how their individual stories weave into the wider story of the Town Hall and the City. For example, Clement Burlison's 1853 full-length portrait of William Henderson, who was mayor between 1848 and 1849, shows the sitter seated holding in his hands a scroll on which can be deciphered the architect P. C. Hardwick's plans for the extension of the Town Hall (opened in 1851).

The other paintings within the Collection comprise portraits of local historical figures and the Burlison Bequest. Of the portraits the most engaging is Edward Hastings' portrait of Count Boruwlaski, the Polish-born aristocrat, only 39 inches tall, who ended his days in the City after touring the courts of late eighteenth-century Europe. The Burlison Bequest is a collection of work mostly by the local artist Clement Burlison (1803–1899) donated to the City by his widow shortly after his death in 1899. Located within the Burlison Room of the Town Hall since the 1920s, the Collection is a mix of landscapes, copies of old masters and animal studies that collectively illustrate another side of an artist who was principally known for his portraiture.

Change is a constant: Durham will undergo a major reshaping of local government in 2009. The City Council will cease to exist, but our legacy will be the rich architectural gem of Durham Town Hall with its associated paintings, artefacts and ephemera. The catalogue produced by the Public Catalogue Foundation at last allows all to really appreciate the artistic and cultural depth of a significant section of this legacy.

Fraser Reynolds, Leader of Durham City Council

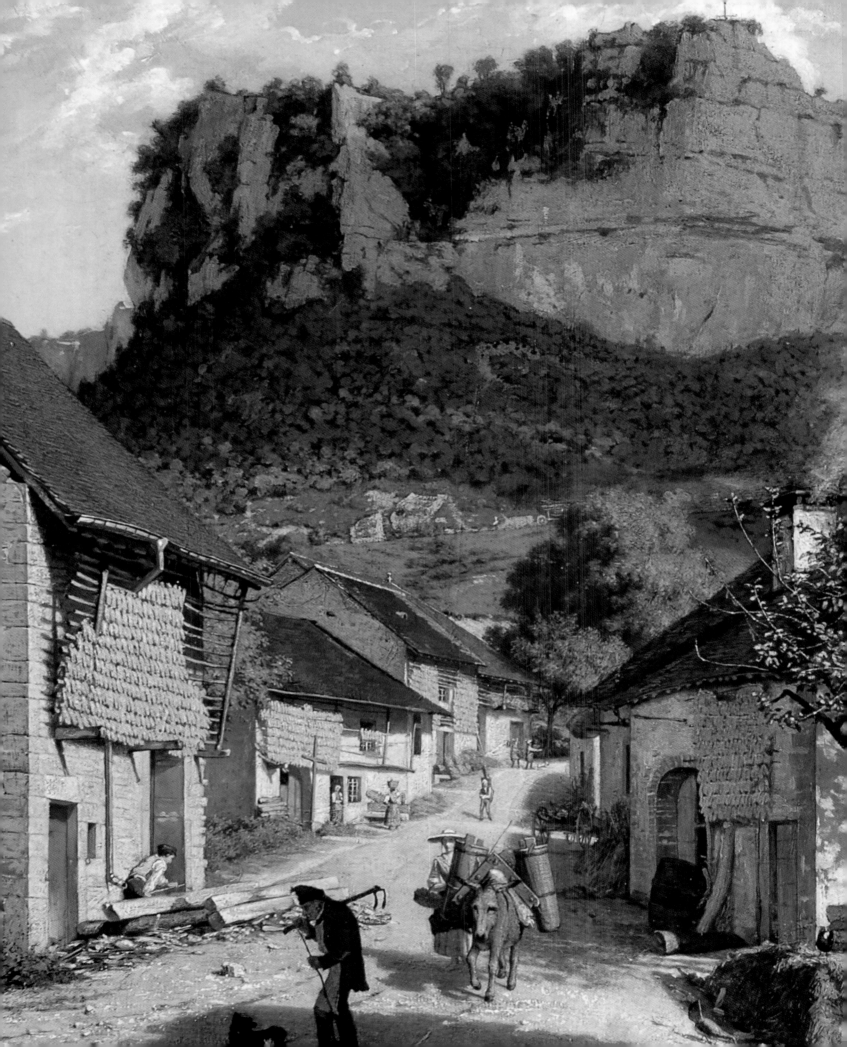

Burlison, Clement 1803–1899
John Philip Kemble (1758–1822), as Hamlet
(copy after Thomas Lawrence) c.1835–1844
oil on canvas 155 x 110 (E)
COD_043_OL

Burlison, Clement 1803–1899
Cain and Abel c.1835–1846
oil on board 34 x 27.1
COD_001_OL

Burlison, Clement 1803–1899
Madonna and Child with St Jerome
(copy after Bartolomé Esteban Murillo)
c.1835–1846
oil on board 39.7 x 27.7
COD_007_OL

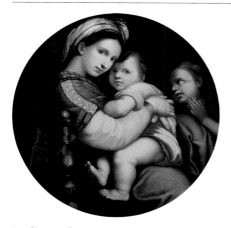

Burlison, Clement 1803–1899
Madonna della Sedia (copy after Raphael)
c.1835–1846
oil on canvas 74
COD_017_OL

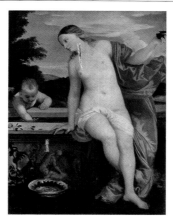

Burlison, Clement 1803–1899
Profane Love (copy after Titian) c.1835–1846
oil on canvas 62.1 x 49.7
COD_029_OL

Burlison, Clement 1803–1899
The Dogana, San Giorgio, Venice, Italy
(copy after Joseph Mallord William Turner)
c.1835–1846
oil on canvas 61 x 92
COD_013_OL

Burlison, Clement 1803–1899
Landscape (after Salomon van Ruysdael)
c.1840–1844
oil on canvas 43.7 x 51
65

Burlison, Clement 1803–1899
The Village Festival (copy after David Wilkie)
1843
oil on canvas 97.2 x 130
63

Burlison, Clement 1803–1899
Madonna and Child with St Catherine and a Rabbit (recto) (copy after Titian) 1844
oil on canvas (?) 39 x 47
COD_010_OL

Facing page: Mire, Noël Jules le, 1814–1878, *View of Arbois in the Jura, France* (detail), The Bowes Museum, (p. 133)

Burlison, Clement 1803–1899
Conversation Piece (verso)
oil on canvas 39 x 47
COD_010_OL

Burlison, Clement 1803–1899
Self Portrait (copy of Anthony van Dyck)
c.1844
oil on canvas 51.5 x 44.6
COD_006_OL

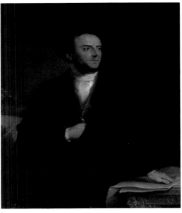

Burlison, Clement 1803–1899
*John Bramwell (1794–1882), Mayor of
Durham (1840–1842, 1845–1846 &
1852–1853)* 1847
oil on canvas 140 x 114 (E)
COD_034_OL

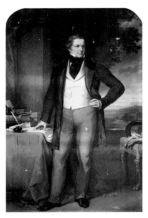

Burlison, Clement 1803–1899
*Sir Robert Peel (1788–1850), 2nd Bt, Prime
Minister* 1852
oil on canvas 275 x 160 (E)
COD_048_OL

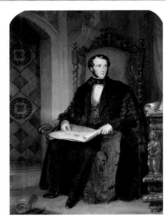

Burlison, Clement 1803–1899
*William Henderson (1813–1891), Mayor of
Durham (1848–1849)* 1853
oil on canvas 230 x 150 (E)
COD_044_OL

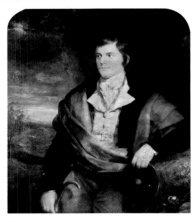

Burlison, Clement 1803–1899
Robert Burns (1759–1796) 1859
oil on canvas (?) 130 x 104 (E)
COD_042_OL

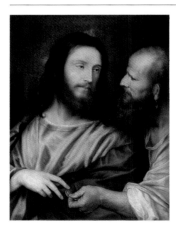

Burlison, Clement 1803–1899
The Tribute Money (copy after Titian) 1868
oil on canvas 79 x 61.5
COD_020_OL

Burlison, Clement 1803–1899
Mrs Horner's Dog 1872
oil on canvas 25.5 x 30.8
COD_005_OL

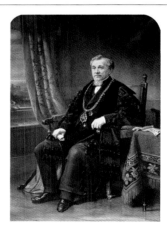

Burlison, Clement 1803–1899
*Alderman James Fowler (1816–1894), JP,
Mayor of Durham (1872–1873, 1881–1884 &
1886–1887)* 1883
oil on canvas 230 x 150 (E)
COD_045_OL

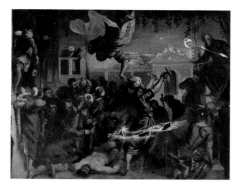

Burlison, Clement 1803–1899
Abraham Sacrificing Isaac (?)
oil on canvas 43 x 54
64

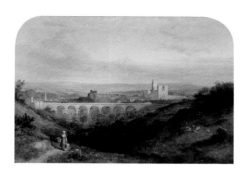

Burlison, Clement 1803–1899
Durham
oil on canvas 71.5 x 102.5
COD_023_OL

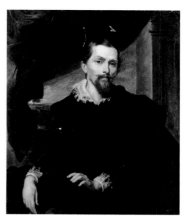

Burlison, Clement 1803–1899
Frans Snyders (1579–1657) (after Anthony van Dyck)
oil on board 35 x 29.5
COD_004_OL

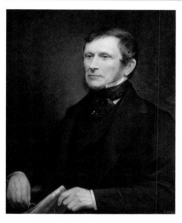

Burlison, Clement 1803–1899
John Fawcett (1800–1883), JP
oil on board 74.5 x 61.5 (E)
COD_056_OL

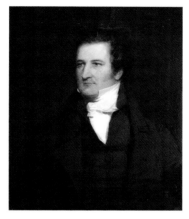

Burlison, Clement 1803–1899
Reverend Dr James Raine (1791–1858), Mayor's Chaplain (1836–1858)
oil on board 75.2 x 63.5 (E)
COD_059_OL

Burlison, Clement 1803–1899
The River Tees near Wynch Bridge
oil on canvas 105 x 155
COD_027_OL

Burlison, Clement 1803–1899
Venice by Sunset, Italy
oil on canvas 20.8 x 43.5
COD_008_OL

Burlison, Clement 1803–1899
White Cat
oil on canvas 76.5 x 64
COD_025_OL

Burlison, Clement (attributed to)
1803–1899
Flora (copy after Titian) c.1835–1846
oil on canvas 79 x 63.5
COD_0112_OL

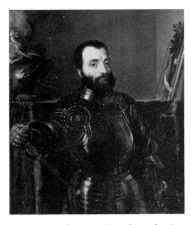

Burlison, Clement (attributed to)
1803–1899
Francesco Maria della Rovere, Duke of Urbino (1490–1538) (copy after Titian) c.1835–1846
oil on panel 24.9 x 21
COD_003_OL

Burlison, Clement (attributed to)
1803–1899
An Italian Girl (possibly Grazia) 1845
oil on canvas 74 x 61
COD_014_OL

Burlison, Clement (attributed to)
1803–1899
Portrait of a Civic Official (possibly Thomas Hutton, 1815–1891, or George (…) 1866
oil on board 130 x 104 (E)
COD_035_OL

Burlison, Clement (attributed to)
1803–1899
James Fowler (1816–1894) 1883
oil on canvas 125 x 98 (E)
COD_038_OL

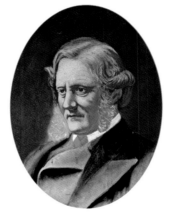

Burlison, Clement (attributed to)
1803–1899
Self Portrait
oil on canvas 30 x 22
COD_002_OL

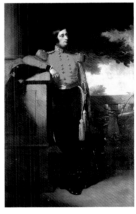

Burlison, Clement (attributed to)
1803–1899
Lord Aldophus Vane-Tempest (1825–1864)
oil on canvas 237.5 x 143.5 (E)
COD_030_OL

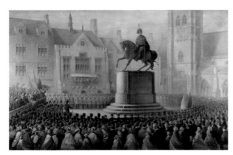

Burlison, Clement (attributed to)
1803–1899
Unveiling the Statue of the 3rd Marquess of Londonderry in Durham Market Place (…)
oil on canvas 94 x 142.5 (E)
COD_019_OL

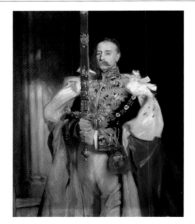

Cooke, John 1866–1932
Charles Vane-Tempest-Stewart (1852–1915), KG, 6th Marquess of Londonderry, Carrying the Sword of State (…) 1902
oil on canvas 150 x 119 (E)
COD_037_OL

Davison, William 1808–1870
View of Durham Looking towards Crook Hall
oil on canvas 87 x 122.2
COD_024_OL

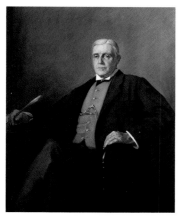

Egan, Wilfred B. active 1901–1909
John Lloyd Wharton (1837–1912)
oil on canvas 128 x 102
COD_018_OL

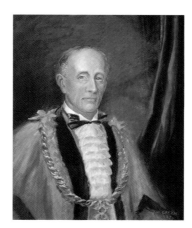

Green, J. W.
*Charles Stewart Henry Vane-Tempest-Stewart
(1878–1949), 7th Marquess of Londonderry*
1937
oil on board 73 x 61.5 (E)
COD_053_OL

Hastings, Edward 1781–1861
Houghall Milk Boy 1855
oil on board 38.5 x 30
COD_009_OL

Hastings, Edward 1781–1861
Count Joseph Boruwlaski (1739–1837)
oil on canvas 143.2 x 92
COD_026_OL

Hastings, Edward 1781–1861
Robert Thwaites (1788–1863), Mayor (1849)
oil on canvas 75 x 60 (E)
COD_046_OL

Hastings, Edward 1781–1861
Thomas Greenwell (d.1839), Mayor (1836)
oil on canvas 150 x 120 (E)
COD_041_OL

Hedley, Ralph 1848–1913
Portrait of a Civic Official (probably Matthew
Fowler, 1846–1898)
oil on canvas (?) 140 x 130 (E)
COD_032_OL

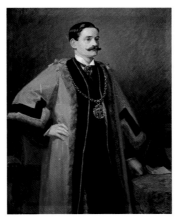

Hedley, Ralph (attributed to) 1848–1913
*John George Lambton (1855–1928), Earl of
Durham* 1899
oil on canvas 146 x 117 (E)
COD_036_OL

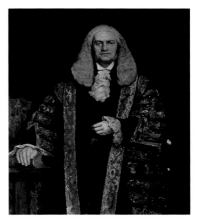

Herkomer, Hubert von (attributed to)
1849–1914
*Rt Hon Farrer (1837–1899), 1st Baron
Herschell, CGB, MP for Durham (…)* 1901 (?)
oil on canvas 140 x 115 (E)
COD_031_OL

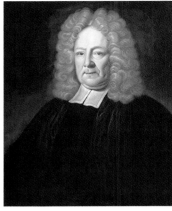

Kneller, Godfrey (attributed to) 1646–1723
Reverend W. Hartwell (1655–1725)
oil on board 74 x 61 (E)
COD_057_OL

Leak, Nicholas
Durham Fantasy 1996
oil on wood 120 x 168.5 (E)
COD_028_OL

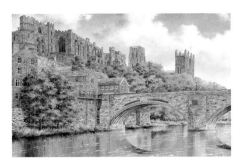

Madgin
View of Durham Cathedral on its 900th Anniversary 1993
oil on board 59 x 89.5 (E)
COD_016_OL

Orde, Cuthbert Julian 1888–1968
The Most Honourable Charles Stewart Henry Vane-Tempest Stewart (1878–1949), 7th Marquess of Londonderry, KG (…)
oil on canvas 126 x 101 (E)
COD_015_OL

Ouless, Walter William 1848–1933
John Lloyd Wharton (1837–1912), of Dryburn, Durham 1891
oil on canvas 112 x 87
COD_021_OL

Patterson
Mrs Hannah Harrison Rushford (1887–1965), JP
oil on canvas 100 x 75 (E)
COD_049_OL

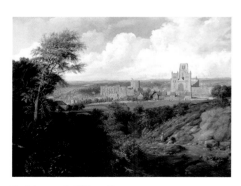

Robinson, William R. 1810–1875
View of Durham Cathedral from Crossgate Peth 1844
oil on canvas 124 x 193
COD_022_OL

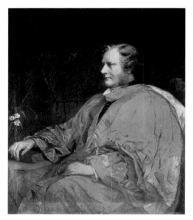

Storey, George Adolphus 1834–1919
Thomas Charles Thompson (1821–1892), MP for Durham (1880–1885)
oil on canvas 155 x 130 (E)
COD_040_OL

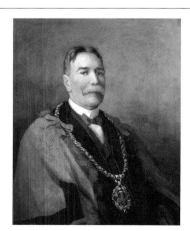

Tuke, Lilian Kate 1873–1946
Robert McLean (1858–1930), JP, Mayor of Durham (1912 & 1922)
oil on board 74 x 59 (E)
COD_054_OL

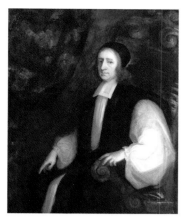

unknown artist early 18th C
*Nathaniel, Lord Crewe (1633–1721), Bishop of
Durham (1674–1721)*
oil on canvas 125 x 100 (E)
COD_060_OL

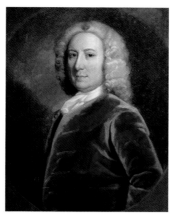

unknown artist 18th C
*John Fawcett, Recorder of Durham
(1719–1760)*
oil on canvas 71.5 x 61 (E)
COD_050_OL

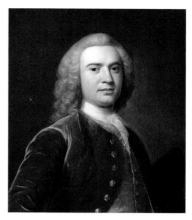

unknown artist 18th C
*Robert Wharton (1690–1752), Mayor of
Durham (1729–1730 & 1736–1737)*
oil on board 63 x 52.5 (E)
COD_058_OL

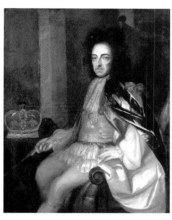

unknown artist 18th C
William III (1650–1702)
oil on canvas 125 x 100 (E)
COD_061_OL

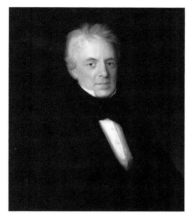

unknown artist early 19th C
William Shields, Mayor (1824)
oil on canvas 75 x 60 (E)
COD_047_OL

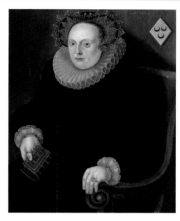

unknown artist mid-19th C
Matilda Lyle (copy after an earlier painting)
oil on wood panel 83.6 x 67
COD_011_OL

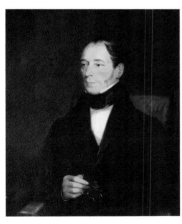

unknown artist 19th C
Dr Fenwick (1761–1856), JP
oil on canvas 89.5 x 73 (E)
COD_062_OL

unknown artist 19th C
Portrait of a Civic Official
oil on canvas (?) 140 x 114 (E)
COD_033_OL

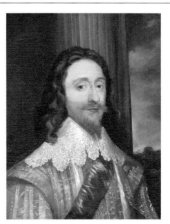

unknown artist
Charles I (1600–1649)
oil on canvas 65.5 x 50 (E)
COD_051_OL

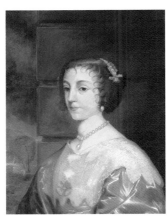

unknown artist
Henrietta (1626–1649)
oil on canvas (?) 65.5 x 50 (E)
COD_052_OL

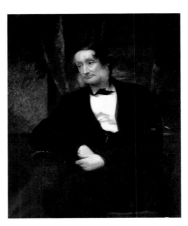

unknown artist
Rowland Burdon, Esq.
oil on canvas (?) 150 x 120 (E)
COD_039_OL

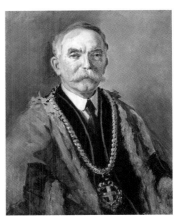

Wood, Frank 1904–1985
Alderman P. J. Waite (1863–1941) 1926
oil on board 62.5 x 50 (E)
COD_055_OL

Durham County Council

Durham County Council was established in 1889 and had a number of offices throughout the City until the opening of Shire Hall in Old Elvet in 1898 enabled it to centralise its operations. The County Council purchased the existing site in 1942 and the current County Hall building was opened by Prince Philip in 1963. The building was carefully designed not to conflict in any way with the Cathedral and Castle.

There are three large murals in the current County Hall, two of which were created especially for the new building. One by Thomas William Pattison shows the building of Durham Cathedral; the second by Norman Cornish is entitled *Durham Miners' Gala Day Scene* and shows men, women and children enjoying a Miners' Gala. The third mural was commissioned in 1989 to commemorate 100 years of the County Council. The artist Julian Cooper has depicted scenes from the modern and historic County, including the original Shire Hall and the current County Hall.

The majority of the paintings listed in the Catalogue are part of the Collection belonging to Durham Learning Resources. Durham Learning Resources is part of the Libraries, Learning and Culture section of Adult and Community Services and it loans books and other related items which support the curriculum to subscribing schools within the County. The collection of paintings was established in the early 1960s as a way of showcasing modern British art to schools. Some of the Collection is also displayed within County Hall and exhibitions are arranged from time to time at the Durham Art Gallery which is part of the Durham Light Infantry Museum at Aykley Heads.

I would like to thank the Public Catalogue Foundation for their work of recording the works of art owned by the County Council, together with other works of art in public ownership in the County. I am sure the Catalogue will be of interest to a wide audience.

Simon Henig, Leader, Durham County Council

Facing page: Hastings, Edward, 1781–1861, *Count Joseph Boruwlaski (1739–1837)* (detail), Durham City Council, (p. 267)

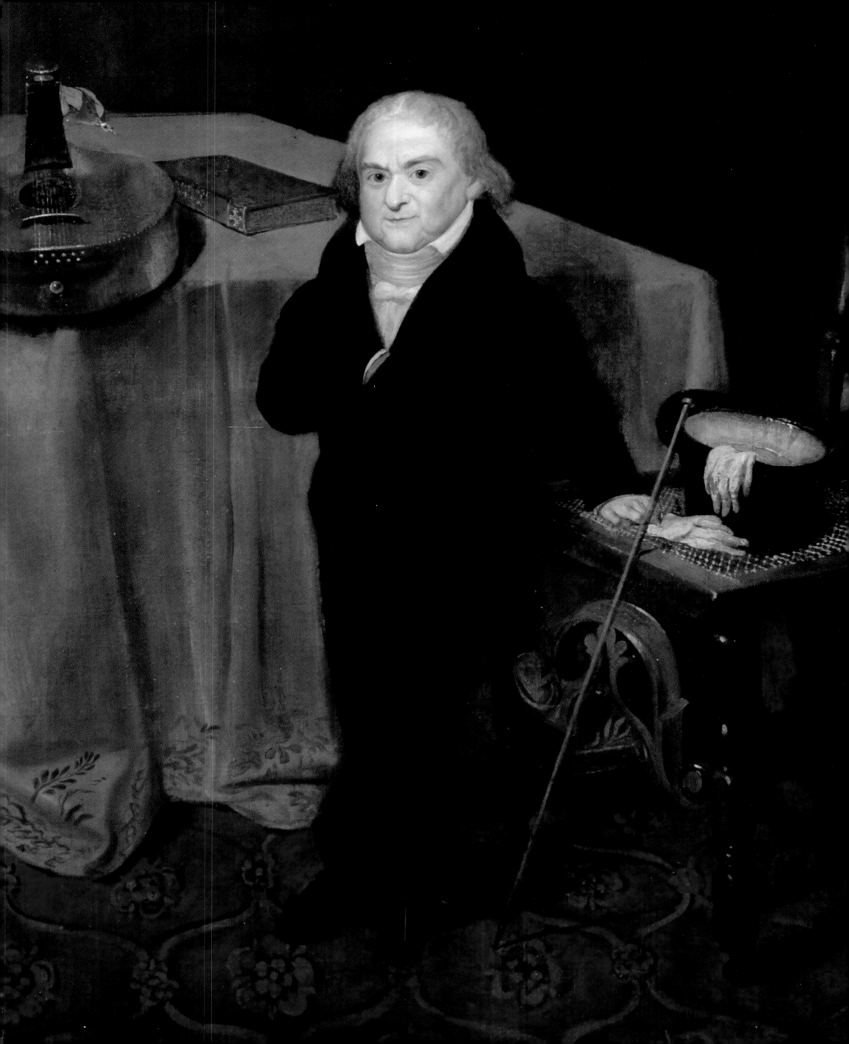

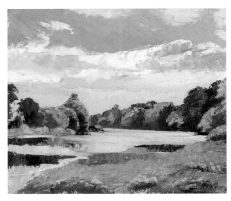

Almond, Henry N. 1918–2000
The River Tees at Neasham, County Durham
oil on board 36 x 41.5
AFO.0010

Awan, Sara
Hospital 1
oil on panel 16 x 31 (E)
AFO.4010

Awan, Sara
Hospital 2
oil on canvas 21 x 27 (E)
AFO.4011

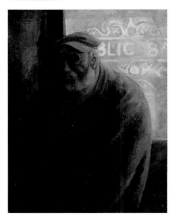

Ayrton, Michael 1921–1975
Pub
oil on board 56 x 43
AFO.0035

T. E. B.
Gatehouse at Greencroft Towers, County Durham
acrylic on board 33.5 x 48 (E)
L4

Bell, D. active 1974
Barnard Castle Station, County Durham
oil on board 41 x 51
AFO.0472

Bell, D. active 1974
Early Engine at Night
oil on board 30.5 x 48.5
AFO.0469

Bell, D. active 1974
Kirkby Stephen Station, Cumbria (North Eastern Railway)
oil on board 46 x 56 (E)
AFO.0468

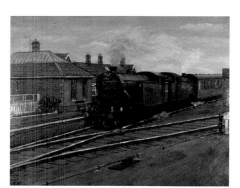

Bell, D. active 1974
Middleton-in-Teesdale Station
oil on board 46 x 56 (E)
AFO.0559

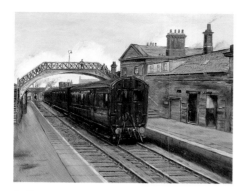

Bell, D. active 1974
Monkwearmouth Station, Sunderland, Tyne and Wear
oil on board 39 x 49.5
AFO.0473

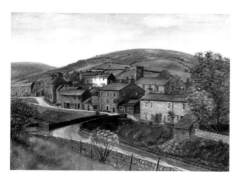

Bell, D. active 1974
Muker, Yorkshire
oil on board 46 x 56
AFO.0470

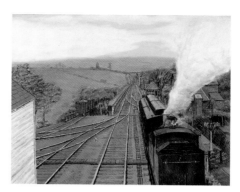

Bell, D. active 1974
Ravenstonedale Station, Cumbria
oil on board 40.5 x 51
AFO.0474

Burns, Joanne b.1959
Durham Cathedral from the Riverbank 1991
oil on panel 19 x 22.5
AFO.4027

Burns, Joanne b.1959
Durham Cathedral Looking Southeast 1991
oil on panel 21 x 27
AFO.4029

Burns, Joanne b.1959
Durham Cathedral Looking West 1991
oil on panel 20 x 24
AFO.4028

Burns, Joanne b.1959
View from Prebends Bridge with Cobalt 2 1991
oil on panel 20 x 26.2
AFO.4030

Cook, Beryl 1926–2008
Two on a Stool 1991
oil on board (?) 36.3 x 24.2
AFO.4007

Cooper, Herbert 1911–1979
Cows in a Byre
oil on board 42.5 x 40
AFO.1048

Cooper, Julian b.1947
The Durham County Council Centenary 1989
oil on canvas 190 x 457
1

Cornish, Norman Stansfield b.1919
A Durham Miners' Gala Day Scene 1963
oil on board (?) 173 x 937
3

Cornish, Norman Stansfield b.1919
Bar Scene, Spennymoor, County Durham
oil on board 57 x 74 (E)
AFO.0019

Cornish, Norman Stansfield b.1919
Durham Miners' Gala Day Scene (Cartoon)
oil on board 53 x 270
AFO.0243

Cornish, Norman Stansfield b.1919
The Crowd at Gala Day (detail)
oil on board 60 x 150
AFO.0245

Cornish, Norman Stansfield b.1919
The Crowd at Gala Day (detail)
oil on board 60 x 150
AFO.0246

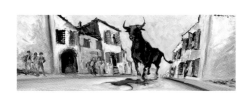

Corrigan, Cavan b.1942
Abbrivado II
oil on board 45 x 122
AFO.0343

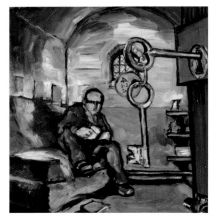

Corrigan, Cavan b.1942
Cell
oil on board (?) 54 x 51 (E)
AFO.0293

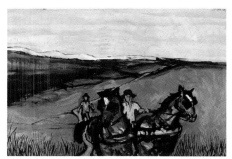

Corrigan, Cavan b.1942
Landscape with Horses
oil on paper (?) 36.5 x 54
AFO.0292

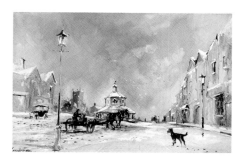

Corrigan, Cavan b.1942
Market Cross, Barnard Castle, County Durham
oil on board 61 x 92
AFO.0817

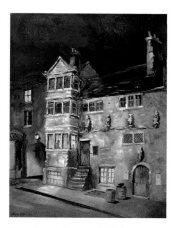

Corrigan, Cavan b.1942
Old Blagraves, Barnard Castle, County Durham
oil on board 101 x 76
AFO.0852

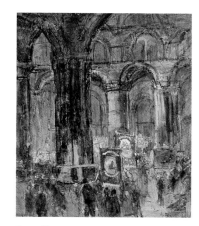

Dewell, Anne
Durham Cathedral, the Big Meeting, 1965
oil on board 82 x 66 (E)
AFO.4004

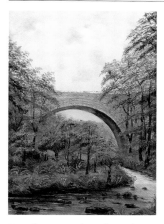

Dundas, R. A. (attributed to)
Causey Arch, Newcastle-upon-Tyne, Tyne and Wear 1912
oil on canvas 51 x 36
L2

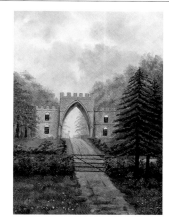

Dundas, R. A. (attributed to)
Gatehouse at Greencroft Towers, County Durham 1912
oil on canvas 51 x 36
L3

Everard
Shotton Colliery, Durham 1967
oil on canvas board 75 x 106
AFO.0374

Fawcett, Brian active 1980–1984
Building the World's Highest Railway, Peru, c.1870 1980
oil on board 44 x 36 (E)
AFO.0837

Fawcett, Brian active 1980–1984
Stalemate at the Causey Arch on Tanfield Wagonway, County Durham, 1750 1980
oil on board 42.5 x 35.5 (E)
AFO.0821

Fawcett, Brian active 1980–1984
Trouble with Raven's Dream Electric Locomotive, 1922 1983
oil on board 37 x 43 (E)
AFO.0915

Fawcett, Brian active 1980–1984
David Gordon's Steam Coach, 1830 1984
oil on board 35.5 x 43.2 (E)
AFO.0976

Fawcett, Brian active 1980–1984
Minerals Transport in the Andes of Peru 1984
oil on board 36 x 53 (E)
AFO.0975

Fell, Sheila Mary 1931–1979
Harbour, Maryport, Cumbria
oil on canvas 45 x 55 (E)
AFO.0135

Foster, Norman
Miner's Cottage, Early Twentieth Century 1970
oil on canvas (?) 54 x 79
AFO.0316

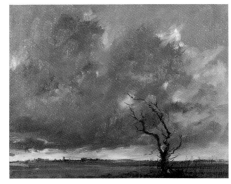

Furness, Robin b.1933
The Storm Cloud
oil on canvas 32 x 37
AFO.0682

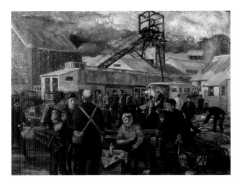

Gordon, W. active 1970
Pithead Incident
oil on canvas board 60 x 81
AFO.0315

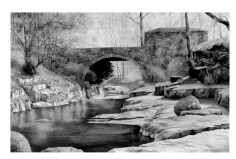

Haire, A. L. active 1976
Greta Bridge, Barnard Castle, County Durham
oil on canvas 61 x 92
AFO.0703

Harper, Andy b.1971
Bounty 2004
oil on camas 26 x 34.5
AFO.4012

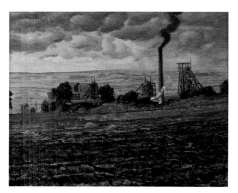

Heslop, Robert John 1907–1988
Dean and Chapter Colliery, Ferryhill, County Durham, at Night 1970
oil on board (?) 31.5 x 38.5
AFO.0361

Heslop, Robert John 1907–1988
Fillers at Work 1972
oil on board 36 x 61
AFO.0365

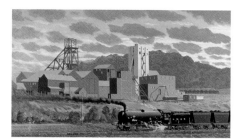

Heslop, Robert John 1907–1988
Mainsforth Colliery, County Durham, c.1950
1973
oil on board 40 x 66
AFO.0466

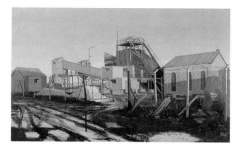

Heslop, Robert John 1907–1988
Whitworth Park Colliery, Spennymoor, County Durham 1973
oil on board 47 x 70
AFO.0389

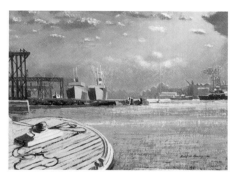

Heslop, Robert John 1907–1988
Coal Drops, Sunderland, Tyne and Wear 1974
oil on board 28 x 36
AFO.0696

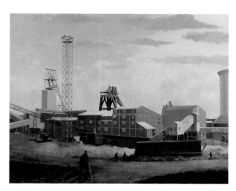

Heslop, Robert John 1907–1988
Horden Colliery, County Durham 1974
oil on board 60 x 76
AFO.0591

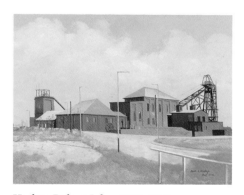

Heslop, Robert John 1907–1988
Usworth Colliery, Sunderland, Tyne and Wear
1974
oil on board 36 x 40
AFO.0554

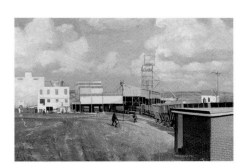

Heslop, Robert John 1907–1988
East Hetton Colliery, County Durham 1976
oil on board 37 x 55.5
AFO.0694

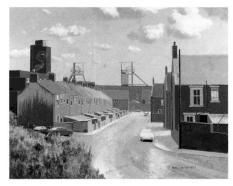

Heslop, Robert John 1907–1988
Easington Colliery, County Durham 1977
oil on board 60 x 75 (E)
AFO.0736

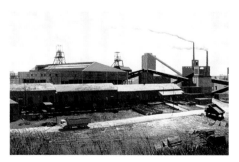

Heslop, Robert John 1907–1988
Fishburn Colliery and Part of the By-Product Plant, County Durham
oil on board (?) 40 x 65 (E)
AFO.0437

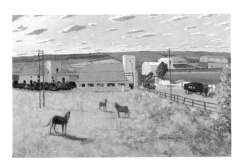

Heslop, Robert John 1907–1988
Langley Park Colliery, County Durham
oil on board 43 x 62
AFO.0693

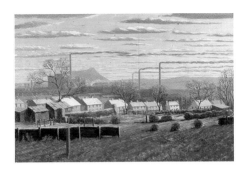

Heslop, Robert John 1907–1988
View of Spennymoor, County Durham
oil on board (?) 47 x 63
AFO.0359

James, Louis 1920–1996
The Urchin
oil on canvas 77 x 36.2
AFO.0034

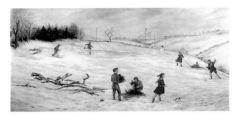

Kipling, Mary Jane 1912–2004
Winter
acrylic on board 106 x 213.5
L7

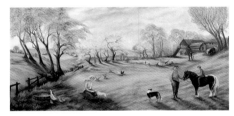

Kipling, Mary Jane 1912–2004
Spring
acrylic on board 106 x 213.5
L6

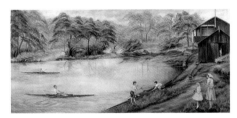

Kipling, Mary Jane 1912–2004
Summer, Ebchester Boathouse, County Durham
acrylic on board 106 x 213.5
L5

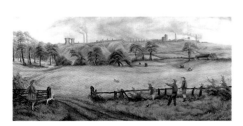

Kipling, Mary Jane 1912–2004
Autumn
acrylic on board 106 x 213.5
L8

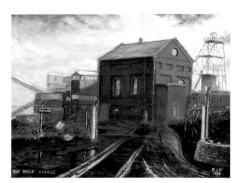

Lay, R.
'The Nack', Seaham, County Durham 1988
oil on canvas 35.5 x 45.5
L1

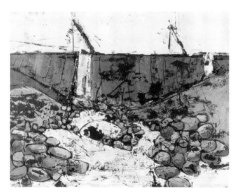

Long, E. M. active 1974
Cow Green Dam
acrylic on paper 58 x 70
AFO.0529

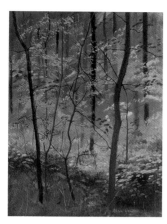

Lowes, Alan
Castle Eden Dene, County Durham
acrylic on paper 34 x 25
AFO.4032

MacTaggart, William 1903–1981
Landscape
oil on board 34 x 38
AFO.0018

Marshall, Anthony d.2007
Harlem Dance Theatre, Firebird 2006
acrylic on paper (?) 38.5 x 22.5
AFO.4018

McGuinness, Tom 1926–2006
Meeting Station
acrylic on paper 16 x 54
AFO.0636

Meninsky, Bernard 1891–1950
The Fruit-Gatherers
oil on canvas 40 x 50 (E)
AFO.0061

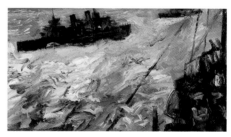

Minton, John 1917–1957
Atlantic Convoy
oil on board (?) 22.5 x 36
AFO.0210

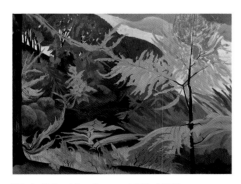

Nash, John Northcote 1893–1977
Berkshire Woods
oil on canvas 60 x 80
AFO.0038

Oliver, Peter 1927–2006
The Pier
oil on board 29.5 x 79
AFO.0013

Ortlieb, Evelyn 1925–2008
Series 1 'O'
mixed media on paper 16.2 x 13.2 (E)
AFO.0348

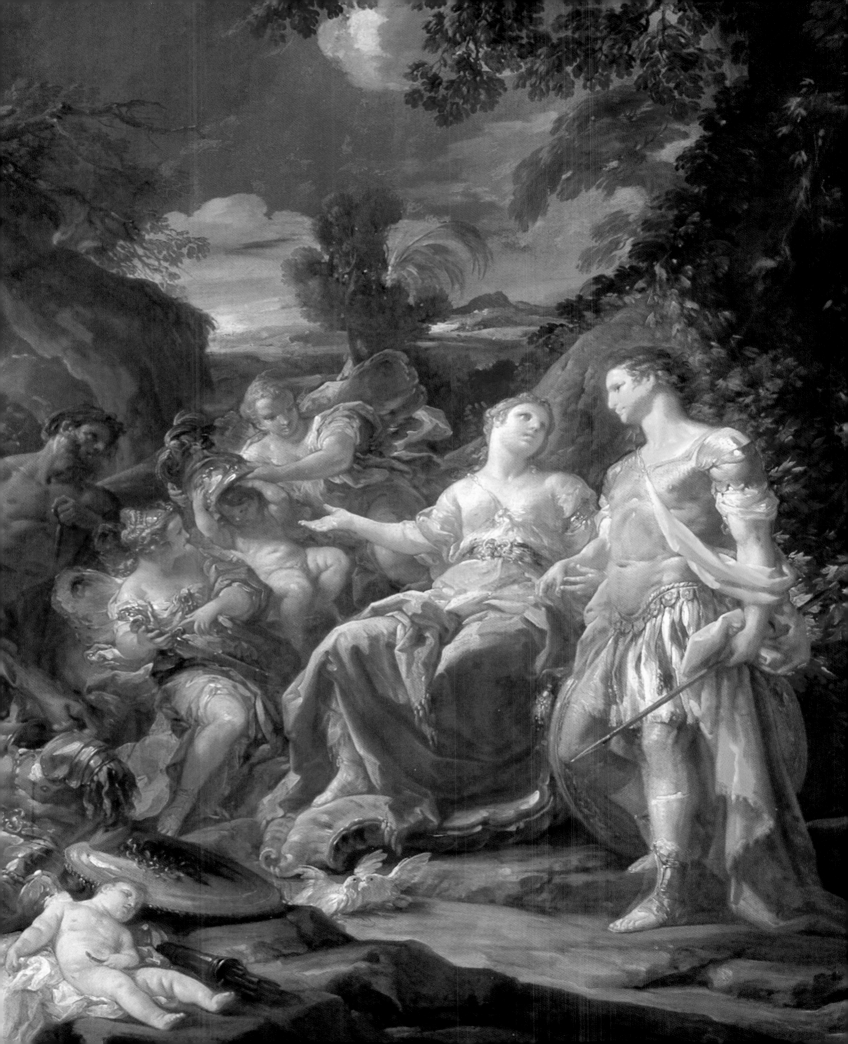

Pattison, Thomas William 1894–1993
The Building of Durham Cathedral
oil on canvas (?) 182 x 716
2

Peace, John b.1933
Colliery Engines in the Snow 1962
oil on board 46 x 71
AFO.0076

Philipson, Robin 1916–1992
Crowing Cock
oil on board 26 x 18
AFO.0042

Pinkney, Arthur
Consett, County Durham
oil on board 51 x 121.5
AFO.0894

Pittuck, Douglas Frederick 1911–1993
Stockton-on-Tees 1975
oil on board 47.5 x 60.5
AFO.0620

Pittuck, Douglas Frederick 1911–1993
*Derelict House, Bridgegate, Barnard Castle,
County Durham*
oil on board 54 x 38 (E)
AFO.0012

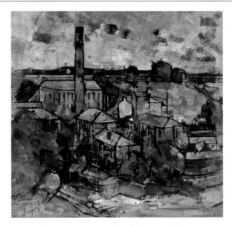

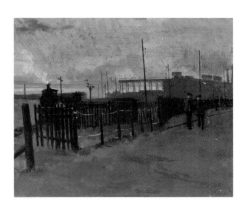

Pittuck, Douglas Frederick 1911–1993
Raby Castle, County Durham
oil on board (?) 69 x 100
AFO.0339

Pittuck, Douglas Frederick 1911–1993
Ullathorne Mill, Startforth, County Durham
oil on board 61 x 61
AFO.0420

Purvis, Owen S. active 1971–1983
Early Morning, Dawdon, County Durham
oil on board 35 x 42
AFO.0319

Facing page: Giaquinto, Corrado, 1703–1765, *Venus Presenting Arms to Aeneas* (detail), The Bowes Museum, (p. 99)

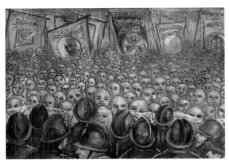

Purvis, Owen S. active 1971–1983
Langleydale, County Durham
oil on board 53 x 66
AFO.0933

Robinson, J. active 1985
Seascape
oil on board 30 x 60.5
AFO.1034

Robson, George b.1945
Confrontation 2006
oil on canvas 75 x 100
4

Rowntree, Kenneth 1915–1997
Saloon Bar Cat
oil on board 17.2 x 9.5 (E)
AFO.0022

Sangster, B. active 1972–1973
Loading Point 1972
oil on canvas 56 x 81
AFO.0386

Sangster, B. active 1972–1973
Breaking In
oil on canvas (?) 29 x 39
AFO.0388

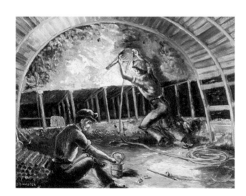

Sangster, B. active 1972–1973
Drilling on the Caunce
oil on canvas (?) 39 x 49
AFO.0387

Smith, Vanessa
Head On 2004
oil & acrylic on board 44 x 49
AFO.4013

Spender, John Humphrey 1910–2005
Rock Pools and Cave 1958
oil on board 62 x 88
AFO.0078

Sutherland, Brian b.1942
Stick Man 1969
oil on canvas 75 x 121 (E)
AFO.0327

Tait, Karen b.1971
Seashore II
oil on canvas 53 x 78
AFO.4020

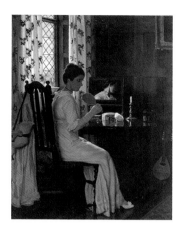

Thompson, Stanley b.1876
Chintz Curtains
oil on canvas 90.5 x 70.5
AFO.0032

Tindle, David b.1932
The Lock Gate at Dundee, Scotland
oil on canvas 61 x 91
AFO.0033

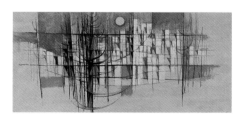

Tuckwell, George Arthur 1919–2000
Arab Town
oil on board (?) 27.5 x 59 (E)
AFO.0036

Wigston, John Edwin b.1939
'Rocket' on the Liverpool and Manchester Railway 1975
oil on board 91.5 x 71
AFO.0635

Wigston, John Edwin b.1939
'Royal George' by Timothy Hackworth's Cottage 1975
oil on canvas 70 x 100 (E)
AFO.0561

Wigston, John Edwin b.1939
Middlesbrough Suspension Bridge 1977
oil on canvas 71.5 x 61
AFO.0735

Wigston, John Edwin b.1939
'The Globe' Locomotive 1978
oil on canvas 47 x 51 (E)
AFO.0772

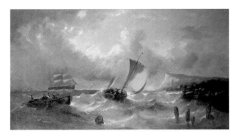

Williamson, William Henry 1820–1883
Boats in a Squall off a Coastline
oil on canvas 74 x 126
AFO.0317

Durham Light Infantry Museum

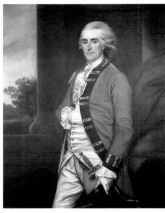

British School
John Bridges Schaw (1744–after 1797), 68th Regiment of Foot (1769–1797), Colonel (1795–1797) c.1775
oil on canvas 124.5 x 99
DLI:P50

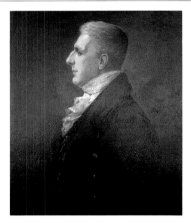

British School
Major George Champion de Crespigny (1788–1813) (killed in action at Vittoria at the head of the 68th Light Infantry) c.1810
oil on canvas 76 x 65
DLI:P48

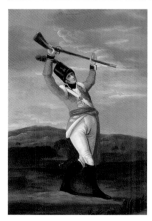

British School
Sergeant of the 68th Durham Light Infantry c.1810
oil on canvas 52 x 35 (E)
DURLI:849

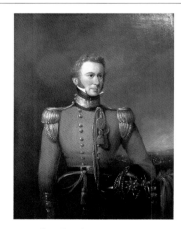

British School
A Major of the 68th Light Infantry (possibly Major John Reed) 1829
oil on canvas 45 x 34
DLI:P45

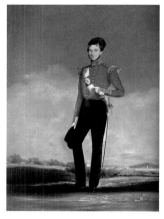

British School
H. E. I. Coy's 2nd Bombay European Light Infantry Officer 1840
oil on canvas 40 x 30
DLI:P46

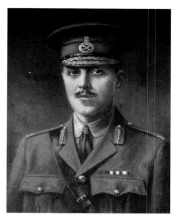

British School
Brigadier General R. B. Bradford (1892–1917), VC, MC, Durham Light Infantry (…)
oil on canvas 76 x 61
DLI:P36

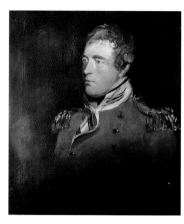

British School
James O'Callaghan, Durham Militia (1798–1816), Colonel (1805–1816)
oil on canvas 75 x 62
DLI:P37

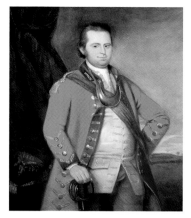

British School
Lieutenant Crosier Surtees (1739–1803), Durham Militia (1759–1761)
oil on canvas 123 x 98 (E)
DURLI:L001 (P)

British School
Unknown General of the 68th Durham Light Infantry
oil on canvas 75 x 62 (E)
PCF1

Hudson, Gerald
Attack of the 2nd Battalion, Durham Light Infantry, at Hooge, Germany, 9 August 1915
1920s
oil on canvas 104.1 x 147.3
883

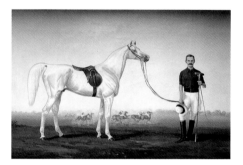

McLeod, Juliet 1917–1982
Captain Henry de Beauvoir de Lisle (1864–1955) and His Pony, 'Snowy', c.1900
1951
oil on canvas 71 x 91
DLI:P49

Ross, T.
General Charles Nicol, CB, Colonel 68th Foot (1844–1850) 1843
oil on canvas 91 x 70
DLI:P47

Durham University

Founded in 1832, Durham University is the third oldest University in England. It owes its existence to William Van Mildert, the last Prince Bishop of Durham, to Charles, 2nd Earl Grey, the then Prime Minister, and to the Dean and Chapter of Durham Cathedral. Their efforts led to an Act of Parliament 'to enable the Dean and Chapter of Durham to appropriate part of the property of their church to the establishment of a University in connection therewith'. Collegiate from its inception (although at first there was just one College), the University now has 16 Colleges, including two at its Queen's Campus in Stockton. Each College makes a unique contribution to the social and cultural life of the University today. The oldest College, University College, is based at Durham Castle, which was given to the University by Bishop Maltby in 1837 and now forms part of the Durham World Heritage Site. The Castle, together with the Cathedral, is an icon of the City of Durham and of the North East of England. The newest College, Josephine Butler College, opened its doors to students in September 2006. This variety, history and grandeur on the one hand and the focus on the twenty-first century and the needs of the academic and wider community on the other, is reflected in the paintings owned by the University, its Colleges and Museums, which are presented together for the first time in this catalogue.

The history of the City of Durham and of its Prince Bishops is represented through a fine collection of paintings, mainly acquired by John Cosin (Bishop from 1660–1672), Nathaniel, Lord Crewe (Bishop from 1674–1721) and subsequent bishops. In addition to portraits of various Prince Bishops themselves, there are paintings of other historical figures such as *Sir George Jeffreys* (Judge Jeffreys) by Godfrey Kneller, as well as landscapes of the City and classical and religious works. These were given to the University after its foundation and, together with further paintings added by the University itself, they form the basis of the collection of the University's Durham Castle Museum (which shares the Castle with University College).

The depictions of Durham within the University's Collection offer interesting historical perspectives of the City over the centuries. They include two representations of *Durham Castle and Cathedral with Bishop's Barge* (circle of Hendrick Danckerts) and two early eighteenth-century grisaille landscapes of the City, *Durham Castle from the South* and *A Panorama of Durham City from the North West* as well as the delightful *Durham from Observatory Hill,* by John Wilson Carmichael. Also of historical interest is *An Informal Procession of Boats on the River Wear to Celebrate the Victory of Waterloo, 1815* by Edward Hastings.

The University's Collection includes portraits of key figures throughout the University's history. There are no less than three portraits of its founding father, Bishop William Van Mildert, all after the portrait by Thomas Lawrence which hangs at Auckland Castle. Vice-Chancellors and Wardens of the University, Principals and Masters of the Colleges, leading academics and other staff have been commemorated in oils. One, Dr W. A. Prowse appears in the Collection both as a sitter, *Dr W. A. Prowse* (1973) by Hubert Andrew Freeth, and as the artist of three paintings *Atomic Theme* (1973), *Electric Currents in the Atmosphere* (1974) and *Red Shift* (1976). University students also feature whether as subject matter, as with *Aspects of Grey College Sporting*

Life (2000) by Dave Barden, or as creators of a work such as the *Trevelyan Hex Cooperative Creation* executed as a fund-raiser in 1998.

Today, the University and its Colleges have a strong commitment to the visual arts which is reflected in a growing collection of twentieth and twenty-first century works. St Chad's currently has an artist-in-residence programme (as other Colleges have had). Both Grey College and Trevelyan College hold regular art exhibitions some of which have been of national importance, such as the 1999 John Piper retrospective at Grey College. Grey College, in particular, has sought to support the work of Northern artists through its exhibitions and acquisition programme. In a review of its John Tunnard retrospective in 2000, the *Burlington Magazine* remarked that 'in a period in which many British universities have moved from being places of cultured reflection to become centres of short-term vocational training, it is quite exceptional to find a College committed to supporting the visual arts.' It is thanks to such enthusiasm from College Art Committees, to generous donations by artists and benefactors and, in some cases, to grant funding, that the University Collection can boast works by such important British artists as John Walker, Mary Fedden, Fay Pomerance and Julian Trevelyan.

One generous bequest was made with the express wish that the collection of paintings would be displayed where 'the young would see it daily'. This they do. All the paintings in this collection, scattered across the University, are enjoyed by the students and staff alike and help to contribute to the cultural life of the University.

This collection of pictures, owned by the University of Durham and associated Trusts within its Colleges, is not owned by the public. However, the University is delighted for the paintings to be included in this catalogue and hopes that this volume will raise public awareness of this increasingly important collection of paintings. Where public access does not inhibit the work of staff and students the University is proud to make its Collection accessible to the public. Durham University is committed to developing spaces to display its collections and has an ongoing commitment to acquiring and commissioning new works of art and sculpture.

Professor Christopher F. Higgins, Vice-Chancellor and Warden

Allison, David b.1960
The Smoker 1999
oil on canvas 62 x 90 (E)
21.41

Amigoni, Jacopo c.1685–1752
Queen Caroline of Ansbach (1683–1737)
oil on canvas 180.5 x 148.5 (E)
18.738

M. B.
Frank Byron Jevons (1858–1935), MA, DLitt
oil on canvas 125 x 98 (E)
20.6

Balinese (Batuan) School
*A Village Temple** 1970s
paint on canvas 83 x 125.5
4.1999.104

Balinese (Kamasan) School
*Hanuman, the Monkey Warrior** 1900–1950
paint on canvas 55.2 x 38
4.1999.68

Balinese (Kamasan) School
Hanuman, the Monkey Warrior and a Sage
(Scene from the Ramayana)* 1990
paint on canvas 55 x 38
4.1999.110

Balinese (Kamasan) School
*Battle Scene** c.1990
paint on canvas 59 x 83.5
4.1999.103

**Balinese (Kamasan) School or Balinese
(Wayang Style)**
*Arunja among the Hermits** 1990
paint on canvas 67 x 32.6
4.1999.67

Balinese (Pengosekan) School
*Five Herons in a Forest and River
Landscape** 1980s
paint on canvas 44 x 29
4.1999.70

Facing page: Granet, François-Marius, 1775–1849, *A Reading Lesson in a Convent* (detail), 1810,
The Bowes Museum, (p. 103)

Balinese (Pengosekan) School
*Ten Cranes Feeding at a River's Edge** 1980s
paint on canvas 66.2 x 86.2
4.1999.101

Balinese School
*Hanuman the Monkey Warrior, Rama, Ravana and Sita** 1900–1950
paint on canvas 50 x 37
4.1999.69

Barden, Dave b.1943
Aspects of Grey College Sporting Life 2000
acrylic on board 182 x 168 (E)
21.13

Batu
Mother and Child
oil on canvas 73 x 22.2 (E)
21.1

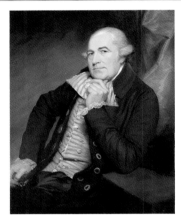

Beechey, William 1753–1839
George Maltby, Esq. (1731–1794) c.1782
oil on canvas 83.5 x 65 (E)
18.742

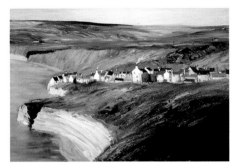

Bennett, Terence b.1935
Robin Hood's Bay, North Yorkshire 1988
oil on canvas 100 x 150 (E)
21.11

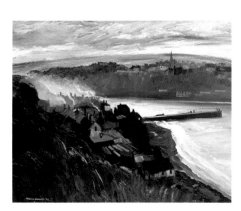

Bennett, Terence b.1935
Whitby from St Mary's Church, North Yorkshire 1998
oil on canvas 54.5 x 64.5 (E)
21.3

Bennett, Terence b.1935
Disused Mine, Stanhope, County Durham
oil on canvas 180 x 200 (E)
21.12

Bickersteth, Jane
Galilee Chapel, Durham Cathedral
oil & collage on paper 74 x 105.5 (E)
5.5

Bickersteth, Jane
Side Aisle
oil on board 85 x 69 (E)
5.6

Birt, Elizabeth
Bamburgh from Lindisfarne, Northumberland
2001
acrylic (?) on board 29.5 x 121 (E)
22.5

Boisnazwivc, O.
Eric Halladay 1987
oil on canvas 180 x 80 (E)
21.6

Borg, Isabelle b.1959
Durham Cathedral from Grey College 1999
mixed media on canvas 50.8 x 66 (E)
21.45

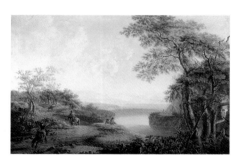

Both, Jan (style of) c.1618–1652
Landscape with a Lake and Horsemen
18th C/ early 19th C
oil on canvas 94 x 129 (E)
18.745

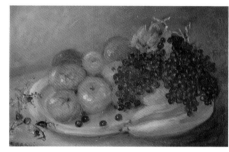

Braun, Grace
Still Life
oil on board 28.5 x 42.2 (E)
21.36

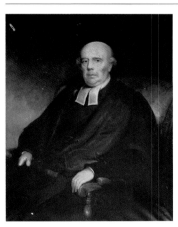

Bridges, John active 1818–1854
Canon David Durrell (1762–1852), MA, DD
oil on canvas 125.1 x 97.8 (E)
18.711

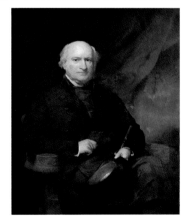

Briggs, Henry Perronet 1791/1793–1844
*Edward Maltby (1770–1859), DD, Bishop of
Durham (1836–1856)*
oil on canvas 127 x 100 (E)
18.717

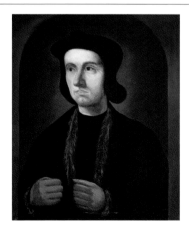

British (English) School
*Cuthbert Tunstall (1474–1559), Bishop of
Durham (1530–1559)* c.1540
oil on canvas 72.4 x 55.8 (E)
18.740

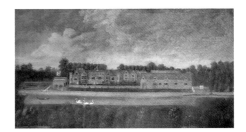

British (English) School
Steane Park, Northamptonshire, the Seat of Lord Crewe c.1700
oil on canvas 100 x 177.8
18.727

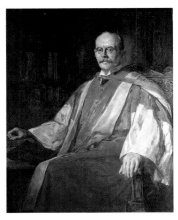

British (English) School 20th C
Arthur Robinson, JP, MA, DCL
oil on canvas 123 x 97 (E)
20.7

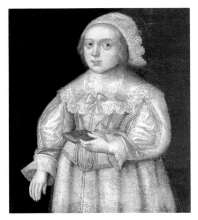

British School early 17th C
A Girl in a Pink Costume
oil on canvas 64.5 x 55
18.772

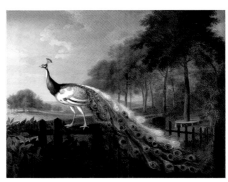

British School
The White Peacock c.1750
oil on canvas 176 x 214 (E)
18.734

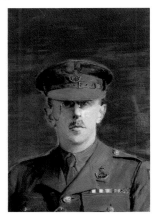

British School early 20th C
Lieutenant Colonel William Douglas Love (1879–1922)
oil on canvas 66.8 x 40 (E)
18.788j

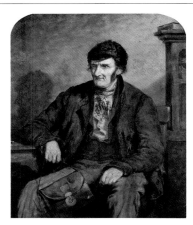

Burlison, Clement 1803–1899
Joe Bainbridge, the Castle Postman 1850
oil on canvas 57 x 47 (E)
18.750

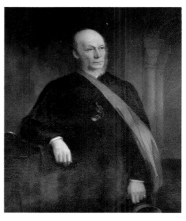

Burlison, Clement 1803–1899
The Reverend Dr John Cundill (1812–1894) 1889
oil on canvas 121 x 94 (E)
18.713

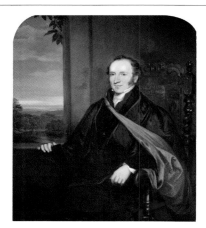

Burlison, Clement 1803–1899
The Reverend Canon Henry Jenkyns (1795–1878), MA, DD
oil on canvas 128.3 x 99.1 (E)
18.700

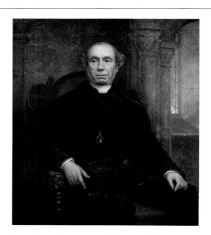

Burlison, Clement 1803–1899
The Reverend Professor Thomas Saunders Evans (1816–1889)
oil on canvas 124.5 x 99.1 (E)
18.702

Burt, Elizabeth
Dobgill Falls, Lake District 2003
acrylic on board 105 x 36.5 (E)
21.32

Carmichael, John Wilson 1800–1868
Durham from Observatory Hill 1847
oil on canvas 90.8 x 128.3
18.741

Carpenter, Margaret Sarah 1793–1872
*The Right Reverend Dr John Bird Sumner
(1780–1862), Bishop of Chichester*
oil on canvas 124.5 x 101 (E)
18.709

Chandra, Avinash 1931–1991
Victor 1961
oil on canvas 89.5 x 69.5
4.1962.212

Clarke, Edward b.1962
Victor Watts
oil on canvas 88.5 x 69 (E)
21.37

Clarke, Edward b.1962
John C. F. Hayward (b.1941), OBE
oil on canvas 102 x 70 (E)
3.1

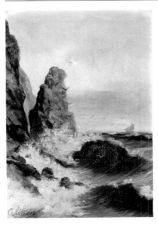

Colinson
A Rocky Coast
oil on canvas 34.2 x 24.2 (E)
18.788c

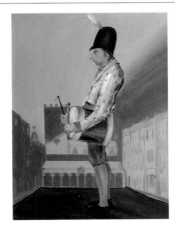

Collier, John (style of) 1708–1786
The Durham Drummer c.1810
oil on panel 19 x 14.5 (E)
18.1201

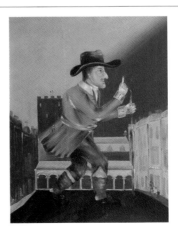

Collier, John (style of) 1708–1786
The Durham Preacher early 19th C
oil on panel 19 x 14.5 (E)
18.1200

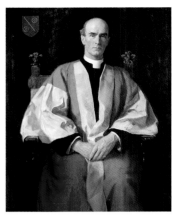

Collier, John 1850–1934
Henry Gee (c.1858–1939), MA, DD, FSA 1918
oil on canvas 125.7 x 100.3 (E)
18.705

Cookson, Mary
Faith
acrylic on board 95 x 30 (E)
21.19

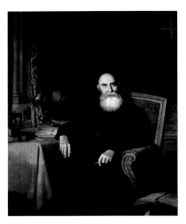

Cope, Charles West 1811–1890
The Reverend Temple Chevallier (1794–1873)
oil on canvas 177.8 x 134.6 (E)
18.695

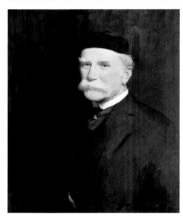

Copnall, Frank T. 1870–1949
Douglas Horsfall
oil on canvas 75 x 60
19.6

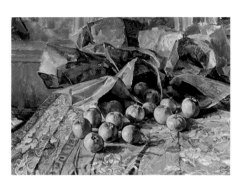

Crowson, Neville b.1936
Apples and Paper Bags 1996
acrylic on paper 54.5 x 73.5 (E)
21.24

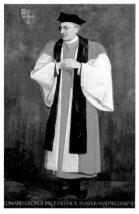

Da Fano, Judith 1919–2000
Edward George Pace (1882–1953), JP, MA, DD 1953
oil on canvas 122 x 75 (E)
20.10

Danckerts, Hendrick (circle of) 1625–1680
Durham Castle and Cathedral with Bishop's Barge (1) late 17th C
oil on canvas 139.8 x 222 (E)
18.693

Danckerts, Hendrick (circle of) 1625–1680
Durham Castle and Cathedral with Bishop's Barge (2) late 17th C
oil on canvas 176 x 230.2 (E)
18.1230

Degeng, N. J. (attributed to)
*Butterflies**
oil on canvas/silk (?) 63 x 94 (E)
21.40

Delve, Jessie active 1912
Walter Kercheval Hilton (1845–1913), MA
oil on canvas 92.7 x 59 (E)
18.721

Denning, Stephen Poyntz 1795–1864
The Reverend David Melville (b.1813), DD
oil on canvas 141 x 110 (E)
20.5

Dickinson, Lowes Cato 1819–1908
The Reverend Joseph Waite (1824–1908), DD
1874
oil on canvas 126.4 x 100.3 (E)
18.701

Drerup, Karl 1904–2000
Basil Bunting (1900–1985), Poet c.1939
oil on canvas 35 x 30
6.BBPA 2002/3:6

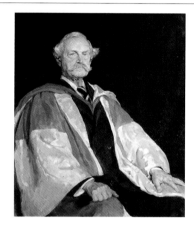

Dugdale, Thomas Cantrell 1880–1952
*John Stapylton Grey Pemberton (1860–1940),
JP, DCL* 1936
oil on canvas 112 x 91.5 (E)
18.696

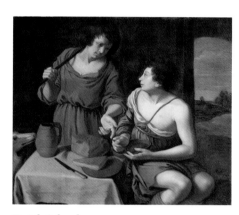

Dutch School
Esau Selling His Birthright to Jacob c.1620
oil on canvas 102 x 107 (E)
18.759

Dutch School 17th C
*Landscape with a Man and a Woman on a
Bridge by a Gorge*
oil on canvas 63.5 x 89
18.773

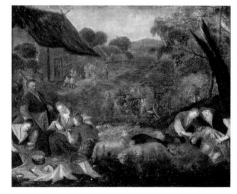

Dutch School 17th C
The Sheep Shearing
oil on panel 34 x 40 (E)
18.730

Dutch School 18th C
The Pilgrim and the Beggar
oil on canvas 33 x 43.2 (E)
18.729

Emerson, Robert Jackson 1878–1944
The Reverend John Hall How (1871–1938),
MA 1943
oil on canvas 111.1 x 85.7 (E)
18.708

Evans, Richard 1784–1871
Dr Richard Prosser (1747–1839)
oil on canvas 124.5 x 99 (E)
18.718

Evans, Richard 1784–1871
Dr Robert Gray (1762–1834), Bishop of Bristol
oil on canvas 127 x 100.3 (E)
18.707

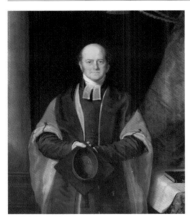

Evans, Richard 1784–1871
Dr William Stephen Gilly (1789–1853)
oil on canvas 127 x 100.3 (E)
18.706

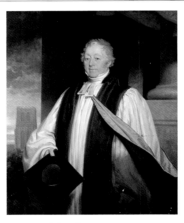

Evans, Richard 1784–1871
John Savile Ogle (1767–1853), DD
oil on canvas 127 x 101 (E)
18.716

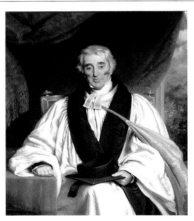

Evans, Richard 1784–1871
The Honourable Gerald Valerian Wellesley
(1770–1848), DD
oil on canvas 126.4 x 100.3 (E)
18.704

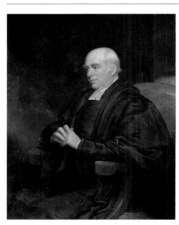

Evans, Richard 1784–1871
The Reverend Samuel Smith (1765–1841), DD
oil on canvas 124.5 x 100.3 (E)
18.710

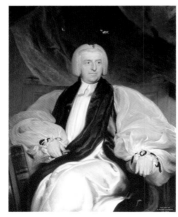

Evans, Richard 1784–1871
The Right Reverend and Honourable Shute
Barrington (1734–1826), Bishop of Durham
(after Thomas Lawrence)
oil on canvas 142.2 x 111.8 (E)
18.718

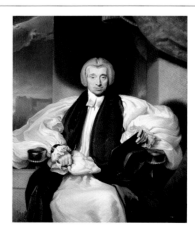

Evans, Richard 1784–1871
William Van Mildert (1765–1836), Bishop of
Durham (1826–1836) (after Thomas
Lawrence)
oil on canvas 140.3 x 112.4 (E)
18.723

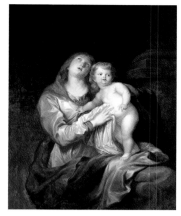

Fancourt, Edward b.1802
The Virgin and Child (after Anthony van Dyck) 1825
oil on canvas 151 x 116 (E)
18.788b

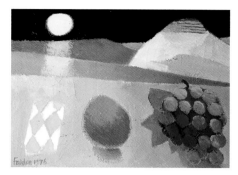

Fedden, Mary b.1915
Landscape, Still Life I 1976
oil on canvas 28.5 x 39 (E)
2.68

Fedden, Mary b.1915
Landscape, Still Life II 1978
oil on canvas 28.5 x 39 (E)
2.69

Fedden, Mary b.1915
Blue Cart 1979
oil on canvas 39 x 49 (E)
2.66

Fedden, Mary b.1915
Red Cupboard 1979
oil on canvas 73.5 x 58 (E)
2.63

Fedden, Mary b.1915
The Red Berry 1979
oil on canvas 28.5 x 39 (E)
2.67

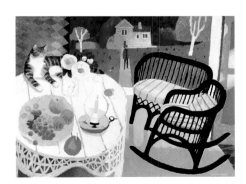

Fedden, Mary b.1915
Pennsylvania 1981
oil on canvas 90 x 121 (E)
2.62

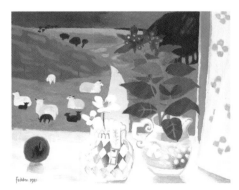

Fedden, Mary b.1915
Sheep in Yorkshire 1981
oil & acrylic on canvas 51 x 61
2.64

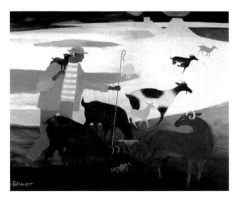

Fedden, Mary b.1915
Goatherd with Goats 1997
oil on canvas 49 x 58.7 (E)
2.101

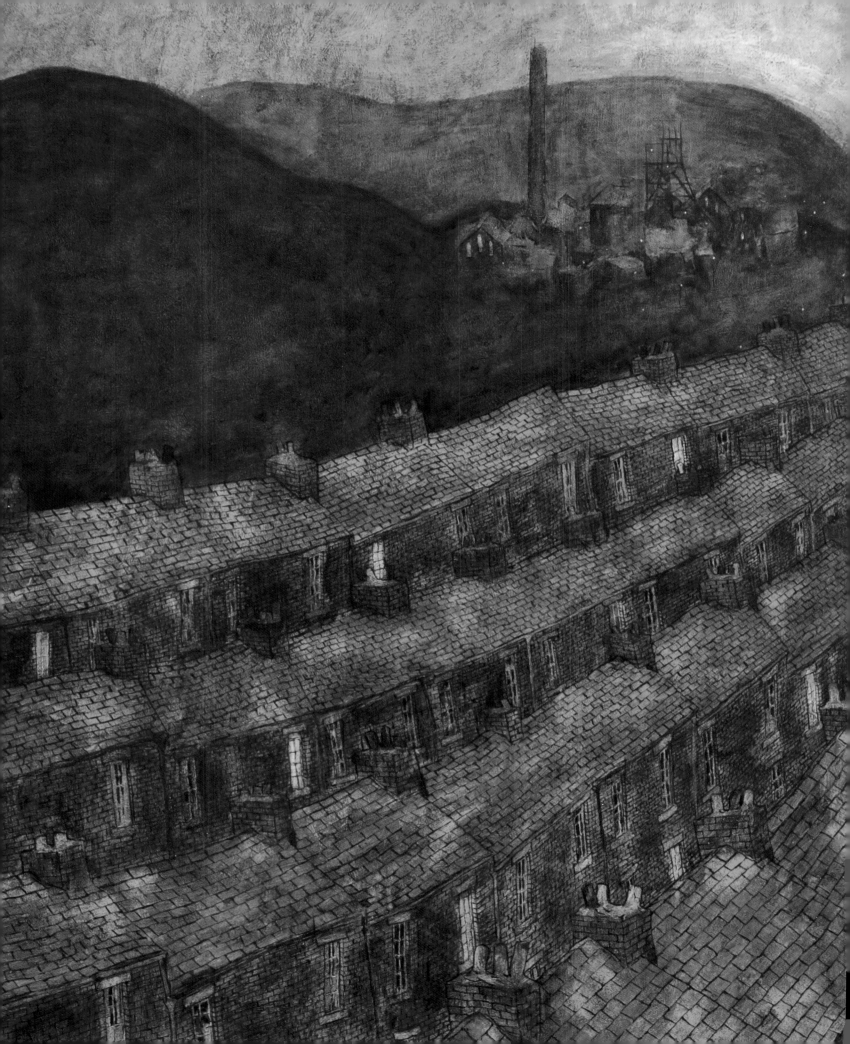

Firth, Margaret 1898–1991
Still Life
oil on board 34 x 26 (E)
2.10

Flemish School 17th C
Woman in a Cave
oil on canvas 41 x 48.5
18.769

Flemish School 18th C
Classical Landscape with Pillars, River and Goats (after Giovanni Paolo Panini)
oil on canvas 165.1 x 146.1
18.768

Freeth, Hubert Andrew 1913–1986
Dr W. A. Prowse 1973
oil on canvas 61 x 51
15.2

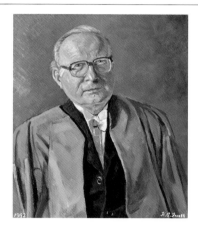

Freeth, Hubert Andrew 1913–1986
Dr P. W. Kent 1982
oil on canvas 61 x 51
15.3

French School 17th C
Man in a Landscape beside a Pool and a Waterfall
oil on canvas 59 x 75 (E)
18.788e

French School early 18th C
Village in a Hilly Landscape with Two Bridges
oil on canvas 46 x 55 (E)
18.1256

French School 18th C
Landscape with Walled Town
oil on canvas 43.7 x 52.7 (E)
18.771

Gaekwad, Ranjit Singh active 2000–2001
Cheese Plant 2000
oil on canvas 130 x 119 (E)
21.30

Facing page: McGuinness, Tom, 1926–2006, *The Caller* (detail), Darlington Borough Art Collection, (p. 242)

Gaekwad, Ranjit Singh active 2000–2001
Indian Lady 2001
oil on canvas 129 x 118 (E)
21.39

Ganderton (Canon), H. Y.
Welsh Landscape c.1900
oil on canvas 33 x 51.5 (E)
21.29

Ganderton (Canon), H. Y.
Reverend Charles Wallis
oil on canvas 78.3 x 53
1.3

Gennari, Cesare (attributed to) 1637–1688
Endymion Asleep
oil on canvas 106.5 x 94.5
18.765

German School mid-17th C
A Scholar in His Study
oil on canvas 150.3 x 113 (E)
18.748

Goes, Hugo van der (copy after)
c.1420–1482
*The Lamentation, the Dead Christ Supported
by John the Baptist (…)* early 16th C
oil on panel 35 x 52
18.725

Gollon, Christopher b.1953
Einstein's Dinner
acrylic on canvas 91.2 x 61.2 (E)
16.2

Gollon, Christopher b.1953
Still Life (Homage to Pittura Metafisica)
acrylic on canvas 40 x 119.7 (E)
16.1

Grant, James Ardern 1887–1973
Miss Ethleen Scott 1956
oil on canvas 75 x 62.5 (E)
8.5

Hager, Inga
Abstract
acrylic on board 59.5 x 78.5 (E)
21.21

Hager, Inga
Danish Seascape
acrylic on board 60.5 x 80 (E)
21.2

Haigh, Robert b.1973
*Seascape**
acrylic on canvas
99.5 x 49.5; 100 x 50; 99.5 x 49.5
3.3

Halliday, Colin Thomas b.1964
Still
oil on board 119.5 (E)
21.34

Harman, G.
*A Former Principal**
oil on canvas 74 x 49 (E)
22.2

Harrison, G. M.
*A Former Principal**
oil on canvas 74.5 x 59 (E)
22.3

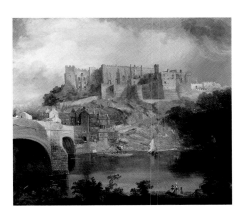

Hastings, Edward 1781–1861
Durham Castle and Framwellgate Bridge,
Looking East c.1840
oil on canvas 104.7 x 109.2 (E)
18.755

Hastings, Edward 1781–1861
An Informal Procession of Boats on the River
Wear to Celebrate the Victory of Waterloo, 1815
oil on canvas 111.7 x 142.2 (E)
18.720

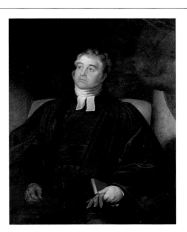

Hastings, Edward 1781–1861
Canon George Townsend (1788–1857)
oil on canvas 130 x 100.5 (E)
19.712

Hastings, Edward (attributed to)
1781–1861
The Great Hall of Durham Castle, Facing South c.1836
oil on paper 53.5 x 64 (E)
18.722

Hawkins, James b.1954
Abstract 1985
mixed media on canvas 77.5 x 102 (E)
21.38

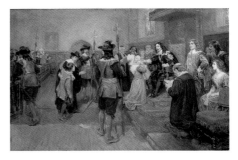

Hedley, Ralph 1848–1913
King Charles I Touching for the King's Evil
1907
oil on canvas 81 x 121
7.764

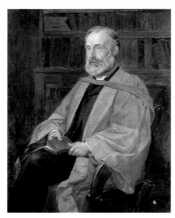

Hedley, Ralph 1848–1913
Alfred Plummer (1841–1926), DD 1912
oil on canvas 128.9 x 99 (E)
18.703

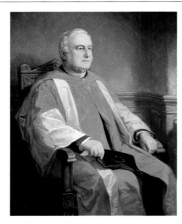

Hedley, Ralph 1848–1913
Joseph T. Fowler (1830–1921), MA, DCL
oil on canvas 132 x 103 (E)
20.9

Heumann, Corinna b.1962
Picasso Meets Lichtenstein, Head of a Woman
acrylic & oil on canvas 110 x 100
3.4

Heumann, Corinna b.1962
Picasso Meets Lichtenstein, Jack-in-the-Box
acrylic & oil on canvas 110 x 100
3.5

Heumann, Corinna b.1962
Picasso Meets Lichtenstein, Woman Seated
acrylic & oil on canvas 110 x 100
3.6

Hondecoeter, Melchior de (follower of)
1636–1695
Farmyard Scene, the Black Turkey
oil on canvas 142.5 x 183
18.726

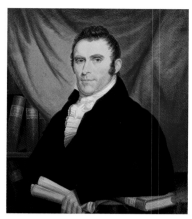

Horsley, John Callcott 1817–1903
John Pemberton, Esq. (d.c.1853)
oil on canvas 75.6 x 62.8 (E)
18.735

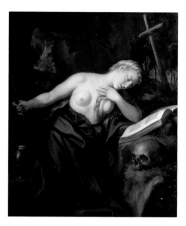

Janssens, Victor Honoré 1658–1736
The Penitent St Mary Magdalene c.1722–1724
oil on canvas 125 x 99 (E)
18.767

Johnson, Ben b.1946
Raby Earthmarks 1997
mixed media on paper 28.5 x 21 (E)
21.31

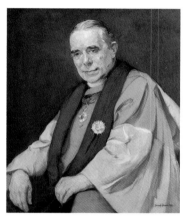

Johnson, Ernest Borough 1866–1949
The Reverend Dr Charles Whiting, MA, DD, BCL 1935
oil on canvas 74 x 61.5
19.4

Jordon, M.
*Through the Keyhole in Blue**
acrylic on board 63 x 76
3.2

Kerr, John J. b.1933
*Durham Cathedral**
acrylic on canvas 60 x 90 (E)
8.3

Kinmont, David 1932–2006
Dark Multi-Light Colours
acrylic on board 56.5 x 43 (E)
2.35

Kinmont, David 1932–2006
Painting, Plant
oil on canvas 44 x 36.2 (E)
2.23

Kjærnstad, Roar b.1975
Art Students 2004
oil on canvas 109.5 x 93.5 (E)
21.22

Kjærnstad, Roar b.1975
Martyn Chamberlain 2005
oil on canvas 190 x 74 (E)
21.4

Kjærnstad, Roar b.1975
Victor Watts 2005
oil on canvas 190 x 120 (E)
21.5

Kneller, Godfrey 1646–1723
Sir George Jeffreys (1644–1689)
oil on canvas 123 x 100 (E)
18.754

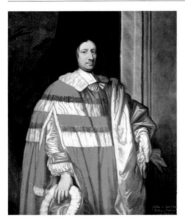

Kneller, Godfrey (after) 1646–1723
*Nathaniel, Lord Crewe (1633–1721), Bishop of
Durham (1674–1721)*
oil on canvas 124 x 100 (E)
18.749

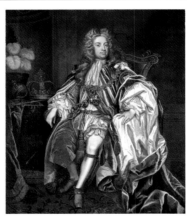

Kneller, Godfrey (studio of) 1646–1723
George II (1683–1760)
oil on canvas 180.5 x 147.5 (E)
18.737

Kuhn, Andrzej b.1930
*The Fisherman**
acrylic on board 122 x 88
22.1

Kulyk, Karen b.1950
Summer Garden 1994
acrylic on canvas 121 x 90 (E)
21.35

Lamb, Henry 1883–1960
Sir James Fitzjames Duff (1898–1970)
oil on canvas 111.5 x 86.5 (E)
18.699

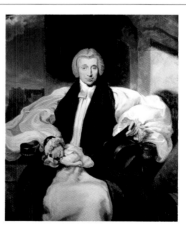

Lawrence, Thomas (after) 1769–1830
*William Van Mildert (1765–1836), Bishop of
Durham (1826–1836)* 19th C
oil on canvas 139 x 109 (E)
20.3

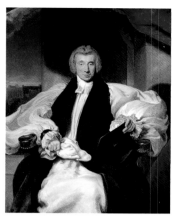

Lawrence, Thomas (after) 1769–1830
William Van Mildert (1765–1836), Bishop of
Durham (1826–1836)
oil on canvas 150 x 100 (E)
15.9

Leake, Nicholas
Sir Kingsley Dunham (1910–2001) 1998
oil on canvas 69.5 x 49 (E)
20.4

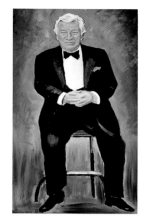

Liebenow
Sir Peter Ustinov (1921–2004)
acrylic on paper 93 x 53 (E)
11.1

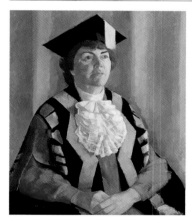

Long, A.
Lady Irene Hindmarsh 1984
oil on canvas 89.5 x 75 (E)
8.4

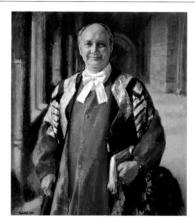

Mackintosh, Anne b.1944
Professor Sir Kenneth Calman 2005
oil on canvas (?) 89 x 74 (E)
13.1

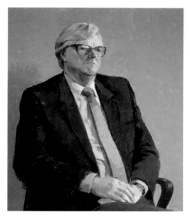

Maclaren, Andrew b.1941
Leslie Brooks (1919–1993) 1985
oil on canvas 75 x 62 (E)
12.3

Marchant, Rowy
Windscape
acrylic (?) on board 44.5 x 54.5 (E)
2.26

Marek
Crystals in Magma (detail) 1961
mixed media on board 338 x 443
10.1

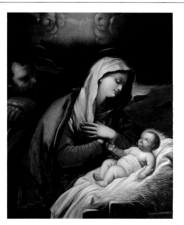

Marescotti, Bartolomeo (style of)
c.1590–1630
The Virgin and Child with Joseph and Angels
oil on canvas 128 x 99 (E)
20.15

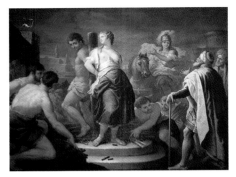

Matteis, Paolo de' 1662–1728
Clorinda Rescuing Olindo and Sophronia from the Stake c.1690
oil on canvas 146 x 178 (E)
18.751

Meshoulam, Yair b.1963
Eden 1990
oil & collage on board 44.5 x 69.7
2.106

Meshoulam, Yair b.1963
Computer Android
oil on board 34.4 x 39
2.117

Mieves, Christian b.1973
Schoolboys 2005
oil on board 119.8 x 241
8.2

Mills, Karen
The Reverend Canon Dr John C. Fenton, MA, BD, DD 1981
oil on canvas 76 x 62
19.5

Ming, Zhu b.1960
Autumn Cicada 2006
acrylic on canvas 50 x 60
4.2008.3

**Morgenstern, Johann Ludwig Ernst
(attributed to)** 1738–1819
A Church Interior in Flanders
oil on canvas 114.3 x 125.7 (E)
18.774

Morton, Alan Kenneth b.1930
Rowan and Martin's Laugh-In 1979
oil on canvas 140 x 170 (E)
21.44

Morton, Alan Kenneth b.1930
Stained Glass Reflections 1979
oil on canvas 150 x 170 (E)
21.42

Facing page: Heemskerck, Maerten van, 1498–1574, *An Allegory of Innocence and Guile* (detail), The Bowes Museum, (p. 107)

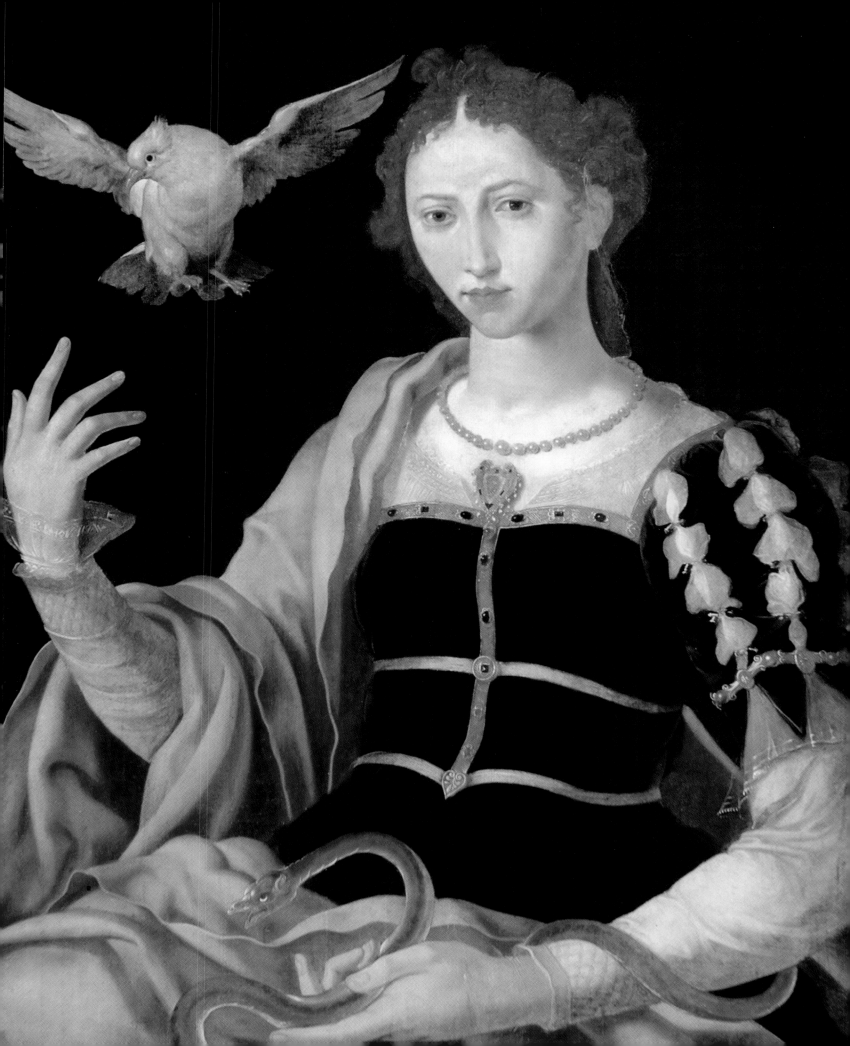

Morton, Alan Kenneth b.1930
Warrior Shrine (detail) 1979
oil on canvas 110 x 120 (E)
21.43

Mouncey, Val b.1957
Phoenix
mixed media on paper 24 x 18 (E)
2.114

Mozley, Charles Alfred 1914–1991
The French Waitress
oil on canvas 82 x 67 (E)
21.28

Mulley, Brighid Susan b.1966
Bernard Robertson (b.1936) 2003
oil on canvas 90 x 69.5 (E)
12_4

Nord, P. (attributed to)
*Abstract** 2002
mixed media on paper 28.8 x 18.8
8.6

Nord, P. (attributed to)
*Head** 2002
mixed media on paper 28.8 x 18.8
8.7

Nord, P. (attributed to)
*Leaf** 2002
mixed media on card 37.5 x 14.2
8.8

Ormsby, Barrie b.1945
Jazz
acrylic on board 97.5 x 119.5 (E)
2.112

Oxley, Mick b.1953
Sunset, Dunstanburgh, Northumberland
oil on canvas 91 x 122 (E)
21.2

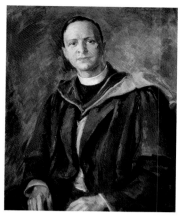

Pattison, Thomas William 1894–1993
The Reverend John S. Brewis, MA
oil on canvas 80 x 60.5
19.7

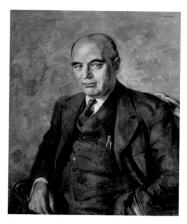

Pattison, Thomas William (attributed to)
1894–1993
Clifford Leech
oil on canvas 75 x 62 (E)
12_1

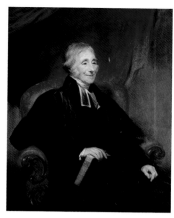

Phillips, Thomas 1770–1845
Canon Thomas Gisborne (1758–1846)
oil on canvas 127 x 96.5 (E)
18.715

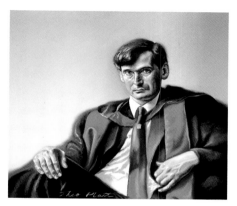

Platt, Theo b.1960
Anthony Tuck 1987
oil on canvas 80 x 90 (E)
5.2

Pomerance, Fay 1912–2001
Part II, Lucifer's River Quest for the Lost Seed of Redemption
tempera on board 91 x 212 (E)
21.15

Pomerance, Fay 1912–2001
Part III, the Threefold Tree of Eden
tempera on board 105 x 244 (E)
21.16

Pomerance, Fay 1912–2001
Part IV, the Way Back
tempera on board 120 x 240 (E)
21.17

Pomerance, Fay 1912–2001
The Sphere of Redemption
acrylic & ink on fibreglass 121.9
21.18

Poole, David b.1931
Professor Sir Derman Christopherson (1915–2000) 1979
oil on board 121 x 90 (E)
13.3

Prowse, W. A. active 1973–1976
Atomic Theme 1973
oil on board 58.4 x 91
9.3

Prowse, W. A. active 1973–1976
Electric Currents in the Atmosphere 1974
oil on metal 72.5 x 122
9.1

Prowse, W. A. active 1973–1976
Red Shift 1976
oil on metal 61 x 90.8
9.2

Ramage, David G. d.1967
Claude Colleer Abbott (1889–1971) 1955
oil on board 35 x 24
6.8

Ramage, David G. d.1967
Self Portrait 1956
oil on board 35 x 24
6.7

Ramage, David G. d.1967
I. J. C. Foster (1908–1978)
oil on board 35 x 24
6.9

Ratcliffe, Andrew b.1948
Dr Edward C. Salthouse (b.1936) 1997
oil on canvas 69.4 x 54 (E)
18.777b

Ratcliffe, Andrew b.1948
Gerald Blake 2001
acrylic (?) on canvas 69.5 x 69.5 (E)
5.3

Ratcliffe, Andrew b.1948
John Atkin 2003
oil on canvas 54.8 x 44.3 (E)
18.1286

Ratcliffe, Andrew b.1948
Professor Evelyn Ebsworth (b.1933)
acrylic on canvas 69 x 69.5
13.4

Rawcliffe, Barrie b.1938
Chatsworth Landscape
oil on board 59.5 x 49 (E)
21.27

Riley, John 1646–1691
Catherine of Braganza (1638–1705),
Queen Consort of Charles II
oil on canvas 124 x 99.5 (E)
18.752

Riley, John 1646–1691
King Charles II (1630–1685)
oil on canvas 124 x 101.5 (E)
18.753

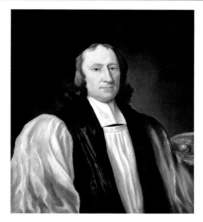

Riley, John (attributed to) 1646–1691
Nathaniel, Lord Crewe (1633–1721), Bishop of
Durham (1674–1721) (after Godfrey Kneller)
oil on canvas 75 x 62.2 (E)
18.733

Robinson, William R. 1810–1875
Fisherfolk and Their Catch on the Northern
French Coast (after Richard Parkes Bonington)
1847
oil on panel 25.5 x 35.5
18.760

Roboz, Zsuzsi b.1939
Professor William Bayne Fisher (1916–1984),
Principal of the Graduate Society 1978
oil on canvas 106 x 76
14.1

Robson, George b.1945
Durham Miners' Gala 2002
oil on canvas (?) 102 x 80
13.5

Roland-Gosselin, Jill
Chinese Bowl and Lemons
oil on board 14 x 18
2.122

Rowe, Lizzie b.1955
James Peden Barber (b.1931), JP, MA, PhD,
1987
oil on canvas 115 x 95 (E)
20.8

Rowe, Lizzie b.1955
Professor Jane Taylor 2007
oil on canvas 124 x 100 (E)
5.4

Rowe, Lizzie b.1955
Professor Sir Frederick Halliday
oil on canvas (?) 216 x 159 (E)
13.2

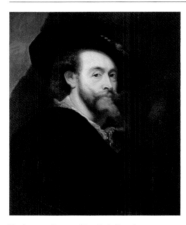

Rubens, Peter Paul (after) 1577–1640
Self Portrait, 1623 late 17th C–early 18th C
oil on canvas 74 x 61.5 (E)
18.756

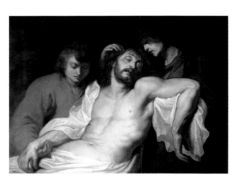

Rubens, Peter Paul (school of) 1577–1640
The Lamentation
oil on canvas 108 x 129
1.OP.0049

Sargeant, Gary b.1939
*Durham Cathedral**
oil & mixed media on board 97.5 x 89.5 (E)
20.1

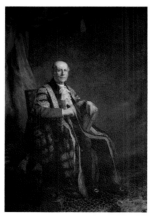

Schofield, John William 1865–1944
Dr George William Kitchin (1827–1912) 1912
oil on canvas 230 x 153 (E)
18.698

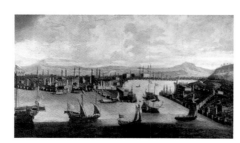

Schranz, Anton (style of) 1769–1839
Constantinople
oil on canvas 103.2 x 176 (E)
18.1228

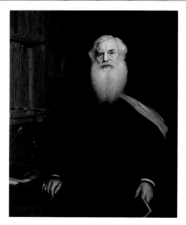

Sephton, George Harcourt
Canon Tristram (1822–1906) 1890
oil on canvas 126 x 101
1.2

Shackleton, Judith
*Abstract**
oil on canvas 75 x 100 (E)
15.7

Shackleton, Judith
*Abstract**
oil on canvas 55 x 100 (E)
15.8

Shackleton, Judith
*Abstract Landscape**
oil on canvas 49 x 60 (E)
15.5

Shackleton, Judith
Double Exposure
oil on canvas 70 x 90 (E)
2.13

Shackleton, Judith
*Landscape with Moon**
oil on canvas 60 x 39.5 (E)
15.6

Shackleton, Judith
Sea Bed
oil on canvas 70 x 90 (E)
2.15

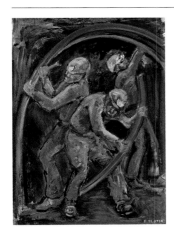

Slater, D.
*Miners at Work**
oil on paper 50 x 36
19.9

Slater, John Falconar 1857–1937
*Landscape**
oil on board 83.5 x 105.5
17.1

Soden, Robert b.1955
*Durham** 1983
mixed media on paper 97.5 x 69
15.1

Sokolov, Kirill 1930–2004
Peter Charles Bayley 1978
oil on board 115 x 100 (E)
5.1

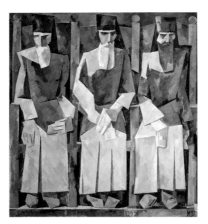

Sokolov, Kirill 1930–2004
Monastery at Panteleimon, Three Monks on Mount Athos, Greece 1997
oil on canvas 198 x 185.5 (E)
21.33

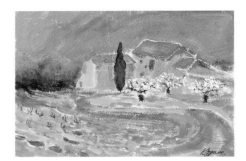

Spare, Kay b.1957
French Spring
oil on board 12.6 x 18.5 (E)
2.128

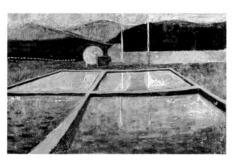

Stage, Ruth b.1969
London to Leeds 1994
tempera on gesso 68.4 x 101.6
2.94

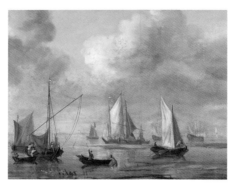

Storck, Abraham (after) 1644–1708
Seascape I, Calm Offshore
oil on canvas 30.2 x 38 (E)
18.731

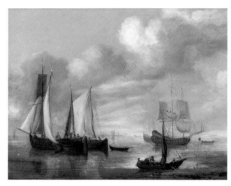

Storck, Abraham (after) 1644–1708
Seascape II, Calm Offshore
oil on canvas 30.2 x 38 (E)
18.732

Swan, Robert John 1888–1980
Leonard Slater (1908–1999), CBE, MA, JP, DL 1973
oil on canvas 64.5 x 54.2 (E)
18.723a

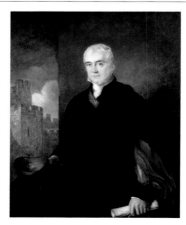

Swinton, James Rannie 1816–1888
Archdeacon Charles Thorpe (1783–1862), DD 1846
oil on canvas 140 x 110 (E)
18.697

A. T.
*Landscape with Colliery**
acrylic on board 32 x 22 (E)
20.2

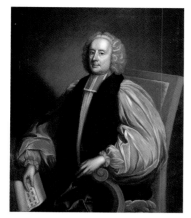

Taylor (of Durham) active 1750–1752
*Joseph Butler (1692–1752), Bishop of Durham
(1750–1752)* c.1750
oil on canvas 125.5 x 100 (E)
18.739

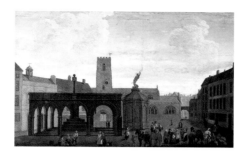

Thompson, Matthew 1790–1851
A Retrospective view of Durham Market Place
c.1815
oil on canvas 29.5 x 46.5 (E)
18.747

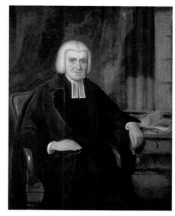

Thompson, Thomas Clement c.1780–1857
Martin Joseph Routh (1755–1854)
oil on canvas 180 x 130 (E)
6.2

Titherley, Hazel b.1935
Avenue of Trees 1990
oil on canvas 100.5 x 50 (E)
21.14

Titherley, Hazel b.1935
Millennium Time Warp 1999
oil on canvas 80 x 111 (E)
21.23

Titherley, Hazel b.1935
Craven Landscape
oil on canvas 71 x 90 (E)
21.26

Trevelyan, Julian 1910–1988
Florence by Night, Italy 1965
oil on canvas 75 x 90.3 (E)
2.49

Trevelyan, Julian 1910–1988
Gozo, Malta 1979
oil on canvas 62.5 x 75.5 (E)
2.54

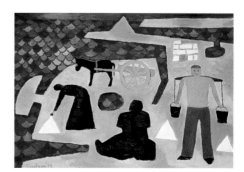

Trevelyan, Julian 1910–1988
Salt-Gatherers 1979
oil on canvas 52 x 71 (E)
2.53

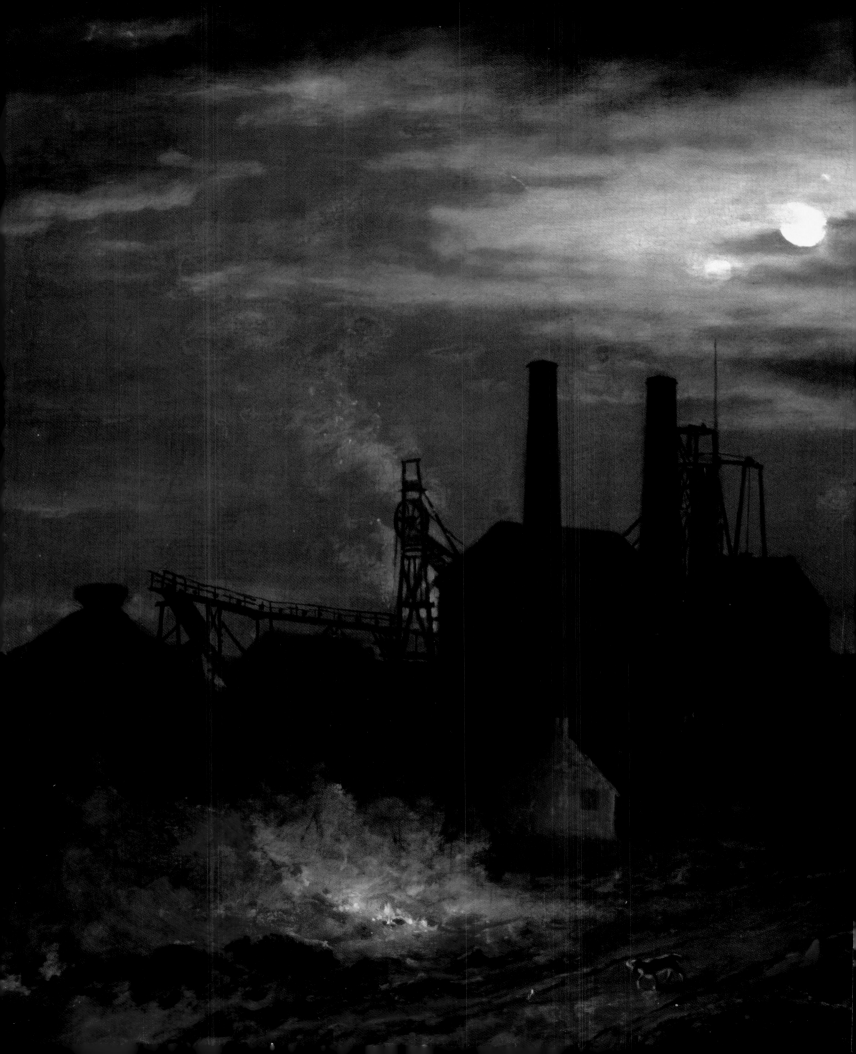

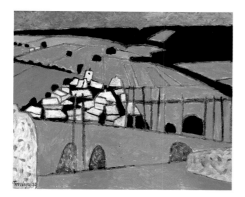

Trevelyan, Julian 1910–1988
French Landscape II 1980
oil on canvas 50 x 60 (E)
2.56

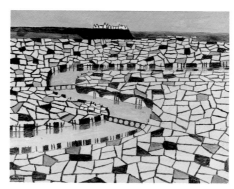

Trevelyan, Julian 1910–1988
Lot, France 1980
oil on canvas 76 x 91.5 (E)
2.57

Trevelyan, Julian 1910–1988
Boats 1981
oil on canvas 48.5 x 58.5 (E)
2.60

Trevelyan, Julian 1910–1988
French Landscape with Large Sun 1981
oil on canvas 75.5 x 90 (E)
2.59

Trevelyan, Julian 1910–1988
Temple Meads Station, Bristol 1981
oil on canvas 74.5 x 90 (E)
2.52

Trevelyan, Julian 1910–1988
The Thames at Richmond 1981
oil on canvas 58 x 48 (E)
2.58

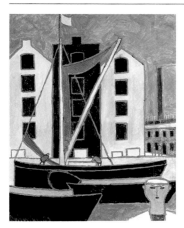

Trevelyan, Julian 1910–1988
Warehouse 1985
oil on canvas 50 x 39.5 (E)
2.61

Trevelyan, Julian 1910–1988
French Landscape I
oil on canvas 49.5 x 39.5 (E)
2.55

unknown artist
John Cosin (1594–1672), Bishop of Durham
c.1665
oil on canvas 198 x 102
7.1263

Facing page: unknown artist, *Colliery by Moonlight* (detail), Beamish, The North of England Open Air Museum, (p. 209)

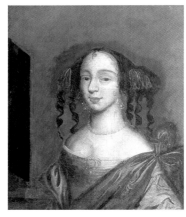

unknown artist 17th C
A Young Lady in a Dark Yellow Dress
oil on canvas 66 x 54 (E)
18.776

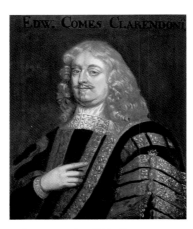

unknown artist 17th C
Edward Hyde (1609–1674), Earl of Clarendon
oil on canvas 82 x 68
7.1268

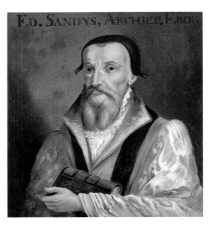

unknown artist 17th C
Edwin Sandys (c.1516–1588), Archbishop of York
oil on canvas 82 x 68
7.1264

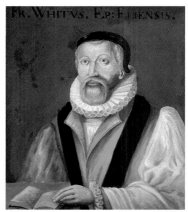

unknown artist 17th C
Francis White (1564–1638), Bishop of Ely
oil on canvas 82 x 68
7.1262

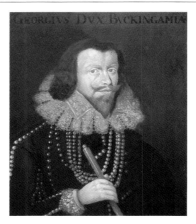

unknown artist 17th C
George Villiers (1592–1628), 1st Duke of Buckingham
oil on canvas 82 x 68
7.1270

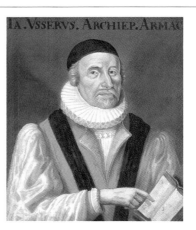

unknown artist 17th C
James Ussher (1581–1656), Archbishop of Armagh
oil on canvas 82 x 68
7.1261

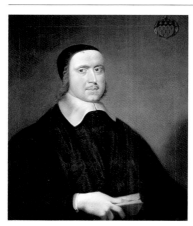

unknown artist 17th C
Jeremy Taylor (1613–1667)
oil on canvas 100 x 60 (E)
7.1260

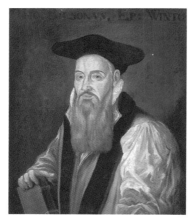

unknown artist 17th C
Thomas Bilson (1597–1616), Bishop of Winchester
oil on canvas 82 x 68
7.1267

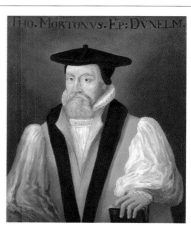

unknown artist 17th C
Thomas Morton (1564–1659), Bishop of Durham
oil on canvas 82 x 68
7.1265

unknown artist 17th C
*William Cecil (1520–1598), 1st Lord Burghley,
Treasurer*
oil on canvas 82 x 68
7.1269

unknown artist late 17th C
Jerusalem, Palestine
oil on canvas 108 x 177 (E)
18.1229

unknown artist late 17th C
The Pedlar (Man Carrying a Load)
oil on canvas 10.8 x 7.6 (E)
18.728

unknown artist late 17th C-early 18th C
*Nathaniel, Lord Crewe (1633–1722), Bishop of
Durham*
oil on canvas 216 x 115
7.1273

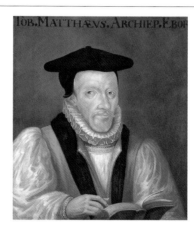

unknown artist late 17th C-early 18th C
*Tobie Matthew (1546–1628), Archbishop of
York*
oil on canvas 82 x 68
7.1266

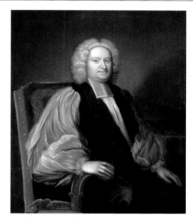

unknown artist
*Edward Chandler (1668–1750), Bishop of
Durham (1730–1750)* c.1730
oil on canvas 125 x 100.5 (E)
18.736

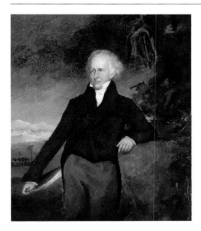

unknown artist
Thomas M. Winterbottom (c.1765–1859)
c.1795
oil on canvas 38 x 32
6.1

unknown artist early 18th C
*A Panorama of Durham City from the North
West*
oil on canvas 152.4 x 242.6 (E)
18.694

unknown artist early 18th C
Durham Castle from the South
oil on canvas 60 x 74 (E)
18.757

unknown artist early 18th C
North Prospect of Durham Cathedral with West Spires
oil on canvas 168 x 180
7.1254

unknown artist 18th C
A Panorama of Durham City from the North West
oil on canvas 84.5 x 152 (E)
18.766

unknown artist 18th C
Fishermen on a Lake Shore
oil on canvas 73.5 x 90 (E)
18.788f

unknown artist late 18th C
Martin Joseph Routh (1755–1854) or His Father, Peter Routh
oil on canvas 125 x 100
6.3

unknown artist
The South Face of the North Gate, Sadler Street, Durham c.1800
oil on canvas 24.8 x 20 (E)
18.746

unknown artist
Eric Halladay 1994 (?)
oil on board 80 x 65
19.2

unknown artist
Trevelyan Hex Cooperative Creation 1998
poster paint on hardboard 122 x 244
2.105

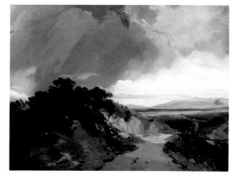

unknown artist 20th C
Landscape with Bushes and Low Cliff
oil on board 21.2 x 29 (E)
18.761

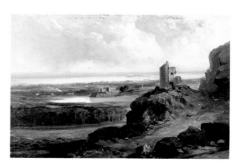

unknown artist 20th C
Landscape with Ruin on the Coast
oil on board 19.2 x 29.2 (E)
18.762

unknown artist
*Abstract**
oil on canvas 44.3 x 90
2.TEMP3

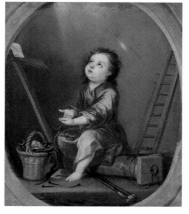

unknown artist
*Child with a Cut Finger**
oil on canvas 62.5 x 54.5
19.8

unknown artist
Classical Landscape
oil on canvas
18.1288

unknown artist
*Duck**
mixed media on canvas 80 x 100
15.10

unknown artist
Jesus Icon
oil on board (?) 60 x 40 (E)
20.16

unknown artist
*Landscape with River**
oil on canvas 90 x 112 (E)
22.4

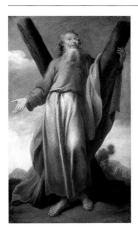

unknown artist
St Andrew
oil on canvas 185.5 x 106.5
18.1213

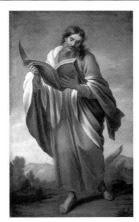

unknown artist
St Bartholomew
oil on canvas 185.5 x 107
18.1214

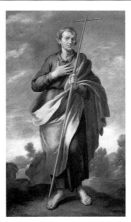

unknown artist
St Filipe
oil on canvas 185 x 106
18.1209

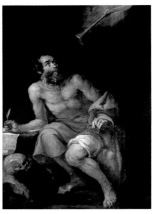

unknown artist
St Jerome
oil on canvas 173 x 118 (E)
18.1226

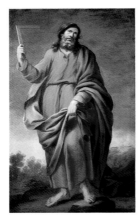

unknown artist
St Matthew
oil on canvas 185.5 x 106.5
18.1215

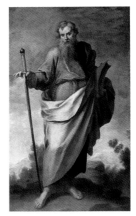

unknown artist
St Paul
oil on canvas 185 x 106.5
18.1210

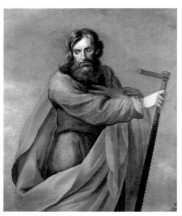

unknown artist
St Simon the Zealot
oil on canvas 110.5 x 91.5
18.1211

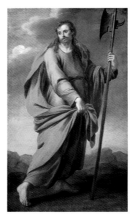

unknown artist
St Taddeus
oil on canvas 186 x 107
18.1208

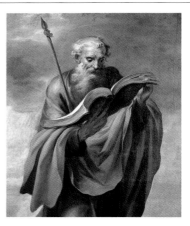

unknown artist
St Thomas
oil on canvas 110.5 x 92.2
18.1212

unknown artist
Samuel Stoker (b.1936)
oil on board 82 x 63.5 (E)
12.2

unknown artist
*The Cigarette-Lighter Vendor**
oil on board (?) 101 x 36 (E)
15.4

unknown artist
The Creation of Adam
acrylic on canvas 100 x 125.5
TAC.131

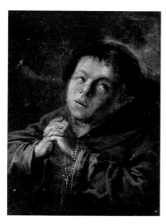

unknown artist
The Novice with a Rosary
oil on panel 21.5 x 12 (E)
18.788a

unknown artist
The Reverend Dr Stephen R. P. Mousdale
oil on canvas 74 x 61.5
19.3

unknown artist
The Reverend Professor David Jasper
oil on canvas 100 x 83
19.2

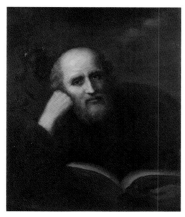

unknown artist
Unknown Saint
oil on canvas 77 x 63
1.4

unknown artist
*Young Man, Abstract Background**
oil & mixed media on canvas board
82.5 x 102 (E)
20.13

unknown artist
*Young Man, Seated with Toy Plane**
oil on board 76 x 54.5 (E)
20.14

Voysey (attributed to)
*A Former Principal** 1965
oil on canvas 75 x 62 (E)
22.6

Walker, John b.1939
*Abstract Series 1** c.1973–1974
oil & mixed media on canvas 305 x 244 (E)
2.3

Walker, John b.1939
*Abstract Series 2** c.1973–1974
oil & mixed media on canvas 305 x 244 (E)
2.4

Walker, John b.1939
*Abstract Series 3** c.1973–1974
oil & mixed media on canvas 305 x 244 (E)
2.5

Walker, John b.1939
*Abstract Series 4** c.1973–1974
oil & mixed media on canvas 305 x 244 (E)
2.6

Walker, John b.1939
*Abstract Series 5** c.1973–1974
oil & mixed media on canvas 305 x 244 (E)
2.7

Walker, John b.1939
*Abstract Series 6** 1974
oil & mixed media on canvas 305 x 244 (E)
2.8

Walker, Roy 1936–2001
Clown Dance 1995
oil on board 58.7 x 40 (E)
2.96

Warren, Vera
Landscape 1985
acrylic (?) & embroidery on board and
cloth 20.5 x 24.5 (E)
2.TEMP1

Waugh
*Queen Elizabeth II (b.1926)**
oil & mixed media on board 136 x 83 (E)
8.1

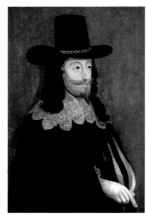

Wenceslaus, Hollar (after) 1607–1677
Charles I (1600–1649)
oil on canvas 93 x 60.5 (E)
18.758

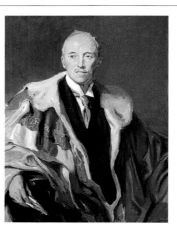

Wilcox, Leslie Arthur 1904–1982
*Charles Robert Grey (1879–1963), the 5th Earl
Grey* (after Philip Alexius de László) 1960s
oil on canvas 190 x 120 (E)
21.9

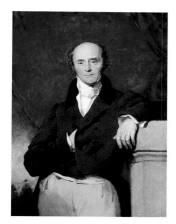

Wilcox, Leslie Arthur 1904–1982
Charles (1764–1845), the 2nd Earl Grey
(after Thomas Lawrence) 1964
oil on canvas 180 x 80 (E)
21.10

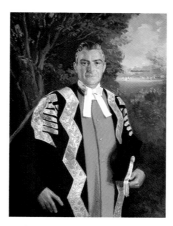

Wilcox, Leslie Arthur 1904–1982
Dr Syd Holgate 1965
oil on canvas 200 x 100 (E)
21.8

Wilcox, Leslie Arthur 1904–1982
Eric Barff Birley (1906–1995), MBE, MA,
FBA, FSA
oil on canvas 108 x 94.5 (E)
20.12

Wilcox, Leslie Arthur 1904–1982
Sir James Fitzjames Duff (1898–1970)
oil on canvas 180 x 80 (E)
21.7

Wilcox, Leslie Arthur 1904–1982
Thomas Anthony Whitworth, MA, DPhil, FGS
oil on canvas 110 x 95 (E)
20.11

Willmore, Joyce 1916–1996
Hollingside Lane
oil on board 44.5 x 59 (E)
21.25

Woodward, William Barry b.1929
Green Harbour Light
oil on board 35.5 x 35.5 (E)
2.121

Woodward, William Barry b.1929
Red Harbour Light
oil on board 35.5 x 35.5 (E)
2.120

Woolnoth, Thomas A. 1785–1857
Bishop Henry Phillpotts (1778–1869) 1851
oil on canvas 118 x 91.5
18.714

Wyck, Jan c.1640–1700
William III at the Battle of the Boyne, 1690
oil on canvas 70 x 95.5 (E)
18.775

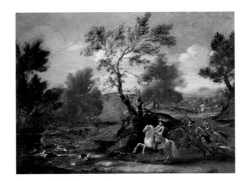

Wyck, Jan (after) c.1640–1700
A Stag Hunt c.1690
oil on canvas 87.6 x 113
18.727a

Easington District Council

Robson, George b.1945
Durham Miners' Gala 2000
oil on canvas 75.5 x 50
2

Robson, George b.1945
Durham Miners' Gala 2000
oil on canvas 59.8 x 90
3

Robson, George b.1945
Durham Miners' Gala (left panel) 2000
oil on canvas 73.6 x 192
1

Robson, George b.1945
Durham Miners' Gala (centre panel) 2000
oil on canvas 73.6 x 48.5
1

Robson, George b.1945
Durham Miners' Gala (right panel) 2000
oil on canvas 73.6 x 192
1

Facing page: Primaticcio, Francesco (circle of), 1504–1570, *The Rape of Helen* (detail), 1533–1535,
The Bowes Museum, (p. 146)

Paintings Without Reproductions

This section lists all the paintings that have not been included in the main pages of the catalogue. They were excluded as it was not possible to photograph them for this project. Additional information relating to acquisition credit lines or loan details is also included. For this reason the information below is not repeated in the Further Information section.

The Bowes Museum

Albani, Francesco (style of) 1578–1660, *Nude*, 117 x 134.6, oil on canvas, O.266, bequeathed by the Founders, 1885, not available at time of photography

Albani, Francesco (style of) 1578–1660, *Venus and Cupid* , 114.3 x 132, oil on canvas, O.267, bequeathed by the Founders, 1885, not available at time of photography

Beerstraten, Johannes (style of) 1653–c.1708, *Harbour Scene*, 17th C, 91.5 x 114, oil on canvas, O.269, bequeathed by the Founders, 1885, not available at time of photography

Beerstraten, Johannes (style of) 1653–c.1708, *Seascape*, 17th C, 91.5 x 114, oil on canvas, O.270, bequeathed by the Founders, 1885, not available at time of photography

Dutch School 17th C, *Sea Piece with Dutch Galliots*, 18.7 x 30.6, oil on canvas, B.M.787, bequeathed by the Founders, 1885, not available at time of photography

Flemish School 17th C, *Child before a High Priest*, 85 x 113, oil on canvas, O.268, bequeathed by the Founders, 1885, not available at time of photography

French School c.1670–c.1700, *Madame Louis de la Vallière as a Repentant Magdalene*, 85.6 x 69.4, oil on canvas, B.M.551, bequeathed by the Founders, 1885, not available at time of photography

French School 17th C, *Marie de' Medici (1575–1642)*, 63.5 x 46, oil on canvas, O.274, bequeathed by the Founders, 1885, not available at time of photography

French School 17th C, *Portrait of a Lady*, 61 x 44.5, oil on canvas, O.277, bequeathed by the Founders, 1885, not available at time of photography

French School 18th C, *Portrait of a Lady*, 70 x 59.5, oil on canvas, O.272, bequeathed by the Founders, 1885, not available at time of photography

French School c.1800–c.1820, early 19th C, *Portrait of a Lady in First Empire Costume*, 73.1 x 60, oil on canvas (?), B.M.289, bequeathed by the Founders, 1885, not available at time of photography

Italian (Venetian) School c.1730–c.1800, *Canal Scene*, 61 x 80, oil on canvas, O.279, bequeathed by the Founders, 1885, not available at time of photography

Lorrain, Claude (after) 1604–1682, *Landscape*, 42.5 x 51.5, oil on canvas, O.275, bequeathed by the Founders, 1885, not available at time of photography

Roos, Philipp Peter (style of) 1657–1706, *Shepherd with Dog and Sheep*, 17th C, 115 x 165, oil on canvas, B.M.74, bequeathed by the Founders, 1885, not available at time of photography

Saftleven, Herman the younger (style of) 1609–1685, *Landscape*, 22.7 x 33, oil on canvas, O.271, bequeathed by the Founders, 1885, not available at time of photography

Sarto, Andrea del (style of) 1486–1530, *Portrait of a Man*, 46 x 37.5, oil on canvas, O.278, bequeathed by the Founders, 1885, not available at time of photography

unknown artist 17th C, *A Saint*, 86.5 x 63, oil on canvas, O.106, bequeathed by the Founders, 1885, not available at time of photography

unknown artist 17th C, *St Judas Thaddeus*, 86.5 x 63, oil on canvas, O.105, bequeathed by the Founders, 1885, not available at time of photography

unknown artist *Lady with Flowers*, c.1775, 35 x 27.5, oil on canvas, O.19.A, bequeathed by the Founders, 1885, not available at time of photography

unknown artist 18th C, *Portrait of a Lady*, 35.5 x 28, oil on canvas, O.19, bequeathed by the Founders, 1885, not available at time of photography

unknown artist 18th C, *Portrait of a Lady*, 61.5 x 52, oil on canvas, O.264, bequeathed by the Founders, 1885, not available at time of photography

unknown artist 18th C, *Portrait of a Lady*, 70 x 58.5, oil on canvas, O.273, bequeathed by the Founders, 1885, not available at time of photography

unknown artist late 18th C-early 19th C, *Van Dyck, When a Young Man*, 56.3 x 45, oil on canvas, B.M.871, bequeathed by the Founders, 1885, not available at time of photography

unknown artist 19th C, *Portrait of a Man*, 91 x 71, oil on canvas, O.67, bequeathed by the Founders, 1885, not available at time of photography

unknown artist 19th C, *Portrait of a Man*, 86 x 68.5, oil on canvas, O.68, bequeathed by the Founders, 1885, not available at time of photography

unknown artist *Boy, Girl and a Dog*, 38.1 x 45.7, oil on canvas, O.127, bequeathed by the Founders, 1885, not available at time of photography

unknown artist *Portrait of a Man*, oil on canvas, O.276, bequeathed by the Founders, 1885, not available at time of photography

unknown artist *Procession*, 55.2 x 73.5, oil on canvas, O.171, bequeathed by the Founders, 1885, not available at time of photography

Darlington Borough Art Collection

Wigston, John Edwin b.1939, *North Eastern*, oil, 441, not available at time of photography

Darlington Railway Museum

unknown artist *Great Northern Railway, 4-2-0, No.266*, 30.1 x 58, oil with ink & crayon on paper, 1992.217, not available at time of photography

unknown artist *North Eastern Railway, Class J.4-2-2, No.1522*, 26.1 x 48.5, oil with ink & pencil on paper, 1992.216, not available at time of photography

Durham County Council

Almond, Henry N. 1918–2000, *The Old House by the Castle*, 67 x 57 (E), oil on canvas, AFO.0669, not available at time of photography

Durham University

Sato, Key 1906–1978, *Paravent allegorique*, 1964, 89 x 116, oil & mixed media on canvas, 4.1964.4.1, not available at time of photography

unknown artist 18th C (?), *The Pool of Bethesda*, 213 x 130, oil on canvas, 18.1227, not available at time of photography

unknown artist *Archbishop Cranmer (1489–1556)*, 192 x 90.5, oil on canvas, 18.1206, not available at time of photography

unknown artist *Bishop Andrews (1555–1626)*, 192 x 90.5, oil on canvas, 18.1205, not available at time of photography

unknown artist *Bishop Overall (1559–1619)*, 192 x 90.5, oil on canvas, 18.1207, not available at time of photography
unknown artist *Landscape with*

River and Central Rocky Hill, oil on canvas, 18.770, not available at time of photography

STOLEN

The Bowes Museum

Eves, Reginald Grenville 1876–1941, *View of a Gorge, Cliff Scene in Upper Teesdale*, 49.5 x 75, oil on canvas, 1973.103.9, purchased at auction through Phillips, Son & Neale, 1973, stolen

Vallin, Jacques Antoine (after) c.1760–1831, *Nymphs Decorating a Term of Ceres with Flowers*, 15.2 x 21.3, oil on panel, B.M.350, bequeathed by the Founders, 1885, stolen, 1988

Further Information

The paintings listed in this section have additional information relating to one or more of the five categories outlined below. This extra information is only provided where it is applicable and where it exists. Paintings listed in this section follow the same order as in the illustrated pages of the catalogue.

I The full name of the artist if this was too long to display in the illustrated pages of the catalogue. Such cases are marked in the catalogue with a (…).

II The full title of the painting if this was too long to display in the illustrated pages of the catalogue. Such cases are marked in the catalogue with a (…).

III Acquisition information or acquisition credit lines as well as information about loans, copied from the records of the owner collection.

IV Artist copyright credit lines where the copyright owner has been traced. Exhaustive efforts have been made to locate the copyright owners of all the images included within this catalogue and to meet their requirements. Any omissions or mistakes brought to our attention will be duly attended to and corrected in future publications.

V The credit line of the lender of the transparency if the transparency has been borrowed. Bridgeman images are available subject to any relevant copyright approvals from the Bridgeman Art Library at www.bridgeman.co.uk

The Bowes Museum

Aertsen, Pieter (after) 1507/1508–1575, *Fruit and Vegetables with Figures in the Background*, bequeathed by the Founders, 1885

Albani, Francesco (after) 1578–1660, *Venus and Vulcan*, bequeathed by the Founders, 1885

Allegrain, Étienne 1644–1736, *Classical Landscape with Figures and Ruins*, bequeathed by the Founders, 1885

Alma-Tadema, Lawrence 1836–1912, *Catherine Lucy Wilhelmina Stanhope (1819–1901), Duchess of Cleveland*, donated by Miss Kay Drummond, 1935

Amstel, Jan van c.1500–c.1542, *Landscape with the Flight into Egypt*, bequeathed by the Founders, 1885

Anastasi, Auguste Paul Charles 1820–1889, *Landscape with a Farm Waggon, Sunset*, bequeathed by the Founders, 1885

Anastasi, Auguste Paul Charles 1820–1889, *Avenue of Poplars at Bougival, France*, bequeathed by the Founders, 1885

Anastasi, Auguste Paul Charles 1820–1889, *Landscape, the Banks of a Canal*, bequeathed by the Founders, 1885

Anastasi, Auguste Paul Charles 1820–1889, *River Scene, Moonlight*, bequeathed by the Founders, 1885

Anastasi, Auguste Paul Charles 1820–1889, *The Cabaret Maurice at Bougival, France*, bequeathed by the Founders, 1885

André, Jane *Still Life*, bequeathed by the Founders, 1885

Antolínez, José 1635–1675, *The Agony in the Garden*, bequeathed by the Founders, 1885

Antolínez, José 1635–1675, *The Immaculate Conception*, bequeathed by the Founders, 1885

Aparicio, José 1773–1838, *Reverend Father Manuel Regidor y Brihuega*, bequeathed by the Founders, 1885

Arco, Alonso del (circle of) 1625–1700, *St Clare Holding a Monstrance*, bequeathed by the Founders, 1885

Arnold, B. Y. *Waterfall*

Arredondo, Isidoro (attributed to) 1653–1702, *The Vision of St Gertrude with St Augustine and the Holy Trinity*, bequeathed by the Founders, 1885

Arthois, Jacques d' 1613–1686, *Landscape, Riverbank with Figures*, bequeathed by the Founders, 1885

Arthois, Jacques d' (attributed to) 1613–1686, *Hunting Party*, bequeathed by the Founders, 1885

Arthois, Jacques d' (style of) 1613–1686, *Landscape with a River and Figures*, bequeathed by the Founders, 1885

Asch, Pieter Jansz. van 1603–1678, *Scene at the Edge of a Wood*, bequeathed by the Founders, 1885

Bachelier, Jean Jacques 1724–1806, *Dog of the Havana Breed*, bequeathed by the Founders, 1885

Backer, Jacob de (attributed to) c.1545–1590s, *The Victory of the Risen Christ*, bequeathed by the Founders, 1885

Bale, Charles Thomas (style of)

b.1849, *Still Life*, bequeathed by the Founders, 1885

Balen, Hendrik van I (style of) 1575–1632, *Vintage Scene*, bequeathed by the Founders, 1885

Bassano, Francesco II (studio of) 1549–1592, *The Adoration of the Shepherds*, bequeathed by the Founders, 1885

Batoni, Pompeo (after) 1708–1787, *Karl Theodore (1724–1799), Elector of Bavaria*, bequeathed by the Founders, 1885

Bayer, William *Old Man with a White Beard*, gift from Reverend Dr A. C. Bouquet, 1952

Beale, S. active 18th C, *Portrait of a Man*, bequeathed by the Founders, 1885

Beaubrun, Charles 1604–1692, *A Lady in a White Dress, with a Bouquet*, bequeathed by the Founders, 1885

Beaubrun, Charles (circle of) 1604–1692, *Anne of Austria (1601–1666), Queen of France, Consort of Louis XIII*, bequeathed by the Founders, 1885

Beaubrun, Charles (after) 1604–1692 & **Beaubrun, Henri the younger** 1603–1677 *Portrait of a Lady in Blue and Gold*, bequeathed by the Founders, 1885

Beerstraten, Anthonie active c.1635–c.1655, *Canal and Houses, Amsterdam, Holland*, bequeathed by the Founders, 1885

Bélanger, Eugène active late 18th C–early 19th C, *Landscape with River and Figures*, bequeathed by the Founders, 1885

Bellier, Charles b.1796, *An Eastern*

Encampment, bequeathed by the Founders, 1885

Bellier, Charles b.1796, *An Eastern Encampment*, bequeathed by the Founders, 1885

Bellier, Jean François Marie 1745–1836, *Landscape with Nymphs Bathing*, bequeathed by the Founders, 1885

Bellini, Giovanni (style of) 1431–1436–1516, *The Madonna and Child with St Paul and St Catherine*, bequeathed by the Founders, 1885

Benson, Ambrosius (circle of) c.1495–before 1550, *Lamentation (Pietà and the Two Marys)*, bequeathed by the Founders, 1885

Bérain, Jean I (style of) 1640–1711, *Decorative Scrolls with Paschal Lamb*, bequeathed by the Founders, 1885

Berch, Gillis Gillisz. de c.1600–1669, *A Basket of Flowers with Seashells*, bequeathed by the Founders, 1885

Berch, Gillis Gillisz. de c.1600–1669, *A Basket of Pears and Grapes*, bequeathed by the Founders, 1885

Beresteyn, Claes van 1629–1684, *Landscape with a Waterfall*, bequeathed by the Founders, 1885

Beresteyn, Claes van (attributed to) 1629–1684, *Landscape with a Lake among Hills*, bequeathed by the Founders, 1885

Bertier, Louis Eugène 1809–after 1870, *A Spanish Beggar with His Daughter*, bequeathed by the Founders, 1885

Besson, Faustin 1821–1882, *Lorédan Larchey (1831–1902),*

bequeathed by the Founders, 1885

Bigg, William Redmore 1755–1828, *Which Way?*

Bigg, William Redmore 1755–1828, *Children Guiding Their Blind Father over a Bridge*

Bijlert, Jan van (after) 1597–1671, *Shepherd with a Flute*, bequeathed by the Founders, 1885

Bijlert, Jan van (after) 1597–1671, *Woman Dressed as a Shepherdess*, bequeathed by the Founders, 1885

Billou, Paul 1821–1868, *Still Life with a Carafe*, bequeathed by the Founders, 1885

Bizon, Edna b.1929, *Jackdaw*, donated by Sandra Grewcock, 1984, © the artist

Blake, B. *Pheasant*, bequeathed by the Founders, 1885

Blanchard, Edouard-Théophile 1844–1879, *Woody Landscape with Buildings and Figures above a River*, bequeathed by the Founders, 1885

Bland, John Francis 1856–1899, *Scarborough Cliffs, North Yorkshire*, gift from Mrs J. G. Hall, 1936

Blay, C. de *A Young Girl, Attended by a Chaperone, Giving a Rose to Her Lover Secretly*, bequeathed by the Founders, 1885

Bloclant, Gerrit van 1589–1650, *Flower Piece*, gift from Mr Gerard Arnhold, 1991

Bloemaert, Abraham (after) 1564–1651, *Adam and Eve*, bequeathed by the Founders, 1885

Blommaerdt, Maximilian (attributed to) active 1696–1697, *Landscape*, bequeathed by the Founders, 1885

Blommaerdt, Maximilian

(attributed to) active 1696–1697, *Landscape*, bequeathed by the Founders, 1885

Blommaerdt, Maximilian (attributed to) active 1696–1697, *Landscape with a River, Buildings and Figures*, bequeathed by the Founders, 1885

Boilly, Louis Léopold (style of) 1761–1845, *Laetitia Ramolino Buonaparte (c.1750–1836), Mother of Napoleon I*, bequeathed by the Founders, 1885

Bonington, Richard Parkes (copy after) 1802–1828, *Quentin Durward at Liège, Belgium*, bequeathed by the Founders, 1885

Bonnefoi, Auguste 1813–1883, *Flowers and Fruit*, donated by Miss Bellis, 1963

Bonnefoi, Auguste 1813–1883, *Flowers and Fruit*, donated by Miss Bellis, 1963

Bonnefoi, Auguste 1813–1883, *Trees*, bequeathed by the Founders, 1885

Bonvin, François 1817–1887, *Self Portrait*, bequeathed by the Founders, 1885

Bonvin, François 1817–1887, *Two Countrywomen*, bequeathed by the Founders, 1885

Bonvin, François 1817–1887, *Grandmamma's Breakfast*, bequeathed by the Founders, 1885

Boquet, Pierre Jean 1751–1817, *Landscape with Figures and a Castle on a Hill*, bequeathed by the Founders, 1885

Borgoña, Juan de c.1495–1536, *St Gregory and St Augustine*, bequeathed by the Founders, 1885

Borgoña, Juan de c.1495–1536, *St Jerome and St Ambrose*, bequeathed by the Founders, 1885

Boss, H. *Portrait of a Gentleman*, bequeathed by the Founders, 1885

Both, Jan (after) c.1618–1652, *Landscape with Cattle*, bequeathed by the Founders, 1885

Both, Jan (style of) c.1618–1652, *Seaport with Shipping*, bequeathed by the Founders, 1885

Boucher, François 1703–1770, *Landscape with a Watermill*, bequeathed by the Founders, 1885

Boucher, François (school of) 1703–1770, *Putti with a Goat in a Landscape*, bequeathed by the Founders, 1885

Boudin, Eugène Louis 1824–1898, *Beach Scene at Low Tide*, bequeathed by the Founders, 1885

Boudin, Eugène Louis 1824–1898, *The Ferry at Deauville, France*, bequeathed by the Founders, 1885

Boulangé, Louis-Jean-Baptiste 1812–1878, *Landscape with Women Keeping Geese*, bequeathed by the Founders, 1885

Bourges, Pauline Elise Léonide 1838–1910, *The House of Monsieur Edouard Frère at Écouen, France*, bequeathed by the Founders, 1885

Bout, Peeter 1658–1719, *Landscape with Buildings and Figures*, bequeathed by the Founders, 1885

Bout, Peeter (style of) 1658–1719, *Winter Landscape with Buildings and Skaters*, bequeathed by the Founders, 1885

Bouton, Charles-Marie (attributed to) 1781–1853, *Cloisters of a Cathedral*, bequeathed by the Founders, 1885

Bouton, Charles-Marie (attributed to) 1781–1853, *Interior of a Church*, bequeathed by the Founders, 1885

Bouton, Charles-Marie (attributed to) 1781–1853, *Interior of a Church*, bequeathed by the Founders, 1885

Bouts, Albert (circle of) c.1452/1455–1549, *The Madonna at Prayer*, bequeathed by the Founders, 1885

Bouts, Dieric the elder (after) c.1415–1475, *The Head of St John the Baptist on a Gold Dish*, bequeathed by the Founders, 1885

Bowes, Joséphine 1825–1874, *The Château du Barry at Louveciennes, France*, bequeathed by the Founders, 1885

Bowes, Joséphine 1825–1874, *Landscape with Trees and Cattle*, bequeathed by the Founders, 1885

Bowes, Joséphine 1825–1874, *Landscape with River and Trees, Sunset*, bequeathed by the Founders, 1885

Bowes, Joséphine 1825–1874, *Souvenir of Savoy, France, Sunrise in the Mountains*, bequeathed by the Founders, 1885

Bowes, Joséphine 1825–1874, *Squally Weather, A Sketch near Boulogne-sur-Mer, France*, bequeathed by the Founders, 1885

Bowes, Joséphine 1825–1874, *A Monastic Funeral by Moonlight*, bequeathed by the Founders, 1885

Bowes, Joséphine 1825–1874, *Moonlight in the Forest*, bequeathed by the Founders, 1885

Bowes, Joséphine 1825–1874, *A Cornfield near Calais*, bequeathed by the Founders, 1885

Bowes, Joséphine 1825–1874, *A Country Lane*, bequeathed by the Founders, 1885

Bowes, Joséphine 1825–1874, *A House with a Lake in the Background*, bequeathed by the Founders, 1885

Bowes, Joséphine 1825–1874, *A Rocky Cliff*, bequeathed by the Founders, 1885

Bowes, Joséphine 1825–1874, *An Old Tower near the Sea*, bequeathed by the Founders, 1885

Bowes, Joséphine 1825–1874, *Bodegón* (copy after Diego Velázquez), bequeathed by the Founders, 1885

Bowes, Joséphine 1825–1874, *Bodegón* (copy after Diego Velázquez), bequeathed by the Founders, 1885

Bowes, Joséphine 1825–1874, *Bridge over a Mountain Stream*, bequeathed by the Founders, 1885

Bowes, Joséphine 1825–1874, *Cliffs near Boulogne-sur-Mer, France*, bequeathed by the

Founders, 1885

Bowes, Joséphine 1825–1874, *Fisherman's Cottage near the Sea*, bequeathed by the Founders, 1885

Bowes, Joséphine 1825–1874, *Fishermen's Cottages near Boulogne-sur-Mer, France, after the Cholera Epidemic*, bequeathed by the Founders, 1885

Bowes, Joséphine 1825–1874, *Forest Scene*, bequeathed by the Founders, 1885

Bowes, Joséphine 1825–1874, *Fruit, Flowers and Vegetables*, bequeathed by the Founders, 1885

Bowes, Joséphine 1825–1874, *Lake with Boatmen at Sunset*, bequeathed by the Founders, 1885

Bowes, Joséphine 1825–1874, *Landscape* (copy after Jean-Honoré Fragonard), bequeathed by the Founders, 1885

Bowes, Joséphine 1825–1874, *Landscape, Souvenir of Switzerland*, bequeathed by the Founders, 1885

Bowes, Joséphine 1825–1874, *Landscape with a Lake and a Ruined Castle*, bequeathed by the Founders, 1885

Bowes, Joséphine 1825–1874, *Landscape with a River, Trees and a Mill*, bequeathed by the Founders, 1885

Bowes, Joséphine 1825–1874, *Landscape with Trees, a Mountain in the Distance*, bequeathed by the Founders, 1885

Bowes, Joséphine 1825–1874, *Landscape with Trees and a Cottage, Windmills in the Distance*, bequeathed by the Founders, 1885

Bowes, Joséphine 1825–1874, *Old Woman beside a Fire*, bequeathed by the Founders, 1885

Bowes, Joséphine 1825–1874, *Pier with Fishing Boats, Town in the Background*, bequeathed by the Founders, 1885

Bowes, Joséphine 1825–1874, *River and Bridge in the South of France*, bequeathed by the Founders, 1885

Bowes, Joséphine 1825–1874, *River Seine near the Bois-de-Boulogne, France*, bequeathed by the Founders, 1885

Bowes, Joséphine 1825–1874, *River View, Misty Weather*, bequeathed by the Founders, 1885

Bowes, Joséphine 1825–1874, *River with Pollard Willows*, bequeathed by the Founders, 1885

Bowes, Joséphine 1825–1874, *Sand Dunes near Boulogne-sur-Mer, France*, bequeathed by the Founders, 1885

Bowes, Joséphine 1825–1874, *Sea Beating against a Rocky Cliff*, bequeathed by the Founders, 1885

Bowes, Joséphine 1825–1874, *Sea View, Sunset*, bequeathed by the Founders, 1885

Bowes, Joséphine 1825–1874, *Sketch near Boulogne-sur-Mer, France*, bequeathed by the Founders, 1885

Bowes, Joséphine 1825–1874, *Sketch of a Rocky Cliff*, bequeathed

by the Founders, 1885

Bowes, Joséphine 1825–1874, *Sketch of Cottages near Boulogne-sur-Mer, France*, bequeathed by the Founders, 1885

Bowes, Joséphine 1825–1874, *Sketch of Ferns*, bequeathed by the Founders, 1885

Bowes, Joséphine 1825–1874, *Sketch of Flowers and Ferns*, bequeathed by the Founders, 1885

Bowes, Joséphine 1825–1874, *Sketch of the Pavillon de Sully, France*, bequeathed by the Founders, 1885

Bowes, Joséphine 1825–1874, *Sketch on the Seashore near Boulogne-sur-Mer, France*, bequeathed by the Founders, 1885

Bowes, Joséphine 1825–1874, *Sketch, Sunset*, bequeathed by the Founders, 1885

Bowes, Joséphine 1825–1874, *Snow Scene*, bequeathed by the Founders, 1885

Bowes, Joséphine 1825–1874, *Snow Scene in the South of France*, bequeathed by the Founders, 1885

Bowes, Joséphine 1825–1874, *Still Life*, bequeathed by the Founders, 1885

Bowes, Joséphine 1825–1874, *Street Scene in a French Town*, bequeathed by the Founders, 1885

Bowes, Joséphine 1825–1874, *Study of Birch Trees*, bequeathed by the Founders, 1885

Bowes, Joséphine 1825–1874, *Study of Birch Trees*, bequeathed by the Founders, 1885

Bowes, Joséphine 1825–1874, *Study of Poplars*, bequeathed by the Founders, 1885

Bowes, Joséphine 1825–1874, *Study of Trees*, bequeathed by the Founders, 1885

Bowes, Joséphine 1825–1874, *Study of Trees*, bequeathed by the Founders, 1885

Bowes, Joséphine 1825–1874, *Sunset on the Sea near Boulogne-sur-Mer, France*, bequeathed by the Founders, 1885

Bowes, Joséphine 1825–1874, *Sunset on the Seashore*, bequeathed by the Founders, 1885

Bowes, Joséphine 1825–1874, *Tall Cliff with Two Figures on Top*, bequeathed by the Founders, 1885

Bowes, Joséphine 1825–1874, *The Castle on the Cliff*, bequeathed by the Founders, 1885

Bowes, Joséphine 1825–1874, *The Forest King*, bequeathed by the Founders, 1885

Bowes, Joséphine 1825–1874, *View on the Seashore*, bequeathed by the Founders, 1885

Bowes, Joséphine 1825–1874, *Waterfall in the Black Forest*, bequeathed by the Founders, 1885

Bowes, Joséphine 1825–1874, *Windmill*, bequeathed by the Founders, 1885

Bowes, Joséphine 1825–1874, *Sketch of an Old Woman at Cernay-le-Roi, France*, bequeathed by the Founders, 1885

Bowes, Joséphine 1825–1874, *View near Cernay-le-Roi, France*, bequeathed by the Founders, 1885

Bowes, Joséphine 1825–1874, *Avenue of Poplars*, bequeathed by the Founders, 1885

Bowes, Joséphine 1825–1874, *Souvenir of the Danube, View in Hungary*, bequeathed by the Founders, 1885

Bowes, Joséphine (attributed to) 1825–1874, *Portrait of a Woman, Head and Neck in Profile*, bequeathed by the Founders, 1885

Bowes, Joséphine (attributed to) 1825–1874, *A Cottage in a Forest*, bequeathed by the Founders, 1885

Bowes, Joséphine (attributed to) 1825–1874, *Coastal Scene*, bequeathed by the Founders, 1885

Bowes, Joséphine (attributed to) 1825–1874, *Port Scene at Sunset with Classical Buildings*, bequeathed by the Founders, 1885

Bowes, Joséphine (attributed to) 1825–1874, *Portrait of a Dog*, bequeathed by the Founders, 1885

Bowes, Joséphine (attributed to) 1825–1874, *Portrait of a Lady with a Black Shawl*, bequeathed by the Founders, 1885

Bowes, Joséphine (attributed to) 1825–1874, *Silver Ink Stand, Mug and Copper Coffee Pot*, bequeathed by the Founders, 1885

Bowes, Joséphine (attributed to) 1825–1874, *Sketch of a Church Interior with Figures*, bequeathed by the Founders, 1885

Bowes, Joséphine (attributed to) 1825–1874, *Sketch of Kitchen Utensils*, bequeathed by the Founders, 1885

Bowes, Joséphine (attributed to) 1825–1874, *Study of a Tree*, bequeathed by the Founders, 1885

Bowes, Joséphine (attributed to) 1825–1874, *Study of a Tree*, bequeathed by the Founders, 1885

Bowes, Joséphine (attributed to) 1825–1874, *Study of Trees*, bequeathed by the Founders, 1885

Bowes, Joséphine (attributed to) 1825–1874, *Sunset, Coastal Scene*, bequeathed by the Founders, 1885

Bowes, Joséphine (attributed to) 1825–1874, *Still Life with Bread and Butter*, bequeathed by the Founders, 1885

Bowes, Joséphine (attributed to) 1825–1874, *Coastal Scene with Figures*, bequeathed by the Founders, 1885

Bredael, Alexander van 1663–1720, *Cattle Market in Antwerp, Belgium*, bequeathed by the Founders, 1885

Bredael, Peeter van 1629–1719, *A Market among Classical Ruins*, bequeathed by the Founders, 1885

Breenbergh, Bartholomeus 1598–1657, *Amarillis Crowning Mirtillo with a Floral Wreath*, bequeathed by the Founders, 1885

Brekelenkam, Quiringh van after 1622–1669 or after, *An Old Vegetable Dealer on Her Stall*, bequeathed by the Founders, 1885

Bricard, François Xavier 1881–1935, *Landscape with Watermill*, bequeathed by the Founders, 1885

Brifaut active 19th C, *A Rocky Coast with Grounded Fishing Boats*, bequeathed by the Founders, 1885

Brissot de Warville, Félix Saturnin 1818–1892, *Landscape with Figures*, bequeathed by the Founders, 1885

Brown, Mather 1761–1831, *Lord Cornwallis Receiving the Sons of Tipu as Hostages*, bequeathed by the Founders, 1885

Brueghel, Jan the elder (school of) 1568–1625, *Cornfield with Reapers*, bequeathed by the Founders, 1885

Brueghel, Jan the elder (school of) 1568–1625, *Landscape with a Castle*, bequeathed by the Founders, 1885

Budelot, Philippe active 1793–1841, *Landscape with a Man on a Donkey and Cattle*, bequeathed by the Founders, 1885

Budelot, Philippe active 1793–1841, *Landscape with a Military Convoy*, bequeathed by the Founders, 1885

Burgau, Franciscus Michael Sigismund von (attributed to) 1678–1754, *Forest Floor Still Life*, bequeathed by the Founders, 1885

Burr, John 1831–1893, *A Wandering Minstrel*, donated by William Lee, 1911

H. J. C. *The Emperor Napoleon III Reviewing Troops on the Champs Elysées, Paris, France*, bequeathed by the Founders, 1885

Cajés, Eugenio (follower of) 1575–1634, *The Immaculate Conception*, bequeathed by the Founders, 1885

Cajés, Eugenio (school of) 1575–1634, *The Presentation of the Virgin in the Temple*, bequeathed by the Founders, 1885

Cals, Adolphe Félix 1810–1880, *Peasant Woman and Child*, bequeathed by the Founders, 1885

Cals, Adolphe Félix 1810–1880, *The Seine at Saint-Ouen, France*, bequeathed by the Founders, 1885

Cals, Adolphe Félix 1810–1880, *A Cook Plucking a Wild Duck*, bequeathed by the Founders, 1885

Cals, Adolphe Félix 1810–1880, *Karl Josef Kuwasseg (1802–1877), Mrs Bowes' Drawing Master*, bequeathed by the Founders, 1885

Camilo, Francisco c.1615–1671, *Our Lady and St John the Evangelist Crowning St John of God with Thorns*, bequeathed by the Founders, 1885

Camilo, Francisco (circle of) c.1615–1671, *St Thomas of Villanueva*, bequeathed by the Founders, 1885

Camphuysen, Govert Dircksz. (attributed to) c.1623–1672, *Landscape with Houses and Figures*, bequeathed by the Founders, 1885

Canaletto 1697–1768, *Regatta on the Grand Canal, Venice, Italy*, purchased with the assistance of the National Heritage Memorial Fund, the Victoria and Albert Museum Purchase Grant Fund, the National Art Collections Fund, the Friends of the Bowes Museum and Durham County Council, 1982

Canaletto 1697–1768, *The Bucintoro Returning to the Molo on Ascension Day after the Ceremony of Wedding the Adriatic, Venice, Italy*, purchased with the assistance of the National Heritage Memorial Fund, the Victoria and Albert Museum Purchase Grant Fund, the National Art Collections Fund, the Friends of the Bowes Museum and Durham County Council, 1982

Cantarini, Simone (after) 1612–1648, *The Rest on the Flight into Egypt*, bequeathed by the Founders, 1885

Caprioli, Domenico c.1494–1528, *Lelio Torelli (1489–1578), Jurisconsult at Fano*, bequeathed by the Founders, 1885

Caracciolo, Giovanni Battista (attributed to) 1578–1635, *St John the Baptist*, bequeathed by the Founders, 1885

Carducho, Bartolomé (after) 1560–1608, *Fray José de Sigüenza (c.1544–1606)*, bequeathed by the Founders, 1885

Carneo, Antonio (attributed to) 1637–1692, *Venus, Vulcan and Cupid*, bequeathed by the Founders, 1885

Carolus, Louis Antoine 1814–1865, *The Reprimand*, bequeathed by the Founders, 1885

Carracci, Annibale (after) 1560–1609, *Pietà*, bequeathed by the Founders, 1885

Carreño de Miranda, Juan 1614–1685, *Belshazzar's Feast*, bequeathed by the Founders, 1885

Cassie, James 1819–1879, *Portrait of a Girl*, bequeathed by the Founders, 1885

Cassinelli, B. active 1850–1860s, *View in the Port of Le Havre, France*, bequeathed by the Founders, 1885

Cassinelli, B. active 1850–1860s, *River with Shipping by Moonlight*, bequeathed by the Founders, 1885

Cassinelli, B. active 1850–1860s, *View near Le Havre, France, Sunset*, bequeathed by the Founders, 1885

Cassinelli, B. active 1850–1860s, *Ships in a Small Anchorage*, bequeathed by the Founders, 1885

Cassinelli, B. active 1850–1860s, *Two Lines of Ships, One Ship Ablaze*, bequeathed by the Founders, 1885

Casteels, Pieter 1684–1749, *A Stone Vase of Flowers with a Parrot, a Monkey and Fruit*, bequeathed by the Founders, 1885

Casteels, Pieter 1684–1749, *A Stone Vase of Flowers with Fruit and Two Parrots*, bequeathed by the Founders, 1885

Castello, Valerio (school of) 1624–1659, *St Jerome*, bequeathed by the Founders, 1885

Caullery, Louis de (attributed to) before 1582–after 1621, *Ascension Day, Venice, Italy*, bequeathed by the Founders, 1885

Caullery, Louis de (attributed to) before 1582–after 1621, *Banqueting Scene in the Open Air*, bequeathed by the Founders, 1885

Cavallino, Bernardo (studio of) 1616/1622–1654/1656, *The Immaculate Conception*, bequeathed by the Founders, 1885

Cazes, Pierre Jacques 1676–1754, *La naissance de Vénus (The Birth of Venus)*, bequeathed by the Founders, 1885

Cecco Bravo 1607–1661, *The Death of Cleopatra*, bequeathed by the Founders, 1885

Ceruti, Giacomo Antonio (style of) 1698–1767, *Portrait of an Elderly Lady in Black*, bequeathed by the Founders, 1885

Champaigne, Philippe de (attributed to) 1602–1674, *Portrait of the Artist's Wife*, bequeathed by the Founders, 1885

Chaplin, Charles 1825–1891, *A Young Girl Drawing*, bequeathed by the Founders, 1885

Chaplin, Charles 1825–1891, *Girl in a Pink Dress Sitting at a Table with a Dog*, bequeathed by the Founders, 1885

Chaplin, Charles 1825–1891, *Girl in White, Reading*, bequeathed by the Founders, 1885

Chaplin, Charles 1825–1891, *The Lost Bird*, bequeathed by the Founders, 1885

Chaplin, Charles 1825–1891, *Two Girls Bathing*, bequeathed by the Founders, 1885

Chaplin, Charles (style of) 1825–1891, *Girl Caging a Bird*, bequeathed by the Founders, 1885

Cicéri, Eugène 1813–1890, *Landscape with a Cloudy Sky*, bequeathed by the Founders, 1885

Cignaroli, Giambettino 1706–1770, *St Martha*, bequeathed by the Founders, 1885

Cipriani, Giovanni Battista (style of) 1727–1785, *Sleeping Female Nude*, bequeathed by the Founders, 1885

Cittadini, Pier Francesco (attributed to) 1616–1681, *Portrait of a Lady Holding a Book*, bequeathed by the Founders, 1885

Claeissins, Pieter II (circle of) before 1536–1623, *A Christian Allegory of the Salvation of a Christian Soul*, bequeathed by the Founders, 1885

Claesz., Jan d.1636, *Portrait of a Child with a Coral Necklace*, bequeathed by the Founders, 1885

Clausen, George 1852–1944, *Nellie St John Heaton*, © Clausen estate

Cleminson, Robert active c.1864–c.1903, *Three Stags*, bequeathed by the Founders, 1885

Clouet, François (attributed to) c.1515–1572, *A Lady in a Black Dress with Marie Stuart Coiffure*, bequeathed by the Founders, 1885

Clouet, François (attributed to) c.1515–1572, *Female Portrait*, bequeathed by the Founders, 1885

Cochet, Augustine 1792–c.1835, *Portrait of a Lady with a Red and White Bonnet*, bequeathed by the Founders, 1885

Codazzi, Viviano c.1604–1670, *Town Scene in Italy with Ancient Ruins*, bequeathed by the Founders, 1885

Coello, Claudio 1642–1693, *Mariana of Austria (1634–1696), Queen of Spain*, bequeathed by the Founders, 1885

Colin, Paul Alfred 1838–1916, *Farm Buildings among Trees*, bequeathed by the Founders, 1885

Colin, Paul Alfred 1838–1916, *Lake in a Forest*, bequeathed by the Founders, 1885

Colin, Paul Alfred 1838–1916, *Landscape with a River, Sunset*, bequeathed by the Founders, 1885

Colin, Paul Alfred 1838–1916, *The Quarry*, bequeathed by the Founders, 1885

Compte-Calix, François Claudius 1813–1880, *Madame de Lamartine Adopting the Children of Patriots Killed at the Barricades in Paris during the Revolution of 1848*, bequeathed by the Founders, 1885

Constantin, Auguste Aristide Fernand 1824–1895, *Still Life with Bread and Onions*, bequeathed by the Founders, 1885

Coosemans, Alexander 1627–1689, *Fruit Piece*, bequeathed by the Founders, 1885

Cornelisz. van Oostsanen, Jacob (studio of) c.1470–1533, *The Crucifixion*, bequeathed by the Founders, 1885

Corot, Jean-Baptiste-Camille 1796–1875, *Landscape with Cattle*, bequeathed by the Founders, 1885

Cortés y Aguilar, Andrés 1810–1879, *Cows at the Watering Place*, bequeathed by the Founders, 1885

Cottin, Pierre 1823–1886, *Farmyard with Poultry*, bequeathed by the Founders, 1885

Courbet, Gustave 1819–1877, *View at Ornans, France*, bequeathed by the Founders, 1885

Court, Joseph-Désiré 1797–1865, *Le Maréchal Soult (1769–1851), Duc de Dalmatie*, bequeathed by the Founders, 1885

Court, Joseph-Désiré 1797–1865, *François Guizot (1787–1874)*, bequeathed by the Founders, 1885

Court, Joseph-Désiré 1797–1865, *La sortie du bal*, bequeathed by the Founders, 1885

Court, Joseph-Désiré 1797–1865, *Le Maréchal Pélissier (1794–1864), Duc de Malakoff*, bequeathed by the Founders, 1885

Court, Joseph-Désiré 1797–1865, *La Duchesse de Berri* (copy after Thomas Lawrence), bequeathed by the Founders, 1885

Courtin, Jacques François (after) 1672–1752, *The Temptress*, bequeathed by the Founders, 1885

Couturier, Philibert Léon 1823–1901, *A Cockerel with Two Ducks*, bequeathed by the Founders, 1885

Couturier, Philibert Léon 1823–1901, *A Poultry Yard*, bequeathed by the Founders, 1885

Couturier, Philibert Léon 1823–1901, *A Poultry Yard*, bequeathed by the Founders, 1885

Couturier, Philibert Léon 1823–1901, *A Yard with Poultry and a Cock Pheasant*, bequeathed by the Founders, 1885

Couturier, Philibert Léon 1823–1901, *Ducks and Hens with a Dead Rat*, bequeathed by the Founders, 1885

Cowning, T. W. active 20th C, *Bright Cattle in Moorland and Slope*, gift from Mr C. Dixon, executor of the estate of the late Miss Marquis

Cowning, T. W. active 20th C, *Decorative Panel*, gift from Mr C. Dixon, executor of the estate of the late Miss Marquis

Cowning, T. W. active 20th C, *Reekie Lynn, Scotland*, gift from Mr C. Dixon, executor of the estate of the late Miss Marquis

Coxie, Goris de active 1685–1693, *Landscape with Figures and a Château*, bequeathed by the Founders, 1885

Coxie, Michiel I (circle of) 1499–1592, *Mary Magdalene Washing Christ's Feet*, bequeathed by the Founders, 1885

Coypel, Antoine (after) 1661–1722, *Susannah Accused by the Elders*, bequeathed by the Founders, 1885

Craesbeeck, Joos van c.1605–1662, *Interior of a Tavern*, bequeathed by the Founders, 1885

Craesbeeck, Joos van c.1605–1662, *Man Holding a Cup and a Wine Bottle*, donated by Reverend Dr A. C. Boquet, 1952

Creswick, Thomas 1811–1869, *A Relic of Old Times (Barnard Castle from the River)*, purchased, 1923

Croos, Anthonie Jansz. van der c.1606–1662/1663, *Landscape with Rijswijk Castle, Holland*, bequeathed by the Founders, 1885

Crosby, F. *The 'Red Lion' Inn*, donated by J. H. Gaster, 1971

Croy, Raoul de b.1791, *Italian Washerwomen*, bequeathed by the Founders, 1885

Croy, Raoul de b.1791, *The Broken Pitcher*, bequeathed by the Founders, 1885

Cuesta, Juan M. de la *An Angel with a Guitar*, bequeathed by the Founders, 1885

Cuyp, Aelbert (after) 1620–1691, *Man with a Goose*, bequeathed by the Founders, 1885

Cuyp, Aelbert (after) 1620–1691, *Woman with a Basket of Eggs and a Cockerel*, bequeathed by the Founders, 1885

W. D. *Flying Grouse*, donated by Miss Sandra Grewcock, 1984

Dagnan, Isidore 1794–1873, *A Mediterranean Seaport*, bequeathed by the Founders, 1885

Dahl, Michael I (attributed to) 1656/1659–1743, *Portrait of a Lady*, bequeathed by the Founders, 1885

Dalvimar, S. active 18th C, *Portrait of a Bavarian Officer*, bequeathed

by the Founders, 1885

Dandini, Cesare (attributed to) 1596–1657, *The Muse Calliope*, bequeathed by the Founders, 1885

Dandrillon, Pierre Bertrand (attributed to) 1725–1784, *A View of the Port of Bordeaux, France*, bequeathed by the Founders, 1885

Danloux, Henri-Pierre 1753–1809, *Portrait of a Lady in a White Dress*, bequeathed by the Founders, 1885

Darondeau, Stanislas Henri Benoît 1807–1841, *Alfred de Musset (1810–1857)*, bequeathed by the Founders, 1885

Daubigny, Charles-François 1817–1878, *Soleil couchant, L'Ile de Bezons, France*, purchased from the late Mrs J. Eyles' sale at Tennants, Boroughbridge, with grants from the Museums, Libraries and Archives Council/Victoria and Albert Museum Purchase Grant Fund and the Friends of the Bowes Museum, 2003

Dauzats, Adrien 1804–1868, *Interior of the Church of St Roch, Paris, France*, bequeathed by the Founders, 1885

Dauzats, Adrien 1804–1868, *Two Goats*, bequeathed by the Founders, 1885

Dauzats, Adrien 1804–1868, *View at Montfort l'Amaury, France*, bequeathed by the Founders, 1885

de Bréa active 1750–1761, *Still Life with a Dead Hare*, bequeathed by the Founders, 1885

de Gombaud *Portrait of a Lady*, bequeathed by the Founders, 1885

Decaisne, Henri 1799–1852, *Portrait of a Man in Early to Mid-Seventeenth Century Costume*, bequeathed by the Founders, 1885

Decamps, Alexandre-Gabriel 1803–1860, *A Monkey Playing a Lute*, bequeathed by the Founders, 1885

Dedreux-Dorcy, Pierre Joseph 1789–1874, *Woman Scouring Pots*, bequeathed by the Founders, 1885

Dedreux-Dorcy, Pierre Joseph 1789–1874, *A Fête Champêtre*, bequeathed by the Founders, 1885

Dedreux-Dorcy, Pierre Joseph 1789–1874, *A Young Girl*, bequeathed by the Founders, 1885

Dedreux-Dorcy, Pierre Joseph 1789–1874, *Girl Crowned with Roses, Holding a Dog*, bequeathed by the Founders, 1885

Dedreux-Dorcy, Pierre Joseph 1789–1874, *Head of a Girl*, bequeathed by the Founders, 1885

Dedreux-Dorcy, Pierre Joseph 1789–1874, *Head of a Girl*, bequeathed by the Founders, 1885

Dedreux-Dorcy, Pierre Joseph 1789–1874, *Head of a Young Girl*, bequeathed by the Founders, 1885

Dedreux-Dorcy, Pierre Joseph 1789–1874, *Head of a Young Girl*, bequeathed by the Founders, 1885

Dedreux-Dorcy, Pierre Joseph 1789–1874, *Le repos*, bequeathed by the Founders, 1885

Delaplace active 19th C, *A Storm at Sea*, bequeathed by the

Founders, 1885

Delaroche, Paul (attributed to) 1797–1856, *An Elder Sister of Mrs Bowes*, bequeathed by the Founders, 1885

Delaval, Pierre-Louis 1790–1870, *Portrait of a Lady in Black*, bequeathed by the Founders, 1885

Delécluze, Étienne-Jean 1781–1863, *The Emperor Augustus Rebuking Cornelius Cinna for His Treachery*, bequeathed by the Founders, 1885

Delen, Dirck van 1604/1605–1671, *Jupiter and Alkmene in an Architectural Setting*, bequeathed by the Founders, 1885

Delrieux, Étienne *Landscape*, bequeathed by the Founders, 1885

Demarne, Jean-Louis 1744–1829, *Landscape with Figures and a Gothic Monument*, bequeathed by the Founders, 1885

Demarne, Jean-Louis 1744–1829, *Rocky Landscape with a Cart*, bequeathed by the Founders, 1885

Denner, Balthasar 1685–1749, *Portrait of a Man in a Fur-Trimmed Hat*, bequeathed by the Founders, 1885

Desanges, Louis William (attributed to) 1822–after 1901, *Joséphine Bowes (1825–1874)*, bequeathed by the Founders, 1885

Descours, Michel Pierre Hubert 1741–1814, *Portrait of Elizabeth de la Vallée de la Roche*, bequeathed by the Founders, 1885

Deshayes, Eugène 1828–1890, *The Shore of a Lake with Boats and Figures*, bequeathed by the Founders, 1885

Deshayes, Eugène 1828–1890, *Misty Landscape with Woodcutters around a Fire*, bequeathed by the Founders, 1885

Deshayes, Eugène 1828–1890, *View of a Village among Trees*, bequeathed by the Founders, 1885

Deshayes, Eugène 1828–1890, *View on the Marne, France*, bequeathed by the Founders, 1885

Desportes, Alexandre-François (attributed to) 1661–1743, *A Dog and a Wild Duck*, bequeathed by the Founders, 1885

Devéria, Eugène 1808–1865, *A Young Woman of the Valley of Ossau with Her Child*, bequeathed by the Founders, 1885

d'Haite active 19th C, *Chickens in a Barn*, bequeathed by the Founders, 1885

d'Haite active 19th C, *Chickens near a Water Trough*, bequeathed by the Founders, 1885

Diziani, Gaspare 1689–1767, *Antiochus and Stratonice*, bequeathed by the Founders, 1885

Domenichino (circle of) 1581–1641, *St George*, bequeathed by the Founders, 1885

Downman, John 1750–1824, *Edwin and Emma*, purchased, 1975

Droochsloot, Cornelis 1630–1673, *The Parable of the Great Supper*, bequeathed by the Founders, 1885

Drouais, François Hubert

(attributed to) 1727–1775, *A Girl Holding a Canary, Time of Louis XV*, bequeathed by the Founders, 1885

Drouais, François Hubert (circle of) 1727–1775, *Portrait of a Child*, bequeathed by the Founders, 1885

Drummond, Samuel (attributed to) 1765–1844, *Sir John Hullock (1767–1829)*

Duck, Jacob c.1600–1667, *Vanitas Scene, an Interior*, bequeathed by the Founders, 1885

Dughet, Gaspard (school of) 1615–1675, *Architectural Landscape*, bequeathed by the Founders, 1885

Dughet, Gaspard (style of) 1615–1675, *Classical Landscape*, bequeathed by the Founders, 1885

Dughet, Gaspard (style of) 1615–1675, *Woods, Lake and Figures*, bequeathed by the Founders, 1885

Dujardin, Karel (style of) 1626–1678, *Girl Driving Cattle*, bequeathed by the Founders, 1885

Dumax, Ernest-Joachim 1811–after 1882, *Seacoast at Port-en-Bessin, Normandy, France*, bequeathed by the Founders, 1885

Dumée *An Open-Air Altar*, bequeathed by the Founders, 1885

Duneuf-Germain, (Mlle) *Portrait of a Girl with a Rose*, bequeathed by the Founders, 1885

Dupont, Ernest 1825–1888, *Portrait of a Young Girl Holding a Dog*, bequeathed by the Founders, 1885

Dupré, Léon Victor 1816–1879, *Landscape with Cows and Figures*, bequeathed by the Founders, 1885

Durand-Brager, Jean Baptiste Henri 1814–1879, *A Rough Sea*, bequeathed by the Founders, 1885

Durand-Brager, Jean Baptiste Henri 1814–1879, *A Rough Sea*, bequeathed by the Founders, 1885

Durand-Brager, Jean Baptiste Henri 1814–1879, *A Ship and a Longboat*, bequeathed by the Founders, 1885

Durand-Brager, Jean Baptiste Henri 1814–1879, *A Ship in a Stormy Sea*, bequeathed by the Founders, 1885

Durand-Brager, Jean Baptiste Henri 1814–1879, *A Ship on Fire at Sea, Another Standing By*, bequeathed by the Founders, 1885

Durand-Brager, Jean Baptiste Henri 1814–1879, *Ships Standing off a Beach*, bequeathed by the Founders, 1885

Durand-Brager, Jean Baptiste Henri 1814–1879, *Vue de Trébizonde, Turquie*, bequeathed by the Founders, 1885

Dürer, Albrecht (after) 1471–1528, *Adam and Eve*, bequeathed by the Founders, 1885

Durieux, Émile active 19th C, *In the Seraglio*, bequeathed by the Founders, 1885

Dury, Antoine 1819–after 1878, *Joséphine Bowes (1825–1874), Countess of Montalbo*, bequeathed by the Founders, 1885

Dury, Antoine 1819–after 1878, *Bernardine (Mrs Bowes's Dog)*, bequeathed by the Founders, 1885

Dutch (Amsterdam) School *Portrait of a Man in a Fur Collar*, bequeathed by the Founders, 1885

Dutch School *Portrait of a Man*, bequeathed by the Founders, 1885

Dutch School *Portrait of a Girl with a Glove*, bequeathed by the Founders, 1885

Dutch School *Portrait of a Lady in a Black Dress*, bequeathed by the Founders, 1885

Dutch School *Portrait of a Lady in a Black Dress*, bequeathed by the Founders, 1885

Dutch School *Portrait of a Lady in Black with a Ruff*, bequeathed by the Founders, 1885

Dutch School *Portrait of a Lady*, bequeathed by the Founders, 1885

Dutch School *Portrait of an Old Lady in Seventeenth-Century Costume*, bequeathed by the Founders, 1885

Dutch School *Cornelia van Vrybergen (1651–1714)*, bequeathed by the Founders, 1885

Dutch School 17th C, *A Seashore with a Beached Ship*, bequeathed by the Founders, 1885

Dutch School 17th C, *Angels Appearing to Abraham*, bequeathed by the Founders, 1885

Dutch School 17th C, *Boors in a Tavern*, bequeathed by the Founders, 1885

Dutch School 17th C, *Judith and Holofernes*, bequeathed by the Founders, 1885

Dutch School 17th C, *Peasants Carousing*, bequeathed by the Founders, 1885

Dutch School 17th C, *Portrait of a Gentleman*, bequeathed by the Founders, 1885

Dutch School 17th C, *Portrait of a Lady*, bequeathed by the Founders, 1885

Dutch School 17th C, *Two Men*, bequeathed by the Founders, 1885

Dutch School 17th C, *View of Dunkirk, France*, bequeathed by the Founders, 1885

Dutch School mid-17th C–mid-18th C, *Interior Scene*, bequeathed by the Founders, 1885

Dutch School 18th C, *Landscape*, bequeathed by the Founders, 1885

Dutch School 18th C, *The Gamblers*, bequeathed by the Founders, 1885

Dutch School *A Boy with a Glass of Wine*, bequeathed by the Founders, 1885

Dyck, Anthony van (after) 1599–1641, *Olivia Boteler Porter (d.1633)*, bequeathed by the Founders, 1885

Dyck, Anthony van (after) 1599–1641, *Queen Henrietta Maria (1609–1669)*, bequeathed by the Founders, 1885

Dyck, Anthony van (circle of) 1599–1641, *The Death of Adonis*, bequeathed by the Founders, 1885

Dyck, Anthony van (copy after) 1599–1641, *Inigo Jones (1573–*

1652), donated by Reverend Bouquet, 1952

Dyck, Anthony van (copy after) 1599–1641, *Self Portrait*, bequeathed by the Founders, 1885

Dyck, Anthony van (school of) 1599–1641, *A Man Leaning on a Spade*, bequeathed by the Founders, 1885

Egmont, Justus van 1601–1674, *La Duchesse d'Aumont (1650–1711)*, bequeathed by the Founders, 1885

El Greco 1541–1614, *The Tears of St Peter*, bequeathed by the Founders, 1885

Elshoecht, Jean Louis 1760–1842, *Portrait of a Lady of 81 years*, bequeathed by the Founders, 1885

Elshoecht, Jean Louis 1760–1842, *Madame Louis Suywens*, bequeathed by the Founders, 1885

Elshoecht, Jean Louis 1760–1842, *Portrait of a Lady*, bequeathed by the Founders, 1885

Elton, Samuel Averill 1827–1886, *View of Gainford from the Yorkshire Side of the River Tees*, gift from Miss Alice Edleston, 1937

Es, Jacob Foppens van c.1596–1666, *Grapes with a Half Walnut*, bequeathed by the Founders, 1885

Esselens, Jacob 1626–1687, *Wooded Landscape with Figures*, bequeathed by the Founders, 1885

Everdingen, Allart van 1621–1675, *Norwegian Landscape*, bequeathed by the Founders, 1885

Eves, Reginald Grenville 1876–1941, *Female Portrait*, purchased at auction through Phillips, Son & Neale, 1973

Eves, Reginald Grenville 1876–1941, *Portrait of a Boy*

Eves, Reginald Grenville 1876–1941, *William John Cavendish Bentinck (1857–1943), 6th Duke of Portland*

Eves, Reginald Grenville 1876–1941, *River Tees*, purchased at auction through Phillips, Son & Neale, 1973

Eves, Reginald Grenville 1876–1941, *Landscape*, purchased at auction through Phillips, Son & Neale, 1973

Eves, Reginald Grenville 1876–1941, *The Duchess of Leinster*, purchased at auction through Phillips, Son & Neale, 1973

Eves, Reginald Grenville 1876–1941, *Portrait of a Man*

Eves, Reginald Grenville 1876–1941, *Above Winch Bridge, Durham*

Eves, Reginald Grenville 1876–1941, *Barnard Castle, County Durham*

Eves, Reginald Grenville 1876–1941, *Birch Trees with Houses*, purchased at auction through Phillips, Son & Neale, 1973

Eves, Reginald Grenville 1876–1941, *Extensive River Scene*, purchased at auction through Phillips, Son & Neale, 1973

Eves, Reginald Grenville 1876–1941, *Female Portrait*, purchased at auction through Phillips, Son & Neale, 1973

Eves, Reginald Grenville 1876–1941, *Female Portrait*, purchased at auction through Phillips, Son & Neale, 1973

Eves, Reginald Grenville 1876–1941, *Female Portrait*, purchased at auction through Phillips, Son & Neale, 1973

Eves, Reginald Grenville 1876–1941, *Female Portrait*, purchased at auction through Phillips, Son & Neale, 1973

Eves, Reginald Grenville 1876–1941, *Gorge*

Eves, Reginald Grenville 1876–1941, *Hercules Brabazon Brabazon (1821–1906)* (copy after John Singer Sargent)

Eves, Reginald Grenville 1876–1941, *High Force*, purchased at auction through Phillips, Son & Neale, 1973

Eves, Reginald Grenville 1876–1941, *High Force*, purchased at auction through Phillips, Son & Neale, 1973

Eves, Reginald Grenville 1876–1941, *Landscape*

Eves, Reginald Grenville 1876–1941, *Landscape*, purchased at auction through Phillips, Son & Neale, 1973

Eves, Reginald Grenville 1876–1941, *Landscape*, purchased at auction through Phillips, Son & Neale, 1973

Eves, Reginald Grenville 1876–1941, *Landscape*, purchased at auction through Phillips, Son & Neale, 1973

Eves, Reginald Grenville 1876–1941, *Landscape*, purchased at auction through Phillips, Son & Neale, 1973

Eves, Reginald Grenville 1876–1941, *Landscape with a River*

Eves, Reginald Grenville 1876–1941, *Low Force*, purchased at auction through Phillips, Son & Neale, 1973

Eves, Reginald Grenville 1876–1941, *March Day, Sussex*, purchased at auction through Phillips, Son & Neale, 1973

Eves, Reginald Grenville 1876–1941, *Over the Hills, Yorkshire*, purchased at auction through Phillips, Son & Neale, 1973

Eves, Reginald Grenville 1876–1941, *Portrait of a Lady* (copy after John Singer Sargent)

Eves, Reginald Grenville 1876–1941, *Portrait of a Man*

Eves, Reginald Grenville 1876–1941, *Portrait of a Man*

Eves, Reginald Grenville 1876–1941, *Portrait of a Man*

Eves, Reginald Grenville 1876–1941, *Portrait of a Man*

Eves, Reginald Grenville 1876–1941, *Portrait of a Man*

Eves, Reginald Grenville 1876–1941, *Portrait of a Man*, purchased at auction through H. Spencer,

1971

Eves, Reginald Grenville 1876–1941, *River Gorge*

Eves, Reginald Grenville 1876–1941, *River Scene*

Eves, Reginald Grenville 1876–1941, *River Scene*, purchased at auction through Phillips, Son & Neale, 1973

Eves, Reginald Grenville 1876–1941, *River Tees*, purchased at auction through Phillips, Son & Neale, 1973

Eves, Reginald Grenville 1876–1941, *Self Portrait*, purchased, 1985

Eves, Reginald Grenville 1876–1941, *Stanley Baldwin*, purchased at auction through Phillips, Son & Neale, 1973

Eves, Reginald Grenville 1876–1941, *Stream Scene*, purchased at auction through Phillips, Son & Neale, 1973

Eves, Reginald Grenville 1876–1941, *The Marquess of Winchester*, purchased at auction through Phillips, Son & Neale, 1973

Eves, Reginald Grenville 1876–1941, *The Winding Road*, purchased at auction through Phillips, Son & Neale, 1973

Eves, Reginald Grenville 1876–1941, *View of a Gorge*, purchased at auction through Phillips, Son & Neale, 1973

Eves, Reginald Grenville 1876–1941, *Waterfall in Teesdale*

N. F. *Portrait of a Lady in a Red Dress*, bequeathed by the Founders, 1885

Faber, H. *The Treaty of Hubertusburg, 15 February 1763*, bequeathed by the Founders, 1885

Faes, Peter 1750–1814, *A Marble Vase of Lilac with Other Flowers on a Marble Shelf*, bequeathed by the Founders, 1885

Fantin-Latour, Henri 1836–1904, *Fruit and Flowers*, bequeathed by the Founders, 1885

Feyen, Jacques Eugène 1815–1908, *The Eldest Sister of Mrs Bowes*, bequeathed by the Founders, 1885

Feyen, Jacques Eugène 1815–1908, *John Bowes, Esq. (1811–1885)*, bequeathed by the Founders, 1885

Feyen, Jacques Eugène 1815–1908, *Monsieur Sergent*, bequeathed by the Founders, 1885

Feyen-Perrin, François Nicolas Auguste 1826–1888, *Digging for Bait, Group on the Seashore*, bequeathed by the Founders, 1885

Fiamengo, P. S. *Still Life Group of a Bust, Vases and a Skull with a Boy Holding a Dish of Beans*, bequeathed by the Founders, 1885

Fichel, Eugène 1826–1895, *The Violoncello Player*, bequeathed by the Founders, 1885

Finart, Noël Dieudonné 1797–1852, *A Knight on a Horse*, bequeathed by the Founders, 1885

Finart, Noël Dieudonné 1797–1852, *A Cavalry Soldier on Horseback*, bequeathed by the Founders, 1885

Finson, Louis (circle of) c.1580–1617, *Christ Healing the Ear of Malchus*, bequeathed by the Founders, 1885

Fischer, Alexandre Georges 1820–1890, *A Peasant Girl Feeding Pigs*, bequeathed by the Founders, 1885

Flemish School *Christ as the Man of Sorrows*, bequeathed by the Founders, 1885

Flemish School *Anne van Weluwe (c.1528–1561)*, bequeathed by the Founders, 1885

Flemish School *Portrait of a Lady in Brown*, bequeathed by the Founders, 1885

Flemish School 16th C, *The Archangel Gabriel*, bequeathed by the Founders, 1885

Flemish School 16th C, *The Virgin Mary*, bequeathed by the Founders, 1885

Flemish School mid-16th C-mid-17th C, *Susannah and the Elders*, bequeathed by the Founders, 1885

Flemish School *Lady in a Black and Red Dress and a Black Flemish Hat*, bequeathed by the Founders, 1885

Flemish School *Portrait of a Lady*, bequeathed by the Founders, 1885

Flemish School *The Blessings of Peace*, bequeathed by the Founders, 1885

Flemish School *The Evil of War*, bequeathed by the Founders, 1885

Flemish School *Portrait of a Lady*, bequeathed by the Founders, 1885

Flemish School *A School of Monkeys*, bequeathed by the Founders, 1885

Flemish School *Mary Magdalene*, bequeathed by the Founders, 1885

Flemish School *A Carmelite Friar*, bequeathed by the Founders, 1885

Flemish School *Portrait of a Man*, bequeathed by the Founders, 1885

Flemish School *Maria Anna van Berchem, Countess of Crykenborch*, bequeathed by the Founders, 1885

Flemish School *Diana and Nymphs*, bequeathed by the Founders, 1885

Flemish School *Landscape with Peasants*, bequeathed by the Founders, 1885

Flemish School *Portrait of a Lady*, bequeathed by the Founders, 1885

Flemish School *Portrait of a Lady*, bequeathed by the Founders, 1885

Flemish School *Flowers in a Gilt Vase with Porcelain Vases*, bequeathed by the Founders, 1885

Flemish School 17th C, *Biblical Scene*, bequeathed by the Founders, 1885

Flemish School 17th C, *Calvariae locus mons calvariae*, bequeathed by the Founders, 1885

Flemish School 17th C, *Christ on the Road to Emmaus*, bequeathed by the Founders, 1885

Flemish School 17th C, *Interior, Peasants Playing Musical Instruments*, bequeathed by the Founders, 1885

Flemish School 17th C, *Landscape*, bequeathed by the Founders, 1885

Flemish School 17th C, *Portrait of a Man*, bequeathed by the Founders, 1885

Flemish School 17th C, *Portrait of a Young Girl Holding a Canary*, bequeathed by the Founders, 1885

Flemish School 17th C, *St Cecilia*, bequeathed by the Founders, 1885

Flemish School 17th C, *Still Life*, bequeathed by the Founders, 1885

Flemish School 17th C, *The Madonna and Child*, bequeathed by the Founders, 1885

Flemish School mid-17th C-mid-18th C, *Interior of a Church*, bequeathed by the Founders, 1885

Flemish School mid-17th C-mid-18th C, *St Joseph with Putti*, bequeathed by the Founders, 1885

Flemish School mid-18th C-mid-19th C, *Kitchen Interior with Figures*, bequeathed by the Founders, 1885

Flemish School *The Deposition from the Cross*, bequeathed by the Founders, 1885

Flemish School *Christ Carrying the Cross and the Mater Dolorosa*, bequeathed by the Founders, 1885

Flers, Camille 1802–1868, *Landscape near Annet-sur-Marne, France*, bequeathed by the Founders, 1885

Fleury, Antoine Claude active 1787–1822, *A Boy Sitting on a Dog's Back*, bequeathed by the Founders, 1885

Fleury, François Antoine Léon 1804–1858, *Landscape with a Boathouse on a River*, bequeathed by the Founders, 1885

Fontaine, André b.1802, *Girl Reading*, bequeathed by the Founders, 1885

Fontana, Prospero (attributed to) 1512–1597, *The Holy Family with St Jerome, St Catherine and the Infant St John the Baptist*, bequeathed by the Founders, 1885

Foschi, Francesco 1710–1780, *Snowy Landscape*, bequeathed by the Founders, 1885

Foschi, Francesco 1710–1780, *Snowy Landscape*, bequeathed by the Founders, 1885

Fosse, Charles de la 1636–1716, *St Paul Commanding St Luke to Accompany Him to Rome*, purchased, 1980

Fracanzano, Cesare (attributed to) c.1605–1651, *St Ambrose*, bequeathed by the Founders, 1885

Fracanzano, Francesco (attributed to) 1612–1656, *St Paul*, bequeathed by the Founders, 1885

Fracanzano, Francesco (attributed to) 1612–1656, *St Peter*, bequeathed by the Founders, 1885

Fragonard, Jean-Honoré (style of) 1732–1806, *Avenue with Figures*, bequeathed by the Founders, 1885

Franchoys, Lucas the elder (attributed to) 1574–1643, *Mathias Hovius (d.1620)*, bequeathed by the Founders, 1885

Francia, Francesco (after) c.1450–1517, *Madonna and Child*, bequeathed by the Founders, 1885

Franciabigio (attributed to) 1482–1525, *Portrait of a Man in a Black Hat*, bequeathed by the Founders, 1885

Francken, Frans II (attributed to) 1581–1642, *The Flagellation of Christ*, bequeathed by the Founders, 1885

Francken, Frans II (attributed to) 1581–1642, *The Miracle of the Loaves and the Fish*, bequeathed by the Founders, 1885

Francken family (style of) active 16th C-17th C, *Biblical Scene*, bequeathed by the Founders, 1885

French School *Portrait of a Man in Brown with a Belt Marked 'AF'*, bequeathed by the Founders, 1885

French School *St Claude and a Monk*, bequeathed by the Founders, 1885

French School *Portrait of a Lady from the Time of Henri IV*, bequeathed by the Founders, 1885

French School *Portrait of a Lady in Black*, bequeathed by the Founders, 1885

French School *Portrait of a Lady*, bequeathed by the Founders, 1885

French School *Portrait of a Lady*, bequeathed by the Founders, 1885

French School *Portrait of a Man*, bequeathed by the Founders, 1885

French School *Messire Bernard (c.1517–1585)*, bequeathed by the Founders, 1885

French School *Male Portrait of the Time of Louis XIII*, bequeathed by the Founders, 1885

French School *Portrait of a Lady with a Book, Aged 35*, bequeathed by the Founders, 1885

French School *Portrait of a Young Girl*, bequeathed by the Founders, 1885

French School *Louis XV (1710–1774), as a Boy*, bequeathed by the Founders, 1885

French School *Portrait of a Lady*, bequeathed by the Founders, 1885

French School *View of Paris, France*, bequeathed by the Founders, 1885

French School *Portrait of a Daughter of Louis XIV*, bequeathed by the Founders, 1885

French School *Portrait of a French Admiral of the Time of Louis XIV*, bequeathed by the Founders, 1885

French School *Portrait of a Lady in a Blue and Red Cloak from the Time of Louis XIV*, bequeathed by the Founders, 1885

French School *The Virgin and Child*, bequeathed by the Founders, 1885

French School *Portrait of a Lady in White Holding a Letter*, bequeathed by the Founders, 1885

French School *Portrait of a French Judge from the Time of Louis XIV*, bequeathed by the Founders, 1885

French School *Portrait of a Lady*, bequeathed by the Founders, 1885

French School *Portrait of a Lady*, bequeathed by the Founders, 1885

French School *Portrait of a Lady in a Pink Dress*, bequeathed by the Founders, 1885

French School *Young Boy as Cupid, Wearing a Red and Gold Dress*, bequeathed by the Founders, 1885

French School *Portrait of a Lady*, bequeathed by the Founders, 1885

French School *Family Portrait Group*, bequeathed by the Founders, 1885

French School *Cupid and a Lady*, bequeathed by the Founders, 1885

French School *Portrait of a Bishop*, bequeathed by the Founders, 1885

French School *Portrait of a Lady*, bequeathed by the Founders, 1885

French School *Portrait of a Lady of the Time of Louis XIV*, bequeathed by the Founders, 1885

French School *Religious Procession*, bequeathed by the Founders, 1885

French School *Portrait of a Lady in a Red Dress*, bequeathed by the Founders, 1885

French School *A Young Prince Wearing the Order of Saint-Esprit*, bequeathed by the Founders, 1885

French School *Portrait of a Lady*, bequeathed by the Founders, 1885

French School *Portrait of a Lady*, bequeathed by the Founders, 1885

French School *Portrait of a Lady with a Lace Fontange Headdress*, bequeathed by the Founders, 1885

French School *Mercury Delivering the Infant Bacchus into the Care of the Nymphs of Nyssa*, bequeathed by the Founders, 1885

French School *Portrait of a Child with a Basket of Flowers*, bequeathed by the Founders, 1885

French School *Portrait of a Lady*, bequeathed by the Founders, 1885

French School *Portrait of a Lady Holding a Dog*, bequeathed by the Founders, 1885

French School *Portrait of a Lady*, bequeathed by the Founders, 1885

French School *Marie Anne de Bourbon (1666–1739), Princesse de Conti*, bequeathed by the Founders, 1885

French School *France, as Minerva, Presents the Portrait of Louis XV* (or Louis XIV) *to the Institut des Beaux-Arts*, bequeathed by the Founders, 1885

French School *Portrait of a Lady*, bequeathed by the Founders, 1885

French School *Portrait of a Man*, bequeathed by the Founders, 1885

French School *Portrait of a Lady*, bequeathed by the Founders, 1885

French School 17th C, *Portrait of a Lady*, bequeathed by the Founders, 1885

French School 17th C, *Portrait of a Lady*, bequeathed by the Founders, 1885

French School 17th C, *Portrait of a Man*, bequeathed by the Founders, 1885

French School *A Nude Young Prince Wearing the Order of Saint-Esprit*, bequeathed by the Founders, 1885

French School *Monsieur Nadaud, Treasurer of the Duc d'Orléans*, bequeathed by the Founders, 1885

French School *Portrait of a Lady*, bequeathed by the Founders, 1885

French School *Portrait of a Lady*, bequeathed by the Founders, 1885

French School *Portrait of a Lady*, bequeathed by the Founders, 1885

French School *Portrait of a Lady*, bequeathed by the Founders, 1885

French School *Portrait of a Lady*, bequeathed by the Founders, 1885

French School *Cupid Watching a Bird* (dessus de porte), bequeathed by the Founders, 1885

French School *Portrait of a Lady*, bequeathed by the Founders, 1885

French School *Flower Piece*, bequeathed by the Founders, 1885

French School *Pan and Apollo*, bequeathed by the Founders, 1885

French School *Two Ladies, One Holding a Fan and the Other a Rose*, bequeathed by the Founders, 1885

French School *Portrait of a Lady and Gentleman Dressed as Pomona and Vertumnus with Attendant Cupids*, bequeathed by the Founders, 1885

French School *Portrait of a Lady*, bequeathed by the Founders, 1885

French School *Portrait of a Lady*, bequeathed by the Founders, 1885

French School *Portrait of a Lady*, bequeathed by the Founders, 1885

French School *Portrait of a Lady and Her Child*, bequeathed by the Founders, 1885

French School *Portrait of a Lady in a Wrap*, bequeathed by the Founders, 1885

French School *Portrait of a Man*, bequeathed by the Founders, 1885

French School *Portrait of a Lady*, bequeathed by the Founders, 1885

French School *Portrait of a Lady*, bequeathed by the Founders, 1885

French School *Portrait of a Lady*, bequeathed by the Founders, 1885

French School *Portrait of a Man*, bequeathed by the Founders, 1885

French School *Portrait of a Lady*, bequeathed by the Founders, 1885

French School *Portrait of a Young Lady*, bequeathed by the Founders, 1885

French School *Portrait of a Lady*, bequeathed by the Founders, 1885

French School *Portrait of a Lady in Black with a Fur Muff*, bequeathed by the Founders, 1885

French School *Portrait of a Boy*, bequeathed by the Founders, 1885

French School *A Young Girl Carrying Cherries in Her Apron*, bequeathed by the Founders, 1885

French School *La Marquise de Pompadour (1721–1764)*, bequeathed by the Founders, 1885

French School *Portrait of a Lady*, bequeathed by the Founders, 1885

French School *Portrait of a Lady at Her Toilet Table, Dressed in a Peignoir*, bequeathed by the Founders, 1885

French School *Portrait of a Lady*, bequeathed by the Founders, 1885

French School *Portrait of a Lady in a Red Dress with an Embroidered Headdress*, bequeathed by the Founders, 1885

French School *Portrait of a Lady*, bequeathed by the Founders, 1885

French School *Portrait of a Lady*, bequeathed by the Founders, 1885

French School *Portrait of a Lady*, bequeathed by the Founders, 1885

French School *Portrait of a Man*, bequeathed by the Founders, 1885

French School *Portrait of a Girl*, bequeathed by the Founders, 1885

French School *Portrait of a Lady*, bequeathed by the Founders, 1885

French School *Portrait of an Old Lady*, bequeathed by the Founders, 1885

French School *A Sacrifice at an Altar*, bequeathed by the Founders, 1885

French School *A Calm Moonlight*, bequeathed by the Founders, 1885

French School *Porta San Paolo, Rome, Italy*, bequeathed by the Founders, 1885

French School *Landscape*, bequeathed by the Founders, 1885

French School *Portrait of a Lady*, bequeathed by the Founders, 1885

French School *Portrait of a Lady*, bequeathed by the Founders, 1885

French School *Portrait of a Lady*, bequeathed by the Founders, 1885

French School *Portrait of a Lady*, bequeathed by the Founders, 1885

French School *Portrait of a Man* (said to be Jean-Baptiste Greuze, 1725–1805), bequeathed by the Founders, 1885

French School *Soldiers Resting*, bequeathed by the Founders, 1885

French School *François Jauffret*, bequeathed by the Founders, 1885

French School *Thérèse Jauffret*, bequeathed by the Founders, 1885

French School *Portrait of a Woman*, bequeathed by the Founders, 1885

French School *Portrait of a Lady*, bequeathed by the Founders, 1885

French School *Portrait of a Lady*, bequeathed by the Founders, 1885

French School *Portrait of a Lady*, bequeathed by the Founders, 1885

French School *Portrait of a Lady*, bequeathed by the Founders, 1885

French School *Portrait of a Lady*, bequeathed by the Founders, 1885

French School *Portrait of a Lady*, bequeathed by the Founders, 1885

French School *Portrait of a Lady*, bequeathed by the Founders, 1885

French School *Portrait of a Lady*, bequeathed by the Founders, 1885

French School *Scene from a Comedy*, bequeathed by the Founders, 1885

French School *Portrait of a Lady*, bequeathed by the Founders, 1885

French School *Portrait of a Lady*, bequeathed by the Founders, 1885

French School *Head of a Girl Wearing a Wreath of Roses*, bequeathed by the Founders, 1885

French School *Portrait of a Gentleman*, bequeathed by the Founders, 1885

French School *Portrait of a Gentleman Reading a Book*, bequeathed by the Founders, 1885

French School *Portrait of a Lady in a Brown Dress*, bequeathed by the Founders, 1885

French School *Portrait of a Lady*, bequeathed by the Founders, 1885

French School *Portrait of a Man in a Red Coat*, bequeathed by the Founders, 1885

French School *Portrait of a Lady*, bequeathed by the Founders, 1885

French School *Portrait of a Man*, bequeathed by the Founders, 1885

French School *Portrait of a Girl*, bequeathed by the Founders, 1885

French School *Portrait of a Lady*, bequeathed by the Founders, 1885

French School *Portrait of a Lady*, bequeathed by the Founders, 1885

French School *Portrait of a Lady in Green with a Lace Bonnet*, bequeathed by the Founders, 1885

French School *Portrait of a Lady*, bequeathed by the Founders, 1885

French School *Portrait of a Woman in Normandy Peasant Dress*, bequeathed by the Founders, 1885

French School *Portrait of a Lady*, bequeathed by the Founders, 1885

French School *Portrait of a Lady*, bequeathed by the Founders, 1885

French School *Portrait of a Lady from the Time of Louis XV*, bequeathed by the Founders, 1885

French School *Portrait of a Lady* (recto), bequeathed by the Founders, 1885

French School *Portrait of a Man* (verso), bequeathed by the Founders, 1885

French School *Portrait of a Lady*, bequeathed by the Founders, 1885

French School *Marie-Jean Hérault de Séchell (1759–1794)*, bequeathed by the Founders, 1885

French School *Portrait of a Gentleman in a Green Coat*, bequeathed by the Founders, 1885

French School *Interior, a Peasant Woman Spinning, Her Daughter Making Lace and Conversing with a Young Man*, bequeathed by the Founders, 1885

French School *Telemachus Refusing the Crown of Crete*, bequeathed by the Founders, 1885

French School *Portrait of a Young Man*, bequeathed by the Founders, 1885

French School 18th C, *Boy with a Hurdy-Gurdy*, bequeathed by the Founders, 1885

French School 18th C, *Girl with a Basket of Pamphlets*, bequeathed by the Founders, 1885

French School 18th C, *Half-Length Figure of Cupid*, bequeathed by the Founders, 1885

French School 18th C, *Jean Michel (b.1387), Bishop of Angers*, bequeathed by the Founders, 1885

French School 18th C, *Leda and the Swan*, bequeathed by the Founders, 1885

French School 18th C, *Portrait of a Man*, bequeathed by the Founders, 1885

French School 18th C, *Storm at Sea*, bequeathed by the Founders, 1885

French School 18th C, *Two Young Girls with a Portrait*, bequeathed by the Founders, 1885

French School 18th C, *Woody Landscape*, bequeathed by the Founders, 1885

French School mid-18th C-mid-19th C, *Flower Piece*, bequeathed by the Founders, 1885

French School mid-18th C-mid-19th C, *Flower Piece*, bequeathed by the Founders, 1885

French School mid-18th C-mid-19th C, *Portrait of a Boy*, bequeathed by the Founders, 1885

French School *Portrait of a Girl in Black with Roses on Her Lap*, bequeathed by the Founders, 1885

French School *Portrait of a Man*, bequeathed by the Founders, 1885

French School *Portrait of a Lady*, bequeathed by the Founders, 1885

French School *Girl in Green with a Bird*, bequeathed by the Founders, 1885

French School *Classical Landscape*, bequeathed by the Founders, 1885

French School *Portrait of a Lady*, bequeathed by the Founders, 1885

French School *The Death of Seneca (AD 65)*, bequeathed by the Founders, 1885

French School *Landscape with a Horseman and Beggars*, bequeathed by the Founders, 1885

French School *Madame Caminet*, bequeathed by the Founders, 1885

French School *Landscape with Equestrian and other Figures*, bequeathed by the Founders, 1885

French School *Landscape with Two Women and a Flock of Sheep*, bequeathed by the Founders, 1885

French School *Landscape*, bequeathed by the Founders, 1885

French School *Landscape with Trees*, bequeathed by the Founders, 1885

French School *Portrait of a Lady*, bequeathed by the Founders, 1885

French School *Portrait of a Man*, bequeathed by the Founders, 1885

French School *Portrait of a Woman*, bequeathed by the Founders, 1885

French School *Portrait of an Elderly Woman in Peasant Costume*, bequeathed by the Founders, 1885

French School *Silenus and Bacchantes*, bequeathed by the Founders, 1885

French School *Garden, Country House and Church*, bequeathed by the Founders, 1885

French School *Pears and Apples*, bequeathed by the Founders, 1885

French School *Rigged Ship under Repair*, bequeathed by the Founders, 1885

French School *Two Waterscapes on One Canvas*, bequeathed by the Founders, 1885

French School *Still Life*, bequeathed by the Founders, 1885

French School *Two Ladies in a Garden*, bequeathed by the Founders, 1885

French School *Interior with Two Ladies with Dogs*, bequeathed by the Founders, 1885

French School *Judge M. Caminet*, bequeathed by the Founders, 1885

French School *Portrait of a Gentleman*, bequeathed by the Founders, 1885

French School *Napoleon II (1811–1832), King of Rome (1811–1814)*, bequeathed by the Founders, 1885

French School *Portrait of a Lady in Red*, bequeathed by the Founders, 1885

French School *Portrait of a Lady*, bequeathed by the Founders, 1885

French School *Château, Lake and Figures*, bequeathed by the Founders, 1885

French School *Portrait of a Lady*, bequeathed by the Founders, 1885

French School *Portrait of a Young Girl in a Red Dress*, bequeathed by the Founders, 1885

French School *Portrait of a Lady*, bequeathed by the Founders, 1885

French School *Still Life*, bequeathed by the Founders, 1885

French School *A Leg of Mutton*, bequeathed by the Founders, 1885

French School *A Cascade in a Rocky Landscape with Figures*, bequeathed by the Founders, 1885

French School *Portrait of a Lady*, bequeathed by the Founders, 1885

French School *Portrait of a Young Lady*, bequeathed by the Founders, 1885

French School *Portrait of a Lady*, bequeathed by the Founders, 1885

French School *Portrait of a Lady*, bequeathed by the Founders, 1885

French School *Portrait of a Lady*, bequeathed by the Founders, 1885

French School *Portrait of a Lady*, bequeathed by the Founders, 1885

French School *Portrait of a Lady in a Grey Dress*, bequeathed by the Founders, 1885

French School *Still Life*, bequeathed by the Founders, 1885

French School *Portrait of a Boy*, bequeathed by the Founders, 1885

French School *Portrait of a Lady*, bequeathed by the Founders, 1885

French School *Portrait of a Lady*, bequeathed by the Founders, 1885

French School *Sportsman Shooting with a Dog*, bequeathed by the Founders, 1885

French School *Portrait of a Lady*, bequeathed by the Founders, 1885

French School *Peasant Woman*, bequeathed by the Founders, 1885

French School *Peasant Woman*, bequeathed by the Founders, 1885

French School *Peasant Woman*, bequeathed by the Founders, 1885

French School *A Young Mother Weeping over the Tomb of Her Child*, bequeathed by the Founders, 1885

French School *Forest Scene*, bequeathed by the Founders, 1885

French School *Interior of a Room with a Lady Painting*, bequeathed by the Founders, 1885

French School *Portrait of a Lady with a Hairpin in the Form of an Arrow*, bequeathed by the Founders, 1885

French School *Portrait of a Peasant Woman*, bequeathed by the Founders, 1885

French School *Wooded Landscape with Rocks*, bequeathed by the Founders, 1885

French School *A Sister of Charity*, bequeathed by the Founders, 1885

French School *Portrait of a Lady Wearing Pearls*, bequeathed by the Founders, 1885

French School *Portrait of a Lady*, bequeathed by the Founders, 1885

French School *Study of an Italian Girl with a Tambourine*, bequeathed by the Founders, 1885

French School *A Lady at a Piano*, bequeathed by the Founders, 1885

French School *Portrait of a Bearded Man*, bequeathed by the Founders, 1885

French School *The Wayside Well*, bequeathed by the Founders, 1885

French School *Portrait of a Girl*, bequeathed by the Founders, 1885

French School *Portrait of an Old Beggar*, bequeathed by the Founders, 1885

French School *River Scene in the Vaucluse, France*, bequeathed by the Founders, 1885

French School *A Seaport Town*, bequeathed by the Founders, 1885

French School *Willow Trees*, bequeathed by the Founders, 1885

French School *Cat*, bequeathed by the Founders, 1885

French School 19th C, *Brick Arch*, bequeathed by the Founders, 1885

French School 19th C, *Marat's Sister*, bequeathed by the Founders, 1885

French School 19th C, *Roses*, bequeathed by the Founders, 1885

Frère, Charles Théodore 1814–1888, *View at Siout, Upper Egypt*, bequeathed by the Founders, 1885

Fuchs, Georg Mathias c.1719–1797, *Boy and Girl Dressed as a Shepherd and a Shepherdess with a Lamb*, bequeathed by the Founders, 1885

Fyt, Jan (style of) 1611–1661, *Still Life with a Dead Hare*, bequeathed by the Founders, 1885

Gabé, Nicolas Edward 1814–1865, *Incident of the Revolution of 1848 in Paris in the Court of the Louvre*, bequeathed by the Founders, 1885

Gabé, Nicolas Edward 1814–1865, *Incident of the Revolution of 1848 in Paris at the Corner of Rue St Jacques*, bequeathed by the Founders, 1885

Gabé, Nicolas Edward 1814–1865, *The Barricade at Porte St Denis, Paris, 1848*, bequeathed by the Founders, 1885

Gabé, Nicolas Edward 1814–1865, *The Congress of Paris*, bequeathed by the Founders, 1885

Gabé, Nicolas Edward 1814–1865, *Cows, Sheep and a Goat at a Drinking Trough*, bequeathed by the Founders, 1885

Gainsborough, Thomas 1727–1788, *Elmsett Church, Suffolk*, donated by Mr F. J. Nettlefold, 1948

Gallier, Achille Gratien 1814–1871, *View across a River with Wooded Banks*, bequeathed by the Founders, 1885

Gandolfi, Gaetano 1734–1802, *Study of a Female Figure*, purchased from L. Evans, 1962

Garbrand, Caleb J. 1748–1794, *Portrait of a Lady in a Black Dress with a Large Black Head-Dress*, bequeathed by the Founders, 1885

García de Miranda, Juan 1677–1749, *The Miracle of Father Francisco de Torres Attacked by Robbers*, bequeathed by the Founders, 1885

Gardner, Daniel 1750–1805, *Miss Alice Bullock of Wigan*, purchased, 1975

Garez, G. *A Notary from the Time of the First French Republic*, bequeathed by the Founders, 1885

Garez, G. *Portrait of a Lady in Black, Seated, Holding a Rose*, bequeathed by the Founders, 1885

Garez, G. *A Donkey*, bequeathed by the Founders, 1885

Gauffier, Louis 1761–1801, *Nine Sample Portraits*, bequeathed by the Founders, 1885

Gaunt, Jonas *Still Life*, given by H. F. Gaunt, 1942

Gautrin, Louise-Thérèse-Aline active c.1830–1840, *The Abbey of Saint-Denis, France*, bequeathed by the Founders, 1885

Geeraerts, Marcus the younger 1561–1635, *A Lady in Black*, bequeathed by the Founders, 1885

Geirnaert, Jozef 1791–1859, *Phaedra and Hippolytus*, bequeathed by the Founders, 1885

Genillion, Jean Baptiste François 1750–1829, *View of the Seine, Paris, Looking East from the Porte St Nicolas towards the Pont Neuf, Morning Effect*, bequeathed by the Founders, 1885

Genillion, Jean Baptiste François 1750–1829, *View of the Seine, Paris, Looking West from the Ile Louviers, Evening Effect*, bequeathed by the Founders, 1885

Gérard, François 1770–1837, *Charles X (1757–1836), in His Coronation Robes*, bequeathed by the Founders, 1885

Gérard, François (after) 1770–1837, *La Duchesse de Berri and Her Two Children Praying before a Bust of Her Husband*, bequeathed by the Founders, 1885

Gérard, François (school of) 1770–1837, *Louis XVIII (1755–1824), Receiving the Crown of Henri IV*, bequeathed by the Founders, 1885

German School mid-15th C–mid-16th C, *St John the Baptist before His Execution*, bequeathed by the Founders, 1885

German School *The Emperor Maximilian (1449–1519)*, bequeathed by the Founders, 1885

German School *Ursula Neff*, bequeathed by the Founders, 1885

German School mid-16th C–mid-17th C, *Christ Carrying His Cross*, bequeathed by the Founders, 1885

German School *Ecclesiastics Gambling*, bequeathed by the Founders, 1885

German School *Portrait of a Middle-Aged Lady in Grey Holding a String of Pearls*, bequeathed by the Founders, 1885

German School *Portrait of a Lady in Grey*, bequeathed by the Founders, 1885

German School *Portrait of a Polish Noblewoman in a Fur-Trimmed Coat*, bequeathed by the Founders, 1885

German School mid-18th C–mid-19th C, *The Toper*, bequeathed by the Founders, 1885

German School *Night in the Harz Mountains, Germany*, bequeathed by the Founders, 1885

German School *Windmill at Sanssouci, Potsdam, Germany*, bequeathed by the Founders, 1885

Ghirlandaio, Domenico (studio of) 1449–1494, *Madonna Adoring the Child*, bequeathed by the Founders, 1885

Giaquinto, Corrado 1703–1765, *Venus Presenting Arms to Aeneas*, bequeathed by the Founders, 1885

Giffroy active 19th C, *Storm at Sea*, bequeathed by the Founders, 1885

Gillemans, Jan Pauwel II 1651–c.1704, *Fruit and Vegetables*, bequeathed by the Founders, 1885

Gillemans, Jan Pauwel II (attributed to) 1651–c.1704, *Still Life of Fruit in a Glass Bowl*, bequeathed by the Founders, 1885

Gillemans, Jan Pauwel II (attributed to) 1651–c.1704, *Still life with Peaches and Grapes*, bequeathed by the Founders, 1885

Gilroy, John Thomas Young 1898–1985, *Sheep Shearing in Baldersdale, County Durham*, bequeathed by Mrs Olive Field, 1974, © the artist's estate

Giordano, Luca (attributed to) 1634–1705, *The Triumph of Judith*, bequeathed by the Founders, 1885

Girodet de Roucy-Trioson, Anne-Louis 1767–1824, *Napoleon I (1769–1821), in Coronation Robes*, bequeathed by the Founders, 1885

Girolamo da Carpi (style of) c.1501–1556, *Diana with Nymph, Bathing*, bequeathed by the Founders, 1885

Giulio Romano (after) 1499–1546, *The Three Graces with Cupid*, bequeathed by the Founders, 1885

Glauber, Johannes (attributed to) 1646–1727, *Classical Landscape with Figures*, bequeathed by the Founders, 1885

Glover, John 1767–1849, *A Bull*, bequeathed by the Founders, 1885

Goes, Hugo van der (after) c.1420–1482, *Pietà (The Lamentation of Christ)*, bequeathed by the Founders, 1885

Goltzius, Hendrick (style of) 1558–1617, *The Temptation of Adam*, bequeathed by the Founders, 1885

Gontier, Pierre-Camille b.1840, *Flowers and Fruit*, bequeathed by the Founders, 1885

González, Bartolomé (after) 1564–1627, *Margaret of Austria (1584–1611), Queen of Spain*, bequeathed by the Founders, 1885

González, Bartolomé (circle of) 1564–1627, *A Young Spanish Princess*, bequeathed by the Founders, 1885

Gordon, John Watson 1788–1864, *Archdeacon John Headlam*, gift from K. A. S. Headlam-Morley

Gossaert, Jan (circle of) c.1478–1532, *Cybele Beseeching Saturn to Spare Her Child*, bequeathed by the Founders, 1885

Goulet active c.1800–1803, *Pope Pius VI (1717–1799)*, bequeathed by the Founders, 1885

Goya, Francisco de 1746–1828, *Interior of a Prison*, bequeathed by the Founders, 1885

Goya, Francisco de 1746–1828, *Juan Antonio Meléndez Valdés (1774–1817)*, bequeathed by the Founders, 1885

Goya, Francisco de (after) 1746–1828, *St Anthony Raising a Dead Man*, donated by the Alexander Collection through the National Art Collections Fund, 1973

Graat, Barent 1628–1709, *The Meeting of Rachel and Jacob*, bequeathed by the Founders, 1885

Granet, François-Marius 1775–1849, *A Reading Lesson in a Convent*, bequeathed by the Founders, 1885

Grassi, Nicola 1682–1748, *St John the Baptist*, bequeathed by the Founders, 1885

Grenet de Joigny, Dominique Adolphe 1821–1885, *Landscape with Poplars, a Town in the Distance*, bequeathed by the Founders, 1885

Greuze, Jean-Baptiste (after) 1725–1805, *Girl with a Dead Canary*, bequeathed by the Founders, 1885

Greuze, Jean-Baptiste (after) 1725–1805, *Head of a Young Girl*, bequeathed by the Founders, 1885

Greuze, Jean-Baptiste (after) 1725–1805, *Portrait of a Lady*, bequeathed by the Founders, 1885

Griffier, Jan II (circle of) active 1738–1773, *Landscape with a River, Bridge and Buildings*, bequeathed by the Founders, 1885

Grimmer, Abel c.1570–c.1619, *The Parable of the Sower*, bequeathed by the Founders, 1885

Grobon, François-Frédéric (attributed to) 1815–1901, *Interior Scene*, bequeathed by the Founders, 1885

Gros, Antoine-Jean 1771–1835, *Marie-Thérèse-Charlotte of France (1778–1851), Duchesse d'Angoulême*, bequeathed by the Founders, 1885

Gros, Antoine-Jean (attributed to) 1771–1835, *Head of a Young Girl*,

bequeathed by the Founders, 1885
Grove, John active 20th C, *Hide and Seek*

Guardi, Francesco 1712–1793, *Capriccio*, gift from the National Art Collections Fund, 1975

Guardi, Francesco 1712–1793, *Capriccio*, gift from the National Art Collections Fund, 1975

Gudin, Henriette Herminie 1825–1876, *Shipping in a Calm*, bequeathed by the Founders, 1885

Gudin, Jean Antoine Théodore 1802–1880, *Coast View in Scotland*, bequeathed by the Founders, 1885

Gudin, Jean Antoine Théodore 1802–1880, *Sea Piece, Calm Hazy Morning*, bequeathed by the Founders, 1885

Gudin, Jean Antoine Théodore 1802–1880, *View on the Coast of Scotland*, bequeathed by the Founders, 1885

Gudin, Jean Antoine Théodore 1802–1880, *On the Sands near Ostend, Belgium*, bequeathed by the Founders, 1885

Gudin, Jean Antoine Théodore 1802–1880, *A Marine View, Moonlight*, bequeathed by the Founders, 1885

Guérard, Henri Charles 1846–1897, *Flowers in a Vase*, bequeathed by the Founders, 1885

Guérard, Henri Charles (attributed to) 1846–1897, *Flowers in a Vase*, bequeathed by the Founders, 1885

Guercino (after) 1591–1666, *Susannah and the Elders*, bequeathed by the Founders, 1885

W. L. H. active 19th C, *'SS John Bowes'*

Haften, Nicolas van 1663–1715, *A Man Smoking a Pipe*, bequeathed by the Founders, 1885

Hagemann, Godefroy de d.1877, *Landscape with a River and a Rustic Bridge*, bequeathed by the Founders, 1885

Hall, Oliver 1869–1957, *Dorset Moorland*, donated by Mrs Lingford, 1950, © the artist's estate

Hamen y León, Juan van der (circle of) 1596–1631, *Still Life with a Basket and Dish of Fruit on a Ledge*, bequeathed by the Founders, 1885

Hardenberg, Cornelis van 1755–1843, *Family Group*, bequeathed by the Founders, 1885

Hardey, Richard d.1902, *Anne Whitaker (d.1902)*, donated by Miss B. Whitaker

Hardey, Richard d.1902, *Charles Whitaker of Melton Hall*, donated by Miss B. Whitaker

Hardey, Richard d.1902, *Rachael Whitaker of Melton Hall*, donated by Miss B. Whitaker

Harley, Robert c.1825–1884, *Joshua Reynolds (1723–1792)* (copy after Joshua Reynolds), donated by Robert Harley (?)

Haslehurst, Ernest William 1866–1949, *The Abbey Bridge (The Dairy Bridge)*

Heem, Cornelis de 1631–1695, *A*

Garland of Fruit, bequeathed by the Founders, 1885

Heemskerck, Egbert van the elder 1634/1635–1704, *Boors Carousing and Playing Cards*, bequeathed by the Founders, 1885

Heemskerck, Maerten van 1498–1574, *Christ Appearing to St Peter on the Sea of Tiberias*, bequeathed by the Founders, 1885

Heemskerck, Maerten van 1498–1574, *An Allegory of Innocence and Guile*, bequeathed by the Founders, 1885

Heil, Daniel van 1604–1662, *Landscape, Carmelite Friars in the Foreground*, bequeathed by the Founders, 1885

Helst, Bartholomeus van der (attributed to) 1613–1670, *Portrait of a Man in Black*, bequeathed by the Founders, 1885

Hemessen, Catharina van 1528–after 1587, *A Lady in Sixteenth-Century Costume*, bequeathed by the Founders, 1885

Héreau, Jules 1839–1879, *Horses Drinking*, bequeathed by the Founders, 1885

Hermann, Franz Ludwig 1710–1791, *Anna Gertrude Hofner, Abbess of Münsterlingen*, bequeathed by the Founders, 1885

Herring, John Frederick I 1795–1865, *Cows*, bequeathed by the Founders, 1885

Herring, John Frederick I 1795–1865, *Sheep*, bequeathed by the Founders, 1885

Herring, John Frederick II 1815–1907, *Mr John Bowes' Bay Colt 'Cotherstone', by 'Touchstone' out of 'Emma', in a Loosebox*, purchased with the assistance of the Friends of the Bowes Museum, 2006

Hilder, Richard 1813–1852, *A Storm Cloud*, donated by F. J. Nettlefold, 1948

Hobson, Victor William 1865–1889, *Rigg Mill, near Whitby, North Yorkshire*, bequeathed by the late Canon Hutchinson, 1911

Hoet, Gerard (style of) 1648–1733, *Bacchanalia*, bequeathed by the Founders, 1885

Hoet, Hendrick Jacob c.1693–1733, *Perseus and Andromeda*, bequeathed by the Founders, 1885

Hold, Abel 1815–1891, *Dead Grouse*, gift from Miss Sandra Grewcock, 1984

Hondecoeter, Melchior de (after) 1636–1695, *Poultry*, bequeathed by the Founders, 1885

Hoogstraten, Abraham van d.1736, *Portrait of a Lady with a Basket of Fruit*, bequeathed by the Founders, 1885, stolen, 1997

Hoppenbrouwers, Johannes Franciscus 1819–1866, *Net Fishing, Moonlight (Paysage avec rivière et pêcheurs, effet de nuit)*, bequeathed by the Founders, 1885

Horsley, T. *Pigs*, donated by the Trustees of the late Miss Neasham, 1938

Huchtenburgh, Jan van 1647–1733, *A Battle between Christians*

and Moors, bequeathed by the Founders, 1885

Hudson, Thomas 1701–1779, *Bishop John Butler (1717–1802)*

Huet, Jean-Baptiste I 1745–1811, *Hen and Chickens*, bequeathed by the Founders, 1885

Hughes, John Joseph 1820–1909, *Brougham Castle, near Penrith, Cumbria*, donated by Cyril Walker

Hugues, Victor Louis 1827–1879, *Pollard Willows*, bequeathed by the Founders, 1885

Huilliot, Pierre Nicolas 1674–1751, *Flowers in a Silver Vase*, bequeathed by the Founders, 1885

Hulle, Anselmus van c.1601–c.1674, *Family Portrait Group*, bequeathed by the Founders, 1885

Hulsdonck, Jacob van 1582–1647, *Breakfast Piece*, bequeathed by the Founders, 1885

Hulsdonck, Jacob van 1582–1647, *A Basket of Fruit*, bequeathed by the Founders, 1885

Italian (Neapolitan) School *Still Life*, bequeathed by the Founders, 1885

Italian (Neapolitan) School 17th C, *Lot and His Daughters*, bequeathed by the Founders, 1885

Italian (Neapolitan) School mid-17th C–mid-18th C, *Portrait of a Girl*, bequeathed by the Founders, 1885

Italian (Piedmontese) School *La Contessa di Faule*, bequeathed by the Founders, 1885

Italian (Roman) School *Still Life of Fruit and Flowers with a Cut Piece of Watermelon*, bequeathed by the Founders, 1885

Italian (Roman) School *Still Life of Fruit and Flowers with a Split Watermelon*, bequeathed by the Founders, 1885

Italian (Venetian) School *Christ and the Woman of Samaria*, bequeathed by the Founders, 1885

Italian School 17th C, *St Agnes*, bequeathed by the Founders, 1885

Italian School 17th C, *The Holy Family*, bequeathed by the Founders, 1885

Italian School 17th C, *The Virgin and Child*, bequeathed by the Founders, 1885

Italian School mid-17th C–mid-18th C, *Still Life*, bequeathed by the Founders, 1885

Italian School mid-17th C–mid-18th C, *The Holy Family and St John*, bequeathed by the Founders, 1885

Italian School *Portrait of a Lady*, bequeathed by the Founders, 1885

Italian School 18th C, *Landscape*, bequeathed by the Founders, 1885

Italian School 18th C, *Venus with Putti*, bequeathed by the Founders, 1885

Italian School *Landscape*, bequeathed by the Founders, 1885

Italian School *Mountainous Wooded Landscape with Husbandmen in the Foreground*, bequeathed by the Founders, 1885

Italian School *Portrait of a Lady*

with Long Hair, bequeathed by the Founders, 1885

Italian School *David and Bathsheba*, bequeathed by the Founders, 1885

Italian School *The Virgin Crowned with Stars*, bequeathed by the Founders, 1885

Italian School *Battle Piece*, bequeathed by the Founders, 1885

Italian School *Battle Piece*, bequeathed by the Founders, 1885

Italian School *Holy Family*, bequeathed by the Founders, 1885

Italian School *Head of a Female Saint*, bequeathed by the Founders, 1885

Italian School *Portrait of a Woman*, bequeathed by the Founders, 1885

Jacobber, Moïse 1786–1863, *Flower Piece*, bequeathed by the Founders, 1885

Jacobber, Moïse (attributed to) 1786–1863, *Decoration of Flowers and Grapes*, bequeathed by the Founders, 1885

Jacque, Charles Émile 1813–1894, *Mowers*, bequeathed by the Founders, 1885

Jarry, Joseph *Cottages*, bequeathed by the Founders, 1885

Jollain, Pierre 1720–c.1762, *The Assumption of the Virgin*, bequeathed by the Founders, 1885

Jonghe, Jan Baptiste de (circle of) 1785–1844, *The Entrance to Brussels, Belgium*, bequeathed by the Founders, 1885

Jonquières, Victor Philippe Auguste de active 1838–c.1873, *Pony Trotter*, bequeathed by the Founders, 1885

Jordaens, Jacob (style of) 1593–1678, *Portrait of a Man*, bequeathed by the Founders, 1885

Jouvenel, Nicholas Wulfram 1788–1878, *View of Amiens Cathedral from along the River*, bequeathed by the Founders, 1885

Jouvenel, Nicholas Wulfram 1788–1878, *View of Amiens Cathedral from across the River*, bequeathed by the Founders, 1885

Jouvenet, Jean 1644–1717, *Madame de Maintenon as St Cecilia and a Boy* (possibly the Duc de Maine) *as an Angel Blowing an Organ*, bequeathed by the Founders, 1885

Keuninck, Kerstiaen de (attributed to) after 1560–1632/1633, *Lot and His Daughter, Guided by Angels Fleeing from Sodom*, bequeathed by the Founders, 1885

Kieser, K. R. *Alnwick Castle, Northumberland*

Kieser, K. R. *Barnard Castle, County Durham*

Kieser, K. R. *High Force*

Kinsoen, François Joseph 1771–1839, *Self Portrait*, bequeathed by the Founders, 1885

Kinsoen, François Joseph 1771–1839, *Jérôme Bonaparte (1784–1860), King of Westphalia*, bequeathed by the Founders, 1885

Kinsoen, François Joseph 1771–

1839, *Joseph Bonaparte (1768–1844), King of Spain*, bequeathed by the Founders, 1885

Kinsoen, François Joseph 1771–1839, *Catherine of Würtemberg (1783–1835), Wife of Jérôme Bonaparte, King of Westphalia*, bequeathed by the Founders, 1885

Kinsoen, François Joseph 1771–1839, *Laetitia Ramolino Bonaparte (1750–1836)*, bequeathed by the Founders, 1885

Kinsoen, François Joseph 1771–1839, *Le Duc d'Angoulême (1775–1844)*, bequeathed by the Founders, 1885

Kinsoen, François Joseph 1771–1839, *Portrait of a German Princess*, bequeathed by the Founders, 1885

Kinsoen, François Joseph 1771–1839, *William II of Holland (1792–1849), as Prince of Orange*, bequeathed by the Founders, 1885

Kinsoen, François Joseph 1771–1839, *The Princess of Orange*, bequeathed by the Founders, 1885

Kinsoen, François Joseph 1771–1839, *Mademoiselle Mars (1779–1847), the Celebrated French Actress*, bequeathed by the Founders, 1885

Kinsoen, François Joseph 1771–1839, *Portrait of a Russian Lady*, bequeathed by the Founders, 1885

Kneller, Godfrey (style of) 1646–1723, *Portrait of a Lady*, bequeathed by the Founders, 1885

Knijff, Wouter c.1607–after 1693, *River Scene with a Castle*, bequeathed by the Founders, 1885

Kobell, Hendrik 1751–1779, *A Rocky Coast with a Town and Ships*, bequeathed by the Founders, 1885

Koningh, Leendert de 1777–1849, *Winter Scene, Frozen River with Skaters*, bequeathed by the Founders, 1885

Kuwasseg, Karl-Joseph 1802–1877, *A Waterfall among Mountains with Figures*, bequeathed by the Founders, 1885

Lacoeur *At the Altar*, bequeathed by the Founders, 1885

Lacroix, Charles François de (attributed to) c.1700–1782, *A Seaport*, bequeathed by the Founders, 1885

Lacroix, Charles François de (style of) c.1700–1782, *Landscape with Washerwomen*, bequeathed by the Founders, 1885

Lagrenée, Louis Jean François (after) 1725–1805, *Diana and Endymion, Allegory of Fidelity* (dessus de porte), bequeathed by the Founders, 1885

Lagrenée, Louis Jean François (after) 1725–1805, *Cupid and Psyche, Allegory of the Five Senses* (dessus de porte), bequeathed by the Founders, 1885

Lagrenée, Louis Jean François (after) 1725–1805, *Two Muses, Allegory of the Five Senses* (dessus de porte), bequeathed by the Founders, 1885

Lagrenée, Louis Jean François (after) 1725–1805, *Dessus-de-Porte,*

Two Nymphs, Allegory of the Five Senses (dessus de porte), bequeathed by the Founders, 1885

Lambert, George c.1700–1765, *View of Chatham, Kent*

Lanfant, François-Louis 1814–1892, *An Old Lady Walking with a Boy and a Girl (Les batons de vieillesse)*, bequeathed by the Founders, 1885

Lanfant, François-Louis 1814–1892, *Brigands Waiting in Ambush*, bequeathed by the Founders, 1885

Lanfant, François-Louis 1814–1892, *Le lever de l'enfant*, bequeathed by the Founders, 1885

Lantara, Simon Mathurin (style of) 1729–1778, *Landscape, Moonlight*, bequeathed by the Founders, 1885

Largillière, Nicolas de (attributed to) 1656–1746, *Portrait of a Lady as Diana*, bequeathed by the Founders, 1885

Largillière, Nicolas de (attributed to) 1656–1746, *A Nobleman from the Time of Louis XIV*, bequeathed by the Founders, 1885

Largillière, Nicolas de (circle of) 1656–1746, *Portrait of a Nobleman*, bequeathed by the Founders, 1885

Largillière, Nicolas de (style of) 1656–1746, *An Infanta of Spain*, bequeathed by the Founders, 1885

Lawrence, Thomas (style of) 1769–1830, *Mr John Hodgson of Norton Conyers*, donated by Miss B. Whitaker

Lawrence, Thomas (style of) 1769–1830, *Mrs Elizabeth Hodgson of Norton Conyers*, donated by Miss B. Whitaker

Lazerges, Paul Jean Baptiste 1845–1902, *Still Life with Crabs and a Bottle*, bequeathed by the Founders, 1885

Le Chevalier d'Arborville active 18th C, *Portrait of an Elderly Woman Holding a Spray of Orange Blossom*, bequeathed by the Founders, 1885

Le Prince, Charles Edouard 1784–after 1850, *Le Château d'Arc*, bequeathed by the Founders, 1885

Lecat active 1862–1865, *Portrait of a Lady in Black*, bequeathed by the Founders, 1885

Lecat active 1862–1865, *Portrait of a Lady*, bequeathed by the Founders, 1885

Lecerf, Louis Alexis 1787–after 1844, *Portrait of a Lady*, bequeathed by the Founders, 1885

Ledesma, Blas de c.1580–c.1640, *Still Life with Asparagus, Artichokes, Lemons and Cherries*, bequeathed by the Founders, 1885

Ledoux, Jeanne Philiberte 1767–1840, *A Girl in Prayer*, bequeathed by the Founders, 1885

Ledoux, Jeanne Philiberte 1767–1840, *Girl Leaning on Her Hand*, bequeathed by the Founders, 1885

Ledoux, Jeanne Philiberte 1767–1840, *Mademoiselle M. A. Lenormand (1772–1843)*, bequeathed by the Founders, 1885

Lee, John c.1869–1934, *Sir Joseph Pease (1828–1903)*, donated by Mrs Mounsey, 1949

Lee, John c.1869–1934, *English Landscape in Woods*

Lee, John c.1869–1934, *High Force, Middleton-in-Teesdale*, gift from Mrs R. G. Eves

Leeuw, Alexis de c.1822–1900, *River Scene with Skaters*, bequeathed by the Founders, 1885

Lefèvre active c.1750–1780, *Portrait of a Gentleman*, bequeathed by the Founders, 1885

Legrip, Frédéric 1817–1871, *A Canal in Brittany, France*, bequeathed by the Founders, 1885

Legrip, Frédéric 1817–1871, *Landscape with Boats Tied up on a Riverbank*, bequeathed by the Founders, 1885

Legrip, Frédéric 1817–1871, *River Scene with Poplars and a Boatman*, bequeathed by the Founders, 1885

Legrip, Frédéric 1817–1871, *The Banks of the Seine near Roche-Guyon, France*, bequeathed by the Founders, 1885

Legrip, Frédéric (attributed to) 1817–1871, *The Ferry*, bequeathed by the Founders, 1885

Lely, Peter (circle of) 1618–1680, *Portrait of a Lady Wearing a Pearl Necklace*, bequeathed by the Founders, 1885

Lemoyne, François (circle of) 1688–1737, *Cephalus and Aurora*, bequeathed by the Founders, 1885

Leonardo, Jusepe 1601–1656, *St John the Evangelist*, bequeathed by the Founders, 1885

Leonardo, Jusepe 1601–1656, *St Luke*, bequeathed by the Founders, 1885

Leonardo, Jusepe 1601–1656, *St Mark*, bequeathed by the Founders, 1885

Leonardo, Jusepe 1601–1656, *St Matthew*, bequeathed by the Founders, 1885

Leoni, Ottavio Maro (after) 1578–1630, *Medallion Portraits of 40 Celebrated Venetians*, bequeathed by the Founders, 1885

Lepesqueur, Hyacinth Florentin *A Man Smoking a Pipe (Self Portrait)*, bequeathed by the Founders, 1885

Lépine, Stanislas 1835–1892, *La forêt de Fontainebleau, France*, purchased from the late Mrs J. Eyles' sale at Tennants, Boroughbridge, with grants from the Museums, Libraries and Archives Council/Victoria and Albert Museum Purchase Grant Fund and the Friends of the Bowes Museum, 2003

Lepoittevin, Eugène Modeste Edmond 1806–1870, *Farm Girl at Her Toilet, Lacing Her Corset*, bequeathed by the Founders, 1885

Leprince, Léopold 1800–1847, *Peasant Woman and Boy*, bequeathed by the Founders, 1885

Leprince, Léopold 1800–1847, *Landscape with Figures and Sheep*, bequeathed by the Founders, 1885

Levis, Henri Jean Baptiste active 1844–1874, *Horses Towing a Boat along a River (Chevaux de halage)*, bequeathed by the Founders, 1885

Levis, Henri Jean Baptiste active 1844–1874, *View on the River near Asnières, France (A Village near Paris)*, bequeathed by the Founders, 1885

Leyden, Lucas van (copy after) c.1494–1533, *Susannah and the Elders*, bequeathed by the Founders, 1885

Lhermitte, Léon-Augustin 1844–1925, *The Reaper's Rest (Le repos du faucheur)*, donated by Mr Garfield Weston, 1977

Liberi, Pietro (attributed to) 1605–1687, *Venus Disarming Cupid*, bequeathed by the Founders, 1885

Liemaker, Nicolaes de (style of) 1600–1644, *The Coronation of the Virgin*, bequeathed by the Founders, 1885

Ligozzi, Jacopo (copy after) 1547–1627, *Christ Bound*, bequeathed by the Founders, 1885

Linard, Jacques 1597–1645, *Still Life, Plums, Melons and Peaches*, bequeathed by the Founders, 1885

Loir, Marianne (attributed to) c.1715–after 1769, *Portrait of a Gentleman Writing a Letter*, bequeathed by the Founders, 1885

Loo, Carle van (attributed to) 1705–1765, *A Hunting Luncheon*, bequeathed by the Founders, 1885

Loo, Carle van (attributed to) 1705–1765, *A Lady and Gentleman as a Shepherd and Shepherdess*, bequeathed by the Founders, 1885

Loo, Louis Michel van (after) 1707–1771, *Louis XV (1710–1774)*, bequeathed by the Founders, 1885

Lorrain, Claude (school of) 1604–1682, *Landscape*, bequeathed by the Founders, 1885

Lorrain, Claude (style of) 1604–1682, *View of the Seashore with Figures*, bequeathed by the Founders, 1885

M. *Head of a Girl*, bequeathed by the Founders, 1885

McLachlan, Thomas Hope 1845–1897, *Landscape of Upper Teesdale*, donated by Miss Sowerby, 1951

McLachlan, Thomas Hope 1845–1897, *Meadow Landscape*, donated by Miss Sowerby, 1951

Maella, Mariano Salvador de (after) 1739–1818, *Portrait of a Monk*, bequeathed by the Founders, 1885

Maes, Jan Baptiste Lodewijk 1794–1856, *An Officer of the First Empire*, bequeathed by the Founders, 1885

Maes, Nicolaes 1634–1693, *Portrait of a Venerable-Looking Old Man*, bequeathed by the Founders, 1885

Maes, Nicolaes (school of) 1634–1693, *Boy in Fancy Dress as a Roman Soldier*, bequeathed by the Founders, 1885

Maino, Juan Bautista 1569–1649, *St Agabus*, bequeathed by the Founders, 1885

Malbrouck *Rustic Landscape*, bequeathed by the Founders, 1885

Mallet, Jean Baptiste 1759–1835, *A Nursery Scene*, bequeathed by the Founders, 1885

Mallet, Jean Baptiste 1759–1835, *The Proposal*, bequeathed by the Founders, 1885

Manglard, Adrien 1695–1760, *A Seaport on a Rocky Coast*, bequeathed by the Founders, 1885

Marchais, J. B. 1818–1876, *Girl in a Blue Skirt, Sewing*, bequeathed by the Founders, 1885

Marchesi, Girolamo 1471/1481–1540/1550, *St Catherine*, bequeathed by the Founders, 1885

Maréchal, Charles Laurent 1801–1887, *A Fishing Village*, bequeathed by the Founders, 1885

Marées, Georges de 1697–1776, *Maria-Anna-Sophie von Saxe (1728–1797)*, bequeathed by the Founders, 1885

Marienhof, Jan A. active c.1640–c.1652, *The Sacrifice of Elijah*, bequeathed by the Founders, 1885

Marilhat, Prosper Georges Antoine 1811–1847, *An Eastern Seaport*, bequeathed by the Founders, 1885

Marrel, Jacob 1614–1681, *Flowers in a Blue and White Vase*, acquired by HM Treasury from the estate of Nancy Helen Turner in lieu of tax, 1990

Marsal, Edouard Antoine 1845–1929, *Still Life with Books, a Bottle and a Bundle of Cigars*, bequeathed by the Founders, 1885

Master of Palanquinos (circle of) active c.1490–1500, *St Paul*, bequeathed by the Founders, 1885

Master of Saint Severin (attributed to) active c.1485–1515, *The Raising of Lazarus* (recto), bequeathed by the Founders, 1886

Master of Saint Severin (attributed to) active c.1485–1515, *The Adoration of the Magi* (verso), bequeathed by the Founders, 1886

Master of the View of Saint Gudule active c.1465–1500, *St Jerome* (verso), bequeathed by the Founders, 1885

Master of the View of Saint Gudule active c.1465–1500, *The Agony in the Garden* (recto), bequeathed by the Founders, 1885

Master of the View of Saint Gudule active c.1465–1500, *Christ Before Pilate* (recto), bequeathed by the Founders, 1885

Master of the View of Saint Gudule active c.1465–1500, *St Gregory* (verso), bequeathed by the Founders, 1885

Master of the View of Saint Gudule active c.1465–1500, *The Adoration of the Magi* (recto), bequeathed by the Founders, 1885

Master of the View of Saint Gudule active c.1465–1500, *The Family of Zebedee* (verso), bequeathed by the Founders, 1885

Master of the View of Saint Gudule active c.1465–1500, *God the Father* (recto), bequeathed by the Founders, 1885

Master of the View of Saint Gudule active c.1465–1500, *St Anthony* (verso), bequeathed by the Founders, 1885

Master of the View of Saint Gudule active c.1465–1500, *The Resurrection* (recto), bequeathed by the Founders, 1885

Master of the View of Saint Gudule active c.1465–1500, *St Ambrose* (verso), bequeathed by the Founders, 1885

Master of the View of Saint Gudule active c.1465–1500, *The Risen Christ* (recto), bequeathed by the Founders, 1885

Master of the View of Saint Gudule active c.1465–1500, *St Augustine* (verso), bequeathed by the Founders, 1885

Master of the View of Saint Gudule (circle of) active c.1465–1500, *St Jerome and the Lion*, bequeathed by the Founders, 1885

Master of the Virgo inter Virgines active c.1483–1498, *Crucifixion* (left panel, recto), bequeathed by the Founders, 1885

Master of the Virgo inter Virgines active c.1483–1498, *Crucifixion*, bequeathed by the Founders, 1885

Master of the Virgo inter Virgines active c.1483–1498, *Crucifixion* (right panel, recto), bequeathed by the Founders, 1885

Master of the Virgo inter Virgines active c.1483–1498, *Crucifixion (The Annunciation)* (left panel, verso), bequeathed by the Founders, 1885

Master of the Virgo inter Virgines active c.1483–1498, *Crucifixion (The Annunciation)* (right panel, verso), bequeathed by the Founders, 1885

Master of Torralba active c.1440, *Christ Standing in the Tomb between the Virgin and St John*, purchased from Eric Young, 1972

Mathieu, Alexis *Still Life with a Copper Kettle, Candlestick and Flowers in a Glass*, bequeathed by the Founders, 1885

Mauduit, Louise-Marie-Jeanne 1784–1862, *Pauline Bonaparte (1780–1825)*, bequeathed by the Founders, 1885

Mauduit, Louise-Marie-Jeanne 1784–1862, *Portrait of a Boy in Green*, bequeathed by the Founders, 1885

Menéndez, Miguel Jacinto 1679–1734, *St Augustine Appearing to Prevent a Plague of Locusts*, bequeathed by the Founders, 1885

Menéndez, Miguel Jacinto (attributed to) 1679–1734, *A Spanish Princess*, bequeathed by the Founders, 1885

Mettenleiter, Johann Jakob 1750–1825, *The Lovers*, bequeathed by the Founders, 1885

Meulen, Adam Frans van der (follower of) 1631/1632–1690, *A Group on Horseback in a Landscape*, bequeathed by the Founders, 1885

Meusnier, Philippe the elder 1655–1734, *A Quay*, bequeathed by the Founders, 1885

Michallon, Achille Etna 1796–1822, *After the Thunderstorm*, bequeathed by the Founders, 1885

Michallon, Achille Etna 1796–1822, *Landscape with a Man Frightened by a Serpent among Ruins*, bequeathed by the Founders, 1885

Mignard, Pierre I (after) 1612–1695, *Equestrian Portrait of Louis XIV*, bequeathed by the Founders, 1885

Mignard, Pierre I (school of) 1612–1695, *Madame de Grignan (1646–1705), Daughter of the Comtesse de Sévigné*, bequeathed by the Founders, 1885

Mignard, Pierre I (studio of) 1612–1695, *Madame de Montespan (1641–1707), a Mistress of Louis XIV*, bequeathed by the Founders, 1885

Mignard, Pierre I (style of) 1612–1695, *Portrait of a Young Lady, Time of Louis XIV*, bequeathed by the Founders, 1885

Mignard, Pierre I (style of) 1612–1695, *Portrait of a Lady*, bequeathed by the Founders, 1885

Mignon, Abraham 1640–c.1679, *Flower Piece*, bequeathed by the Founders, 1885

Mignon, Abraham (style of) 1640–c.1679, *Fruit Piece*, bequeathed by the Founders, 1885

Miller, Joseph active c.1812–1858, *Streatlam Castle, County Durham*, purchased, 1972

Millet, Jean-François (after) 1814–1875, *Peasant Woman of Burgundy, France*, bequeathed by the Founders, 1885

Mire, Noël Jules le 1814–1878, *View of Arbois in the Jura, France*, bequeathed by the Founders, 1885

Molenaer, Jan Miense c.1610–1668, *Boors Carousing*, bequeathed by the Founders, 1885

Mommers, Hendrick 1623–1693, *View from the Pont Neuf, Paris, France*, bequeathed by the Founders, 1885

Mommers, Hendrick 1623–1693, *Italian Market Scene*, bequeathed by the Founders, 1885

Momper, Joos de the younger (attributed to) 1564–1635, *A Grotto Landscape*, bequeathed by the Founders, 1885

Momper, Joos de the younger (follower of) 1564–1635, *Landscape with a Sportsman Shooting Ducks and a Boy Playing Bagpipes*, bequeathed by the Founders, 1885

Monnoyer, Jean-Baptiste (style of) 1636–1699, *Two Vases of Flowers*, bequeathed by the Founders, 1885

Monticelli, Adolphe Joseph Thomas 1824–1886, *Landscape with Figures and Goats*, bequeathed by the Founders, 1885

Monticelli, Adolphe Joseph Thomas 1824–1886, *The Garden of Delights I*, bequeathed by the Founders, 1885

Monticelli, Adolphe Joseph

Thomas 1824–1886, *The Garden of Delights II*, bequeathed by the Founders, 1885

Moormans, Frans 1832–after 1882, *A Game of Chess*, bequeathed by the Founders, 1885

Morales, Luis de (after) c.1509–c.1586, *Madonna and Child*, gift from Yvonne Carey, née Coulette, in memory of her husband, 1995

Moucheron, Isaac de (attributed to) 1667–1744, *Classical Landscape*, bequeathed by the Founders, 1885

Muller, Charles Louis Lucien 1815–1892, *The Wounded Soldier*, bequeathed by the Founders, 1885

Muñoz, Pedro active c.1640–1650, *The Virgin of Mercy*, bequeathed by the Founders, 1885

Mura, Francesco de (school of) 1696–1782, *Maria Xavieri Romano*, bequeathed by the Founders, 1885

Murillo, Bartolomé Esteban (copy of) 1618–1682, *San Diego of Alcalá in Ecstasy before the Cross*, bequeathed by the Founders, 1885

Mytens, Daniel I (follower of) c.1590–before 1648, *Charles I (1600–1649)*, bequeathed by the Founders, 1885

Mytens, Jan (after) c.1614–1670, *La Duchesse de la Valliere, Mistress of Louis XIV, Crowning the King with Flowers, Who is Disguised in Female Attire*, bequeathed by the Founders, 1885

Naigeon, Jean Claude (attributed to) 1753–1832, *Juno Instructing Cupid*, bequeathed by the Founders, 1885

Naigeon, Jean Claude (attributed to) 1753–1832, *Numa Consulting the Nymph Egeria*, bequeathed by the Founders, 1885

Naiveu, Matthys (attributed to) 1647–1726, *Girl with a Dog*, bequeathed by the Founders, 1885

Nardi, Angelo (attributed to) 1584–1665, *Christ on the Cross*, bequeathed by the Founders, 1885

Nardi, Angelo (studio of) 1584–1665, *Christ on the Cross*, bequeathed by the Founders, 1885

Nattier, Jean-Marc (school of) 1685–1766, *Portrait of a Lady of the Time of Louis XV Dressed as Hebe*, bequeathed by the Founders, 1885

Nattier, Jean-Marc (school of) 1685–1766, *Portrait of a Lady with Powdered Hair*, bequeathed by the Founders, 1885

Neeffs, Peeter the elder c.1578–1656–1661, *Interior of a Catholic Church*, bequeathed by the Founders, 1885

Neeffs, Peeter the elder c.1578–1656–1661, *Interior of the Cathedral of Our Lady at Antwerp, Belgium (Onze-Lieve-Vrouwekerk, Cathédrale de Notre Dame)*, bequeathed by the Founders, 1885

Neer, Aert van der (after) 1603–1677, *Landscape, Moonlight*, bequeathed by the Founders, 1885

Neer, Aert van der (style of) 1603–1677, *Mountainous Landscape*, bequeathed by the Founders, 1885

Neer, Aert van der (style of) 1603–

1677, *River Scene with a Bonfire, Moonlight*, bequeathed by the Founders, 1885

Netscher, Constantin (attributed to) 1668–1723, *Portrait of a Young Girl Holding a Rose*, bequeathed by the Founders, 1885

Nieudorp, Thys Wiertsz. active mid-17th C, *Boors Carousing*, bequeathed by the Founders, 1885

Nieudorp, Thys Wiertsz. active mid-17th C, *Interior with an Old Woman Eating Soup*, bequeathed by the Founders, 1885

Nocchi, Pietro c.1783–c.1855, *A Lady with a Harp Lute*, bequeathed by the Founders, 1885

Noël, Gustave Joseph 1823–1881, *River Landscape with Figures and Buildings*, bequeathed by the Founders, 1885

Noël, Jules Achille 1815–1881, *Souvenir of Fécamp, France*, bequeathed by the Founders, 1885

Noël, Jules Achille 1815–1881, *Souvenir de Douarnenez, France*, bequeathed by the Founders, 1885

Noël, Jules Achille 1815–1881, *Stormy Sea at the Entrance to a Harbour*, bequeathed by the Founders, 1885

Nogaro, Carlo active 1837–1881, *The Fable of the Fox and the Crow*, bequeathed by the Founders, 1885

Northcote, James 1746–1831, *Vulture and Snake*

Northern Italian School mid-17th C-mid-18th C, *Susannah*, bequeathed by the Founders, 1885

Northern Italian School mid-17th C-mid-18th C, *The Martyrdom of St Agnes*, bequeathed by the Founders, 1885

Northern Italian School *Portrait of a Gentleman in Black*, bequeathed by the Founders, 1885

Núñez del Valle, Pedro c.1590–1657, *Portrait of a Cleric*, bequeathed by the Founders, 1885

Orley, Bernaert van (circle of) c.1492–1541, *The Holy Family with St Catherine and St Barbara*, bequeathed by the Founders, 1885

Oudry, Jacques Charles 1720–1778, *A Dog Pointing Partridge (dessus de porte)*, bequeathed by the Founders, 1885

Oudry, Jacques Charles 1720–1778, *A Spaniel Chasing Two Partridges*, bequeathed by the Founders, 1885; on loan to the Turf Club, London

Oudry, Jacques Charles 1720–1778, *An Eagle Attacking Two Ducks*, bequeathed by the Founders, 1885

Oudry, Jacques Charles 1720–1778, *Two Dogs Fighting over a Bone*, bequeathed by the Founders, 1885

Oudry, Jean-Baptiste (attributed to) 1686–1755, *Dead Game*, bequeathed by the Founders, 1885

Ouvrie, Pierre Justin 1806–1879, *Vue de Château de Pierrefonds, France*, bequeathed by the Founders, 1885

Ouvrie, Pierre Justin 1806–1879,

A Derelict Country Church, bequeathed by the Founders, 1885

Ouvrie, Pierre Justin 1806–1879, *View on the Grand Canal, Venice, Italy*, bequeathed by the Founders, 1885

Ovens, Jürgen (attributed to) 1623–1678, *Portrait of a Girl with a Watchful or Guarded Look*, bequeathed by the Founders, 1885

Pacheco, Francisco 1564–1644, *The Last Communion of St Peter Nolasco*, donated by W. G. Thwaytes in memory of Tony Ellis, 1964

Pacheco, Francisco (circle of) 1564–1644, *The Surrender of Seville to Ferdinand III*, bequeathed by the Founders, 1885

Palamedesz., Anthonie 1601–1673, *Portrait of a Lady Wearing a Wreath of Roses*, bequeathed by the Founders, 1885

Palizzi, Filippo 1818–1899, *A Spaniel with Two Puppies*, bequeathed by the Founders, 1885

Palizzi, Giuseppe 1812–1888, *A Child Feeding a Donkey in a Farmyard*, bequeathed by the Founders, 1885

Palizzi, Giuseppe 1812–1888, *A Horse in a Stable*, bequeathed by the Founders, 1885

Palma, Jacopo il giovane (after) 1544/1548–1628, *The Entombment*, bequeathed by the Founders, 1885

Pantoja de la Cruz, Juan (after) 1553–1608, *Philip IV of Spain (1605–1665)*, bequeathed by the Founders, 1885

Pantoja de la Cruz, Juan (after) 1553–1608, *The Archduke Albert of Austria (1559–1621), Governor of The Netherlands*, bequeathed by the Founders, 1885

Pantoja de la Cruz, Juan (after) 1553–1608, *The Infante Cardinal Ferdinand (1609–1641)*, bequeathed by the Founders, 1885

Pantoja de la Cruz, Juan (attributed to) 1553–1608, *St Luke*, gift from Linda Murray in memory of her husband Professor Peter Murray, through the National Art Collections Fund, 2002

Pantoja de la Cruz, Juan (style of) 1553–1608, *The Emperor Charles V (1500–1558)*, bequeathed by the Founders, 1885

Parrocel, Joseph (style of) 1646–1704, *Landscape with Horsemen*, bequeathed by the Founders, 1885

Patel, Pierre Antoine (style of) 1648–1707, *Architectural Landscape with Ruins*, bequeathed by the Founders, 1885

Peeters, Jan I 1624–c.1677, *Coast Scene (On the Baltic Sea)*, bequeathed by the Founders, 1885

Pere, Antonio van de c.1618–c.1688, *The Communion of St Maria Maddalena de' Pazzi (detail)*, bequeathed by the Founders, 1885

Pereda y Salgado, Antonio 1611–1678, *Tobias Restoring His Father's Sight*, bequeathed by the Founders, 1885

Pereda y Salgado, Antonio (circle

of) 1611–1678, *The Immaculate Conception*, bequeathed by the Founders, 1885

Pereda y Salgado, Antonio (follower of) 1611–1678, *Christ Shown to the People*, bequeathed by the Founders, 1885

Perrot, Ferdinand 1808–1841, *Seascape Sunset*, bequeathed by the Founders, 1885

Pether, Sebastian 1790–1844, *Ruined Church by Moonlight*

Petit, Pierre Joseph 1768–1825, *Landscape with a Temple and an Artist Sketching*, bequeathed by the Founders, 1885

Petit, Pierre Joseph 1768–1825, *Landscape with Cattle and a River*, bequeathed by the Founders, 1885

Petit, Pierre Joseph 1768–1825, *Mountainous Landscape with a Ruined Castle*, bequeathed by the Founders, 1885

Phillip, John 1817–1867, *Italian Pifferari*

Piemean (Professor) active 19th C, *View in Greece*, bequeathed by the Founders, 1885

Pignoni, Simone (style of) 1611–1698, *Two Women, One with a Caduceus, the Other with Fasces*, bequeathed by the Founders, 1885

Pils, Edouard-Aimé (attributed to) 1823–1850, *A Dead Bittern*, bequeathed by the Founders, 1885

Pils, Isidore Alexandre Augustin 1813/1815–1875, *Head of an Arab in a Fez*, bequeathed by the Founders, 1885

Pils, Isidore Alexandre Augustin 1813/1815–1875, *An Arab*, bequeathed by the Founders, 1885

Pinchon, Jean Antoine 1772–1850, *A Lady in Oriental Fancy Dress*, bequeathed by the Founders, 1885

Pinson, Isabelle (attributed to) active 1763–1823, *Family Group*, bequeathed by the Founders, 1885

Pittuck, Douglas Frederick 1911–1993, *The Bowes Museum from the Kitchen Gardens of Barnard Castle School, County Durham*, gift from John Pittuck, 1993, © the artist's estate

Plas, Laurens 1828–1893, *Sheep and Goats*, bequeathed by the Founders, 1885

Plasschaert, Jacobus c.1730–1765, *Trompe l'Oeil Still Life*, bequeathed by the Founders, 1885

Platzer, Johann Georg 1704–1761 & Orient, Josef 1677–1747 *The Judgement of Paris*, bequeathed by the Founders, 1885

Porcellis, Jan (school of) c.1584–1632, *Sea Piece*, bequeathed by the Founders, 1885

Porpora, Paolo (school of) 1617–1673, *Fruit and Shells*, bequeathed by the Founders, 1885

Porta, Giuseppe 1520–1575, *The Rape of the Sabine Women*, bequeathed by the Founders, 1885

Poussin, Nicolas (style of) – c.1699, *Architectural Landscape*, bequeathed by the Founders, 1885

Primaticcio, Francesco (circle of) 1504–1570, *The Rape of Helen*,

bequeathed by the Founders, 1885

Primaticcio, Francesco (style of) 1504–1570, *The Three Graces (Aglaia, Thalia and Euphrosyne)*, bequeathed by the Founders, 1885

Provost, Jan (attributed to) c.1465–1529, *The Adoration of the Magi with St John the Baptist, St Anne and Donors*, gift from Mr Roland Cookson in memory of Mrs Rosamond Cookson, through the National Art Collections Fund, 1980

Prudhomme, Antione Daniel 1745–c.1826, *Coast Scene with Figures*, bequeathed by the Founders, 1885

Prud'hon, Pierre-Paul (style of) 1758–1823, *Girl Looking out of a Window*, bequeathed by the Founders, 1885

Pryde, James 1866–1941, *The Birdcage*, gift from Mr Garfield Weston, 1977

Puga, Antonio 1602–1648, *St Jerome*, bequeathed by the Founders, 1885

Quinkhard, Jan Maurits 1688–1772, *Portrait of a Gentleman with a Red Cloak*, bequeathed by the Founders, 1885

Quinkhard, Jan Maurits (circle of) 1688–1772, *Portrait of a Lady in a Blue Dress*, bequeathed by the Founders, 1885

Ramsay, Allan 1713–1784, *Portrait of a Man*, bequeathed by the Founders, 1885

Raoux, Jean (follower of) 1677–1734, *Vestal Virgin*, bequeathed by the Founders, 1885

Raphael (after) 1483–1520, *The Holy Family with St Elizabeth and the Infant St John the Baptist*, bequeathed by the Founders, 1885

Raphael (copy of) 1483–1520, *The Holy Family with the Infant St John the Baptist*, bequeathed by the Founders, 1885

Rauch, Johann Nepomuk 1804–1847, *Landscape with a Château*, bequeathed by the Founders, 1885

Recco, Giuseppe (circle of) 1634–1695, *Kitchen Utensils*, bequeathed by the Founders, 1885

Régnier, Nicolas (after) c.1590–1667, *Portrait of a Girl, Aged 16*, bequeathed by the Founders, 1885

Regters, Tibout 1710–1768, *Portrait of a Lady in a Black Dress Holding a Book*, bequeathed by the Founders, 1885

Rembrandt van Rijn (copy of) 1606–1669, *Portrait of a Boy*, bequeathed by the Founders, 1885

Reni, Guido (after) 1575–1642, *The Abduction of Helen*, bequeathed by the Founders, 1885

Reni, Guido (after) 1575–1642, *The Death of Lucretia*, bequeathed by the Founders, 1885

Reni, Guido (follower of) 1575–1642, *St Francis in Ecstasy*, bequeathed by the Founders, 1885

Reus, Johann George 1730–c.1810, *Portrait of a Lady in Blue and Black*, bequeathed by the Founders, 1885

Reynolds, Joshua 1723–1792,

Portrait of a Lady, bequeathed by the Founders, 1885

Ribera, Jusepe de (after) 1591–1652, *A Levitation of St Francis*, bequeathed by the Founders, 1885

Richard, Pierre Louis 1810–1886, *A Girl with a Flock of Geese*, bequeathed by the Founders, 1885

Richard, Pierre Louis (attributed to) 1810–1886, *The Tears of St Peter* (copy after Jusepe de Ribera), bequeathed by the Founders, 1885

Richardson, J. (attributed to) active 18th C, *Christopher Sanderson III*, donated by Colonel Roger, 1954

Richardson, Thomas Miles I 1784–1848, *Barnard Castle, County Durham*

Rivalz, Antoine (studio of) 1667–1735, *Jean Jacques Fortic, Capitoul of Toulouse*, bequeathed by the Founders, 1885

Rizi, Juan Andrés 1600–1681, *The Virgin of Montserrat with a Donor*, bequeathed by the Founders, 1885

Rizi, Juan Andrés (attributed to) 1600–1681, *St Gregory*, bequeathed by the Founders, 1885

Robert, Hubert 1733–1808, *Architectural Capriccio with Obelisk*, bequeathed by the Founders, 1885

Robert, Hubert 1733–1808, *Architectural Capriccio with Bridge and Triumphal Arch*, bequeathed by the Founders, 1885

Robert, Hubert 1733–1808, *The Dismantling of the Church of the Holy Innocents, Paris, France, 1785*, bequeathed by the Founders, 1885

Robert-Fleury, Tony 1837–1911, *Lesbia and the Sparrow*, bequeathed by the Founders, 1885

Rochussen, Charles 1814–1894, *Fisherfolk with a Boat on the Seashore*, bequeathed by the Founders, 1885

Rodríguez Barcaza, Ramón 1820–1892, *Head of an Italian Woman*, bequeathed by the Founders, 1885

Román, Bartolomé (attributed to) 1596–1647, *Behold My Hand*, bequeathed by the Founders, 1885

Romano, Giulio (after) 1499–1546, *A Boar Hunt*, bequeathed by the Founders, 1885

Roos, Joseph (attributed to) 1726–1805, *Landscape with Oxen and Goats*, bequeathed by the Founders, 1885

Roos, Philipp Peter (attributed to) 1657–1706, *Shepherd with Dog, Goats and Sheep*, bequeathed by the Founders, 1885

Roos, Philipp Peter (follower of) 1657–1706, *Sheep*, bequeathed by the Founders, 1885

Roos, Philipp Peter (style of) 1657–1706, *Birds in a Landscape*, bequeathed by the Founders, 1885

Rootius, Jan Albertsz. (attributed to) c.1615–1674, *Portrait of a Lady in a Fur-Trimmed Dress Holding a Pair of White Gloves*, bequeathed by the Founders, 1885

Rootius, Jan Albertsz. (style of) c.1615–1674, *Portrait of a Boy with*

a Goat, bequeathed by the Founders, 1885

Rosa, Salvator (style of) 1615–1673, *Landscape with Figures*, bequeathed by the Founders, 1885

Rosa, Salvator (style of) 1615–1673, *Rocky Landscape with River, Ruin and Figures*, bequeathed by the Founders, 1885

Rosa, Salvator (style of) 1615–1673, *Wild Landscape with Castle on a Crag*, bequeathed by the Founders, 1885

Roslin, Alexander (attributed to) 1718–1793, *Portrait of a Lady in Green and Pink*, bequeathed by the Founders, 1885

Rousseau, Philippe 1816–1887, *The Heron's Pool*, bequeathed by the Founders, 1885

Rozier, Jules Charles 1821–1882, *Wooded Landscape with Cottages*, bequeathed by the Founders, 1885

Rozier, Jules Charles 1821–1882, *The Seine at Carrières Saint-Denis, France*, bequeathed by the Founders, 1885

Rubens, Peter Paul (after) 1577–1640, *Christ with Martha and Mary at Bethany*, bequeathed by the Founders, 1885

Rubens, Peter Paul (copy after) 1577–1640, *Child Seated on a Red Cushion*, bequeathed by the Founders, 1885

Ruelles, Pieter des c.1630–1658, *Landscape with a Castle and a Drawbridge*, bequeathed by the Founders, 1885

Ruisdael, Jacob van (follower of) 1628/1629–1682, *Wooded Landscape with a River*, bequeathed by the Founders, 1885

Ruiz de la Iglesia, Francisco Ignazio (attributed to) 1649–1704, *Marie Louis of Orleans (1662–1689), Queen of Spain*, bequeathed by the Founders, 1885

Russell, John 1745–1806, *The Blind Beggar and His Granddaughter*, bequeathed by Mrs M. S. Gordon through the National Art Collections Fund, 1963

Russian School *Peter the Great (1672–1725)*, bequeathed by the Founders, 1885

Russian School *The Empress Catherine the Great of Russia (1729–1796)*, bequeathed by the Founders, 1885

Ruysdael, Salomon van (style of) c.1602–1670, *View at the Mouth of a River*, bequeathed by the Founders, 1885

Ruysdael, Salomon van (style of) –1670, *View at the Mouth of a River with Shipping*, bequeathed by the Founders, 1885

Sacchi, Andrea (after) 1599–1661, *The Baptism of Christ*, bequeathed by the Founders, 1885

Saeys, Jakob Ferdinand (follower of) 1658–c.1725, *A Palace with a Courtyard and Figures*, bequeathed by the Founders, 1885

Saftleven, Cornelis (attributed to) 1607–1681, *Still Life of Inanimate Objects in a Peasant Interior*,

bequeathed by the Founders, 1885

Saftleven, Cornelis (attributed to) 1607–1681, *The Temptation of St Anthony*, bequeathed by the Founders, 1885

Saftleven, Herman the younger 1609–1685, *View on the Rhine*, bequeathed by the Founders, 1885

Saftleven, Herman the younger 1609–1685, *Mountainous Landscape*, bequeathed by the Founders, 1885

Saftleven, Herman the younger (style of) 1609–1685, *Landscape*, bequeathed by the Founders, 1885

Sánchez Coello, Alonso c.1531–1588, *Catherine of Austria (1507–1578), Queen of Portugal* (copy of Antonis Mor), bequeathed by the Founders, 1885

Sánchez Coello, Alonso (follower of) c.1531–1588, *The Duchess of Lerma*, bequeathed by the Founders, 1885

Sánchez Coello, Alonso (follower of) c.1531–1588, *Portrait of a Boy*, bequeathed by the Founders, 1885

Sánchez Cotán, Juan (circle of) c.1561–1627, *St Joseph Leading the Infant Christ*, bequeathed by the Founders, 1885

Santa Croce, Girolamo da 1480/1485–1556, *The Presentation in the Temple*, bequeathed by the Founders, 1885

Sassetta 1395–1450, *The Miracle of the Holy Sacrament*, bequeathed by the Founders, 1885

Sauvage, Philippe François active 1872, *Girl Making Clothes for a Doll (La robe de la poupée)*, bequeathed by the Founders, 1885

Schäufelein, Hans (style of) c.1480/1485–1538/1540, *Christ Crowned with Thorns*, bequeathed by the Founders, 1885

Scorel, Jan van (school of) 1495–1562, *The Deposition with Donors and Saints*, bequeathed by the Founders, 1885

Sellaer, Vincent (attributed to) c.1500–c.1589, *The Death of Lucretia*, bequeathed by the Founders, 1885

Snayers, Pieter (school of) 1592–1667, *The Battle of Kalloo, 1638*, bequeathed by the Founders, 1885

Snyders, Frans 1579–1657, *A Boar Hunt*, bequeathed by the Founders, 1885

Snyders, Frans (attributed to) 1579–1657, *A Fruit Stall*, bequeathed by the Founders, 1885

Solario, Andrea (after) c.1465–1524, *The Head of the Baptist on a Tazza*, bequeathed by the Founders, 1885

Solario, Andrea (attributed to) c.1465–1524, *St Jerome in the Wilderness*, bequeathed by the Founders, 1885

Solimena, Francesco 1657–1747, *The Birth of the Virgin*, purchased with the assistance of the Victoria and Albert Museum Purchase Grant Fund, 1963

Solis, Francisco de 1629–1684, *Angels Ministering to Christ*,

bequeathed by the Founders, 1885

Solis, Francisco de 1629–1684, *St Mark*, bequeathed by the Founders, 1885

Solis, Francisco de 1629–1684, *St Matthew*, bequeathed by the Founders, 1885

Sorg, Johann Jacob 1743–1821, *Portrait of a Lady*, bequeathed by the Founders, 1885

Sorg, Johann Jacob 1743–1821, *Portrait of an Elderly Lady in a Large Ruched Lace Cap*, bequeathed by the Founders, 1885

Sorg, Johann Jacob (style of) 1743–1821, *Portrait of a Lady*, bequeathed by the Founders, 1885

Soulacroix, Joseph Frédéric Charles 1825–1879, *Madonna and Child in a Landscape*, bequeathed by the Founders, 1885

Spada, Leonello (attributed to) 1576–1622, *Christ Disputing with the Doctors*, bequeathed by the Founders, 1885

Spaendonck, Gerard van (school of) 1746–1822, *Flowers and Fruit*, bequeathed by the Founders, 1885

Spanish School mid-16th C–mid-17th C, *Christ before Pilate*, bequeathed by the Founders, 1885

Spanish School *Portrait of a Lady with a Dog*, bequeathed by the Founders, 1885

Spanish School *Nativity Scene*, bequeathed by the Founders, 1885

Spanish School *St Charles Borromeo in Prayer*, bequeathed by the Founders, 1885

Spanish School *Still Life with a Red Macaw*, bequeathed by the Founders, 1885

Spanish School *A Carmelite Nun with a Crucifix*, bequeathed by the Founders, 1885

Spanish School *A Franciscan Nun with a Crucifix*, bequeathed by the Founders, 1885

Spanish School 17th C, *A Saint*, bequeathed by the Founders, 1885

Spanish School 17th C, *A Saint*, bequeathed by the Founders, 1885

Spanish School 17th C, *A Saint*, bequeathed by the Founders, 1885

Spanish School 17th C, *A Saint*, bequeathed by the Founders, 1885

Spanish School 17th C, *St Bartholomew*, bequeathed by the Founders, 1885

Spanish School 17th C, *St James the Younger*, bequeathed by the Founders, 1885

Spanish School 17th C, *St Peter*, bequeathed by the Founders, 1885

Spanish School 17th C, *St Simon*, bequeathed by the Founders, 1885

Spanish School 17th C, *The Infanta Isabel Clara Eugenia (1566–1633), Governess of The Netherlands*, bequeathed by the Founders, 1885

Spanish School 17th C, *The Infante Carlos von Habsburg (1607–1632), Grand Admiral of Spain*, bequeathed by the Founders, 1885

Spanish School 17th C, *The Presentation of the Chasuble to St*

Ildephonsus, bequeathed by the Founders, 1885

Spanish School mid-17th C-mid-18th C, *The Madonna and Child Giving Rules to St Basil and St Bernard*, bequeathed by the Founders, 1885

Spanish School *The Virgin Mary*, bequeathed by the Founders, 1885

Spanish School *Portrait of a Lady*, bequeathed by the Founders, 1885

Spanish School *Portrait of a Lady*, bequeathed by the Founders, 1885

Spanish School 18th C-19th C, *Charles II (1661–1700), King of Spain*, bequeathed by the Founders, 1885

Spanish School *A Spanish Beggar Boy*, bequeathed by the Founders, 1885

Spanish School 19th C, *The Madonna and Child with Saints*, bequeathed by the Founders, 1885

Speeckaert, Michel Joseph 1748–1838, *Roses with a Bird's Nest*, bequeathed by the Founders, 1885

Spirinx, Louis (after) 1596–1669, *Rooks and Pigeons*, bequeathed by the Founders, 1885

Stanzione, Massimo (copy of) 1585–1656, *The Beheading of St John the Baptist*, bequeathed by the Founders, 1885

Steen, Jan 1626–1679, *Villagers Merrymaking Outside an Inn*, bequeathed by Lady Zetland, 2003

Stella, Jacques 1596–1657, *The Nativity*, bequeathed by the Founders, 1885

Stella, Jacques (circle of) 1596–1657, *Susannah and the Elders*, bequeathed by the Founders, 1885

Stevens, Albert George 1863–1927, *Portrait of a Man*

Stöcklin, Christian 1741–1795, *Interior of a Church with Figures*, bequeathed by the Founders, 1885

Storck, Abraham 1644–1708, *View of Amsterdam, Holland*, bequeathed by the Founders, 1885

Storck, Abraham 1644–1708, *View of Antwerp, Belgium*, bequeathed by the Founders, 1885

Storck, Abraham (follower of) 1644–1708, *Dutch Sea Port with Shipping*, bequeathed by the Founders, 1885

Strozzi, Bernardo (circle of) 1581–1644, *Head of an Apostle*, bequeathed by the Founders, 1885

Subleyras, Pierre Hubert 1699–1749, *Academic Study of a Seated Male Nude*, bequeathed by the Founders, 1885

Subleyras, Pierre Hubert (after) 1699–1749, *A Girl in a Turban*, bequeathed by the Founders, 1885

Subleyras, Pierre Hubert (style of) 1699–1749, *Academic Study of a Standing Male Figure*, bequeathed by the Founders, 1885

Swagers, Frans 1756–1836, *Landscape with a River, Boats, Sheep and a Tower*, bequeathed by the Founders, 1885

Swagers, Frans 1756–1836, *Coast Scene with a Wooded Landscape*, bequeathed by the Founders, 1885

Swagers, Frans 1756–1836, *Landscape*, bequeathed by the Founders, 1885

Swagers, Frans 1756–1836, *Landscape with a River and a Sportsman*, bequeathed by the Founders, 1885

Swagers, Frans 1756–1836, *Landscape with Figures*, bequeathed by the Founders, 1885

Swagers, Frans 1756–1836, *Landscape with River and Sunset*, bequeathed by the Founders, 1885

Swagers, Frans 1756–1836, *Landscape with River, Ships in the Distance*, bequeathed by the Founders, 1885

Swagers, Frans 1756–1836, *Riverside Inn*, bequeathed by the Founders, 1885

Swagers, Frans 1756–1836, *The Mill*, bequeathed by the Founders, 1885

Swagers, Frans (attributed to) 1756–1836, *Landscape*, bequeathed by the Founders, 1885

Swiss School *Portrait of a Swiss Girl in a Black Bonnet*, bequeathed by the Founders, 1885

Tabar, François Germain Léopold 1818–1869, *View on the Grand Canal, Venice, Italy*, bequeathed by the Founders, 1885

Tabar, François Germain Léopold 1818–1869, *A Shipbuilding Yard*, bequeathed by the Founders, 1885

Taillasson, Jean Joseph 1745–1809, *Spring (or Flora) Leading Cupid Back to Nature*, bequeathed by the Founders, 1885

Tanché, Nicolas c.1740–c.1776, *Infant Bacchus and Putti*, bequeathed by the Founders, 1885

Tanneur, Philippe 1795–1878, *Wooded Landscape with Farm Buildings and a Woman Drawing Water*, bequeathed by the Founders, 1885

Tavella, Carlo Antonio 1668–1738, *Snowy Landscape*, bequeathed by the Founders, 1885

Tendran, A. (school of) active 18th C, *Landscape*, bequeathed by the Founders, 1885

Teniers, David I (after) 1582–1649, *Interior, Woman Cleaning Vegetables*, bequeathed by the Founders, 1885

Teniers, David II (circle of) 1610–1690, *Fête champêtre* , bequeathed by the Founders, 1885

Tennick, William George 1847–1913, *Blacksmith's Shop*, donated by Mrs Jesse Atkinson, 1984

Tennick, William George 1847–1913, *Ground Beck, Selaby, County Durham*, donated by Miss Alice Edleston, 1994

Thompson, Mark 1812–1875, *Sheep Walk, Cronkley Crags, Teesdale, County Durham*

Thulden, Theodore van 1606–1669, *Allegory of the Submission of Magdeburg to Frederick William of Brandenburg and of the Birth of Frederick's Son, Ludwig*, bequeathed by the Founders, 1885

Tiepolo, Giovanni Battista 1696–1770, *The Harnessing of the Horses of the Sun*, bequeathed by the Founders, 1885

Titian (copy after) c.1488–1576, *Ecce Homo*, bequeathed by the Founders, 1885

Titian (style of) c.1488–1576, *Portrait of a Man with a Beard*, purchased from Streatlam Castle, 1879

Tocqué, Louis (attributed to) 1696–1772, *Portrait of a Man 'en robe de chambre'*, bequeathed by the Founders, 1885

Touzé, Jacques Louis François (after) 1747–1807, *Panel of Trompe l'Oeil Ornament*, bequeathed by the Founders, 1885

Traversi, Gaspare (attributed to) c.1722–c.1770, *Family Portrait Group*, bequeathed by the Founders, 1885

Treleaven, Richard Barrie b.1920, *'Chaku', First Year Goshawk*, gift from Miss Sandra Grewcock, 1984, © the artist

Treleaven, Richard Barrie b.1920, *Hen 'Merlin' on the Moors*, gift from Miss Sandra Grewcock, 1984, © the artist

Trevisani, Francesco 1656–1746, *Cardinal Pietro Ottoboni (1667–1740)*, bequeathed by the Founders, 1885

Tristán de Escamilla, Luis 1585–1624, *The Martyrdom of St Andrew*, bequeathed by the Founders, 1885

Troyon, Constant (style of) 1810–1865, *Wooded Landscape with Dogs and Dead Game*, bequeathed by the Founders, 1885

Uden, Lucas van 1595–1672, *Ulysses and Nausicaä*, bequeathed by the Founders, 1885

Ughi, F. active 19th C, *Hen*, bequeathed by the Founders, 1885

unknown artist 16th C, *Portrait of a Gentleman*, bequeathed by the Founders, 1885

unknown artist 16th C, *Triptych Wing*, bequeathed by the Founders, 1885

unknown artist 16th C, *Triptych Wing*, bequeathed by the Founders, 1885

unknown artist late 16th C-early 17th C, *Portrait of a Girl in a Grey Dress with a Lace Collar*, bequeathed by the Founders, 1885

unknown artist *Portrait of a Man*, bequeathed by the Founders, 1885

unknown artist *Portrait of a Lady*, bequeathed by the Founders, 1885

unknown artist *A Mill*, bequeathed by the Founders, 1885

unknown artist *Lettice, Baroness of Offaly (c.1580–1588–1653)*, bequeathed by the Founders, 1885 (?)

unknown artist *Portrait of a Gentleman Dressed in Black, Holding a Pen*, bequeathed by the Founders, 1885

unknown artist *Portrait of a Lady Holding an Apple*, bequeathed by the Founders, 1885

unknown artist *Portrait of a Lady*, bequeathed by the Founders, 1885, stolen, 1985

unknown artist *Landscape with a Town on a Hill*, bequeathed by the Founders, 1885

unknown artist *Portrait of a Lady Resting Her Head on Her Hand*, bequeathed by the Founders, 1885

unknown artist early 17th C, *A Basket of Flowers with a Dog Chasing a Bird*, bequeathed by the Founders, 1885

unknown artist early 17th C, *A Basket of Flowers with Birds*, bequeathed by the Founders, 1885

unknown artist 17th C, *Crucifix*, bequeathed by the Founders, 1885

unknown artist 17th C, *Geoffrey Chaucer (c.1343–1400)*, bequeathed by the Founders, 1885

unknown artist 17th C, *Interior Scene*, bequeathed by the Founders, 1885

unknown artist 17th C, *Landscape with a Building*, bequeathed by the Founders, 1885

unknown artist 17th C, *Madonna and Child*, bequeathed by the Founders, 1885

unknown artist 17th C, *Night Scene*, bequeathed by the Founders, 1885

unknown artist 17th C, *Night Scene*, bequeathed by the Founders, 1885

unknown artist 17th C, *Portrait of a Lady*, bequeathed by the Founders, 1885

unknown artist 17th C, *Portrait of a Lady*, bequeathed by the Founders, 1885

unknown artist 17th C, *Portrait of a Lady*, bequeathed by the Founders, 1885

unknown artist 17th C, *Portrait of a Lady*, bequeathed by the Founders, 1885

unknown artist 17th C, *Portrait of a Lady*, bequeathed by the Founders, 1885

unknown artist 17th C, *Portrait of a Lady*, bequeathed by the Founders, 1885

unknown artist 17th C, *Portrait of a Lady* (recto), bequeathed by the Founders, 1885

unknown artist 17th C, *Landcape* (verso), bequeathed by the Founders, 1885

unknown artist 17th C, *Portrait of a Lady*, bequeathed by the Founders, 1885

unknown artist 17th C, *Portrait of a Man*, bequeathed by the Founders, 1885

unknown artist 17th C, *Religious Scene*, bequeathed by the Founders, 1885

unknown artist 17th C, *Street Carnival Scene*, bequeathed by the Founders, 1885

unknown artist 17th C-19th C, *Fragment of Ruff and Neck*, bequeathed by the Founders, 1885

unknown artist late 17th C-early 18th C, *Portrait of a Lady*, bequeathed by the Founders, 1885

unknown artist *Portrait of a Lady*, bequeathed by the Founders, 1885

unknown artist *Portrait of a Lady*, bequeathed by the Founders, 1885

unknown artist *Venus and Cupid (Mother and Child)*, bequeathed by the Founders, 1885

unknown artist *Dead Game*, bequeathed by the Founders, 1885

unknown artist *A Child Dressed as Cupid*, bequeathed by the Founders, 1885

unknown artist *Landscape*, bequeathed by the Founders, 1885

unknown artist *Portrait of a Lady*, bequeathed by the Founders, 1885

unknown artist *Portrait of a Man*, bequeathed by the Founders, 1885

unknown artist *Portrait of a Lady*, bequeathed by the Founders, 1885

unknown artist *Portrait of a Man*, bequeathed by the Founders, 1885

unknown artist *Portrait of a Girl*, bequeathed by the Founders, 1885

unknown artist *Portrait of a Lady*, bequeathed by the Founders, 1885

unknown artist *Fountain near a River*, bequeathed by the Founders, 1885

unknown artist *Fountain near a River*, bequeathed by the Founders, 1885

unknown artist *Portrait of a Lady*, bequeathed by the Founders, 1885

unknown artist *Portrait of a Lady*, bequeathed by the Founders, 1885

unknown artist *Portrait of a Man*, bequeathed by the Founders, 1885

unknown artist *Portrait of a Lady*, bequeathed by the Founders, 1885

unknown artist *Portrait of a Lady*, bequeathed by the Founders, 1885

unknown artist *Portrait of a Lady*, bequeathed by the Founders, 1885

unknown artist *Portrait of a Lady*, bequeathed by the Founders, 1885

unknown artist *Portrait of a Lady*, bequeathed by the Founders, 1885

unknown artist *Portrait of a Girl*, bequeathed by the Founders, 1885

unknown artist *Portrait of a Lady*, bequeathed by the Founders, 1885

unknown artist *Portrait of a Lady*, bequeathed by the Founders, 1885

unknown artist early 18th C, *Portrait of a Lady*, bequeathed by the Founders, 1885

unknown artist early 18th C, *Portrait of a Lady*, bequeathed by the Founders, 1885

unknown artist early 18th C, *Portrait of a Lady in Red with a Lace Cap*, bequeathed by the Founders, 1885

unknown artist early 18th C, *Woman and Child*, bequeathed by the Founders, 1885

unknown artist 18th C, *A Man on Horseback*, bequeathed by the Founders, 1885

unknown artist 18th C, *A Seaport with Ruins and an English Ship*, bequeathed by the Founders, 1885

unknown artist 18th C, *A Storm*, bequeathed by the Founders, 1885

unknown artist 18th C, *A Wooded Coastal Scene*, bequeathed by the

Founders, 1885

unknown artist 18th C, *A Youth in Blue and White Dress with a Hawk and a Hunting Spear*, bequeathed by the Founders, 1885

unknown artist 18th C, *A Young Girl in a Blue and White Dress with a Yellow Scarf*, bequeathed by the Founders, 1885

unknown artist 18th C, *Church Interior*, bequeathed by the Founders, 1885

unknown artist 18th C, *Cupid Blindfolded Carrying a Sword and Scales*, bequeathed by the Founders, 1885

unknown artist 18th C, *Diana and Her Companions in a Landscape*, bequeathed by the Founders, 1885

unknown artist 18th C, *Flower Piece*, bequeathed by the Founders, 1885

unknown artist 18th C, *Interior Scene*, bequeathed by the Founders, 1885

unknown artist 18th C, *Jacob Christian Schäffer (1718–1790)*, bequeathed by the Founders, 1885

unknown artist 18th C, *Landscape*, bequeathed by the Founders, 1885

unknown artist 18th C, *Landscape*, bequeathed by the Founders, 1885

unknown artist 18th C, *Landscape*, bequeathed by the Founders, 1885

unknown artist 18th C, *Landscape*, bequeathed by the Founders, 1885

unknown artist 18th C, *Landscape*, bequeathed by the Founders, 1885

unknown artist 18th C, *Landscape*, bequeathed by the Founders, 1885

unknown artist 18th C, *Landscape*, bequeathed by the Founders, 1885

unknown artist 18th C, *Landscape* (one of a series representing different times of the day), bequeathed by the Founders, 1885

unknown artist 18th C, *Landscape* (one of a series representing different times of the day), bequeathed by the Founders, 1885

unknown artist 18th C, *Landscape* (one of a series representing different times of the day), bequeathed by the Founders, 1885

unknown artist 18th C, *Landscape* (one of a series representing different times of the day), bequeathed by the Founders, 1885

unknown artist 18th C, *Landscape with Palm Trees and Chinese Figures*, bequeathed by the Founders, 1885

unknown artist 18th C, *Margaret Melbourne*, donated by Colonel Raper, 1954

unknown artist 18th C, *Mater Dolorosa*, bequeathed by the Founders, 1885

unknown artist 18th C, *Mythological Scene*, bequeathed by the Founders, 1885

unknown artist 18th C, *Nude*

Female Bust, bequeathed by the Founders, 1885

unknown artist 18th C, *Portrait of a Boy*, bequeathed by the Founders, 1885

unknown artist 18th C, *Portrait of a Lady*, bequeathed by the Founders, 1885

unknown artist 18th C, *Portrait of a Lady*, bequeathed by the Founders, 1885

unknown artist 18th C, *Portrait of a Lady*, bequeathed by the Founders, 1885

unknown artist 18th C, *Portrait of a Lady*, bequeathed by the Founders, 1885

unknown artist 18th C, *Portrait of a Lady*, bequeathed by the Founders, 1885

unknown artist 18th C, *Portrait of a Lady*, bequeathed by the Founders, 1885

unknown artist 18th C, *Portrait of a Lady*, bequeathed by the Founders, 1885

unknown artist 18th C, *Portrait of a Man*, bequeathed by the Founders, 1885

unknown artist 18th C, *Portrait of a Man*, bequeathed by the Founders, 1885

unknown artist 18th C, *Portrait of a Man*, bequeathed by the Founders, 1885

unknown artist 18th C, *Ship Sinking*, bequeathed by the Founders, 1885

unknown artist 18th C, *The Dead Christ*, bequeathed by the Founders, 1885

unknown artist 18th C, *The Infant Christ Giving Emblems of the Passion to Carmelite Saints*, bequeathed by the Founders, 1885

unknown artist 18th C–19th C, *Fragment of a Study of a Female Hand Holding a Brush*, bequeathed by the Founders, 1885

unknown artist 18th C–19th C, *Portrait of a Boy*, bequeathed by the Founders, 1885

unknown artist 18th C–19th C, *The Virgin and Child*, bequeathed by the Founders, 1885

unknown artist late 18th C, *Portrait of a Gentleman*, donated by Colonel Raper, 1954

unknown artist late 18th C–early 19th C, *Portrait of a Lady*, bequeathed by the Founders, 1885

unknown artist late 18th C–early 19th C, *The Martyrdom of St John the Baptist*, bequeathed by the Founders, 1885

unknown artist *Tarquin and Lucretia*, bequeathed by the Founders, 1885

unknown artist *Portrait of a Lady*, bequeathed by the Founders, 1885

unknown artist *Startforth Old Church before Restoration, Barnard Castle, County Durham*, donated by James Howlett, 1962

unknown artist early 19th C, *Landscape with Figures and Horses*, bequeathed by the Founders, 1885

unknown artist early 19th C,

Portrait of a Lady, bequeathed by the Founders, 1885

unknown artist early 19th C, *Portrait of an Elderly Lady in Black with a White Cap*, bequeathed by the Founders, 1885

unknown artist early 19th C, *Sketch of a Woman and Children*, bequeathed by the Founders, 1885

unknown artist 19th C, *A Pair of Female Grouse*, donated by Miss Sandra Grewcock, 1984

unknown artist 19th C, *A White Dog*, bequeathed by the Founders, 1885

unknown artist 19th C, *Catherine Stephens (1794–1882), Later Countess of Essex*

unknown artist 19th C, *Elizabeth Hodgson (d.1859), Breckamore*

unknown artist 19th C, *Horses Standing in a Mews*, bequeathed by the Founders, 1885

unknown artist 19th C, *Hunting Scene*, donated by Miss Sandra Grewcock, 1984

unknown artist 19th C, *Hunting Scene*, donated by Miss Sandra Grewcock, 1984

unknown artist 19th C, *Hunting Scene*, donated by Miss Sandra Grewcock, 1984

unknown artist 19th C, *John Lambton (1792–1840), 1st Earl of Durham, MP for County Durham*

unknown artist 19th C, *John Walker*, donated by Mrs E. Simmons, 1974

unknown artist 19th C, *Landscape*, bequeathed by the Founders, 1885

unknown artist 19th C, *Landscape with a Castle, Lake and Two Figures on a Path*, bequeathed by the Founders, 1885

unknown artist 19th C, *Landscape with a Figure and a Stream*, bequeathed by the Founders, 1885

unknown artist 19th C, *Lord Herbert Vane Stewart*, donated by C. R. Hudleston, 1954

unknown artist 19th C, *Portrait of a Dog*, bequeathed by the Founders, 1885

unknown artist 19th C, *Portrait of a Dog*, bequeathed by the Founders, 1885

unknown artist 19th C, *Portrait of a Lady*, bequeathed by the Founders, 1885

unknown artist 19th C, *Portrait of a Lady*, bequeathed by the Founders, 1885

unknown artist 19th C, *Portrait of a Lady*, bequeathed by the Founders, 1885

unknown artist 19th C, *Portrait of a Lady*, bequeathed by the Founders, 1885

unknown artist 19th C, *Portrait of a Lady with a Fan*, bequeathed by the Founders, 1885

unknown artist 19th C, *Portrait of a Man*

unknown artist 19th C, *Portrait of a Man in Classical Robes*, bequeathed by the Founders, 1885

unknown artist 19th C, *Portrait of a Woman in a Blue Dress and a*

White Cap, bequeathed by the Founders, 1885

unknown artist 19th C, *Profile of a Roman Soldier*, bequeathed by the Founders, 1885

unknown artist 19th C, *Racing Plate of 'Daniel O'Rourke'*, gift from Miss F. M. Young

unknown artist 19th C, *Racing Plate of 'West Australian'*, gift from Miss F. M. Young

unknown artist 19th C, *Seascape*

unknown artist 19th C, *Still Life*, bequeathed by the Founders, 1885

unknown artist 19th C, *Still Life with a Dog*, bequeathed by the Founders, 1885

unknown artist 19th C, *Still Life with a Dog and a Cat*, bequeathed by the Founders, 1885

unknown artist 19th C, *Still Life with a Green-Headed Duck*, bequeathed by the Founders, 1885

unknown artist 19th C, *Still Life with a Hen*, bequeathed by the Founders, 1885

unknown artist 19th C, *The Deposition from the Cross*, bequeathed by the Founders, 1885

unknown artist 19th C, *The Lakeland Shepherd*

unknown artist 19th C, *The Madonna and Child*, bequeathed by the Founders, 1885

unknown artist 19th C, *Thomas Dixon*, gift from the executors the estate of the late Mr J. E. Dent, 1961

unknown artist 19th C, *View through a Doorway*, bequeathed by the Founders, 1885

unknown artist 19th C, *William Blackett of Wolsingham*, bequeathed by the Founders, 1885

unknown artist 19th C–20th C, *Barnard Castle Bridge, County Durham*

unknown artist 20th C, *Balder Mill, Teesdale, County Durham*

unknown artist 20th C, *Moorland Scene with Stream*, gift from Miss Sandra Grewcock, 1984

unknown artist *Icon*, bequeathed by the Founders, 1885

unknown artist *Melon*, bequeathed by the Founders, 1885

Utrecht, Adriaen van 1599–1652, *Still Life with Lovers*, bequeathed by the Founders, 1885

E. V. *Study of an Old Man*, bequeathed by the Founders, 1885

E. V. *A Woman Polishing Kitchen Utensils*, bequeathed by the Founders, 1885

Vaccaro, Andrea 1604–1670, *The Infant Christ with the Infant St John the Baptist*, bequeathed by the Founders, 1885

Vadder, Lodewijk de 1605–1655, *Wooded Landscape with Figures in a Ravine*, bequeathed by the Founders, 1885

Vaillant, Wallerand (after) 1623–1677, *Marie Marion del Court (1634–1702)*, donated by Reverend Bouquet, 1952

Valdés Leal, Juan de 1622–1690, *St Eustochium*, bequeathed by the

Founders, 1885

Valenciennes, Pierre Henri de 1750–1819, *Mercury and Argus*, bequeathed by the Founders, 1885

Valenciennes, Pierre Henri de 1750–1819, *Landscape, Moonlight*, bequeathed by the Founders, 1885

Valenciennes, Pierre Henri de 1750–1819, *Landscape, Storm*, bequeathed by the Founders, 1885

Valenciennes, Pierre Henri de 1750–1819, *Landscape with a Man Frightened by a Snake*, bequeathed by the Founders, 1885

Valenciennes, Pierre Henri de 1750–1819, *Landscape with Ruins, Sunset*, bequeathed by the Founders, 1885

Valentin active mid-19th C, *Girl Disrobing*, bequeathed by the Founders, 1885

Valentini, Pietro (style of) active 17th C, *Gypsies*, bequeathed by the Founders, 1885

Vallayer-Coster, Anne 1744–1818, *Portrait of an Elderly Woman with Her Daughter*, bequeathed by the Founders, 1885

Vallin, Jacques Antoine c.1760–after 1831, *Half-Length Figure of a Bacchante*, bequeathed by the Founders, 1885

Vallin, Jacques Antoine c.1760–after 1831, *Madamme Bigottini (1785–1858), as a Bacchante*, bequeathed by the Founders, 1885

Vallin, Jacques Antoine c.1760–after 1831, *Nymphs Dancing with a Faun*, bequeathed by the Founders, 1885, stolen

Vaudet, Auguste Alfred 1838–1914, *Landscape with a Lake, Evening*, bequeathed by the Founders, 1885

Velde, Adriaen van de (style of) 1636–1672, *Landscape with Cattle and Sheep*, bequeathed by the Founders, 1885

Velde, Willem van de II (school of) 1633–1707, *A Warship and Other Vessels*, bequeathed by the Founders, 1885

Venne, Adriaen van de (attributed to) 1589–1662, *Death with the Three Orders of Church, State and People*, bequeathed by the Founders, 1885

Venusti, Marcello (attributed to) c.1512–1579, *Time with Four Putti Representing the Seasons*, bequeathed by the Founders, 1885

Verbeeck, Cornelis c.1590–c.1637, *Beach Scene*, bequeathed by the Founders, 1885

Verdussen, Jan Peeter c.1700–1763, *A Cavalry Engagement*, bequeathed by the Founders, 1885

Verelst, Herman c.1642–1702, *Virgin, Child and St John*, bequeathed by the Founders, 1885

Verelst, Herman (circle of) c.1642–1702, *Portrait of a Lady*, bequeathed by the Founders, 1885

Verelst, Pieter Harmensz. c.1618–c.1678, *Boors Carousing*, bequeathed by the Founders, 1885

Vermeer van Haarlem, Jan I (style of) c.1600–1670, *Evening*,

bequeathed by the Founders, 1885

Vermeer van Haarlem, Jan III 1656–1705, *Landscape with a River*, bequeathed by the Founders, 1885

Vernet, Claude-Joseph 1714–1789, *Nymphs Bathing, the Time is the Morning*, bequeathed by the Founders, 1885

Vernet, Claude-Joseph (style of) 1714–1789, *View of a Fortified Seaport*, bequeathed by the Founders, 1885

Veron, Alexandre René 1826–1897, *Paris, the Outlying Boulevards*, bequeathed by the Founders, 1885

Verwee, Charles Louis 1818–1882, *A Nun*, bequeathed by the Founders, 1885

Vestier, Antoine 1740–1824, *The Wife of the Composer Christoph Willibald Gluck* (copy after Étienne Aubry), bequeathed by the Founders, 1885

Veyrassat, Jules Jacques 1828–1893, *Interior with an Old Woman Eating Soup*, bequeathed by the Founders, 1885

Vignon, Claude 1593–1670, *Croesus and Solon*, bequeathed by the Founders, 1885

Vignon, Jules de 1815–1885, *The Emperor Napoleon III (1808–1873)* (copy after Franz Xaver Winterhalter), donated by Miss Edleston, 1954

Vilain, Philip active 1694–1717, *Girl with a Dog*, bequeathed by the Founders, 1885

Vincenzo da Pavia c.1495/1500–1557, *The Adoration of the Magi with a Donor*, bequeathed by the Founders, 1885

Vinckeboons, David 1576–1632, *Joanna of Flanders Freeing Prisoners*, bequeathed by the Founders, 1885

Viola, Giovanni Battista 1576–1622, *Landscape with Figures*, bequeathed by the Founders, 1885

Viola, Giovanni Battista 1576–1622, *A Seashore with a Castle*, bequeathed by the Founders, 1885

Vita, Vincenzo d.1782, *A Musical Party*, bequeathed by the Founders, 1885

Vlieger, Simon de 1601–1653, *Dutch Men of War at Anchor*, bequeathed by the Founders, 1885

Vogler, F. *Genre Scene*, bequeathed by the Founders, 1885

Vogler, F. *Genre Scene*, bequeathed by the Founders, 1885

Vogler, F. *Genre Scene*, bequeathed by the Founders, 1885

Vogler, F. *Genre Scene*, bequeathed by the Founders, 1885

Voille, Jean Louis 1744–c.1796, *A Lady with a Book*, bequeathed by the Founders, 1885

Voiriot, Guillaume 1713–1799, *Caillaud (1732/1733–1816), the Singer, in Costume for the Opera 'Les chasseurs et la laitière'*, bequeathed by the Founders, 1885

Vollevens, Johannes II 1685–1758, *A Lady with a Dog*, bequeathed by the Founders, 1885

Vollon, Antoine 1833–1900, *Old Houses*, bequeathed by the Founders, 1885

Voorhout, Johannes 1647–1723, *Portrait of a Gentleman*, bequeathed by the Founders, 1885

Vos, Maarten de (attributed to) 1532–1603, *The Death of St Anthony Abbot*, bequeathed by the Founders, 1885

Vos, Maarten de (style of) 1532–1603, *Peasants with a Man Dancing*, bequeathed by the Founders, 1885

Vos, Maarten de (after) 1532–1603 & **Sadeler family** active 16th C-17th C *St Paul the Hermit in the Desert*, bequeathed by the Founders, 1885

Vries, Roelof van (attributed to) c.1631–after 1681, *Landscape with Ruins and a River*, bequeathed by the Founders, 1885

G. W. *Still Life*

Watteau, François Louis Joseph (attributed to) 1758–1823, *An Assemblage of Monkeys in a Park Dressed as Humans*, bequeathed by the Founders, 1885

Watteau, Louis Joseph 1731–1798, *Venus Chastising Cupid*, bequeathed by the Founders, 1885

Watts, George Frederick 1817–1904, *Harry George (1803–1891), 4th Duke of Cleveland*, donated by Miss Kay Drummond, 1935

Willaerts, Adam 1577–1664, *An Embarkation Scene*, bequeathed by the Founders, 1885

Willaerts, Adam (attributed to) 1577–1664, *Christ Preaching from a Ship on the Sea of Galilee*, bequeathed by the Founders, 1885

Wilson, Richard 1714–1787, *River Scene with a Farmhouse*, presented by the National Art Collections Fund, 1955

Wilson, Thomas Fairbairn (attributed to) 1776–1847, *Sheep in a Sale Pen*, donated by the Trustees of the late Miss Neasham, 1938

Winghe, Joos van (copy of) 1544–1603, *Solomon Surrounded by His Wives*, bequeathed by the Founders, 1885

Wouwerman, Philips (imitator of) 1619–1668, *A Seashore with Figures and Horses*, bequeathed by the Founders, 1885

Wyck, Jan (style of) c.1640–1700, *Hunting Scene*, bequeathed by the Founders, 1885

Ziem, Félix François Georges Philibert 1821–1911, *A Windmill, Snow Effect*, bequeathed by the Founders, 1885

Zucchi, Antonio (attributed to) 1726–1796, *Autumn*, purchased, 1975

Zucchi, Antonio (attributed to) 1726–1796, *Spring*, purchased, 1975

Zucchi, Antonio (attributed to) 1726–1796, *Summer*, purchased, 1975

Zurbarán, Francisco de (school of) 1598–1664, *St Peter of Alcántara*, bequeathed by the Founders, 1885

Beamish, The North of England Open Air Museum

N. B. *Cats in a Basket*

N. B. *Dogs in a Basket*

Bateman, Norman active 1926–1928, *A Rest on the Way*, gift from an anonymous donor, 1984

Bateman, Norman active 1926–1928, *Sunset on the Highlands*, gift from an anonymous donor, 1984

Bowes, J. *A Cobbler at Work*, gift from an anonymous donor, 2001

Bradley, Norman active 1906–1914, *The Braes of Balquhidder, Lochearnhead, Scotland*, donated by Mr W. B. Bowron, 1968

Bradley, Norman active 1906–1914, *At the Close of Day*, donated by Mr W. B. Bowron, 1968

Cooper, Herbert 1911–1979, *Beehive Coke Ovens*, donated by the artist, 1979

Cuitt, George the elder (style of) 1743–1818, *Teesdale Ox*, purchased with the assistance of the PRISM grant fund, 2001

Dalby, John 1810–1865, *'Duke of Northumberland' (A Bull)*, donated by Mr Baites, 1981

Dousa, Henry 1820–after 1891, *The Stallion 'Hewson'*, donated by Mrs Kerr, 1980

Duval, John 1816–1892, *Prize Pigs*, purchased, 1990

Duval, John 1816–1892, *Suffolk Punch*, purchased, 1990

Finn, R. *Tug Boat 'Fulwell'*, donated by Mr John Watson, 2002

Galloway, S. *East Hetton Disaster, 6 May 1897*, donated by Mrs E. Foster, 1973

Garrard, George 1760–1826, *A Durham Ox*, donated by Mr Howden, 1988

Garrard, George 1760–1826, *'Juno'*, donated by Mr Howden, 1988

Harrogate, Davey active late 19th C, *Mrs Elizabeth Murray, née Seymour*, donated by the Durham Cheshire Home, 1992

Harrogate, Davey active late 19th C, *Richard Murray (b.1839), JP, Director of the Neptune Steam Navigation Company*, donated by the Durham Cheshire Home, 1992

Hedley, Ralph (copy after) 1848–1913, *Geordie Haa'd the Bairn*, purchased, 1994

Hood, D. active c.1900–1921, *Cottage near the 'Rose and Crown'*, donated by Janet Ather, 2000

Hood, D. active c.1900–1921, *Whickham Church, County Durham*, donated by Mrs Wilson, 2001

Hood, D. active c.1900–1921, *Lang Jack's House, Whickham, County Durham*, donated by Mrs Wilson, 2001

Hood, D. active c.1900–1921, *Pennyfine Road, Sunniside*, donated

by Janet Ather, 2000

Hudson, Willis Richard Edwin 1862–1936, *Bridlington Quay, East Yorkshire*, donated by Miss Wilson, 1968

Jolly, J. active 1976–1985, *The Big Meeting, Durham Cathedral*, donated by the artist, 1985

Lennox, E. *A British Soldier Attending to His Wounds in South Africa*, purchased from Jane Dodds Antiques, 1978

Linton, Jane active 1999, *Taylor's Farm, Beamish, County Durham*, on loan from a private lender

Longbottom, Sheldon 1856–after 1901, *Old Gentleman with a Jack Russell Leaving an Off-Licence*, donated, 1965

Mackenzie, James b.1927, *Back Canch Man, Bedlington 'A' Pit*, donated by the artist, 1993, © the artist

Mackenzie, James b.1927, *Back to Stables, Bedlington 'A' Pit*, donated by the artist, 1993, © the artist

Mackenzie, James b.1927, *Barrington Colliery*, donated by the artist, 1993, © the artist

Mackenzie, James b.1927, *Barrington Colliery School*, donated by the artist, 1993, © the artist

Mackenzie, James b.1927, *Bedlington 'A' Pit, Plessey Seam*, donated by the artist, 1993, © the artist

Mackenzie, James b.1927, *Bill's Been Hurt*, donated by the artist, 1993, © the artist

Mackenzie, James b.1927, *Breaking in the Riding Cob, Barrington Stables*, donated by the artist, 1993, © the artist

Mackenzie, James b.1927, *Calling the Weigh*, donated by the artist, 1993, © the artist

Mackenzie, James b.1927, *Choppington Flower Show, £50 Professional Handicap Race*, donated by the artist, 1993, © the artist

Mackenzie, James b.1927, *Down the Barrington Burn*, donated by the artist, 1993, © the artist

Mackenzie, James b.1927, *End of Shift, Bathing at 19 Alexandra Road*, donated by the artist, 1993, © the artist

Mackenzie, James b.1927, *Filler, Bedlington 'A' Pit, Harvey Seam*, donated by the artist, 1993, © the artist

Mackenzie, James b.1927, *Howicking Preparing Leeks on Show Day, Alexandra Road, Barrington*, donated by the artist, 1993, © the artist

Mackenzie, James b.1927, *Jack Arkle at the Pigeons, Alexandra Road, Barrington*, donated by the artist, 1993, © the artist

Mackenzie, James b.1927, *Miner's Still Life*, donated by the artist, 1993, © the artist

Mackenzie, James b.1927, *Paddy Gets a Rabbit*, donated by the artist, 1993, © the artist

Mackenzie, James b.1927, *The

Busty Kip Collecting Jockies and Pushing around to the Shaft*, donated by the artist, 1993, © the artist

Mackenzie, James b.1927, *Washing Day*, donated by the artist, 1993, © the artist

Mackenzie, James b.1927, *'You Haven't Lost Your Touch Bill'*, donated by the artist, 1993, © the artist

Marsden, M. *Shorthorn*, anonymous donation, 1991

Matthewson, M. *Lang Jack's House*, donated by Mrs A. Mallam, 1972

Matthewson, M. *Winlaton Mill, County Durham*, donated by Mrs A. Mallam, 1972

Mills, S. *Country Scene with River*, gift from an anonymous donor, 1984

Mills, S. *Country Scene with River*, gift from an anonymous donor, 1984

Mitchell, R. J. *Victorian London Street Scene*, donated by P. D. Dempsey, 1999

Norman-Crosse, George c.1871–1912, *Ayresome Ironworks, Middlesbrough, Tees Valley*, donated by Mr Jack Crabtree, 1980

Oughton, Francis *Thomas Ramsay ('Craky Tommy')*, donated by Elona and Peter Rogers, 1999

Parker, Henry Perlee (copy after) 1795–1873, *Quoit Players*

Phillip, John 1817–1867, *Portrait of an Unknown Lady*, donated by Mrs C. Hunter, 1971

Reid, C. *The Tanfield Ploughman*, donated by John Gall, 1979

Richardson, A. W. *Lady with a Book*, purchased, 1990

Robinson, R. *Bath Night*, donated by Mrs McSherry, 1988

Rutherford, W. *Arab*, gift from an anonymous donor, 2003

Speight, B. *Forest Scene*, donated by the Trustees of the Bell-Knight Collection, 2002

Stephenson, Charles W. b.c.1900, *Gateway to Greencroft Hall, near Stanley, County Durham*, donated by Iris Parker, 1999

Stuart, C. *Highland Scene with Stag*, donated by Miss Wilson, 1968

Thirby, F. *'Highland Laddie'*, donated by Owen Ashguis, 1993

Thornfield, Fred active 1892–1893, *Still Life*, donated by Mr F. W. Bickerton, 1997

Thornfield, Fred active 1892–1893, *Still Life with a Dark Blue Vase*, donated by Mr F. W. Bickerton, 1997

unknown artist 17th C/18th C, *Portrait of an Unknown Man*, acquired from an anonymous donor, 2001

unknown artist *Portrait of an Unknown Lady*, purchased, 1995

unknown artist *Early Days of the Steam Train (Effects of the Railroad on the Brute Creation)*, purchased, 1994

unknown artist *Tom Sayers*, purchased by the Friends of Beamish, 1993

unknown artist *Portrait of an Unknown Gentleman with a Scroll in His Hand*, donated (?) by Mr Lisle, 1979

unknown artist *Portrait of an Unknown Man*, donated by Mr Leo Murray, General Secretary, and Mr Sidney Keir, Treasurer, of the Durham Miners' Permanent Relief Fund, 1995

unknown artist *Mountain Scene with a Broken Ring of Rocks*, donated by Mr Atkinson, 1971

unknown artist *Mountain Scene with a Ring of Rocks and a Tree*, donated by Mr Atkinson, 1971

unknown artist *Portrait of an Unknown Man*, donated by Mr John Goddard, 1990

unknown artist *Tanfield Village, County Durham*, donated by the Clerk of the Council, Stanley, County Durham, 1972

unknown artist *Farmhouse and Farmyard*, donated by Andy Guy, 1992

unknown artist *Mary Alice Oliver with Her Dog*, donated by Miss Bell, 1987

unknown artist *A Horse*, donated by Mr J. Naylor, 1972

unknown artist *An Old Time Miner*, donated by W. Pearse, Clerk of Spennymoor Urban District Council, 1965

unknown artist *Ballet Dancers*, donated by Christopher Bell Knight, 2002

unknown artist *Bridge with River Below*, gift from an anonymous donor, 1978

unknown artist *Cattle by a River*, donated by Mr Atkinson, 1971

unknown artist *Colliery by Moonlight*, donated by Mrs Elizabeth Dodds, 2008

unknown artist *Cottage Scene*, gift from an anonymous donor, 2003

unknown artist *Country Scene with a Woodland Path Leading to the Sea*, donated by Mr Atkinson, 1971

unknown artist *Durham Cathedral*, donated by Mrs Lillie Lewis, 1970

unknown artist *Flour Mill*, acquired from an anonymous donor, 2003

unknown artist *Horse Working in a Harness*, purchased, 1993

unknown artist *House and a River*, donated by Mr and Mrs E. Hunter, 1971

unknown artist *Joseph Pease*, donated by Barclays Bank, 1998

unknown artist *Man and Woman Shoemakers*, transferred from the Darlington Museum Collection, 1999

unknown artist *Man Drinking*, donated by John Spencer, 2007

unknown artist *Man on a Donkey Leading a Stallion*, purchased, 1997

unknown artist *Mother and Child Reading from a Book*

unknown artist *Mythological Figures*, donated by Sir Hedworth Williamson, 1970

unknown artist *Mythological Figures*, donated by Sir Hedworth Williamson, 1970

unknown artist *Old Gentleman Standing with a Greyhound*, acquired from an anonymous donor, 1980

unknown artist *Portrait of an Unknown Man*, donated by Miss H. Lomax, 2001

unknown artist *Portrait of an Unknown Woman in a Bonnet*, gift from an anonymous donor, 2001

unknown artist *Profile of a Small Boy*, donated by Mrs E. Blyth, 1974

unknown artist *Profile of a Small Girl*, donated by Mrs E. Blyth, 1974

unknown artist *Religious*, donated by Mrs Hodgson, 1972

unknown artist *Seascape*, donated by Miss D. Butterfield, 1992

unknown artist *Seaside Scene*, donated by Mr Armstrong, 1971

unknown artist *Seaton Delaval Colliery*, donated by Dr T. Yellowley, 1998

unknown artist *Sewing Group*, donated by the Village Antique Centre, Weedon, 1991

unknown artist *Soldier with a Young Woman*, transferred from the Darlington Museum Collection, 1999

unknown artist *William Woods*, donated by Barclays Bank, 1996

unknown artist *Young Boy with a Bow Tie and a Cap*, donated by Mrs M. A. Gatiss, 1988

unknown artist *Young Girl in a Red Dress*, transferred from the Darlington Museum Collection, 1999

Walker, Miranda (attributed to) *Samphire Gatherer*, donated by Miss C. Pittison, 1967

Weaver, Thomas 1774–1843, *'Comet'*, donated by Mr Howden, 1988

Weaver, Thomas 1774–1843, *'Wildair'*, donated by Mr Howden, 1988

Wilson, Lawrence *Cock o' the North on the Forth Bridge*, acquired from an anonymous donor, 1979

Wilson, Thomas Fairbairn 1776–1847, *Collings Sheep*, on loan from a private lender

Wilson, Thomas Fairbairn 1776–1847, *Houghton Ox*, donated by Mr Howden, 1988

Wylie *Euphemia Douglas (1840–1925)*, donated by Miss M. L. Ross (daughter of the sitter), 1961

Young, R. T. active 1908–1909, *Boat Offshore*, donated by Mrs Pearl Alderson, 1995

Young, R. T. active 1908–1909, *Ships at Anchor*, donated by Mrs Pearl Alderson, 1995

Young, Robert *Philadelphia, County Durham*, donated by Mrs Bulmer, 1986

Zampighi, Eugenio 1859–1944, *Elderly Couple Reading*, donated by Mrs Anne Wood, 1991

Auckland Castle

Bruce, George J. D. b.1930, *David Jenkins (b.1925), Bishop of Durham (1984–1994)*, © the artist

Dandini, Vincenzo (attributed to) 1686–1734, *The Wedding Feast at Cana in Galilee* (copy after Paolo Veronese)

Fayram, William (attributed to) active c.1730, *Joseph Butler (1692–1752), Bishop of Durham (1750–1752)*

Fox, Buscall c.1819–1887, *Thomas Morton (1564–1659), Bishop of Durham (1632–1659)* (copy after an earlier painting)

Fox, Buscall c.1819–1887, *Richard Neile (1562–1640), Bishop of Durham (1617–1628)* (copy after an earlier painting)

Giorgione (circle of) 1477–1510, *The Judgement of Solomon*

Kneller, Godfrey (attributed to) 1646–1723, *Nathaniel, Lord Crewe (1633–1721), Bishop of Durham (1674–1721)*

Lawrence, Thomas 1769–1830, *Shute Barrington (1734–1826), Bishop of Durham (1791–1826)*

Lawrence, Thomas 1769–1830, *William Van Mildert (1765–1836), Bishop of Durham (1826–1836)*

Noakes, Michael b.1933, *Michael Turnbull (b.1935), Bishop of Durham (1994–2003)*, © the artist

Pond, Arthur 1701–1758, *Benjamin XII* (copy after Francisco de Zurbarán), commissioned by Bishop Trevor, 1756

Powell, Hugh *John Habgood (b.1927), Bishop of Durham (1973–1983)*

C. R. *Michael Ramsey (1904–1988), Bishop of Durham (1952–1956)*

Richmond, George 1809–1896, *Charles Longley (1794–1868), Bishop of Durham (1856–1860)*

Richmond, William Blake 1842–1921, *Joseph Lightfoot (1828–1889), Bishop of Durham (1879–1889)*

Richmond, William Blake 1842–1921, *Brooke Westcott (1825–1901), Bishop of Durham (1890–1901)*

Riviere, Hugh Goldwin 1869–1956, *Handley Moule (1841–1920), Bishop of Durham (1901–1920)*, © the artist's estate

Speake, George active 1966–1976, *Ian Ramsey (1915–1972), Bishop of Durham (1966–1972)*

Speed, Harold 1872–1957, *Hensley Henson (1863–1947), Bishop of Durham (1920–1939)*, presented to his Lordship by the Diocese, 1929

Taylor (of Durham) active 1750–1752, *Joseph Butler (1692–1752), Bishop of Durham (1750–1752)*

unknown artist *William James (1542–1617), Bishop of Durham (1606–1617)*

unknown artist *George Monteigne, Bishop of Durham (1627–1628)*

unknown artist *John Howson (d.1632), Bishop of Durham (1628–1632)*

unknown artist *John Cosin (1594–1672), Bishop of Durham (1660–1672)*

unknown artist *Auckland Castle*

unknown artist *Auckland Castle, View from the South East*

unknown artist *Alwyn Williams (1888–1968), Bishop of Durham (1939–1952)*

unknown artist *Charles Baring (1807–1879), Bishop of Durham (1861–1879)*

unknown artist *Cuthbert Tunstall (1474–1559), Bishop of Durham (1530–1559)*

unknown artist *Devotional Painting*

unknown artist *Edward Chandler (1668–1750), Bishop of Durham (1730–1750)*

unknown artist *John Egerton (1721–1787), Bishop of Durham (1771–1787)*

unknown artist *Mathew Hutton (1529–1606), Bishop of Durham (1589–1595)*

unknown artist *Maurice Harland (1896–1986), Bishop of Durham (1956–1966)*

unknown artist *Montagne Villiers (1813–1861), Bishop of Durham (1860–1861)*

unknown artist *Nathaniel, Lord Crewe (1633–1721), Bishop of Durham (1674–1721)*

unknown artist *Richard Fox (c.1448–1528), Bishop of Durham (1494–1501)*

unknown artist *Richard Trevor (1707–1771), Bishop of Durham (1752–1771)*

unknown artist *Thomas Wolsey (1473–1530), Bishop of Durham (1523–1529)*

unknown artist *Tobias Matthew (1546–1628), Bishop of Durham (1595–1606)*

unknown artist *William Talbot (1658–1730), Bishop of Durham (1721–1730)*

Vanderbank, John c.1694–1739, *Joseph Butler (1692–1752), Bishop of Durham (1750–1752)*

Wolfaerts, Artus (attributed to) 1581–1641, *St John*

Wolfaerts, Artus (attributed to) 1581–1641, *St Luke*

Wolfaerts, Artus (attributed to) 1581–1641, *St Mark*

Wolfaerts, Artus (attributed to) 1581–1641, *St Matthew*

Zurbarán, Francisco de 1598–1664, *Asher VIIII*, purchased by Bishop Trevor, 1756

Zurbarán, Francisco de 1598–1664, *Dan VII*, purchased by Bishop Trevor, 1756

Zurbarán, Francisco de 1598–1664, *Gad VIII*, purchased by Bishop Trevor, 1756

Zurbarán, Francisco de 1598–1664, *Issachar VI*, purchased by Bishop Trevor, 1756

Zurbarán, Francisco de 1598–1664, *Jacob*, purchased by Bishop Trevor, 1756

Zurbarán, Francisco de 1598–1664, *Joseph XI*, purchased by Bishop Trevor, 1756

Zurbarán, Francisco de 1598–1664, *Judah IIII*, purchased by Bishop Trevor, 1756

Zurbarán, Francisco de 1598–1664, *Levi III*, purchased by Bishop Trevor, 1756

Zurbarán, Francisco de 1598–1664, *Naphtali X*, purchased by Bishop Trevor, 1756

Zurbarán, Francisco de 1598–1664, *Reuben I*, purchased by Bishop Trevor, 1756

Zurbarán, Francisco de 1598–1664, *Simeon II*, purchased by Bishop Trevor, 1756

Zurbarán, Francisco de 1598–1664, *Zebulun V*, purchased by Bishop Trevor, 1756

Bishop Auckland Town Hall

Abel, Sue b.1950, *Deer Park*, purchased, 2007, © the artist

McGuinness, Tom 1926–2006, *Pigeon Crees*, bequeathed by Jack Reading, 1996

McGuinness, Tom 1926–2006, *Canchmen*, bequeathed by Jack Reading, 1996

McGuinness, Tom 1926–2006, *Miners in the Roadway*, bequeathed by Jack Reading, 1996

McGuinness, Tom 1926–2006, *Pit Head Bath*, bequeathed by Jack Reading, 1996

McGuinness, Tom 1926–2006, *Salvage Men Brawing Rings*, bequeathed by Jack Reading, 1996

Meehan, Myles 1904–1974, *Panorama of South Church, Bishop Auckland, County Durham*, acquired, c.1985

Parkin, Gloria *Triptych of Twelfth-Century Figures in the Chapter House of Durham Cathedral*, presented to the people of Bishop Auckland by the Bishop Auckland Civic Society in acknowledgment of the refurbishment of the Town Hall, 1993

Robson, George b.1945, *Following the Banner on Gala Day*, donated by the artist, c.2005, © the artist

Rogers, George John 1885–1996, *Newton Cap Bridge and Viaduct, near Bishop Auckland, County Durham*, acquired, 2004

Rogers, George John 1885–1996, *Market Place, Bishop Auckland, County Durham*, acquired, 2004

Wilkinson Daniel, Henry 1875–1959, *Joseph Lingford (1829–1918)*, given to the people of Bishop Auckland, 1911

Derwentside District Council

Kipling, Mary Jane 1912–2004, *Landscape with Consett Steel Works**, presented by Mr Eric Amos at the opening of the Consett Silver Jubilee Show, 1972, © the artist's estate

Mackie, Sheila Gertrude b.1928, *It's Good to Be Home*, purchased, © the artist

Mackie, Sheila Gertrude b.1928,

Lazy Days at the Spa, purchased, © the artist

Mackie, Sheila Gertrude b.1928, *Roe Deer Fawn*, purchased, © the artist

Mackie, Sheila Gertrude b.1928, *Taking a Dip in the Derwent*, purchased, © the artist

Mackie, Sheila Gertrude b.1928, *Waiting in the Undergrowth*, purchased, © the artist

Wear Valley District Council

Carmichael, John Wilson 1800–1868, *Flower Show in Auckland Park, County Durham, 1859*

Doyle, Caroline *Jesmond Dene, Newcastle-upon-Tyne*

Mansell, C. *Busy Abstract: Black and Gold*, gift, 1988

Mansell, C. *Busy Abstract: Blue, Black, Gold and Green*, gift, 1988

Mansell, C. *Busy Abstract: White on Gold*, gift, 1988

McGuinness, Tom 1926–2006, *Procession to Durham Cathedral*

Darlington Borough Art Collection

Alderson, Dorothy Margaret 1900–1992 & **Alderson, Elizabeth Mary** 1900–1988 *Poodlemania*

Appleyard, John b.1923, *Bondgate Chapel, Darlington, County Durham*

Appleyard, John b.1923, *Cockerton Chapel, Darlington, County Durham*

Appleyard, John b.1923, *The Brickyard*

Appleyard, John b.1923, *Victoria Road Methodist Church, Darlington, County Durham*

Banting, John 1902–1972, *Abstract with Holes*

Barnes, George E. *Myles*

Beaton, Malcolm A. b.1918, *Tubwell Row, Darlington*

Bewick, William 1795–1866, *Cauldron Snout*

Bewick, William 1795–1866, *Castle Eden Dene*

Bewick, William 1795–1866, *Jeremiah* (copy after Michelangelo)

Bewick, William 1795–1866, *John Buckton of Buckton's Yard*

Bewick, William 1795–1866, *John Douthwaite Nesham*

Bird, James Lindsay 1903–1972, *Alderman Robert Henry Loraine, JP, Mayor of Darlington (1961–1962)*

Bird, James Lindsay 1903–1972, *The Queen Mother (1900–2002)*

Bird, James Lindsay 1903–1972, *Walter Woodward Allen*

Bond, W. *Blackwell Mill*

Briault, Sydney 1887–1955, *Man Holding a Sword*

Brocklebank, W. *Off Church Row, Darlington, County Durham*

Brocklebank, W. *Old Smithy, Cockerton, Darlington, County Durham*

Browne, Piers b.1949, *Castle*

Bolton, Yorkshire, March Afternoon, © the artist

Bryce, Gordon b.1943, *Renaissance*, © the artist

Bryett, M. Theodore *Margaret Caroline Surtees (1816–1869)*

Burlison, Clement 1803–1899, *Holy Trinity Church, Darlington, County Durham*

Burrows, Robert 1810–1893, *Gainsborough's Lane*

Burrows, Robert 1810–1893, *Cattle on Road*

Burrows, Robert 1810–1893, *Evening*

Burrows, Robert 1810–1893, *Woodland Scene*

Carmichael, John Wilson 1800–1868, *Seascape*

Cemmick, David b.1955, *After the Snowstorm*

Clark, J. *Alderman J. K. Wilkes, Mayor (1885–1886)*

Clarke, Howard *Uphill Road*

Clarke, May *Equipoise*

Cleeland, J. Alan *Little Girl*

Coad, Charles 1854–1914, *Sir Henry Havelock-Allan (1830–1897)*

Cole, George Vicat 1833–1893, *Landscape*

Collier, John 1850–1934, *Brotherhood of Man*

Common, Alfred *Landscape in Autumn*

Cornish, Norman Stansfield b.1919, *Bishop's Close Street, Spennymoor, County Durham*

Crosby, William 1830–1910, *A Victorian Lady*

Cuberle, A. active 1871–1895, *Landscape*

Cuberle, A. active 1871–1895, *Landscape*

Dadswell, Margaret *Sunflowers*

Dillon, Paul b.1943, *Pease House, Houndgate, Darlington, County Durham*

Downman, John 1750–1824, *Jane Surtees* (daughter of Robert Surtees)

Drinkwater, Milton H. *St Cuthbert's Church, Darlington, County Durham*

Dunning, R. *Richmond Castle, North Yorkshire*

Dunstan, Bernard b.1920, *Dawn*, © the artist/www.bridgeman.co.uk

Elgood, Thomas Scott 1845–1912, *Hurworth-on-Tees, County Durham*

Eurich, Richard Ernst 1903–1992, *Landscape*, © the artist's estate/ www.bridgeman.co.uk

Fenwick, C. *J. G. Harbottle (1858–1920)*

Fothergill, George Algernon 1868–1945, *Dog and Pheasant* (1)

Fothergill, George Algernon 1868–1945, *Dog and Pheasant* (2)

Fothergill, George Algernon 1868–1945, *English Setter*

Fothergill, George Algernon 1868–1945, *Hunt Terriers* (1)

Fothergill, George Algernon 1868–1945, *Hunt Terriers* (2)

Fothergill, George Algernon 1868–1945, *Pointer*

Fothergill, S. *Swans on the River*

Fothergill, S. *Thread Mill and Dam*

Freiles, Antonio b.1943, *Colloquio Fulleylove, John* 1845–1908, *Holy Trinity Church, Darlington, County Durham*

Gibb, Thomas Henry 1833–1893, *Otter Hunting on the Tweed*

Gibbs, John Binney 1859–1935, *High Row, Darlington, County Durham*

Gibbs, John Binney 1859–1935, *William Ferguson (1841–1908)*

Gore, Spencer 1878–1914, *Yorkshire Landscape*

Gray, Laurie E. *Church Lane, Darlington, County Durham*

Gush, William 1813–1888, *Robert Lampton Surtees*

Halswelle, Keeley 1832–1891, *Landscape*

Harmar, Fairlie 1876–1945, *Chibbet, Exmoor, Somerset*

Harrison, John Brown 1876–1958, *The Morning After*

Haughton, Benjamin 1865–1924, *Wild Hyacinths*

Hawksley, Maude *The Long Bill*

Haynes-Williams, John 1836–1908, *The Miniature*

Heath, Adrian 1920–1992, *Composition*, © the estate of Adrian Heath

Hedley, Ralph 1848–1913, *Breezy Day*

Heywood, Harry *Edward Pease (1767–1858)*

Hicks, Peter Michael b.1937, *Inland Cliff, Cleveland*, © the artist

Hill, Ernest *Jarrow Slake, Tyne and Wear*

Hobson, Victor William 1865–1889, *Portrait of an Old Man*

Hobson, Victor William 1865–1889, *North Lodge Park, Darlington, County Durham*

Hogarth, William (attributed to) 1697–1764, *The Writ*

Hunt, C. *The Donkey Cart*

Hyde, E. *Autumn Tints in the Wood*

Jennens & Bettridge active c.1845–1850, *El Kaf, the Ancient Sicca Veneria, Tunis, Tunisia*

Jennens & Bettridge active c.1845–1850, *Suez, Egypt*

Jennens & Bettridge active c.1845–1850, *Tripoli, Libya*

Johnson, Derek Blyth b.1943, *Figure in Crowd*

Kessell, Mary 1914–1977, *The Bombed House*

Kiesel, Conrad 1846–1921, *In the Studio*

Lake, Philip *Flower Study*

Lamb, Henry 1883–1960, *The Garden, Coombe Bissett, Wiltshire*, © estate of Henry Lamb

Larry, K. *Works*

Laudelle, E. (attributed to) *Brigadier Sir General Conyers Surtees of Mainsforth Hall*

Lawson, F. *Darlington Market Place, County Durham*

Layng, Mabel Kathleen 1898–1987, *Millinery*

Lear, William Henry 1860–1932, *Carting Sand*

Lee, I. *George David Wilson (1846–1903)*

Lee, John c.1869–1934, *Victor*

Hobson (1865–1889)

Lévy, Simon 1886–1973, *Skull Mark, Brenda* 1922–1960, *Girl with a Bowl of Fruit*, © the artist's estate

McBeth, Murray *Edmund Backhouse (1824–1906)*

McGuinness, Tom 1926–2006, *Miners in the Return*

McGuinness, Tom 1926–2006, *The Caller*

McLachlan, Thomas Hope 1845–1897, *Pastoral*

McLachlan, Thomas Hope 1845–1897, *Bathers*

McLachlan, Thomas Hope 1845–1897, *Goose Girl*

McLachlan, Thomas Hope 1845–1897, *Moorland Scene*

McLachlan, Thomas Hope 1845–1897, *At Shut of Eve*

Meecham, Charles Stephen *Goodnight Kiss*

Meehan, Myles 1904–1974, *North Country*

Meehan, Myles 1904–1974, *St Cuthbert's, Darlington, County Durham*

Meehan, Myles 1904–1974, *The Birthplace of Edward Pease, Darlington, County Durham*

Meehan, Myles 1904–1974, *White Lilac*

Meehan, Myles 1904–1974, *Pease's Mill, Darlington, County Durham*

Miller, Joseph active c.1812–1858, *Landscape with Castle and Bridge*

Miller, Joseph active c.1812–1858, *Barnard Castle, County Durham*

Miller, Joseph active c.1812–1858, *Borrowdale, Cumbria*

Miller, Joseph active c.1812–1858, *Coniscliffe Church, Bishop Auckland, County Durham*

Miller, Joseph active c.1812–1858, *Dog Kennels, Raby Castle, County Durham*

Miller, Joseph active c.1812–1858, *High Force*

Miller, Joseph active c.1812–1858, *Raby Castle, County Durham*

Minton, John 1917–1957, *The Entombment*, © Royal College of Art

Moore, Henry 1831–1895, *The North Sea*

Nasmyth, Patrick 1787–1831, *A Homestead*

Nasmyth, Patrick 1787–1831, *Yews near Turner's Hill, East Grinstead, West Sussex*

Neasham, W. W. *Building Shop, Faverdale, Darlington, County Durham*

Noble, R. *Woman with Aborigines*

Olivier, Herbert Arnould 1861–1952, *Lady Southampton (d.1957)*, © the artist's estate

Parkinson, Harold *Pat*

Peart, Tony b.1961, *Fear of the Unknown*, © the artist

Peel, James 1811–1906, *The Tinker*

Peel, James 1811–1906, *Borrowdale, Cumbria*

Peel, James 1811–1906, *Landscape with Cows*

Peel, James 1811–1906, *Landscape with Cows and Cowman*

Peel, James 1811–1906, *Landscape with Fisherman*

Peel, James 1811–1906, *Landscape with Shepherd and Sheep*

Peel, James 1811–1906, *Landscape with Two Figures*

Peel, James 1811–1906, *The Reaper*

Potworowski, Peter 1898–1962, *Window on the Sun*, © the artist's estate

Rathwell, William *Mary Spark*

Rathwell, William *Henry King Spark (1824–1899), Landowner and Colliery Owner*

Reuss, Albert 1889–1975, *Black Statue*

Ross, Robert Thorburn 1816–1876, *The Salmon Fishers*

H. S. (attributed to) *Post House Wynd, Darlington, County Durham*

Salisbury, Frank O. 1874–1962, *Sir Winston Churchill (1874–1965)*, © estate of Frank O. Salisbury/DACS 2008

Schmitt, Guido Philipp 1834–1922, *Henry King Spark (1824–1899), Landowner and Colliery Owner*

Selby, James *Carnival*

Slater, John Falconar 1857–1937, *Landscape*

Stephenson, J. E. *Joseph Lingford (1829–1919)*

Surtees, Robert d.1802, *Self Portrait*

Sutherland, Graham Vivian 1903–1980, *Fallen Tree against Sunset*, © estate of Graham Sutherland

Swift, John Warkup 1815–1869, *Off Flamborough, East Yorkshire*

Swinden, Ralph Leslie 1888–1967, *The Venerable Bede Teaching at Jarrow*

Swinden, Ralph Leslie 1888–1967, *Caxton and the Printing Press*

Swinden, Ralph Leslie 1888–1967, *King Arthur and the Sword in the Stone*

Swinden, Ralph Leslie 1888–1967, *Councillor Clive Dougherty (1907–1988)*

Swinden, Ralph Leslie 1888–1967, *George Stephenson and Nicholas Wood at Bulmer Stone before Going to Interview Edward Pease, 1821*

Swinden, Ralph Leslie 1888–1967, *The Elizabethan Eras*

Swinden, Ralph Leslie 1888–1967, *Lewis Carroll at St Peter's Rectory, Croft, Yorkshire*

Swinden, Ralph Leslie 1888–1967, *A Scriptorium*

Swinden, Ralph Leslie 1888–1967, *Audrey Reid (1914–1999), in Fancy Dress*

Taylor, Frank active 1884–1897, *Bridge and Moonlight*

Taylor, Frank active 1884–1897, *Waterfall*

Taylor, Frank active 1884–1897, *Snow Scene with Watermill*

Taylor, Frank active 1884–1897, *Figures on a Bridge above a Waterfall*

Taylor, Frank active 1884–1897, *White Flowers*

Taylor, Frank active 1884–1897, *Landscape with Bridge and Castle*

Taylor, Frank active 1884–1897, *Bridge and Moonlight*

Taylor, Frank active 1884–1897, *By the Well*

Taylor, Frank active 1884–1897, *Church at Moonlight*

Taylor, Frank active 1884–1897, *Lake Scene*

Taylor, Frank active 1884–1897, *Lake Scene*

Taylor, Frank active 1884–1897, *Lake Scene and Minarets*

Taylor, Frank active 1884–1897, *Landscape in Moonlight*

Taylor, Frank active 1884–1897, *Moonlit Castle*

Taylor, Frank active 1884–1897, *Rural Scene with Girl and Geese*

Taylor, Frank active 1884–1897, *The Mill*

Taylor, Henry King 1799–1869, *Fishing on the Zyder Zee, Holland*

Taylor, R. *Windmill*

Thirtle, Pat b.1938, *Centenary of Darlington Library*, © the artist

Thompson, Mark 1812–1875, *Doune Castle, near Stirling, Scotland*

Thompson, Mark 1812–1875, *Sniffing the Breeze*

Thompson, Mark 1852–1926, *Lynn Burn, near Witton-le-Wear, County Durham*

Thomson, Alfred Reginald 1894–1979, *Joseph Malaby Dent (1849–1926), Publisher*

Thorp, William Eric 1901–1993, *The Tower Pier, Late Afternoon*

Tindle, David b.1932, *Thames Warehouses and Barge*, © the artist

Train, Edward 1801–1866, *On the Esk*

unknown artist 18th C, *Bobby Shafto (d.1797)*

unknown artist 18th C, *Crozier Surtees and His Wife, Jane*

unknown artist *Plan of Action near Corunna, Spain*

unknown artist *Horse and Dog in a Stable*

unknown artist *H. M. Whitwell (1799–1886), Wife of Isaac Whitwell*

unknown artist *John Morell*

unknown artist *Arthur Pease (1866–1927), Mayor (1873–1874)*

unknown artist early 19th C, *Landscape with Children*

unknown artist early 19th C, *Woman Threading a Needle*

unknown artist 19th C, *Fisherman and Lady*

unknown artist 19th C, *Landscape with Horses*

unknown artist 19th C, *Man with Books*

unknown artist 19th C, *Woman with Children*

unknown artist *Richmond Castle, North Yorkshire*

unknown artist *Mrs G. D. Wilson*

unknown artist early 20th C, *The Meeting of the Waters*

unknown artist 20th C, *High Row, Darlington, County Durham*

unknown artist 20th C, *Young Woman*

unknown artist *Alderman T. T. Sedgewick (1843–1904), Mayor*

(1887–1888)

unknown artist *'Baydale Beck Inn', Darlington, County Durham*

unknown artist *'Comet' (The Durham Ox)*

unknown artist *Cooling Towers, Darlington, County Durham*

unknown artist *Diana*

unknown artist *Edward Pease (1767–1858)*

unknown artist *Eliza Chauncey of Dane End*

unknown artist *Irish Peasants*

unknown artist *James Atkinson*

unknown artist *Jane Crozier of Redworth*

unknown artist *John Feetham (1833–1917)*

unknown artist *John Peacock (1761–1841)*

unknown artist *Joseph Pease (1799–1872)*

unknown artist *Joseph Pease (1799–1872)*

unknown artist *Joseph Pease (1799–1872)*

unknown artist *Joseph Whitwell Pease (1828–1903)*

unknown artist *Neddy Place of Blakehouse Hill, Darlington*

unknown artist *Northgate Cottages and Bulmer Stone, Darlington, County Durham*

unknown artist *Pierremont, Darlington, County Durham*

unknown artist *Portrait of an Unknown Gentleman*

unknown artist *Portrait of an Unknown Gentleman*

unknown artist *Portrait of an Unknown Gentleman*

unknown artist *Portrait of an Unknown Woman*

unknown artist *Portrait of an Unknown Woman*

unknown artist *Portrait of an Unknown Woman*

unknown artist *Reverend W. Clementson, Headmaster of Darlington Grammar School (1807–1836)*

unknown artist *St Cuthbert's Church, Darlington, County Durham*

unknown artist *St Cuthbert's Church, Darlington, County Durham*

unknown artist *St Cuthbert's Church, Darlington, County Durham, in the Moonlight*

unknown artist *Sir David Dale (1829–1906)*

unknown artist *Sir Henry Moreton Havelock-Allan*

unknown artist *Sir John Harbottle (1858–1920)*

unknown artist *The Welcome*

unknown artist *Thomas Bowes (1777–1846), Bailiff of Darlington (1816–1846)*

unknown artist *Unknown Man*

unknown artist *William Emerson of Hurworth (1701–1782)*

Vanderbank, John c.1694–1739, *Robert Surtees of Redworth (1694–1785)*

Vanderbank, John (attributed to) c.1694–1739, *Dorothy Lampton of*

Hardwick, Wife of Robert Surtees

Wallace, Aidan b.1903, *Yellow Roses on Black Velvet*

Webb, James 1825–1895, *Mountain Torrent*

White, Ethelbert 1891–1972, *Woods*, © the Ethelbert White estate

Wicksteed, Owen 1904–1999, *View of the Queen Elizabeth Grammar School*

Wigston, John Edwin b.1939, *The Stockton and Darlington Railway*, © the artist

Wilson, Henry active 20th C, *Landscape*

Darlington Railway Museum

Carr, Ann active 1987, *Mallard'*, donated by the artist, 1987

Glendenning, J. A. *A Collecting Dog Richardson, Warwick 'Darlington'*, donated by Mr Ramshaw, 1991

Wigston, John Edwin b.1939, *'Darlington'*, donated by the Mayor's Charity Fund, 1979, © the artist

Durham City Council

Burlison, Clement 1803–1899, *John Philip Kemble (1758–1822), as Hamlet* (copy after Thomas Lawrence), acquired via the Burlison Bequest, donated to the city, 1899

Burlison, Clement 1803–1899, *Cain and Abel*, acquired via the Burlison Bequest, donated to the City, 1899

Burlison, Clement 1803–1899, *Madonna and Child with St Jerome* (copy after Bartolomé Esteban Murillo), acquired via the Burlison Bequest, donated to the City, 1899

Burlison, Clement 1803–1899, *Madonna della Sedia* (copy after Raphael), acquired via the Burlison Bequest, donated to the City, 1899

Burlison, Clement 1803–1899, *Profane Love* (copy after Titian), acquired via the Burlison Bequest, donated to the City, 1899

Burlison, Clement 1803–1899, *The Dogana, San Giorgio, Venice, Italy* (copy after Joseph Mallord William Turner), acquired via the Burlison Bequest, donated to the City, 1899

Burlison, Clement 1803–1899, *Landscape* (after Salomon van Ruysdael), acquired via the Burlison Bequest, donated to the City, 1899

Burlison, Clement 1803–1899, *The Village Festival* (copy after David Wilkie), acquired via the Burlison Bequest, donated to the City, 1899

Burlison, Clement 1803–1899, *Madonna and Child with St Catherine and a Rabbit* (recto) (copy after Titian), acquired via the Burlison Bequest, donated to the City, 1899

Burlison, Clement 1803–1899, *Conversation Piece* (verso),

acquired via the Burlison Bequest, donated to the City, 1899

Burlison, Clement 1803–1899, *Self Portrait* (copy of Anthony Van Dyck), acquired via the Burlison Bequest, donated to the City, 1899

Burlison, Clement 1803–1899, *John Bramwell (1794–1882), Mayor of Durham (1840–1842, 1845–1846 & 1852–1853)*, presented, 1847

Burlison, Clement 1803–1899, *Sir Robert Peel (1788–1850), 2nd Bt, Prime Minister*, paid for by public subscription

Burlison, Clement 1803–1899, *William Henderson (1813–1891), Mayor of Durham (1848–1849)*

Burlison, Clement 1803–1899, *Robert Burns (1759–1796)*, presented by members of the Durham Caledonian Society on the centenary of the sitter's birth, 1859

Burlison, Clement 1803–1899, *The Tribute Money* (copy after Titian), acquired via the Burlison Bequest, donated to the City, 1899

Burlison, Clement 1803–1899, *Mrs Horner's Dog*, presented by the executors of the estate of the late Alderman J. S. Graydon, JP

Burlison, Clement 1803–1899, *Alderman James Fowler (1816–1894), JP, Mayor of Durham (1872–1873, 1881–1884 & 1886–1887)*, presented, 1883

Burlison, Clement 1803–1899, *Abraham Sacrificing Isaac (?)*, acquired via the Burlison Bequest, donated to the City, 1899

Burlison, Clement 1803–1899, *Durham*, acquired via the Burlison Bequest, donated to the City, 1899

Burlison, Clement 1803–1899, *Frans Snyders (1579–1657)* (after Anthony van Dyck), acquired via the Burlison Bequest, donated to the City, 1899

Burlison, Clement 1803–1899, *John Fawcett (1800–1883), JP*

Burlison, Clement 1803–1899, *Reverend Dr James Raine (1791–1858), Mayor's Chaplain (1836–1858)*

Burlison, Clement 1803–1899, *The River Tees near Wynch Bridge*, acquired via the Burlison Bequest, donated to the City, 1899

Burlison, Clement 1803–1899, *Venice by Sunset, Italy*, acquired via the Burlison Bequest, donated to the City, 1899

Burlison, Clement 1803–1899, *White Cat*, acquired via the Burlison Bequest, donated to the City, 1899

Burlison, Clement (attributed to) 1803–1899, *Flora* (copy after Titian), acquired via the Burlison Bequest, donated to the City, 1899

Burlison, Clement (attributed to) 1803–1899, *Francesco Maria della Rovere, Duke of Urbino (1490–1538)* (copy after Titian), acquired via the Burlison Bequest, donated to the City, 1899

Burlison, Clement (attributed to) 1803–1899, *An Italian Girl*

(possibly Grazia), acquired via the Burlison Bequest, donated to the City, 1899

Burlison, Clement 1803–1899, *Self Portrait* (copy of Anthony Van Dyck), acquired via the Burlison Bequest, donated to the City, 1899

Burlison, Clement (attributed to) 1803–1899, *Portrait of a Civic Official* (possibly Thomas Hutton, 1815–1891, or George Robson, 1813–1873)

Burlison, Clement (attributed to) 1803–1899, *James Fowler (1816–1894)*

Burlison, Clement (attributed to) 1803–1899, *Self Portrait*, donated, 1969

Burlison, Clement (attributed to) 1803–1899, *Lord Aldophus Vane-Tempest (1825–1864)*, presented by 7th Marquess of Londonderry

Burlison, Clement (attributed to) 1803–1899, *Unveiling the Statue of the 3rd Marquess of Londonderry in Durham Market Place, 2 December 1861*, presented by the 7th Marquess of Londonderry

Cooke, John 1866–1932, *Charles Vane-Tempest-Stewart (1852–1915), KG, 6th Marquess of Londonderry, Carrying the Sword of State at the Coronation of King Edward VII, 9 August 1902* (copy after John Singer Sargent), presented by Lord Londonderry, 1911

Davison, William 1808–1870, *View of Durham Looking towards Crook Hall*

Egan, Wilfred B. active 1901–1909, *John Lloyd Wharton (1837–1912)*

Green, J. W. *Charles Stewart Henry Vane-Tempest-Stewart (1878–1949), 7th Marquess of Londonderry*

Hastings, Edward 1781–1861, *Houghall Milk Boy*, presented by the executors of the estate of the late Alderman J. S. Graydon, JP

Hastings, Edward 1781–1861, *Count Joseph Boruwlaski (1739–1837)*

Hastings, Edward 1781–1861, *Robert Thwaites (1788–1863), Mayor (1849)*

Hastings, Edward 1781–1861, *Thomas Greenwell (d.1839), Mayor (1836)*, paid for by public subscription

Hedley, Ralph 1848–1913, *Portrait of a Civic Official* (probably Matthew Fowler, 1846–1898), acquired, 1899

Hedley, Ralph (attributed to) 1848–1913, *John George Lambton (1855–1928), Earl of Durham*

Herkomer, Hubert von (attributed to) 1849–1914, *Rt Hon Farrer (1837–1899), 1st Baron Herschell, CGB, MP for Durham (1874–1875)*, presented by the sitter's widow and son

Kneller, Godfrey (attributed to) 1646–1723, *Reverend W. Hartwell (1655–1725)*

Leak, Nicholas *Durham Fantasy*

Madgin *View of Durham Cathedral on its 900th Anniversary*, presented by the artist, 1993

Orde, Cuthbert Julian 1888–1968, *The Most Honourable Charles Stewart Henry Vane-Tempest*

Stewart (1878–1949), 7th Marquess of Londonderry, KG (after John Singer Sargent), presented by the sitter on ceasing to be Mayor of the City (1936–1937), 1937

Ouless, Walter William 1848–1933, *John Lloyd Wharton (1837–1912), of Dryburn, Durham,* presented by the sitter's daughter, Mrs Charles Darwin, 1919

Patterson *Mrs Hannah Harrison Rushford (1887–1965), JP,* acquired, 1966

Robinson, William R. 1810–1875, *View of Durham Cathedral from Crossgate Peth,* presented by Mrs Ann Wilson, 1909

Storey, George Adolphus 1834–1919, *Thomas Charles Thompson (1821–1892), MP for Durham (1880–1885),* presented by Mary Penelope Gwendoline Fisher

Tuke, Lilian Kate 1873–1946, *Robert McLean (1858–1930), JP, Mayor of Durham (1912 & 1922)*

unknown artist early 18th C, *Nathaniel, Lord Crewe (1633–1721), Bishop of Durham (1674–1721)*

unknown artist 18th C, *John Fawcett, Recorder of Durham (1719–1760),* presented by the sitter's great grandson, 1852

unknown artist 18th C, *Robert Wharton (1690–1752), Mayor of Durham (1729–1730 & 1736–1737),* presented by Mrs Charles Darwin

unknown artist 18th C, *William III (1650–1702)*

unknown artist early 19th C, *William Shields, Mayor (1824)*

unknown artist mid-19th C, *Matilda Lyle (copy after an earlier painting)*

unknown artist 19th C, *Dr Fenwick (1761–1856), JP*

unknown artist 19th C, *Portrait of a Civic Official*

unknown artist *Charles I (1600–1649),* presented by Mayor George Robson, 1865

unknown artist *Henrietta (1626–1649),* presented by Mayor George Robson, 1865

unknown artist *Rowland Burdon, Esq.*

Wood, Frank 1904–1985, *Alderman P. J. Waite (1863–1941)*

Durham County Council

Almond, Henry N. 1918–2000, *The River Tees at Neasham, County Durham,* purchased from the artist, 1960

Awan, Sara *Hospital 1*

Awan, Sara *Hospital 2*

Ayrton, Michael 1921–1975, *Pub,* purchased, 1962, © the artist's estate

T. E. B. *Gatehouse at Greencroft Towers, County Durham*

Bell, D. active 1974, *Barnard Castle Station, County Durham,* purchased from the artist, 1974

Bell, D. active 1974, *Early Engine at Night,* purchased from the artist, 1974

Bell, D. active 1974, *Kirkby Stephen Station, Cumbria (North Eastern Railway),* purchased from the artist, 1974

Bell, D. active 1974, *Middleton-in-Teesdale Station,* purchased from the artist, 1974

Bell, D. active 1974, *Monkwearmouth Station, Sunderland, Tyne and Wear,* purchased from the artist, 1974

Bell, D. active 1974, *Muker, Yorkshire,* purchased from the artist, 1974

Bell, D. active 1974, *Ravenstonedale Station, Cumbria,* purchased from the artist, 1974

Burns, Joanne b.1959, *Durham Cathedral from the Riverbank,* donated by the artist, 2006, © the artist

Burns, Joanne b.1959, *Durham Cathedral Looking Southeast,* donated by the artist, 2006, © the artist

Burns, Joanne b.1959, *Durham Cathedral Looking West,* donated by the artist, 2006, © the artist

Burns, Joanne b.1959, *View from Prebends Bridge with Cobalt 2,* donated by the artist, 2006, © the artist

Cook, Beryl 1926–2008, *Two on a Stool,* donated by the artist, 2004

Cooper, Herbert 1911–1979, *Cows in a Byre,* donated by Miss N. A. Johnson, 1989

Cooper, Julian b.1947, *The Durham County Council Centenary,* commissioned by Durham County Council with funding from Northern Arts, the Co-operative Bank, British Coal Enterprise Ltd, the National Government Officers Association and Durham County Council, 1989, © the artist

Cornish, Norman Stansfield b.1919, *A Durham Miners' Gala Day Scene,* acquired, 1968

Cornish, Norman Stansfield b.1919, *Bar Scene, Spennymoor, County Durham,* acquired, 1961

Cornish, Norman Stansfield b.1919, *Durham Miners' Gala Day Scene (Cartoon),* acquired, 1968

Cornish, Norman Stansfield b.1919, *The Crowd at Gala Day (detail),* acquired, 1968

Cornish, Norman Stansfield b.1919, *The Crowd at Gala Day (detail),* acquired, 1968

Corrigan, Cavan b.1942, *Abbrivado II,* purchased from the artist, 1972, © the artist

Corrigan, Cavan b.1942, *Cell,* purchased from the artist, 1970, © the artist

Corrigan, Cavan b.1942, *Landscape with Horses,* purchased from the artist, 1970, © the artist

Corrigan, Cavan b.1942, *Market Cross, Barnard Castle, County Durham,* purchased from the artist, 1979, © the artist

Corrigan, Cavan b.1942, *Old Blagraves, Barnard Castle, County Durham,* purchased from the artist, 1981, © the artist

Dewell, Anne *Durham Cathedral, the Big Meeting, 1965,* donated by Ms A. E. Mace, Huddersfield, 2002

Dundas, R. A. (attributed to) *Causey Arch, Newcastle-upon-Tyne, Tyne and Wear*

Dundas, R. A. (attributed to) *Gatehouse at Greencroft Towers, County Durham*

Everard *Shotton Colliery, Durham,* purchased, 1972

Fawcett, Brian active 1980–1984, *Building the World's Highest Railway, Peru, c.1870,* purchased from the artist, 1981

Fawcett, Brian active 1980–1984, *Stalemate at the Causey Arch on Tanfield Wagonway, County Durham, 1750,* purchased from the artist, 1980

Fawcett, Brian active 1980–1984, *Trouble with Raven's Dream Electric Locomotive, 1922,* purchased from the artist, 1983

Fawcett, Brian active 1980–1984, *David Gordon's Steam Coach, 1830*

Fawcett, Brian active 1980–1984, *Minerals Transport in the Andes of Peru,* purchased from the artist, 1984

Fell, Sheila Mary 1931–1979, *Harbour, Maryport, Cumbria,* purchased from the artist, 1965

Foster, Norman *Miner's Cottage, Early Twentieth Century,* purchased from the artist, 1970

Furness, Robin b.1933, *The Storm Cloud,* purchased, 1976, © the artist

Gordon, W. active 1970, *Pithead Incident,* purchased from the artist, 1970

Haire, A. L. active 1976, *Greta Bridge, Barnard Castle, County Durham,* purchased from the artist, 1976

Harper, Andy b.1971, *Bounty,* purchased from Art Futures, 2004, © the artist

Heslop, Robert John 1907–1988, *Dean and Chapter Colliery, Ferryhill, County Durham, at Night,* purchased from the artist, 1972

Heslop, Robert John 1907–1988, *Fillers at Work,* purchased from the artist, 1972

Heslop, Robert John 1907–1988, *Mainsforth Colliery, County Durham, c.1950,* purchased from the artist, 1973

Heslop, Robert John 1907–1988, *Whitworth Park Colliery, Spennymoor, County Durham,* purchased from the artist, 1973

Heslop, Robert John 1907–1988, *Coal Drops, Sunderland, Tyne and Wear,* purchased from the artist, 1976

Heslop, Robert John 1907–1988, *Horden Colliery, County Durham,* purchased from the artist, 1975

Heslop, Robert John 1907–1988, *Usworth Colliery, Sunderland, Tyne and Wear,* purchased from the artist, 1974

Heslop, Robert John 1907–1988, *East Hetton Colliery, County Durham,* purchased from the artist, 1976

Heslop, Robert John 1907–1988, *Easington Colliery, County Durham,* purchased from the artist, 1977

Heslop, Robert John 1907–1988, *Fishburn Colliery and Part of the By-Product Plant, County Durham,* purchased from the artist, 1973

Heslop, Robert John 1907–1988, *Langley Park Colliery, County Durham,* purchased from the artist, 1976

Heslop, Robert John 1907–1988, *View of Spennymoor, County Durham,* purchased from the artist, 1972

James, Louis 1920–1996, *The Urchin,* purchased from the Bear Lane Gallery, 1962, © DACS 2008

Kipling, Mary Jane 1912–2004, *Winter,* donated by the artist to Consett Library on its opening, 1959, © the artist's estate

Kipling, Mary Jane 1912–2004, *Spring,* donated by the artist to Consett Library on its opening, 1959, © the artist's estate

Kipling, Mary Jane 1912–2004, *Summer, Ebchester Boathouse, County Durham,* donated by the artist to Consett Library on its opening, 1959, © the artist's estate

Kipling, Mary Jane 1912–2004, *Autumn,* donated by the artist to Consett Library on its opening, 1959, © the artist's estate

Lay, R. *'The Nack', Seaham, County Durham*

Long, E. M. active 1974, *Cow Green Dam,* purchased from the artist, 1974

Lowes, Alan *Castle Eden Dene, County Durham,* acquired, 2006

MacTaggart, William 1903–1981, *Landscape,* purchased from the Stone Gallery, 1961, © by permission of the artist's family

Marshall, Anthony d.2007, *Harlem Dance Theatre, Firebird,* purchased from The Biscuit Factory, Newcastle, 2006, © DACS 2008

McGuinness, Tom 1926–2006, *Meeting Station,* purchased from Abbott & Holder, 1975

Meninsky, Bernard 1891–1950, *The Fruit-Gatherers,* purchased from the Artists International Association, 1962, © the artist's estate

Minton, John 1917–1957, *Atlantic Convoy,* purchased from Abbott & Holder, 1965, © Royal College of Art

Nash, John Northcote 1893–1977, *Berkshire Woods,* purchased from the Stone Gallery, 1960, © the artist's estate/www.bridgeman.co.uk

Oliver, Peter 1927–2006, *The Pier,* purchased from the artist, 1960, © the artist's estate

Ortlieb, Evelyn 1925–2008, *Series 1 'O',* purchased from Anthony Dawson, 1972, © the artist's estate

Pattison, Thomas William 1894–1993, *The Building of Durham Cathedral,* acquired, 1968

Peace, John b.1933, *Colliery Engines in the Snow,* purchased from the Stone Gallery, 1963

Philipson, Robin 1916–1992, *Crowing Cock,* purchased from Stone Gallery, 1960, © the artist's estate

Pinkney, Arthur *Consett, County Durham,* purchased from Northern Arts, 1983

Pittuck, Douglas Frederick 1911–1993, *Stockton-on-Tees,* purchased from the artist, 1975, © the artist's estate

Pittuck, Douglas Frederick 1911–1993, *Derelict House, Bridgegate, Barnard Castle, County Durham,* purchased from the artist, 1960, © the artist's estate

Pittuck, Douglas Frederick 1911–1993, *Raby Castle, County Durham,* purchased, 1972, © the artist's estate

Pittuck, Douglas Frederick 1911–1993, *Ullathorne Mill, Startforth, County Durham,* purchased, 1973, © the artist's estate

Purvis, Owen S. active 1971–1983, *Early Morning, Dawdon, County Durham,* purchased from the artist, 1971

Purvis, Owen S. active 1971–1983, *Langleydale, County Durham,* purchased from the artist, 1983

Robinson, J. active 1985, *Seascape,* purchased from the artist, 1985

Robson, George b.1945, *Confrontation,* © the artist

Rowntree, Kenneth 1915–1997, *Saloon Bar Cat,* purchased from Abbott & Holder, 1962, © the artist's estate

Sangster, B. active 1972–1973, *Loading Point,* purchased from the artist, 1973

Sangster, B. active 1972–1973, *Breaking In,* purchased from the artist, 1973

Sangster, B. active 1972–1973, *Drilling on the Caunce,* purchased from the artist, 1973

Smith, Vanessa *Head On,* purchased from Art Futures, 2005

Spender, John Humphrey 1910–2005, *Rock Pools and Cave,* purchased from the Artists International Association, 1963, © the Humphrey Spender Archive

Sutherland, Brian b.1942, *Stick Man,* purchased from the artist, 1971, © the artist

Tait, Karen b.1971, *Seashore II,* purchased from The Biscuit Factory, Newcastle, 2006

Thompson, Stanley b.1876, *Chintz Curtains,* acquired from Mrs Amy Maddison, 1961

Tindle, David b.1932, *The Lock Gate at Dundee, Scotland,* purchased from William Dodd, 1962, © the artist

Tuckwell, George Arthur 1919–2000, *Arab Town,* purchased from The Stone Gallery, 1962

Wigston, John Edwin b.1939,

'Rocket' on the Liverpool and Manchester Railway, purchased from the artist, 1975, © the artist
Wigston, John Edwin b.1939, 'Royal George' by Timothy Hackworth's Cottage, purchased from the artist, 1974, © the artist
Wigston, John Edwin b.1939, Middlesbrough Suspension Bridge, purchased from the artist, 1977, © the artist
Wigston, John Edwin b.1939, 'The Globe' Locomotive, purchased from the artist, 1978, © the artist
Williamson, William Henry 1820–1883, Boats in a Squall off a Coastline, donated by Fencehouses Community Centre, 1970

Durham Light Infantry Museum

British School John Bridges Schaw (1744–after 1797), 68th Regiment of Foot (1769–1797), Colonel (1795–1797)
British School Major George Champion de Crespigny (1788–1813) (killed in action at Vittoria at the head of the 68th Light Infantry)
British School Sergeant of the 68th Durham Light Infantry
British School A Major of the 68th Light Infantry (possibly Major John Reed)
British School H. E. I. Coy's 2nd Bombay European Light Infantry Officer
British School Brigadier General R. B. Bradford (1892–1917), VC, MC, Durham Light Infantry (killed in action on 30 November 1917 aged 25 years, awarded the Victoria Cross, 1 October 1916)
British School James O'Callaghan, Durham Militia (1798–1816), Colonel (1805–1816)
British School Lieutenant Crosier Surtees (1739–1803), Durham Militia (1759–1761), on loan, since 1983
British School Unknown General of the 68th Durham Light Infantry
Hudson, Gerald Attack of the 2nd Battalion, Durham Light Infantry, at Hooge, Germany, 9 August 1915, commissioned for the Officers Mess, 2nd Battalion, Durham Light Infantry
McLeod, Juliet 1917–1982, Captain Henry de Beauvoir de Lisle (1864–1955) and His Pony, 'Snowy', c.1900, presented by former officers of the 2nd Battalion to commemorate the reforming of the Battalion, 1952
Ross, T. General Charles Nicol, CB, Colonel 68th Foot (1844–1850)

Durham University

Allison, David b.1960, The Smoker
Amigoni, Jacopo c.1685–1752, Queen Caroline of Ansbach (1683–1737), presented by Bishop Butler, 1750 (?)

M. B. Frank Byron Jevons (1858–1935), MA, DLitt, acquired, 1920 (?)
Balinese (Batuan) School A Village Temple*, gift from the Dr & Mrs J. T. Roberts Balinese Collection
Balinese (Kamasan) School Hanuman, the Monkey Warrior*, gift from the Dr & Mrs J. T. Roberts Balinese Collection, 1999
Balinese (Kamasan) School Hanuman, the Monkey Warrior and a Sage (Scene from the Ramayana)*, gift from the Dr & Mrs J. T. Roberts Balinese Collection, 1999
Balinese (Kamasan) School Battle Scene*, gift from the Dr & Mrs J. T. Roberts Balinese Collection, 1999
Balinese (Kamasan) School or Balinese (Wayang Style) Arunja among the Hermits*, gift from the Dr & Mrs J. T. Roberts Balinese Collection, 1999
Balinese (Pengosekan) School Five Herons in a Forest and River Landscape*, gift from the Dr & Mrs J. T. Roberts Balinese Collection, 1999
Balinese (Pengosekan) School Ten Cranes Feeding at a River's Edge*, gift from the Dr & Mrs J. T. Roberts Balinese Collection, 1999
Balinese School Hanuman the Monkey Warrior, Rama, Ravana and Sita*, gift from the Dr & Mrs J. T. Roberts Balinese Collection
Barden, Dave b.1943, Aspects of Grey College Sporting Life
Batu Mother and Child, © the artist
Beechey, William 1753–1839, George Maltby, Esq. (1731–1794), presented by Edward Maltby, Bishop of Durham (?)
Bennett, Terence b.1935, Robin Hood's Bay, North Yorkshire, © the artist
Bennett, Terence b.1935, Whitby from St Mary's Church, North Yorkshire, © the artist
Bennett, Terence b.1935, Disused Mine, Stanhope, County Durham, © the artist
Bickersteth, Jane Galilee Chapel, Durham Cathedral, commissioned jointly with Durham City Arts as part of Durham Arts Festival
Bickersteth, Jane Side Aisle, commissioned jointly with Durham City Arts as part of Durham Arts Festival
Birt, Elizabeth Bamburgh from Lindisfarne, Northumberland
Boisnazwivc, O. Eric Halladay
Borg, Isabelle b.1959, Durham Cathedral from Grey College
Both, Jan (style of) c.1618–1652, Landscape with a Lake and Horsemen
Braun, Grace Still Life
Bridges, John active 1818–1854, Canon David Durrell (1762–1852), MA, DD
Briggs, Henry Perronet 1791/1793–1844, Edward Maltby (1770–1859), DD, Bishop of Durham (1836–1856)
British (English) School Cuthbert

Tunstall (1474–1559), Bishop of Durham (1530–1559)
British (English) School Steane Park, Northamptonshire, the Seat of Lord Crewe, commissioned by Nathaniel, Lord Crewe, Bishop of Durham (?)
British (English) School 20th C, Arthur Robinson, JP, MA, DCL, commissioned, 1927
British School early 17th C, A Girl in a Pink Costume
British School The White Peacock
British School early 20th C, Lieutenant Colonel William Douglas Love (1879–1922), presented, c.1926
Burlison, Clement 1803–1899, Joe Bainbridge, the Castle Postman
Burlison, Clement 1803–1899, The Reverend Dr John Cundill (1812–1894)
Burlison, Clement 1803–1899, The Reverend Canon Henry Jenkyns (1795–1878), MA, DD
Burlison, Clement 1803–1899, The Reverend Professor Thomas Saunders Evans (1816–1889)
Burt, Elizabeth Dobgill Falls, Lake District
Carmichael, John Wilson 1800–1868, Durham from Observatory Hill, donated by Ralph William Godwin Robinson, 1970
Carpenter, Margaret Sarah 1793–1872, The Right Reverend Dr John Bird Sumner (1780–1862), Bishop of Chichester
Chandra, Avinash 1931–1991, Victor, purchased from the Molton Gallery, London, 1962, © by kind permission of Osborne Samuel Ltd
Clarke, Edward b.1962, Victor Watts, commissioned, 1998, © the artist
Clarke, Edward b.1962, John C. F. Hayward (b.1941), OBE, commissioned, 2001, © the artist
Colinson A Rocky Coast
Collier, John (style of) 1708–1786, The Durham Drummer
Collier, John (style of) 1708–1786, The Durham Preacher, donated by Colonel Macfarlane-Grieve, 1953
Collier, John 1850–1934, Henry Gee (c.1858–1939), MA, DD, FSA
Cookson, Mary Faith
Cope, Charles West 1811–1890, The Reverend Temple Chevallier (1794–1873)
Copnall, Frank T. 1870–1949, Douglas Horsfall
Crowson, Neville b.1936, Apples and Paper Bags
Da Fano, Judith 1919–2000, Edward George Pace (1882–1953), JP, MA, DD, commissioned, 1953, © the artist's estate
Danckerts, Hendrick (circle of) 1625–1680, Durham Castle and Cathedral with Bishop's Barge (1)
Danckerts, Hendrick (circle of) 1625–1680, Durham Castle and Cathedral with Bishop's Barge (2)
Degree, N. J. (attributed to) Butterflies*
Delve, Jessie active 1912, Walter Kercheval Hilton (1845–1913), MA

Denning, Stephen Poyntz 1795–1864, The Reverend David Melville (b.1813), DD, given by the artist to the sitter, c.1850
Dickinson, Lowes Cato 1819–1908, The Reverend Joseph Waite (1824–1908), DD
Drerup, Karl 1904–2000, Basil Bunting (1900–1985), Poet, donated to the Basil Bunting Poetry Archive by Oliver Drerup, son of the artist, 2003, © the artist's estate
Dugdale, Thomas Cantrell 1880–1952, John Stapylton Grey Pemberton (1860–1940), JP, DCL, presented by the sitter, © Joanna Dunham
Dutch School Esau Selling His Birthright to Jacob
Dutch School 17th C, Landscape with a Man and a Woman on a Bridge by a Gorge
Dutch School 17th C, The Sheep Shearing
Dutch School 18th C, The Pilgrim and the Beggar
Emerson, Robert Jackson 1878–1944, The Reverend John Hall How (1871–1938), MA, © the artist's estate
Evans, Richard 1784–1871, Dr Richard Prosser (1747–1839)
Evans, Richard 1784–1871, Dr Robert Gray (1762–1834), Bishop of Bristol
Evans, Richard 1784–1871, Dr William Stephen Gilly (1789–1853)
Evans, Richard 1784–1871, John Savile Ogle (1767–1853), DD
Evans, Richard 1784–1871, The Honourable Gerald Valerian Wellesley (1770–1848), DD
Evans, Richard 1784–1871, The Reverend Samuel Smith (1765–1841), DD
Evans, Richard 1784–1871, The Right Reverend and Honourable Shute Barrington (1734–1826), Bishop of Durham (after Thomas Lawrence), donated by Archdeacon Charles Thorp, 1842
Evans, Richard 1784–1871, William Van Mildert (1765–1836), Bishop of Durham (1826–1836) (after Thomas Lawrence)
Fancourt, Edward b.1802, The Virgin and Child (after Anthony van Dyck), gift from Mr Chaytor of Chipchase Castle, c.1850
Fedden, Mary b.1915, Landscape, Still Life I, donated by Jean Chamberlin, 1990, © the artist
Fedden, Mary b.1915, Landscape, Still Life II, donated by Jean Chamberlin, 1990, © the artist
Fedden, Mary b.1915, Blue Cart, donated by Jean Chamberlin, 1990, © the artist
Fedden, Mary b.1915, Red Cupboard, donated by Jean Chamberlin, 1990, © the artist
Fedden, Mary b.1915, The Red Berry, donated by Jean Chamberlin, 1990, © the artist
Fedden, Mary b.1915, Pennsylvania, donated by Jean Chamberlin, 1990, © the artist

Fedden, Mary b.1915, Sheep in Yorkshire, donated by Jean Chamberlin, 1990, © the artist
Fedden, Mary b.1915, Goatherd with Goats, donated by the artist as part of her bequest of her work to all public collections, 1997, © the artist
Firth, Margaret 1898–1991, Still Life, © the artist's estate
Flemish School 17th C, Woman in a Cave
Flemish School 18th C, Classical Landscape with Pillars, River and Goats (after Giovanni Paolo Panini)
Freeth, Hubert Andrew 1913–1986, Dr W. A. Prowse, © Freeth family
Freeth, Hubert Andrew 1913–1986, Dr P. W. Kent, © Freeth family
French School 17th C, Man in a Landscape beside a Pool and a Waterfall
French School early 18th C, Village in a Hilly Landscape with Two Bridges
French School 18th C, Landscape with Walled Town
Gaekwad, Ranjit Singh active 2000–2001, Cheese Plant
Gaekwad, Ranjit Singh active 2000–2001, Indian Lady
Ganderton (Canon), H. Y. Welsh Landscape
Ganderton (Canon), H. Y. Reverend Charles Wallis
Gennari, Cesare (attributed to) 1637–1688, Endymion Asleep
German School mid-17th C, A Scholar in His Study
Goes, Hugo van der (copy after) c.1420–1482, The Lamentation, the Dead Christ Supported by John the Baptist, Joseph of Arimathea, and Nicodemus with the Virgin Mary and Mary Magdalene
Gollon, Christopher b.1953, Einstein's Dinner, acquired, 2007, © the artist
Gollon, Christopher b.1953, Still Life (Homage to Pittura Metafisica), acquired, 2007, © the artist
Grant, James Ardern 1887–1973, Miss Ethleen Scott
Hager, Inga Abstract
Hager, Inga Danish Seascape
Haigh, Robert b.1973, Seascape*, purchased, 2007, © Robert Haigh 2004 Lucyart.co.uk
Halliday, Colin Thomas b.1964, Still, © the artist
Harman, G. A Former Principal*
Harrison, G. M. A Former Principal*
Hastings, Edward 1781–1861, Durham Castle and Framwellgate Bridge, Looking East
Hastings, Edward 1781–1861, An Informal Procession of Boats on the River Wear to Celebrate the Victory of Waterloo, 1815, bequeathed by Lieutenant Colonel W. D. Lowe, 1922
Hastings, Edward 1781–1861, Canon George Townsend (1788–1857)

Hastings, Edward (attributed to) 1781–1861, *The Great Hall of Durham Castle, Facing South*

Hawkins, James b.1954, *Abstract*, © the artist

Hedley, Ralph 1848–1913, *King Charles I Touching for the King's Evil*

Hedley, Ralph 1848–1913, *Alfred Plummer (1841–1926), DD*

Hedley, Ralph 1848–1913, *Joseph T. Fowler (1830–1921), MA, DCL*, gift from the sitter, 1918

Heumann, Corinna b.1962, *Picasso Meets Lichtenstein, Head of a Woman*, purchased, 2002, © the artist

Heumann, Corinna b.1962, *Picasso Meets Lichtenstein, Jack-in-the-Box*, purchased, 2002, © the artist

Heumann, Corinna b.1962, *Picasso Meets Lichtenstein, Woman Seated*, purchased, 2002, © the artist

Hondecoeter, Melchior de (follower of) 1636–1695, *Farmyard Scene, the Black Turkey*

Horsley, John Callcott 1817–1903, *John Pemberton, Esq. (d.c.1853)*

Janssens, Victor Honoré 1658–1736, *The Penitent St Mary Magdalene*

Johnson, Ben b.1946, *Raby Earthmarks*

Johnson, Ernest Borough 1866–1949, *The Reverend Dr Charles Whiting, MA, DD, BCL*

Jordon, M. *Through the Keyhole in Blue**

Kerr, John J. b.1933, *Durham Cathedral**, donated by the friends of Angela Fox in her memory

Kinmont, David 1932–2006, *Dark Multi-Light Colours*, purchased, 1981, © the artist's estate

Kinmont, David 1932–2006, *Painting, Plant*, purchased, 1981, © the artist's estate

Kjærnstad, Roar b.1975, *Art Students*, © the artist

Kjærnstad, Roar b.1975, *Martyn Chamberlain*, © the artist

Kjærnstad, Roar b.1975, *Victor Watts*, © the artist

Kneller, Godfrey 1646–1723, *Sir George Jeffreys (1644–1689)*, acquired from the collection of Nathaniel, Lord Crewe, Bishop of Durham (?)

Kneller, Godfrey (after) 1646–1723, *Nathaniel, Lord Crewe (1633–1721), Bishop of Durham (1674–1721)*, donated by W. G. Clarke Maxwell, after 1892

Kneller, Godfrey (studio of) 1646–1723, *George II (1683–1760)*

Kuhn, Andrzej b.1930, *The Fisherman**, © the artist

Kulyk, Karen b.1950, *Summer Garden*

Lamb, Henry 1883–1960, *Sir James Fitzjames Duff (1898–1970)*, © estate of Henry Lamb

Lawrence, Thomas (after) 1769–1830, *William Van Mildert (1765–1836), Bishop of Durham (1826–1836)*, presented by University College, 1967

Lawrence, Thomas (after) 1769–1830, *William Van Mildert (1765–1836), Bishop of Durham (1826–1836)*

Leake, Nicholas *Sir Kingsley Dunham (1910–2001)*

Liebenow *Sir Peter Ustinov (1921–2004)*, donated, 2007

Long, A. *Lady Irene Hindmarsh*

Mackintosh, Anne b.1944, *Professor Sir Kenneth Calman*, commissioned, 2005, © the artist

Maclaren, Andrew b.1941, *Leslie Brooks (1919–1993)*, presented by Professor Brooks, 1985

Marchant, Rowy *Windscape*

Marek *Crystals in Magma (detail)*, commissioned through the University Buildings Committee

Marescotti, Bartolomeo (style of) c.1590–1630, *The Virgin and Child with Joseph and Angels*

Matteis, Paolo de' 1662–1728, *Clorinda Rescuing Olindo and Sophronia from the Stake*

Meshoulam, Yair b.1963, *Eden*, donated by the artist, 1999

Meshoulam, Yair b.1963, *Computer Android*, purchased, 1998

Mieves, Christian b.1973, *Schoolboys*, © the artist

Mills, Karen *The Reverend Canon Dr John C. Fenton, MA, BD, DD*

Ming, Zhu b.1960, *Autumn Cicada*, gift from the artist, 2007, © the artist

Morgenstern, Johann Ludwig Ernst (attributed to) 1738–1819, *A Church Interior in Flanders*

Morton, Alan Kenneth b.1930, *Rowan and Martin's Laugh-In*, © the artist

Morton, Alan Kenneth b.1930, *Stained Glass Reflections*, © the artist

Morton, Alan Kenneth b.1930, *Warrior Shrine (detail)*, © the artist

Mouncey, Val b.1957, *Phoenix*, purchased, 2000, © the artist

Mozley, Charles Alfred 1914–1991, *The French Waitress*, © the artist's estate

Mulley, Brighid Susan b.1966, *Bernard Robertson (b.1936)*, commissioned upon the sitter's retirement, © the artist

Nord, P. (attributed to) *Abstract**

Nord, P. (attributed to) *Head**

Nord, P. (attributed to) *Leaf**

Ormsby, Barrie b.1945, *Jazz*, purchased, 2000, © the artist

Oxley, Mick b.1953, *Sunset, Dunstanburgh, Northumberland*, © the artist

Pattison, Thomas William 1894–1993, *The Reverend John S. Brewis, MA*

Pattison, Thomas William (attributed to) 1894–1993, *Clifford Leech*

Phillips, Thomas 1770–1845, *Canon Thomas Gisborne (1758–1846)*

Platt, Theo b.1960, *Anthony Tuck*, acquired, 1987 (?), © the artist

Pomerance, Fay 1912–2001, *Part II, Lucifer's River Quest for the Lost Seed of Redemption*

Pomerance, Fay 1912–2001, *Part III, the Threefold Tree of Eden*

Pomerance, Fay 1912–2001, *Part IV, the Way Back*

Pomerance, Fay 1912–2001, *The Sphere of Redemption*

Poole, David b.1931, *Professor Sir Derman Christopherson (1915–2000)*, commissioned, 1978, © the artist

Prowse, W. A. active 1973–1976, *Atomic Theme*, donated

Prowse, W. A. active 1973–1976, *Electric Currents in the Atmosphere*, donated

Prowse, W. A. active 1973–1976, *Red Shift*, donated

Ramage, David G. d.1967, *Claude Colleer Abbott (1889–1971)*, donated by the artist

Ramage, David G. d.1967, *Self Portrait*, donated by the artist

Ramage, David G. d.1967, *I. J. C. Foster (1908–1978)*, donated by the artist

Ratcliffe, Andrew b.1948, *Dr Edward C. Salthouse (b.1936)*, commissioned, 1997, © the artist

Ratcliffe, Andrew b.1948, *Gerald Blake*, acquired, 2001 (?), © the artist

Ratcliffe, Andrew b.1948, *John Atkin*, commissioned, 2002, © the artist

Ratcliffe, Andrew b.1948, *Professor Evelyn Ebsworth (b.1933)*, commissioned, 1998, © the artist

Rawcliffe, Barrie b.1938, *Chatsworth Landscape*, © the artist

Riley, John 1646–1691, *Catherine of Braganza (1638–1705), Queen Consort of Charles II*

Riley, John 1646–1691, *King Charles II (1630–1685)*

Riley, John (attributed to) 1646–1691, *Nathaniel, Lord Crewe (1633–1721), Bishop of Durham (1674–1721)* (after Godfrey Kneller), donated by Bishop Maltby, 1842

Robinson, William R. 1810–1875, *Fisherfolk and Their Catch on the Northern French Coast* (after Richard Parkes Bonington)

Roboz, Zsuzsi b.1939, *Professor William Bayne Fisher (1916–1984), Principal of the Graduate Society*, donated by Professor Robin Mills, 1978, © the artist

Robson, George b.1945, *Durham Miners' Gala*, donated, © the artist

Roland-Gosselin, Jill b.1951, *Chinese Bowl and Lemons*, purchased, 2004, © the artist

Rowe, Lizzie b.1955, *James Peden Barber (b.1931), JP, MA, PhD*, acquired, 1994/1995, © the artist

Rowe, Lizzie b.1955, *Professor Jane Taylor*, acquired, 2007 (?), © the artist

Rowe, Lizzie b.1955, *Professor Sir Frederick Halliday*, commissioned, 1990, © the artist

Rubens, Peter Paul (after) 1577–1640, *Self Portrait, 1623*

Rubens, Peter Paul (school of) 1577–1640, *The Lamentation*

Sargeant, Gary b.1939, *Durham Cathedral**, © the artist

Schofield, John William 1865–1944, *Dr George William Kitchin (1827–1912)*

Schranz, Anton (style of) 1769–1839, *Constantinople*

Sephton, George Harcourt *Canon Tristram (1822–1906)*

Shackleton, Judith *Abstract**

Shackleton, Judith *Abstract**

Shackleton, Judith *Abstract Landscape**

Shackleton, Judith *Double Exposure*, purchased, 1994

Shackleton, Judith *Landscape with Moon**

Shackleton, Judith *Sea Bed*, purchased, c.1980

Slater, D. *Miners at Work**

Slater, John Falconar 1857–1937, *Landscape**

Soden, Robert b.1955, *Durham**, © the artist

Sokolov, Kirill 1930–2004, *Peter Charles Bayley*, acquired, 1978 (?), © the artist's estate

Sokolov, Kirill 1930–2004, *Monastery at Panteleimon, Three Monks on Mount Athos, Greece*, © the artist's estate

Spare, Kay b.1957, *French Spring*, donated by the artist, 2007, © the artist

Stage, Ruth b.1969, *London to Leeds*, purchased, 1994, © Ruth Stage. All rights reserved, DACS 2008

Storck, Abraham (after) 1644–1708, *Seascape I, Calm Offshore*

Storck, Abraham (after) 1644–1708, *Seascape II, Calm Offshore*

Swan, Robert John 1888–1980, *Leonard Slater (1908–1999), CBE, MA, JP, DL*, commissioned, 1973

Swinton, James Rannie 1816–1888, *Archdeacon Charles Thorpe (1783–1862), DD*

A. T. *Landscape with Colliery**

Taylor (of Durham) active 1750–1752, *Joseph Butler (1692–1752), Bishop of Durham (1750–1752)*

Thompson, Matthew 1790–1851, *A Retrospective view of Durham Market Place*

Thompson, Thomas Clement c.1780–1857, *Martin Joseph Routh (1755–1854)*, bequeathed with Martin Routh's library, 1855

Titherley, Hazel b.1935, *Avenue of Trees*, acquired in memory of Jo Court, © the artist

Titherley, Hazel b.1935, *Millennium Time Warp*, © the artist

Titherley, Hazel b.1935, *Craven Landscape*, © the artist

Trevelyan, Julian 1910–1988, *Florence by Night, Italy*, purchased, 1987, © the artist's estate

Trevelyan, Julian 1910–1988, *Gozo, Malta*, donated by Jean Chamberlin, 1990, © the artist's estate

Trevelyan, Julian 1910–1988, *Salt-Gatherers*, donated by Jean Chamberlin, 1990, © the artist's estate

Trevelyan, Julian 1910–1988, *French Landscape II*, donated by Jean Chamberlin, 1990, © the artist's estate

Trevelyan, Julian 1910–1988, *Lot, France*, donated by Jean Chamberlin, 1990, © the artist's estate

Trevelyan, Julian 1910–1988, *Boats*, donated by Jean Chamberlin, 1990, © the artist's estate

Trevelyan, Julian 1910–1988, *French Landscape with Large Sun*, donated by Jean Chamberlin, 1990, © the artist's estate

Trevelyan, Julian 1910–1988, *Temple Meads Station, Bristol*, donated by Jean Chamberlin, 1990, © the artist's estate

Trevelyan, Julian 1910–1988, *The Thames at Richmond*, donated by Jean Chamberlin, 1990, © the artist's estate

Trevelyan, Julian 1910–1988, *Warehouse*, donated by Jean Chamberlin, 1990, © the artist's estate

Trevelyan, Julian 1910–1988, *French Landscape I*, donated by Jean Chamberlin, 1990, © the artist's estate

unknown artist *John Cosin (1594–1672), Bishop of Durham*, possibly made to hang in Cosin's Library

unknown artist 17th C, *A Young Lady in a Dark Yellow Dress*

unknown artist 17th C, *Edward Hyde (1609–1674), Earl of Clarendon*, possibly made to hang in Cosin's Library

unknown artist 17th C, *Edwin Sandys (c.1516–1588), Archbishop of York*, possibly made to hang in Cosin's Library

unknown artist 17th C, *Francis White (1564–1638), Bishop of Ely*, possibly made to hang in Cosin's Library

unknown artist 17th C, *George Villiers (1592–1628), 1st Duke of Buckingham*, possibly made to hang in Cosin's Library

unknown artist 17th C, *James Ussher (1581–1656), Archbishop of Armagh*, possibly made to hang in Cosin's Library

unknown artist 17th C, *Jeremy Taylor (1613–1667)*, donated by Mr Sutton of Elton Hall, Stockton, 1842

unknown artist 17th C, *Thomas Bilson (1597–1616), Bishop of Winchester*, possibly made to hang in Cosin's Library

unknown artist 17th C, *Thomas Morton (1564–1659), Bishop of Durham*, possibly made to hang in Cosin's Library

unknown artist 17th C, *William Cecil (1520–1598), 1st Lord Burghley, Treasurer*, possibly made to hang in Cosin's Library

unknown artist late 17th C, *Jerusalem, Palestine*

unknown artist late 17th C, *The Pedlar (Man Carrying a Load)*, donated by Mr Barry

unknown artist late 17th C–early 18th C, *Nathaniel, Lord Crewe*

(1633–1722), Bishop of Durham, possibly made to hang in Cosin's Library

unknown artist late 17th C-early 18th C, *Tobie Matthew (1546–1628), Archbishop of York,* possibly made to hang in Cosin's Library

unknown artist *Edward Chandler (1668–1750), Bishop of Durham (1730–1750)*

unknown artist *Thomas M. Winterbottom (c.1765–1859)*

unknown artist early 18th C, *A Panorama of Durham City from the North West*

unknown artist early 18th C, *Durham Castle from the South*

unknown artist early 18th C, *North Prospect of Durham Cathedral with West Spires*

unknown artist 18th C, *A Panorama of Durham City from the North West*

unknown artist 18th C, *Fishermen on a Lake Shore*

unknown artist late 18th C, *Martin Joseph Routh (1755–1854) or His Father, Peter Routh*, transferred from Durham Cathedral Chapter (?)

unknown artist *The South Face of the North Gate, Sadler Street, Durham*

unknown artist *Eric Halladay*

unknown artist *Trevelyan Hex Cooperative Creation*, executed as a fundraiser (£1 per hexagon) in Duck Week, 1998

unknown artist 20th C, *Landscape with Bushes and Low Cliff*

unknown artist 20th C, *Landscape with Ruin on the Coast*

unknown artist *Abstract**

unknown artist *Child with a Cut Finger**

unknown artist *Classical Landscape*

unknown artist *Duck**

unknown artist *Jesus Icon*

unknown artist *Landscape with River**

unknown artist *St Andrew*, purchased, c.1850

unknown artist *St Bartholomew*, purchased, c.1850

unknown artist *St Filipe*, purchased, c.1850

unknown artist *St Jerome*, purchased, c.1850

unknown artist *St Matthew*, purchased, c.1850

unknown artist *St Paul*, purchased, c.1850

unknown artist *St Simon the Zealot*, purchased, c.1850

unknown artist *St Taddeus*, purchased, c.1850

unknown artist *St Thomas*, purchased, c.1850

unknown artist *Samuel Stoker (b.1936)*, commissioned upon the sitter's retirement, 2000

unknown artist *The Cigarette-Lighter Vendor**, presented by Mark Jones, 2007

unknown artist *The Creation of Adam*, funded by students, 2006

unknown artist *The Novice with a Rosary*

unknown artist *The Reverend Dr Stephen R. P. Mousdale*

unknown artist *The Reverend Professor David Jasper*

unknown artist *Unknown Saint*

unknown artist *Young Man, Abstract Background**

unknown artist *Young Man, Seated with Toy Plane**

Voysey (attributed to) *A Former Principal**

Walker, John b.1939, *Abstract Series 1**, commissioned with the Arts Council, 1971, © the artist

Walker, John b.1939, *Abstract Series 2**, commissioned with the Arts Council, 1971, © the artist

Walker, John b.1939, *Abstract Series 3**, commissioned with the Arts Council, 1971, © the artist

Walker, John b.1939, *Abstract Series 4**, commissioned with the Arts Council, 1971, © the artist

Walker, John b.1939, *Abstract Series 5**, commissioned with the Arts Council, 1971, © the artist

Walker, John b.1939, *Abstract Series 6**, commissioned with the Arts Council, 1971, © the artist

Walker, Roy 1936–2001, *Clown Dance*, purchased, 1995, © the artist's estate

Warren, Vera *Landscape*, purchased, 1985

Waugh *Queen Elizabeth II (b.1926)**

Wenceslaus, Hollar (after) 1607–1677, *Charles I (1600–1649)*

Wilcox, Leslie Arthur 1904–1982, *Charles Robert Grey (1879–1963), the 5th Earl Grey* (after Philip Alexius de László)

Wilcox, Leslie Arthur 1904–1982, *Charles (1764–1845), the 2nd Earl Grey* (after Thomas Lawrence)

Wilcox, Leslie Arthur 1904–1982, *Dr Syd Holgate*

Wilcox, Leslie Arthur 1904–1982, *Eric Barff Birley (1906–1995), MBE, MA, FBA, FSA*, acquired, 1954/1955

Wilcox, Leslie Arthur 1904–1982, *Sir James Fitzjames Duff (1898–1970)*

Wilcox, Leslie Arthur 1904–1982, *Thomas Anthony Whitworth, MA, DPhil, FGS*, commissioned, 1974

Willmore, Joyce 1916–1996, *Hollingside Lane*, © the artist's estate

Woodward, William Barry b.1929, *Green Harbour Light*, acquired, 2004, © the artist

Woodward, William Barry b.1929, *Red Harbour Light*, donated by the artist, 2004, © the artist

Woolnoth, Thomas A. 1785–1857, *Bishop Henry Phillpotts (1778–1869)*

Wyck, Jan c.1640–1700, *William III at the Battle of the Boyne, 1690*

Wyck, Jan (after) c.1640–1700, *A Stag Hunt*

Easington District Council

Robson, George b.1945, *Durham Miners' Gala*, commissioned by Easington District Council, 2000, © the artist

Robson, George b.1945, *Durham Miners' Gala*, commissioned by Easington District Council, 2000, © the artist

Robson, George b.1945, *Durham Miners' Gala* (left panel), commissioned by Easington District Council, 2000, © the artist

Robson, George b.1945, *Durham Miners' Gala* (centre panel), commissioned by Easington District Council, 2000, © the artist

Robson, George b.1945, *Durham Miners' Gala* (right panel), commissioned by Easington District Council, 2000, © the artist

Collection Addresses

Barnard Castle

The Bowes Museum
Barnard Castle DL12 8NP
Telephone 01833 690606

Beamish

Beamish, The North of England Open Air Museum
Regional Resource Centre, Beamish DH9 0RG
Telephone 0191 370 4000

Bishop Auckland

Auckland Castle
Bishop Auckland DL14 7NR
Telephone 01388 601627

Bishop Auckland Town Hall
Market Place, Bishop Auckland DL14 7NP
Telephone 01388 602610

Consett

Derwentside District Council
Civic Centre, Medamsley Road, Consett DH8 5JA
Telephone 01207 218000

Crook

Wear Valley District Council
Civic Centre, North Terrace, Crook DL15 9ES
Telephone 01388 765555

Darlington

Darlington Borough Art Collection:

> Darlington Arts Centre
> Vane Terrace, Darlington DL3 7AX
> Telephone 01325 348843

> Darlington Library
> Darlington Centre for Local Studies
> Crown Street, Darlington DL1 1ND
> Telephone 01325 349630

Darlington Railway Museum
North Road Station, Darlington DL3 6ST
Telephone 01325 460532

Durham

Durham City Council
17 Claypath, Durham DH 1 1RH
Telephone 0191 301 8499

Durham County Council
County Hall, Durham DH1 5UL
Telephone 0191 383 3000

Durham Light Infantry Museum
Aykley Heads, Durham DH1 5TU
Telephone 0191 384 2214

Durham University
University Office, Old Elvet DH1 3HP
Telephone 0191 334 2000

Easington

Easington District Council
Arts Development, District of Easington Council Offices
Seaside Lane, Easington SR8 3TN
Telephone 0191 527 0501

Index of Artists

In this catalogue, artists' names and the spelling of their names follow the preferred presentation of the name in the Getty Union List of Artist Names (ULAN) as of February 2004, if the artist is listed in ULAN.

The page numbers next to each artist's name below direct readers to paintings that are by the artist; are attributed to the artist; or, in a few cases, are more loosely related to the artist being, for example, 'after', 'the circle of' or copies of a painting by the artist. The precise relationship between the artist and the painting is listed in the catalogue.

Gaunt, Jonas 97

Gautrin, Louise-Thérèse-Aline (active c.1830–1840) 97

Geeraerts, Marcus the younger (1561–1635) 97

Geirnaert, Jozef (1791–1859) 97

Genillion, Jean Baptiste François (1750–1829) 97

Gennari, Cesare (1637–1688) 300

Gérard, François (1770–1837) 97, 98

German School 98, 99, 300

Ghirlandaio, Domenico (1449–1494) 99

Giaquinto, Corrado (1703–1765) 99, 280

Gibb, Thomas Henry (1833–1893) 237

Gibbs, John Binney (1859–1935) 237

Giffroy (active 19th C) 99

Gillemans, Jan Pauwel II (1651–c.1704) 99, 101

Gilroy, John Thomas Young (1898–1985) 101

Giordano, Luca (1634–1705) 101

Giorgione (1477–1510) 216

Girodet de Roucy-Trioson, Anne-Louis (1767–1824) 101, 199

Girolamo da Carpi (c.1501–1556) 101

Giulio Romano (1499–1546) 101

Glauber, Johannes (1646–1727) 101

Glendenning, J. A. 260

Glover, John (1767–1849) 101

Goes, Hugo van der (c.1420–1482) 101, 300

Gollon, Christopher (b.1953) 300

Goltzius, Hendrick (1558–1617) 102

Gontier, Pierre-Camille (b.1840) 102

González, Bartolomé (1564–1627) 102

Gordon, John Watson (1788–1864) 102

Gordon, W. (active 1970) 276

Gore, Spencer (1878–1914) 237

Gossaert, Jan (c.1478–1532) 102

Goulet (active c.1800–1803) 102

Goya, Francisco de (1746–1828) 102, 103, 118

Graat, Barent (1628–1709) 103

Granet, François-Marius (1775–1849) 103, 289

Grant, James Ardern (1887–1973) 300

Grassi, Nicola (1682–1748) 103

Gray, Laurie E. 237

Green, J. W. 267

Grenet de Joigny, Dominique Adolphe (1821–1885) 103

Greuze, Jean-Baptiste (1725–1805) 103

Griffier, Jan II (active 1738–1773) 103

Grimmer, Abel (c.1570–c.1619) 104

Grobon, François-Frédéric (1815–1901) 104

Gros, Antoine-Jean (1771–1835) 104

Grove, John (active 20th C) 104

Guardi, Francesco (1712–1793) 104

Gudin, Henriette Herminie (1825–1876) 104

Gudin, Jean Antoine Théodore (1802–1880) 104, 105

Guérard, Henri Charles (1846–1897) 105

Guercino (1591–1666) 105

Gush, William (1813–1888) 238

W. L. H. (active 19th C) 105

Haften, Nicolas van (1663–1715) 105

Hagemann, Godefroy de (d.1877) 106

Hager, Inga 301

Haigh, Robert (b.1973) 301

Haire, A. L. (active 1976) 276

Hall, Oliver (1869–1957) 106

Halliday, Colin Thomas (b.1964) 301

Halswelle, Keeley (1832–1891) 238

Hamen y León, Juan van der (1596–1631) 106

Hardenberg, Cornelis van (1755–1843) 106

Hardey, Richard (d.1902) 106

Harley, Robert (c.1825–1884) 106

Harman, G. 301

Harmar, Fairlie (1876–1945) 238

Harper, Andy (b.1971) 276

Harrison, G. M. 301

Harrison, John Brown (1876–1958) 238

Harrogate, Davey (active late 19th C) 200

Haslehurst, Ernest William (1866–1949) 106

Hastings, Edward (1781–1861) 267, 271, 301, 302

Haughton, Benjamin (1865–1924) 238

Hawkins, James (b.1954) 302

Hawksley, Maude 238

Haynes-Williams, John (1836–1908) 217, 238

Heath, Adrian (1920–1992) 238

Hedley, Ralph (1848–1913) 200, 238, 267, 302

Heem, Cornelis de (1631–1695) 64, 107

Heemskerck, Egbert van the elder (1634/1635–1704) 107

Heemskerck, Maerten van (1498–1574) 107, 307

Heil, Daniel van (1604–1662) 107

Helst, Bartholomeus van der (1613–1670) 107

Hemessen, Catharina van (1528–after 1587) 107

Héreau, Jules (1839–1879) 107

Herkomer, Hubert von (1849–1914) 267

Hermann, Franz Ludwig (1710–1791) 107

Herring, John Frederick I (1795–1865) 108

Herring, John Frederick II (1815–1907) 108

Heslop, Robert John (1907–1988) 276–278

Heumann, Corinna (b.1962) 302

Heywood, Harry 239

Hicks, Peter Michael (b.1937) 239

Hilder, Richard (1813–1852) 108

Hill, Ernest 239

Hobson, Victor William (1865–1889) 108, 239

Hoet, Gerard (1648–1733) 108

Hoet, Hendrick Jacob (c.1693–1733) 108

Hogarth, William (1697–1764) 239

Hold, Abel (1815–1891) 108

Hondecoeter, Melchior de (1636–1695) 108, 302

Hood, D. (active c.1900–1921) 200, 201

Hoogstraten, Abraham van (d.1736) 110

Hoppenbrouwers, Johannes Franciscus (1819–1866) 110

Horsley, John Callcott (1817–1903) 303

Horsley, T. 110

Huchtenburgh, Jan van (1647–1733) 110

Hudson, Gerald 285

Hudson, Thomas (1701–1779) 110

Hudson, Willis Richard Edwin (1862–1936) 201

Huet, Jean-Baptiste I (1745–1811) 110

Hughes, John Joseph (1820–1909) 110

Hugues, Victor Louis (1827–1879) 110

Huilliot, Pierre Nicolas (1674–1751) 110

Hulle, Anselmus van (c.1601–c.1674) 111

Hulsdonck, Jacob van (1582–1647) 111

Hunt, C. 239

Hyde, E. 239

Italian (Neapolitan) School 111

Italian (Piedmontese) School 111

Italian (Roman) School 111

Italian (Venetian) School 112, 328

Italian School 112–114

Jacobber, Moïse (1786–1863) 114

Jacque, Charles Émile (1813–1894) 114

James, Louis (1920–1996) 278

Janssens, Victor Honoré (1658–1736) 303

Jarry, Joseph 114

Jennens & Bettridge (active c.1845–1850) 239, 240

Johnson, Ben (b.1946) 303

Supporters of The Public Catalogue Foundation

Master Patrons

The Public Catalogue Foundation is greatly indebted to the following Master Patrons who have helped it in the past or are currently working with it to raise funds for the publication of their county catalogues. All of them have given freely of their time and have made an enormous contribution to the work of the Foundation.

Peter Andreae *(Hampshire)*
Sir Henry Aubrey-Fletcher, Bt, Lord Lieutenant of Buckinghamshire *(Berkshire and Buckinghamshire)*
Sir Nicholas Bacon, DL, High Sheriff of Norfolk *(Norfolk)*
The Hon. Mrs Bayliss, JP, Lord Lieutenant of Berkshire *(Berkshire)*
Ian Bonas *(County Durham)*
Peter Bretherton *(West Yorkshire: Leeds)*
Sir Hugo Brunner, KCVO, JP, Lord Lieutenant of Oxfordshire *(Oxfordshire)*
Lady Butler *(Warwickshire)*
Richard Compton *(North Yorkshire)*
George Courtauld, DL, Vice Lord Lieutenant of Essex *(Essex)*
The Marquess of Downshire *(North Yorkshire)*
Jenny Farr, MBE, DL, *(Nottinghamshire)*
John Fenwick *(Tyne & Wear Museums)*
Mark Fisher, MP *(Staffordshire)*
Patricia Grayburn, MBE, DL *(Surrey)*
Algy Heber-Percy, Lord Lieutenant of Shropshire *(Shropshire)*
The Lady Mary Holborow, Lord Lieutenant of Cornwall *(Cornwall)*

Sarah Holman *(Warwickshire)*
Tommy Jowitt *(West Yorkshire)*
Sir Michael Lickiss *(Cornwall)*
The Rt. Hon. The Lord Mayor of the City of London *(City of London)*
Lord Marlesford, DL *(Suffolk)*
Loraine Morgan-Brinkhurst *(Somerset)*
Lady Sarah Nicholson *(County Durham)*
Sir John Riddell, Lord Lieutenant of Northumberland *(Northumberland)*
Bridget Riley *(Arts Council)*
The Most Hon. The Marquess of Salisbury, PC, DL *(Hertfordshire)*
Julia Somerville *(Government Art Collection)*
Tim Stevenson, OBE, Lord Lieutenant of Oxfordshire *(Oxfordshire)*
Phyllida Stewart-Roberts, OBE, Lord Lieutenant of East Sussex *(East Sussex)*
Lady Juliet Townsend *(Northamptonshire)*
Leslie Weller, DL *(West Sussex)*

Financial support

The Public Catalogue Foundation is particularly grateful to the following organisations and individuals who have given it generous financial support since the project started in 2003.

National Sponsor

Christie's

359